PHOTOGRAPHY IN PRINT

Writings from 1816 to the Present

Edited by Vicki Goldberg

A TOUCHSTONE BOOK
PUBLISHED BY SIMON AND SCHUSTER
NEW YORK

10 9 8 7 6 5 4 3 2 1
10 9 8 7 6 5 4 3 2 1 **Pbk.**

Library of Congress Cataloging in Publication Data

Main entry under title:
Photography in Print.

(A Touchstone book)
Includes bibliographical references and index.
1. Photography—Addresses, essays, lectures.
I. Goldberg, Vicki.
TR185.T5 770 80-16815
ISBN 0-671-25034-5
ISBN 0-671-25035-3 Pbk.

Grateful acknowledgment is made to the following publishers, journals and authors for permission to reprint this material:
Mirror Image: The Influence of the Daguerreotype on American Society (excerpt) by Richard Rudisill. Reprinted by permission of the University of New Mexico Press. Copyright © 1971 by Richard Rudisill.

Some of the pieces in this book fall in the public domain. I am including bibliographic information in order that the reader may refer to the original source.

The Truth Concerning the Invention of Photography: Nicéphore Niépce, His Life and Works, by V. Fouque, New York, Tennant and Ward, 1935.

Bill Presented to the Chamber of Deputies, France, June 15, 1839. Copied from *An Historical and Descriptive Account of the Various Processes of the Daguérreotype and the Diorama*, by Daguerre, London, McLean, 26 Haymarket, 1839.

"Some Account of the Art of Photogenic Drawing", by William Henry Fox Talbot, *The London and Edinburgh Philosophical Magazine and Journal of Science*, vol. XIV, March 1839.

The Edinburgh Review of January 1843.

"An Historical Letter," by L. E. Chittenden, *Camera Notes*, vol. II, no. 1, 1898.

Photographic Pleasures, by Cuthbert Bede, London, T. McLean, 1855. This book was reprinted by Amphoto American Photographic Book Publishing Co., Inc., Garden City, New York, 1973.

A Review by Lady Eastlake, *The London Quarterly Review*, C1, 1857, (American edition). Reprinted in *On Photography, A Source Book of Photo History in Facsimile*, edited by Beaumont Newhall, Century House, Watkins Glen, N.Y., 1956.

"The Stereoscope and the Stereograph," by Oliver Wendell Holmes, *Atlantic Monthly*, June 1859. Reprinted in *On Photography, A Source Book of Photo History in Facsimile*, edited by Beaumont Newhall, Century House, Watkins Glen, N.Y., 1956.

"Photography Extraordinary," by Lewis Carroll, 1855. Reprinted in *Lewis Carroll, Photographer*, by Helmut Gernsheim, New York, Chanticleer Press, Inc., 1950.

"Hiawatha's Photographing,".by Lewis Carroll, 1859. Reprinted in *Lewis Carroll, Photographer*, by Helmut Gernsheim, New York, Chanticleer Press, Inc., 1950.

"An Apology for Art-Photography," Oscar G. Rejlander, *The British Journal of Photography*, Feb. 16, 1863.

The Camera and the Pencil, Marcus Aurelius Root, 1864. Reprinted by Helios, Pawlet, Vermont, 1971.

The Works of John Ruskin, edited by E. T. Cook and Alexander Wedderburn. London: George Allen; New York: Longmans, Green, and Co., 1903. 38 volumes.

Pictorial Effect in Photography, by Henry Peach Robinson, 1869. Reprinted with a new introduction by Robert A. Sobieszek, Helios, Pawlet, Vermont, 1971.

Illustrations of China and Its People, John Thomson. London: Sampson Low, Marston, Low, and Searle, 1873.

"Annals of My Glass House," Julia Margaret Cameron, 1874. Reprinted in *Julia Margaret Cameron, Her Life and Photographic Work*, by Helmut Gernsheim, an Aperture Monograph © 1975 by Helmut Gernsheim.

The Photographic News, March 21, 1889. Reprinted in *Eadweard Muybridge: The Father of the Motion Picture*, Gordon Hendricks, Grossman Publishers, 1975.

Naturalistic Photography, by Peter Henry Emerson, 1889.

"The Death of Naturalistic Photography," by Peter Henry Emerson. Portions of this work are reprinted in *P. H. Emerson: The Fight for Photography as a Fine Art*, by Nancy Newhall, New York, an Aperture Monograph, 1975, and in *P. H. Emerson: Photographer of Norfolk*, © 1974, by Peter Turner and Richard Wood, Gordon Fraser, London.

Interview with Mathew Brady, *The World (The New York World)*, April 12, 1891, by George Alfred Townsend.

"Afield with the Wet Plate," Valentine Blanchard, *The Practical Photographer*, 1891. Reprinted in *Image*, vol. 1, no. 1, Jan. 1952.

"Is Photography among the Fine Arts?" by Joseph Pennell, *Contemporary Review*, vol. 72, 1897.

"The Hand Camera: Its Present Importance," by Alfred Stieglitz, *American Annual of Photography*, 1897.

Photography as a Fine Art, by Charles H. Caffin, 1901, with an introduction by Thomas F. Barrow, New York, Morgan and Morgan, Inc., 1971.

"On the London Exhibitions," by George Bernard Shaw, *Amateur Photographer*, Oct. 1901. Reprinted in *Camera Work*, 1906, no. 14.

Contents

Photo insert follows page 224

PHOTOGRAPHY IN PRINT

Introduction

Photography first stopped time and squeezed an image of the world into a small frame at a moment when time was shifting gears and the earth shrinking. The steam engine was invented in the late eighteenth century, changing the pace of work and travel. Samuel Morse, inventor and later photographer, tapped out his first telegraph message in 1832, seven years before the daguerreotype was announced to the French public. Steam engine, telegraph, and photograph shortened distances between people and between places. One could travel faster and farther by photograph than by train. The engine was an extension of muscle, the telegraph a superhuman voice, and the photograph an unblinking eye with a new outlook on history and knowledge. The photograph could even bring the dear departed closer to the present, a feat highly valued in the first days.

Great inventions cause displacements. Steam power undid John Henry. The telegraph changed the shape of communications, and thereby of business, diplomacy, war. Many of the changes photography would wreak were foreseen from the first; others were so subtle and far reaching we have not yet managed to unravel them. From the beginning, the power of the new instrument to render reality struck the world as mysterious, awesome, frightening, and some even said blasphemous, since only God could actually produce in His own

image. John Thomson was attacked by Chinese who believed the camera could shorten their lives. Balzac feared it would strip away one of the limited number of auras allotted to every being.

Artists feared it would replace painting; it did in fact replace the itinerant portrait painter. "From this day painting is dead," declared the painter Paul Delaroche in 1839—painting's highest aspiration being the faithful reproduction of the world. Well, painting still has a lot of life in it. But it is hard to comprehend how profoundly photography has affected both art and vision. We look at art—indeed, at the visible world—differently because we can hold its simulacrum in our hands.

When photography was born, mechanical efficiency was much on everybody's mind. A number of observers thought photographs would be great time savers for artists: make more studies than they could ever make, catch details they'd missed. We know now that artists relied heavily on photographs, but kept mum about it. Too embarrassing. The hand and eye were supposed to be enough; mechanical intervention was suspect. Yet Renoir, and later Picasso, said boldly that photography had freed painting for other tasks. If this machine could bring back nature as it was (only a few doubted that it really did that), maybe art didn't have to bother. Photography, however, wanted everything, its own natural province and any other it could attain. Almost as soon as it became clear that art could do without the everyday world altogether, photography tried to follow suit. The camera had already been flirting with abstraction for some time when, in 1917, Alvin Langdon Coburn took his first non-objective photographs.

Photography's relation to the other arts has always been equivocal. It was clear right away that the new medium would broaden general knowledge of art. In the nineteenth century, a thoughtful man like M. A. Root could assume that a wide dissemination of images would increase happiness and improve taste. In our own day we are less certain about happiness and taste; the glut of images threatens to reduce nearly everything to the same measurable staleness. What we appreciate and how we see have doubtless changed, for better or worse, because of photographs. William Ivins, an expert on prints, pointed out how limiting was the syntax of the graphic arts, which had been the only transmitters of painting and sculpture, and how photography made available certain styles, certain eras that could not be perceived clearly before.

Photography and art were always tangled, are tangled still. D. O. Hill doctored his photographs to make them more painterly. Illustrators were soon forced to copy photographs. The pictorialists fiddled with gum prints till they looked like chalk drawings, charcoals, any-

thing but photographs. Today painters from Rauschenberg to Warhol appropriate photographs, which they use as freely as palette knives. The photo realist painters make a virtue of looking merely photographic. The holograph approaches sculpture.

Is photography among the fine arts? Once that was a burning question; it smolders in some spots even now. In 1857, Lady Eastlake wrote that what photography does best is "beneath the doing of a real artist at all." Two years later Baudelaire stormed against the heartless bourgeois 'facticity' of the camera. Critics said photography was art if the photographer's hand tinkered heavily with the print in the darkroom. Illustrators cried shame, humbug, and mechanical besides. Then Stieglitz took to the battlements to proclaim that a true artist could produce art no matter what the medium. In a typical fencing posture, George Bernard Shaw announced that photography was not only an art but a better one than painting. Eventually, the proponents of straight photography decided that photographs were art only if they were pure: no laying on of hands, no tinkering.

All that is clear is that the question is unclear. Probably it doesn't matter. The way the issue is usually put, it excludes news, fashion, advertising photographs, and of course snapshots. In the 1970s, the surging popularity (and marketability) of photography brought all these maverick forms into the fold, at least temporarily. These forms—and passport photographs, police photographs, x-ray, microscopic, and telescopic photographs, not to mention film and television—influence the way we dress, eat, vote, think, live, and even die. We have no appropriate definition for photography yet. Possibly it is so complex we never will. Lady Eastlake offered a good starting point when she spoke of a "new form of communication between man and man—neither letter, message, nor picture, which now happily fills up the space between them."

Without a definition, one would think a form would be hard to discuss, but that is not the case. It is only hard to define. Life and love, for example, are difficult to agree on but argued endlessly, whereas pudding, which is easily defined, is seldom debated. Photography has been the cause of a scandalous outpouring of both pictures and, rather more recently, words. It should come as no great surprise that only a small minority of those pictures and words are worth looking at—but that minority is worth looking at over and over. Writing about photography has been notoriously inferior, though photographers have kept up their end. On the other hand, it is something of a relief to realize that the good photographers outnumber the good critics; in the film community, for a while, the matter looked a little dicey. And good

minds have contemplated the photograph. Some exceptional thinkers who were neither professional photographers nor photography critics turned their attention to it: Oliver Wendell Holmes, Baudelaire, Shaw, Santayana, Walter Benjamin, Lewis Mumford, among others. The subject, clearly, is not inferior. In time, it may call up a larger literature worthy of it. Till then, we can pick some plums from a limited orchard.

Many of the first commentators tried to trample the new invention under foot, but the rest spent a fair number of lines marveling. Here was a wonder: under a magnifying glass, a painter's tidy streets turned to a muddy sea of brush strokes, but the daguerreotype kept revealing new details, like tiny shop signs that were entirely legible. Writers in the early years had a lot of predicting and assessing to do. They tackled the issues of whether this was science, art, industry, miracle, or piffle. They appraised its possible functions, they rated its moral value. H. P. Robinson and P. H. Emerson led the battle between the doctored and the "naturalistic" photograph. By the turn of the century, if not engaged in hot and lengthy discussion on photography vs. art, writers indulged in the kind of discursive criticism that World War I killed off: leisurely strolls through the salons, with nods in every direction and side trips to inspect the photographer's personality. The great controversy after the war pitted the straight photograph against the manipulated—again, in a contest that invoked purity, nobility, and art on both sides. Photographers worried about where the art in photography resided. A prestigious group—Edward Weston, Ansel Adams, et al.—swore that self-expression, the individual behind the camera, was the key. As a counter-weight, Moholy-Nagy and much of the next generation were devoted to impersonality; the camera, courting reality, demanded an objective eye.

The pundits swung into action again. Social observers, philosophers, and film critics have dug into photographic territory in surprising numbers; somebody out there believes that photography's influence exceeds the question of is-it-art. Lately art historians, photography historians, and critics have been on the wax, with histories and detailed attention to aesthetics in their pens, not necessarily a guarantee that the state of a literature will improve vastly.

Still, good words about pictures exist in far too great numbers for one book. Some here are very good indeed, and all can lay claim to illuminating some corner of photographic history or aesthetics, or to giving insights into a particular photographer. Well, all but a few, and those are just for fun. By no means comprehensive, this collection ran into the usual publishing problems of space, which meant that many eminent photographers and critics ended up on the cutting-room floor.

As it is, space is unfairly allocated and does not reflect value judgments about photographers; Robert Frank, to name but one example, has only his own few lines because I just couldn't locate an appropriate piece that measured up to his importance. Other good pieces were simply unavailable. My hope is that the book will be useful anyway, and even, on occasion, edifying. Should a reader grow bored reading about photography, he or she is advised to put the book down and go look at photographs. Good photographs beat explanations any day of the week. As for dates, all those in this book have been checked against Beaumont Newhall's invaluable *The History of Photography*.

My thanks to many who offered advice and help, particularly Susan Kismaric and Betsy Jablow at the Museum of Modern Art, Weston Naef, Dennis Longwell, Julie Van Haaften, Gene Thornton, and Sally Stein. Special thanks to those who agreed to let their words appear on the following pages.

V. Fouque

The Truth Concerning
the Invention of Photography:
Nicéphore Niépce, His Life and Works
1935

AN EXCERPT

The earliest existing photograph (now in the Helmut and Alison Gernsheim collection) was taken in 1826 by Nicéphore Niépce (1765–1833) in France. Earlier experimenters, principally Thomas Wedgwood, had produced images; Niépce made them permanent. As early as 1816, he had managed to produce what amounted to a negative, though he did not think to try to print from it. That year he realized he could produce an image without direct sunlight. Niépce also experimented, successfully, with photoengraving. In 1829 he signed a contract with Daguerre "for the purpose of perfecting the heliographic process," (literally "sun drawing"), a process which was his discovery rather than Daguerre's. Before it could be perfected, Niépce died.

. . . .

"When my lens was broken, I could not use my camera. I put an 'artificial eye' in Isidore's jewel case, a small box 18 lignes (the $\frac{1}{12}$th part of the old French 'inch') square. Fortunately I still had the lenses of the solar microscope which, as you know, came from our Grandfather Barrault. I found that one of these small lenses is exactly of the proper focus; the image of the objects is received very sharply and clearly on a field of 13 lignes in diameter.

"I placed the apparatus in the room where I work, facing the bird-house, and the open casement. I made the experiment according to the process which you know, my dear friend, and I saw on the white paper all that part of the bird-house which is seen from the window and a faint image of the casement which was less illuminated than the exterior objects. The effects of the light could be distinguished in the representation of the bird-house up to the sash of the window. This is only a very imperfect attempt; but the image of the objects was extremely small. The possibility of painting in this manner is, I believe, almost demonstrated; and if I succeed in perfecting my process, I am eager to include you in it, in return for the kind interest which you have shown me. I do not deceive myself at all that I face great difficulties, especially in fixing the colours, but with labor and great patience one can do much. That which you have foreseen has happened. The background of the picture you have foreseen has happened. The background of the picture is black, and the objects white, that is, lighter than the background.

"I believe that this manner of painting has been used, and I have seen engravings of this kind. Besides, it would not perhaps be impossible to change this arrangement of colours, also I have some information on it which I am curious to verify. . . ."

Four days have elapsed since the preceding letter. Nicéphore, in his letter of the 9th of the same month, made a very important declaration, and he could at this very moment replace the word *Heliography* with the word *Photography*, since he announced that it is not necessary that the *sun shine* in order to perform the operation. Here are the terms in which he expresses himself:

"I have constructed another camera obscura of a size between the small and larger; and I have employed for this purpose the lens of our old microscope, which is in good condition and which will do very well. This will enable me to compare my experiments at least two at a time: which will be a great advantage.

"I forgot to tell you in my last letter that it is not necessary to operate when the sun shines, and that the movement of this luminary does not cause any change in the position of the image; at least I have not observed any, which I certainly should have noticed. . . ."

Let us repeat that, since May 1816, Nicéphore Niépce had recognized and declared that it was not necessary that the *sun shine* in order to receive in the camera obscura the images of exterior objects, and that consequently he was entitled from this time on to give to his operations on the effects of light the name *Photography!*

. . . .

As we have seen also from the two last letters of Lemaître and of Nicéphore Niépce, the latter had offered to associate himself with Daguerre for cooperating in the perfecting of his heliographic processes and for the purpose of drawing from it the advantages which they were capable of producing.

The month of November and a part of December were employed by the future associates in conferences and in discussions of the terms of their association. Having agreed, Daguerre went to Chalon, and on the 14th of December 1829 the contracting parties approved and signed the preliminary act which we copy literally.

BASIS OF PROVISIONAL AGREEMENT

"Between the undersigned Monsieur Joseph-Nicéphore Niépce, land-owner, living at Chalon-sur-Saône, department of Saône-et-Loire, party of the first part, and

"Monsieur Louis-Jacques-Mandé Daguerre, artist, painter, member of the Legion of Honour, director of the Diorama, living at Paris, party of the second part;

"Who, in order to succeed in the formation of the Society which they propose to form between them, before everything else, have set forth the following:

"Monsieur Niépce, desirous of fixing by a new method, without having recourse to a designer, the views offered by nature, has made researches on this subject; the numerous samples proving this discovery have been the result of his researches. This discovery consists in the spontaneous reproduction of images obtained in the camera obscura.

"Monsieur Daguerre whom he has acquainted with his discovery, and who showing his full interest, especially since it is susceptible of considerable perfection, offers to Monsieur Niépce to join him in order to arrive at this perfection and associate himself in recovering all possible advantages from this new kind of industry.

"This statement having been made, the respective gentlemen have agreed between themselves in the following manner on the provisional and fundamental status of their association:

"Article 1. There will be between MM. Niépce and Daguerre a Society under the commercial name Niépce-Daguerre and for the purpose of cooperating in perfecting the said discovery invented by M. Niépce and perfected by M. Daguerre.

"Article 2. The duration of this Society shall be for ten years from the fourteenth of December instant; it cannot be dissolved before this

term, without the mutual consent of the interested parties. In case of the decease of one of the two associates, he will be replaced in the said society, during the balance of the ten years which have not expired, by him who naturally replaces him. In case of the decease of one of the two associates, the said discovery can never be made public without the signature of both names designated in the first article.

"Article 3. As soon as the present agreement is signed, M. Niépce must confide to M. Daguerre, under the seal of secrecy which must be conserved under penalty of all expense, damages and interest, the principle upon which his discovery rests and he must furnish him with the most exact and substantial documents of the nature, the use, and the different modes of application of the processes which apply to it; finally he must devote himself with all his ability and speed to researches and experiments directed towards the purpose of perfecting and utilizing this discovery.

"Article 4. M. Daguerre undertakes under the above-mentioned condition to guard with greatest secrecy both the fundamental principle of the discovery as well as the nature, use and explanations of the processes which will be communicated to him, and to cooperate to the fullest extent in the improvements which are judged necessary by the useful contribution of his lights and talents.

"Article 5. M. Niépce puts at the disposal and releases to the society, his share as partner in the invention, representing the value of half of the product of which it may be susceptible; and M. Daguerre contributes a new combination of the camera obscura, his talents and his industry, equivalent to the other half of the above-mentioned product.

"Article 6. Immediately after the signature to the present agreement, M. Daguerre must confide to M. Niépce, under the seal of secrecy, which must be conserved under penalty of expense, damages and interest, the principle on which are based the perfections which he contributes to the camera obscura and he must furnish the most precise documents on the nature of the said improvement.

"Article 7. MM. Niépce and Daguerre will furnish in equal parts the cash required for the establishment of this society.

"Article 8. Whenever the partners find it practical to apply said discovery to the process of engraving, that is, the use of the advantages which will result for an engraver from the application of the said process which would give him the preliminary sketch, MM. Niépce and Daguerre agree not to choose any other person than M. Lemaître for making the said application.

"Article 9. After the final contract, the associates will nominate

between them the director and treasurer of the Society whose office will be at Paris. The director will administer the operations ordered by the partners; and the treasurer will receive and pay the bills and demands required by the directors in the interest of the Society.

"Article 10. The term of office of the director and treasurer will extend for the period of the present agreement; however they may be reelected. Their services will be gratuitous, or there may be allowed them a part of the profits, as it may be deemed proper by the partners, according to the final contract.

"Article 11. Each month the treasurer will render his accounts to the director, giving the condition of the Society; at each semester the partners will draw the profits in accordance with the article stated later.

"Article 12. The accounts of the treasurer and the statement of affairs will be audited, signed and initialed each semester by the two partners.

"Article 13. The improvements and perfections contributed to the said discovery as well as the improvements contributed to the camera obscura are and remain acquired for the profit of the two partners who, after they have arrived at the object which they propose, will make a final contract between them on the basis of the present one.

"Article 14. The profits of the partners and the net products of the Society will be distributed equally between M. Niépce in his capacity of inventor, and M. Daguerre for his improvements.

"Article 15. Any disputes which may arise between the two partners in consequence of the present agreement will be finally adjudged, without appeal or recourse to the courts, by arbitrators, nominated by each of the parties in order to settle any quarrel amicably and conforming with article 51 of the Commercial Code.

"Article 16. In case of the dissolution of this Society, the liquidation will be made by the treasurer, also amicably, or by both of the partners, or finally by a third person whom they will amicably nominate or who will be nominated by a competent tribunal in the best interests of the partners.

"All this is regulated provisionally between the parties who, for the execution of the present, will elect a domicile in their respective homes designated above.

"Signed in duplicate at Chalon-sur-Saône, on the fourteenth of December, one thousand eight hundred twenty-nine.

"I approve, although not written by my hand,

"J.-N. NIÉPCE.

"I approve, although not written by my hand,

"DAGUERRE.

"Recorded at Chalon-sur-Saône on the thirteenth of March 1830, fol. 32, Vol. C.9 and following. Received five francs fifty centimes, ⅒th included.

"DUCORDEAUX."

. . . .

Bill Presented to
the Chamber of Deputies, France
June 15, 1839

By 1837, Louis Jacques Mandé Daguerre (1787–1851) had produced a permanent image by modifying Niépce's technique. He demonstrated the process in secret to François Arago, director of the Paris Observatory. Since it seemed impossible to protect a patent on the invention, Arago recommended that the French government purchase it and make it available to the public, a measure which was proposed and accepted in 1839. The minister who introduced the bill foresaw that photography would render great service to the study of science and even greater to the arts.

CHAMBER OF DEPUTIES
SECOND SESSION OF 1839

The Particulars and Motives of a Bill

Tending to grant: 1st, to Mr. Daguerre, an annuity for life of 6,000 francs; 2d, to Mr. Niépce, junior, an annuity for life of 4,000 fr., in return for the cession made by them of the process to fix the objects reflected in a *camera obscura*,

Presented by the Minister of the Interior

Sitting of the Fifteenth June 1839

Gentlemen,

We believe that we shall have anticipated the desire of the House by proposing to you to make the acquisition, in the name of the State, of the property of a discovery as useful as it was unexpected, and, which, it is important, for the interest of the arts and sciences, should be brought before the public.

You all know, and some of you, Gentlemen, may have already had an opportunity of convincing yourselves of the fact, that, after fifteen years of expensive and persevering labour, Mr. Daguerre has at length succeeded in discovering a process to fix the different objects reflected in a camera obscura, and also, to describe, in four or five minutes, by the power of light drawings, in which the objects preserve their mathematical delineation in its most minute details, and in which the effects of linear perspective, and the diminution of shades arising from aerial perspective, are produced with a degree of nicety quite unprecedented.

We shall not dwell here on the immense utility of such an invention. It will easily be conceived what resources, what new facility it will afford to the study of science, and, as regards the fine arts, the services it is capable of rendering, are beyond calculation.

Draughtsmen and painters, even the most skilful, will find a constant subject of observation in this most perfect reproduction of nature. On the other hand, the process will afford them a quick and easy method of forming collections of sketches and drawings, which they would not be able to procure, unless they were to spend much time and trouble in doing them with their own hand, and even then they would be far less perfect.

The art of engraving, which consists in multiplying, by reproducing them, these figures, traced as it were from nature itself, will derive fresh and important benefits from the discovery.

In fact to the traveller, to the archaiologist (sic) and also to the naturalist, the apparatus of M. Daguerre will become an object of continual and indispensable use. It will enable them to note what they see, without having recourse to the hand of another. Every author will in future be able to compose the geographical part of his own work: by stopping awhile before the most complicated monument, or the most extensive *coup-d'oeil*, he will immediately obtain an exact *facsimile* of them.

Unfortunately, the authors of this beautiful discovery cannot make an industry of it, so as to recover a part of the immense sacrifices that so many and long unsuccessful experiments have required. No patent that can be taken out will protect their invention. As soon as a knowledge of it be acquired, everybody may apply it to their own purpose. With it, the most unskilful may make drawings, with the same dexterity as the most clever artist. The process will, therefore, either become the property of everybody, or forever remain a secret. What would not be the just regret of the friends of the arts and sciences, if such an important secret were to remain impenetrable to the public, if it were to be lost, and die, as it were, in the hands of its inventors.

In such an exclusive case, it is proper that Government should come forward and enable the public to possess a discovery, which, it is of general interest, they should be allowed to enjoy to its fullest extent, by previously granting to its inventors the price, or we would rather say, a reward for their invention.

Such are the motives which have induced us to conclude with Messrs. Daguerre and Niépce a provisional treaty, of which the bill, that we have now the honour to submit to you, has for object to request your sanction.

Before we lay before you the fundamental clauses of this treaty, it is expedient that we should state some further particulars.

The possibility of fixing transiently the objects reflected in a *camera obscura*, was ascertained as early as the last century; but the discovery afforded no likelihood of success, for this reason, that the substance, on which the rays of the sun described the objects, possessed not the property of preserving them, and that the substance itself became instantly black when exposed to the light.

Mr. Niépce, senior, discovered the means of rendering the objects permanent. But, although he had succeeded in solving this difficult problem, still was his invention highly imperfect. He could only obtain a mere *silhouette* of the objects, and twelve hours at least were requisite to enable him to obtain a drawing of the smallest dimensions.

It is by quite a different course, and by completely laying aside the traditions of Mr. Niépce, that Mr. Daguerre has attained the admirable results which we now behold, that is to say, the extreme promptitude of the operation, and the re-production of aerial perspective, together with the full effects of shades and lights. The method of Mr. Daguerre is of his own invention, and is distinct from that of his predecessor, in its course as well as in its effects. However, whereas before the death of Mr. Niépce, senior, a treaty had been concluded between the latter and Mr. Daguerre, whereby they mutually agreed

to divide between them, whatever benefits they might reap from their respective discoveries; and whereas, this stipulation was extended in behalf of the son of Mr. Niépce, it would be impossible to treat with Mr. Daguerre alone, even as regards the process which he has not only brought to perfection, but has also invented. Besides, it would be hard to infer, that because the method of Mr. Niépce has hitherto remained in a state of imperfection, it may never be liable to be improved upon, or to be applied with success in certain circumstances, and that, for that reason, it is of little or no import to history and science whether it be given to the public at the same time as that of Mr. Daguerre or not.

These explanations, Gentlemen, will, we trust, give you fully to understand wherefore and in what right MM. Daguerre and the son of Mr. Niépce were admitted by us as the contracting parties in the convention, which you will find annexed to the bill which we now bring before you.

The sum of 2,000,000 fr. had in the first instance been asked, for the concession of the processes of Messrs. Niépce and Daguerre, and we think it right to state here, that offers made by the sovereigns of certain foreign powers fully justified such high pretensions. However, we have obtained that in lieu of the sum of capital required, a life interest only should be granted, viz.: a pension of 10,000 fr. revertible in equal halves only to the widows.

The attribution of this pension will be effected as follows:

6,000 fr. to Mr. Daguerre;

4,000 fr. to Mr. Niépce's son.

Besides the reasons which we submitted to you above, one alone fully justifies this unequal division. Mr. Daguerre has consented to make public the processes, by which he produces the effects of the Diorama, an invention of which he alone possesses the secret, and which it would be a pity to lose.

Previous to signing the convention, Mr. Daguerre placed in our hands, but under seal, the description of the process of Mr. Niépce, that of his own method, and also that of the Diorama.

We can affirm, in this House, that these descriptions are complete and correct: for a member of this Chamber, whose name also may be considered an incontestable authority,[1] who has received from Mr. Daguerre, in confidence, communication of the whole of his processes, and who has himself made experiments, has examined one and all the documents in question, and certifies them to be correct.

We hope, Gentlemen, that you will approve the motives which

1. *Mr. Arago*

have induced us to consent to the treaty, as well as the conditions on which it is granted. You will, we feel confident, participate in an idea which has already excited general sympathy, and you will never suffer us to allow any foreign power to have the glory of having bestowed on the learned and artistick [sic] world one of the most wonderful discoveries of which our country can boast.

William Henry Fox Talbot

"Some Account of the Art of Photogenic Drawing"
1839

William Henry Fox Talbot (1800–1877), an English mathematician, scientist, and linguist, began experiments with photography in 1833 with objects placed directly on sensitized paper and exposed to the sun. He proceeded to work with the camera obscura; a tiny negative of a window, taken in 1835, still survives. Evidently he did not know of Daguerre's research until the announcement of 1839; he hurriedly delivered a paper on his work to establish priority. Shortly thereafter he began printing from his paper negatives. In the result lay the future of photography, but for the moment, the daguerreotype held the field. Talbot later invented a process that was the forerunner of photomechanical reproduction.

I.

In the spring of 1834 I began to put in practice a method which I had devised some time previously, for employing to purposes of utility the very curious property which has been long known to chemists to be possessed by the nitrate of silver; namely, its discoloration when ex-

posed to the violet rays of light. This property appeared to me to be perhaps capable of useful application in the following manner.

I proposed to spread on a sheet of paper a sufficient quantity of the nitrate of silver, and then to set the paper in the sunshine, having first placed before it some object casting a well-defined shadow. The light, acting on the rest of the paper, would naturally blacken it, while the parts in shadow would retain their whiteness. Thus I expected that a kind of image or picture would be produced, resembling to a certain degree the object from which it was derived. I expected, however, also, that it would be necessary to preserve such images in a portfolio, and to view them only by candle-light; because if by daylight, the same natural process which formed the images would destroy them, by blackening the rest of the paper.

Such was my leading idea before it was enlarged and corrected by experience. It was not until some time after, and when I was in possession of several novel and curious results, that I thought of inquiring whether this process had been ever proposed or attempted before? I found that in fact it had; but apparently not followed up to any extent, or with much perseverance. The few notices that I have been able to meet with are vague and unsatisfactory; merely stating that such a method exists of obtaining the outline of an object, but going into no details respecting the best and most advantageous manner of proceeding.

The only definite account of the matter which I have been able to meet with, is contained in the first volume of the Journal of the Royal Institution, page 170, from which it appears that the idea was originally started by Mr. Wedgwood, and a numerous series of experiments made both by him and Sir Humphry Davy, which however ended in failure. I will take the liberty of quoting a few passages from this memoir.

" The copy of a painting, immediately after being taken, must be kept in an obscure place. It may indeed be examined in the shade, but in this case the exposure should be only for a few minutes. No attempts that have been made to prevent the uncoloured parts from being acted upon by light, have as yet been successful. They have been covered with a thin coating of fine varnish; but this has not destroyed their susceptibility of becoming coloured. When the solar rays are passed through a print and thrown upon prepared paper, the unshaded parts are slowly copied; but the lights transmitted by the shaded parts are seldom so definite as to form a distinct resemblance of them by producing different intensities of colour.

" The images formed by means of a *camera obscura* have been found to be too faint to produce, in any moderate time, an effect upon the

nitrate of silver. To copy these images was the first object of Mr. Wedgwood, but all his numerous experiments proved unsuccessful."

These are the observations of Sir Humphry Davy. I have been informed by a scientific friend that this unfavourable result of Mr. Wedgwood's and Sir Humphry Davy's experiments, was the chief cause which discouraged him from following up with perseverance the idea which he had also entertained of fixing the beautiful images of the *camera obscura*. And no doubt, when so distinguished an experimenter as Sir Humphry Davy announced " that all experiments had proved unsuccessful," such a statement was calculated materially to discourage further inquiry. The circumstance also, announced by Davy, that the paper on which these images were depicted was liable to become entirely dark, and that nothing hitherto tried would prevent it, would perhaps have induced me to consider the attempt as hopeless, if I had not (fortunately) before I read it, already discovered a method of overcoming this difficulty, and of *fixing* the image in such a manner that it is no more liable to injury or destruction.

In the course of my experiments directed to that end, I have been astonished at the variety of effects which I have found produced by a very limited number of different processes when combined in various ways; and also at the length of time which sometimes elapses before the full effect of these manifests itself with certainty. For I have found that images formed in this manner, which have appeared in good preservation at the end of twelve months from the time of their formation, have nevertheless somewhat altered during the second year. This circumstance, added to the fact that the first attempts which I made became indistinct in process of time (the paper growing wholly dark), induced me to watch the progress of the change during some considerable time, as I thought that perhaps *all* these images would *ultimately* be found to fade away. I found, however, to my satisfaction, that this was not the case; and having now kept a number of these drawings during nearly five years without their suffering any deterioration, I think myself authorized to draw conclusions from my experiments with more certainty.

2. EFFECT AND APPEARANCE OF THESE IMAGES

The images obtained in this manner are themselves white, but the ground upon which they display themselves is variously and pleasingly coloured.

Such is the variety of which the process is capable, that by merely varying the proportions and some trifling details of manipulation, any of the following colours are readily attainable:

Sky-blue,	Brown, of various shades,
Yellow,	Black.
Rose-colour,	

Green alone is absent from the list, with the exception of a dark shade of it, approaching to black. The blue-coloured variety has a very pleasing effect, somewhat like that produced by the Wedgwood-ware, which has white figures on a blue ground. This variety also retains it colours perfectly if preserved in a portfolio, and not being subject to any spontaneous change, requires no preserving process.

These different shades of colour are of course so many different chemical compounds, or mixtures of such, which chemists have not hitherto distinctly noticed.

3. FIRST APPLICATIONS OF THIS PROCESS

The first kind of objects which I attempted to copy by this process were flowers and leaves, either fresh or selected from my herbarium. These it renders with the utmost truth and fidelity, exhibiting even the venation of the leaves, the minute hairs that clothe the plant, &c.

It is so natural to associate the idea of *labour* with great complexity and elaborate detail of execution, that one is more struck at seeing the thousand florets of an *Agrostis* depicted with all its capillary branchlets (and so accurately, that none of all this multitude shall want its little bivalve calyx, requiring to be examined through a lens), than one is by the picture of the large and simple leaf of an oak or a chestnut. But in truth the difficulty is in both cases the same. The one of these takes no more time to execute than the other; for the object which would take the most skilful artist days or weeks of labour to trace or to copy, is effected by the boundless powers of natural chemistry in the space of a few seconds.

To give an idea of the degree of accuracy with which some objects can be imitated by this process, I need only mention one instance. Upon one occasion, having made an image of a piece of lace of an elaborate pattern, I showed it to some persons at the distance of a few feet, with the inquiry, whether it was a good representation? when the reply was, " That they were not to be so easily deceived, for that it was evidently no picture, but the piece of lace itself."

At the very commencement of my experiments upon this subject, when I saw how beautiful were the images which were thus produced by the action of light, I regretted the more that they were destined to have such a brief existence, and I resolved to attempt to find out, if

possible, some method of preventing this, or retarding it as much as possible. The following considerations led me to conceive the possibility of discovering a preservative process.

The nitrate of silver, which has become black by the action of light, is no longer the same chemical substance that it was before. Consequently, if a picture produced by solar light is subjected afterwards to any chemical process, the white and dark parts of it will be differently acted upon; and there is no evidence that after this action has taken place, these white and dark parts will any longer be subject to a spontaneous change; or, if they are so, still it does not follow that that change will *now* tend to assimilate them to each other. In case of their remaining *dissimilar*, the picture will remain visible, and therefore our object will be accomplished.

If it should be asserted that exposure to sunshine would *necessarily* reduce the whole to one uniform tint, and destroy the picture, the *onus probandi* evidently lies on those who make the assertion. If we designate by the letter A the exposure to the solar light, and by B some indeterminate chemical process, my argument was this: Since it cannot be shown, *à priori*, that the final result of the series of processes A B A will be the same with that denoted by B A, it will therefore, be worth while to put the matter to the test of experiment, viz. by varying the process B until the right one be discovered, or until so many trials have been made as to preclude all reasonable hope of its existence.

My first trials were unsuccessful, as indeed I expected; but after some time I discovered a method which answers perfectly, and shortly afterwards another. On one of these more especially I have made numerous experiments; the other I have comparatively little used, because it appears to require more nicety in the management. It is, however, equal, if not superior, to the first in brilliancy of effect.

This chemical change, which I call the *preserving process*, is far more effectual than could have been anticipated. The paper, which had previously been so sensitive to light, becomes completely insensible to it, insomuch that I am able to show the Society specimens which have been exposed for an hour to the full summer sun, and from which exposure the image has suffered nothing, but retains its perfect whiteness.

4. ON THE ART OF FIXING A SHADOW

The phænomenon which I have now briefly mentioned appears to me to partake of the character of the *marvellous*, almost as much as any fact

which physical investigation has yet brought to our knowledge. The most transitory of things, a shadow, the proverbial emblem of all that is fleeting and momentary, may be fettered by the spells of our " *natural magic*," and may be fixed for ever in the position which it seemed only destined for a single instant to occupy.

This remarkable phænomenon, of whatever value it may turn out in its application to the arts, will at least be accepted as a new proof of the value of the inductive methods of modern science, which by noticing the occurrence of unusual circumstances (which accident perhaps first manifests in some small degree), and by following them up with experiments, and varying the conditions of these until the true law of nature which they express is apprehended, conducts us at length to consequences altogether unexpected, remote from usual experience, and contrary to almost universal belief. Such is the fact, that we may receive on paper the fleeting shadow, arrest it there, and in the space of a single minute fix it there so firmly as to be no more capable of change, even if thrown back into the sunbeam from which it derived its origin.

5.

Before going further, I may however add, that it is not always necessary to use a preserving process. This I did not discover until after I had acquired considerable practice in this art, having supposed at first that all these pictures would ultimately become indistinct if not preserved in some way from the change. But experience has shown to me that there are at least two or three different ways in which the process may be conducted, so that the images shall possess a character of durability, provided they are kept from the action of direct sunshine. These ways have presented themselves to notice rather accidentally than otherwise; in some instances without any particular memoranda having been made at the time, so that I am not yet prepared to state accurately on what particular thing this sort of semi-durability depends, or what course is best to be followed in order to obtain it. But as I have found that certain of the images which have been subjected to no preserving process remain quite white and perfect after the lapse of a year or two, and indeed show no symptom whatever of changing, while others differently prepared (and left unpreserved) have grown quite dark in one tenth of that time, I think this singularity requires to be pointed out. Whether it will be of much value I do not know; perhaps it will be thought better to incur at first the small additional trouble of employing the preserving process, especially as the drawings

thus prepared will stand the sunshine; while the unpreserved ones, however well they last in a portfolio or in common daylight, should not be risked in a very strong light, as they would be liable to change thereby, even years after their original formation. This very quality, however, admits of useful application. For this semi-durable paper, which retains its whiteness for years in the shade, and yet suffers a change whenever exposed to the solar light, is evidently well suited to the use of a naturalist travelling in a distant country, who may wish to keep some memorial of the plants he finds, without having the trouble of drying them and carrying them about with him. He would only have to take a sheet of this paper, throw the image upon it, and replace it in his portfolio. The defect of this particular paper is, that in general the *ground* is not even; but this is of no consequence where utility alone, and not beauty of effect is consulted.

6. PORTRAITS

Another purpose for which I think my method will be found very convenient, is the making of the outline portraits, or *silhouettes*. These are now often traced by the hand from shadows projected by a candle. But the hand is liable to err from the true outline, and a very small deviation causes a notable diminution in the resemblance. I believe this manual process cannot be compared with the truth and fidelity with which the portrait is given by means of solar light.

7. PAINTINGS ON GLASS

The shadow-pictures which are formed by exposing paintings on glass to solar light are very pleasing. The glass itself, around the painting, should be blackened; such, for instance, as are often employed for the magic lantern. The paintings on the glass should have no bright yellows or reds, for these stop the violet rays of light, which are the only effective ones. The pictures thus formed resemble the productions of the artist's pencil more, perhaps, than any of the others. Persons to whom I have shown them have generally mistaken them for such, at the same time observing, that the *style* was new to them, and must be one rather difficult to acquire. It is in these pictures only that, as yet, I have observed indications of *colour*. I have not had time to pursue this branch of the inquiry further. It would be a great thing if by any means we could accomplish the delineation of objects in their natural colours.

I am not very sanguine respecting the possibility of this; yet, as I have just now remarked, it appears possible to obtain at least *some indication* of variety of tint.

8. APPLICATION TO THE MICROSCOPE

I now come to a branch of the subject which appears to me very important and likely to prove extensively useful, the application of my method of delineating objects to the solar microscope.

The objects which the microscope unfolds to our view, curious and wonderful as they are, are often singularly complicated. The eye, indeed, may comprehend the whole which is presented to it in the field of view; but the powers of the pencil fail to express these minutiæ of nature in their innumerable details. What artist could have skill or patience enough to copy them? or granting that he could do so, must it not be at the expense of much most valuable time, which might be more usefully employed?

Contemplating the beautiful picture which the solar microscope produces, the thought struck me, whether it might not be possible to cause that image to impress itself upon the paper, and thus to let Nature substitute her own inimitable pencil, for the imperfect, tedious, and almost hopeless attempt of copying a subject so intricate.

My first attempt had no success. Although I chose a bright day, and formed a good image of my object upon prepared paper, on returning at the expiration of an hour I found that no effect had taken place. I was therefore half inclined to abandon this experiment, when it occurred to me, that there was no reason to suppose that either the nitrate or muriate of silver, as commonly obtained, was the most sensitive substance that exists to the action of the chemical rays[1]; and though such should eventually prove to be the fact, at any rate it was not to be assumed without proof. I therefore began a course of experiments in order to ascertain the influence of various modes of preparation, and I found these to be signally different in their results. I considered this matter chiefly in a practical point of view; for as to the theory, I confess that I cannot as yet understand the reason why the paper prepared in one way should be so much more sensitive than in another.

The result of these experiments was the discovery of a mode of preparation greatly superior in sensibility to what I had originally em-

1. *Sir H. Davy somewhere says that the iodide is more sensitive, which I have hardly found to be the case in my experiments.*

ployed: and by means of this, all those effects which I had before only anticipated as theoretically possible were found to be capable of realization.

When a sheet of this, which I shall call " *Sensitive Paper,*" is placed in a dark chamber, and the magnified image of some object thrown on it by the solar microscope, after the lapse of perhaps a quarter of an hour, the picture is found to be completed. I have not as yet used high magnifying powers, on account of the consequent enfeeblement of the light. Of course, with a more sensitive paper, greater magnifying power will become desirable.

On examining one of these pictures, which I made about three years and a half ago, I find, by actual measurement of the picture and the object, that the latter is magnified seventeen times in linear diameter, and in surface consequently 289 times. I have others which I believe are considerably more magnified; but I have lost the corresponding objects, so that I cannot here state the exact numbers.

Not only does this process save our time and trouble, but there are many objects, especially microscopic crystallizations, which alter so greatly in the course of three or four days (and it could hardly take any artist less to delineate them in all their details), that they could never be drawn in the usual way.

I will now describe the *degree of sensitiveness* which this paper possesses, premising that I am far from supposing that I have reached the limit of which this quality is capable. On the contrary, considering the few experiments which I have made (few, that is, in comparison with the number which it would be easy to imagine and propose), I think it most likely, that other methods may be found, by which substances may be prepared, perhaps as much transcending in sensitiveness the one which I have employed, as that does the nitrate of silver which I used in my first experiments.

But to confine myself to what I have actually accomplished, in the preparation of a very sensitive paper. When a sheet of this paper is brought towards a window, not one through which the sun shines, but looking in the opposite direction, it immediately begins to discolour. For this reason, if the paper is prepared by daylight, it must by no means be left uncovered, but as soon as finished be shut up in a drawer or cupboard and there left to dry, or else dried at night by the warmth of a fire. Before using this paper for the delineation of any object, I generally approach it for a little time towards the light, thus intentionally giving it a slight shade of colour, for the purpose of seeing that the *ground* is *even*. If it appears so when thus tried to a small extent, it will generally be found to prove so in the final result. But if there are some

places or spots in it which do not acquire the same tint as the rest, such a sheet of paper should be rejected: for there is a risk that, when employed, instead of presenting a *ground* uniformly dark, which is essential to the beauty of the drawing, it will have large white spots, places altogether insensible to the effect of light. This singular circumstance I shall revert to elsewhere: it is sufficient to mention it here.

The paper then, which is thus readily sensitive to the light of a common window, is of course much more so to the direct sunshine. Indeed, such is the velocity of the effect then produced, that the picture may be said to be ended almost as soon as it is begun.

To give some more definite idea of the rapidity of the process, I will state, that after various trials the nearest evaluation which I could make of the time necessary for obtaining the picture of an object, so as to have pretty distinct outlines, when I employed the full sunshine, was *half a second*.

9. ARCHITECTURE, LANDSCAPE, AND EXTERNAL NATURE

But perhaps the most curious application of this art is the one I am now about to relate. At least it is that which has appeared the most surprising to those who have examined my collection of pictures formed by solar light.

Every one is acquainted with the beautiful effects which are produced by a camera obscura and has admired the vivid picture of external nature which it displays. It had often occurred to me, that if it were possible to retain upon the paper the lovely scene which thus illuminates it for a moment, or if we could but fix the outline of it, the lights and shadows, divested of all *colour*, such a result could not fail to be most interesting. And however much I might be disposed at first to treat this notion as a scientific dream, yet when I had succeeded in fixing the images of the solar microscope by means of a peculiarly sensitive paper, there appeared no longer any doubt that an analogous process would succeed in copying the objects of external nature, although indeed they are much less illuminated.

Not having with me in the country a *camera obscura* of any considerable size, I constructed one out of a large box, the image being thrown upon one end of it by a good object glass fixed in the opposite end. This apparatus being armed with a sensitive paper, was taken out in a summer afternoon and placed about one hundred yards from a building favourably illuminated by the sun. An hour or two afterwards I opened the box, and I found depicted upon the paper a very distinct

representation of the building, with the exception of those parts of it which lay in the shade. A little experience in this branch of the art showed me that with smaller *cameræ obscuræ* the effect would be produced in a smaller timer. Accordingly I had several small boxes made, in which I fixed lenses of shorter focus, and with these I obtained very perfect but extremely small pictures: such as without great stretch of imagination might be supposed to be the work of some Lilliputian artist. They require indeed examination with a lens to discover all their minutiæ.

In the summer of 1835 I made in this way a great number of representations of my house in the country, which is well suited to the purpose, from its ancient and remarkable architecture. And this building I believe to be the first that was ever yet known *to have drawn its own picture*.

The method of proceeding was this: having first adjusted the paper to the proper focus in each of these little *cameræ*, I then took a number of them with me out of doors and placed them in different situations around the building. After the lapse of half an hour I gathered them all up, and brought them within doors to open them. When opened, there was found in each a miniature picture of the objects before which it had been placed.

To the traveller in distant lands, who is ignorant, as too many unfortunately are, of the art of drawing, this little invention may prove of real service; and even to the artist himself, however skilful he may be. For although this natural process does not produce an effect much resembling the productions of his pencil, and therefore cannot be considered as capable of replacing them, yet it is to be recollected that he may often be so situated as to be able to devote only a single hour to the delineation of some very interesting locality. Now, since nothing prevents him from simultaneously disposing, in different positions, any number of these little *cameræ*, it is evident that their collective results, when examined afterwards, may furnish him with a large body of interesting memorials, and with numerous details which he had not had himself time either to note down or to delineate.

10. DELINEATIONS OF SCULPTURE

Another use which I propose to make of my invention is for the copying of statues and bas-reliefs. I place these in strong sunshine, and put before them at a proper distance, and in the requisite position, a small camera obscura containing the prepared paper. In this way I have

obtained images of various statues, &c. I have not pursued this branch of the subject to any extent; but I expect interesting results from it, and that it may be usefully employed under many circumstances.

I I. COPYING OF ENGRAVINGS

The invention may be employed with great facility for obtaining copies of drawings or engravings, or facsimiles of MSS. For this purpose the engraving is pressed upon the prepared paper, with its engraved side in contact with the latter. The pressure must be as uniform as possible, that the contact may be perfect; for the least interval sensibly injures the result, by producing a kind of cloudiness in lieu of the sharp strokes of the original.

When placed in the sun, the solar light gradually traverses the paper, except in those places where it is prevented from doing so by the opake (sic) lines of the engraving. It therefore of course makes an exact image or print of the design. This is one of the experiments which Davy and Wedgwood state that they tried, but failed, from want of sufficient sensibility in their paper.

The length of time requisite for effecting the copy depends on the thickness of the paper on which the engraving has been printed. At first I thought that it would not be possible to succeed with thick papers; but I found on trial that the success of the method was by no means so limited. It is enough for the purpose, if the paper allows any of the solar light to pass. When the paper is thick, I allow half an hour for the formation of a good copy. In this way I have copied very minute, complicated, and delicate engravings, crowded with figures of small size, which were rendered with great distinctness.

The effect of the copy, though of course unlike the original, (substituting as it does lights for shadows, and *vice versa*,) yet is often very pleasing, and would, I think, suggest to artists useful ideas respecting light and shade.

It may be supposed that the engraving would be soiled or injured by being thus pressed against the prepared paper. There is not much danger of this, provided both are perfectly dry. It may be well to mention, however, that in case any stain should be perceived on the engraving, it may be readily removed by a chemical application which does no injury whatever to the paper.

In copying engravings, &c. by this method, the lights and shadows are reversed, consequently the effect is wholly altered. But if the picture so obtained is first *preserved* so as to bear sunshine, it may be

afterwards itself employed as an object to be copied; and by means of this second process the lights and shadows are brought back to their original disposition. In this way we have indeed to contend with the imperfections arising from two processes instead of one; but I believe this will be found merely a difficulty of manipulation. I propose to employ this for the purpose more particularly of multiplying at small expense copies of such rare or unique engravings as it would not be worth while to re-engrave, from the limited demand for them.

I will now add a few remarks concerning the very singular circumstance, which I have before briefly mentioned, viz. that the paper sometimes, although intended to be prepared of the most sensitive quality, turns out on trial to be wholly insensible to light, and incapable of change. The most singular part of this is the very small difference in the mode of preparation which causes so wide a discrepancy in the result. For instance, a sheet of paper is all prepared at the same time, and with the intention of giving it as much uniformity as possible: and yet, when exposed to sunshine, this paper will exhibit large white spots of very definite outline, where the preparing process has failed; the rest of the paper, where it has succeeded, turning black as rapidly as possible. Sometimes the spots are of a pale tint of cœrulean blue, and are surrounded by exceedingly definite outlines of perfect whiteness, contrasting very much with the blackness of the part immediately succeeding. With regard to the theory of this, I am only prepared to state as my opinion at present, that it is a case of what is called " unstable equilibrium." The process followed is such as to produce one of two definite chemical compounds; and when we happen to come near the limit which separates the two cases, it depends upon exceedingly small and often imperceptible circumstances, which of the two compounds shall be formed. That they are both definite compounds, is of course at present merely my conjecture; that they are signally different, is evident from their dissimilar properties.

I have thus endeavoured to give a brief outline of some of the peculiarities attending this new process, which I offer to the lovers of science and nature. That it is susceptible of great improvements, I have no manner of doubt; but even in its present state I believe it will be found capable of many useful and important applications besides those of which I have given a short account in the preceding pages.

The Edinburgh Review
January, 1843
AN EXCERPT

In a century that believed strongly in progress, and in the potential of the machine for conferring good on mankind, photography appeared to some as an almost unlimited blessing, "as great a step in the fine arts as the steam engine was in the mechanical arts." This account extols photography's value to both science and art, as did several early observers. It tries to assess fairly the relative merits and drawbacks of daguerreotypes and Talbotypes, remarking of the latter's painterly qualities that they are a match for Rembrandt's sketches. The first publications concerning photography preserve some of the wonder occasioned by this invention.

. . . .

In following the steps of social improvement, and tracing the rise of those great inventions which add to the happiness of our species, we can scarcely fail to recognise the law of progressive development under which the efforts of individual minds are regulated and combined, and by which reason is destined to attain its maximum of power, and knowledge to reach its limits of extension. Under the influence of a similar law, our moral and religious condition is gradually ascending to its climax; and when these grand purposes have been fulfilled—when the high commission of the Saint and the Sage has been executed—

man, thus elevated to the perfection of his nature, will enter upon a new scene of activity and enjoyment.

The supreme authority which has ordained this grand movement in the living world—this double current of our moral and intellectual sympathies—has prepared the material universe as the arena of its development; and all our civil and religious institutions have been organized as instruments by which that development is to be effected. The confusion of tongues—the physical disunion of empires—the rivalries of industrious nations—are among the auxiliaries by which this triumph is to be consummated. The outbursts of the moral and the physical world form a powerful alliance in the same cause; and in the vigorous reactions which they invoke, the highest qualities of our moral and intellectual being are called into play. The war which desolates, and the fire and flood which destroy, undermine the strongholds of prejudice and corruption, and sweep away the bulwarks in which vice and error have been intrenched. Amid convulsions like these, indeed, civilization often seems to pause, or to recede; but her pauses are only breathing stations, at which she draws a fuller inspiration, and her retrograde steps are but surer footings, from which she is to receive a fresh and onward impulse.

The powers and positions of individuals, too, are all nicely adjusted to the functions they have to discharge. Corporeal frames of every variety of strength—moral courage of every shade of intensity —and intellectuals of every degree of vigour—are among the cardinal elements which are to be set in action. The Sovereign who wields the sceptre, and the Serf who crouches under it, differ only in the place which they occupy in the mysterious mechanism. While one class of agents is stationed amid the heats of friction and pressure, others occupy the quiet points of stable equilibrium; and a larger class forms the inertial mass, or acts as a drag against the stupendous momentum which has been generated. But while busy man is thus labouring at the wheel, the impelling, the maintaining, and the regulating power, is not in him: by an agency unseen are all the heterogeneous elements of force harmonized, and the whole moral and intellectual dynamics of our species brought to bear upon that single point of resistance, where vice and ignorance are to be crushed for ever.

From these general views it is a corollary not to be questioned, that when great inventions and discoveries in the arts and sciences either abridge or supersede labour—when they create new products, or interfere with old ones—they are not on these accounts to be abandoned. The advance which is thus made involves not only a grand and irrevocable fact in the progress of truth, but it is a step in the social

march which can never be retraced. The wants, or the cupidity of a
minister, for his ignorance it cannot be, may tax inventions and knowl-
edge—the fanaticism of a priesthood may proscribe education, and
even the Scriptures of truth—and the blind fury of a mob may stop or
destroy machinery—but cupidity, fanaticism, and rage, have counter
checks within themselves which re-act on the springs of truth and
justice, and finally crush the conspiracy which they had themselves
hatched. If, in the conflict of rival principles, the species gains, and the
individual loses, redress can only be looked for in those compensatory
adjustments which so often and so strangely reconcile general and
individual interests. The same law which closes one channel of labour,
necessarily opens up another, and that often through a richer domain,
and with a wider outlet; and in every substitution of mechanical for
muscular action, man rises into a higher sphere of exertion, in which
the ingenuity of his mind is combined with the exercise of his body.
He is no longer on a professional level with the brutes that perish,
when he ceases to exercise functions which are measured only by so
many horse power, and which can be better extracted from so many
pounds of coal, and so many ounces of water.

Nor is it a less questionable corollary that when one of the arts is
left behind in the race of improvement, and has been lingering amid
the sloth and avarice of its cultivators, it can have no claim on the
sympathy and protection of the community.[1] Were it the art of build-
ing ships, of forging anchors, or of welding cables to form the defensive
bulwarks of the nation, or were it the most trivial manipulation which
administers to the personal vanity of the most frivolous, the principle
would have the same foundation in truth and justice. But when it is
the art of manufacturing food—when the poor and the rich are the
antagonists in the combat—and when it involves the life and death of
starving multitudes, the crime of protection will, in future ages, be
ranked in the same category with that of burning for heresy, or drown-
ing for witchcraft.

Although these observations apply in an especial manner to those
great mechanical inventions which have in this country altered the very
form and pressure of society, yet they are not less applicable to those
remarkable improvements in the Fine Arts which the progress of sci-
ence has so rapidly developed. The arts of painting, sculpture, and
architecture, exhibit in their progress a series of anomalies which occur
in the history of almost no other pursuit. Without any very adequate

1. *We would refer the reader to an admirable letter on this subject by Professor
Johnston of Durham to the Marquis of Northampton.*

cause, they have alternately advanced and receded; and we can discover no leading epoch—no cardinal principle—no striking invention immortalizing the name of any of their cultivators. It would be hazardous to assert that Apelles and Zeuxis were surpassed by Reynolds and Lawrence, and still more so that Praxiteles and Phidias must have yielded the palm to Canova and Chantrey. In our own day, however, very extraordinary inventions and discoveries have already given an impulse, and will soon give a new form to the imitative arts.

The art of multiplying statues by machinery, which we owe to the celebrated James Watt, and which has since been brought to greater perfection, might have been regarded as a vast step in the fine arts; had it not been eclipsed by the splendid process of copying all sorts of sculpture, by the voltaic deposition of metals from their solutions.[2] But even this has been surpassed by the art of Photography, by which we obtain perfect representations of all objects, whether animate or inanimate, through the agency of the light which they emit or reflect. From being at first a simple, and not very interesting process of taking profiles of the human face, it has called to its aid the highest resources of chemistry and physics; and while it cannot fail to give a vigorous impulse to the fine arts, it has already become a powerful auxiliary in the prosecution of physical science; and holds out no slight hope of extending our knowledge of the philosophy of the senses. The art of *Photography*, or *Photogeny* as it has been called, is indeed as great a step in the fine arts, as the steam-engine was in the mechanical arts; and we have no doubt that when its materials have become more sensitive, and its processes more certain, it will take the highest rank among the inventions of the present age.[3]

But before we proceed to exhibit its powers, and discuss its merits, we must put our readers in possession of its history and methods. The action of light and heat upon coloured bodies has been long known, and the changes they produce have been recorded in various countries.
. . . .

2. *The* Electrotype *or* Galeano-plastic *art, which was discovered by Mr. Spencer and M. Jacobi, and which is daily finding new applications to the useful arts.*

3. *We have not here referred to the new and beautiful art of* Anaglyptography, *by which all works in relief, and even statues, may be copied on a plane surface (and even engraved) by means of parallel lines, which deviate from their parallelism in proportion as different points, in all parallel sections of the original, rise above the general plane. This art was, we believe, first invented by an American, then tried in France, but finally brought to perfection by Mr. R. Bate, the son of the well-known optician, Mr. B. Bate of London.*

These interesting facts, though well known throughout Europe, had never been applied to the arts till 1802,[4] when a *method of copying paintings upon glass, and of making profiles by the agency of light upon nitrate of silver*, was first given to the world. This method was the unquestionable invention of our celebrated countryman Mr. Thomas Wedgewood, who published it in the *Journals of the Royal Institution*,[5] where it was accompanied with a few observations in a note by Sir H. Davy.

Having found that white paper or white leather, moistened with a solution of nitrate of silver, passes through different shades of grey and brown, and at length becomes nearly black by exposure to daylight, Mr. Wedgewood exposed papers thus moistened to light of different intensities and colours. In the direct beams of the sun, the full effect upon the paper was produced in two or three minutes. In the shade, several hours were required. The most decided and powerful effects were produced by *blue* and *violet* glasses, while very little action took place when the sun's rays passed through *red* glasses. Hence, says Mr. Wedgewood, 'when a white surface, covered with a solution of *nitrate* of silver, (one part of the nitrate to ten of water,) is placed behind a painting on glass exposed to the solar light, the rays transmitted through the differently painted surfaces produce distinct tints of brown and black, sensibly differing in intensity according to the shades of the picture; and where the light is unaltered, the colour of the light becomes deepest. For copying paintings on glass the solution should be applied on *leather*, and in this case, it is more readily acted upon than when *paper* is used.'

Mr. Wedgewood made various attempts to *fix* these copies, that is, to prevent the uncoloured parts of the copy from being acted upon by light. He tried repeated washings, and thin coatings of fine varnish; but all his trials were unsuccessful; and hence he was obliged to preserve his copies in an obscure place—to take a glimpse of them only in the shade, or to view them by candle light. He applied this method to take profiles or shadows of figures by throwing the shadows on the nitrated surface, the part concealed by the shadows remaining *white*,

4. *M. Arago informs us that M. Charles had in the first year of the 19th century used prepared paper to produce black profiles by the action of light; but he never described the preparation; and he did not claim any priority, although he lived for a long time after the publication of Mr. Wedgewood's process.*

5. *Vol i. p. 170, June 1802. See also Nicholson's Journal, 8vo series, vol. iii. p. 167, Nov. 1802. An Account of a Method of Copying Paintings upon Glass, and of Making Profiles by the Agency of Light upon Nitrate of Silver. Invented by T. Wedgewood, Esq., with Observations by H. Davy. Journals of the Royal Institution, vol. i, p. 170. 1802.*

and the other parts speedily becoming black. He applied it also to make delineations of the woody fibres of leaves, and the wings of insects, and likewise to the copying of prints; but in this last case the results were very unsatisfactory. But the primary object of all Mr. Wedgewood's experiments was to copy the images formed by means of a *camera obscura*. ' His numerous experiments, however, proved unsuccessful,' and the images were ' found to be too faint to produce, in any moderate time, an effect upon the nitrate of silver.' ' In following these processes,' he adds, I have found that the images of small objects, produced by means of the solar microscope, may be copied without difficulty on prepared paper;' but in this case, ' it is necessary that the paper be placed at but a small distance from the lens.'

. . . .

So long ago as 1803, a Notice of Mr. Wedgewood's interesting process was published in an Edinburgh Journal, but the subject does not seem to have excited any attention either in Britain or on the continent. A friend of Mr. Talbot's, indeed, who had entertained the idea of fixing the images of the camera obscura, was discouraged from the attempt by the recorded failure of Mr. Wedgewood. Mr. Talbot himself, however, without any knowledge of Mr. Wedgewood's previous invention, had, some time previous to 1834, been led to the same process, of taking pictures by the agency of light upon nitrate of silver; and, in the spring of that year, he had actually applied it to several useful purposes, and had even overcome the difficulty of fixing the images of the camera obscura, before he knew that that difficulty had stopped the progress of Mr. Wedgewood and his own friend. Mr. Talbot continued to improve his new art, to which he gave the name of *Calotype*, for it had now become entirely his; and, by the aid of his intimate knowledge of chemistry and physics, he has succeeded in bringing it to a very high degree of perfection.

But before we proceed to give an account of his labours, we must return to a period prior to their commencement, when a similar art— the splendid art of the *Daguerreotype*—took its rise in France. So early as 1814, M. Niepce, a private gentleman, who resided on his estate near Chalons, on the Saone, had turned his attention to the subject of Photography. His object was to fix the images of the camera, but more especially to perfect his methods of copying engravings when laid upon substances sensible to the action of light. In 1824, M. Daguerre had begun a series of experiments for the purpose of fixing the images in the camera. He had made some progress in 1826; and in that year a Parisian optician had indiscreetly disclosed to M. Niepce some of the results at which Daguerre had arrived. In 1827, M. Niepce made a

journey to England, and, in December of that year, he communicated an account of his photographic experiments to the Royal Society of London, accompanying his memoirs with several sketches on metal, in the state of advanced etchings, which proved that he had a method of making the shadows correspond to shadows, and of preventing his copies from being injured by the light of the sun. The Royal Society appears to have attached no value to the discovery of Niepce, though they had ocular demonstration of its reality. His Paper does not even seem to have been read, and the plates which accompanied it appear to have passed into the repositories of some of its members. One would have expected that a picture, painted or copied by the agency of light, would have fixed the attention of any body of men to which it was submitted; and we should have experienced some difficulty in giving credit to the statement, did we not know that the same body has refused to publish the photographic discoveries of Mr. Talbot!

Having become acquainted with each other's labours, MM. Niepce and Daguerre entered into a copartnery in 1829; the object of which was to pursue for their mutual benefit the photographic researches which they had respectively begun. The process of Niepce differed entirely from that of Daguerre. The principle on which it rests is, that light renders some substances more or less insoluble, in proportion to the duration or intensity of its action. The substance in which he found this property, was a solution of asphaltum in essential oil of lavender. A thin film of this substance spread over the clean surface of a plate of silvered copper was exposed, so as to receive the image of a landscape in the camera obscura: The parts on which no light fell were thus made more soluble than the rest; and when a solvent, consisting of one part of essential oil of lavender, and ten parts of oil of white petroleum, was made to cover the plate, the image gradually unfolded itself; and, after being washed with water, the picture was completely developed. The plate was then dried, and kept from humidity and the action of light.

Into this process, which was doubtless both troublesome in its details, and uncertain in its results, M. Daguerre introduced essential improvements; but in the course of his researches, he was led into an entirely new field of discovery, and soon abandoned the process of his colleague. M. Niepce died in July 1833, and a new agreement was entered into between Daguerre and his son, M. Isidore Niepce; in which it was admitted that the former had discovered an entirely new process, and it was at the same time provided, that it should bear the name of Daguerre as its sole inventor.

. . . .

. . . In this remarkable representation of nature, there is depicted, with the minutest accuracy, all her finest forms; but her gay colours are wanting; and the blue sky and the green turf are exhibited in the same monotony of light and shadow, as when we view a highly-coloured landscape, in water-colours or in oil, by the light of a monochromatic lamp.

But notwithstanding this defect, which, sanguine as we are, we can scarcely hope will ever be supplied, there is a power and truth in the delineation which almost compensates its want of colour. Self-painted by the rectilineal pencils of light, every fixed object transfers its mimic image to the silver tablet; and the only deviation from absolute truth which can intervene, is the imperfection of the lenses by which the image is formed. By an ordinary observer this defect, if it can be called one, is so inappreciable, that the perfection of the picture exceeds as it were the accuracy of the eye as its judge; and by means of a magnifying glass we can make discoveries of minute features, in the same manner as we can do in the real landscape by the application of a telescope.[6] But it is not merely the minuteness of its delineations that surprise us in the Daguerreotype. Every object is seen in true geometrical perspective; and even the aerial perspective is displayed in the diminution of sharpness which marks the outlines of all objects that recede from the eye. The combination of these two effects, the last of which is often beyond the reach of art, gives a depth—a third dimension—to the picture, which it is scarcely possible to conceive without actually seeing it. In the representation, for example, of a Grecian portico with two or three columns deep, the actual depth of the recess is more distinctly seen with a magnifying glass than by the naked eye.

If any object in the picture either moves or changes its place, that object, of course, must be imperfectly delineated in the Daguerreotype. The agitated foliage, the running stream, the flying clouds, and the motions of living animals, all destroy the picture in which they occur. This great imperfection is capable of only one remedy. We must increase the sensitiveness of the ground upon which the lights act, so as to diminish the time that the plate remains in the camera. M. Daguerre saw very early the consequences of this defect in his process; and in the course of a series of experiments on the subject, he made the important discovery, that by electrifying the plate, the action of light

6. *Every picture formed by a camera obscura, in which the focal lengths of the lens exceeds the distance at which we see objects distinctly, is magnified, and on this account objects are recognized in the perfect image which the eye cannot see in the original landscape.*

upon the film of iodine was so instantaneous, that the part of the plate first exposed was overdone before the action had begun on the other part of the plate.[7]

Two other methods have been invented for accelerating the action of light upon the plate. The first of these is founded on a beautiful optical discovery by M. Edmund Becquerel. If we conceive the solar spectrum to be divided into two halves, the *first* half containing the *violet* and *blue* rays, and the *second* the *green*, *yellow*, and *red*, M. Becquerel found that the first half, containing the *violet* and the *blue* rays, were those which formed the picture on the plate; and hence he called them the *exciting* rays, (*rayons excitateurs;*) while the other half, the *green*, *yellow*, and *red* rays, had no power of excitation, but *continued* the excitement when passed over the surface of the plate after it was taken out of the camera, and when the *exciting* rays no longer acted upon it. Hence he called them the *continuing* rays, (*rayons continuateurs.*) The power of *exciting* was a *maximum* at the violet extremity of the spectrum, and gradually diminished towards the middle or green space; while the power of *continuing* the action was a *maximum* at the *red* extremity, and gradually diminished towards the *green* space, where a sort of neutral state existed. Hence, as the solar spectrum consists of three equal spectra, viz. violet, yellow, and red superposed, with their *maximum* illumination at different points, we may conceive the *exciting* power to be diffused along with the *violet* rays throughout the whole spectrum; the continuing rays to be diffused throughout the same along with the *red;* while the neutral *yellow* possess only the powers of heat and illumination. In this way only we can account for the diminution of the exciting and continuing powers towards the middle of the spectrum; and the entire disappearance of both these actions will take place, at the point where the ordinates of *excitation* and *continuation* are equal.

In applying this principle to the Daguerreotype, the plate is exposed only a short time to the action of the lights in the original picture —so short a time, indeed, that the vapour of mercury would not form a picture upon the plate. The plate being taken out of the camera, the sun's rays, passing through a red glass, are made to shine upon it for a few minutes. The action already excited is thus continued; and the plate, when exposed to the mercurial vapour, yields a picture as perfect as it would have done had it remained the proper time in the camera.

Beautiful, however, as this process is in its scientific relations, it is

7. *The particulars of this process have not been published; but we have no doubt that M. Daguerre, with his usual success, will find some way of reducing the speed of this new method.*

obviously one which is not fitted for the professional artist: for if the sun does not shine, the picture cannot be formed, and may be lost before the luminary reappears. This defect, however, we need not regret; for a practical and simple process of hastening the production of the picture has been discovered by M. Claudet, the ingenious artist who superintends the photographical department in the Adelaide Gallery. He discovered that the sensitiveness of the iodine film was singularly increased by passing it over the mouth of a bottle, containing the *chloride of iodine* or of *bromine*. As soon as the vapour of either of these bodies has spread itself over the film of iodine, the plate is placed in the camera, and in a very few seconds the action of light is completed.

In consequence of these improvements, the Photographic art has assumed a new character. When the patient (for so the sitter must be described) sat for five or ten minutes in a constrained attitude, with his face exposed to a strong light, the portrait thus taken could neither be correct nor agreeable. A look of distress pervaded almost every feature; the eye, exposed to the strongest light, was half closed; the cheek was drawn up, and wrinkles, never seen in society, planted themselves upon the smooth and expanded forehead of youth and beauty. These evils are now entirely removed from the Daguerreotype. Even the momentary expression of passion or feeling may be seized, and the graceful form, which never fails to accompany it, simultaneously arrested. Motion of course it is impossible to represent; but the expressions of the face, and the positions of the muscles and limbs, which precede and follow motion, and therefore necessarily indicate it, are given as they existed at the moment when the exposure of the plate took place.

Such is the invention, in its improved state, which, after fifteen years of laborious research, M. Daguerre has given to the world—an invention with which his name will be indissolubly associated. It is, more than any other art we know, peculiarly his own; for the previous labours of Wedgewood and Niepce have with it nothing in common. It belongs, therefore, to France alone; and the liberality with which she has purchased it for the benefit of universal science, will secure to her the gratitude of all nations. This wise and generous step was, we believe, the suggestion of her most eminent philosopher, M. Arago, to whom M. Daguerre had unhesitatingly confided the secrets of his art. Struck with the splendour of the discovery, and foreseeing the advantages which science and art would receive from its application, he induced the government to offer M. Daguerre an annual pension of 6000 francs, and M. Niepce a pension of 4000 francs,[8] for surrendering

8. *One-half of each is settled in reversion on their widows.*

to the public the use of their inventions; and, on the 3d July 1839, he presented to the Chamber of Deputies the report of a Commission, of which he was the chief, explaining the nature and estimating the value of the invention. Baron Gay Lussac submitted a similar report to the Chamber of Peers, breathing the same sentiments, and recommending the same national reward. The following passages from these reports, which were unanimously adopted by the Chambers, may be usefully perused in England, and show the entire unanimity of feeling which animated all parties in completing this interesting transaction:—

' The members of this Chamber, (M. Arago,) to whom the Ministry gave full powers, never bargained with M. Daguerre. Their communications had no other object than to determine whether the recompense, so justly due to the accomplished artist, should be a pension or a sum of money. From the first M. Daguerre perceived, that the payment of a stipulated sum might give to the transaction the base character of a sale. The case was different with a pension. By a pension you recompense the warrior who has been wounded in the field, and the magistrate who has grown grey on the bench. It is thus that you honour the families of Cuvier—of Jussieu, and of Champollion. Reflections like these could not fail to present themselves to a man of his exalted character, and M. Daguerre decided on a pension. He fixed the amount at 8000 francs, to be divided equally between himself and his partner, M. Niepce, junior. The proportion payable to M. Daguerre has been since raised to 6000 francs, making 10,000 in all; both on account of the condition specially imposed upon that artist of publishing *the secret of painting and illuminating the dioramic views*, and making known all future improvements with which he may enrich his photographic methods.'

' From these considerations,' says Baron Gay Lussac, ' it was thought desirable that this process should become public property. From a different motive it merited the attention of government, and ought to procure for its author a conspicuous reward. To those who are not insensible to national glory —who know that a people shine with greater splendour among the nations of the earth, only as they have realized a higher advancement in civilization—to those, we say, the process of M. Daguerre is a noble discovery. It is the origin of a new art in the middle of an old civilization;—an art which will constitute an era, and be preserved as a title of glory. And shall it descend to posterity companioned with ingratitude? Let it rather stand forth a splendid evidence of the

protection which the Chambers—the Government of July—
the whole country—offered to great inventions.

' It is, in reality, an act of national munificence which
consecrates the bill in favour of M. Daguerre. We have given
it our unanimous assent, yet not without marking how ele-
vated and honourable is a reward voted by the country. And
this we have done on purpose to remind the nation—not
without some sad remembrances—that France has not always
shown herself so grateful; and that too many useful labours
—too many works of genius—have often procured for their
authors only a barren glory. These are not accusations which
we urge—they are errors which we deplore, in order now to
avoid a new one.'

From the homage which we have cheerfully paid to the liberality
of French philosophers and legislators, we could have desired to make
no deduction; but there has been an *omission* in the transaction with
M. Daguerre, which affects all nations, and which we would almost
venture to request M. Arago still to supply. It is evident, from the
whole tenor of the two Reports to the Chambers, that France pur-
chased Daguerre's invention *for the benefit of all nations*, and not exclu-
sively for the French people. It would be an insult to the two
distinguished Reporters, and, indeed, to all parties concerned, to sup-
pose that they had any other object in view. M. Arago emphatically
says, ' This discovery France has adopted; from the first moment she
has cherished a pride in liberally bestowing it—A GIFT TO THE WHOLE
WORLD!' And M. Duchatel, the Minister of the Interior, on presenting
the bill to the Chambers, distinctly declares, as an argument for a
public reward, ' *that Daguerre's invention does not admit of being secured by
patent.* So soon as it becomes known, every one may avail himself of its
advantages. The most unskilful will produce designs with the same
exactness as the most accomplished artist. Of necessity, then, this
process must belong to all, or remain unknown.'

The Daguerrian Bill had scarcely passed the legislature, when on
or about the 15th July 1839, *a certain foreigner residing in France*, in-
structed Mr. Miles Berry, patent agent in London, ' immediately to
petition her Majesty to grant her Royal Letters Patent for the exclusive
use of the same within these kingdoms;' ' and in consequence of these
instructions, Mr. Miles Berry ' did apply for such letters patent; and
her Majesty's solicitor-general (Sir Thomas Wilde,) after hearing *all
parties who opposed the same*, was pleased on or about the 2d of August,
now last past, to issue his report to the Crown *in favour of the patent
being granted;* and it consequently passed the great seal in the usual

course, being sealed on the day above named, *which is* SOME DAYS PRIOR to the date of the exposition of the said invention or discovery to the French Government at Paris, by MM. Daguerre and Niepce, according to the terms of their agreement.' '

This remarkable statement, the object of which is very palpable, is thrust into the specification of the patent, after the usual preamble to all such deeds; and the patentee states with great *naiveté*, that *he believes* it to be the invention or discovery of Messrs. Louis Jacques Mande Daguerre, and Joseph Isidore Niepce, junior, both of the kingdom of France; from whom the French Government have purchased the invention, FOR THE BENEFIT OF THAT COUNTRY!

The purpose of the preceding statement is obviously to create a belief, that Mr. Daguerre was not the foreigner who instructed the patent agent to petition her Majesty, and that he had transferred the benefit of his invention only to his own country. It is not our desire to investigate this part of the transaction any further: but we are bound to say, that the Solicitor-General of England would have done better, to advise her Majesty not to withhold from *her subjects*, that very invention which the King of the French had purchased for the benefit, not only of *his own people*, but of *all nations*. The patent cannot stand a moment's examination, and we would exhort the interested parties to apply for a writ of *scire facias*, for its immediate repeal.

It is a singular fact, though not without its parallel in the history of science, that when Daguerre in France was engaged in his beautiful experiments, another philosopher in England should have been occupied in analogous researches. Mr. Henry Fox Talbot, of Lacock Abbey, a Fellow of the Royal Society, and well known as a mathematician and natural philosopher, had, as we have seen, previous to 1834, been attempting to fix the images of the camera obscura, and to copy objects and pictures by the action of light upon nitrate of silver. The first account which he gave of his labours, was in a Paper entitled *Some Account of the art of Photogenic Drawing, or the process by which natural objects may be made to delineate themselves without the aid of the artist's pencil.* This Paper was read to the Royal Society, on the 31st January 1839, several months before the disclosure of Daguerre's invention and methods.[9] We mention this fact, not for the purpose of claiming for our countryman any priority in reference to Daguerre; but merely to show that his labours, whatever analogy there may be between them, were wholly independent of those of the French philosophers. In this Paper,

9. *It was printed in the* Lond. and Edin. Phil. Mag. *for March 1839. Vol. xiv.* p. *196.*

Mr. Talbot did not give any account of his processes; but in a subsequent letter addressed to the Secretary of the Royal Society, and read to that body on the 21st February 1839,[10] he described his method of preparing the paper, and the process by which he fixed the design.
. . . .

The patent right, and the important discovery which it secures, have now been brought into actual operation and use as a branch of the fine arts. Mr. Henry Collen, a distinguished miniature-painter, has quitted his own beautiful art, and devoted his whole time to the calotype process. The portraits which he has produced, one of which is now before us, are infinitely superior to the finest miniatures that have ever been painted. Devoting his chief attention to the correct and agreeable delineation of the face by the action of light alone, he corrects any imperfection in the drapery, or supplies any defects in the figure, by his professional skill, so that his works have an entirely different aspect from those of the amateur, who must, generally speaking, be content with the result which the process gives him. In making this comparison we do not intend to convey the idea, that *perfect pictures*, both landscapes and portraits, cannot be produced without additional touches from the pencil of an artist. Without referring to the fine calotype delineations by Mr. Talbot himself, who could not be otherwise than master of his own art, we have now before us a collection of admirable photographs executed at St. Andrew's, by Dr. and Mr. Robert Adamson,[11] Major Playfair, and Captain Brewster. Several of these have all the force and beauty of the sketches of Rembrandt, and some of them have been pronounced by Mr. Talbot himself to be among the best he has seen.

Although the calotype art has attained, by Mr. Talbot's labours alone, a singular degree of perfection in its ordinary results, there is yet a good deal to be done in simplifying its processes;[12] in obtaining a more perfect material than common writing-paper for the negative pictures; in giving it additional sensitiveness to enable it to succeed

10. *Id. Id. vol. xiv. p. 209.*

11. *All these calotypes were taken by means of excellent camera-obscuras constructed by Mr. Thomas Davidson, optician, Edinburgh.*

Mr. Robert Adamson, whose skill and experience in photography is very great, is about to practise the art professionally in our northern metropolis.

12. *Mr. William F. Channing of Boston gives a simpler process than Mr. Talbot's; but it is only by omitting some of the steps of it. The calotype paper is therefore less sensitive. We have tried this simplified process, but without any desire to repeat it; for a good negative picture is worth all the trouble of Mr. Talbot's process—See the* American Journal of Science and the Arts, *July 1842, vol. xliii. p. 73.*

with the light of gas; and in rendering the result of the whole process more certain than it now is. The extension of the art, which is at this moment exciting great attention throughout the continent of Europe and also in America, will, doubtless, add to its methods and its resources; and bring it to a degree of perfection which Mr. Talbot himself had never contemplated. In the mean time, it gives us great pleasure to learn, that though none of his photographical discoveries adorn the transactions of the Royal Society, yet the president and council have adjudged to him the Rumford Medals for the last biennial period.

Having thus given our readers a pretty ample account of the history of the Daguerreotype and Calotype, we shall now attempt to point out the advantages which these two arts, considered as the science of Photography, have conferred upon society; and shall afterwards endeavour to form an estimate of their respective merits and applications.

It would be an idle task to eulogize the arts of painting and sculpture, whether we view their productions as works of fancy, or as correct representations of what is beautiful and grand in nature. The splendid galleries of art throughout Europe, private as well as public, form their most appropriate eulogy. Any art, therefore, which should supersede that of the painter, and deprive of employment any of its distinguished cultivators, would scarcely be hailed as a boon conferred upon society. An invention which supersedes animal, or even professional labour, must be viewed in a very different light from an invention which supersedes the efforts of genius. That the art of painting will derive incalculable advantages from Photography it is impossible to doubt. M. Delaroche, a distinguished French painter, quoted by M. Arago, considers it as ' carrying to such perfection certain of the essential principles of art, that they must become subjects of study and observation even to the most accomplished artist.*** The finish of inconceivable minuteness disturbs in no respect the repose of the masses, nor impairs in any manner the general effect.' ' The correctness of the lines,' he continues, the precision of the forms in the designs of M. Daguerre, are as perfect as it is possible they can be, and yet at the same time we discover in them a broad and energetic manner, and a whole equally rich in tone as in effect. The painter will obtain, by this process, a quick method of making collections of studies which he could not otherwise procure without much time and labour, and in a style very far inferior, whatever might be his talents in other respects.'[13] The same remarks are equally applicable to the arts of sculpture and architecture.

13. History and Practice of Photogenic Drawing, *pp. 16, 17.*

But if the artist is thus favoured by the photographer, what must be the benefit which he confers on the public—the addition which he makes to our knowledge—the direct enjoyment which he affords to our senses. How limited is our present knowledge of the architectural ornaments of other nations—of the ruined grandeur of former ages— of the gigantic ranges of the Himalaya and the Andes—and of the enchanting scenery of lakes, and rivers and valleys, and cataracts, and volcanoes, which occur throughout the world! Excepting by the labours of some travelling artists, we know them only through the sketches of hurried visitors, tricked up with false and ridiculous illustrations, which are equal mockeries of nature and of art. But when the photographer has prepared his truthful tablet, and ' held his mirror up to nature,' she is taken captive in all her sublimity and beauty; and faithful images of her grandest, her loveliest, and her minutest features, are transferred to her most distant worshippers, and become the objects of a new and pleasing idolatry. The hallowed remains which faith has consecrated in the land of Palestine, the scene of our Saviour's pilgrimage and miracles—the endeared spot where he drew his first and his latest breath—the hills and temples of the Holy City—the giant flanks of Horeb, and the awe-inspiring summits of Mount Sinai, will be displayed to the Christian's eye in the deep lines of truth, and appeal to his heart with all the powerful associations of an immortal interest. With feelings more subdued, will the antiquary and the architect study the fragments of Egyptian, Grecian, and Roman grandeur—the pyramids, the temples, the obelisks of other ages. Every inscription, every stone, will exhibit to them its outline; the gray moss will lift its hoary frond, and the fading inscription unveil its mysterious hieroglyphics. The fields of ancient and modern warfare will unfold themselves to the soldier's eye in faithful perspective and unerring outline; and reanimated squadrons will again form on the plains of Marathon, and occupy the gorge of Thermopylæ.

But it is not only the rigid forms of art and of external nature— the mere outlines and subdivisions of space—that are thus fixed and recorded. The self-delineated landscape is seized at one epoch of time, and is embalmed amid all the co-existing events of the social and physical world. If the sun shines, his rays throw their gilding upon the picture. If rain falls, the earth and the trees glisten with its reflections. If the wind blows, we see in the partially obliterated foliage the extent of its agitation. The objects of still life, too, give animation to the scene. The streets display their stationary chariots, the esplanade its military array, and the market-place its colloquial groups—while the fields are studded with the various forms and attitudes of animal life. Thus are the incidents of time, and the forms of space simultaneously recorded;

and every picture becomes an authentic chapter in the history of the world.

In considering the relations of Photography to the art of portrait painting, we are disposed to give it a still higher rank. Could we now see in photogenic light and shadow Demosthenes launching his thunder against Macedon—or Brutus at Pompey's statue bending over the bleeding Cæsar—or Paul preaching at Athens—or Him whom we must not name, in godlike attitude and celestial beauty, proclaiming good-will to man, with what rapture would we gaze upon impersonations so exciting and divine! The heroes and sages of ancient times, mortal though they be, would thus have been embalmed with more than Egyptian skill; and the forms of life and beauty, and the lineaments of noble affections and intellectual power, the real incarnations of living man, would have replaced the hideous fragments of princely mortality scarcely saved from corruption.

But even in the narrower, though not less hallowed, sphere of the affections, where the magic names of kindred and home are inscribed, what a deep interest do the realities of photography excite! In the transition forms of his offspring, which link infancy with manhood, the parent will discover the traces of his own mortality; and in the successive phases which mark the sunset of life, the child, in its turn, will read the lesson that his pilgrimage too has a period which must close.

Nor are these delineations interesting only for their minute accuracy as works of art, or for their moral influence as incentive to virtue. They are instinct with associations equally vivid and endearing. The picture is connected with its prototype by sensibilities peculiarly touching. It was the very light which radiated from his brow—the identical gleam which lighted up his eye—the pallid hue which hung upon his cheek—that penciled the cherished image, and fixed themselves for ever there.

But the useful arts, too, and even the sciences themselves, have become the willing eulogists of the photographer. As the picture in the Daguerreotype is delineated by vapours of mercury, which are effaced by a touch of the finger, it became desirable to fix them upon the silvered copper by a more permanent tracery. Dr. Berres of Vienna is said to have discovered a method of doing this, in such an effective manner, that copies can be taken from the plate as from ordinary copperplates; and it has been asserted by Dr. Donné, that the Daguerreotype plates may be directly etched by very dilute nitric acid, which acts most powerfully upon the parts of the picture that have the least quantity of mercurial vapour. As we have not seen any of these results, and are not able to adduce the testimony of others who have seen them,

we cannot form an idea of the accuracy with which they may represent the original Daguerreotype picture. We have now, however, before us *four* engravings, obtained from Daguerreotype plates by the process of Mr. Boscawen Ibbetson. *One* of these is from a Daguerreotype portrait, in which the original picture on the silvered plate is stippled by an engraver, and an impression thrown off in the usual way; and *three* of them represent objects of natural history obtained in the following manner. The exact outline of all the parts of the picture was traced by the engraver in the Daguerreotype plate by stippling; a print was next taken from the plate and transferred to stone; and the lithographer then filled in the necessary shading. One of these specimens is a thin section of a madrepore, taken by the oxy-hydrogen microscope, and magnified 12½ times. The other specimens represent a silicified Pentagonaster, and a Scaphite, accompanied with other fossils; and we venture to say, that these specimens possess every requisite that the naturalist could desire. Had the drawings been taken by the Calotype, that is, upon paper, they could have been transposed at once to stone with all their minute details, and without the intermediate step of an imperfect etching, depending on the engraver for its accuracy.

But there is still a simpler process by which the fine arts are aided by the Daguerreotype, and the results of this process are now before the world. Foreseeing the advantages of photographic pictures of the most interesting scenery in Europe, M. Lerebours, well known as one of the most distinguished opticians in Paris, has collected more than twelve hundred Daguerreotype views of the most beautiful scenery and antiquities in the world. The remarkable views from the East were taken by MM. Horace Vernet and Goupil. M. Las Cases has furnished the interesting scenery of St. Helena; and M. Jomard has been occupied with Spanish scenery and the beauties of the Alhambra. These Daguerreotype pictures, of which it is impossible to speak too highly, are engraved in *aqua tinta*, upon steel, by the first artists; and they actually give us the real representation of the different scenes and monuments at a particular instant of time, and under the existing lights of the sun and the atmosphere. The artists who took them, sketched separately the groups of persons, &c., that stood in the street, as the Daguerreotype process was not then sufficiently sensitive to do this of itself; but in all the landscapes, which shall now be reproduced by this singular art, we shall possess accurate portraits of every living and moving object within the field of the picture.[14]

14. *M. Lerebours' work is entitled* Excursions Daguerriennes, collection de 50 planches, representant les Vues et les Monumens les plus remarquable du

It would be almost an insult to our readers to dwell with any detail on the utility of the new art, in promoting and extending science. We have already seen its advantages in giving the most faithful representation of objects of natural history; and it cannot fail to be equally useful in all the sciences of observation, where visible forms are to be represented. The civil engineer and the architect have claimed it as an art incalculably useful in their profession; and the meteorologist has seized upon it as a means of registering successive observations of the barometer, thermometer, hygrometer, and magnetometer, in the observer's absence; and thus exhibiting to his eye, at the end of every day, accurate measures of all the atmospheric changes which have taken place.[15] We shall not say any thing at present of the great discoveries to which it has already conducted us in physical optics, as we must devote a separate part of this article to their discussion.

In thus stating the peculiar advantages of Photography, we have supposed the Daguerreotype and Calotype to be the same art. Our readers have already seen in what the difference really consists; but it is still necessary that we should attempt to draw a comparison between them, as sister arts, with advantages peculiar to each.

In doing this, our friends in Paris must not suppose that we have any intention of making the least deduction from the merits of M. Daguerre, or the beauty of his invention; which cannot be affected by the subsequent discovery of the Calotype by Mr. Talbot. While a Daguerreotype picture is much more sharp and accurate in its details than a Calotype, the latter possesses the advantage of giving a greater breadth and massiveness to its landscapes and portraits. In the one, we can detect hidden details by the application of the microscope; in the other, every attempt to magnify its details is injurious to the general effect. In point of expense, a Daguerreotype picture vastly exceeds a Calotype one of the same size. With its silver plate and glass covering, a quarto plate must cost five or six shillings, while a Calotype one will not cost as many pence. In point of portability, permanence, and facility of examination, the Calotype picture possesses a peculiar advantage. It has been stated, but we know not the authority, that Daguerreotype

Globe. *The views are from Paris, Milan, Venice, Florence, Rome, Naples, Switzerland, Germany, London, Malta, Egypt, Damascus, St. Jean D'Acre, Constantinople, Athens, &c.*

15. *This application will be understood by supposing a sheet of sensitive paper to be* placed *behind the mercurial column of the barometer, and a light before the same column: the shadow of the top of the mercury will leave a white image on the paper blackened by the light, and the paper itself being moved behind the mercury by a clock, we shall thus observe the various heights of the mercury depicted at every instant of time.*

pictures have been effaced before they reached the East Indies; but if this be true, we have no doubt that a remedy will soon be found for the defect. The great and unquestionable superiority of the Calotype pictures, however, is their power of multiplication. One Daguerreotype cannot be copied from another; and the person whose portrait is desired, must sit for every copy that he wishes. When a pleasing picture is obtained, another of the same character cannot be produced. In the Calotype, on the contrary, we can take any number of pictures, within reasonable limits, from a negative; and a whole circle of friends can procure, for a mere trifle, a copy of a successful and pleasing portrait. In the Daguerreotype the landscapes are all reverted, whereas in the Calotype the drawing is exactly conformable to nature. This objection can of course be removed, either by admitting the rays into the camera after reflection from a mirror, or by total reflection from a prism; but in both these cases, the additional reflections and refractions are accompanied with a loss of light, and also with a diminution, to a certain extent, of distinctness in the image. The Daguerreotype may be considered as having nearly attained perfection, both in the quickness of its operations and in the minute perfection of its pictures; whereas the Calotype is yet in its infancy—ready to make a new advance when a proper paper, or other ground, has been discovered, and when such a change has been made in its chemical processes as shall yield a better colour, and a softer distribution of the colouring material. · · · ·

In the middle of this physiological difficulty, our exhausted limits compel us to stop. But we cannot allow ourselves to conclude this article without some reflections, which the preceding details must have excited in the minds of our readers, as well as in ours. Two great inventions, the produce of two of the greatest and most intellectual nations in the world, have illustrated the age in which we live. With a generous heart and open hand, France has purchased the secret of the Daguerreotype; and while she has liberally rewarded the genius which created it, she has freely offered it as a gift to all nations—a boon to universal science—a donation to the arts—a source of amusement and instruction to every class of society. All the nations of Europe—save one—and the whole hemisphere of the New World, have welcomed the generous gift. They have received the free use of it for all their subjects; they have improved its processes; they have applied it to the arts; they have sent forth travellers to distant climes to employ it in delineating their beauties and their wonders. In England alone, the land of free-trade—the enemy of monopoly—has the gift of her neighbour had been received with contumely and dishonour. It has been

treated as contraband—not at the Custom-house, but at the Patent-office. Much as we admire the principle of our Patent laws, as the only reward of mechanical genius under governments without feeling and without wisdom, we would rather see them utterly abrogated, than made, as they have in this case been made, an instrument of injustice. While every nation in the world has a staff of pilgrim philosophers, gathering on foreign shores the fragments of science and practical knowledge for the benefit of their country, England marshals only a coast-guard of patent agents, not to levy duties, but to extinguish lights; not to seize smugglers, but to search philosophers; not to transmit their captures to the national treasury, but to retain them as fees and profits to interested individuals.

Nor does the fate of the Calotype redeem the treatment of her sister art. The Royal Society—the philosophical organ of the nation—has refused to publish its processes in their Transactions. No Arago—no Gay Lussac, drew to it the notice of the Premier or his Government. No representatives of the People or the Peers unanimously recommended a national reward. No enterprizing artists started for our colonies to portray their scenery, or repaired to our insular rocks and glens to delineate their beauty and their grandeur. The inventor was left to find the reward of his labours in the doubtful privileges of a patent—and thus have these two beautiful and prolific arts been arrested on English ground, and doomed to fourteen years' imprisonment in the labyrinths of Chancery Lane!

Richard Rudisill

Mirror Image:
The Influence of the Daguerreotype
on American Society
1971
AN EXCERPT

The daguerreotype had the disadvantage of being a unique image as opposed to the infinitely reproducible Talbotype. In this limitation lay its eventual downfall, but its brilliant and remarkably detailed reproduction of the subject won it far the greater following for some years. As soon as portraiture was feasible, daguerreotype studios sprang up like mushrooms. The first in America was established in 1840, and Americans soon flocked to have their pictures taken. The daguerreotype was ultimately edged out by the reproducible collodion process, but not before it had inspired such ambitious projects as a portrait gallery of great Americans. Richard Rudisill is at the Museum of New Mexico in Santa Fe.

. . . .

The daguerreotype completely captured public favor in America during the twenty years before the Civil War. In that time it answered a myriad of needs with effectiveness, and it played a major part in the cultural development of the time. As a technological medium in the hands of devoted operators, the daguerreotype was assimilated into national consciousness as few inventions have been accepted in history. No other nation produced more or better daguerreotypes, and no other nation more widely employed the medium than the United States.

When all the facets of the daguerreotype's use in America come to-
gether for review, we can summarize the medium's function in three
primary ways—it served as a direct aid to cultural nationalism, it
helped Americans adjust themselves intuitively to the transition from
an agrarian to a technological society, and it was ultimately a reflection
of spiritual concerns motivating the nation.

The first half of the nineteenth century found Americans eager to
produce national artifacts of culture whenever possible, preferring to
endorse native conceptions loudly or to berate just as loudly an absence
in local productions of quality equal to that of European productions.
Within such a climate of nationalistic impulse, it is not surprising that
stress should have been laid on the worth of what America excelled at
doing. Hence the attitude of a man like Horatio Greenough, who
warned against expecting Americans to sit down in the wilderness
between an Indian and a rattlesnake to play European airs on the violin.
Hence, also, the stress of Greenough and others on the mechanical
ingenuity of America, which was often given favorable attention as
being worth more than artistic luxuries in answering national needs. In
such a climate Horace Greeley grew so excited about the significance
of anything at all American in competition against Europe at the Crys-
tal Palace Exposition that he could twit the Europeans by referring to
Yankee ploughs, hoes, wood screws, axes, clocks, and even cut nails.[1]
In such a time anything which could enhance national feelings or reflect
national qualities stood to become a source of pride.

Greeley hailed American superiority with the photographic me-
dium at London, observing that in "Daguerreotypes . . . we beat the
world."[2] Not only did Greeley appropriate the French invention to the
ends of American nationalism, but American daguerreotypists them-
selves had already given him basis for doing so with their refinements
of the medium universally called "the American process." At the Ex-
position, Mathew Brady led the victorious Americans by placing in
competition a summary of American character mirrored in the faces of
the nation's leading men. He was joined at the Crystal Palace in stamp-
ing "Made in America" upon use of the medium by operators such as
Jesse Whitehurst who presented Niagara Falls to the Europeans, and
John Adams Whipple who captured the moon and sent it to London
on a silver plate.

The Crystal Palace triumph merely emphasized the fact that
America was nationally involved with the photographic medium.

1. *Horace Greeley*, Glances at Europe . . . *(New York: Dewitt & Davenport,
1851), p. 26.*
2. *Ibid.*

Throughout the period at home, daguerreotypists in all parts of the country were at least indirectly active under the same impulses to define American culture pictorially. There was Insley's American cities project which was planned to summarize the urban face of the nation into one definitive exhibition. There was Barnum's project of identifying the first "Miss America" by photographic competition. There were Vance's *Views in California* and Jones's *Pantoscope* of half the continent, of which it was proudly said that

> American scenery and American talent have here stamped their own eulogy—and an eloquent one it is! Such productions make us proud of our country and our countrymen! [3]

The list of activities and operators was varied—Carvalho in the Rockies, Anthony on the Maine boundary, Brown with the Japan expedition, Moore and Walter in the Capitol, Simpson up and down the Mississippi, Ryder moving across New York and Ohio, Hesler on the inland rivers, Draper in the laboratory of New York University, Whipple at the Harvard Observatory, and portrait-makers everywhere.

The portrait-makers in particular grappled with the problem of national character. Their work reflected the underlying feeling that the true nature of the American would stand revealed if only adequate representations of each citizen could be produced. Most daguerreotypists were concerned with reflecting the maximum of character in making a portrait. They sought to reveal the individual person whether he was an ordinary citizen or a leading figure such as Lemuel Shaw. It was generally felt in the trade that a searching portrait was the best indication available of who a person was and what he meant to his loved ones—and successful portraits were displayed in every studio in the country, where Americans were confronted with Americans as the daguerreotype revealed them. Characteristic types such as Fitzgibbon's portrait of the Arkansaw Traveler were juxtaposed with the remarkable, such as a portrait of General Tom Thumb, until a mosaic of images was spread before the public that displayed every attribute of the people and their moods.

In summarizing attributes and appearances, daguerreotypists came to the point of deliberately attempting to define national characteristics. Expanded summaries such as Brady's collection at the Crystal Palace and Anthony's National Daguerreotype Miniature Gallery were conscious efforts to display the nation in her ideal character as defined

3. *Quoted by John Ross Dix in* Amusing and Thrilling Adventures . . . *(Boston: published for the author, 1854), p. 47.*

by images of the men who determined it. Great popular attendance at such exhibitions and at other summarizing projections such as the *Pantoscope* indicate that Americans found encouragement and reinforcement as nationals in these pictures. Gabriel Harrison romantically expressed the nationalistic sentiment that welled up in him during contemplation of such a pantheon:

> here let me rest, and do homage at the shrine of my country's glory, for my soul hath its content so absolute, that if it were now to die, it were now to be most happy.[4]

In nationalistic summations of this type, a conscious didactic element is visible. The daguerreotypist saw his role as one of guide as well as recorder. Mathew Brady spoke of the influence of the daguerreotype as having "found its way where other phases of artistic beauty would have been disregarded."[5] Marcus Root wrote of the daguerreotype's power to "train society" even at the level of the

> specimens, inferior as so many of them are, exhibited at the doors of the Heliographic Galleries, in numbers of our city streets [which] constitute a sort of artistic school for the developing of idealistic capabilities of the masses. . . .[6]

Operators such as these tried consciously through pictures to educate Americans about themselves and about the qualities of their society and their time. Root and Brady both made clear that the individual portrait and the collection were significant elements in this national encouragement of taste and response to ideals. Even non-professionals became sensitive to the didactic potential of national picture collections. A congressional committee noted of Brady's gallery of celebrity portraits that, if put on permanent display in the Library of Congress, it would "exert the most salutary influence, kindling the patriotism as well as the artistic taste of the people."[7]
. . . .

In a subsidiary way, the operation of the daguerreotype was pressed beyond defining America for Americans to the point of informing other nations of how Americans saw the world. Eliphalet Brown,

4. *Gabriel Harrison, "Lights and Shadows of Daguerrean Life," No. 2,* Photographic Art-Journal, *vol. I, no. 4 (April 1851), p. 231.*

5. *Quoted by Beaumont Newhall in* The Daguerreotype in America *(New York: Duell, Sloan & Pearce, 1961), p. 83.*

6. *M. A. Root,* The Camera and the Pencil *(Philadelphia: J. B. Lippincott & Co., 1864), p. xv.*

7. *U.S. 41st Cong., 3rd sess., House of Representatives Report No. 46, p. 2.*

Jr. applied American vision to the opening of Japan. His selection of subject matter and his interpretation of it in pictures were the basis of the first representations of the hidden land for the outside world. Similarly, Americans actively recorded the appearance of far places such as the Philippines, Hawaii, Mexico, and South America. North Americans were often first to introduce the photographic medium into Central and South America where they established extensive portrait practices that set the style for native developments. Even in Europe an American often stood as one of the leading daguerreotypists in a chief city—Warren Thompson was a major operator in Paris and John Jabez Edwin Mayall vitalized the trade in London. London and Paris alike acclaimed Draper and Whipple for scientific and astronomical daguerreotypes. Both American vision and American technology were thus influential in the development of daguerreotype photography over much of the world even before the full international triumph with the medium came at the Crystal Palace.
. . . .

The period of the introduction of daguerreotypy into America was also the period of Emerson's ocular concern for spiritual insight through perceiving nature. This was the time when Emerson could speak of becoming a "transparent eyeball" as the means to achieving unity in creation with God. This thought of seeing beyond the surface of nature by keenly observing the surface was ideally the same concern for perception as the wish of the portrait-maker to reveal the inner character of his sitter by making a searching likeness of his features. The daguerreotypist's concern was specifically enunciated by Hawthorne as a way of relating the photographic medium to the spiritual truth of nature. In the words of Holgrave, the novelist's typical example of the American daguerreotype artist,

> There is a wonderful insight in heaven's broad and simple sunshine. While we give it credit only for depicting the merest surface, it actually brings out the secret character with a truth that no painter would ever venture upon, even could he detect it. [8]

As Holgrave speaks the thought, it is actually nature herself who provides the insights of truth—the sun sees all things more precisely than even a painter can. We have also seen that Dion Boucicault drew upon

8. *Nathaniel Hawthorne,* The House of the Seven Gables *(New York: The New Modern Library, 1961), p. 85.*

the same thought of the all-seeing eye of heaven as an agent of justice projecting its truth through the camera in *The Octoroon*. The camera thus becomes a sort of insight machine by which limited human capacity is enabled to receive the truth which nature provides out of herself. It becomes a means of intensifying human perception to the point that man can produce pictorial records of the essence underlying nature and within man himself.

Dr. Edward Hitchcock, President of Amherst College from 1845 to 1854, saw nature as the source of a total photographic record of the character and existence of man within the universe. A former Congregationalist minister, he preached on the idea that the image of whatever man does is imprinted on the fabric of the universe forever—a permanent moral record of the history of human existence to be observed by a greater Being able to see it—making the entire universe a great picture gallery in which the truth alone remains of what man has been.[9]

Emerson himself, and others such as Thoreau, relied specifically on the landscape in their search after spiritual insight. Emerson's speculations about the Oversoul began with observation of the forest or the countryside. Thoreau wrote of the uplift of the spirit of a locomotive driver who recalled visual images of Walden Pond. One of the oldest surviving daguerreotypes in America is a simple view of a tree in a meadow made in the summer of 1840 which still carries a sense of perception beyond the visible facts—a transcendental experience recorded in permanent form. The daguerreotypist Solomon Carvalho reported in words the feelings of a man making a picture during such an experience at the summit of the Rocky Mountains:

> Standing as it were in this vestibule of God's holy Temple, I forgot I was of this mundane sphere; the divine part of man elevated itself, undisturbed by the influences of this world. I looked from nature, up to nature's God, more chastened and purified than I ever felt before.
> Plunged up to my middle in snow, I made a panorama of the continuous ranges of mountains around us.[10]

. . . .

The daguerreotype process itself appealed to its operators partly because of the appeal of the "things" employed in using it—the camera in particular. In the reminiscences of James F. Ryder we can see his

9. *Edward Hitchcock*, Religion of Geology . . . *(Boston: Phillips, Sampson, and Company, 1851), p. 426.*

10. *S. N. Carvalho*, Incidents of Travel and Adventure in the Far West *(New York: Derby & Jackson, 1857), p. 83.*

fascination with the technological character of the machine combined with awe at the spiritual insight of the wonderful device. Referring to his "little box machine," fifty years later, Ryder described his first camera in terms glowing with charm and affection:

> I can picture it in my mind's eye now as plainly as though I had seen it last week. I can see its rosewood veneer, the edges at front and back chamfered to an angle of forty-five degrees; its sliding inside box, with the focusing glass which was drawn up and out of the top through open doors and the plateholder was slid down into its place. These doors were hinged to open one toward the front and the other toward the back, each having a little knob of turned bone by which to lift it, and there were two little inset knobs of the same material turned into the top of the box upon which the knobs of the doors should strike, and the concussion of those bone knobs more than fifty years ago is remembered today as plainly as though I had been hearing them every day from then until now; while the odor of iodine from the coated plates in that dear old box lingers with me like a dream. The box was the body, the lens was the soul, with an "all-seeing eye," and the gift of carrying the image to the plate.[11]

There is no doubt in Ryder's view that his camera held the power of discernment and searching insight. He personifies the machine as

> truth itself. What he told me was as gospel. No misrepresentations, no deceits, no equivocations. He saw the world without prejudices; he looked upon humanity with an eye single to justice. What he saw was faithfully reported, exact, and without blemish. He could read and prove character in a man's face at sight. To his eye a rogue was a rogue; the honest man, when found, was recognized and properly estimated.[12]

A machine gifted with discernment of character and truth must have seemed the ultimately desirable fusion of technology and natural spirit to an age eagerly concerned with both.
. . . .

11. *James F. Ryder*, Voigtlander and I . . . *(Cleveland: Cleveland Printing & Publishing Co., 1902), p. 16.*
12. *Ibid., p. xi.*

L. E. Chittenden

"An Historical Letter"
1898

In the beginning, daguerreotype exposures took so long that
someone posing out of doors was liable to get a suntan, and
pedestrians moved too quickly to appear at all in the first
pictures of city streets. A portrait subject had to sit extremely
still so as not to appear on the plate with four eyes; a photo-
graphic sitting was something of an ordeal. This letter, pub-
lished in *Camera Notes*, recollects the whole business none too
fondly.

It is not often that historical fact and humor are so happily combined
as in the following interesting letter from our valued friend, the Hon.
L. E. Chittenden, who vividly narrates his early experiences as a pho-
tographic sitter:

My Dear Murphy:
 You ask for a confession of my first experience in the art of Da-
guerre, and since confession is good for the soul, you shall have it.
 In September, 1842, when I was eighteen years old, I had read
Blackstone, and thought myself a greater lawyer than I have since
supposed or claimed myself to be. I was at the Court of Franklin
County in St. Albans, Vt. There I met two peripatetic artists from the
great City of Boston, who were offering to make portraits of such
accuracy that they were more like than the sitter, for five dollars each.

They called them Daguerreotypes. They had not been able to secure a victim, for their mechanism was fearfully made and its operation awful to behold!

They offered to *give* me my portrait if I would endure the trial. I was ambitious and did not wish to deprive the bar of the opportunity of securing my portrait so cheaply, and in a moment of weakness I consented. The operators rolled out what looked like an overgrown barber's chair with a ballot box attachment on a staff in front of it. I was seated in the chair and its Briarean arms seized me by the wrists, ankles, waist and shoulders. There was an iron bar which served as an elongation of the spine, with a cross bar in which the head rested, which held my head and neck as in a vice. Then, when I felt like a martyr in the embrace of the Nuremburg "Maiden," I was told to assume my best Sunday expression, to fix my eyes on the first letter of the sign of a beer saloon opposite, and not to move or wink on pain of "spoiling the exposure." One of the executioners then said I must not close my eyes or move for ten minutes, at the end of which he would signal by a tap on the ballot box. The length of that cycle was too awful for description. There was not such another in the "time, times and an half," of the Prophet Daniel, or in the whole of "Pollock's Course of Time." It was a time of agony, and I supposed at first that it would come to an end, but I had to abandon that hope. I began to recall and review the tortures of which I had read, "Fox's Book of Martyrs," "The History of the Inquisition," and had nearly finished "Las Casas," "Tyranies and Cruelties of the Spaniards," when the tap came and the anguish ended.

Some days afterward the portrait was produced. It was a portrait with a tremolo attachment of wavy lines, the eyes leaden, the nose too large, the expression dull and heavy. And yet it was regarded as a triumph of art. The printing of anything directly from the object was in itself so extraordinary that one scarcely thought of criticising the print. I myself thought it the most wonderful advance in art that had ever occurred. Now when I recall the pitiful results of this experiment and mentally compare them with the exquisitely beautiful illustrations in the number of CAMERA NOTES you have sent me, I cannot but feel that the world owes a larger debt to photography than to wood and line engraving and etching combined. I think I have never seen an etching which surpasses the "Lombardy Pastoral" in all the qualities that make an etching attractive.

Cordially yours,

(Signed), L. E. CHITTENDEN.

March 14, 1898.

Cuthbert Bede

Photographic Pleasures
1855
AN EXCERPT

Edward Bradley (1827–1889), a scholar of theology at Oxford
University, was of the opinion that photography, being a
light subject, should be treated lightly. He adopted the
pseudonym Cuthbert Bede in honor of the Venerable Bede,
an eighth-century ecclesiastical writer and biographer of St.
Cuthbert. He is particularly sharp about the use of the pho-
tograph as a recording device, from its employment as early
as 1852 in making police mug shots to its use in the Paris
National Library catalogue and its future job reproducing
wills, records, and manuscripts.

PHOTOGRAPHY IN A PORTRAIT-PAINTING LIGHT

The application of Photography to portraiture was for a long time
considered impracticable. No sitter could maintain immobility of fea-
ture for the space of twenty-five, or even five minutes; and immobility
was quite necessary in a process where, if you wink your eye, you
destroy it altogether, and where, if you sneeze, you blow your head
off!

In the earliest days of Photography "it was required," says the

Jury Report of the Great Exhibition, "that for a Daguerreotype portrait a person should sit without moving for twenty-five minutes in the glaring sunlight." We have not the pleasure of an intimacy with any one who ever performed this daring feat of salamanderism; but if the case was such as is represented, we are surprised that this twenty-five minutes' sitting was not made profitable to the Daguerreotypist by placing eggs beneath the sitter, and converting him into an Eccaleobion, or patent hatching machine.

It seems that the slow process was attributable to the plate being merely prepared with iodine, and the lens having a long focus. When object-glasses with a shorter focus were constructed, and when Mr. Wolcott (of New York) had concentrated the light by substituting a concave mirror for the refracting glasses, and when Mr. Goddard had added chlorine and bromine to the iodine, and when M. Fizeau had discovered his fixing coating, and when Mr. Claudet made public to the scientific world in England and France the invention of the accelerating process,—then the time required for the production of a portrait was diminished from minutes to seconds; nay, even (by Mr. Scott Archer's Collodion process) to a single second, and less than that! even to the flash of an electric spark.

Thus the difficulties that beset Photography in its attempts to become a portrait-painter were, step by step, overcome, and the Camera was now enabled to make faces, and otherwise to follow out the bent of its inclinations.

I well recollect the time when I went in all the pride of my ungraduateship to have a Photograph of my features struck off for the delectation of that Anna Elisabeth, of whom I was then so greatly enamoured, and who, by the way, in less than three months returned the portrait, and ruthlessly jilted me for a fellow who had not even whiskers! I well remember how I went elaborately got up for the occasion, how I tastefully arranged my hair before the Daguerreotypist's mirror, how I went into his little greenhouse of an operating room, how I took my seat on a platform before the Camera with the sort of consciousness that Anna Elisabeth was going to be favoured with something like a portrait.

I can call to mind how the Daguerreotyper fixed my head in a brazen vice, and having reduced me thereby to the verge of discomfort, maliciously told me to keep my eyes steadily fixed on a paper pinned against the wall, and to think of something pleasant. I can well remember how the Daguerreotyper thereupon left me, and how I, feeling exceedingly uncomfortable, and being lamentably ignorant that the operation had commenced, released my head from the vice, and prom-

enaded the room for some ten minutes, admiring the various designs in chimney pots which are usually to be studied with advantage from a Daguerreotype studio. Then, hearing the sound of returning steps, I mounted my platform, and resumed my seat and vice.

I can call to mind *my* dismay when the Daguerreotyper took the plate out of the camera, and *his* dismay, when, on the development of the picture, he found that it merely contained a representation of the chair-back and vice. But we concealed our real feelings under these speeches—"We had not been *quite* successful this time, sir! I must trouble you to sit again."—"Oh! certainly."

I sat; and Anna Elisabeth had the portrait. Six months afterwards it was in the possession of Sarah Jane. The moral whereof may be supplied by the reader.
. . . .

PHOTOGRAPHY IN A DETECTIVE LIGHT

It will be remembered by the friends of Mr. Pickwick, that, when that immortal gentleman was conveyed to the Fleet, in the delicate matter of "Bardell *v.* Pickwick," his first intimation of his being a prisoner, was, by his having to undergo the ceremony of "sitting for his Portrait;" which ceremony consisted in the Turnkeys making a careful inspection of Mr. Pickwick's person and features. This was a method of taking mental Daguerreotypes which proved highly disagreeable to Mr. Pickwick; and has doubtless given pain to many others. But, as the world grows older, it grows wiser in refining methods; and so, this system of portrait-painting, has, since Mr. Pickwick's time, been greatly improved.

Late in the year 1852, the 'Revue Génève' stated, that the Department of Justice and Police were authorised by the Federal Council to incur the charge of photographing the portraits of those persons who broke the laws by mendicancy in those cantons where they had no settlement. The verbal descriptions which had been heretofore relied on, were found to be insufficient for the identification of the offenders; the features of the beggars, beggared description.

The reformation, which had thus begun in Geneva, soon spread to France and England, and was warmly adopted by the authorities of Scotland Yard, who, in the most friendly spirit, received and recognised Photography as an able Detective. By its aid, the Force started a new paper called the 'Illustrated Hue and Cry,' the chief features to which were given through the countenance of that class of gentlemen

who find the society of the members of the Police Force so extremely captivating. I have not yet met with a number of this paper, but I should imagine it to be almost as amusing and instructive as Madame Tussaud's "Chamber of Horrors." I can imagine its illustrations to depict the same scowling features, the same hang-dog look, the same ruffianly brutality of countenance, the same sensual, hardened, callousness of demeanour, the same illiterate, animal, demoralized, rapscalion set of rascals, as those with which the eyes and feelings of the British public are delighted in that charming Chamber of Horrors; and I would venture to suggest to the Wax-work proprietors, that if a few illustrations, on the principle of those in the "Illustrated Hue and Cry," were to be added to their catalogue, it would double the value of that most interesting and entertaining work.

In this used-up age, when the heads of the people have been placed before us, in all kinds of plates, and with every variety of dressing, the formation of a Blackguard's Portrait Gallery would probably be an event that would even make Sir Charles Coldstream's pulse beat to a new sensation. There seems a propriety in assigning a special place in the galleries of England to the portraits of England's blackguards. The old English worthies ought not to be mixed up with the unworthies. We ought not to gaze on the famous and infamous from the same point of observation; we ought not to look on the bad Mr. Goode, who ended his days on the scaffold, with the same feelings with which we should regard the portrait of any other good man: we ought not to hang the great Burke side by side with Burke the pitch-plaister murderer. To everything there should be a place; and the Blackguards should take a place by themselves, and that, the lowest.

In such an Exhibition, the Burglars would probably form the most attractive part; for it would be but natural for the thieves to "take" the most. The portraits of gentlemen who had committed arson, should be treated in a blaze of colour, in the style of the fiery Venetians. Pickpockets should receive the handling of a Constable; while the murderers would, of course, be hung on the line, and would receive every attention at the hands of the Hanging Committee. Altogether, I do not see why a Blackguard's Portrait Gallery should not succeed. It would have one advantage over other galleries, in not calling people by wrong names. It would not write "the portrait of a gentleman" under the representation of a man who may smile and smile, and yet, be a villain still; while it would probably decimate half the picture galleries in England, if it could claim for its own all who came under the designation of the vulgar and expressive epithet "Blackguard."

PHOTOGRAPHY IN ALL MANNER OF LIGHTS

In whatever light we may regard Photography—whether we look at it in Mr. Stewart's Pantographic Process, or in Dr. Wood's Catalissotype Process, or in Mons. Niepce's Heliographic Process, or in Mons. Tardieu's Tardiochromic Process, or in Mons. Daguerre's Daguerreotype Process, or in Mr. Fox Talbot's Photogenic Process, or in Mr. Talbot's friends' Talbotype Process, or (again) in Mr. Talbot's Calotype Process, or in Mr. Scott Archer's Collodion Process, or in Mr. Crooke's Wax-paper Process, or in Mr. Maxwell Lyte's Instantaneous Process, or in Mr. Weld Taylor's Iodizing Process, or in Sir David Brewster's Stereoscopic Process, or in Mons. Claudet's Accelerating Process, or in Mr. Anybody's Paper Process, or in Sir Wm. Herschel's Photographic Process—in whatever light, and under whatever alias, we may regard Photography, we cannot but fail to see in it much to interest and amuse. Of its benefit to the human race we can even now form something more than conjectures, by glancing at the variety of its performances, and the various uses to which the art has already been applied: for the human face divine has by no means monopolised the attentions of our friend Camera.

It has now become a matter for history, that her Majesty was enabled by photographic agency to trace the progress of her people's Palace at Sydenham through every phase of its crystal beauty. Her personal visits, although numerous, would have failed to put the Sovereign in possession of the progressive details of the building; but Mr. Philip Delamotte, by a wave of his Enchanter's Wand, could summon up before his Queen the shades of changing and passing forms, and could bid the spirit of the scene to rise before her. Afar from the spot, and in the retirement of her own castled home, the Royal Lady could sit and mark that Crystal Palace springing silently into perfected beauty: like a second Solomon's temple,

> *"No hammer fell, no ponderous axes rung;*
> *Like some tall palace the mystic fabric sprung."*

How wonderful the art that could achieve such magic as this!

In a like manner to Mr. Delamotte did Mr. Fenton take Photographic views of the progress of Mons. Vignolle's bridge across the Dnieper at Kieff. Every pile was there, and even every little wave that beat against it. What fairy wonder was ever like this!

From these cases, it will be obvious, that Photography can be made most serviceable to Engineers and Architects, in illustrating— either for themselves or their employers—the progress of the works on which they may be engaged. Accurate ideas may thus be obtained of newly-built mansions, churches, or public edifices. Indeed, Estate agents are already awake to the advantages of the art; and, in place of the gaudily-coloured idealities which they were in the habit of exhibiting as the correct representations of the villas and mansions of which they had the disposal, many of them now set before you the less attractive, but more faithful Calotypes. May such truth-telling prosper as it deserves!

Artists and Sculptors, too, can make abundant use of Photography. If Mr. McGuilp merely desires a chiaroscuro study—instead of keeping his model for hours and paying him accordingly, he can put him before the Camera, and get all his muscular developments in a twinkling. If Mr. Chalk is desirous to take a copy of his picture, or Mr. Chisel of his statue, before those productions of art leave their respective studios for the galleries of their respected purchasers, what do Messrs. Chalk and Chisel do, but call in the aid of our friend Camera.

The proprietors of our great Illustrated Newspaper would tell you that our friend was one of their most valuable contributors; and that he gives them portraits of persons,[1] places and things. Perhaps the day is not far distant, when their paper will receive the greater part of its illustrations through Photographs which have placed the object immediately upon the *wood*, and have been at once engraved, without the intermediate aid (and expense) of the draughtsman, and, of course, with greater claims to accuracy of delineation. In the *Art Journal* for August, 1853, appeared a small wood engraving, being a reduced copy (some twenty-four times less) of Mr. Nasmyth's map of the moon, photographed upon the wood in a manner suitable for the graver, by the Rev. St. Vincent Beechy, and engraved by Mr. Robt. Langton, of Manchester. This is but the first fruits of a harvest, the magnitude and importance of which I may conjecture, but will not pretend to determine.

I need only refer to the Photographs of celebrated line engravings,

1. The Illustrated London News *for January 6th, 1855, contains a portrait of the late Dr. Routh, engraved from a photograph, for which the venerable President of Magdalen sat on his* hundredth *birthday. The photograph of a centenarian, who might have shaken hands with the Pretender, may be taken as a good illustration of the immense strides which Science has made during the past hundred years.*

that the reader may not altogether forget those most lovely specimens of this most lovely art.[2] It may be that we shall live to see it no uncommon thing for books to be illustrated with genuine Photographs[3] —not that the engraver need despair, for *his* art can never perish.

There is one use of Photography which may be carried out, and probably *will* be, to a far greater sphere of usefulness than it has yet reached; and that is, its application to MSS. and catalogues of books. That interminable Catalogue of the British Museum, which seems to be "not for an age, but for all time," and appears as if it would not receive its completion until the Greek Kalends—might be made of unusual value if it contained small Photographs of the title-pages of its principal works, more particularly the older ones. They manage these things better in France, where they have got the start of us, by illustrating, in the manner just mentioned, the Catalogue of the National Library of Paris. As to old and valuable MSS. which are at present lost to the general world, and accessible only to a few, how many of them might be made public, "in faultless fac-simile, without trouble and expense," merely by an application of our friend Camera! Mr. W. J. Thoms, F.S.A., states, that he thus saw two pages of a fine old folio edition of Aldrovandus, with a woodcut on one of them, exquisitely and distinctly copied, though the copy was only about an inch and a quarter by two inches.[4] And, Mr. Thoms further states, that an accomplished Photographic amateur, having had occasion to make an official return of which he wished to retain a copy, saved himself the trouble

2. *I may here mention, as valuable instances of the application of Photography to the Fine Arts, Mr. Contencin's copies of portraits in chalks, and Mr. Thurston Thompson's copies of the Raphael drawings belonging to Her Majesty.*

3. *I do not here refer to publications consisting solely of Photographic pictures—such as Mr. Delamotte's "Progress of the Crystal Palace at Sydenham"; Mr. Shaw's "Photographic Studies"; Mr. Owen's "Photographic Pictures"; Messrs. Fenton and Delamotte's "Photographic Album"; Mr. Sedgfield's "Photographic Delineations"; Mons. Bisson's "Photographic Copies of Rembrandt," &c. —or even to those Photographic Manuals and Primers which are illustrated with a specimen of the art—but rather to works on routine subjects, which shall be illustrated, out of the routine manner, with photographs. A work of this character ("Illustrations of Scripture, by an Animal Painter") has already appeared, and its example will probably be extensively followed. Dr. Diamond has also published some photographic "Portraits of the Insane"; a work of great value to the medical world.*

4. *I greatly value a beautiful copy (collodion), made by Mr. Thoms, of two of the designs in the present volume (the Frontispiece, and "a Photographer astonishing the natives") when they originally appeared as woodcuts, in the pages of 'Punch.' The clearness of these miniature miniatures is such, that all the writing and printing upon them is distinctly visible and readable.*

of re-writing it, by taking a Photographic copy.[5] Might not Public Offices—and especially Will and Record Offices, take a hint from this?

The Camera has been introduced to the Microscope,[6] and they have been so mutually pleased with their acquaintance, that they have agreed to assist each other in the production of pictures. They will be the Lee and Cooper, among the R.A.'s of the Scientific Academy.

Perhaps, indeed, their Scientific Academy will soon outrival Messrs. Lee and Cooper's Royal Academy. Already, and quite as a matter of course, has our friend Camera begun to throw open his Picture Galleries. Besides the "Photographic Institution" in New Bond street, there is the "Photographic Society," which gave its first annual Exhibition in Suffolk street, Pall mall, January, 1854.

In our Observatories at Greenwich, and elsewhere, the night-work has been annulled by a little Photographic watchman, who takes all the duty and responsibility upon himself, and is never caught napping. Winds and storms now register their own doings, and write their own truthful memoirs; while Mr. Brooke's Cylinder of Photographic Paper makes revolutions of a far more useful kind than you would meet with in Spain.

Far away, out in mysterious Egypt, on certain ruins there are certain inscriptions which are at too great an elevation to be deciphered, and remain an agonising mystery to all curious travellers; when, forthwith, steps in our friend Camera, puts up his eye-glass, and reads you the riddle, as easily as the Sphinx would read the second column of the *Times*.

But what is there that our friend Camera will not do? If I go upon the Continent there he is before me, sketching glorious old Gothic churches and crumbling ruins. If I wander into the green lanes and leafy dells of my own sweet country, there is our friend upon his tripod, making ready to carry off the village church, and even the sexton himself. If I betake myself to the fenny flats of the eastern Counties, and imagine myself to be remote from civilization, lo! and behold, there is our friend with his apparatus on his back, going the round of the scattered farmsteads, and persuading fond mothers not to neglect the present favourable opportunity of securing likenesses of their children.

Camera even goes out to the Crimea, into the very thick of the fight; and, of his doings there we occasionally catch a glimpse through

5. 'Notes and Queries.' VI. 347.
6. I may here particularise Mr. Kingsley's "Illustrations of the Breathing System of Insects," exhibited in the "Photographic Society," 1855.

the columns of the 'Illustrated News.' I read in the papers, too, that the Photographers in the camp of our brave Allies have already sent to France numerous pictures of the campaign.[7] And, the other day, I read of an enthusiastic amateur of Bourg, named Daviel, who (after the fashion of Vandervelde) was very coolly photographing a hot engagement between the Turks and Russians near Kars, and was cruelly interrupted, in his pursuit of scientific pleasure under difficulties, by the Russians coming upon him in their full retreat, and carrying him away captive, together with his apparatus.

Out to the Baltic, too, goes our friend Camera; and, so rapid is he with his pencil, that he will sketch you the Three Crown Battery at Copenhagen, being on board her Majesty's ship, which is sailing merrily along at eleven knots an hour. Then he goes to see his friend Mr. Kibble, of Glasgow, and, in a twinkling, he puts down for him, in black and white, the exterior of the Glasgow Theatre, and the crowd of people thronging its doors. With the same rapidity, too, did he sketch the ceremonial attendant upon the opening of the Sydenham Palace,[8] giving you, in a moment, faithful likenesses of all the Royal and distinguished visitors, with hundreds of other figures, all correctly delineated on a piece of glass measuring three inches by five.

But it little matters to him of what size his pictures must be. He will take you the size of life; or he will make for you a miniature copy —inch size—of the 'Times' newspaper—though you must make use of a powerful glass if you wish to peruse its leaders. Indeed, if he takes a miniature of you or me—and he (or we) should afterwards wish it on an enlarged scale, he can even, with the help of his friend Mons. Heilman, successfully get over this difficulty.

In short, what cannot our friend Camera do? Although young, he is such an extraordinary fellow, that I shall not feel surprised at anything that I may hear of him. Shall you?

7. *Mr. Nicklin, the Photographer, sent out to the seat of war by the English Government, was lost, together with his assistants, in the wreck of the* Rip Van Winkle, *which foundered in the hurricane off Balaclava, November 15th, 1854.*

8. *Exhibited on the evening of the same day, by Mr. Williams, at Lord Rosse's soirée.*

Lady Eastlake

A Review in the
London Quarterly Review
1857
AN EXCERPT

Lady Elizabeth Eastlake (1809–1893) was the wife of Sir
Charles Eastlake, the director of London's National Gallery,
president of the Royal Academy, and first president of the
Photographic Society (later the Royal Photographic Society).
The following was published unsigned in the *London Quarterly
Review* in 1857; it is the second half of a review of several
books on photography. The author confronts and struggles
intelligently with the issue of art and photography.
. . . .

As respects the time of the day, one law seems to be thoroughly estab-
lished. It has been observed by Daguerre and subsequent photogra-
phers that the sun is far more active, in a photographic sense, for the
two hours before, than for the two hours after it has passed the merid-
ian. As a general rule, too, however numerous the exceptions, the
cloudy day is better than the sunny one. Contrary, indeed, to all
preconceived ideas, experience proves that the brighter the sky that
shines above the camera the more tardy the action within it. Italy and
Malta do their work slower than Paris. Under the brilliant light of a
Mexican sun, half an hour is required to produce effects which in
England would occupy but a minute. In the burning atmosphere of
India, though photographical the year round, the process is compara-

tively slow and difficult to manage; while in the clear, beautiful, and, moreover, cool light of the higher Alps of Europe, it has been proved that the production of a picture requires many more minutes, even with the most sensitive preparations, than in the murky atmosphere of London. Upon the whole, the temperate skies of this country may be pronounced most favourable to photographic action, a fact for which the prevailing characteristic of our climate may partially account, humidity being an indispensable condition for the working state both of paper and chemicals.

But these are at most but superficial influences—deeper causes than any relative dryness or damp are concerned in these phenomena. The investigation of the solar attributes, by the aid of photographic machinery, for which we are chiefly indebted to the researches of Mr. Hunt and M. Claudet, are, scientifically speaking, the most interesting results of the discovery. By these means it is proved that besides the functions of light and heat the solar ray has a third, and what may be called photographic function, the cause of all the disturbances, decompositions, and chemical changes which affect vegetable, animal, and organic life. It had long been known that this power, whatever it may be termed—energia—actinism—resided more strongly, or was perhaps less obstructed, in some of the coloured rays of the spectrum than in others—that solutions of silver and other sensitive surfaces were sooner darkened in the violet and the blue than in the yellow and red portions of the prismatic spectrum. Mr. Hunt's experiments further prove that mere light, or the luminous ray, is little needed where the photographic or 'chemical ray' is active, and that sensitive paper placed beneath the comparative darkness of a glass containing a dense purple fluid, or under that deep blue glass commonly used as a finger-glass, is photographically affected almost as soon as if not shaded from the light at all. Whereas, if the same experiment be tried under a yellow glass or fluid, the sensitive paper, though robbed neither of light nor heat, will remain a considerable time without undergoing any change.[1]

We refer our readers to this work for results of the utmost interest —our only purpose is to point out that the defects or irregularities of photography are as inherent in the laws of Nature as its existence—

1. *We may add, though foreign to our subject, that the same experiment applied by Mr. Hunt to plants has been attended with analogous results. Bulbs of tulips and ranunculuses have germinated beneath yellow and red glasses, but the plant has been weakly and has perished without forming buds. Under a green glass (blue being a component part of the colour) the plants have been less feeble, and have advanced as far as flower buds; while beneath the blue medium perfectly healthy plants have grown up, developing their buds, and flowering in perfection.*

being coincident with the first created of all things. The prepared paper or plate which we put into the camera may be compared to chaos, without form and void, on which the merest glance of the sun's rays calls up image after image till the fair creation stands revealed: yet not revealed in the order in which it met the solar eye, for while some colours have hastened to greet his coming, others have been found slumbering at their posts, and have been left with darkness in their lamps. So impatient have been the blues and violets to perform their task upon the recipient plate, that the very substance of the colour has been lost and dissolved in the solar presence; while so laggard have been the reds and yellows and all tints partaking of them, that they have hardly kindled into activity before the light has been withdrawn. Thus it is that the relation of one colour to another is found changed and often reversed, the deepest blue being altered from a dark mass into a light one, and the most golden-yellow from a light body into a dark.

It is obvious, therefore, that however successful photography may be in the closest imitation of light and shadow, it fails, and must fail, in the rendering of true chiaroscuro, or the true imitation of light and dark. And even if the world we inhabit, instead of being spread out with every variety of the palette, were constituted but of two colours —black and white and all their intermediate grades—if every figure were seen in monochrome like those that visited the perturbed vision of the Berlin Nicolai—photography could still not copy them correctly. Nature, we must remember, is not made up only of actual lights and shadows; besides these more elementary masses, she possesses innumerable reflected lights and half-tones, which play around every object, rounding the hardest edges, and illuminating the blackest breadths, and making that sunshine in a shady place, which it is the delight of the practised painter to render. But of all these photography gives comparatively no account. The beau ideal of a Turner and the delight of a Rubens are caviar to her. Her strong shadows swallow up all timid lights within them, as her blazing lights obliterate all intrusive half-tones across them; and thus strong contrasts are produced, which, so far from being true to Nature, it seems one of Nature's most beautiful provisions to prevent.

Nor is this disturbance in the due degree of chiaroscuro attributable only to the different affinities for light residing in different colours, or to the absence of true gradation in light and shade. The quality and texture of a surface has much to do with it. Things that are very smooth, such as glass and polished steel, or certain complexions and parts of the human face, or highly-glazed satin-ribbon—or smooth

leaves, or brass-buttons—everything on which the light *shines*, as well as everything that is perfectly white, will photograph much faster than other objects, and thus disarrange the order of relation. Where light meets light the same instantaneous command seems to go forth as that by which it was at first created, so that, by the time the rest of the picture has fallen into position, what are called the high lights have so rioted in action as to be found far too prominent both in size and intensity.

And this brings us to the artistic part of our subject, and to those questions which sometimes puzzle the spectator, as to how far photography is really a picturesque agent, what are the causes of its successes and its failures, and what in the sense of art are its successes and failures? And these questions may be fairly asked now when the scientific processes on which the practice depends are brought to such perfection that, short of the coveted attainment of colour, no great improvement can be further expected. If we look round a photographic exhibition we are met by results which are indeed honourable to the perseverance, knowledge, and in some cases to the taste of man. The small, broadly-treated, Rembrandt-like studies representing the sturdy physiognomies of Free Church Ministers and their adherents, which first cast the glamour of photography upon us, are replaced by portraits of the most elaborate detail, and of every size not excepting that of life itself. The little bit of landscape effect, all blurred and uncertain in forms, and those lost in a confused and discoloured ground, which was nothing and might be anything, is superseded by large pictures with minute foregrounds, regular planes of distance, and perfectly clear skies. The small attempts at architecture have swelled into monumental representations of a magnitude, truth, and beauty which no art can surpass—animals, flowers, pictures, engravings, all come within the grasp of the photographer; and last, and finest, and most interesting of all, the sky with its shifting clouds, and the sea with its heaving waves, are overtaken in their course by a power more rapid than themselves.

But while ingenuity and industry—the efforts of hundreds working as one—have thus enlarged the scope of the new agent, and rendered it available for the most active, as well as for the merest still life, has it gained in an artistic sense in like proportion? Our answer is not in the affirmative, nor is it possible that it should be so. Far from holding up the mirror to nature, which is an assertion usually as triumphant as it is erroneous, it holds up that which, however beautiful, ingenious, and valuable in powers of reflection, is yet subject to certain distortions and deficiencies for which there is no remedy. The science therefore which has developed the resources of photography, has but

more glaringly betrayed its defects. For the more perfect you render an imperfect machine the more must its imperfections come to light: it is superfluous therefore to ask whether Art has been benefited, where Nature, its only source and model, has been but more accurately falsified. If the photograph in its early and imperfect scientific state was more consonant to our feelings for art, it is because, as far as it went, it was more true to our experience of Nature. Mere broad light and shade, with the correctness of general forms and absence of all convention, which are the beautiful conditions of photography, will, when nothing further is attempted, give artistic pleasure of a very high kind; it is only when greater precision and detail are superadded that the eye misses the further truths which should accompany the further finish.

For these reasons it is almost needless to say that we sympathise cordially with Sir William Newton, who at one time created no little scandal in the Photographic Society by propounding the heresy that pictures taken slightly out of focus, that is, with slightly uncertain and undefined forms, 'though less *chemically*, would be found more *artistically* beatiful.' Much as photography is supposed to inspire its votaries with æsthetic instincts, this excellent artist could hardly have chosen an audience less fitted to endure such a proposition. As soon could an accountant admit the morality of a false balance, or a sempstress the neatness of a puckered seam, as your merely scientific photographer be made to comprehend the possible beauty of 'a slight *burr*.' His mind proud science never taught to doubt the closest connexion between cause and effect, and the suggestion that the worse photography could be the better art was not only strange to him, but discordant. It was hard too to disturb his faith in his newly acquired powers. Holding, as he believed, the keys of imitation in his camera, he had tasted for once something of the intoxicating dreams of the artist; gloating over the pictures as they developed beneath his gaze, he had said in his heart 'anch' io son' pittore.' Indeed there is no lack of evidence in the Photographic Journal of his believing that art had hitherto been but a blundering groper after that truth which the cleanest and precisest photography in his hands was now destined to reveal. Sir William Newton, therefore, was fain to allay the storm by qualifying his meaning to the level of photographic toleration, knowing that, of all the delusions which possess the human breast, few are so intractable as those about art.

But let us examine a little more closely those advances which photography owes to science—we mean in an artistic sense. We turn to the portraits, our *premiers amours*, now taken under every appliance of facility both for sitter and operator. Far greater detail and precision

accordingly appear. Every button is seen—piles of stratified flounces in most accurate drawing are there—what was at first only suggestion is now all careful making out—but the likeness to Rembrandt and Reynolds is gone! There is no mystery in this. The first principle in art is that the most important part of a picture should be best done. Here, on the contrary, while the dress has been rendered worthy of a fashion-book, the face has remained, if not so unfinished as before, yet more unfinished in proportion to the rest. Without referring to M. Claudet's well-known experiment of a falsely coloured female face, it may be averred that, of all the surfaces a few inches square the sun looks upon, none offers more difficulty, artistically speaking, to the photographer, than a smooth, blooming, clean washed, and carefully combed human head. The high lights which gleam on this delicate epidermis so spread and magnify themselves, that all sharpness and nicety of modelling is obliterated—the fineness of skin peculiar to the under lip reflects so much light, that in spite of its deep colour it presents a light projection, instead of a dark one—the spectrum or intense point of light on the eye is magnified to a thing like a cataract. If the cheek be very brilliant in colour, it is as often as not represented by a dark stain. If the eye be blue, it turns out as colourless as water; if the hair be golden or red, it looks as if it had been dyed, if very glossy it is cut up into lines of light as big as ropes. This is what a fair young girl has to expect from the tender mercies of photography—the male and the older head, having less to lose, has less to fear. Strong light and shade will portray character, though they mar beauty. Rougher skin, less glossy hair, Crimean moustaches and beard overshadowing the white under lip, and deeper lines, are all so much in favour of a picturesque result. Great grandeur of feature too, or beauty of *pose* and sentiment, will tell as elevated elements of the picturesque in spite of photographic mismanagement. Here and there also a head of fierce and violent contrasts, though taken perhaps from the meekest of mortals, will remind us of the Neapolitan or Spanish school, but, generally speaking, the inspection of a set of faces, subject to the usual conditions of humanity and the camera, leaves us with the impression that a photographic portrait, however valuable to relative or friend, has ceased to remind us of a work of art at all.

And, if further proof were wanted of the artistic inaptitude of this agent for the delineation of the human countenance, we should find it in those magnified portraits which ambitious operators occasionally exhibit to our ungrateful gaze. Rightly considered, a human head, the size of life, of average intelligence, and in perfect drawing, may be expected however roughly finished, to recall an old Florentine fresco of

four centuries ago. But, 'ex nihilo, nihil fit': the best magnifying lenses can in this case only impoverish in proportion as they enlarge, till the flat and empty Magog which is born of this process is an insult, even in remotest comparison with the pencil of a Masaccio.

The falling off of artistic effect is even more strikingly seen if we consider the department of landscape. Here the success with which all accidental blurs and blotches have been overcome, and the sharp perfection of the object which stands out against the irreproachably speckless sky, is exactly as detrimental to art as it is complimentary to science. The first impression suggested by these buildings of rich tone and elaborate detail, upon a glaring white background without the slightest form or tint, is that of a Chinese landscape upon looking-glass. We shall be asked why the beautiful skies we see in the marine pieces cannot be also represented with landscapes; but here the conditions of photography again interpose. The impatience of light to meet light is, as we have stated, so great, that the moment required to trace the forms of the sky (it can never be traced in its cloudless gradation of tint) is too short for the landscape, and the moment more required for the landscape too long for the sky. If the sky be given, therefore, the landscape remains black and underdone; if the landscape be rendered, the impatient action of the light has burnt out all cloud-form in one blaze of white. But it is different with the sea, which, from the liquid nature of its surface, receives so much light as to admit of simultaneous representation with the sky above it. Thus the marine painter has both hemispheres at his command, but the landscape votary but one; and it is but natural that he should prefer Rydal Mount and Tintern Abbey to all the baseless fabric of tower and hill which the firmament occasionally spreads forth. But the old moral holds true even here. Having renounced heaven, earth makes him, of course, only an inadequate compensation. The colour green, both in grass and foliage, is now his great difficulty. The finest lawn turns out but a gloomy funeral-pall in his hands; his trees, if done with the slower paper process, are black, and from the movement, uncertain webs against the white sky—if by collodion, they look as if worked in dark cambric, or stippled with innumerable black and white specks; in either case missing all the breadth and gradations of nature. For it must be remembered that every leaf reflects a light on its smooth edge or surface, which, with the tendency of all light to over-action, is seen of a size and prominence disproportioned to things around it; so that what with the dark spot produced by the green colour, and the white spot produced by the high light, all intermediate grades and shades are lost. This is especially the case with hollies, laurels, ivy, and other smooth-leaved evergreens, which form

so conspicuous a feature in English landscape gardening—also with
foreground weeds and herbage, which, under these conditions, instead
of presenting a sunny effect, look rather as if strewn with shining bits
of tin, or studded with patches of snow.

For these reasons, if there be a tree distinguished above the rest of
the forest for the harshness and blueness of its foliage, we may expect
to find it suffer less, or not at all, under this process. Accordingly, the
characteristic exception will be found in the Scotch fir, which, however
dark and sombre in mass, is rendered by the photograph with a deli-
cacy of tone and gradation very grateful to the eye. With this exception
it is seldom that we find any studies of trees, in the present improved
state of photography, which inspire us with the sense of pictorial truth.
Now and then a bank of tangled bushwood, with a deep, dark pool
beneath, but with no distance and no sky, and therefore no condition
of relation, will challenge admiration. Winter landscapes also are beau-
tiful, and the leafless Burnham beeches a real boon to the artist; but
otherwise such materials as Hobbema, Ruysdael, and Cuyp converted
into pictures unsurpassable in picturesque effect are presented in vain
to the improved science of the photographic artist. What strikes us
most frequently is the general *emptiness* of the scene he gives. A house
stands there, sharp and defined like a card-box, with black blots of
trees on each side, all rooted in a substance far more like burnt stubble
than juicy, delicate grass. Through this winds a white spectral path,
while staring palings or linen hung out to dry (oh! how unlike the
luminous spots on Ruysdael's bleaching-grounds!), like bits of the
white sky dropped upon the earth, make up the poverty and patchiness
of the scene. We are aware that there are many partial exceptions to
this; indeed, we hardly ever saw a photograph in which there was not
something or other of the most exquisite kind. But this brings us no
nearer the standard we are seeking. Art cares not for the right finish
unless it be in the right place. Her great aim is to produce a whole; the
more photography advances in the execution of parts, the less does it
give the idea of completeness.

There is nothing gained either by the selection of more ambitious
scenery. The photograph seems embarrassed with the treatment of
several gradations of distance. The finish of background and middle
distance seems not to be commensurate with that of the foreground;
the details of the simplest light and shadow are absent; all is misty and
bare, and distant hills look like flat, grey moors washed in with one
gloomy tint. This emptiness is connected with the rapidity of collo-
dion, the action of which upon distance and middle ground does not
keep pace with the hurry of the foreground. So much for the ambition

of taking a picture. On the other hand, we have been struck with mere studies of Alpine masses done with the paper process, which allows the photograph to take its time, and where, from the absence of all foreground or intermediate objects, the camera has been able to concentrate its efforts upon one thing only—the result being records of simple truth and precision which must be invaluable to the landscape-painter.

There is no doubt that the forte of the camera lies in the imitation of one surface only, and that of a rough and broken kind. Minute light and shade, cognisant to the eye, but unattainable by hand, is its greatest and easiest triumph—the mere texture of stone, whether rough in the quarry or hewn on the wall, its especial delight. Thus a face of rugged rock, and the front of a carved and fretted building, are alike treated with a perfection which no human skill can approach; and if asked to say what photography has hitherto best succeeded in rendering, we should point to everything near and rough—from the texture of the sea-worn shell, of the rusted armour, and the fustian jacket, to those glorious architectural pictures of French, English, and Italian subjects, which whether in quality, tone, detail, or drawing, leave nothing to be desired.

Here, therefore, the debt of Science for additional clearness, precision, and size may be gratefully acknowledged. What photography can do is now, with her help, better done than before; what she can but partially achieve is best not brought too elaborately to light. Thus the whole question of success and failure resolves itself into an investigation of the capacities of the machine, and well may we be satisfied with the rich gifts it bestows, without straining it into a competition with art. For everything for which Art, so-called, has hitherto been the means but not the end, photography is the allotted agent—for all that requires mere manual correctness, and mere manual slavery, without any employment of the artistic feeling, she is the proper and therefore the perfect medium. She is made for the present age, in which the desire for art resides in a small minority, but the craving, or rather necessity for cheap, prompt, and correct facts in the public at large. Photography is the purveyor of such knowledge to the world. She is the sworn witness of everything presented to her view. What are her unerring records in the service of mechanics, engineering, geology, and natural history, but facts of the most sterling and stubborn kind? What are her studies of the various stages of insanity—pictures of life unsurpassable in pathetic truth—but facts as well as lessons of the deepest physiological interest? What are her representations of the bed of the ocean, and the surface of the moon—of the launch of the Marlborough, and of the contents of the Great Exhibition—of Charles Kean's now

destroyed scenery of the 'Winter's Tale,' and of Prince Albert's now slaughtered prize ox—but facts which are neither the province of art nor of description, but of that new form of communication between man and man—neither letter, message, nor picture—which now happily fills up the space between them? What indeed are nine-tenths of those facial maps called photographic portraits, but accurate landmarks and measurements for loving eyes and memories to deck with beauty and animate with expression, in perfect certainty that the ground plan is founded upon fact?

In this sense no photographic picture that ever was taken, in heaven, or earth, or in the waters underneath the earth, of any thing, or scene, however defective when measured by an artistic scale, is destitute of a special, and what we may call an historic interest. Every form which is traced by light is the impress of one moment, or one hour, or one age in the great passage of time. Though the faces of our children may not be modelled and rounded with that truth and beauty which art attains, yet minor things—the very shoes of the one, the inseparable toy of the other—are given with a strength of identity which art does not even seek. Though the view of a city be deficient in those niceties of reflected lights and harmonious gradations which belong to the facts of which Art takes account, yet the facts of the age and of the hours are there, for we count the lines in that keen perspective of telegraphic wire, and read the characters on the playbill or manifesto, destined to be torn down on the morrow.

Here, therefore, the much-lauded and much-abused agent called Photography takes her legitimate stand. Her business is to give evidence of facts, as minutely and as impartially as, to our shame, only an unreasoning machine can give. In this vocation we can as little overwork her as tamper with her. The millions and millions of hieroglyphics mentioned by M. Arago may be multiplied by millions and millions more—she will render all as easily and as accurately as one. When people, therefore, talk of photography, as being intended to supersede art, they utter what, if true, is not so in the sense they mean. Photography *is* intended to supersede much that art has hitherto done, but only that which it was both a misappropriation and a deterioration of Art to do. The field of delineation, having two distinct spheres, requires two distinct labourers; but though hitherto the freewoman has done the work of the bondwoman, there is no fear that the position should be in future reversed. Correctness of drawing, truth of detail, and absence of convention, the best artistic characteristics of photography, are qualities of no common kind, but the student who issues from the academy with these in his grasp stands, nevertheless, but on

the threshold of art. The power of selection and rejection, the living application of that language which lies dead in his paint-box, the marriage of his own mind with the object before him, and the offspring, half stamped with his own features, half with those of Nature, which is born of the union—whatever appertains to the free-will of the intelligent being, as opposed to the obedience of the machine—this, and much more than this, constitutes that mystery called Art, in the elucidation of which photography can give valuable help, simply by showing what it is not. There is, in truth, nothing in that power of literal, unreasoning imitation, which she claims as her own, in which, rightly viewed, she does not relieve the artist of a burden rather than supplant him in an office. We do not even except her most pictorial feats—those splendid architectural representations—from this rule. Exquisite as they are, and fitted to teach the young, and assist the experienced in art, yet the hand of the artist is but ignobly employed in closely imitating the texture of stone, or in servilely following the intricacies of the zigzag ornament. And it is not only in what she can do to relieve the sphere of art, but in what she can sweep away from it altogether, that we have reason to congratulate ourselves. Henceforth it may be hoped that we shall hear nothing further of that miserable contradiction in terms 'bad art'—and see nothing more of that still more miserable mistake in life 'a bad artist.' Photography at once does away with anomalies with which the good sense of society has always been more or less at variance. As what she does best is beneath the doing of a real artist at all, so even in what she does worst she is a better machine than the man who is nothing but a machine.

Let us, therefore, dismiss all mistaken ideas about the harm which photography does to art. As in all great and sudden improvements in the material comforts and pleasures of the public, numbers, it is true, have found their occupation gone, simply because it is done cheaper and better in another way. But such improvements always give more than they take. Where ten self-styled artists eked out a precarious living by painting inferior miniatures, ten times that number now earn their bread by supplying photographic portraits. Nor is even such manual skill as they possessed thrown out of the market. There is no photographic establishment of any note that does not employ artists at high salaries—we understand not less than 1*l.* a day—in touching, and colouring, and finishing from nature those portraits for which the camera may be said to have laid the foundation. And it must be remembered that those who complain of the encroachments of photography in this department could not even supply the demand. Portraits, as is evident to any thinking mind, and as photography now proves, belong

to that class of facts wanted by numbers who know and care nothing about their value as works of art. For this want, art, even of the most abject kind, was, whether as regards correctness, promptitude, or price, utterly inadequate. These ends are not only now attained, but, even in an artistic sense, attained far better than before. The coloured portraits to which we have alluded are a most satisfactory coalition between the artist and the machine. Many an inferior miniature-painter who understood the mixing and applying of pleasing tints was wholly unskilled in the true drawing of the human head. With this deficiency supplied, their present productions, therefore, are far superior to anything they accomplished, single-handed, before. Photographs taken on ivory, or on substances invented in imitation of ivory, and coloured by hand from nature, such as are seen at the rooms of Messrs. Dickinson, Claudet, Mayall, Kilburn, &c., are all that can be needed to satisfy the mere portrait want, and in some instances may be called artistic productions of no common kind besides.

. . . .

. . . If, as we understand, the higher professors of miniature-painting—and the art never attained greater excellence in England than now—have found their studios less thronged of late, we believe that the desertion can be but temporary. At all events, those who in future desire their exquisite productions will be more worthy of them. The broader the ground which the machine may occupy, the higher will that of the intelligent agent be found to stand. If, therefore, the time should ever come when art is sought, as it ought to be, mainly for its own sake, our artists and our patrons will be of a far more elevated order than now: and if anything can bring about so desirable a climax, it will be the introduction of Photography.

Oliver Wendell Holmes

"The Stereoscope and the Stereograph"
1859

AN EXCERPT

Stereographs by the hundreds filled many nineteenth-century homes with the scenery of far-off places and the events of the day. If the camera amazed by its faithful retrieval of nature, the stereograph completed the illusion by counterfeiting binocular vision, usually with two lenses set in the same camera at a distance equal to that between the human eyes. Oliver Wendell Holmes (1809–1894), physician, man of letters, amateur photographer, collector of stereoscopic views, and inventor of the basic hand viewer, wrote perceptively on photography more than once.

Democritus of Abdera, commonly known as the Laughing Philosopher, probably because he did not consider the study of truth inconsistent with a cheerful countenance, believed and taught that all bodies were continually throwing off certain images like themselves, which subtile emanations, striking on our bodily organs, gave rise to our sensations. Epicurus borrowed the idea from him, and incorporated it into the famous system, of which Lucretius has given us the most popular version. Those who are curious on the matter will find the poet's description at the beginning of his fourth book. Forms, effigies, membranes, or *films*, are the nearest representatives of the terms ap-

plied to these effluences. They are perpetually shed from the surfaces of solids, as bark is shed by trees. *Cortex* is, indeed, one of the names applied to them by Lucretius.

These evanescent films may be seen in one of their aspects in any clear, calm sheet of water, in a mirror, in the eye of an animal by one who looks at it in front, but better still by the consciousness behind the eye in the ordinary act of vision. They must be packed like the leaves of a closed book; for suppose a mirror to give an image of an object a mile off, it will give one at every point less than a mile, though this were subdivided into a million parts. Yet the images will not be the same; for the one taken a mile off will be very small, at half a mile as large again, at a hundred feet fifty times as large, and so on, as long as the mirror can contain the image.

Under the action of light, then, a body makes its superficial aspect potentially present at a distance, becoming appreciable as a shadow or as a picture. But remove the cause—the body itself—and the effect is removed. The man beholdeth himself in the glass and goeth his way, and straightway both the mirror and the mirrored forget what manner of man he was. These visible films or membranous *exuviæ* of objects, which the old philosophers talked about, have no real existence, separable from their illuminated source, and perish instantly when it is withdrawn.

If a man had handed a metallic speculum to Democritus of Abdera, and told him to look at his face in it while his heart was beating thirty or forty times, promising that one of the films his face was shedding should stick there, so that neither he, nor it, nor anybody should forget what manner of man he was, the Laughing Philosopher would probably have vindicated his claim to his title by an explosion that would have astonished the speaker.

This is just what the Daguerreotype has done. It has fixed the most fleeting of our illusions, that which the apostle and the philosopher and the poet have alike used as the type of instability and unreality. The photograph has completed the triumph, by making a sheet of paper reflect images like a mirror and hold them as a picture.

This triumph of human ingenuity is the most audacious, remote, improbable, incredible—the one that would seem least likely to be regained, if all traces of it were lost, of all the discoveries man had made. It has become such an everyday matter with us, that we forget its miraculous nature, as we forget that of the sun itself, to which we owe the creations of our new art. Yet in all the prophecies of dreaming enthusiasts, in all the random guesses of the future conquests over matter, we do not remember any prediction of such an inconceivable

wonder, as our neighbor round the corner, or the proprietor of the small house on wheels, standing on the village common, will furnish any of us for the most painfully slender remuneration. No Century of Inventions includes this among its possibilities. Nothing but the vision of a Laputan, who passed his days in extracting sunbeams out of cucumbers, could have reached such a height of delirium as to rave about the time when a man should paint his miniature by looking at a blank tablet, and a multitudinous wilderness of forest foliage or an endless Babel of roofs and spires stamp itself, in a moment, so faithfully and so minutely, that one may creep over the surface of the picture with his microscope and find every leaf perfect, or read the letters of distant signs, and see what was the play at the "Variétés" or the "Victoria," on the evening of the day when it was taken, just as he would sweep the real view with a spy-glass to explore all that it contains.

Some years ago, we sent a page or two to one of the magazines— the "Knickerbocker," if we remember aright—in which the story was told from the "Arabian Nights," of the three kings' sons, who each wished to obtain the hand of a lovely princess, and received for answer, that he who brought home the most wonderful object should obtain the lady's hand as his reward. Our readers, doubtless, remember the original tale, with the flying carpet, the tube which showed what a distant friend was doing by looking into it, and the apple which gave relief to the most desperate sufferings only by inhalation of its fragrance. The railroad-car, the telegraph, and the apple-flavored chloroform could and do realize, every day—as was stated in the passage referred to, with a certain rhetorical amplitude not doubtfully suggestive of the lecture-room—all that was fabled to have been done by the carpet, the tube, and the fruit of the Arabian story.

All these inventions force themselves upon us to the full extent of their significance. It is therefore hardly necessary to waste any considerable amount of rhetoric upon wonders that are so thoroughly appreciated. When human art says to each one of us, I will give you ears that can hear a whisper in New Orleans, and legs that can walk six hundred miles in a day, and if, in consequence of any defect of rail or carriage, you should be so injured that your own very insignificant walking members must be taken off, I can make the surgeon's visit a pleasant dream for you, on awaking from which you will ask when he is coming to do that which he has done already—what is the use of poetical or rhetorical amplification? But this other invention of *the mirror with a memory*, and especially that application of it which has given us the wonders of the stereoscope, is not so easily, completely, universally recognized in all the immensity of its applications and suggestions. The

stereoscope, and the pictures it gives, are, however, common enough
to be in the hands of many of our readers; and as many of those who
are not acquainted with it must before long become as familiar with it
as they are now with friction-matches, we feel sure that a few pages
relating to it will not be unacceptable.

Our readers may like to know the outlines of the process of making
daguerreotypes and photographs, as just furnished us by Mr. Whipple,
one of the most successful operators in this country. We omit many of
those details which are everything to the practical artist, but nothing to
the general reader. We must premise, that certain substances undergo
chemical alterations, when exposed to the light, which produce a
change of color. Some of the compounds of silver possess this faculty
to a remarkable degree—as the common indelible marking-ink, (a so-
lution of nitrate of silver,) which soon darkens in the light, shows us
every day. This is only one of the innumerable illustrations of the
varied effects of light on color. A living plant owes its brilliant hues to
the sunshine; but a dead one, or the tints extracted from it, will fade in
the same rays which clothe the tulip in crimson and gold—as our
lady-readers who have rich curtains in their drawing-rooms know full
well. The sun, then is a master of *chiaroscuro*, and, if he has a living
petal for his pallet, is the first of colorists.—Let us walk into his studio,
and examine some of his painting machinery.
· · · ·

We owe the suggestion to a great wit, who overflowed our small
intellectual home-lot with a rushing freshet of fertilizing talk the other
day—one of our friends, who quarries thought on his own premises,
but does not care to build his blocks into books and essays—that per-
haps this world is only the *negative* of that better one in which lights
will be turned to shadows and shadows into light, but all harmonized,
so that we shall see why these ugly patches, these misplaced gleams
and blots, were wrought into the temporary arrangements of our pla-
netary life.

For, lo! when the sensitive paper is laid in the sun under the
negative glass, every dark spot on the glass arrests a sunbeam, and so
the spot of the paper lying beneath remains unchanged; but every light
space of the negative lets the sunlight through, and the sensitive paper
beneath confesses its weakness, and betrays it by growing dark just in
proportion to the glare that strikes upon it. So, too, we have only to
turn the glass before laying it on the paper, and we bring all the natural
relations of the object delineated back again—its right to the right of
the picture, its left to the picture's left.

On examining the glass negative by transmitted light with a power

of a hundred diameters, we observe minute granules, whether crystalline or not we cannot say, very similar to those described in the account of the daguerreotype. But now their effect is reversed. Being opaque, they darken the glass wherever they are accumulated, just as the show darkens our skylights. Where these particles are drifted, therefore, we have our shadows, and where they are thinly scattered, our lights. On examining the paper photographs, we have found no distinct granules, but diffused stains of deeper or lighter shades.

Such is the sun-picture, in the form in which we now most commonly meet it—for the daguerreotype, perfect and cheap as it is, and admirably adapted for miniatures, has almost disappeared from the field of landscape, still life, architecture, and *genre* painting, to make room for the photograph. Mr. Whipple tells us that even now he takes a much greater number of miniature portraits on metal than on paper; and yet, except occasionally a statue, it is rare to see anything besides a portrait shown in a daguerreotype. But the greatest number of sun-pictures we see are the photographs which are intended to be looked at with the aid of the instrument we are next to describe, and to the stimulus of which the recent vast extension of photographic copies of Nature and Art is mainly owing.

The Stereoscope—This instrument was invented by Professor Wheatstone, and first described by him in 1838. It was only a year after this that M. Daguerre made known his discovery in Paris; and almost at the same time Mr. Fox Talbot sent his communication to the Royal Society, giving an account of his method of obtaining pictures on paper by the action of light. Iodine was discovered in 1811, bromine in 1826, chloroform in 1831, gun-cotton, from which collodion is made, in 1846, the electro-plating process about the same time with photography; "all things, great and small, working together to produce what seemed at first as delightful, but as fabulous, as Aladdin's ring, which is now as little suggestive of surprise as our daily bread."

A stereoscope is an instrument which makes surfaces look solid. All pictures in which perspective and light and shade are properly managed, have more or less of the effect of solidity; but by this instrument that effect is so heightened as to produce an appearance of reality which cheats the senses with its seeming truth.

There is good reason to believe that the appreciation of solidity by the eye is purely a matter of education. The famous case of a young man who underwent the operation of couching for cataract, related by Cheselden, and a similar one reported in the Appendix to Müller's Physiology, go to prove that everything is seen only as a superficial extension, until the other senses have taught the eye to recognize *depth*,

or the third dimension, which gives solidity, by converging outlines, distribution of light and shade, change of size, and of the texture of surfaces. Cheselden's patient thought "all objects whatever touched his eyes, as what he felt did his skin." The patient whose case is reported by Müller could not tell the form of a cube held obliquely before his eye from that of a flat piece of pasteboard presenting the same outline. Each of these patients saw only with one eye—the other being destroyed, in one case, and not restored to sight until long after the first, in the other case. In two months' time Cheselden's patient had learned to know solids; in fact, he argued so logically from light and shade and perspective that he felt of pictures, expecting to find reliefs and depressions, and was surprised to discover that they were flat surfaces. If these patients had suddenly recovered the sight of *both* eyes, they would probably have learned to recognize solids more easily and speedily.

We can commonly tell whether an object is solid, readily enough with one eye, but still better with two eyes, and sometimes *only* by using both. If we look at a square piece of ivory with one eye alone, we cannot tell whether it is a scale of veneer, or the side of a cube, or the base of a pyramid, or the end of a prism. But if we now open the other eye, we shall see one or more of its sides, if it have any, and then know it to be a solid, and what kind of a solid.

We see something with the second eye which we did not see with the first; in other words, the two eyes see different pictures of the same thing, for the obvious reason that they look from points two or three inches apart. By means of these two different views of an object, the mind as it were, *feels round it* and gets an idea of its solidity. We clasp an object with our eyes, as with our arms, or with our hands, or with our thumb and finger, and then we know it to be something more than a surface. This, of course, is an illustration of the fact, rather than an explanation of its mechanism.

Though, as we have seen, the two eyes look on two different pictures, we perceive but one picture. The two have run together and become blended in a third, which shows us everything we see in each. But, in order that they should so run together, both the eye and the brain must be in a natural state. Push one eye a little inward with the forefinger, and the image is doubled, or at least confused. Only certain parts of the two retinæ work harmoniously together, and you have disturbed their natural relations. Again, take two or three glasses more than temperance permits, and you see double; the eyes are right enough, probably, but the brain is in trouble, and does not report their telegraphic messages correctly. These exceptions illustrate the every-

day truth, that, when we are in right condition, our two eyes see two somewhat different pictures, which our perception combines to form one picture, representing objects in all their dimensions, and not merely as surfaces.

Now, if we can get two artificial pictures of any given object, one as we should see it with the right eye, the others as we should see it with the left eye, and then, looking at the right picture, and that only, with the right eye, and at the left picture, and that only, with the left eye, contrive some way of making these pictures run together as we have seen our two views of a natural object do, we shall get the sense of solidity that natural objects give us. The arrangement which effects it will be a *stereoscope*, according to our definition of that instrument. How shall we attain these two ends?

1. An artist can draw an object as he sees it, looking at it only with his right eye. Then he can draw a second view of the same object as he sees it with his left eye. It will not be hard to draw a cube or an octahedron in this way; indeed, the first stereoscopic figures were pairs of outlines, right and left, of solid bodies, thus drawn. But the minute details of a portrait, a group, or a landscape, all so nearly alike to the two eyes, yet not identical in each picture of our natural double view, would defy any human skill to reproduce them exactly. And just here comes in the photograph to meet the difficulty. A first picture of an object is taken—then the instrument is moved a couple of inches or a little more, the distance between the human eyes, and a second picture is taken. Better than this, two pictures are taken at once in a double camera.

We were just now stereographed, ourselves, at a moment's warning, as if we were fugitives from justice. A skeleton shape, of about a man's height, its head covered with a black veil, glided across the floor, faced us, lifted its veil, and took a preliminary look. When we had grown sufficiently rigid in our attitude of studied ease, and got our umbrella into a position of thoughtful carelessness, and put our features with much effort into an unconstrained aspect of cheerfulness tempered with dignity, of manly firmness blended with womanly sensibility, of courtesy, as much as to imply—"You honor me, Sir," toned or sized, as one may say, with something of the self-assertion of a human soul which reflects proudly, "I am superior to all this"—when, I say, we were all right, the spectral Mokanna dropped his long veil, and his waiting-slave put a sensitive tablet under its folds. The veil was then again lifted, and the two great glassy eyes stared at us once more for some thirty seconds. The veil then dropped again; but in the mean time, the shrouded sorcerer had stolen our double image; we were

immortal. Posterity might thenceforth inspect us, (if not otherwise engaged,) not as a surface only, but in all our dimensions as an undisputed *solid* man of Boston.

2. We have now obtained the double-eyed or twin pictures, or STEREOGRAPH, if we may coin a name. But the pictures are two, and we want to slide them into each other, so to speak, as in natural vision, that we may see them as one. How shall we make one picture out of two, the corresponding parts of which are separated by a distance of two or three inches?

We can do this in two ways. First, by *squinting* as we look at them. But this is tedious, painful, and to some impossible, or at least very difficult. We shall find it much easier to look through a couple of glasses that *squint for us*. If at the same time they *magnify* the two pictures, we gain just so much in the distinctness of the picture, which, if the figures on the slide are small, is a great advantage. One of the easiest ways of accomplishing this double purpose is to cut a convex lens through the middle, grind the curves of the two halves down to straight lines, and join them by their thin edges. This is a *squinting magnifier*, and if arranged so that with its right half we see the right picture on the slide, and with its left half the left picture, it squints them both inward so that they run together and form a single picture.

Such are the stereoscope and the photograph, by the aid of which *form* is henceforth to make itself seen through the world of intelligence, as thought has long made itself heard by means of the art of printing. The *morphotype*, or form-print, must hereafter take its place by the side of the *logotype*, or word-print. The *stereograph*, as we have called the double picture designed for the stereoscope, is to be the card of introduction to make all mankind acquaintances.

The first effect of looking at a good photograph through the stereoscope is a surprise such as no painting ever produced. The mind feels its way into the very depths of the picture. The scraggy branches of a tree in the foreground run out at us as if they would scratch our eyes out. The elbow of a figures stands forth so as to make us almost uncomfortable. Then there is such a frightful amount of detail, that we have the same sense of infinite complexity which Nature gives us. A painter shows us masses; the stereoscopic figure spares us nothing—all must be there, every stick, straw, scratch, as faithfully as the dome of St. Peter's, or the summit of Mont Blanc, or the ever-moving stillness of Niagara. The sun is no respecter of persons or of things.

This is one infinite charm of the photographic delineation. Theoretically, a perfect photograph is absolutely inexhaustible. In a picture you can find nothing which the artist has not seen before you; but in a

perfect photograph there will be as many beauties lurking, unobserved, as there are flowers that blush unseen in forests and meadows. It is a mistake to suppose one knows a stereoscopic picture when he has studied it a hundred times by the aid of the best of our common instruments. Do we know all that there is in a landscape by looking out at it from our parlor-windows? In one of the glass stereoscopic views of Table Rock, two figures, so minute as to be mere objects of comparison with the surrounding vastness, may be seen standing side by side. Look at the two faces with a strong magnifier, and you could identify their owners, if you met them in a court of law.

Many persons suppose that they are looking on *miniatures* of the objects represented, when they see them in the stereoscope. They will be surprised to be told that they see most objects as large as they appear in Nature. A few simple experiments will show how what we see in ordinary vision is modified in our perceptions by what we think we see. We made a sham stereoscope, the other day, with no glasses, and an opening in the place where the pictures belong, about the size of one of the common stereoscopic pictures. Through this we got a very ample view of the town of Cambridge, including Mount Auburn and the Colleges, in a single field of vision. We do not recognize how minute distant objects really look to us, without something to bring the fact home to our conceptions. A man does not deceive us as to his real size when we see him at the distance of the length of Cambridge Bridge. But hold a common black pin before the eyes at the distance of distinct vision, and one-twentieth of its length, nearest the point, is enough to cover him so that he cannot be seen. The head of the same pin will cover one of the Cambridge horse-cars at the same distance, and conceal the tower of Mount Auburn, as seen from Boston.

We are near enough to an edifice to see it well, when we can easily read an inscription upon it. The stereoscopic views of the arches of Constantine and of Titus give not only every letter of the old inscriptions, but render the grain of the stone itself. On the pediment of the Pantheon may be read, not only the words traced by Agrippa, but a rough inscription above it, scratched or hacked into the stone by some wanton hand during an insurrectionary tumult.

This distinctness of the lesser details of a building or a landscape often gives us incidental truths which interest us more than the central object of the picture. Here is Alloway Kirk, in the churchyard of which you may read a real story by the side of the ruin that tells of more romantic fiction. There stands the stone "Erected by James Russell, seedsman, Ayr, in memory of his children,"—three little boys, James, and Thomas, and John, all snatched away from him in the space of

three successive summer-days, and lying under the matted grass in the
shadow of the old witch-haunted walls. It was Burns's Alloway Kirk
we paid for, and we find we have bought a share in the griefs of James
Russell, seedsman; for is not the stone that tells this blinding sorrow of
real life the true centre of the picture, and not the roofless pile which
reminds us of an idle legend?

We have often found these incidental glimpses of life and death
running away with us from the main object the picture was meant to
delineate. The more evidently accidental their introduction, the more
trivial they are in themselves, the more they take hold of the imagina-
tion. It is common to find an object in one of the twin pictures which
we miss in the other; the person or the vehicle having moved in the
interval of taking the two photographs. There is before us a view of the
Pool of David at Hebron, in which a shadowy figure appears at the
water's edge, in the right-hand farther corner of the right-hand picture
only. This muffled shape stealing silently into the solemn scene has
already written a hundred biographies in our imagination. In the lovely
glass stereograph of the Lake of Brienz, on the left-hand side, a vaguely
hinted female figure stands by the margin of the fair water; on the
other side of the picture she is not seen. This is life; we seem to see her
come and go. All the longings, passions, experiences, possibilities of
womanhood animate that gliding shadow which has flitted through our
consciousness, nameless, dateless, featureless, yet more profoundly
real than the sharpest of portraits traced by a human hand. Here is the
Fountain of the Ogre, at Berne. In the right picture two women are
chatting, with arms akimbo, over its basin; before the plate for the left
picture is got ready, "one shall be taken and the other left"; look! on
the left side there is but one woman, and you may see the blur where
the other is melting into thin air as she fades forever from your eyes.

Oh, infinite volumes of poems that I treasure in this small library
of glass and pasteboard! I creep over the vast features of Rameses, on
the face of his rockhewn Nubian temple; I scale the huge mountain-
crystal that calls itself the Pyramid of Cheops. I pace the length of the
three Titanic stones of the wall of Baalbec—mightiest masses of quar-
ried rock that man has lifted into the air; and then I dive into some
mass of foliage with my microscope, and trace the veinings of a leaf so
delicately wrought in the painting not made with hands, that I can
almost see its down and the green aphis that sucks its juices. I look into
the eyes of the caged tiger, and on the scaly train of the crocodile,
stretched on the sands of the river that has mirrored a hundred dynas-
ties. I stroll through Rhenish vineyards, I sit under Roman arches, I
walk the streets of once buried cities, I look into the chasms of Alpine

glaciers, and on the rush of wasteful cataracts. I pass, in a moment, from the banks of the Charles to the ford of the Jordan, and leave my outward frame in the arm-chair at my table, while in spirit I am looking down upon Jerusalem from the Mount of Olives.

"Give me the full tide of life at Charing Cross," said Dr. Johnson. Here is Charing Cross, but without the full tide of life. A perpetual stream of figures leaves no definite shapes upon the picture. But on one side of this stereoscopic doublet a little London "gent" is leaning pensively against a post; on the other side he is seen sitting at the foot of the next post—what is the matter with the little "gent?"

The very things which an artist would leave out, or render imperfectly, the photograph takes infinite care with, and so makes its illusions perfect. What is the picture of a drum without the marks on its head where the beating of the sticks has darkened the parchment? In three pictures of the Ann Hathaway Cottage, before us—the most perfect, perhaps, of all the paper stereographs we have seen—the door at the farther end of the cottage is open, and we see the marks left by the rubbing of hands and shoulders as the good people came through the entry, or leaned against it, or felt for the latch. It is not impossible that scales from the epidermis of the trembling hand of Ann Hathaway's young suitor, Will Shakspeare, are still adherent about the old latch and door, and that they contribute to the stains we see in our picture.

Among the accidents of life, as delineated in the stereograph, there is one that rarely fails in any extended view which shows us the details of streets and buildings. There may be neither man nor beast nor vehicle to be seen. You may be looking down on a place in such a way that none of the ordinary marks of its being actually inhabited show themselves. But in the rawest Western settlement and the oldest Eastern city, in the midst of the shanties at Pike's Peak and stretching across the court-yards as you look into them from above the clay-plastered roofs of Damascus, wherever man lives with any of the decencies of civilization, you will find the *clothes-line*. It may be a fence, (in Ireland) —it may be a tree, (if the Irish license is still allowed us)—but clothes-drying, or a place to dry clothes on, the stereoscopic photograph insists on finding, wherever it gives us a group of houses. This is the city of Berne. How it brings the people who sleep under that roof before us to see their sheets drying on that fence! and how real it makes the men in that house to look at their shirts hanging, arms down, from yonder line!

The reader will, perhaps, thank us for a few hints as to the choice of stereoscopes and stereoscopic pictures. The only way to be sure of

getting a good instrument is to try a number of them, but it may be well to know which are worth trying. Those made with achromatic glasses may be as much better as they are dearer, but we have not been able to satisfy ourselves of the fact. We do not commonly find any trouble from chromatic aberration (or false color in the image). It is an excellent thing to have the glasses adjust by pulling out and pushing in, either by the hand, or, more conveniently, by a screw. The large instruments, holding twenty-five slides, are best adapted to the use of those who wish to show their views often to friends; the owner is a little apt to get tired of the unvarying round in which they present themselves. Perhaps we relish them more for having a little trouble in placing them, as we do nuts that we crack better than those we buy cracked. In optical effect, there is not much difference between them and the best ordinary instruments. We employ one stereoscope with adjusting glasses for the hand, and another common one upon a broad rosewood stand. The stand may be added to any instrument, and is a great convenience.

Some will have none but glass stereoscopic pictures; paper ones are not good enough for them. Wisdom dwells not with such. It is true that there is a brilliancy in a glass picture, with a flood of light pouring through it, which no paper one, with the light necessarily falling *on* it, can approach. But this brilliancy fatigues the eye much more than the quiet reflected light of the paper stereograph. Twenty-five glass slides, well inspected in a strong light, are *good* for one headache, if a person is disposed to that trouble.

Again, a good paper photograph is infinitely better than a bad glass one. We have a glass stereograph of Bethlehem, which looks as if the ground were covered with snow—and paper ones of Jerusalem, colored and uncolored, much superior to it both in effect and detail. The Oriental pictures, we think, are apt to have this white, patchy look; possibly we do not get the best in this country.

A good view on glass or paper is, as a rule, best uncolored. But some of the American views of Niagara on glass are greatly improved by being colored; the water being rendered vastly more suggestive of the reality by the deep green tinge. *Per contra*, we have seen some American views so carelessly colored that they were all the worse for having been meddled with. The views of the Hathaway Cottage, before referred to, are not only admirable in themselves, but some of them are admirably colored also. Few glass stereographs compare with them as real representatives of Nature.

In choosing stereoscopic pictures, beware of investing largely in *groups*. The owner soon gets tired to death of them. Two or three of

the most striking among them are worth having, but mostly they are detestable—vulgar repetitions of vulgar models, shamming grace, gentility, and emotion, by the aid of costumes, attitudes, expressions, and accessories worthy only of a Thespian society of candle-snuffers. In buying brides under veils, and such figures, look at the lady's *hands*. You will very probably find the young countess is a maid-of-all-work. The presence of a human figure adds greatly to the interest of all architectural views, by giving us a standard of size, and should often decide our choice out of a variety of such pictures. No view pleases the eye which has glaring patches in it—a perfectly white-looking river, for instance—or trees and shrubs in full leaf, but looking as if they were covered with snow—or glaring roads, or frosted-looking stones and pebbles. As for composition in landscape, each person must consult his own taste. All have agreed in admiring many of the Irish views, as those about the Lakes of Killarney, for instance, which are beautiful alike in general effect and in nicety of detail. The glass views on the Rhine, and of the Pyrenees in Spain, are of consummate beauty. As a specimen of the most perfect, in its truth and union of harmony and contrast, the view of the Circus of Gavarni, with the female figure on horseback in the front ground, is not surpassed by any we remember to have seen.

What is to come of the stereoscope and the photograph we are almost afraid to guess, lest we should seem extravagant. But, premising that we are to give a *colored* stereoscopic mental view of their prospects, we will venture on a few glimpses at a conceivable, if not a possible future.

Form is henceforth divorced from matter. In fact, matter as a visible object is of no great use any longer, except as the mould on which form is shaped. Give us a few negatives of a thing worth seeing, taken from different points of view, and that is all we want of it. Pull it down or burn it up, if you please. We must, perhaps, sacrifice some luxury in the loss of color; but form and light and shade are the great things, and even color can be added, and perhaps by and by may be got direct from Nature.

There is only one Coliseum or Pantheon; but how many millions of potential negatives have they shed—representatives of billions of pictures—since they were erected! Matter in large masses must always be fixed and dear; form is cheap and transportable. We have got the fruit of creation now, and need not trouble ourselves with the core. Every conceivable object of Nature and Art will soon scale off its surface for us. Men will hunt all curious, beautiful, grand objects, as they hunt the cattle in South America, for their *skins*, and leave the carcasses as of little worth.

The consequence of this will soon be such an enormous collection of forms that they will have to be classified and arranged in vast libraries, as books are now. The time will come when a man who wishes to see any object, natural or artificial, will go to the Imperial, National or City Stereographic Library and call for its skin or form, as he would for a book at any common library. We do now distinctly propose the creation of a comprehensive and systematic stereographic library, where all men can find the special forms they particularly desire to see as artists, or as scholars, or as mechanics, or in any other capacity. Already a workman has been travelling about the country with stereographic views of furniture, showing his employer's patterns in this way, and taking orders for them. This is a mere hint of what is coming before long.

Again, we must have special stereographic collections, just as we have professional and other special libraries. And as a means of facilitating the formation of public and private stereographic collections, there must be arranged a comprehensive system of exchanges, so that there may grow up something like a universal currency of these bank-notes, or promises to pay in solid substance, which the sun has engraved for the great Bank of Nature.

To render comparison of similar objects, or of any that we may wish to see side by side, easy, there should be a stereographic *metre* or fixed standard of focal length for the camera lens, to furnish by its multiples or fractions, if necessary, the scale of distances, and the standard of power in the stereoscope lens. In this way the eye can make the most rapid and exact comparisons. If the "great elm" and the Cowthorpe oak, if the State-House and St. Peter's, were taken on the same scale, and looked at with the same magnifying power, we should compare them without the possibility of being misled by those partialities which might tend to make us overrate the indigenous vegetable and the dome of our native Michel Angelo.

The next European war will send us stereographs of battles. It is asserted that a bursting shell can be photographed. The time is perhaps at hand when a flash of light, as sudden and brief as that of the lightning which shows a whirling wheel standing stock still, shall preserve the very instant of the shock of contact of the mighty armies that are even now gathering. The lightning from heaven does actually photograph natural objects on the bodies of those it has just blasted—so we are told by many witnesses. The lightning of clashing sabres and bayonets may be forced to stereotype itself in a stillness as complete as that of the tumbling tide of Niagara as we see it self-pictured.

We should be led on too far, if we developed our belief as to the transformations to be wrought by this greatest of human triumphs over

earthly conditions, the divorce of form and substance. Let our readers fill out a blank check on the future as they like—we give our indorsement to their imaginations beforehand. We are looking into stereoscopes as pretty toys, and wondering over the photograph as a charming novelty; but before another generation has passed away, it will be recognized that a new epoch in the history of human progress dates from the time when He who

> ——*never but in uncreated light*
> *Dwelt from eternity—*

took a pencil of fire from the hand of the "angel standing in the sun," and placed it in the hands of a mortal.

Lewis Carroll

"Photography Extraordinary" 1855

In 1851, the collodion wet-plate process was perfected and made available without patent restrictions. Photography was still a difficult business, but its popularity as a hobby in England increased greatly. Charles Dodgson (1832–1898), better known as Lewis Carroll, tried his hand at it, studying for a time with O. G. Rejlander. He took portraits of Tennyson, Millais, the Rosettis, and many young girls such as Alice Liddell, the model for *Alice in Wonderland*. (Tennyson thought one of these portraits the most beautiful photograph he had ever seen.) "Photography Extraordinary" was printed in one of Carroll's family magazines in 1855, "Hiawatha's Photographing" in *The Train*, in 1859.

The recent extraordinary discovery in Photography, as applied to the operations of the mind, has reduced the art of Novel-writing to the merest mechanical labour. We have been kindly permitted by the artist to be present during one of his experiments, but as the invention has not yet been given to the world, we are only at liberty to relate the results, suppressing all details of chemicals and manipulation.

The operator began by stating that the ideas of the feeblest intellect, when once received on properly prepared paper, could be "devel-

oped" up to any required degree of intensity. On hearing our wish that he would begin with an extreme case, he obligingly summoned a young man from an adjoining room, who appeared to be of the very weakest possible physical and mental powers. On being asked what we thought of him we candidly confessed that he seemed incapable of anything but sleep; our friend cordially assented to this opinion.

The machine being in position, and a mesmeric rapport established between the mind of the patient and the object glass, the young man was asked whether he wished to say anything; he feebly replied "Nothing." He was then asked what he was thinking of, and the answer, as before, was "Nothing." The artist on this pronounced him to be in a most satisfactory state, and at once commenced the operation.

After the paper had been exposed for the requisite time, it was removed and submitted to our inspection; we found it to be covered with faint and almost illegible characters. A closer scrutiny revealed the following:

"The eve was soft and dewy mild; a zephyr whispered in the lofty glade, and a few light drops of rain cooled the thirsty soil. At a slow amble, along the primrose-bordered path rode a gentle-looking and amiable youth, holding a light cane in his delicate hand; the pony moved gracefully beneath him, inhaling as it went the fragrance of the roadside flowers; the calm smile, and languid eyes, so admirably harmonizing with the fair features of the rider, showed the even tenor of his thoughts. With a sweet though feeble voice, he plaintively murmured out the gentle regrets that clouded his breast:

> 'Alas! she would not hear my prayer!
> Yet it were rash to tear my hair;
> Disfigured, I should be less fair.

> 'She was unwise, I may say blind;
> Once she was lovingly inclined;
> Some circumstance has changed her mind.'

There was a moment's silence; the pony stumbled over a stone in the path, and unseated his rider. A crash was heard among the dried leaves; the youth arose; a slight bruise on his left shoulder, and a disarrangement of his cravat, were the only traces that remained of this trifling accident."

"This," we remarked, as we returned the paper, "belongs apparently to the milk-and-water School of Novels."

"You are quite right," our friend replied, "and, in its present state, it is, of course, utterly unsaleable in the present day: we shall find,

however, that the next stage of development will remove it into the strong-minded or Matter-of-Fact School." After dipping it into various acids, he again submitted it to us; it had now become the following:

"The evening was of the ordinary character, barometer at 'change,' a wind was getting up in the wood, and some rain was beginning to fall; a bad lookout for the farmers. A gentleman approached along the bridle-road, carrying a stout knobbed stick in his hand, and mounted on a serviceable nag, possibly worth some £40 or so; there was a settled business-like expression on the rider's face, and he whistled as he rode; he seemed to be hunting for rhymes in his head, and at length repeated, in a satisfied tone, the following composition:

> 'Well! so my offer was no go!
> She might do worse, I told her so;
> She was a fool to answer "No."
>
> 'However, things are as they stood;
> Nor would I have her if I could,
> For there are plenty more as good.'

At this moment the horse set his foot in a hole, and rolled over; his rider rose with difficulty; he had sustained several severe bruises and fractured two ribs; it was some time before he forgot that unlucky day."

We returned this with the strongest expression of admiration, and requested that it might now be developed to the highest possible degree. Our friend readily consented, and shortly presented us with the result, which he informed us belonged to the Spasmodic or German School. We perused it with indescribable sensations of surprise and delight:

"The night was wildly tempestuous—a hurricane raved through the murky forest—furious torrents of rain lashed the groaning earth. With a headlong rush—down a precipitous mountain gorge—dashed a mounted horseman armed to the teeth—his horse bounded beneath him at a mad gallop, snorting fire from its distended nostrils as it flew. The rider's knotted brows—rolling eyeballs—and clenched teeth—expressed the intense agony of his mind—weird visions loomed upon his burning brain—while with a mad yell he poured forth the torrent of his boiling passion:

> 'Firebrands and daggers! hope hath fled!
> To atoms dash the doubly dead!
> My brain is fire—my heart is lead!

'Her soul is flint, and what am I?
Scorch'd by her fierce, relentless eye.
Nothingness is my destiny!'

There was a moment's pause. Horror! his path ended in a fathomless abyss. . . . A rush—a flash—a crash—all was over. Three drops of blood, two teeth, and a stirrup were all that remained to tell where the wild horseman met his doom."

The young man was now recalled to consciousness, and shown the result of the workings of his mind; he instantly fainted away.

In the present infancy of the art we forbear from further comment on this wonderful discovery; but the mind reels as it contemplates the stupendous addition thus made to the powers of science.

Our friend concluded with various minor experiments, such as working up a passage of Wordsworth into strong, sterling poetry: the same experiment was tried on a passage of Byron, at our request, but the paper came out scorched and blistered all over by the fiery epithets thus produced.

As a concluding remark: *could* this art be applied (we put the question in the strictest confidence)—*could* it, we ask, be applied to the speeches in Parliament? It may be but a delusion of our heated imagination, but we will still cling fondly to the idea, and hope against hope.

Lewis Carroll

"Hiawatha's Photographing"
1859

From his shoulder Hiawatha
Took the camera of rosewood,
Made of sliding, folding rosewood;
Neatly put it all together.
In its case it lay compactly,
Folded into nearly nothing;
But he opened out the hinges,
Pushed and pulled the joints and hinges,
Till it looked all squares and oblongs,
Like a complicated figure
In the Second Book of Euclid.

This he perched upon a tripod—
Crouched beneath its dusky cover—
Stretched his hand, enforcing silence—
Said, 'Be motionless, I beg you!'
Mystic, awful was the process.

All the family in order
Sat before him for their pictures:
Each in turn as he was taken,
Volunteered his own suggestions,
His ingenious suggestions.

First the Governor, the Father:

He suggested velvet curtains
Looped about a massy pillar;
And the corner of a table,
Of a rosewood dining-table.
He would hold a scroll of something,
Hold it firmly in his left-hand;
He would keep his right-hand buried
(Like Napoleon) in his waistcoat;
He would contemplate the distance
With a look of pensive meaning,
As of ducks that die in tempests.
 Grand, heroic was the notion:
Yet the picture failed entirely:
Failed, because he moved a little,
Moved, because he couldn't help it.
 Next, his better half took courage:
She would have her picture taken
She came dressed beyond description,
Dressed in jewels and in satin
Far too gorgeous for an empress.
Gracefully she sat down sideways,
With a simper scarcely human,
Holding in her hand a bouquet
Rather larger than a cabbage.
All the while that she was sitting,
Still the lady chattered, chattered,
Like a monkey in the forest.
'Am I sitting still?' she asked him.
'Is my face enough in profile?
Shall I hold the bouquet higher?
Will it come into the picture?'
And the picture failed completely.
 Next the Son, the Stunning-Cantab:
He suggested curves of beauty,
Curves pervading all his figure,
Which the eye might follow onward,
Till they entered in the breast-pin,
Centred in the golden breast-pin.
He had learnt it all from Ruskin
(Author of 'The Stones of Venice,'
'Seven Lamps of Architecture,'
'Modern Painters,' and some others);

And perhaps he had not fully
Understood his author's meaning;
But, whatever was the reason.
All was fruitless, as the picture
Ended in an utter failure.
 Next to him the eldest daughter:
She suggested very little,
Only asked if he would take her
With her looks of 'passive beauty,'
 Her idea of passive beauty
Was a squinting of the left-eye,
Was a drooping of the right-eye,
Was a smile that went up sideways
To the corner of the nostrils.
 Hiawatha, when she asked him.
Took no notice of the question,
Looked as if he hadn't heard it:
But, when pointedly appealed to,
Smiled in his peculiar manner.
Coughed and said it 'didn't matter,'
Bit his lip and changed the subject.
 Nor in this was he mistaken,
As the picture failed completely.
 So in turn the other sisters.
 Last, the youngest son was taken:
Very rough and thick his hair was,
Very round and red his face was,
Very dusty was his jacket,
Very fidgety his manner.
And his overbearing sisters
Called him names he disapproved of:
Called him Johnny, 'Daddy's Darling,'
Called him Jacky, "Scrubby School-boy.'
And, so awful was the picture,
In comparison the others
Seemed, to one's bewildered fancy
To have partially succeeded.
 Finally my Hiawatha
Tumbled all the tribe together,
('Grouped' is not the right expression),
And, as happy chance would have it
Did at last obtain a picture

Where the faces all succeeded:
Each came out a perfect likeness.
 Then they joined and all abused it,
Unrestrainedly abused it,
As the worst and ugliest picture
They could possibly have dreamed of
'Giving one such strange expressions—
Sullen, stupid, pert expressions.
Really anyone would take us
(Anyone that did not know us)
For the most unpleasant people!'
(Hiawatha seemed to think so,
Seemed to think it not unlikely.)
All together rang their voices,
Angry, loud, discordant voices,
As of dogs that howl in concert,
As of cats that wail in chorus.
 But my Hiawatha's patience,
His politeness and his patience,
Unaccountably had vanished,
And he left that happy party.
Neither did he leave them slowly,
With the calm deliberation,
The intense deliberation
Of a photographic artist:
But he left them in a hurry,
Left them in a mighty hurry,
Stating that he would not stand it,
Stating in emphatic language
What he'd be before he'd stand it.
Hurriedly he packed his boxes:
Hurriedly the porter trundled
On a barrow all his boxes:
Hurriedly he took his ticket:
Hurriedly the train received him:
Thus departed Hiawatha.

Charles Baudelaire

"The Salon of 1859"

Translated by Jonathan Mayne

1859

AN EXCERPT

The poet Charles Baudelaire (1821–1867) was also a critic and
the friend of many artists. His wrath at the camera and the
public that so slavishly followed it in the quest for a perfect
copy of nature expresses not only the mid-century's growing
unease with machines but a philosophy that would strongly
influence the art of the future. Baudelaire's emphasis on imag-
ination and dream, the inner response rather than the exterior
fact, influenced the art of such painters as Van Gogh and
Gauguin.

. . . .

During this lamentable period, a new industry arose which contributed
not a little to confirm stupidity in its faith and to ruin whatever might
remain of the divine in the French mind. The idolatrous mob de-
manded an ideal worthy of itself and appropriate to its nature—that is
perfectly understood. In matters of painting and sculpture, the pres-
ent-day *Credo* of the sophisticated, above all in France (and I do not
think that anyone at all would dare to state the contrary), is this: 'I
believe in Nature, and I believe only in Nature (there are good reasons
for that). I believe that Art is, and cannot be other than, the exact

reproduction of Nature (a timid and dissident sect would wish to exclude the more repellent objects of nature, such as skeletons or chamber-pots). Thus an industry that could give us a result identical to Nature would be the absolute of art.' A revengeful God has given ear to the prayers of this multitude. Daguerre was his Messiah. And now the faithful says to himself: 'Since Photography gives us every guarantee of exactitude that we could desire (they really believe that, the mad fools!), then Photography and Art are the same thing.' From that moment our squalid society rushed, Narcissus to a man, to gaze at its trivial image on a scrap of metal. A madness, an extraordinary fanaticism took possession of all these new sun-worshippers. Strange abominations took form. By bringing together a group of male and female clowns, got up like butchers and laundry-maids at a carnival, and by begging these *heroes* to be so kind as to hold their chance grimaces for the time necessary for the performance, the operator flattered himself that he was reproducing tragic or elegant scenes from ancient history. Some democratic writer ought to have seen here a cheap method of disseminating a loathing for history and for painting among the people, thus committing a double sacrilege and insulting at one and the same time the divine art of painting and the noble art of the actor. A little later a thousand hungry eyes were bending over the peepholes of the stereoscope, as though they were the attic-windows of the infinite. The love of pornography, which is no less deep-rooted in the natural heart of man than the love of himself, was not to let slip so fine an opportunity of self-satisfaction. And do not imagine that it was only children on their way back from school who took pleasure in these follies; the world was infatuated with them. I was once present when some friends were discreetly concealing some such pictures from a beautiful woman, a woman of high society, not of mine—they were taking upon themselves some feeling of delicacy in her presence; but 'No,' she cried. 'Give them to me! Nothing is too much for me.' I swear that I heard that; but who will believe me? 'You can see that they are great ladies,' said Alexandre Dumas. 'There are some still greater!' said Cazotte.[1]

As the photographic industry was the refuge of every would-be painter, every painter too ill-endowed or too lazy to complete his studies, this universal infatuation bore not only the mark of a blindness, an imbecility, but had also the air of a vengeance. I do not believe, or at least I do not wish to believe, in the absolute success of such a brutish

1. *The first remark is taken from Dumas's play* La Tour de Nesle *(Act I, sc. 9); the second from Gérard de Nerval's preface to Cazotte's* Le Diable amoureux. *The somewhat complicated point of the joke is explained by Crépet in his note on this passage* (Curiosités esthétiques, *p. 490*).

conspiracy, in which, as in all others, one finds both fools and knaves; but I am convinced that the ill-applied developments of photography, like all other purely material developments of progress, have contributed much to the impoverishment of the French artistic genius, which is already so scarce. In vain may our modern Fatuity roar, belch forth all the rumbling wind of its rotund stomach, spew out all the undigested sophisms with which recent philosophy has stuffed it from top to bottom; it is nonetheless obvious that this industry, by invading the territories of art, has become art's most mortal enemy, and that the confusion of their several functions prevents any of them from being properly fulfilled. Poetry and progress are like two ambitious men who hate one another with an instinctive hatred, and when they meet upon the same road, one of them has to give place. If photography is allowed to supplement art in some of its functions, it will soon have supplanted or corrupted it altogether, thanks to the stupidity of the multitude which is its natural ally. It is time, then, for it to return to its true duty, which is to be the servant of the sciences and arts—but the very humble servant, like printing or shorthand, which have neither created nor supplemented literature. Let it hasten to enrich the tourist's album and restore to his eye the precision which his memory may lack; let it adorn the naturalist's library, and enlarge microscopic animals; let it even provide information to corroborate the astronomer's hypotheses; in short, let it be the secretary and clerk of whoever needs an absolute factual exactitude in his profession—up to that point nothing could be better. Let it rescue from oblivion those tumbling ruins, those books, prints and manuscripts which time is devouring, precious things whose form is dissolving and which demand a place in the archives of our memory—it will be thanked and applauded. But if it be allowed to encroach upon the domain of the impalpable and the imaginary, upon anything whose value depends solely upon the addition of something of a man's soul, then it will be so much the worse for us!

I know very well that some people will retort, 'The disease which you have just been diagnosing is a disease of imbeciles. What man worthy of the name of artist, and what true connoisseur, has ever confused art with industry?' I know it; and yet I will ask them in my turn if they believe in the contagion of good and evil, in the action of the mass on individuals, and in the involuntary, forced obedience of the individual to the mass. It is an incontestable, an irresistible law that the artist should act upon the public, and that the public should react upon the artist; and besides, those terrible witnesses, the facts, are easy to study; the disaster is verifiable. Each day art further diminishes its self-respect by bowing down before external reality; each day the

painter becomes more and more given to painting not what he dreams but what he sees. Nevertheless *it is a happiness to dream*, and it used to be a glory to express what one dreamt. But I ask you! does the painter still know this happiness?

Could you find an honest observer to declare that the invasion of photography and the great industrial madness of our times have no part at all in this deplorable result? Are we to suppose that a people whose eyes are growing used to considering the results of a material science as though they were the products of the beautiful, will not in the course of time have singularly diminished its faculties of judging and of feeling what are among the most ethereal and immaterial aspects of creation?

Nadar

My Life as a Photographer
Translated by Thomas Repensek

1900
AN EXCERPT

Gaspar Félix Tournachon (1820–1910), known as Nadar, began as a caricaturist, but in 1853 he and his brother Adrian established a photography studio. It was Nadar's idea to photograph his subjects before drawing them, yet his photographs themselves soon made him known as one of the best French portraitists of artists, writers, and composers. In 1858, he took the first aerial photographs from a balloon. In 1860 he photographed the sewers of Paris by electric light; these are among the earliest pictures taken by artificial light. In 1874, the Impressionists held their first exhibit in his studio. *Quand j'étais photographe*, the story of his years as a photographer, was published in 1900 and includes this curious little anecdote about Balzac.

. . . .

The uneducated and the ignorant were not the only ones to hesitate before this peril. "The lowliest to the most high," so the common saying goes, trembled before the Daguerreotype. More than a few of our most brilliant intellects shrank back as if from a disease. To choose only from among the very highest: Balzac was one of those who could

not rid himself of a certain uneasiness about the Daguerreotype pro-
cess. . . .

According to Balzac's theory, all physical bodies are made up
entirely of layers of ghostlike images, an infinite number of leaflike
skins laid one on top of the other. Since Balzac believed man was
incapable of making something material from an apparition, from
something impalpable—that is, creating something from nothing—he
concluded that every time someone had his photograph taken, one of
the spectral layers was removed from the body and transferred to the
photograph. Repeated exposures entailed the unavoidable loss of sub-
sequent ghostly layers, that is, the very essence of life.

Was each precious layer lost forever or was the damage repaired
through some more or less instantaneous process of rebirth? I would
expect that a man like Balzac, having once set off down such a prom-
ising road, was not the sort to go half way, and that he probably arrived
at some conclusion on this point, but it was never brought up between
us.

As for Balzac's intense fear of the Daguerreotype, was it sincere
or affected? I for one believe it was sincere, although Balzac had only
to gain from his loss, his ample proportions allowing him to squander
his layers without a thought. In any case, it did not prevent him from
posing at least for that one Daguerreotype of him that belonged to
Gavarni and Silvy before I bought it and that is now in the possession
of M. Spoelberg de Lovenjoul.
. . . .

Max Kozloff

"Nadar and the Republic of Mind"
1976

> Though Nadar photographed above and below ground, it is
> by his portraits that he is chiefly remembered. Max Kozloff,
> art critic, photography critic, and photographer, investigates
> the social import of Nadar's portraits and the changing social
> climate he mirrored.

During the middle of the last century, the two best known photographers doing business in Paris were Disdéri, who popularized the *carte-de-visite*, and Félix Tournachon, whose nickname, Nadar, became as familiar in his time as Kodak in ours. Portraits were the cash crop of both their studios, as for many others, because the portrait mode enjoyed artistic prestige and huge market turnover.

Let's define a portrait as the picture of an individual or group whose character is either described by social, ethnic, and class affiliations, or may, in some measure, be invoked in contrast to them. Some times, in the history of the genre, the "personality" of the sitter has gained the upper hand, and, sometimes, his or her status. More often, the portrait turns out to be an unpredictable composite image of both. Now, in the business milieu of the Second Empire, an important new motif got introduced into portraits. You can see by their clothes and stance that people rendered homage to a then grand ideal—Progress.

A marvelous index of progress was speed, the increased rapidity with which things could get done, and space could be traversed. One has only to look at that great public castle or temple, the 19th-century railroad station, to see how arrivals and departures—mass movement, in short—were glorified. And wasn't the photograph itself a characteristic witness of the age's lust for accelerated record and communication, power and efficiency? What once took weeks or months to limn by hand could now be accomplished in minutes, mechanically. And so urgent was the need for progress that photographic exposures were reduced to seconds. Time, in 1860, was burning up.

Cartes-de-visite, postcard-size portraits, were cranked out by means of a new multiple-lens camera with consecutively releasable shutters, furnishing as many as six or eight different exposures on a single plate. Like the Gatling gun of 1862, its aim was to decrease the ratio of effort to output by mechanizing the product. Poses could be standardized, droves of assistants could be hired, and sales volume could be increased. Photographic studios came to be very lavish affairs, like terminals, palaces of art. Disdéri's was built on a fortune parlayed through engineering a rationalized technique at the most opportune moment.

As for Nadar, he grew out of caricature, a graphic mode living by its wits in the popular press. The merits of caricature were briskness and dash, as they seized on the essentials of a face or a scene.

> Its essence is realism . . . but reality given the twist of derision: a kind of poor man's Baroque . . . it realized that its task was to cater to the insatiable curiosity of the new mass audience, to capture the event on everybody's mind and lips today and forgotten tomorrow; in short, *the topical* . . . all this by a graphic technique ever more rapid, more elliptic—that it . . . ends in the *instantane*. (Pierre Schneider)

Nadar's life kept apace with his trade, *con brio*. There was considerable truth in his record as an adventurer, political radical, harebrained inventor, novelist and crony of the entire French world of letters and arts.

The portraits of these two photographers, then, were absorbed into the gravitational field of progress, however differently they were articulated. And the values of such progress worked a great deal to disrupt the social presentation of the human being in art. The poor creature was caught in a crossfire between the memorial aims of the image, which were essentially realist, and its type-casting function, which was definitely symbolic. Since the *carte-de-visite* operated as a

fashion plate, the whole question of its truthfulness was mooted from the very first. Everyone was simply leveled, more or less interchangeably, to the role of actors in a charade. But it's much more interesting to think of the problem when a caricaturist took up the camera.

If he hankered after the topical, an ever fugitive present, his means often restricted him to the schematic. In coming to photography, Nadar's work betrayed a whiff of the schematic, that is, a single social idea assigned to a single person. But though it works much faster than a pencil, a photograph also gives far more information, more passively, more waywardly. A portrait photograph imparts meaning by a false sufficiency which we call the person's appearance . . . at a certain moment. An element of chance enters into the dialogue between photographer and model—chance, initially in what is recorded, and secondly, in how it may be interpreted.

The identity of a figure may not, therefore, emerge quite as intended. A middle-aged gentleman, in checkered vest, has a relaxed and sympathetic demeanor. The folds of his day coat are elegantly crisped, worthy of an Ingres. Between him and the photographer we automatically project an easy rapport. The image displays a certain hands-in-the-pocket aplomb long associated with Nadar's modernity. But on the back of this picture Nadar pencils "Dagneaux . . . Mouchard [spy, parasite] . . . Police Imperiale." We do not expect a ferocious Republican to discover urbanity in a policeman. I suppose we can argue that this discord is token of a real-life situation, and that it would have been naive to think otherwise. For it's an illusion to imagine that character, whatever that may be, and expression reciprocally illuminate each other, or that a repressive official can't be a loving grandfather. But M. Dagneaux's "image" is the antithesis of the one the photographer privately declares.

Of course, the same conflict may occur even when we know him to be sympathetic to the model. How, for instance, do we respond to Nadar's photo of Gérard de Nerval? "Our dreams," wrote Nerval in *Aurelia*,

> are a second life. . . . The first moments of sleep are an image of death; a hazy torpor grips our thoughts and it becomes impossible for us to determine the exact instant when the "I," under another form, continues the task of existence.

This mystic and dreamy poet, reader of Swedenborg and the Cabala, a confirmed eccentric and finally a mad suicide, was beloved by Proust, Apollinaire, and the Surrealists. Nadar shows us a small,

round, bald-headed plebian, seemingly a lumpfaced butcher or at best a bailiff, whose figure we have to equate with that of a dandy once capable of walking a lobster with a pale blue ribbon through the Palais Royal because "lobsters knew the secrets of the deep." For Nadar it was a "saddening photograph" which rendered "neither the simplicity, nor the finesse, nor the charm of the model." And Nerval thought it was his likeness, well enough, but posthumous: "I am the other."

For the artist and his sitter, the image was unreal because devoid of life. But we needn't let it go at that. This particular portrait has recently been redated, from a couple of weeks to about two years before the poet's death. Such information, when available, must influence the way we speculate about the photographic cipher. The knowledge may lighten some of the fatigue we think we see in the poet's face, but I don't think it weakens its indelible presence. Nadar, though powerfully engaged in the present, has sensitized himself to that "second life," that "I under another form," which "continues the task of existence."

If 19th-century people experienced considerable physical strain in posing for longish exposures, there was less self-consciousness in their stance because they either accepted or shared the values of the photographers. They incarnated distinct ideas of authority and class with which the artistic pretensions of the photographers were absorbed. Southworth's and Hawes' Daniel Webster (1850) is a cousin of Ingres' M. Bertin, but with too small a waistcoat pulled tight over his girth, and far more tensility in the bolt-upright pose. For their part, Julia Cameron's Herschel, Tennyson, and Darwin all form up as a gentlewoman's visions of partriarchal wisdom, but not interchangeably, and with intense drama. Her closely seen young women, on the other hand, often look sorrowful or hardpressed, despite having been cast as willowy damsels. As often as not, these figures were garbed in robes, or their bodies, minus all gesture, were made to dissolve in shadow, the better to invoke a stoicism that radiated beyond their physical frailty.

But whether it be in the work of this amateur, using her friends to exposit genteel virtue, or in the output of straight commercial portraitists, the locale of the figure was always problematic. The studio, functionally, was a non-environment whose neutrality could be accentuated or partially and affectedly reconstructed. A model had no choice but to be situated in a limbo, whole zones of which went occasionally out of focus, including those invariable re-used, sawed-off columns and corner drapes, sad and debased props that exuded all the dignity of a half-removed stage set for a third-run play. In no other photographic

genre were the subjects necessarily less at home than in the formalized portrait. Peopling such threadbare scenes, with their schematic decor, the figure was not only alienated, but deprived of any potential for natural movement.

These were the norms under which Nadar operated. They are to be seen assimilated but, from the first, profoundly modified by his work. Thereafter they continued, though overtly demoted, provincialized, and made vulnerably innocent in their pretension. Portraits in their mode were now more likely to commemorate members of aspiring rather than established social groups. Like Cameron in purging the studio of most background objects, he also associated with distinguished artist peers, at the very pulse of their culture. Beyond this, all resemblance between the two photographers ends.

His sitters adopt any mien they will and disport themselves without script in an unarticulated space against which they profile their figures and display their energies. The environment within the photo is something they either command or displace, with whatever animation they think appropriate to the pose. For they appear to be responding far more to the photographic act than they are merely enduring it. And their reflexes, under the circumstances, become its subject. Not for one minute does this openness banish role-playing from the occasion, but you feel that it is a role or a style that has been individually assumed rather than performed for the sake of external reasons. A good deal of pressure and strangeness has been lost as a result of these *laissez faire* conditions, but much spontaneity has been gained. Instead of wondering about the peculiar obsession behind the camera, the spectator is invited to empathize with the newly readable psychological complexities in those seated or standing before it. The more familiarity gained of Nadar's work, the more the characterizations of his Anglo-Saxon contemporaries begin to look emotionally monogamous.

With the latitude now permitted, or that welled up amiably in the "contract" between photographer and sitter, facial mobility came into its own. If Daudet, Dumas *père*, and Champfleury, among many others, seem to be addressing us, on the verge even of conversation, they suggest that the barrier between the activity of posing and normal intercourse had been relaxed, or somewhat blurred in the interest of sociability or reportage.

For proof, one has only to look at the first published interview in the history of photography, in *Le Journal Illustré*, August 1886, for which Paul Nadar took innumerable shots of his father conversing with Chevreul, the famous chemist and color theoretician. Not only was this technically advanced, made possible through a fast shutter (1/133

of a second), but it epitomized the ongoing candor that suffuses Nadar's portraits. Perhaps even further, he might have wanted to demonstrate how to overcome the fragmentary aspect of the still photograph by multiplying stills through a short time span. In this he could be said to have hinted, in portraiture, at what Marey, whom he admired, and Muybridge, whose work he surely knew, were accomplishing in the representation of animal movement. (It gives an even stronger notion of their aims to learn that the Nadars originally wanted to record Chevreul's remarks on a phonograph.) Just as significantly, Nadar captions the interview "On the Art of Living One Hundred Years" (Chevreul's age), and is therefore rendering homage to a longevity captured admirably in the old man's crankiness. At one point Chevreul comments, aptly from Nadar's point of view: "I haven't told you everything. But to talk is nothing: one must prove, must see. I will make you see, you must see, because when I see I believe."

Nadar's keenness of seeing qualified him as a photographer whose tactics can be discussed easily enough on a visual level. For him, volumes, which should be clear and prominent, were modeled by a natural light that he controlled from one side and/or above the head. Varied by screens and reflecting panels, this approach yielded strong graphic designs (Monnier, Guys, Garnier, Barbey d'Aurevilly, Baron Taylor). "Photographic theory can be learned in an hour; the first steps in practice, in a day. . . . That which one doesn't learn . . . is the sentiment of light, the artistic appreciation of effects produced on different days." And when these were wanting, he could still silhouette a dark torso against a darker field by complex mirror arrangements that cast glows into his velvet depths (Gautier, Daumier, Chenavard). "That which is still less understood," he wrote, "is the moral intelligence of your subject—the rapid tact which puts you in communion with your model . . . and which permits you to give . . . the most familiar and favorable resemblance, the intimate resemblance." To invoke these intangibles, Nadar asserted the most subtle changes in depth of field, a trifle softening, for example, in the near folds of a coat to bring out the sharpness of a nose, or the converse, when the subject benefited by a hazier definition of the face. Full length or bust, direct or angled in glance, viewed slightly from beneath or above, the repose of the figure appears almost in transience—as if a grasp of its special, unique weight would somehow hold down the elusiveness of the present. And so, make it intimate.

But none of these concerns was shaped that it should draw attention to itself. The question of Nadar as a self-conscious artist is not dependent on his use of technical devices that, in any case, were in the

hands of many talented contemporaries. Portraits by Holbein, Van Dyck, and Ingres were known to him, but his photos deal only intermittently with their tradition. What he could have admired from the photographs of Hill and Adamson, Gustave LeGray, the Bisson brothers, Mayer and Pierson, and Adam Solomon, famous in their day but still neglected in ours, he duly acknowledged, without being swerved from his course. The featureless, abstract backgrounds in some of his friend Manet's single-figure compositions are highly reminiscent of Nadar's but post-date them about 10 years, and far from exerting an influence on them, might be reflecting it. If one is to explain the amplitude of Nadar, one really has to drop these art historical criteria or even stylistic analyses and think about his social psychology.

Nadar's images of artists, tokens of an environment like all portraits, set forth their own terms of discourse. Because they initially witnessed certain qualities of friendship and remembrance among comrades, they were spared the rhetorical distancing that stiffened the genre all around. Variations of "rank," the photographer's or the sitter's, are quite dissolved in them, a phenomenon that seems to have catalyzed the individual prides of all concerned. There is no evidence to say that Nadar felt compelled to put on artistic airs or to denigrate his position. That "tact" of which he spoke, being freely given, rarely hardened into a mold or a manner. It seems to have permitted subject and photographer a new trust in the camera, and to have redefined the social tone of the portrait.

Whether directly or not, most portraits registered the bonding of people to their community, if only because innumerable clues were given to show their place within its hierarchies. So, these images were about social power, of which they themselves provided an instrument. (This state of affairs did not hamper individualism, but it certainly categorized it.) With Nadar, the aim was to give an account of, rather than to station the "moral intelligence" of the sitter. That was why intimacy was one of his ideals, but not reverence.

When he showed that petulant old warhorse of an artist, Horace Vernet, haberdashed with medals, Nadar had no trouble revealing a seeker of official honors. Delacroix had come to pose, too, that same year, 1858, for an arm-in-coat portrait to accompany an article on his work. But he had been ill, shocked with the results and begged that "these sad effigies" be destroyed. Nadar did not accede to the request, though it was uttered in the name of friendship. I'm pleased to think he refused, not just because he saw that he had gotten a remarkable, even cruel illusion of *personal* power, but because his loyalty was claimed by the image, if it seemed worthy, and not by the ego of the

model. Though he was deeply involved with the values of his social set, he could not bring them close to others except by a certain detachment from its interests.

As a reporter, he had every reason to get his facts straight; as a novelist, he felt justified in amplifying character and etching personal myths. So, the contingent had great importance for him, as did the more abiding self-creation of his sitters. In giving testimony of both, the photograph was well suited to his goals. It took imagination to realize this, a delicacy of feeling, a consciousness hospitable to the idea that foibles may honor, contribute to the lasting human memory of the person.

Still, Nadar's particular authenticity was cut out for a rhetorical role, which it played with verve. Iconographically, his portraits fall under the three main headings: romantic and bohemian intellectuals who had come of age before the *coup-d'état* of Louis Napoleon; cultural workers and dignitaries grown to prominence tacitly under his patronage; and the ubiquitous bourgeoisie. The first group, whose adventures he shared, was the decisive one in the formation of his outlook.

Since the advent of the Prince-President, and the assumption of the Second Empire in 1851 (Nadar only commenced to photograph in 1854), the French left had grown more and more demoralized. Its various Utopian, anarchist, or socialist hopes had been cast to the wind. Whatever they had been in 1830, the moderate bourgeois liberals of 1848 had ceased to be a revolutionary force, and everywhere closed ranks against a threat to the social order from impoverished workers. The revolution had combined "the greatest promise, the widest scope, and the most immediate success with the most unqualified and rapid failure" (E. H. Hobsbawm, *The Age of Capitalism*).

Nadar photographed a number of those once heartened by the "springtime of peoples," but only during its bitter aftermath, or long thereafter. This is not merely to speak of his luminous portraits of Hugo, Bakunin, Barbes, Prudhon, and Kropotkin, durable rebels throughout the period. I'm referring to those fellow-traveling artists who would have temperamentally symbolized an opposition to imperialism, and whose earlier life-styles embodied freer codes of conduct and thought than could be presently afforded. It is not too farfetched to imagine the political poignance of Nadar's memorial to the world they had inhabited. That such a portrait was received cordially by middle classes that had nothing to fear from eruptions beneath them is a matter of record. Above all, however, Nadar had "fixed" a certain image of artistic nobility, and therefore of private values, within the public consciousness. The typical cast of earlier protraiture had been

made up of those distinguished by wealth, privilege, and birth, or pretensions thereof. More colorfully than anyone else, Nadar saw to it that a new group of mandarins rose to take their place, on the basis of individual talent, vibrancy, and brains—in short, personal qualities having nothing to do with a class structure, and therefore transcending it. To have established such a legend in photography was a *coup de théâtre*, not only because of the verism of the medium, but because it permitted a wide distribution of images.

Yet, Nadar's republic of mind can't be said to have formed any counterculture within the Second Empire, as if it were simply a question of hip versus straight life-styles. On the contrary, time and again, his artist characters present themselves in the severest terms, the most funereal raiment. In an essay on the Père Lachaise cemetery, Frederick Brown writes: "Black broadcloth had always been a flag of sobriety in which Europe's bourgeoisie draped itself, not with any illusions that clothing made the man, but, on the contrary, hoping that it would serve to hide him." It's a sign of their imaginative astuteness that Nadar's sitters often seemed to have used the costume of bourgeois anonymity to *reveal* themselves. It became a foil against which they dramatized, for posterity's benefit, a vision of their own unique and sovereign identity. Nadar seems instinctively to have grasped this, in defining just that moment when the face ripens into characteristic self-assertion, toward which the body also swells. In his astonishing image of Millet, we have nothing less than Jove in a frock coat.

There is a definite contrast between these romantic figures, with their sartorial restraint, and the bourgeoisie of the 1860s, whom Nadar shows to be almost sporty in their get-up. Instead of admonishing or troubled frowns, we now have a sunnier race, in amused or elegant postures. And why not? It was a period of unparalleled capitalist triumph. "The world's trade between 1800 and 1840 had not quite doubled. Between 1850 and 1870 it increased by 260 percent" (E. H. Hobsbawm). The prosperity that accompanied it seems to have brought a lighter tone, which is visible in such figures of the entertainment world as Finette, an actress of the *Théâtre Mabille*, with her exquisite grace, and Offenbach, whose droll smile accords well with his music. M. Dagneaux, the nice police officer, shares this mood no less than the boulevardier Manet (though we're aware he happened to be more than that). It is not generally known that the Nadar studios produced thousands of routine pictures of ordinary mortals under normal commercial conditions.

By 1860, Nadar moved from his cramped quarters in Rue St. Lazare to the first elevator building in Paris, an ampler and more

fashionable Boulevard des Capucines installation, whose facade he embellished with a gigantic sign of his signature. Though shadow is largely dispelled from the portraits of his mundane clientele, and with that, a charged presence, they have their charm. It is exerted through the degrees of a modishness that is no longer with us. These people can elicit our curiosity without confronting us. Above all, they do not convey the illusion of being in our time and space, as if history itself has melted away in the intensity of the artist's stare.

It could not have been otherwise, in view of Nadar's business competition. "In the summer of 1861," says Gernsheim, "it was stated that 33,000 people made their living from the production of photographs and photographic materials in Paris alone." A craze does not accelerate that quickly without a spectacular social incentive. In London, also in 1861, J. E. Mayall started it with his card-sized portraits of Victoria and her family, which were merchandised in albums by the hundreds of thousands. As for the French, their time came when Louis Napoleon casually dropped into Disdéri's place to have his picture taken, while the army which the emperor was leading off to Italy waited outside. The royals had found a novel way of coining their images and of putting to use a new technology whose economic success originated in the cachet of their patronage. Disdéri was appointed the official court photographer. At the same time, it became clear that an intimate form of social exchange and personal talisman had had a public impetus and played a propaganda role. Ruling families could mime the domestic virtues in cheap, easily distributed images. Bourgeois could have themselves portrayed by means of an aristocratic emblem. From one form of imperial state portraiture to the modern photomat, there is a lineal development.

Though he, too, flirted with mass communications, Nadar's way had been different, and to understand its symbolism, one must look a little into the career of this complex and utterly engaging character. This is how he judged himself more or less correctly in 1899: "A bygone maker of caricatures, a draftsman without knowing it, an impertinent fisher of bylines in the little newspapers, mediocre author of disdained novels . . . and finally, refugee in the Botany Bay of photography." These few phrases do not mention his training as a medical student, his would-be soldiering in Poland, his German spy mission for the Second Republic, his balloon courier service for the Commune, or the scandal caused when he lent his studio for the first opening of the Impressionists. Possibly the old man might have considered these the false starts and raffish follies of his younger self. There were many such off-the-wall things in his life. And sometimes on-the-ground ones

too, such as the crash of his balloon, *Le Géant*, the largest in the world, near Hanover, after it had been seen off by about 100,000 people in Paris. "Giant," as an epithet, fitted the self-image of a very tall man, with a taste for the burlesque, more than once given to colossal projects. In all these events a protean character is manifested, one in continual process of self-invention. From his studio we have self-portraits in the guise of a young, flow-haired artist, hands posed *à la* Stieglitz, of a top-hatted bourgeois going up in a balloon, and of a scientist in a lab coat, nibbling grapes. His friend Jules Verne would have approved of that, the Verne who modelled a character after Nadar in one of his science-fiction novels. But then, who wasn't Nadar's friend? He was famous for having friends and for his knack of keeping them.

In 1854, after several years' team preparation, he issued an enormous lithograph, caricaturing some 250 notables of French culture, winding their way in a cortege toward the bust of George Sand (another dear friend). The plate was called, with typical bravado, *Panthéon Nadar*. From the sensation it caused he became a celebrity, no mean feat when one remembers it was achieved in a satiric field whose practitioners included Cham, Gavarni, Bertall, Grandville, and Daumier. Much later Nadar wrote of this work that one doesn't know if the caricatural charge was the portrait, or the portrait was the caricature, an indication of its actual mildness. As a draftsman, Nadar had a flair for seizing on the main traits of a face, but no lasting graphic skill. It is said that to aid in his portrayal of the notables, he relied on available photographs and took some himself. Evidently the main camera work of Nadar grew out of this experience, and therefore had its origin in a group portrait tradition. In photography, the precedent had been David Octavius Hill's mob of Scottish clergy; in art, for example, Daumier's *Les Représentants Représentés* (1848). There were innumerable albums, "galleries," etc., showing well known contemporaries, for which the public market was insatiable. Everything was coming together for Nadar, the motifs of his life; his generosity, his enterprise, his role-playing. Even his politics. Louis Napoleon is shown being kicked out of the cortege because a pantheon, after all, is a structure that contains the tombs of the *illustrious* dead of the nation.

Many photographers during the period made their names by a bit of exotic travel to China, Russia, or Egypt. Nadar adventurously trumped them by discovering unseen views within the boundaries of Paris. Though he was an apostle of heavier-than-air flying machines (helicopters), it was from a balloon that he tried some of the first aerial photographs in the history of the medium (1858). By 1861, though, a joke had it that if you couldn't find Nadar in the skies, you should look

for him underground. A sporadically restless experimenter, he had been trying out artificial lights in studio portraiture, and now took his equipment, a pile of Bunsen batteries, for another first into the catacombs and sewers of Paris. Undertaken in a scientific spirit—for the necropolis was hardly a tourist attraction—the results are yet intensely expressive. Seen under his harsh, Gothic glares, these boneyard vistas are the antithesis of his airborne work. The shattered darks disjoint them strangely, within unmarked, oppressive closures. Only mannikins could hold still long enough for the necessary 18 minutes, yet together with the skulls, they start up with a false and horrid life. This is now, literally, the second world, of which Nerval spoke. After thumbing through the glowing portraits in Vitali's monograph on Nadar, one is shocked to come across these charnel sets at its end, as if the artist all along had been pointing up a lesson about the vanity of the flesh. If so, it must surely have been connected in his mind with the destinations of history. In his autobiography, *Quand j'étais photographe*, he wrote: "Since the Caesars and the Norman invasions up to the last bourgeois . . . extracted from the Vaugirard cemetery in 1861, all who have lived and died in Paris sleep here, vile multitudes and great acclaimed men, canonized saints and criminals. . . . In the egalitarian confusion of death, the Merovingian king keeps the eternal silence next to the massacred of September, '92."

Nadar had a second coming as a photographer in Marseilles, during the 1890s. But his new subjects such as the Boer president or the Queen of Madagascar represented quite a spiritual comedown when compared with those in the republic of the mind. None of his later work could have given the old man, who had started as a grub and hack in the July Monarchy, the joy he felt when Blériot flew across the English Channel. His congratulatory telegram, reproduced in all the press, acknowledged a new age of speed that signified for him a fresh purchase on life.

Oscar C. Rejlander

"An Apology for Art-Photography"
1863

AN EXCERPT

In 1855, O. G. Rejlander (1813–1875), a Swede who worked in England, exhibited his first combination prints. He became famous for the *Two Ways of Life* of 1857, a large allegory of the paths of vice and virtue. The picture was made from thirty negatives. It was much praised, and bought by Queen Victoria herself, but also heavily censured for the inclusion of nudity. Combination printing was frequently used to introduce clouds into landscapes in a time when film could not handle both landscape and sky. For a while it was supposed that by such artifice photography could equal the scope of art, but criticism was soon leveled at the attempt to fashion the ideal from a pastiche and at deriving unreal effects from the most realistic of instruments. Rejlander himself said he thought of photography as a handmaid to art.

. . . .

In 1852 I was in Rome, and saw photographs of the *Apollo Belridere*, the *Laocoon*, the *Torso*, Gibson's *Venus*, &c., &c., which I bought and studied; and I was delighted to have a fair chance of measuring the relative proportions of the antique on the flat and true copies of the originals. That was my first acquaintance with the fair results of pho-

tography. I merely recollected having seen some reddish landscape photographs the year before at Ackermann's, in Regent Street, but these made no impression on me. What I saw in the Exhibition of 1851 had proved as evanescent as looking at myself in a glass—"out of sight out of mind." They were all Daguerreotypes. It awakened in me at the moment nothing but curiosity. But in Rome I was fairly taken with the capabilities of the art, so I made up my mind to study photography as soon as I returned to England.

My view at this period, to the best of my recollection, did not extend farther than showing me the usefulness of photography in enabling me to take children's portraits, in aid of painting, and for studies for foregrounds in landscapes.

· · · ·

It is curious to notice how frequently trifles decide some men's actions. What really hurried me forward was my having seen the photograph of a gentleman, and the fold in his coat sleeve was just the very thing I required for a portrait I was then painting at home, and could not please myself in this particular point. My sitter had not time or inclination to sit for it; my lay figure was too thin (I soon sold that); but this was just "like life!" "Now," said I, "I shall get all I want." I could not exercise proper patience. I therefore took all the lessons at once, to turn out as a ready-made photographer the next day. Alas! for a very long period my attempts at photography resembled those of a young Miss at the piano, looking alternately at the music and the keys. If I had to speak at the time of operation, I very easily went wrong—often drawing up the shutter of the plate-holder with the collodionised plate outside!

I cannot forbear mentioning that some of the earliest portraits that I took, and which I had sensitised with ammonia-nitrate, are as vigorous now as they were then, although they had but three changes of water—ten minutes or a quarter-of-an-hour in each dish after hypo., as my instructor had told me—while others, and later, according to the usual process, have proved as treacherous as a bad memory. At length Maxwell Lyte let his *light* in on my manipulations by the publication of the alkaline gold-toning process. At that time I was nearly giving up photography. I felt as if I were only writing in sand.

My first attempt at "double printing," as some call it, was exhibited in London in 1855. It was named in the catalogue *Groupe Printed from Three Negatives*. That plan I hit upon through sheer vexation, because I could not get a gentleman's figure in focus, though he was close behind a sofa on which two ladies were seated. Up to this time I considered postures on the principle of *bas-reliefs*—it is as few foreshortenings as possible; but now I felt freer.

I will now tell you how I first drifted into making photographic pictures; and it seems to me that any one might excuse me—even Mr. Sutton—after hearing it. I had taken a group of two. They were expressive and composed well. The light was good, and the chemistry of it successful. A very good artist was staying in the neighbourhood, engaged on some commission. He called, saw this picture, was very much delighted with it, and so was I. Before he left my house he looked at the picture again, and said it was "marvellous"; but added—"Now, if I had drawn that, I should have introduced another figure between them, or some light object to keep them together. You see there is where you photographers are at fault. Good morning!" I snapped my fingers after he left—but not at him—and exclaimed aloud, "I can do it!" Two days afterwards I called at my artist-friend's hotel, as proud as—anybody. He looked at my picture and at me, and took snuff twice. He said—"This is another picture." "No," said I, "it is the same, except with the addition you suggested." "Never!" he exclaimed; "and how is it possible? You should patent that!" * * * Well, our interview ended with another suggestion that if a basket or something else had been on the left side in the foreground it would have given greater depth to the picture, and adding that the light dress of the female on the shady side was not shady or dark enough. I agreed fully with my friend's criticism; and, after a week, I sent to him, to London, the picture amended as a present. He wrote some time afterwards and thanked me, saying that it was very successful; but (he wrote), of course, now that that was known, any one who practised photography could do it. * * * This was my first sip at the sweet and bitter cup in my photographic career.[1] A thought of the share he had in this first effort in composition-photography did not occur to my friend. I should very likely not have done it but for his "you can't!" Now why should this cause all the fuss and abuse for interfering with legitimate art? To me double printing seems most natural. Vignetting is allowed and admired. The manual part of photographic composition is but wholesale vignetting. It has proved most useful in portraiture when a family group was to be taken; for if one figure moved, he or she could be taken over again alone, and put in afterwards; or, what is still better, a sketch of the group may first be made, then take each figure separately—for then each would be more perfect—and print them in agreeably with the sketch.

But please to believe that I did not look upon photography as an

1. *It is not difficult to understand the vague notions of an artist the first time he sees such a thing accomplished—such a result in so short a time—when compared with his own laborious method.*

ultimate art, or an art depending on itself, or complete in itself, except details; though I can guess of its extended applicability, or rather plasticity. In almost all the art-studies I have made, I have had one object in view—they were for the use of artists; and if I had not done them, how could artists, who are not acquainted with photography, know what could be done? They know now, and they avail themselves of it.

But as there is no mind in the photographic picture, so according to some it cannot contain any new idea, pose, light, or expression capable of representing impressions produced on the human mind, and "not being the work of man" it must be, indirectly, the work of the devil—and, since as "the work of man is indirectly the work of God," as Mr. Sutton has it, where are we to go to?

Still I think highly of photography. It is fair, open, and aboveboard. There is no sham about it—no pretensions to anything that is not desirable. And the world wouldn't be without it, in all its branches —including the one I most practise, art-studies and details from the life. Though to me this branch of the art is unprofitable, yet it gives me pleasure. I live in it, if not by it. As to those dreadful composition photographs, I have only executed one since the "abominable" *Two Ways of Life*, and that one I meant as a set-off to the other, and called it the *Scripture Reader;* but that was neither good nor bad enough to attract any notice whatever. I have not exhibited for some years, so I think I might have been let alone.

I have been so ill used and abused about the picture of the *Two Ways of Life*, I should be glad to once more—not describe it, as I did to the Central Society—but explain that it was dedicated to English artists, which dedication was written under the one exhibited at the Manchester Exhibition—not as a challenge, for that would have been ridiculous, but to show various studies from nature, which at that time were rather novel. And again, as the most difficult drawing is that from the living model, I presumed thereby to point out a handmaid to art— not alone in full light, but in shade—yet transparent. Each figure was meant as a specimen of variety of light and shade. I dislike a mere nude, if it (apart from study) conveys no idea. So I brought all the figures together as well as I could, and gave the resulting picture a name. This composition was also meant to show that there might be a little real sun-painting employed when needed, to harmonise or soften harsher light in photographs. These are indeed no afterthoughts.

I will not tire you with further description. Those that objected to the *Two Ways of Life* being exhibited had a perfect right to their opinion; but they have no right to ask the names or profession or religion of models, still less to use vile epithets in speaking of them, as Mr. Sutton

has done in his paper read before the Photographic Society of Scotland. When children are inconveniently inquisitive, we tell them they were "found in a parsley bed"; and a similar answer might be given to those who cannot or will not comprehend the matter. There are many female models whose good name is as dear to them as to any other woman. But I prefer to believe that Mr. Sutton did not use those harsh expressions on mere supposition; but that he may have been misinformed, in his search for the truth, by those who wished to increase their attraction by saying that they had been models for Mr. So and So; for I have been told that that is not an uncommon practice. Of course I need not be ashamed to say I have heard it. . . .

It is very hard—but I must confess it—that I positively dare not now make a composition photograph, even if I thought that it might be very perfect. I have brought with me a sketch over which I have thought for a very long time. Up to this moment it is a work of art. Is it not? The same way a painter goes if he means to paint a photographer must go if he wishes to make a composition-photograph. The two go together—part here, and meet again.

Fine art consists of many parts; and a photographic composition commenced in this manner must contain many parts in common with art; and even where they part company photographic art does not stand still, but proceeds and gathers other merits on another road—though a more humble one, yet full of difficulties, requiring much thought and skill up to the last moment, when they again converge, in the production of light, shade, and reflected lights which have been predetermined—in general keeping and aërial perspective.

There is no valid reason for saying that, because you have not seen a good photographic composition, there could not be one. I believe there can be produced—even after all that has been done—wonderful pictures by photography. And why are there no good art-photographs? Because it requires art and long training to execute them, beside encouragement. I do not believe in haphazard excellence. Photography, in my opinion, is essentially excellent for details. You may take twenty good figures separately, but they cannot be taken at once. You cannot take even four good ones at once; but then you cannot draw or paint a picture at once.

I believe photography will make painters better artists and more careful draughtsmen. You may test their figures by photography. In Titian's *Venus and Adonis*, Venus has her head turned in a manner that no female could turn it and at the same time show so much of her back. Her right leg also is too long. I have proved the correctness of this opinion by photography with variously-shaped female models. In *Peace*

and War, by Rubens, the back of the female with the basket is painted from a male, as proved by the same test.

The real good old painters—such as Raffaelle, Leonardo da Vinci, Luini, Velasquez, Teniers, Titian—you often find reflected in photography in apparent finish and effect. I can exemplify presently what I mean by the photographs which are now before you.

There are many ways in which photography can prove useful to artists, although few of them are aware of it. Here is one—After they have made their sketch, or uncoloured cartoon, they may have a photograph taken from it; and then on the prepared albumen paper they may play with colours as much as they like, until they arrive at what they wish for their painting; for a wet brush removes any colour objected to, just as if it had never been there, yet the outline underneath remains the same.

One of the reasons why painters are troubled in using a photograph to paint from, is that almost in every case (I am now speaking of portraits or figure pictures) the light on the photograph is different to that on the sitter at the artist's studio. Here is a source of confusion and vexation. I have often felt it, and wished that I had not looked at the photograph; yet it saved the time of the sitter. But if a photographic study is taken in a light similar to that at artists' studios generally, and that be enlarged, if the artist gets the same model or sitter into his own studio, the work is only pleasure.

I think picture-dealers are, or have been, from interested motives, the greatest opponents to photography, and they have great influence. As to art-critics, they vary so much in their opinion from one year to another, and differ so much between themselves, I am induced to conclude that they write generally from the information they have received from persons they trust to; for I believe if they possessed even the data that we have, they would be more Christian-like—rather help with their criticism than damn with their sneers. Though individually I must not complain much. I have had praise, and I was silent. Lately the tables have been turned, and from a "successful delineator," &c.— happy in catching transient expressions—I had come down to be a "clever operator," when recently I was reduced to the position of a "manipulator" in a notice—and such a notice!—in the *Athenæum* of an allegorically-treated photograph of *Garibaldi Wounded, Supported by Hope, Pointing to Rome.* My intention in this photograph was to show that my opinion of the hero was that he never would give up the idea of possessing Rome. But in the notice in the *Athenæum* above alluded to I was rudely taken to task. It was intimated that I had paid my model 1s. 6d. per hour, when I myself was the model, and never realised 6d.

per hour! After my many days' trials, and heavy printing expenses, my publisher ceased to order immediately upon that veto being placed upon the picture. I hoped to have secured an adequate return from its publication: I never had a catchpenny yet. But what angered me most was that the critic called the photograph indecent! I cannot guess in what.

A funny thing it is that some people actually prefer the chalkings of a boy on the walls and shutter to the finest photographic pictures! Just think how superior are the mackerel and ship at sea we find drawn on the pavement in coloured chalks! I am ambitious, too—

"I wish I was in Dixie! I do! I do!"

I have here a picture,[2] in which I have attempted to draw something, like a good boy, and beg the Chairman's acceptance of it. I only wish there had been another sunny day, to have enabled me to have made it more perfect. It is a real sun-painting, or rather it has been painted by me with pencils of light about ninety-three millions of miles long! and the points varying considerably. I exposed it so much to diffused daylight for want of sun, that I have been obliged to take up some lights still that have been done chemically by the cyanide of potassium. When I painted it I almost imagined I heard its notes whistling.—Now, Use Photography: Don't Abuse It.

2. *A donkey's head, drawn by light alone, guided by me.*

Marcus Aurelius Root

The Camera and the Pencil
1864

AN EXCERPT

From 1846, Marcus A. Root (1808–1888) operated one of
the largest daguerreotype studios in America, first in Phila-
delphia and later in New York. *The Camera and the Pencil,*
written while Root was convalescing from a serious accident,
was the first American book that was not merely a technical
manual but a brief for photography as a fine art. Root believed
he could speak authoritatively about portraits, since he had
taken nearly 70,000 himself. It was Root who coined the term
ambrotype for the collodion process, which superseded the
daguerreotype.

USES OF THE HELIOGRAPHIC ART

Though heliography is but a new-discovered art, and is, of course, far
from having reached perfection, it has already conferred various and
important benefits on society. These benefits must be augmented, as
the art progresses. Let me specify some of these.

1st. In the order of nature, families are dispersed, by death or
other causes; friends are severed; and the "old familiar faces" are no
longer seen in our daily haunts. By heliography, our loved ones, dead
or distant, our friends and acquaintances, however far removed, are

retained within daily and hourly vision. To what extent domestic and social affections and sentiments are conserved and perpetuated by these "shadows" of the loved and valued originals, every one may judge. The cheapness of these pictures brings them within reach, substantially, of all.

In this competitious and selfish world of ours, whatever tends to vivify and strengthen the social feelings should be hailed as a benediction. With these literal transcripts of features and forms, once dear to us, ever at hand, we are scarcely more likely to forget, or grow cold to their originals, than we should be in their corporeal presence. How can we exaggerate the value of an art which produces effects like these?

2d. But not alone our near and dear are thus kept with us; the great and the good, the heroes, saints, and sages of all lands and all eras are, by these life-like "presentments," brought within the constant purview of the young, the middle-aged, and the old. The pure, the high, the noble traits beaming from these faces and forms—who shall measure the greatness of their effect on the impressionable minds of those who catch sight of them at every turn? Who can behold the "mimic" Washington of Stuart or Peale, without recalling, for an instant at least, who and what was the original once enshrined in that majestic face and figure? And the representation of the "Divine Man of Nazareth,"—not, of course, a transcript from *actual life*, but the picture whereby an artist of supreme genius, in his most rapt devotional moods, made visible *his* conception of what must have been the aspect of One thus endowed and inspired—could any individual look upon it daily, and not experience that a "virtue had gone out of it," and had done somewhat towards moulding his own dispositions and character?

Indeed, our education is accomplished far more by the circumstances amid which we live, than by all the direct, technical instruction we receive; and from infancy to old age we are continually acted upon for good and for evil by the sights and sounds with which we are familiar. And he who beholding, on every side within his dwelling, spectacles of the class above named, derives from them no elevating moral influence, must be made of almost hopelessly impenetrable stuff. But taking a still wider view, consider

3d. What this art is doing, and is still more largely to do hereafter, for increasing the knowledge and happiness of the masses. What, heretofore, the traveller alone could witness (and travelling was out of the reach of ninety-nine hundredths of mankind), even the humblest may now behold, substantially, without crossing his own threshold. The natural scenery, grand, beautiful, or picturesque, of every quarter of the globe; the noblest edifices, secular and religious, of the most

highly civilized lands; together with the weird, fantastic piles, reared by semi-barbaric peoples to their "strange gods"; the multitudinous reliques still remaining of the skill and the power, the pomps and the glories of the most celebrated regions of the ancient world; the localities, on either continent, where conflicts have been waged, or events have occurred, which have acted powerfully on the destinies of nations, and perhaps have turned the currents of the world's history into new channels; the inhabitants of every zone, from the Arctic to the Antarctic Circle, with their costumes and their exterior ways of life; the finest existing specimens of art, ancient and modern, of foreign countries or our own; the most exciting, impressive, and awful acts or scenes which may occur anywhere at any moment—a thunder-storm, a tempest at sea, a great battle, in the very heat and fury of its crisis—all these, and whatever else of interest the world may present to the sight, caught, as they may be, with absolute exactitude, by the infallible pencil of the sun, are now brought within reach of all, even the lowliest of the community.

But while the masses are thus supplied with abundant and infinitely various stores of knowledge and entertainment, they are, at the same time, receiving no small measure of artistic training. Of course, in the multitudes of heliographs sent abroad into the world, there are very many various degrees of excellence in execution and finish, and the observer of different specimens is naturally moved to compare one with another, and to form his own judgment of which are the superior and which the inferior. By this simple process, carried on, perhaps, for the most part, unconsciously or but semi-consciously, the community is being trained to a taste for art and a love of the beautiful. Thus sun-painting promises to do for the moderns, what art, in other forms, did for the ancient Greeks. And who can even imagine what would be the purifying and elevating effects of a relish and enjoyment of beauty, both in nature and art, universally diffused—especially when combined, as it is among the moderns, with the influence flowing from the precepts and the life of the "Good Master"? But

4th. Heliography, we believe, is destined to do much for the improvement of the other fine arts and their professors. To the portraitist, for example, a good heliograph furnishes important aid in transferring a face and form to the canvass or ivory. By its means he is able to get a more exact outline of his sitter, besides being helped to catch his brightest and best expression. For obtaining such outline, as also the drapery and all other accessories, the sitter need not be subjected to the long, wearisome sessions formerly required, as these may be taken directly from the heliograph. And then a few brief sittings,

devoted exclusively to studying the subject's type of mind and character, and thus settling the fittest mode of expressing the same in the countenance, will fully suffice—especially if the heliographer has been fully successful in calling up and representing the sitter's best expression at the outset. In a word, this use of the heliograph is a mode of *economizing* both time and force, leaving to the painter more of both for producing the highest effects of his art.

The landscape-painter, the sculptor, and the architect, as well as all others, whose aim is visible representation, may in like manner derive essential help from copies of their originals.

But especially is heliography, with the late discovered devices for *instantaneous taking*, calculated to benefit other artists, by supplying them with most interesting "studies." For example, the clouds, seen occasionally to rise aloft like dark craggy mountains leaning against higher and lighter-tinted ones, above which appear still others, darker, grander, and more irregular in outline, and tipped with light—the whole having a dark blue sky for a background—all can be accurately and *instantly* pictured by the solar pencil.

So the high-rolling and high-capped billows of a storm-lashed sea, as they follow each other, dashing furiously against or curling triumphantly over the overtaken ship or the immovable rock, may be stamped upon the plate exactly as the eye beholds them, and almost as rapidly as the eye can take them in.

Again, waterfalls; choice bits of landscape; large moving masses of people assembled on occasions of festival or public celebration; and all kindred spectacles, may be reproduced in the same way.

And thus, taken on a small scale, they can, by methods recently devised, be enlarged to a magnitude of many feet square, without losing their original exactitude of truthfulness.

Such pieces, to an artist in colors, must be invaluable as "studies" of nature; while the imaginative artist, by idealizing them, may win an enviable reputation.

It will readily be seen how useful the art, with its present facilities, must be for illustrating books, periodicals, &c.—supplying them with reliable sketches of machinery, of architecture, of scenes of disaster or of jubilee, of portraits; and, in short, of whatever is suited to interest or instruct the public.

It seems, too, that the French savans are applying heliography to physical astronomy and the mathematical measurement of the heavenly bodies. Several valuable pictures of this class have already been taken, and the art promises to render important services in this direction.

. . . .

John Ruskin

Various writings 1845-1879

EXCERPTS

John Ruskin (1819–1900), the foremost English art critic of his time, was an eager advocate of photography in his early career. He tried photography himself, and claimed to have been the first to photograph the Matterhorn. From his own experience as a draughtsman, he enthusiastically declared that photography would be a great aid to art. At some point, Ruskin changed his mind. He decided that photography used neither the soul nor the active, designing intellect, and therefore could not be judged a high art.

From letters dated 1845 and 1846, printed in the "Library Edition" of *The Complete Works*, published by George Allen:

". . . Amongst all the mechanical poison that this terrible nineteenth century has poured upon men, it has given us at any rate one antidote—the Daguerreotype. It's a most blessed invention, that's what it is.

"It is certainly the most marvellous invention of the century; given us, I think, just in time to save some evidence from the . . . wreckers. As regards art, I wish it had never been discovered, it will make the eye too fastidious to accept mere handling."

Ruskin gradually grew disillusioned with photography and the possibility of its assisting painting; ultimately he turned against photography altogether. In "Lectures on Art," delivered in 1870, he said:

"Let me . . . recommend you once more with great earnestness the patient study of the chiaroscuro of landscape . . . and this the rather, because you might suppose that the facility of obtaining photographs which render such effects, as it seems with absolute truth and unapproachable subtilty (sic), superseded the necessity of study and the use of sketching . . . let me assure you once for all that photographs supersede no single quality nor use of fine art. . . . They supersede no good art, for the definition of art is 'human labour regulated by human design,' and this design, or evidence of active intellect in choice and arrangement is the essential part of the work, which so long as you cannot perceive, you perceive no art whatsoever; which when you once do perceive, you will perceive also to be replaceable by no mechanism."

In "The Cestus of Agalia," 1865:

"I tell you (dogmatically, if you like to call it so, knowing it well) a square inch of man's engraving is worth all the photographs that were ever dipped in acid (or left half-washed afterwards, which is saying something). Only it must be man's engraving, not machine's engraving. . . . Believe me, photography can do against line engraving just what Madame Tussaud's waxwork can do against sculpture. That and no more."

In "The Eagle's Nest," 1874:

"Anything more beautiful than the photographs of the Valley of Chamouni, now in your print-sellers' windows, cannot be conceived. For geographical and geological purposes, they are worth anything; for art purposes, worth—a good deal less than zero."

In the chapter "All Great Art is Praise," in "The Laws of Fesole," 1879:

". . . You may think that a bird's nest by William Hunt is better than a real bird's nest . . . But it would be better for us that all the pictures in the world perished, than that birds should cease to build nests. And it is precisely in its expression of this inferiority that the drawing itself becomes valuable. It is because a photograph cannot condemn itself that it is worthless. The glory of a great picture is in its shame; and the charm of it in expressing the pleasure of a loving heart that there is something better than picture. Also it speaks with the

voices of many: the efforts of thousands dead, and their passions, are in the pictures of their children to-day. Not with the skill of an hour, nor of a life, nor of a century, but with the help of numberless souls, a beautiful thing must be done."

Henry Peach Robinson

Pictorial Effect in Photography
1869

AN EXCERPT

Sharp attacks were leveled at Henry Peach Robinson's (1830–
1901) combination prints, but when the Royal House patron-
ized his work, he became England's most successful pictorial
photographer. His influence was widespread, since his book,
Pictorial Effect in Photography, was translated into French and
German and often reprinted. His advocacy of artificial studio
settings fell into disrepute, and the sentimentality of his sub-
jects and the "impurity" of his methods made him the subject
of scorn in the twentieth century, but photographers since
World War II have increasingly used combination techniques
such as he practiced.

COMBINATION PRINTING

In some of the later chapters of this work I have introduced complicated
groups of figures with landscape and other backgrounds, which, to
those who are unacquainted with the scope of our art, may appear
impossible in photography. My object in introducing engravings from
paintings of complicated forms has not been to offer to photographers
examples for exact imitation, but that it may be shown how immutable

laws exist in all good works of art, whether that art is exemplified in the lowest subjects, or the highest; that the same laws of balance, contrast, unity, repetition, repose, and harmony are to be found in all good works, irrespective of subject; and that the arrangement of the general form of nearly all pictures in which true art is visible is based on the diagonal line and the pyramid. I have thought it of more consequence to fix these facts on the mind of the student than to set before him examples for imitation, however good, which he would have blindly to follow without understanding and without profit.

But the scope of photography is wider than those who have only taken a simple portrait or landscape suppose. There has not been a single group introduced into these lessons that could not have been reproduced from life by the means our art places at our disposal. I do not mean to assert that a subject containing so many difficulties as Goodall's "Swing," for instance, has ever been done in photography; but it is not so much the fault of the art, as of the artists, that such a picture has not been successfully attempted. It has not been the failing of the materials, unplastic as they are when compared with paint and pencils; it has been the absence of the requisite amount of skill in the photographer in the use of them, that will account for the dearth of great works in photography. The means by which these pictures could have been accomplished is Combination Printing, a method which enables the photographer to represent objects in different planes in proper focus, to keep the true atmospheric and linear relation of varying distances, and by which a picture can be divided into separate portions for execution, the parts to be afterwards printed together on one paper, thus enabling the operator to devote all his attention to a single figure or sub-group at a time, so that if any part be imperfect from any cause, it can be substituted by another without the loss of the whole picture, as would be the case if taken at one operation. By thus devoting the attention to individual parts, independently of the others, much greater perfection can be obtained in details, such as the arrangement of draperies, refinement of pose, and expression.

The most simple form of combination printing, and the one most easy of accomplishment and most in use by photographers, is that by which a natural sky is added to a landscape. It is well known to all photographers that it is almost impossible to obtain a good and suitable sky to a landscape under ordinary circumstances. Natural skies are occasionally seen in stereoscopic slides and very small views, but I am now writing of pictures, and not of toys. It rarely happens that a sky quite suitable to the landscape occurs in the right place at the time it is taken, and, if it did, the exposure necessary for the view would be

sufficient to quite obliterate the sky; and if this difficulty were obviated by any of the sun-shades, cloud-stops, or other inefficient dodges lately proposed, the movement of the clouds during the few seconds necessary for the landscape would quite alter the forms and light and shade, making what should be the sky—often sharp and crisp in effect—a mere smudge, without character or form. All these difficulties are got over by combination printing, the only objections being that a little more care and trouble are required, and some thought and knowledge demanded. The latter should be considered an advantage, for photographs, of a kind, are already too easy to produce. Of course, when a landscape is taken with a blank sky, and that blank is filled up with clouds from another negative, the result will depend, to a very great degree, upon the art knowledge of the photographer in selecting a suitable sky, as well as upon his skill in overcoming the mechanical difficulties of the printing. It is not necessary here to enter into a description of the art aspect of the matter, as that has been discussed in a former portion of this work; so we will confine ourselves to the mechanical details.

The landscape negative must have a dense sky, or, if it be weak, or have any defects, it must be stopped out with black varnish. In this case it is better to apply the varnish to the back of the glass; by this means a softer edge is produced in printing than if painted on the varnished surface. With some subjects, such as those that have a tolerably level horizon, it is sufficient to cover over part of the sky while printing, leaving that part near the horizon gradated from the horizon into white.

I may here remark, that in applying black varnish to the back of a negative, occasions will often be found where a softened or vignetted edge is required for joining, where a vignette glass or cotton wool cannot be applied; in such cases, the edge of the varnish may be softened off, by dabbing slightly, before it is set, with the finger, or, if a broader and more delicate gradated edge be required, a dabber made with wash-leather may be employed with great effect.

When an impression is taken, the place where the sky ought to be, will, of course, be plain white paper; a negative of clouds is then placed in the printing-frame, and the landscape is laid down on it, so arranged that the sky will print on to the white paper in its proper place; the frame is then exposed to the light, and the landscape part of the picture is covered up with a mask edged with cotton wool. The sky is vignetted into the landscape, and it will be found that the slight lapping over of the vignetted edge of the sky negative will not be noticed in the finished print. There is another way of vignetting the sky into the landscape,

which is, perhaps, better and more convenient. Instead of the mask edged with cotton wool, which requires moving occasionally, a curved piece of zinc or cardboard is used. Here is a section of the arrangement.

The straight line represents the sky negative, and the part where it joins the landscape is partly covered with the curved shade. Skies so treated must not, of course, be printed in sunlight.

It is sometimes necessary to take a panoramic view. This is usually done, when the pantascopic camera is not employed, by mounting two prints together, so that the objects in the landscape shall coincide; but this is an awkward method of doing what could be much better accomplished by combination printing. The joining of the two prints is always disagreeably visible, and quite spoils the effect. To print the two halves of a landscape, taken on two plates, together, the following precautions must be observed: both negatives must be taken before the camera-stand is moved, the camera, which must be quite horizontal, pointing to one half of the scene for the first negative, and then turned to the remaining half of the view for the second negative. The two negatives should be obtained under exactly the same conditions of light, or they will not match; they should also be so taken that a margin of an inch and a-half or two inches is allowed to overlap each other; that is to say, about two inches of each negative must contain the same or centre portion of the scene. It is advisable, also, that they should be of the same density, but this is not of very great consequence, because any slight discrepancy in this respect can be allowed for in printing. In printing, vignette, with cotton wool, or a straight-edged vignette glass, the edge of the left hand negative on the side that is to join the other, taking care to cover up the part of the paper that will be required for the companion negative; when sufficiently printed, take the print out of the frame, and substitute the right-hand negative; lay down the print so that it exactly falls on the corresponding parts of the first part printed (this will be found less difficult, after a little practice, than it appears), and expose to the light, vignetting the edge of this negative, also, so that the vignetted part exactly falls on the softened edge of the impression already done. If great care be taken to print both plates exactly alike in depth, it will be impossible to discover the join in the finished print. If thought necessary, a sky may be added, as before described, or it may be gradated in the light, allowing the horizon to be lighter than the upper part of the sky.

Perhaps the greatest use to which combination printing is now put

is in the production of portraits with natural landscape backgrounds. Many beautiful pictures, chiefly cabinets and cards, have been done in this way by several photographers. The easiest kind of figure for a first attempt would be a three-quarter length of a lady, because you would then get rid of the foreground, and have to confine your attention to the upper part of the figure and the distance. Pictures of this kind have a very pleasing effect. In the figure negative, everything should be stopped out, with the exception of the figure, with black varnish; this should be done on the back of the glass when practicable, which produces a softer join; but for delicate parts—such as down the face— where the joins must be very close, and do not admit of anything approaching to vignetting, the varnish must be applied on the front. A much better effect than painting out the background of the figure negative is obtained by taking the figure with a white or very light screen behind it; this plan allows sufficient light to pass through the background to give an agreeable atmospheric tint to the distant landscape; and stopping out should only be resorted to when the background is too dark, or when stains or blemishes occur, that would injure the effect. An impression must now be taken which is not to be toned or fixed. Cut out the figure, and lay it, face downwards, on the landscape negative in the position you wish it to occupy in the finished print. It may be fixed in its position by gumming the corners near the lower edge of the plate. It is now ready for printing. It is usually found most convenient to print the figure negative first. When this has been done, the print must be laid down on the landscape negative so that the figure exactly covers the place prepared for it by the cut-out mask. When printed, the picture should be carefully examined, to see if the joins may be improved or made less visible. It will be found that, in many places, the effect can be improved and the junctions made more perfect, especially where a light comes against a dark—such as a distant landscape against the dark part of a dress—by tearing away the edge of the mask covering the dark, and supplying its place by touches of black varnish at the back of the negative; this, in printing, will cause the line to be less defined, and the edges to soften into each other. If the background of the figure negative has been painted out, the sky will be represented by white paper; and as white paper skies are neither natural nor pleasing, it will be advisable to sun it down.

If a full-length figure be desired, it will be necessary to photograph the ground with the figure, as it is almost impossible to make the shadow of a figure match the ground on which it stands in any other way. This may be done either out of doors or in the studio. The figure taken out of doors would, perhaps, to the critical eye, have the most

natural effect, but this cannot always be done, neither can it be, in many respects, done so well. The light is more unmanageable out of doors, and the difficulty arising from the effect of wind on the dress is very serious. A slip of natural foreground is easily made up in the studio; the error to be avoided is the making too much of it. The simpler a foreground is in this case, the better will be the effect.

The composition of a group should next engage the student's attention. In making a photograph of a large group, as many figures as possible should be obtained in each negative, and the position of the joins so contrived that they shall come in places where they will be least noticed, if seen at all. It will be found convenient to make a sketch in pencil or charcoal of the composition before the photograph is commenced. The technical working out of a large group is the same as for a single figure; it is, therefore, not necessary to repeat the details; but I give a reduced copy, by Mr. J. R. Johnson's new carbon process, of a large combination picture, entitled "Autumn," which I made some years ago, a description of the progress and planning of which may be of use to the student. I have chosen this picture because the junctions are more plainly visible, and, therefore, the manner more clear to the student, than in my recent productions.

A small rough sketch was first made of the idea, irrespective of any considerations of the possibility of its being carried out. Other small sketches were then made, modifying the subject to suit the figures available as models, and the scenery accessible, without very much going out of the way to find it. From these rough sketches a more elaborate sketch of the composition, pretty much as it stands, and of the same size, was made, the arrangement being divided so that the different portions may come on 15 by 12 plates, and that the junctions may come in unimportant places, easy to join, but not easy to be detected afterwards. The separate negatives were then taken. The picture is divided as follows. The first negative taken includes the four figures to the left, the tree trunks, and stile, with the wheat sheaves and ground immediately under them. The join runs round the edges of the figures, and down the foreground, where it is rather clumsily vignetted into the next negative, consisting of the remaining figure and the rest of the foreground. The landscape is in two pieces, vignetted into each other just over the arm of the girl with the hand to her head, the only place where they come in contact.

At first sight, it will appear difficult to place the partly-printed pictures in the proper place on the corresponding negative. There are many ways of doing this, either of which may be chosen to suit the subject. Sometimes a needle may be run through some part of the

print, the point being allowed to rest on the corresponding part of the second negative. The print will then fall in its place at that point. Some other point has then to be found at a distance from the first; this may be done by turning up the paper to any known mark on the negative, and allowing the print to fall upon it; if the two separate points fall on the right places, all the others must be correct. Another way of joining the prints from the separate negatives is by placing a candle or lamp under the glass of the printing-frame—practically, to use a glass table —and throwing a light through the negative and paper, the join can then be seen through. But the best method is to make register marks on the negatives. This is done in the following manner. We will suppose that we wish to print a figure with a landscape background from two negatives, the foreground having been taken with the figure. At the two bottom corners of the figure negative make two marks with black varnish, thus ⌊ ⌋ ; these, of course, will print white in the picture. A proof is now taken, and the outline of the figure cut out accurately. Where the foreground and background join, the paper may be torn across, and the edges afterwards vignetted with black varnish on the back of the negatives. This mark is now fitted in its place on the landscape negative. Another print is now taken of the figure negative, and the white corner marks cut away very accurately with a pair of scissors. The print is now carefully applied to the landscape negative, so that the mark entirely covers those parts of the print already finished. The landscape is then printed in. Before, however, it is removed from the printing-frame, if, on partial examination, the joins appear to be perfect, two lead pencil or black varnish marks are made on the mark round the cut-out corners at the bottom of the print. After the first successful proof there is no need for any measurement or fitting to get the two parts of the picture to join perfectly; all that is necessary is, merely to cut out the little white marks, and fit the corners to the corresponding marks on the mask; and there is no need to look if the joins coincide at other places, because, if two points are right, it follows that all must be so. This method can be applied in a variety of ways to suit different circumstances.

There are one or two things to consider briefly before concluding this subject.

It is true that combination printing, allowing, as it does, much greater liberty to the photographer, and much greater facilities for representing the truth of nature, also admits, from these very facts, of a wide latitude for abuse; but the photographer must accept the conditions at his own peril. If he find that he is not sufficiently advanced in knowledge of art, and has not sufficient reverence for nature, to allow

him to make use of these liberties, let him put on his fetters again, and confine himself to one plate. It is certain (and this I will put in italics, to impress it more strongly on the memory) that *a photograph produced by combination printing must be deeply studied in every particular, so that no departure from the truth of nature shall be discovered by the closest scrutiny.* No two things must occur in one picture that cannot happen in nature at the same time. If a sky is added to a landscape, the light must fall on the clouds and on the earth from the same source and in the same direction. This is a matter that should not be done by judgment alone, but by judgment guided by observation of nature. Effects are often seen, especially in cloud land, very puzzling to the calm reasoner when he sees them in a picture, but these are the effects that are often best worth preserving, and which should never be neglected, because it may possibly happen that somebody will not understand it, and therefore say it is false, and, arguing still further on the wrong track, will say that combination printing always produces falsehoods, and must be condemned. A short anecdote may perhaps be allowed here. A short time ago I sent a photograph of a landscape and sky to a friend whose general judgment in art I admit to be excellent, but he knew that I sometimes employed combination printing. His reply was, "Thank you for the photograph; it is a most extraordinary effect; sensational, certainly, but very beautiful; but it shows, by what it is, what photography cannot do; your sky does not match your landscape; it must have been taken at a different time of day, at another period of the year. A photograph is nothing if not true." Now it so happened that the landscape and sky were taken at the same time, the only difference being that the sky had a shorter exposure than the landscape, which was absolutely necessary to get the clouds at all, and does not affect the result. Another instance has arisen in my picture of "Autumn," which I have just been dissecting for the benefit of the student. Four of the figures, as I have explained, were taken on one plate, at one operation; yet a would-be critic some years ago wrote at some length to prove that these figures did not agree one with another; that the light fell on them from different quarters; that the perspective of each had different points of sight; and that each figure was taken from a different point of view. I mention these two cases to show that it is sometimes a knowledge of the means employed, rather than a knowledge of nature—a foregone conclusion that the thing must be wrong, rather than a conviction, from observation, that it is not right—that influences the judgment of those who are not strong enough to say, "This thing is right," or "This thing is wrong, no matter by what means it may have been produced."

John Thomson

Introduction to
Illustrations of China
and Its People
1873

AN EXCERPT

The first known European photographer in China, Felice A.
Beato, arrived in 1860. John Thomson (1837–1921), who had
some reputation as an architectural photographer in his native
Scotland, went east not long after, established a photography
studio in Singapore, and by 1868 had begun his four- to five-
thousand-mile trek across China with a camera. He photo-
graphed people, places, and customs unheard of in Europe at
the time, and published them in *Illustrations of China and Its
People* in 1873. In 1877 Thomson published *Street Life in Lon-
don*, an early documentary account of the life of the urban
poor.

. . . .

My design for the accompanying work is to present a series of pictures
of China and its people, such as shall convey an accurate impression of
the county I traversed as well as the arts, usages, and manners which
prevail in different provinces of the Empire. With this intention I made
the camera the constant companion of my wanderings, and to it I am
indebted for the faithful reproduction of the scenes I visited, and of the
types of race with which I came into contact.

Those familiar with the Chinese and their deeply-rooted supersti-

163

tions will readily understand that the carrying out of my task involved both difficulty and danger. In some places there were many who had never yet set eyes upon a pale-faced stranger; and the literati, or educated classes, had fostered a notion amongst such as these, that, while evil spirits of every kind were carefully to be shunned, none ought to be so strictly avoided as the "Fan Qui" or "Foreign Devil," who assumed human shape, and appeared solely for the furtherance of his own interests, often owing the success of his undertakings to an ocular power, which enabled him to discover the hidden treasures of heaven and earth. I therefore frequently enjoyed the reputation of being a dangerous geomancer, and my camera was held to be a dark mysterious instrument, which, combined with my naturally, or supernaturally, intensified eyesight gave me power to see through rocks and mountains, to pierce the very souls of the natives, and to produce miraculous pictures by some black art, which at the same time bereft the individual depicted of so much of the principle of life as to render his death a certainty within a very short period of years.

Accounted, for these reasons, the forerunner of death, I found portraits of children difficult to obtain, while, strange as it may be thought in a land where filial piety is esteemed the highest of virtues, sons and daughters brought their aged parents to be placed before the foreigner's silent and mysterious instrument of destruction. The trifling sums that I paid for the privilege of taking such subjects would probably go to help in the purchase of a coffin, which conveyed ceremoniously to the old man's house, would there be deposited to await the hour of dissolution, and the body of the parent whom his son had honoured with the gift. Let none of my readers suppose that I am speaking in jest. To such an extreme pitch has the notion of honouring ancestors with due mortuary rites been carried in China, that an affectionate parent would regard children who should present him with a cool and comfortable coffin as having begun in good time to display the duty and respect which every well-regulated son and daughter is expected to bestow.

The superstitious influences, such as I have described, rendered me a frequent object of mistrust, and led to my being stoned and roughly handled on more occasions than one. It is, however, in and about large cities that the widespread hatred of foreigners is most conspicuously displayed. In many of the country districts, and from officials who have been associated with Europeans, and who therefore appreciate the substantial benefits which foreign intercourse can confer, I have met with numerous tokens of kindness, and a hospitality as genuine as could be shown to a stranger in any part of the world.

It is a novel experiment to attempt to illustrate a book of travels with photographs, a few years back so perishable, and so difficult to reproduce. But the art is now so far advanced, that we can multiply the copies with the same facility, and print them with the same materials as in the case of woodcuts or engravings. I feel somewhat sanguine about the success of the undertaking, and I hope to see the process which I have thus applied adopted by other travellers; for the faithfulness of such pictures affords the nearest approach that can be made towards placing the reader actually before the scene which is represented.

. . . .

William Henry Jackson

Diaries
1874
AN EXCERPT

In 1870, William Henry Jackson (1843–1942) accompanied the Hayden geological survey out West. A canyon was named after Jackson, and in 1871 he made the first photographs of Yellowstone, which Congress soon decreed a national park, largely because of Jackson's photographs. (Thomas Moran, the famous landscape painter, also went on this expedition.) In seven expeditions with Hayden, Jackson produced over 800 negatives. Twelve were the largest photographs ever taken in the field (20 by 24 inches), difficult both to carry and develop in the mountain wilderness. Jackson photographed in the Rockies, the Tetons, and other parts of the West where one had to be almost as much explorer as photographer.

. . . .

FRIDAY 21ST. Were on hand early at the Agency and set up tent in the Stocks for ox shoeing. It was ration day, and the Indians were to draw beef, sugar, etc. All the village would come up and we expected great times, and much rich material. As they were slow in coming up and would not be on hand before 11 o'clock or noon, commenced operations on some teepees nearby securing half a doz. negs. Some ponies came under my *Instrument*, & got good pictures. Then by a little sharp

practice we got a capital negative of Peah's pappoose. Tried to get the squaw too, but failed as Peah came & took her away. Tried then to get a group from the Agency porch, but Peah and some half dozen others came up, protesting vehemently, taking hold of the camera and preventing me from either focussing or making an exposure. Peah kept on exclaiming that the Indians *no sabe* picture, making all Indians *heap sick*, tapping his head at the time. Would listen to no explanation whatever, but reiterated his assertion, That it make Indian heap sick, all die, pony die, pappoose die. His idea seemed to be that no harm would result from making a picture from one Indian, or two or three more together, but I must not attempt their village, their squaws or pappooses. Defeated in that quarter—for they were persistent, & stood all around watching closely—we went over to the cook house, taking the camera inside the door and intending to get groups outside. Just as I was ready to expose, an Indian rode up on horseback & tried to spur his horse into the doorway & failing in that wheeled himself across it & throwing his blanket over his arm, placed it so that he completely covered the doorway. There was no fooling about him either, and he was well backed up by half a dozen others who seemed to wait upon his movements. Gave it up then, for the usual afternoon storm was coming up and the sky was overcast with dark clouds. For the rest of the P.M. watched the Indians drawing their rations, & a lively bustling scene it was. Squaws, nearly all with pappooses settled about in a semi circle and taking their turn drawing sugar, etc. The beef is drawn by apportioning one steer to every six lodges for 10 days. The Indians are drawn up in a line, the cattle turned loose, and then they chase them down with pistol & rifle, as in a buffalo hunt. The scene was very picturesque and somewhat exciting. Indians were scattered all over the valley, groups of 8 or 10 after each beef and popping away until brought down. Some were too tame to run much and were easily dispatched. Others more wild gave them a lively chase, and scattered away a mile or two from the post. The sight was a fine one could it only be caught in the camera, but 'twas no use, it was beyond us.
. . . .

William Henry Jackson

Time Exposure
1940

AN EXCERPT

Late the next afternoon we had our first close view of the enchanted land, when our party came upon the Mammoth Hot Springs. We were, so far as records show, the first white men ever to see those bubbling caldrons of nature, and I found myself excited by the knowledge that next day I was to photograph them for the first time.

I was peculiarly fortunate that first day. The subject matter close at hand was so rich and abundant that it was necessary to move my dark box only three or four times. My invariable practice was to keep it in the shade, then, after carefully focussing my camera, return to the box, sensitize a plate, hurry back to the camera while it was still moist, slip the plate into position, and make the exposure. Next step was to return to the dark box and immediately develop the plate. Then I would go through the entire process once more from a new position. Under average conditions a "round trip" might use up three-quarters of an hour. At Mammoth Springs, however, there was so little shifting to do that I was able to cut the average time to less than fifteen minutes. Another thing that helped was the hot water at our finger tips. By washing the plates in water that issued from the springs at 160° Fahrenheit, we were able to cut the drying time more than half.

But soon the inevitable compensation occurred. After going up the Yellowstone as far as Baronet's Bridge, we proceeded to Tower

Creek. At the point where that stream drops into the gorge the view is magnificent—but recording it on a glass plate from the bed beneath turned out to be my biggest photographic problem of the year. Clambering down, and even up, the steep sides of the canyon was not an insuperable task. Neither was moving the camera over the same precipitous route. But getting the heavy dark box within working distance was a stickler. In fact, in the absence of mechanical aid, it couldn't be done.

Since the mountain could not be brought to Mohammed, another method had to be worked out, and finally I solved the situation. After setting up and focussing my camera at the bottom of the gorge, I would prepare a plate, back the holder with wet blotting paper, then slip and slide and tumble down to my camera and make the exposure. After taking my picture, I had to climb to the top carrying the exposed plate wrapped up in a moist towel. With Dixon to help, cleaning and washing the plates, I succeeded in repeating the procedure four or five times. The end of the day found us exhausted but very proud; and we had reason to be pleased with ourselves, for not a single one of our plates had dried out before being developed.

Pictorially the climax of the expedition came with our week's stay at the Falls and Grand Canyon of the Yellowstone. There were four of our party making pictures, the two painters, Elliot and Moran, and two photographers. The other photographer was J. Crissman, then of Bozeman, Montana, whom I had met in Utah two summers earlier. Crissman had been taken along as a guest, and since he was a good companion in every sense, he had made himself fully welcome. A little later I was able to return the courtesies he had shown me in Corinne, where he let me use his dark room. When his own camera was blown over into a canyon and destroyed I turned over my old 6½ x 8½ to him for the rest of the trip.

So far as I am concerned, the great picture of the 1871 expedition was no photograph, but a painting by Moran of Yellowstone Falls, which hangs, or used to hang, in the Capitol in Washington. It captured, more than any other painting I know, the color and the atmosphere of spectacular nature. Unfortunately that particular canvas was so badly neglected—and later, so badly restored—as to lose its original character. But a fine copy, which Moran made some years afterward, may still be seen in the National Gallery. . . .

Moran became greatly interested in photography, and it was my good fortune to have him at my side during all that season to help me solve many problems of composition. While learning a little from me, he was constantly putting in far more than he took out.

Meanwhile, of course, Hayden and the others were out doing their work. Pictures were essential to the fulfillment of the doctor's plan for publicizing this Survey; but the basic purpose was always exploration. I cannot be too careful in emphasizing the fact that in this and all the following expeditions I was seldom more than a sideshow in a great circus. . . .

From the far end or "thumb" of the lake we visited all the near-by hot springs and mud puffs, and all my daylight hours were filled with picture-taking. But one day my turn came to do some exploring on my own account, into the Firehole country to the west of our camp. Somewhere beyond rose the Madison River, and we wanted general information about the country thereabout. I was rewarded by the discovery of a new basin of geyser cones and caught one of them in eruption.

We were now prepared to return to our base, and we left the lake by way of Pelican Creek and crossed over to the East Fork of the Yellowstone. At Soda Butte we laid over one day, while I completed my first series of hot-spring pictures, and then the party made its way back to Botelers' Ranch by the same route we had followed on our ascent. We had spent exactly forty days in the Yellowstone. . . .

Within the next few months I was to begin to taste that little fame which comes to every man who succeeds in doing a thing before someone else. Besides myself there had been two other photographers in the Yellowstone that season. One of them was Crissman, whose pictures never passed the confines of a purely local market. The second man was the expert T. J. Hine of Chicago, who had been attached to the Barlow-Heap party. Hine got back to Chicago just in time to have every single negative destroyed in the terrible fire of 1871. And so the fact that my pictures were the only ones to be published that year is something for which I have to thank Mrs. O'Leary's cow.

Barbara Novak

"Landscape Permuted: From Painting to Photography" 1975

By the middle of the nineteeth century, both the romantic and the realistic attitudes toward landscape were changing the character of American landscape painting. The lens was trained on the wilderness at precisely the right moment. A newly reverent attitude toward landscape coincided with the opening up of the West through exploration, and also with the advance in glass-plate photography which made it possible to reproduce photographs made out of doors for publication and sale. Barbara Novak, a scholar of nineteenth-century art, discusses the early photography of the West in the context of contemporary attitudes toward nature as voiced by such men as Emerson, Thoreau, and Agassiz.

No study of nature attitudes in 19th-century America can be adequate without considering their late rehearsal in a new medium. Landscape photography extended further the early impulse to capture "undefiled nature." As might be expected, this was accomplished in the "virgin land" of the West by photographers hot on the heels of the illustrators and artists who had accompanied the earliest expeditions. At a moment when the desire to commune with nature had matured to the point of mellowing, the photographers injected it with a fresh quota of reality

and fact, informed on the one hand by a sensitivity to geological science, and on the other by an authentic understanding of the spiritual resonance which, in America, was inseparable from natural fact. They emerged with some of the most compelling landscape images of the 19th century.

Many of these were presented recently at the Albright Knox Gallery and the Metropolitan Museum of Art in "Era of Exploration: The Rise of Landscape Photography in the American West, 1860–1885," a major contribution to our understanding of the history of photography in this country. It made visible the extraordinary qualities of these early photographers, and just as important, invited us to compare them to the immensely prolific landscape oeuvre of the American 19th century. If 19th-century visual culture at large was enriched by an American achievement, it was surely in that area.

The exhibition instructed us on the particular situation of the photographer working on the spot, *a la prima*, as it were, as distinct from the more studied process in time that absorbed the painters. It indicated the dialogue of conventions between both media, and brought us into an area where landscape photography and landscape painting have been converging with each other and with the larger field of American studies. Here, the exhibition, and especially the catalogue (written by Weston Naef and James Wood, with an essay by Therese Thau Heyman) is a pioneering event. The nature attitudes that dominated this period, and the one immediately preceding it, are examined. These attitudes joined art, science and religion in a common cause: recording nature to recover from it meanings which illuminate the culture at large; and through facts, to discover the "end and issue of spirit."

Scholars delimit the main activity of landscape painting in America from about 1830 to 1865. If we consider landscape photography from the early 1860s to 1880, it is clear that the photographers extended the vitality of a tradition beginning to wane by the Civil War. The units of time we are dealing with are quite narrow. Church's masterpiece, *Niagara*, dates from 1857, his *Heart of the Andes* from 1859. Bierstadt's reputation rested for years on his *Rocky Mountains* of 1863. Lane offered luminist masterpieces until his death in 1865, while Heade's best luminist contributions were still issuing strong in the late 1860s. Moran's important paintings of Yellowstone date from the early 1870s.

Moran's works, to my mind, represent the end point of a tradition, even in color resembling an overripe fruit. They could be said to issue the last wail of the "old sublime." W. H. Jackson's direct photographs

of Yellowstone, by contrast, expose in Moran an affectation of manner we would prefer not to find, just as Watkins and Muybridge expose the coloristic and painterly stylizations of Bierstadt at Yosemite. Thomas Cole, earlier, had been right when he claimed that one advantage of the daguerreotype was that it would reveal the painters of "false views."

The masses of mountains and rocks, the sharpness of foreground detail and clarity of space in many of these photographs are paralleled only by a few luminist images and some aspects of Church's works in South America, in which detail and effect are sharply articulated. Even more than with pictorial luminism, the camera eye maintains an anonymity; stroke does not intercept image, nor is it superimposed upon it.

The photograph, by definition, replaces the artist's hand with the so-called pencil of nature. For the camera operates not only as a mechanical device but as a medium for Mind, which could serve as an instrument of the photographer's intention. For those of us trained on paintings, the never-touched surface of the photograph is elusively impersonal; its smooth tonality baffles our usual anxious readings. The image has a factual lucidity that holds the surface. This instrument, with its new "truth," in many ways fulfilled a mid-19th-century injunction against "manner." Subject to the same proscriptions as painting, narrowly bounded on the one side by manner and on the other by the "merely mechanical," photography complied with the necessities of contemporary esthetics even as it transformed them.

This transformation took place well within the context of contemporary nature attitudes. The photographs often utilize familiar structural modes designed by the painters to convey large ideas about nature, God and time that concerned them. We can recognize the more conventional "view" derived from Claude and carrying connotations of the pastoral ideal in some of Watkins's photographs. In *Three Brothers, 4,480 Ft., Yosemite*, the stock Claudian components are literally mimicked by the composition: the trees framing the lateral edges, the water in the foreground, the mountain looming in the distance. The Claudian conventions were used so frequently by the painters that they are among the most durable clichés of the period. The compositional stamp of the "pastorale" carried with it an elegiac sense of Eden, and on this tired reference viewers could heap a burden of meaning which had to do with American nature as a garden, with ideal nature as a locus between wilderness and culture that could accommodate man's intrusion.

The photographs often recharge the cliché with some of its original conviction. With discreet spatial modifications, the Claudian stamp (via

Turner) carried some of the awesome connotations of the 18th-century sublime. Church's South American spaces have a natural counterpart in the American West. The vantage points assumed by the camera emphasize Whitman's "sublime" statistics.[1] Church's paintings were Humboldtean syntheses, compositions reflectively put together in the studio after the fact. The photographs represent the single choice of a site that would convey the same synthetic meaning Humboldt had stressed in *Cosmos:* "the grandeur and vast expanse of nature, revealing to the soul, by a mysterious inspiration, the existence of laws that regulate the forces of the universe."[2] To make viewers sense that, Watkins, with scores of images like *View of the Yosemite Valley from Mariposa Trail*, literally transported the observing eye to the tops of the mountains.

Yet on the whole, these Western photographs hush their scenes with a quietude that is hardly rhetorical. Frequently they register a gentler insight that sounds the profoundest nature feeling of the age. In painting, the "new sublime" (as I have called it elsewhere),[3] can be fathomed in the luminist canvases of Lane, Heade, Kensett, Gifford, and sometimes less typically in those of Church, Bierstadt and other figures. Luminist conventions of classic structure contribute to a quietistic mood in the works of all the photographers represented here: Watkins, Russell, O'Sullivan, Muybridge and Jackson. . . .

Often in the luminist photographs, reflections dominate. In Muybridge's *Kee-Koo-Too-Yem (Water Asleep) Mirror Lake, Valley of the Yosemite*, the reflection occupies about three-fourths of the surface image, assuming a tangibility that recalls the Swedenborgian world of correspondences that so dominated the mid-century. We are dealing here with Thoreau's forest mirror:

> Sky water . . . a mirror which no stone can crack, whose quicksilver will never wear off, whose gilding Nature continually repairs; no storms, no dust, can dim its surface ever

1. *I've appropriated the idea of sublime statistics from Whitman, who used it specifically in reference to the Western prairies in* Specimen Days, *when he suggested "Even their simplest statistics are sublime."* (The Portable Walt Whitman, New York, 1974, p. 575.) *I use it here to refer to the vastness of Western space in general.*

2. *Alexander Von Humboldt,* Cosmos: A Sketch of a Physical Description of the Universe, New York, 1850, Vol. I, p. 25.

3. *I have contrasted the idea of a quietistic or new sublime, which manifested itself in the mid-19th century, with the more awesome sublime which derived from the 18th century in "American Landscape, Changing Concepts of the Sublime,"* The American Art Journal, *Spring 1972, pp. 36–42. Whitman's sublime, quoted above, may be read as a reference to the new sublime.*

fresh—a mirror in which all impurity presented to it sinks, swept and dusted by the sun's hazy brush—this the light dust-cloth—which retains no breath that is breathed on it, but sends its own to float as clouds high above its surface, and be reflected in its bosom still.[4]

On these glistening surfaces, the visible world, transcended, could become Emerson's "dial plate of the invisible."[5] The period, which found a basic moral virtue in the nature experience, could recognize the literal embodiment here of his famous comment: "the laws of moral nature answer to those of matter as face to face in a glass."[6]

Emerson had also seen man's "own beautiful nature" in the tranquil landscape, especially in the distant line of the horizon. The luminist image countered the indulgent sentimentalism of the age with a spare classicism that offered the tranquil landscape as physical evidence of Swedenborg's contention that God is order, or Thoreau's that "all nature is classic and akin to art."[7] The calm structures of the luminist photographs (Watkins's *Castle Rock, Columbia River, Oregon,* Jackson's *View on The Sweetwater (Wyoming),* or O'Sullivan's *Alkaline Lake, Carson Desert, (Nevada)* fortify silence. Thoreau had commented that "silence is best adapted to the acoustics of space."[8] Those acoustics were there in abundance in the western landscape.

I've stressed painterly parallels here only to show how much the photographers were part of an integral vision, not to detract from their art, or to imply that they worked only through already established schemata. Quite the contrary. If they revitalized a waning landscape tradition, they brought to its deeply felt attitudes toward nature, God and science the tempering of properties intrinsic to their medium.

One of these was a pragmatism that disrupted received pictorial codes. Nowhere is the 19th-century conflict between the conventional and the empirical more sharply joined than here, in the *frisson* generated by a new medium as it enters a relatively new landscape. We could talk of occasional painterly counterparts: Durand's remarkable "happened upon" nature studies of the mid-1850s. But their spontaneity seems more exceptional in painting, while it is common in photography.

4. *Henry David Thoreau,* Walden, *New York, 1953, p. 129.*

5. *Alfred Kazin and Daniel Aaron, eds.,* Emerson: A Modern Anthology, *Boston, 1958, p. 110.*

6. Ibid.

7. *Carl Bode, ed.,* The Selected Journals of Henry David Thoreau, *New York, 1967, p. 81.*

8. Bradford Torrey and Francis H. Allen, eds., The Journal of Henry D. Thoreau, *New York, 1962, Vol. I., p. 62.*

These landscape photographs raise the problem of how it is they can urge on us the context of ideas that gave the old conventions their authority while moving away from those conventions.

It is our conceit to see some of these photographs as "modern," to respond instinctively to the inspired casualness that fixes natural data with such powerful simplicity. In doing this we may be retroactively substituting some of the habits of our own era. To some degree it would be proper to see these photographs as pioneering exercises in the establishment of new modes, urgently discovered in the empirical heat of perceiving a strange territory. Sometimes, however, nature itself donates the form of the photograph, the task of which is now to record as exactly as it can—to isolate the subject with each detail apprehended, the scale occasionally measured by a standing figure.

The photographer who most fully confirms this reading is Timothy O'Sullivan; he produced whole series of photographs for which we can find no parallels in the painting of his time. They seem to arise without the intervention of ideas about "art," from a one-to-one encounter of camera and nature. The artist's control, though convention-free, is of course present, but often in the most informal way, as if the photographs were taking themselves. A theme declares itself here. O'Sullivan turned geological striations into abstractions which convey a time component not so much derived from conceptual association as it is implicit: *Rock Carved by Drifting Sand, Below Fortification Rock, Arizona*, or *Ancient Ruins in the Canyon de Chelle, New Mexico*. The six exposures of *Green River, Colorado* isolate time with a precision that, in 1872, precedes Monet. The changes of light modulate and alter the landscape, surveying its basic forms and harvesting a rich variety of moods from a single subject. O'Sullivan's curiosity here is unusual both in its degree and quality. Some images speak for more than their subject, and he must have been conscious of this. What was he looking for? Perhaps *Vermillion Creek Canyon, Utah* gives us as much of an answer as we are likely to get. The subject is almost unrecognizable, as the sky becomes a positive space biting into the silhouettes below. Presented here is not a locale so much as an idea, perhaps an abstract one, forced into a new meaning by the intersection of structure and expression.

The photographs in this exhibition, even more than the rhetorical paintings of Moran and Bierstadt, embody the exploratory energies that vitalized the Western expeditions. They were the issue of pragmatism and an idealism so intrinsic to the culture that it was an unconscious part of the equipment of the photographers who perceived these wonders. Landscape photography rarely had this rich matrix of technical, spiritual and perceptual resources informing its exertions. Artists

and photographers accompanied these expeditions to assist science, to record, to register images of a nature that was virgin to most American eyes. By documenting the unknown, they were making it readable, intelligible—above all, usable. But there was, I feel, another impulse, closer to their deepest feelings, and very much a part of their cultural context: a tropism toward the silence and solitude that characterized the first moment of encounter with primal nature, an encounter that carried the promise of spiritual renewal. The world's "serene order . . . inviolable by us" was, as Emerson put it, "the present expositor of the divine mind."[9] Emerson's wise silence, like Eckhart's central silence, was the vehicle through which God might enter. Clarence King, who conducted the geological survey that included O'Sullivan as photographer, found on Mount Tyndall:

> a silence which gratefully contrasting with the surrounding tumult of form conveyed to me a new sentiment . . . there is around these summits the soundlessness of a vacuum. The sea stillness is that of sleep . . . the desert of death, this silence is like the waveless calm of space.[10]

King's commitment, as a geologist, to catastrophism was really a conservative one in that Darwinian age.[11] Uniformitarianism had been the enlightened geological attitude at least since the advent of Lyell. And Lyell, in 1830, with his *Principles of Geology*, had altered the concept of the earth's age as violently as the atom altered our concept of its structure. Lyell managed to change the idea of the earth's age from the Biblical 6,000 years to millions, thereby fortifying with scientific "truth" all the romantic yearnings for the primordial that had been developing among artists and writers since the late 18th century. But though Biblical truths were challenged in this pre-Darwinian period,

9. *Kazin and Aaron, p. 130.*
10. *Clarence King,* Mountaineering in the Sierra Nevada, *Boston, 1872, p. 80.*
11. *The catalogue essay, p. 57, notes that King "would now be considered very conservative scientifically, compared to a Darwinian like Harvard's Asa Gray, but in his time King's words and deeds had the ring of progress." I would tend to disagree with this. Although the conservatives were anti-Darwinian, most of them seem to have at least accepted Uniformitarianism over Catastrophism, so that even to them, King must have sounded a bit behind the times. Though the problem is complicated by our present understanding of what is, and is not, progress, William H. Goetzmann, in* Exploration & Empire, *(New York, 1966) would seem to have a truer grasp of the way King's colleagues received his catastrophism speech to the class of 1877 of the Sheffield Scientific School: "It appeared that in the heightened emotion of a June afternoon's commencement, King, a humanist at heart, had overreached himself," and "King's brave sally was for the most part greeted by his scientific friends with embarrassment, though Henry Adams came to base much of his philosophy of history upon it." (p. 465)*

the idea of God as nature and God in nature remained firm. The painters, all during the time that an American landscape art was developing, were acutely aware of geological time, which they eagerly converted back into spiritual and religious currency.

It really comes as no surprise then, that the main intellectual commitment, on the part of Emerson, Thoreau, the artists and the photographers, seems to have been to Darwin's arch-rival and antagonist, Louis Agassiz. For Agassiz had restated the importance of Mind, always crucial to the mid-19th century, and his idea of the world created by a thought in the mind of God was much more compatible with the prevailing belief that science, like art, would be a route to God.

Even Darwin, I am quite sure, didn't mean to strike the hammer blow to religion that followed the publication of *The Origin of the Species* in 1859. The two decades after *Origin*, exactly those in which the photographers undertook to document God's still undefiled nature, desperately sought to reconcile science and religion. Church had on his bookshelves at Olana books such as John Fiske's *The Idea of God as Affected by Modern Knowledge*, written as late as 1892, in which the author claimed: "Although it was the Darwinian theory of natural selection which overthrew the argument for design, . . . when thoroughly understood it will be found to replace as much teleology as it destroys . . ." [12]

This reference to design, still alive in the minds of many so long after William Paley's *Natural Theology* (1802) had popularized the concept that "there is no design without a designer," is an indication of the powerful tenacity with which such ideas survived in 19th-century America. The photographs, presumably scientific in intent, registered geological effects. But those effects were somehow transmuted by the photographers into larger ideas which, through awe, silence, solitude and infinite time, summoned the universal Mind that obsessed the age.

We tend to identify many of these ideas more readily with New England Transcendentalism. Yet it is important to recognize them in the West, where the possibility of that primal encounter motivated artists, photographers and scientists alike. Underneath it all, they seem to have been searching, like de Tocqueville, for

> those rare moments in life when physical well-being prepares
> the way for calm of soul, and the universe seems before your
> eyes to have reached a perfect equilibrium; then the soul, half

12. *John Fiske*, The Idea of God as Affected by Modern Knowledge, *New York, 1892, p. 158.*

asleep, hovers between the present and the future, between the real and the possible, while with natural beauty all around and the air tranquil and mild, at peace with himself in the midst of universal peace, man listens to the even beating of his arteries that seems to him to mark the passage of time flowing drop by drop through eternity.[13]

13. *Alexis de Tocqueville*, Journey to America, *Garden City, 1971, p. 398.*

Julia Margaret Cameron

"Annals of My Glass House" 1874

Julia Margaret Cameron (1815–1879) took up photography in middle age. She dated her first successful portrait 1864; after that she pursued the great, such as Tennyson, Darwin, Browning, relentlessly, and sometimes the not-so-great as well. Preferring a broad effect, she used large lenses, which were incapable of sharp focus, even ordering them specially made to give poor definition, a richly atmospheric light, and few details. She said she wished to picture the sitter's soul, and so reverent was she before the great men of her day that she likened her photography to a prayer. Her allegorical pictures, highly praised at the time, are today out of favor. This autobiographical account was written in 1874 and first published in the catalogue of her 1889 London exhibition.

Mrs. Cameron's Photography, now ten years old, has passed the age of lisping and stammering and may speak for itself, having travelled over Europe, America and Australia, and met with a welcome which has given it confidence and power. Therefore, I think that the *Annals of My Glass House* will be welcome to the public, and, endeavouring to clothe my little history with light, as with a garment, I feel confident that the truthful account of indefatigable work, with the anecdote of human interest attached to that work, will add in some measure to its value.

That details strictly personal and touching the affections should be avoided, is a truth one's own instinct would suggest, and noble are the teachings of one whose word has become a text to the nations—

> *Be wise; not easily forgiven*
> *Are those, who setting wide the doors that bar*
> *The secret bridal chamber of the heart*
> *Let in the day.* [1]

Therefore it is with effort that I restrain the overflow of my heart and simply state that my first [camera and] lens was given to me by my cherished departed daughter and her husband, with the words, "It may amuse you, Mother, to try to photograph during your solitude at Freshwater."

The gift from those I loved so tenderly added more and more impulse to my deeply seated love of the beautiful and from the first moment I handled my lens with a tender ardour, and it has become to be as a living thing, with voice and memory and creative vigour. Many and many a week in the year '64 [2] I worked fruitlessly, but not hopelessly—

> *A crowd of hopes*
> *That sought to sow themselves like winged lies*
> *Born out of everything I heard and saw*
> *Fluttered about my senses and my soul.*

I longed to arrest all beauty that came before me, and at length the longing has been satisfied. Its difficulty enhanced the value of the pursuit. I began with no knowledge of the art. I did not know where to place my dark box, how to focus my sitter, and my first picture I effaced to my consternation by rubbing my hand over the filmy side of the glass. It was a portrait of a farmer of Freshwater, who, to my fancy, resembled Bollingbroke. The peasantry of our island are very handsome. From the men, the women, the maidens and the children I have had lovely subjects, as all the patrons of my photography know.

This farmer I paid half-a-crown an hour, and, after many half-crowns and many hours spent in experiments, I got my first picture, and this was the one I effaced when holding it triumphantly to dry.

I turned my coal-house into my dark room, and a glazed fowl house I had given to my children became my glass house! The hens were liberated, I hope and believe not eaten. The profit of my boys

1. *Quotation from Alfred Tennyson's* The Gardener's Daughter.
2. *The date 1864 is a mistake. It was in Dec. 1863 that Mrs. Cameron took up photography.*

upon new laid eggs was stopped, and all hands and hearts sympathised in my new labour, since the society of hens and chickens was soon changed for that of poets, prophets, painters and lovely maidens, who all in turn have immortalized the humble little farm erection.

Having succeeded with one farmer, I next tried two children; my son, Hardinge, being on his Oxford vacation, helped me in the difficulty of focussing. I was half-way through a beautiful picture when a splutter of laughter from one of the children lost me that picture, and less ambitious now, I took one child alone, appealing to her feelings and telling her of the waste of poor Mrs. Cameron's chemicals and strength if she moved. The appeal had its effect, and I now produced a picture which I called "My First Success."

I was in a transport of delight. I ran all over the house to search for gifts for the child. I felt as if she entirely had made the picture. I printed, toned, fixed and framed it, and presented it to her father that same day—size, 11 in. by 9 in.[3]

Sweet, sunny-haired little Annie! No later prize has effaced the memory of this joy, and now that this same Annie is 18, how much I long to meet her and try my master hand upon her.

Having thus made my start, I will not detain my readers with other details of small interest; I only had to work on and to reap a rich reward.

I believe that what my youngest boy, Henry Herschel, who is now himself a very remarkable photographer, told me is quite true— that my first successes in my out-of-focus pictures were a fluke. That is to say, that when focussing and coming to something which, to my eye, was very beautiful, I stopped there instead of screwing on the lens to the more definite focus which all other photographers insist upon.

I exhibited as early as May '65.[4] I sent some photographs to Scotland[5]—a head of Henry Taylor, with the light illuminating the countenance in a way that cannot be described; a Raphaelesque Madonna, called "La Madonna Aspettante." These photographs still exist, and I think they cannot be surpassed.[6] They did not receive the prize. The picture that did receive the prize, called "Brenda," clearly proved to

3. *The size refers to the plate only. The actual print, which is reproduced on page 87, measures 5½ x 7½ in.*

4. *A slip of memory. Mrs. Cameron exhibited as early as May, 1864, at the 10th exhibition of the Photographic Society.*

5. *Exhibition of the Edinburgh Photographic Society.*

6. *Both in the Gernsheim Collection, but unsuccessful pictures from the technical as well as pictorial point of view.*

me that detail of table-cover, chair and crinoline skirt were essential to the judges of the art, which was then in its infancy. Since that miserable specimen, the author of "Brenda"[7] has so greatly improved that I am content to compete with him and content that those who value fidelity and manipulation should find me still behind him. Artists, however, immediately crowned me with laurels, and though "Fame" is pronounced "The last infirmity of noble minds," I must confess that when those whose judgment I revered have valued and praised my works, "my heart has leapt up like a rainbow in the sky," and I have renewed all my zeal.

The Photographic Society of London in their *Journal* would have dispirited me very much had I not valued that criticism at its worth. It was unsparing and too manifestly unjust for me to attend to it.[8] The more lenient and discerning judges gave me large space upon their walls which seemed to invite the irony and spleen of the printed notice.

To Germany I next sent my photographs. Berlin, the very home of photographic art,[9] gave me the first year a bronze medal, the succeeding year a gold medal, and one English institution—the Hartly Institution—awarded me a silver medal, taking, I hope, a home interest in the success of one whose home was so near to Southampton.

Personal sympathy has helped me on very much. My husband from first to last has watched every picture with delight, and it is my daily habit to run to him with every glass upon which a fresh glory is newly stamped, and to listen to his enthusiastic applause. This habit of running into the dining-room with my wet pictures has stained an immense quantity of table linen with nitrate of silver, indelible stains, that I should have been banished from any less indulgent household.

Our chief friend, Sir Henry Taylor, lent himself greatly to my early efforts. Regardless of the possible dread that sitting to my fancy might be making a fool of himself, he, with greatness which belongs to unselfish affection, consented to be in turn Friar Laurence with Juliet, Prospero with Miranda, Ahasuerus with Queen Esther, to hold my poker as his sceptre, and do whatever I desired of him. With this great good friend was it true that so utterly

> *The chord of self with trembling*
> *Passed like music out of sight.*

7. *The author of "Brenda" was Henry Peach Robinson.*
8. *The criticisms voiced in* The Photographic Journal *in August, 1864, and again in February and May, 1865, have been quoted.*
9. *Quite incorrect. London and Paris were the leading centers of photography.*

and not only were my pictures secured for me, but entirely out of the Prospero and Miranda picture sprung a marriage[10] which has, I hope, cemented the welfare and well-being of a real King Cophetua who, in the Miranda, saw the prize which has proved a jewel in that monarch's crown. The sight of the picture caused the resolve to be uttered which, after 18 months of constancy, was matured by personal knowledge, then fulfilled, producing one of the prettiest idylls of real life that can be conceived, and, what is of far more importance, a marriage of bliss with children worthy of being photographed, as their mother had been, for their beauty; but it must also be observed that the father was eminently handsome, with a head of the Greek type and fair ruddy Saxon complexion.

Another little maid of my own from early girlhood has been one of the most beautiful and constant of my models,[11] and in every manner of form has her face been reproduced, yet never has it been felt that the grace of the fashion of it has perished. This last autumn her head illustrating the exquisite Maud

> *There has fallen a splendid tear*
> *From the passion flower at the gate.*

is as pure and perfect in outline as were my Madonna studies ten years ago, with ten times added pathos in the expression. The very unusual attributes of her character and complexion of her mind, if I may so call it, deserve mention in due time, and are the wonder of those whose life is blended with ours as intimate friends of the house.

I have been cheered by some very precious letters on my photography, and having the permission of the writers, I will reproduce some of those which will have an interest for all.

An exceedingly kind man from Berlin displayed great zeal, for which I have ever felt grateful to him. Writing in a foreign language, he evidently consulted the dictionary which gives two or three meanings for each word, and in the choice between these two or three the result is very comical. I only wish that I was able to deal with all foreign tongues as felicitously—

> *Mr.* ——— announces to Mrs. Cameron that he received the first half, a Pound Note,[12] and took the Photographies as Mrs. Cameron wishes. He will take the utmost sorrow** to place the pictures were good.

10. *This is the romantic love story of Mary Ryan and (Sir) Henry Cotton.*
11. *Mrs. Cameron here refers to Mary Hillier.*
12. *Doubtless the entrance fee for the exhibition.*

Mr. _____ and the Comitie regret heavily*** that it is now impossible to take the Portfolio the rooms are filled till the least winkle.**** The English Ambassude takes the greatest interest of the placement the Photographies of Mrs. Cameron and Mr. _____ sent his extra ordinarest respects to the celebrated and famous female photographs.—Yours most obedient, etc.

The kindness and delicacy of this letter is self-evident and the mistakes are easily explained—

** Care—which was the word needed—is expressed by "Sorgen" as well as "Sorrow." We invert the sentence and we read—To have the pictures well placed where the light is good.

*** Regret—Heavily, severely, seriously.

**** Winkle—is corner in German.

The exceeding civility with which the letter closes is the courtesy of a German[13] to a lady artist, and from first to last, Germany has done me honour and kindness until, to crown all my happy associations with that country, it has just fallen to my lot to have the privilege of photographing the Crown Prince and Crown Princess of Germany and Prussia.

This German letter had a refinement which permits one to smile *with* the writer, not *at* the writer. Less sympathetic, however, is the laughter which some English letters elicit, of which I give one example—

Miss Lydia Louisa Summerhouse Donkins informs Mrs. Cameron that she wishes to sit to her for her photograph. Miss Lydia Louisa Summerhouse Donkins is a Carriage person, and, therefore, could assure Mrs. Cameron that she would arrive with her dress uncrumpled.

Should Miss Lydia Louisa Summerhouse Donkins be satisfied with her picture, Miss Lydia Louisa Summerhouse Donkins has a friend who is *also* a Carriage person who would *also* wish to have her likeness taken.

I answered Miss Lydia Louisa Summerhouse Donkins that Mrs. Cameron, not being a professional photographer, regretted she was not able to "take her likeness," but that had Mrs. Cameron been able to do so she would have very much preferred having her dress crumpled.

13. *Dr. Wilhelm Hermann Vogel, Professor of Photography at the Institute of Technology (Technische Hochschule), Berlin, was at the time Germany's leading writer on photography and editor of* Photographische Mitteilungen.

A little art teaching seemed a kindness, but I have more than once regretted that I could not produce the likeness of this individual with her letter affixed thereto.

This was when I was at L.H.H.,[14] to which place I had moved my camera for the sake of taking the great Carlyle.

When I have had such men before my camera my whole soul has endeavoured to do its duty towards them in recording faithfully the greatness of the inner as well as the features of the outer man.

The photograph thus taken has been almost the embodiment of a prayer. Most devoutly was this feeling present to me when I photographed my illustrious and revered as well as beloved friend, Sir John Herschel. He was to me as a Teacher and High Priest. From my earliest girlhood I had loved and honoured him, and it was after a friendship of 31 years' duration that the high task of giving his portrait to the nation was allotted to me.[15] He had corresponded with me when the art was in its first infancy in the days of Talbot-type and auto-type.[16] I was then residing in Calcutta, and scientific discoveries sent to that then benighted land were water to the parched lips of the starved, to say nothing of the blessing of friendship so faithfully evinced.

When I returned to England the friendship was naturally re-newed. I had already been made godmother to one of his daughters, and he consented to become godfather to my youngest son. A memo-rable day it was when my infant's three sponsors stood before the font, not acting by proxy, but all moved by real affection to me and to my husband to come in person, and surely Poetry, Philosophy and Beauty were never more fitly represented than when Sir John Herschel, Henry Taylor and my own sister, Virginia Somers, were encircled round the little font of the Mortlake Church.

When I began to photograph I sent my first triumphs to this revered friend, and his hurrahs for my success I here give. The date is 25th September 1866—

My dear Mrs. Cameron—
This last batch of your photographs is indeed wonderful, and wonderful in two distinct lines of perfection. That head of

14. *L.H.H. stands for Little Holland House.*

15. *Mrs. Cameron met Herschel at the same time as her future husband at the Cape of Good Hope, South Africa, where Herschel had established an observatory to survey the sky of the Southern Hemisphere in 1834.*

16. *Mrs. Cameron means daguerreotype. The carbon process of Sir Joseph Wilson Swan was not introduced until 1866 by the Autotype Company.*

the "Mountain Nymph, Sweet Liberty" (a little *farouche* and *égarée*, by the way, as if first let loose and half afraid that it was too good), is really a most astonishing piece of high relief. She is absolutely alive and thrusting out her head from the paper into the air. This is your own special style. The other of "Summer Days" is in the other manner—quite different, but very beautiful, and the grouping perfect. "Proserpine" is awful. If ever she was "herself the fairest flower" her "cropping" by "Gloomy Dis" has thrown the deep shadows of Hades into not only the colour, but the whole cast and expression of her features. "Christabel" is a little too indistinct to my mind, but a fine head. The large profile is admirable, and altogether you seem resolved to out-do yourself on every fresh effort.

This was encouragement eno' for me to feel myself held worthy to take this noble head of my great Master myself, but three years I had to wait patiently and longingly before the opportunity could offer.[17]

Meanwhile I took another immortal head, that of Alfred Tennyson, and the result was that profile portrait which he himself designates as the "Dirty Monk." It is a fit representation of Isaiah or of Jeremiah, and Henry Taylor said the picture was as fine as Alfred Tennyson's finest poem. The Laureate has since said of it that he likes it better than any photograph that has been taken of him *except* one by Mayall,[18] that "*except*" speaks for itself. The comparison seems too comical. It is rather like comparing one of Madame Tussaud's waxwork heads to one of Woolner's ideal heroic busts. At this same time Mr. Watts gave me such encouragement that I felt as if I had wings to fly with.

17. *The three years is reckoned not from the date of the letter, but from Mrs. Cameron's "first success' in photography in 1864.*

18. *There exists a photograph of Tennyson bearing the following autograph inscription: "I prefer the Dirty Monk to the others of me. A Tennyson." And as if by an afterthought he added "except one by Mayall."*

The Photographic News
1889

The earliest photographs could not capture motion, but by
the time of the Civil War, Oliver Wendell Holmes was study-
ing photographs of men walking to better understand what
was needed in an artificial limb. In 1873, Eadweard Muy-
bridge (1830–1904), a fine landscape photographer, began his
attempts to picture a horse in various stages of running. He
began with a succession of photographs taken with carefully
spaced cameras. The results proved that no one had ever
correctly observed the horse's gait before, and prompted dis-
may and intense discussion over whether it was artistically
truthful, or even convincing, for an artist to copy such a
photograph and paint what the eye could not see. In 1880,
Muybridge projected these pictures in such rapid sequence
that they had the effect of a motion picture. He took thou-
sands of pictures for his volumes of *Animal Locomotion* and
later, The *Human Figure in Motion*.

Mr. Muybridge's photographs are, perhaps, rather of indirect impor-
tance to the artist, as showing him what actually takes place, than as a
direct means of assisting him to represent what the eye sees. The eye
certainly does not see an instantaneous phase, such as is shown by one

of Mr. Muybridge's photographs, but it sees a resultant of many motions, and it is this resultant which the artist generally aims at reproducing.

The [London] *Globe* sums up the case as follows:—"Scientifically the inquiry is most interesting, but though Mr. Muybridge's labour has been watched with much attention . . . we doubt whether the contribution to art will be of much importance. Art for the purpose of representation does not require to give to the eye more than the eye can see; and when Mr. Sturgess gives us a picture of a close finish for the Gold Cup, we do not want Mr. Muybridge to tell us that no horses ever strode in the fashion shown in the picture. It may indeed be fairly contended that the incorrect position (according to science) is the correct position (according to art). Nor is this a paradox; for only extremists contend that art must discard every other consideration in an endeavor to represent merely the True."

Peter Henry Emerson

Naturalistic Photography 1889

AN EXCERPT

Peter Henry Emerson (1856–1936), an American who lived and photographed in England, was a forceful advocate of the notion that photography is a fine art. His interest in science (he was trained as a doctor) led him to base his theory of art on Hermann von Helmholtz's *Physiological Optics*. In 1886 Emerson declared that the finest art was based on representations that approximated the way the human eye saw. *Naturalistic Photography*, in 1889, spelled out his theory and his passionate opposition to H. P. Robinson and O. G. Rejlander's sentimental "art-pictures." Emerson contended that the eye focussed clearly only on a central field and that photographers should imitate this limitation by putting their lenses slightly out of focus. A great hubbub ensued. Even his admirers misunderstood, and the era of fuzzy pictures was ushered in.

. . . .

ART PRINCIPLES DEDUCTED FROM THE DATA CITED

We have shown why the human eye does not see nature exactly as she is, but sees instead a number of signs which represent nature, signs which the eye grows accustomed to, and which from habit we call nature herself. We shall now discuss the relation of pictorial art to nature, and shall show the fallacy of calling the most scientifically perfect images obtained with photographic lenses artistically true. They are not correct, as we have shown, and shall again show, but what is artistically true is really what we have all along advocated; that is that the photographer must so use his technique as to render a true impression of the scene. The great heresy of 'sharpness' has lived so long in photographic circles because firstly the art has been practised by scientists, and secondly by unphilosophical scientists, for all through the lens has been considered purely from the physical point of view, the far more important physiological and psychological stand-points being entirely ignored, so that but one-third of the truth has been hitherto stated.

To begin with, it must be remembered that a picture is a representation on a plane surface of limited area of certain physical facts in the world around us, for abstract ideas cannot be expressed by painting. In all the works in the world the painter, if he has tried to express the unseen or the supernatural, has expressed the unnatural. If he paints a dragon, you find it is a distorted picture of some animal already existing; if he paints a deity, it is but a kind of man after all. No brain can conjure up and set down on paper a monster such as has never existed, or in which there are no parts homologous with some parts of a living or fossil creature. We defy any man to draw a devil, for example, that is totally unlike anything in existence. All so-called imaginative works fall then within the category of the real, for they are in certain parts real because they are all based on realities, even though they may be utterly false to the appearance of reality. By this we mean that an ideal dragon may be based on existing animals; his form may be a mixture of a Cobra, Saurian, and a reptile, as is often the case; so far it may be real, but then the way in which it is painted may be utterly false, for the natural effect of light and atmosphere on the dragon may and probably will be ignored, for there is no such animal to study from. The modern pre-Raphaelites are good examples of painters who painted in this way; they painted details, they imitated the local colour and texture of objects, but for all that their pictures are as false as false

can be, for they neglected those subtleties of light and colour and atmosphere which pervade all nature, and which are as important as form. Children and savages make this same error, they imitate the local colour, not the true colour as modified by light, adjacent colour, and atmosphere. But what the most advanced thinkers of art in all ages have sought for is the rendering of the true impression of nature.

Proceed we now to discuss the component parts of this impression.

When we open our eyes in the morning the first thing we see is light, the result of those all-pervading vibrations of ether. The effects of light on all the objects of nature and on sight have been dealt with in the beginning of this chapter, it only remains, therefore, to deduce our limits from those facts. In the first place, from what has been said in that section it is evident we cannot compete with painting, for we are unable to pitch our pictures in so high a key as the painter does, and how limited is his scale has been shown, but by the aid of pigments he can go higher than we can. It has been shown, too, that it is impossible to have the values correct *throughout* a picture, for that would make the picture too black and untrue in many parts. This fact shows how wrong are those photographers who maintain that every photograph should have a patch of pure white and a patch of pure black, and that all the lighting should be nicely gradated between these two extremes. This idea arose, no doubt, from comparing photography with other incomplete methods of translation, such as line-engraving.

The real point is that the darks of the picture shall be in true relation, and the high lights must take care of themselves. By this means a truer tone is obtained throughout. Now to have these tones in true relation it is of course implied that the local colours must be truly rendered, yellow must not come out black, or blue as white, therefore it is evident that colour-corrected plates are necessary. But such plates are useless when the quantity of silver in the film is little, for the subtleties of delicate tonality are lost, which are not compensated for by gain in local colour, and this is a point the makers of orthochromatic plates must take into consideration. It will be seen now why photographs on uncorrected plates (even when the greatest care and knowledge in using them is exercised) are not, as a rule, perfectly successful, and why the ordinary silver printing-paper is undesirable, for it exaggerates the darkness of the shadows, a fatal error. False tonality destroys the sense of atmosphere, in fact, for the true rendering of atmosphere, a photograph must be relatively true in tone; in other words the relative tones, in shadow and half shadow, must be true. If a picture is of a bright, sunlit subject, brilliancy is of course a necessary quality, and by brilliancy is *not* meant that "sparkle" which so delights

the craftsman. Of course the start of tone is naturally made from less deep shadows, when the picture is brightly lighted, for the black itself reflects light, and all the shadows are filled with reflected light. It will be seen, therefore, that it is of paramount importance that the shadows shall not be too black, that in them shall be light as there always is in nature—more of course in bright pictures, less in low-toned pictures —that therefore the rule of "detail in the shadows" is in a way a good rough-and-ready photographic rule. Yet photographers often stop down their lens and cut off the light, at the same time sharpening the shadows and darkening them, and throwing the picture out of tone. It cannot be too strongly insisted upon that "strength" in a photograph is not to be judged by its so-called "pluck" or "sparkle," but by its subtlety of tone, its truthful relative values in shadow and middle shadow, and its true textures. Photographers have been advised by mistaken craftsmen to spot out the "dotty high lights" of an ill-chosen or badly-rendered subject to give it "breadth." Such a proceeding of course only increases the falsity of the picture, for the high lights, as we have shown, are never high enough in any picture, and if a man is so unwise as to take a picture with "spotty lights," he is only increasing his display of ignorance by lowering the high lights, which are already not high enough. This does not of course apply to the case where a single spot of objectionable white fixes the eye and destroys harmony, but to the general habit of lowering the high lights in a "spotty" photograph. Spotty pictures in art as well as in nature are abominations to a trained eye, and it is for that very reason that such subjects are more common among photographers who are untrained in art matters than in the works of even third-rate painters. The effect of the brightest sunlight in nature, for reasons explained, is to *lessen* contrast, the effect of a sharply-focussed, stopped-down photograph is to increase contrast in the subject and thus falsify the impression. As the tendency of "atmosphere" is to grey all the colours in nature more or less, and of a mist to render all things grey, it follows that "atmosphere" in all cases helps to give breadth by lessening contrast, as it also helps to determine the distance of objects. . . . this aërial "turbidity," by which is meant atmosphere, takes off from the sharpness of outline and detail of the image, and the farther off the object is, the thicker being the intervening layer of atmosphere, the greater is the turbidity *cæteris paribus*, therefore from this fact alone objects in different planes are not and should not be represented equally sharp and well-defined. This is most important to seize—as the prevalent idea among photographers seems to be that all the objects in all the planes *should be sharp at once*, an idea which no artist could or ever did entertain, and which nature at once

proves to be untenable. The atmosphere in the main rules the general appearance of things, for if this turbidity be little, objects look close together, and under certain other conditions are poor in quality.

In addition to tone and atmosphere, the diminished drawing of objects as they recede from us (mathematical perspective) helps to give an idea of distance, but by choosing a suitable lens, which does our drawing correctly, we need not regard this matter of drawing. A minor aid to rendering depth is the illumination of the object, a lateral illumination giving the greatest idea of relief, but the photographer should be guided by no so-called "schemes of lighting," because, for more important reasons, it may be advisable to choose a subject lighted directly by the sun, or silhouetted against the sun. All depends on what is desired to be expressed. For example, an artist may wish to express the sentiment and poetry of a sunset behind a row of trees. Is he to consider the minor matter that there will be little relief, and it is not a good "scheme of lighting?" No, certainly not, otherwise he must forgo the subject. Nature ignores all such laws. The only law is that the lighting must give a relatively true translation of the subject expressed, and that a landscape must not be lighted by two or more suns. In portrait work, even, it must be remembered that the aërial lighting must stand out against the background, for in all rooms there is a certain amount of turbidity between us and distant objects.

The reason we prefer pictures which are not too bright lies in the fact that the eye cannot look long at very bright paintings without tiring. As a physical fact, too, the most delicate modelling and tonality is to be obtained in a medium light. From what has been previously said, it will now be understood that a picture should not be quite sharply focussed in any part, for then it becomes false; it should be made just *as sharp as the eye sees it and no sharper*, for it must be remembered the eye does not see things as sharply as the photographic lens, for the eye has the faults due to dispersion, spherical aberration, astigmatism, aërial turbidity, blind spot, and beyond twenty feet it does not adjust perfectly for the different planes. All these slight imperfections make the eye's visions more imperfect than that of the optician's lens, even when objects in one plane only are sharply focussed, therefore, except in very rare cases . . . the chief point of interest should be slightly—very slightly—out of focus, while all things, out of the plane of the principal object, it is perfectly obvious, from what has been said, should also be slightly out of focus, not to the extent of producing *destruction of structure* or fuzziness, but sufficiently to keep them back and in place. For, as we have been told, "to look at anything means to place the eye in such a position that the image of the object falls on the

small region of perfectly clear vision . . . and . . . whatever we want to see, we look at, and see it accurately; what we do not look at, we do not, as a rule, care for at the moment, and so do not notice how imperfectly we see it." Such is the case, as has been shown, for when we fix our sight on the principal object or *motif* of a picture, binocular vision represents clearly by direct vision only the parts of the picture delineated on the points of sight. The rule in focussing, therefore, should be, focus for the principal object of the picture, but all else must not be sharp; and even that principal object must not be as perfectly sharp as the optical lens will make it. It will be said, but in nature the eye wanders up and down the landscape, and so gathers up the impressions, and all the landscape in turn appears sharp. But a picture is not "all the landscape," it should be seen at a certain distance—the focal length of the lens used, as a rule, and the observer, to look at it thoughtfully, *if it be a picture*, will settle on a principal object, and dwell upon it, and when he tires of this, he will want to gather up *suggestions* of the rest of the picture. If it be a commonplace photograph taken with a wide-angle lens, say, of a stretch of scenery of equal value, as are most photographic landscapes, of course the eye will have nothing to settle thoughtfully upon, and will wander about, and finally go away dissatisfied. But such a photograph is no work of art, and not worthy of discussion here. Hence it is obvious that panoramic effects are not suitable for art, and the angle of view included in a picture should never be large. It might be argued from this, that Pseudo-Impressionists who paint the horse's head and top of a hansom cab are correct, since the eye can only see clearly a very small portion of the field of view at once. We assert, no, for if we look in a casual way at a hansom cab in the streets, we only see *directly* the head of the horse and the top of the cab, yet, indirectly, that is, in the retinal circle around the *fovea centralis* we have far more suggestion and feeling of horse's legs than the eccentricities of the Pseudo-Impressionist school give us, for in that part of the retinal field indirect vision aids us. The field of indirect vision must be *suggested* in a picture, but subordinated. But we shall go into this matter later on, here we only wish to establish our principles on a scientific basis. Afterwards, in treating of art questions, we shall simply give our advice, presuming the student has already studied the scientific data on which that advice is based. All good art has its scientific basis. Sir Thomas Lawrence said, "Painting is a science, and should be pursued as an inquiry into the laws of nature. Why, then, may not landscape painting be considered as a branch of natural philosophy, of which pictures are but experiments?"

Some writers who have never taken the trouble to understand

even these points, have held that we admitted fuzziness in photography. Such persons are labouring under a great misconception; we have nothing whatever to do with any "fuzzy school." Fuzziness, to us, means *destruction of structure*. We do advocate broad suggestions of organic structure, which is a very different thing from destruction, although, there may at times be occasions in which patches of "fuzziness" will help the picture, yet these are rare indeed, and it would be very difficult for any one to show us many such patches in our published plates. We have, then, nothing to do with "fuzziness," unless by the term is meant that broad and ample generalization of detail, so necessary to artistic work. We would remind these writers that it is always fairer to read an author's writings than to read the stupid constructions put upon them by untrained persons.

Peter Henry Emerson

"The Death of Naturalistic Photography" 1891

In 1890, Vero Charles Driffield and Ferdinand Hurter pub-
lished their measurements of "the characteristic curve," a
graph of the relation between exposure and negative density.
Their publication allowed predetermined development times
for every kind of film, but it convinced Emerson that photog-
raphers could not control tonal values to the extent he had
thought they could, and that their art was therefore quite
limited, or not art at all. In 1891 he sent to all the photo-
graphic editors a black-bordered pamphlet titled "The Death
of Naturalistic Photography."

In the following excerpt, the first and third paragraphs are from Nancy
Newhall's book on Emerson, the second is from Peter Turner and
Richard Wood.

The limitations of photography are so great that, though the re-
sults may, and sometimes do give a certain aesthetic pleasure, the
medium must rank the lowest of all arts, *lower than* any graphic art, for
the individuality of the artist is cramped, in short, it can hardly show
itself. Control of the picture is possible to a slight degree . . . But the
all-vital powers of selection and rejection are fatally limited. . . . I once

thought (Hurter and Driffield have taught me differently) that true values could be obtained and that values could be *altered at will by development.* They cannot; therefore to talk of getting values in any subject whatever as you wish and of getting them true to nature is to talk nonsense.

. . . I have, I regret it deeply, compared photographs to great works of art and photographers to great artists. I was rash and thoughtless and my punishment is having to acknowledge it now. . . .

. . . In short, I throw my lot in with those who say that photography is a very limited art. I regret deeply that I have come to this conclusion.

The New York World
Interview with Mathew Brady
by Geo. Alfred Townsend ("Gath")
1891

Mathew B. Brady (1823–1896) began as a painter but soon
learned photography from Samuel Morse. In 1884 he opened
a daguerreotype studio in New York; three years later he
added a branch in Washington, D.C. He photographed most
of the illustrious men of his day, and his work was widely
disseminated through lithographs and engravings in news-
papers and journals. At the outbreak of the Civil War, Brady
determined to record it; Lincoln gave his permission but no
money. Over the course of the war, Brady sent twenty differ-
ent teams into the field. He gave none of his photographers
credit on the photographs. Brady was not the first to take
combat pictures. In 1855 Roger Fenton photographed the
Crimean War, and portraits of soldiers had been taken earlier
still. Brady himself went broke recording this tumultuous
moment in history.

STILL TAKING PICTURES

BRADY, THE GRAND OLD MAN OF AMERICAN PHOTOGRAPHY

HARD AT WORK AT SIXTY-SEVEN

A Man Who Has Photographed More Prominent Men Than Any Other Artist in the Country—Interesting Experiences with Well-known Men of Other Days—Looking "Pleasant"

WASHINGTON, APRIL 10.—"Brady the photographer alive? The man who daguerreotyped Mrs. Alexander Hamilton and Mrs. Madison, Gen. Jackson and Edgar A. Poe, Taylor's Cabinet, and old Booth? Thought he was dead many a year."

No, like a ray of light still travelling toward the vision from some past world or star, Matthew B. Brady (sic) is at the camera still and if he lives eight years longer, will reach the twentieth century and the age of seventy-five. I felt as he turned my head a few weeks ago between his fingers and thumb, still intent upon that which gave him his greatest credit—finding the expression of the inner spirit of a man—that those same digits had lifted the chins and smoothed the hairs of virgin sitters, now grandmothers, the elite of the beauty of their time, and set the heads up or down like another Warwick of the rulers of parties, sects, agitations and the stage. As truly as Audubon, Wagner or Charles Willson Peele (sic), Mr. Brady has been an idealist, a devotee of the talent and biography of his fifty years of career. He sincerely admired the successful, the interesting men and women coming and going, and because he had a higher passion than money, we possess many a face in the pencil of the sun and the tint of the soul thereof which otherwise would have been imbecile in description or fictitious by the perversion of some portrait painter. For the same reason, perhaps, Brady is not rich. He allowed the glory of the civil war to take away the savings and investments of the most successful career in American photography; his Center Park lots fed his operators in Virginia, Tennessee and Louisiana, who were getting the battle-scenes. It is for this reason, perhaps, that he is at work now over the Pennsylvania Railroad ticket office, near the Treasury Department, and only yesterday he took the whole Pauncerote family, to their emphatic satisfaction—minister, wife and daughter—as he took the American Commission officially. His gallery is set around with photographs he has made from his own daguerreo-

types of public people from Polk's administration down, for he was very active in the Mexican War, taking Taylor, Scott, Santa Anna, Quitman and Lopez. I thought as I looked at that white cross of his moustache and goatee and blue spectacles and felt the spirit in him still of the former exquisite and good-liver which had brought so many fastidious people to his studio, that I was like Leigh Hunt taking the hand of old Poet Banker Rogers, who had once shaken hands with Sam Johnson, who had been touched for the king's evil by Queen Anne, and I had almost asked Mr. Brady about Nelly Custis and Lord Cornbury and Capt. John Smith.

"How old are you, Mr. Brady?"

"Never ask that of a lady or a photographer; they are sensitive. I will tell you, for fear you might find it out, that I go back to near 1823–'24, that my birthplace was Warren County, N.Y., in the woods about Lake George, and that my father was an Irishman."

"Not just the zenith-place to drop into art from?"

"Ah! Just there was Saratoga, where I met William Page, the artist, who painted Page's Venus. He took an interest in me and gave me a bundle of his crayons to copy. This was at Albany. Now Page became a pupil of Prof. Morse in New York city, who was then painting portraits at starvation prices in the University rookery on Washington (indecipherable). I was introduced to Morse; he had just come home from Paris and had invented upon the ship the telegraphic alphabet, of which his mind was so full that he could give but little attention to a remarkable discovery one Daguerre, a friend of his, had made in France."

"Was Daguerre Morse's friend?"

"He was. Daguerre had traveled in this country exhibiting dissolving views and Morse had known him. While Morse was abroad Daguerre and Nipes (sic) had after many experiments fixed the picture in sensitive chemicals, but they applied it chiefly or only to copying scenes. Morse, as a portrait painter, thought of it as something to reduce the labor of his portraits. He had a loft in his brother's structure at Nassau and Beekman streets, with a telegraph stretched and an embryo camera also at work. He ordered one of Daguerre's cameras for a Mr. Wolf, and felt an interest in the new science. Prof. John W. Draper and Prof. Doremus counselled me, both eminent chemists. It was Draper who invented the enamelling of a daguerreotype and entered at last into the business, say about 1842–'43. My studio was at the corner of Broadway and Fulton streets, where I remained fifteen years, or till the verge of the civil war. I then moved up Broadway to between White and Franklin, and latterly to Tenth street, maintaining

also a gallery in Washington City. From the first I regarded myself as under obligation to my country to preserve the faces of the historic men and mothers. Better for me perhaps, if I had left out the ornamental and been an ideal craftsman."

"What was the price of daguerreotypes forty-five years ago?"

"Three to five dollars apiece. Improvements not very material were made from time to time, such at the Talbotype and the ambrotype. I think it was not till 1855 that the treatment of glass with collodion brought the photograph to supersede the daguerreotype. I sent to the Hermitage and had Andrew Jackson taken barely in time to save his aged lineaments to posterity. At Fulton street, bearing the name of the great inventor before Morse, I took many a great man and fine lady. Father Matthew, Kossuth, Pack, Case, Webster, Benton and Edgar A. Poe. I had great admiration for Poe, and had William Ross Wallace bring him to my studio. Poe rather shrank from coming, as if he thought it was going to cost him something. Many a poet has had that daguerreotype copied by me. I loved the men of achievement, and went to Boston with a party of my own once to take the Athenian dignitaries, such as Longfellow, whom I missed. In 1850 I had engraved on stone twelve great pictures of mine, all Presidential personages like Scott, Calhoun, Webster and Taylor; they cost me $100 apiece for the stones, and the book sold for $30. John Howard Payne, the author of "Home, Sweet Home," was to have written the letter-press, but Lester did it. In 1851 I exhibited at the great Exhibition of London, the first exhibition of its kind, and took the first prize away from all the world. I also issued the first sheet of photographic engravings of a President and his Cabinet, namely, Gen. Taylor in 1849, I sent this to old James Gordon Bennett and he said, 'Why, man, do Washington and his Cabinet look like that?' Alas! They were dead before my time. I went to Europe in 1851 upon the same ship with Mr. Bennett, wife and son. His wife I often took, but the old man was shy of the camera. He did, however, come in at last, and I took him with all his staff— son, Dr. Wallace, Fred Hudson, Ned Hudson, Ned Williams, Capt. Lyons, as I took Horace Greeley and all his staff, Dana, Kipley, Stone, Hildreth, Fry."

"Was the London Exhibition of benefit to you?"

"Indeed, it was. That year I went through the galleries of Europe and found my pictures everywhere as far as Rome and Naples. When in 1860 the Prince of Wales came to America I was surprised amidst much competition that they came to my gallery and repeatedly so. So I said to the Duke of Newcastle: 'Your Grace, might I ask to what I owe your favor to my studio? I am at a loss to understand your kindness.' 'Are you not the Mr. Brady,' he said, 'who earned the prize nine

years ago in London? You owe it to yourself. We had your place of business down in our notebooks before we started.' "

"Did you take pictures in England in 1851?"

"Yes. I took Cardinal Wiseman, the Earl of Carlisle and others. I took in Paris Lamartine, Cavaignec and others, and Mr. Thompson with me took Louis Napoleon, then freshly Emperor."

I could still see the deferential, sincere way Brady had in procuring these men. His manner was much in his conscientious appreciation of their usefulness. Men who disdain authority and cultivate rebellion know not the victories achieved by the conquering sign of *Ich Dien* — "I serve."

Mr. Brady is a person of thin, wiry, square-shouldered figure, with the light of the Irish shower-sun in his smile. Said I:

"Did nobody ever rebuff you?"

"No, not that I can think of. Some did not keep their engagements. But great men are seldom severe. I recollect being much perplexed to know how to get Fenimore Cooper. That, of course, was in the day of daguerreotyping. I never had an excess of confidence, and perhaps my diffidence helped me out with genuine men. Mr. Cooper had quarrelled with his publishers, and a celebrated daguerreotyper, Chilton, I think, one of my contemporaries, made the mistake of speaking about the subject of irritation. It was reported that Cooper had jumped from the chair and refused to sit. After that, daguerreotypers were afraid of him. I ventured in at Biggsby's, his hotel, corner of Park place. He came out in his morning gown and asked me to excuse him till he had dismissed a caller. I told him what I had come for. Said he: 'How far from here to your gallery?' 'Only two blocks.' He went right along, stayed two hours, had half a dozen sittings, and Charles Elliott painted from it the portrait of Cooper for the publishers, Stringer & Townsend. I have had Willis, Bryant, Halleck, Gulian C. Vorplank in my chair."

"And Albert Gallatin?"

"Yes, I took a picture of him who knew Washington Irving and fought him and ended by adopting most of his views. Washington Irving was a delicate person to handle for his picture, but I had him sit and years afterwards I sent to Baltimore to try to get one of those pictures of Irving from John P. Kennedy, who had it."

"Jenny Lind?"

"Yes. Mr. Barnum had her in charge and was not exact with me about having her sit. I found, however, an old schoolmate of hers in Sweden who lived in Chicago, and he got me the sitting. In those days a photographer ran his career upon the celebrities who came to him, and many, I might say most of the pictures I see floating about this

country are from my ill-protected portraits. My gallery has been the magazine to illustrate all the publications in the land. The illustrated papers got nearly all their portraits and war scenes from my camera. Sontag, Alboni, La Grange, the historian Prescott—what images of bygone times flit through my mind."

"Fanny Eisler?"

"She was brought to me by Chevalier Waken (second letter unclear) for a daguerreotype."

"Not in her Herodias raiment?"

"No! It was a bust picture. The warm life I can see as she was, though dead many a year ago."

"Did you daguerreotype Cole, the landscape artist?"

"I did, with Henry Purman. I think Cole's picture is lost from my collection."

"Agassiz?"

"I never took him, through the peculiarity of his tenure in New York; he would come over from Boston in the day, lecture the same night and return to Boston by night. One day I said sadly to him: 'I suppose you never mean to come?' 'Ah!' said he, 'I went to your gallery and spent two hours studying public men's physiognomies, but you were in Washington City.' So I never got him."

"I suppose you remember many ladies you grasped the shadows of?"

"Mrs. Lincoln often took her husband's picture when he came to New York after the Douglas debates and spoke at the Cooper Institute. When he became President, Marshal Lamon said: 'I have introduced Mr. Brady.' Mr. Lincoln answered in his ready way, 'Brady and the Cooper Institute made me President.' I have taken Edwin Forrest's wife when she was a beautiful woman; Mrs. Sickles and her mother; Harriet Lane; Mrs. Polk. Yes, old Booth, the father of Edwin, I have posed, and his son, John Wilkes, who killed the President. I remember when I took Mr. Lincoln, in 1859, he had no beard. I had to pull up his shirt and coat collar; that was at the Tenth-street gallery. Mr. Seward got the gallery for the Treasury to do the bank-note plates by conference with me. I took Stanton during the Sickles trial and Philip Barton Key while alive. I had John Quincy Adams to sit for his daguerreotype and the full line of Presidents after that. I took Jefferson Davis when he was a senator and Gen. Taylor's son-in-law. Mrs. Alexander Hamilton was ninety-three when she sat for me."

"All men were to you as pictures?"

"Pictures because events. It is my pleasant remembrance that Grant and Lee helped me out and honored me on remarkable occasions. I took Gen. Grant almost at once when he appeared in Washington

City from the West, and Lee the day but one after he arrived in Richmond."

"Who helped you there?"

"Robert Ould and Mrs. Lee. It was supposed that after his defeat it would be preposterous to ask him to sit, but I thought that to be the time for the historical picture. He allowed me to come to his house and photograph him on his back porch in several situations. Of course I had known him since the Mexican war when he was upon Gen. Scott's staff, and my request was not as from an intruder."

"Did you have trouble getting to the war to take views?"

"A good deal. I had long known Gen. Scott, and in the days before the war it was the considerate thing to buy wild ducks at the steamboat crossing of the Susquehanna and take them to your choice friends, and I often took Scott, in New York, his favorite ducks. I made to him my suggestion in 1861. He told me, to my astonishment, that he was not to remain in command. Said he to me: 'Mr. Brady, no person but my aide, Schuyler Hamilton, knows what I am to say to you. Gen. McDowell will succeed me to-morrow. You will have difficulty, but he and Col. Whipple are the persons for you to see.' I did have trouble; many objections were raised. However, I went to the first battle of Bull Run with two wagons from Washington. My personal companions were Dick McCormick, then a newspaper writer, Ned House, and Al Wand, the sketch artist. We stayed all night at Centreville; we got as far as Blackburne's Ford; we made pictures and expected to be in Richmond next day, but it was not so, and our apparatus was a good deal damaged on the way back to Washington; yet we reached the city. My wife and my most conservative friends had looked unfavorably upon this departure from commercial business to pictorial war correspondence, and I can only describe the destiny that overruled me by saying that, like Euphorios, I felt that I had to go. A spirit in my feet said, 'Go,' and I went. After that I had men in all parts of the army, like a rich newspaper. They are nearly all dead, I think. One only lives in Connecticut. I spent over $100,000 in my war enterprises. In 1873 my New York property was forced from me by the panic of that year. The Government later bought my plates and the first fruits of my labors, but the relief was not sufficient and I have had to return to business. Ah! I have a great deal of property here. Mark Twain was here the other day."

"What said he?"

"He looked over everything visible, but of course not at the unframed copies of my works, and he said: 'Brady, if I was not so tied up in my enterprises I would join you upon this material, in which there is a fortune. A glorious gallery to follow that engraved by Sartain, and

cover the expiring mighty period of American men can be had out of these large, expressive photographs; it would make the noblest subscription book of the age.' "

"I suppose you sold many photographs according to the notoriety of the time?"

"Of such men as Grant and Lee, at their greatest periods of rise or ruin, thousands of copies; yet all that sort of work takes rigid, yes, minute worldly method. My energies were expended in getting the subjects to come to me, in posing them well and in completing the likeness. Now that I think of it, the year must have been 1839, when Morse returned from Europe, and soon after that Wolf made my camera. I had a large German instrument here a few weeks ago, and someone unknown stole the tube out of it, which cost me $150."

I reflected that this man had been taking likenesses since before the birth of persons now half a century old.

Brady lived strongest in that day when it was a luxury to obtain one's own likeness, and he had some living people who began with the American institution. John Quincy Adams, for instance, was a schoolboy at the Declaration of Independence, or soon after, but, living to 1849, Brady seized his image in the focus of the sun. Had he been thirteen years earlier he could have got John Adams and Jefferson, too, and he missed the living Madison and Monroe and Aaron Burr by only four or five years. For want of such an art as his we worship the Jesus of the painters, knowing not the face of our Redeemer, and see a Shakespeare we know not to have been the true Will or a false testament. Our Washington City photographer probably beheld a greater race of heroes in the second half of the nineteenth century than the first, but in the growth of the mighty nation has come a refined passion to see them who were the Magi at the birth of this new star. Before Mr. Brady was Sully the painter, before Sully, Charles Willson Peale, working to let no great American visage escape, and in their disposition and devotion these three men were worthy of Vandyke's (sic) preserving pencil. The determined work of M. B. Brady resembles the literary antiquarianism of Peter Force (?—hard to read), who lived in the city of Washington also, and the great body of collections of both have been acquired by the Government.

Valentine Blanchard

"Afield with the Wet Plate"
1891

There are many tales of the difficulties of lugging heavy
equipment through China, Egypt (so hot the chemicals
boiled), the mountains of the American West, and the battle-
fields of the world. Back at home, too, the man who left his
house had a lot to contend with before he came home with a
masterpiece.

*Valentine Blanchard was an extremely successful landscape photographer in
England during the 1860s; his photographs of famous scenes and historic build-
ings were sold by the thousand.*

*In 1891 he recalled for younger photographers some of the routine problems
that faced the wet-plate worker in the field. His account is one of the most vivid
of the reminiscences of the "good old days" which filled the photographic press in
the years following the introduction of gelatin dry plates. The following is a
condensation of the original article.*

Let us go back thirty years, and in imagination prepare for a short
photographic campaign in pursuit of the picturesque. Even for pictures
of small dimensions the impedimenta assumed dimensions almost suf-
ficient to fill a small wagon. The whole of the work had to be done in
the field, and therefore everything necessary for the completion of the

negative had to be carried; and woe to the careless photographer who omitted the "roll call" of apparatus before starting!

We are ready for a start. The day is a stormy one at the seaside. Just the day for grand cloud and wave effects. Some shelter must be found for the tent somehow; for it carries too much canvas to stand the force of such a gale in the open. At length the tent is comparatively safe, so we proceed to put everything in order inside. The various bottles are in their proper places. The nitrate of silver bath is put into its light-tight well. The water tank is put outside, and a flexible tube carries the contents into the interior. Before we start we must have fairly liberal supply of water. This may mean a journey of half-a-mile for salt water will not do. We struggle with the ample folds of the drapery of the tent, and we are safely tucked inside. The bath was capricious, and you never knew how it was going to act. The (glass) plates had been carefully cleaned and dusted beforehand, and wisely so, for the air is heavy with salt spray. The stopper had not blown out of the collodion bottle during its jolting journey to the scene of action, so we are able to pour the contents over the plate—and sometimes up our sleeves as well—and after waiting till the film has properly set, immerse it in the nitrate bath. So far all has gone well. The plate is carefully drained, and inserted in the darkslide, and we emerge half suffocated from our black hole. The camera is on its tripod, and we are ready. Our journey is probably down the face of a cliff, for we had to seek shelter for the tent some distance from the shore. Now we feel the force of the gale, and the legs of the tripod have to be well spread in order to keep the camera firm. Focusing is difficult, for the velvet prefers to cover the lens instead of the head, but the moment is chosen and the exposure made. A hard climb up the cliff brings us back to the tent, once more muffled up we proceed to develop, and are perhaps rewarded with a fairly presentable negative.

Can wasps have been photographers in some former world? The interest in photographic proceedings displayed by them is remarkable. The moment the yellow window of the tent is opened an inch, just to admit a mouthful of air to the panting operator inside, as sure as fate in comes one of these gaudy yellow-and-black gentlemen to inspect the proceedings. He evidently thinks the photographer deaf, and comes much too near the ear to be pleasant. Perhaps he is anxious to communicate some tip. His language is distracting and incomprehensible, and so after a time he flies away in disgust only to give place to another of his fraternity the moment the window is once more opened.

In spite of all the fatigue and frequent vexation of spirit, there were compensative joys. After waiting and watching for some particu-

lar atmospheric effect, the delight on escaping from the confinement of the suffocating tent to find reward for all the patience in the shape of a successful negative, is an experience known only to the workers in the days of wet collodion.

Joseph Pennell

"Is Photography Among the Fine Arts?" 1897

AN EXCERPT

As the nineteenth century progressed, illustrators were increasingly called on to copy photographs or sometimes to amend their styles to accord with the new fashions. Joseph Pennell (1860?–1926) was an illustrator best known for his illustrations to travel books. In this angry polemic he repeats what many others had said, that photography was merely mechanical and did not require the training that art did. He is also against photographs that try to look like prints or other art forms.

And now, what is the training of the photographer who is noisiest in his assertion that he is an artist? Does he devote his whole life, or a year, or a month to the study of art? Does he give up his whole life to the study and the practice even of photography? Is photography his profession, his occupation, his sole concern and interest? Is he first the apprentice, then the master, in the shop, the useless room with no window, or studio, as he prefers to call it? I look down the list of exhibitors at the Photographic Salon, where the gospel of art is most strenuously preached; I see among them the names of persons, of Government clerks, of solicitors, of a beef-extract maker, of a banker, and some titles—in fact, the amateur rampant. It is the time left over from

his serious work in life that this photographer gives to his "art." Photography is his amusement, his relaxation. He labours in his pulpit or at his desk all the week, and then, when the half-holiday comes, he seizes his little black box, skips nimbly to the top of a 'bus, hurries from his Hampstead heights to the Embankment, plants his machine in a convenient corner, and, with the pressing of a button or the loosing of a cap, creates for you a nocturne which shall rank with the lifework of the master. Or, at odd moments, in his wilds of Clapham, he will evolve the scheme of a poster that shall humble Chéret into the dust. Or, getting a model to pose stark naked for him, he will present you an idyl out of the same little box that should put—and it does—Botticelli to shame. He sees what he likes, for he has been taught what to like by reading books upon painting, which he does not understand, and which teach nothing for him; he prepares his camera; he focusses it, or knocks it out of focus; he puts in his glassplate or his film. And who does the work? Who makes the picture? Why, he does not as much as know whether there is a picture on it until he brings the plate or film home and develops it. What does the painter do? He either sits down in front of his subject—a landscape, let us suppose—makes a careful study of it with his unaided hands, which he is able to do because he had had a certain training, and has the power to do it—a power in which the photographer is totally deficient; or he looks at it, and his observation and his memory are so keen that he can absorb the whole character of the scene before him, and then, later, reproduce it out of his box—his brain—without, perhaps, doing a scrap of work on the spot. Let the photographer find his subject in the same fashion, and study it in his way, and having, to his own great delight, selected and arranged and composed it, as he says—for he uses only the artist's technical terms —forget to take the cap off his lens. What happens then? But he does not forget; he pushes the button, and a picture is the result. Until lately he was the mute inglorious Milton; now he has discovered a machine to make his masterpiece for him. No wonder he laughs at the poor artist who must humbly toil to create beauty, which a camera manufactures for him at once. What a farce it is to think of Titian and Velasquez and Rembrandt actually studying and working, puzzling their brains over subtleties of drawing and modelling, or light and atmosphere and colour, when the modern master has but to step into a shop, buy a camera, play a few tricks with gum chromate—I believe it is called—to turn you out a finished masterpiece which is far more like the real thing, he says, than any mere handmade picture ever could be. Is it not natural that he should boast of his "avowedly revolutionary" aims? Is he not doing for art what Watt and Stephenson have done for

labour? There are to be machine-made pictures, as there are machine-made shirts and carpets. In time he hopes to be "released from mechanical trammels," to which the artist has ever been subjected. He is not "bound down by any rule of accuracy of definition," which the artist has given his life to make or to break. He dispenses with "capability of producing a documentary fact," when the greatest artists would give their lives to render, only approximately, one of the smallest. He, however, is in no need of fact; he can, he says, exercise his "fancy and imagination," which, apparently, he thinks everybody possesses naturally; the artist, for his part, spends his life curbing his fancy and imagination—if he has any. For pictorial work by photography, "an indissoluble connection with the abstruse mysteries of chemistry, optics, and mathematics is . . . very slight indeed"; for the artist, if I understand what is meant, it is indispensable. He discards the world's universally accepted traditions; it is the artist's proudest boast to have conserved them. He creates new principles for himself; the artist has jealously preserved those handed down from the earliest ages.

In a word, the photographer is the bold independent who has broken loose from tradition and asserted his individuality, not by the cultivation of his hand and his brain and his eye, that these three unruly members may work together to produce the harmony the artist almost despairs of; no, by sticking his head into a black box, and at the crucial moment letting a machine do everything for him. It is the chemistry he despises, the optics he is superior to, the science he scoffs at which do the whole thing. I have heard of one artist who, like the photographer, hands over his task to an agent—the Emperor of Germany. He too, with no trouble to himself, through his faithful Knackfuss, may produce masterpieces; and they are more amusing than photographs because, in this case, the agent is human, not mechanical. When the photographer touches his great works with his hands they cease to be photographs. The most skilful painter is a bungler who takes months to put a figure on his canvas; a photographer's machine will put it on the same canvas while you wait. And the art? Why, with his machinery and his chemicals, he can put upon canvas, upon paper, upon metal, pictures which look to himself and his friends surprisingly like the real thing. The man who sells margarine for butter, and chalk and water for milk, does much the same, and renders himself liable to legal prosecution by doing it. The art of the photographer, as now explained, is to make his photographs as much like something that they are not as he can. The old-fashioned idea was to give a straightforward photograph, as direct and clear and true as possible, a photograph that was of some use as a record. The revolutionary photograph is one that

bears upon the surface a vague resemblance to a poor photograph of a charcoal, a sepia, or a wash drawing, to an aquatint or a water-colour. I never heard of a great painter who endeavored to palm off his paintings as chromos.

. . . .

Alfred Stieglitz

"The Hand Camera—
Its Present Importance"
1897

By the 1880s, the faster gelatin dry plate made hand-held cameras a reality. The new "detective camera" was hidden in derby hats, binoculars, canes, and cravats to allow the taking of truly candid, unposed pictures. In 1888, George Eastman marketed the "You press the button, and we do the rest" Kodak, which made photography available to just about everyone. The development of the hand-held camera contributed to the drive for straight photographs, unposed and unretouched, which Alfred Stieglitz (1864–1946) favored. Though he had originally been opposed to its use, he employed it in the nineties for some of his best-known pictures. Stieglitz maintained his dislike of complicated mechanisms throughout his life.

Photography as a fad is well-nigh on its last legs, thanks principally to the bicycle craze. Those seriously interested in its advancement do not look upon this state of affairs as a misfortune, but as a disguised blessing, inasmuch as photography had been classed as a sport by nearly all of those who deserted its ranks and fled to the present idol, the bicycle. The only persons who seem to look upon this turn of affairs as entirely unwelcome are those engaged in manufacturing and selling photo-

graphic goods. It was, undoubtedly, due to the hand camera that pho-
tography became so generally popular a few years ago. Every Tom,
Dick and Harry could, without trouble, learn how to get something or
other on a sensitive plate, and this is what the public wanted—no work
and lots of fun. Thanks to the efforts of these persons hand camera and
bad work became synonymous. The climax was reached when an en-
terprising firm flooded the market with a very ingenious hand camera
and the announcement, "You press the button, and we do the rest."
This was the beginning of the "photographing-by-the-yard" era, and
the ranks of enthusiastic Button Pressers were enlarged to enormous
dimensions. The hand camera ruled supreme.

Originally known under the odious name of "Detective," necessar-
ily insinuating the owner to be somewhat of a sneak, the hand camera
was in very bad repute with all the champions of the tripod. They
looked upon the small instrument, innocent enough in itself, but terri-
ble in the hands of the unknowing, as a mere toy, good for the purposes
of the globe-trotter, who wished to jot down photographic notes as he
passed along his journey, but in no way adapted to the wants of him
whose aim it is to do serious work.

But in the past year or two all this has been changed. There are
many who claim that for just the most serious work the hand camera is
not only excellently adapted, but that without it the pictorial photog-
rapher is sadly handicapped.

The writer is amongst the advocates who cannot too strongly
recommend the trial of the hand camera for this class of photography.
He frankly confesses that for many years he belonged to that class
which opposed its use for picture making. This was due to a prejudice
which found its cause in the fact that the impression had been given
him that for hand camera exposures strong sunlight was *sine qua non*.
The manufacturer is chiefly to be blamed for this false impression, as
it was he who put up the uniform rule that the camera should be held
in such a position that the sunlight comes from over one of the shoul-
ders, in order to insure such lighting as to fully expose the plate. In
short, the manufacturer himself did not realize the possibilities of his
own ware and invention.

In preparing for hand camera work, the choice of the instrument
is of vital importance. Upon this subject that able artist, J. Craig
Annan, of Glasgow, who does much of his work with the hand camera,
says: "Having secured a light-tight camera and suitable lens, there is
no more important quality than ease in mechanical working. The ad-
justments ought to be so simple that the operator may be able to bring
it from his satchel and get it in order for making an exposure without

a conscious thought. Each worker will have his own idea as to which style of camera comes nearest to perfection in this respect, and having made his choice he should study to become so intimate with it that it will become a second nature with his hands to prepare the camera while his mind and eyes are fully occupied with the subject before him."

To this let me add, that whatever camera may be chosen let it be waterproof, so as to permit photographing in rain or shine without damage to the box. The writer does not approve of complicated mechanisms, as they are sure to get out of order at important moments, thus causing considerable unnecessary swearing, and often the loss of a precious opportunity. My own camera is of the simplest pattern and has never left me in the lurch, although it has had some very tough handling in wind and storm. The reliability of the shutter is of greater importance than its speed. As racehorse scenes, express trains, etc., are rarely wanted in pictures, a shutter working at a speed of one-fourth to one-twenty-fifth of a second will answer all purposes. Microscopic sharpness is of no pictorial value. A little blur in a moving subject will often aid in giving the impression of action and motion.

As for plates, use the fastest you can get. They cannot be too fast. Do not stop down your lens except at the seashore, and set your shutter at as slow speed as the subject will permit. This will ensure a fully exposed plate. Under exposures are best relegated to the ashbarrel, as they are useless for pictorial work.

The one quality absolutely necessary for success in hand camera work is *Patience*.

This is really the keynote to the whole matter. It is amusing to watch the majority of hand camera workers shooting off a tone of plates helter-skelter, taking their chances as to the ultimate result. Once in a while these people make a hit, and it is due to this cause that many pictures produced by means of the hand camera have been considered flukes. At the same time it is interesting to note with what regularity certain men seem to be the favorites of chance—so that it would lead us to conclude that, perhaps, chance is not everything, after all.

In order to obtain pictures by means of the hand camera it is well to choose your subject, regardless of figures, and carefully study the lines and lighting. After having determined upon these watch the passing figures and await the moment in which everything is in balance; that is, satisfies your eye. This often means hours of patient waiting. My picture, "Fifth Avenue, Winter," is the result of a three hours' stand during a fierce snow-storm on February 22nd, 1893, awaiting the proper moment. My patience was duly rewarded. Of course, the result

contained an element of chance, as I might have stood there for hours without succeeding in getting the desired picture. I remember how upon having developed the negative of the picture I showed it to some of my colleagues. They smiled and advised me to throw away such rot. "Why, it isn't even sharp, and he wants to use it for an enlargement!" Such were the remarks made about what I knew was a piece of work quite out of the ordinary, in that it was the first attempt at picture making with the hand camera in such adverse and trying circumstances from a photographic point of view. Some time later the laugh was on the other side, for when the finished picture was shown to these same gentlemen it proved to them conclusively that there was other photographic work open to them during the "bad season" than that so fully set forth in the photographic journals under the heading, "Work for the Winter Months." This incident also goes to prove that the making of the negative alone is not the making of the picture. My hand camera negatives are all made with the express purpose of enlargement, and it is but rarely that I use more than part of the original shot.

Most of my successful work of late has been produced by this method. My experience has taught me that the prints from the direct negatives have but little value as such.

The hand camera has come to stay—its importance is acknowledged.

A word to the wise is sufficient.

Charles H. Caffin

Photography as a Fine Art
1901

AN EXCERPT

Charles H. Caffin (1854–1918), primarily an art critic, was also one of the better photography critics toward the beginning of this century. He published in both *Camera Notes* and *Camera Work*. Together with Stieglitz, he was an early advocate of straight photography and a defender of "art" photographers as hard-working, patient students, like artists themselves. This excerpt is from the only book he wrote on photography; he published many on art.

. . . .

So far we have been discussing the general principles involved in the making of figure-pictures, and may now apply them more particularly to photography. Surely they demand, except in the case of purely illustrative prints, such as are used in the daily and weekly papers, qualifications which by no means every one possesses; calling, in fact, for qualities of a very high artistic order. It cannot be too often insisted that the mere snap-shooting of figures or the mere posing of them in some agreeable position is as far removed from the artistic possibilities of picture photography as night from day. The ultimate possibilities of the art are only matter of conjecture, but already results are obtained which would have been deemed impossible a short time ago, and their

beauty proceeds from reliance upon the artistic qualities common to painting, with the sole exception of many colors. The photograph is still a monochrome; yet in the opportunities it gives of rich and delicate tones, the limitation is less of a hindrance than some would suppose. The real limitation, the one most difficult to circumvent, comes from the physical and mental imperfections of the model. In studies from the nude this fact is often painfully apparent. Even when the form is comparatively free from faults, a consciousness or even an excess of unconsciousness, amounting to blank indifference, or some simpering expression of sentiment will mar the picture. And yet we have seen how successfully this difficulty has been surmounted by Frank Eugene and F. Holland Day. The latter has done some very beautiful work from the nude model, particularly with a Nubian, and again with children. His motive in these, I should imagine, has been purely decorative; and it is the entire absence of any sentiment that is an element in his success, since it leaves one to uninterrupted enjoyment of the beauties of form, color and texture. Mr. Eugene, also, in his *Adam and Eve* has obliterated the faces by scoring the surface of the plate with lines. The reason is obvious, and again we find ourselves concentrated upon the abstract beauties of the picture. These and other examples, in fact, suggest a conclusion that the best way of securing an acceptable picture in the nude is by adopting some expedient to cancel the personality of the model, either by hiding the face, or by keeping the figure far back in the picture whence the features do not count, or else by so accentuating the other elements of the picture that the attention is diverted from the face.

In the *genre* picture also this problem has to be met in a mitigated form, for the least self-consciousness stiffens, and under- or over-realization of the part that is being played may jar upon the general feeling of the subject. But in *genre* the accessories may be made to play, and ought to play, so important a part that the figure becomes merged in them, if properly treated. Indeed, one may almost divide the examples of this class of picture into two kinds: those in which there is a *mise-en-scene* including figures and those in which there are figures with some sort of setting added, and it is the former which, in photography at least, appear to be the more satisfactory; and such complete identity of figure and environment demands the most synthetic arrangement. If a profusion of detail is allowed, the figure will necessarily obtrude itself, without, however, necessarily gaining separate importance, for the general confusion distracts. While, therefore, there should be some central motive to which everything is subordinated, the same should not be the figures, but some abstract quality, especially that of the

lighting of the picture. Let this clearly express the sentiment of the picture, as it may very readily be made to do, and everything will fall into due relation to it, the accessories as well as the figure, and the latter, relieved from the chief burden of expressing the meaning of the picture, will contribute its share with all the greater spontaneity.

On the other hand, the artist may wish to solve the problem by confronting it instead of getting around it, and may determine to make the expression of the face the prime factor in the picture. Then he must either find a model that already corresponds to his conception, that may, indeed, have inspired it, or he will diligently coach his model, or, as a final resort, act as model himself. Here, again, I am reminded of Mr. Day, who in several cases, notably in a series of heads, portraying the *Seven Last Words* of the Savior, posed for himself. Silly objections have been raised to this on the score of propriety, as if all the religious pictures had not been painted from models. A more tenable criticism would be that the theme is too tremendous to be treated with main reliance on the expression of the faces as in this case, and that the result attained, though very impressive, is rather histrionic than religious.

This allusion to religious subjects reminds one of many points depicting some tragic emotion, none of which seemed satisfactory. I recall, especially, some examples by Mr. Clarence H. White, cleverly posed and very beautiful in their rich quality of color. Their failure to convey the impression intended may possibly be due to the fact that Mr. White's temperament does not so strongly incline towards such subjects as to others of tenderer sentiment. At least such might be inferred from a study of a large number of his prints. Mr. Joseph A. Keiley has also essayed this kind of picture, as in the case of a Shylock, using an actor for a model and relying very much upon the latter's contribution to the result. But an actor's power to create an impression is in a general way a relative one; dependent to a great extent upon the readiness of his audience to accept the illusion. Between the two there is a constant reciprocity of feeling and the connecting link is the sequence of the words. In a picture the artist has to establish the connection in order to help out the efforts of his model, and it is just because Mr. Keiley has depended too exclusively on the cleverness of his model, that he seems to me to have failed. And this brings one back to the point, which the more one thinks of it seems of greater importance, that to succeed in *genre* the artist must make some abstract quality the prime feature of his picture.

So far I have been considering the deliberate posing of the model; but there is a class of pictures in which the figure is introduced without its knowledge or, at any rate, without knowledge of the actual moment

at which the exposure is made. Mr. Alfred Stieglitz has done some notable work in this direction, particularly in the series of pictures, made at Katwyk, and they bear out what I have said about the wisdom of subordinating the figure to some abstract motive. In *The Gossips*, for example, and *Going to Church*, he has treated the figures as part of the scene, related to it and deriving from it their own significance. And the pictures were not made, I understand, until the essential features of the subject had been thoroughly digested and the relation of the figures to the scene and the exact part they should play in it, as to position and relative importance from a pictorial standpoint, had been well considered. This brings one back to the comparison of Millet's *Sower* with the photographs of a Sicilian sower. Can the photographer emulate the methods of the painter, even if he fail to reach his results? I am unable to see why not. Millet must have made an exhaustive analysis of the man at work until he had mastered the salient features of the operation; then, many studies were probably executed before he reached the final formula of expression. The analysis is certainly within the possibilities of the photographer; and repeated snap-shots might take the place of sketches, until, at last, the desired result has been attained. But this involves the sincerity, patience and self-criticism that mark the procedure of the artist, very far removed from the easy conscience and ready self-satisfaction of a mere toucher of the button. It distinguishes the artist of the camera from him who is only playing with it, and justifies the statement that really good figure-photography, so far from being a thing in which any one can succeed, is indeed the highest test of the photographer's ability.

This problem of expressing movement seems full of difficulty. Some years ago a number of photographs were publicly exhibited, representing the position of horses at different instants of their gait, and it was clear, at once, that such positions were entirely different from those depicted by painters and accepted by the public as true to life. Immediately it was assumed that, as the painter was manifestly untrue to life, he must be wrong; the point being missed, that according to our sense of what we see, the photographs themselves were entirely false. The picture-maker does not attempt to depict the actual thing, but the impression which it makes upon him, and, in the matter of a horse's gallop, sums up the different phases of the gait into one synthetic formula; which may be arbitrary, but justified, if it succeeds in conveying the impression to ourselves. Therefore, the snap-shot, while no doubt recording accurately some instant of the action, may be very far from expressing the composite result, conveying instead a suggestion of suspended movement. For one photograph of a man walking, a

222 PHOTOGRAPHY IN PRINT

hundred can be seen in which he appears to be standing on one leg with the other held up in the air as if it had been hurt.

But the difficulties which photography presents are the measure of its possibilities. If anyone could succeed there would be no chance for the artist. It is in a realization of the difficulties and in the persistent endeavor to surmount them that picture photography is being gradually brought to the level of an art.

George Bernard Shaw

"On the London Exhibitions"
1901

AN EXCERPT

George Bernard Shaw (1856–1950), who said he wanted to
be an artist more than a writer, was an avid amateur photog-
rapher himself and willingly posed for all manner of others.
He was an astute commentator who wrote appreciatively of
Frederick H. Evans and Alvin Langdon Coburn, to name just
two favorites, and who tackled the dilemma of the mechanical
in art head on. The view that it is individual inspiration that
informs the picture, no matter how the image is made, is
essentially the position held by M. A. Root, by Stieglitz, and
later by Weston, Adams, and numerous other photographers.

The fable of Pilpay, in which the three rogues persuaded the Brahman
that an unclean beast was a lamb fit for sacrifice, has been used by
Macaulay to illustrate the methods and efficacy of modern puffery and
log-rolling. But if Pilpay had been a photographer he would have
turned his fable inside out and described three Brahmans persuading
some poor rogue, who had brought a lamb to the altar, that it was only
a mangy goat.

 I know nothing funnier in criticism than the assurance of the
painter and his press-parasite, the art-critic, that all high art is brush-
work; except, perhaps, the humility of the photographer, who is not

yet allowed a parasite of his own, and must timidly beg for a contemptuous bite or two from that of the brusher. For surely nobody can take three steps into a modern photographic exhibition without asking himself, amazedly, how he could ever allow himself to be duped into admiring and even cultivating an insane connoisseurship in the old barbarous smudging and soaking, the knifing and graving, rocking and scratching, faking and forging, all on a basis of false and coarse drawing, the artist either outfacing his difficulties by making a merit of them, or else falling back on convention and symbolism to express himself when his lame powers of representation break down. In this year's exhibitions I find two portraits of myself—one in the Salon by Frederick Evans, the other in the New Gallery by Furley Lewis. Compare them with the best work with pencil, crayon, brush, or silver point you can find—with Holbein's finest Tudor drawings, with Rembrandt's Saskia, with Velasquez's Admiral, with anything you like. If you can not see at a glance that the old game is up, that the camera has hopelessly beaten the pencil and paint-brush as an instrument of artistic representation, then you will never make a true critic; you are only, like most critics, a picture-fancier. And please observe that these two portraits of me, far from being mechanically alike, are less so than any two drawings of me that have ever been made. The style of Mr. Evans contrasts as strongly with the style of Mr. Furley Lewis as the style of Velasquez with the style of Holbein. The portraits, too, though both like me, are not like one another. When I compare their subtle diversity with the monotonous inaccuracy and infirmity of drawings, I marvel at the gross absence of analytic power and of imagination which still sets up the works of the great painters, defects and all, as the standard, instead of picking out the qualities they achieved and the possibilities they revealed, in spite of the barbarous crudity of their methods. But that is what always happens; for to those whose fancy for pictures is "an acquired taste," the faults of the brush are as dear as its qualities. It was once considered that the tone given to an Italian picture (late sixteenth century preferred) by a filthy coat of tallow-soot, acquired by a century of exposure to the smoke of a host of altar-candles, was a chief element in its value; and "old masters," which had accidentally remained clean, were actually washed with porter to bring them down to the picture-fanciers' standard. May I venture to add that I am not quite sure that I have not seen a few photographs this year that have been deliberately faked to make them resemble pictures?

It is now more than twenty years since I first said in print that nine-tenths (or ninety-nine-hundredths, I forget which) of what was then done by brush and pencil would presently be done, and far better

Nadar (Gaspard-Félix Tournachon). *Champfleury. c.* 1865
9 × 7¼ on 15 × 10½" mount, Woodbury type
Collection, Museum of Modern Art, New York

Timothy H. O'Sullivan. *Ancient Ruins in the Canyon de Chelly.* New Mexico,
1873
Collodion print, 10⅞ × 8".
Collection, Museum of Modern Art, New York
Gift of Ansel Adams in memory of Albert M. Bender

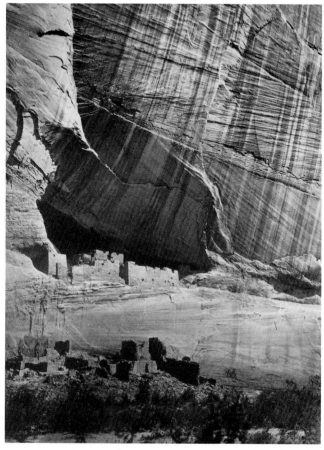

Dr. Peter Henry Emerson. *The Old Order and The New, East Anglia 1886*
Plate 12, from the album *Life and Landscape on the Norfolk Broads.* London, 1886
Platinum print, 4¾ × 9³⁄₁₆″.
Collection, Museum of Modern Art, New York. Gift of William A. Grigsby

Alfred Stieglitz. *The Steerage.* 1907
Gravure from *Camera Work*, 7¾ × 6¼″
Collection, Museum of Modern Art, New York

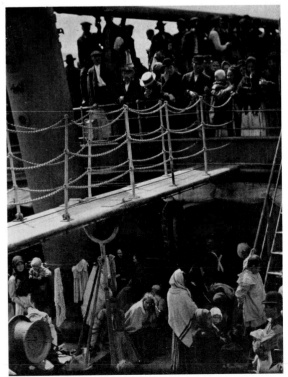

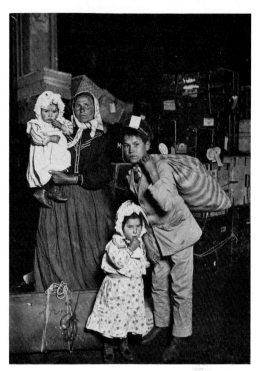

Lewis Hine. *Looking for Lost Baggage, Ellis Island.* 1905
Collection, International Museum of Photography at George Eastman House

Edward Steichen. *Rodin—Le Penseur.* 1902
Silver print, 13½ × 16½"
Collection, Museum of Modern Art, New York
Gift of the photographer

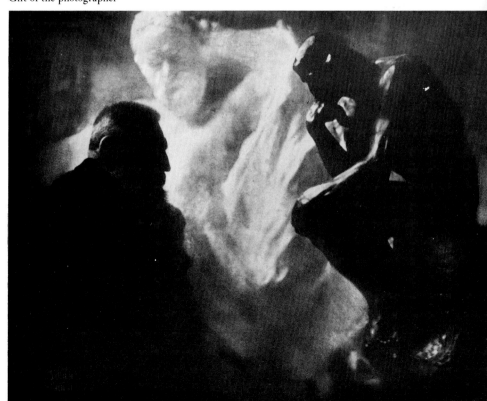

Eugène Atget. *St. Cloud #7 (Garden Walk with Statues)*. *c.* 1925
Silver print from dry plate, 6¾ × 8¾″
Collection, Museum of Modern Art, New York

Paul Strand. *Portrait*. New York City, 1915
Enlargement on to glass, 11 × 14″ plate, contact on Eastman platinum paper
Collection, Museum of Modern Art, New York
Gift of the photographer
Copyright © 1971 by the Estate of Paul Strand
Reprinted by permission of the Estate

Edward Weston. *Cypress—Point Lobos.* 1929
Silver print, 7½ × 9⅜"
Collection, Museum of Modern Art, New York
Gift of David H. McAlpin
Reprinted by permission of the Estate of Edward Weston

Walker Evans. *Furniture store sign near Birmingham, Alabama.* 1936
Silver print, 6⅜ × 8⅞"
Collection, Museum of Modern Art, New York. Parkinson Fund

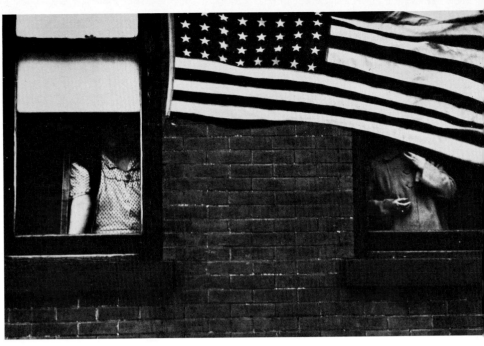

Robert Frank. *Number 2, Hoboken, 1955.* 1955
Silver print, 8⅟₁₆ × 12¼"
Collection, Museum of Modern Art, New York
Reprinted by permission of Robert Frank

Weegee (Arthur Fellig). *Tenement Fire, Brooklyn, New York, December 14, 1939*
Silver print 10¾ × 13¼"
Collection, Museum of Modern Art, New York

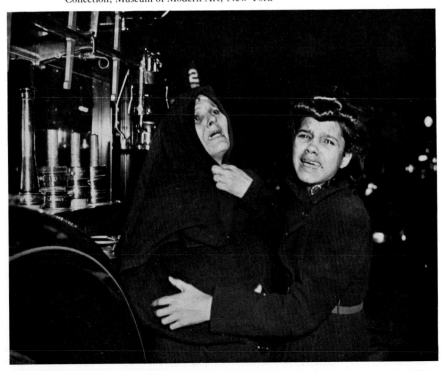

Aaron Siskind. (Painted wall; no date)
8³⁄₁₆ × 13⁵⁄₁₆″ on Masonite
Collection, Museum of Modern Art, New York
Gift of the photographer
Reprinted by permission of Aaron Siskind

W. Eugene Smith. (Two soldiers; 1944)
Silver print, 13¼ × 10³⁄₁₆″
Collection, Museum of Modern Art
Anonymous gift
© W. Eugene Smith
Reprinted by permission
of the Estate of
W. Eugene Smith

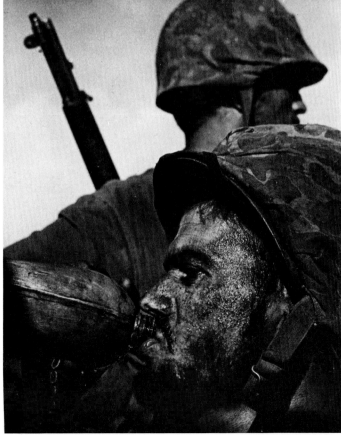

Jerry N. Uelsmann. *Self-Portrait as Robinson and Rejlander.* 1964
Silver print, 7½ × 8″
Collection, Museum of Modern Art, New York
Reprinted by permission of Jerry N. Uelsmann

Garry Winogrand. *Party, Norman Mailer's Fiftieth Birthday, New York, 1973*
Silver print, 10⅝ × 15¹³⁄₁₆″
Collection, Museum of Modern Art, New York
Reprinted by permission of Garry Winogrand

done, by the camera. But it needed some imagination, as well as some hardihood, to say this at that time, not because the photographic exhibitions were less convincing then, in spite of their delight in representing nature as eternally reflected in silver dish-covers, but because the photographers of that day were not artists (except when they photographed by stealth and exhibited the results in Bond Street and Burlington House as drawing), but craftsmen, more interested in their process than in its results, and often having no artistic purpose whatever—that is, no feeling to convey. Still, they photographed just as well, and plenty of them a good deal better than some of the modern artist-photographers; and they never played the old painters' game of making a merit of their failures—for instance, calling underexposure impressionism and fog-tone. If they are out of fashion now, let us not forget that when Tintoretto, the artist-painter, was in fashion, Orcagna, the craftsman-painter, was out of fashion, and that National Galleries are nevertheless just as keen on Orcagnas as on Tintorettos. Let us admit handsomely that some of the older men had the root of the matter in them as much as the younger men of to-day; but the process did not then attract artists. It may be asked why, if photography be so exquisite an artistic process, it did not attract them. Well, there were many reasons. The first and principal one is never mentioned. It was, that artists were terrified by the difficulty and mystery of the process, which, as compared with the common run of their daubing, in which any fool can acquire a certain proficiency, certainly did require some intelligence, some practical science, and some dexterity. However, many artists were quite handy and clever enough for it; and a good many of them, as I have hinted, used it secretly, with lucrative results. But, on the whole, the process was not quite ready for the ordinary artist, because (1) it could not touch color or even give colors their proper light-values; (2) the impressionist movement had not then rediscovered and popularized the great range of art that lies outside color; (3) the eyes of artists had been so long educated to accept the most grossly fictitious conventions as truths of representation that many of the truths of the focusing-screen were at first repudiated as grotesque falsehoods; (4) the wide-angled lens did in effect lie almost as outrageously as a Royal Academician, whilst the anastigmat was revoltingly prosaic, and the silver print, though so exquisite that the best will, if they last, be one day prized by collectors, was cloying, and only suitable to a narrow range of subjects; (5) above all, the vestries would cheerfully pay £50 for a villainous oil-painting of a hospitable chairman, whilst they considered a guinea a first-rate price for a dozen cabinets, and two pound ten a noble bid for an enlargement, even when

the said enlargement had been manipulated so as to be as nearly as possible as bad as the £50 painting. But all that is changed nowadays. Mr. Whistler, in the teeth of a storm of ignorant and silly ridicule, has forced us to acquire a sense of tone, and has produced portraits of almost photographic excellence; the camera has taught us what we really saw as against what the draughtsmen used to show us; and the telephoto-lens and its adaptations, with the isochromatic plate and screen, and the variety and manageableness of modern printing processes, have converted the intelligent artists, smashed the picture-fancying critics, and produced exhibitions such as those now open at the Dudley and New Galleries, which may be visited with pleasure by people who, like myself, have long since given up as unendurable the follies and falsehoods, the tricks, fakes, happy accidents, and desolating conventions of the picture-galleries. The artists have still left to them invention, didactics, and (for a little while longer) color. But selection and representation, covering ninety-nine-hundredths of our annual output of art, belong henceforth to photography. Some day the camera will do the work of Velasquez and Peter de Hooghe, color and all; and then the draughtsmen and painters will be left to cultivate the pious edifications of Raphael, Kaulbach, Delaroche, and the designers of the S.P.C.K. And even then they will photograph their models instead of drawing them.

So much for the general situation and its prospects. As to the exhibitions, which are the immediate pretexts of this article, the Salon impresses me, as it has done before, with a sense of the extent to which the most sensitive photographers have allowed themselves to be bull-dozed into treating painting, not as an obsolete makeshift which they have surpassed and superseded, but as a glorious ideal to which they have to live up. I remember once accidentally spilling some boiling water over a photograph of myself, which immediately converted it into so capital an imitation of the damaged parts of Mantegna's frescoes in Mantua that the print delighted me more in its ruin than it had in its original sanity. On another occasion I photographed an elderly laborer with a scythe, and incautiously left the negative near a hot-air flue, with the result that the film crinkled and produced a powerful and extraordinary caricature of death, which had all the imaginative force of a lithograph by Delacroix, and very nearly all the unattainable infamy of his drawing. I have also a remarkable turn for forgetting something in taking a photograph: for instance, by inadvertently focusing with one lens and exposing the plate with another, I have produced fantastic images which would have qualified me for the extreme left of the New English Art Club in its early days. Now, so thoroughly has

my own experience as a critic and picture-fancier sophisticated me that these accidental imitations of the products of the old butter-fingered methods of picture-making often fascinate me so that I have to put forth all my strength of mind to resist the temptation to become a systematic forger of damaged frescoes and gothic caricatures. That this temptation is not always vanquished is proved by several works in both the exhibitions. Deliberate imitations of the priming of canvas and of the strokes of the crayon are to be found there: and one gentleman, exasperated at the revolting oversharpness of the real Lucerne, has put it out of focus to an extent that would do injustice to Lincoln's Inn Fields on a November afternoon. Another gentleman, by imparting a high-art mildew to some otherwise presentable photographs, and clapping them into frames of a color that suggests nothing but the feebly baleful green of a sick glow-worm, has made the judges so afraid of being called Philistines if they confess their natural dislike of the effect that they have awarded him a medal. But the giving of medals is at best an undignified and incurably invidious practice, involving a "judgment" which no really capable critic could honestly pretend to deliver. The Royal Photographic Society ought to discriminate between a lens (which may legitimately be Kew-certificated or medaled for passing a certain measurable test) and an artist, to whose nature and function anything like competition is abhorrent as a matter of feeling and irrelevant as a matter of fact.

On the whole, I greatly prefer the photographers who value themselves on being photographers, and aim at a characteristically photographic technique instead of a sham brush-and-pencil one. Look at the enormous humor and vividness of Mr. Craig Annan's George Frampton (only to be appreciated fully by those who know G. F.), and the fine sympathy of Mr. Holland Day's "Maeterlinck!" Would either of them have been possible if the artists had studied, not their sitters, but the possibilities of making the negative come up like a portrait by Mr. Sargent? It would be easy, I should think, for Mr. Furley Lewis to take his negative of Mr. Malcolm Lawson, and, by making a cleverly doctored enlargement, produce the effect of a portrait by Franz Hals, just as other exhibitors have aimed at something as unlike a photograph and as like a smart impressionist picture as possible; but Mr. Lewis has not thought of trying any such trick, knowing, I take it, that this sort of dissembling is not the strength of the forward movement, but its besetting weakness.

Mr. Steichen and Mr. Emmerich are justly distinguished by their work; but they dissemble sometimes; for instance, Mr. Emmerich's "Mill on the Elbe" is meant to look, not like a mill on the Elbe, but like

a certain sort of picture of a mill on the Elbe. And then comes Mr. Frederick Graves, and says, "Steichen and Emmerich show me the way to fame; I also will dissimulate," his Birches being the result. And I certainly should not like a gallery full of such birches, though I could hardly have too much of such tones as Mr. Emmerich has produced in his quite undissembled photograph of a Church interior. All the good church interiors, by the way, show the influence of Mr. Evans, who was, as far as I know, alone in that field some years ago; and Mr. Evans made himself the most artistic of photographers by being the most simply photographic of artists. Yet I have a crow to pluck with Mr. Evans, too, for what I take to be a stroke of technical satire at the New Gallery. In photographing Mr. Dallmeyer with the Dallmeyer-Bergheim lens, he has, by the slimmest of hairs' breadths, overdone the soft definition which is the quality of that lens, and thus burlesqued the sort of portrait represented most favorably by Mr. Auld's medaled "Study of a Head," in which the softness is carried to the point of suggesting incipient decomposition. Mr. Evans has used the lens with consummate judgment in his other portraits; and it seems hard that because Mr. Dallmeyer's invention has been abused to decompose other people Mr. Evans should revenge them by disintegrating Mr. Dallmeyer himself with it. But the sarcasm need not be lost because it has fallen on the innocent; for it certainly strikes at a growing folly. When it was discovered by photographers that their cherished sharp focusing was detestable to artists, a convention arose that sharp focusing was wrong and soft focusing right. Hence we are getting focusing that is as much too soft as the old focusing was too sharp; and the "judges" are hastening to medal it, to show how advanced they are. Side by side with the satirist I detect also the propagandist. Just as, fifteen years ago, Mr. Whistler, in order to force the public to look at and for certain qualities in his work, would draw a pretty girl and then obliterate her face by slashing his pencil backward and forward across it, in order to checkmate the "Who is she?" and "Ain't she pretty!" people, so does Mr. Horsley-Hinton somewhat sacrifice one of his contributions to the Salon to teaching how the photographer can select a certain plane in his landscape for emphasis, and thus get effects of composition and perspective which are spoiled by the old plan of producing "depth of focus" by the use of a small stop, and flattening all the world into one well-defined plane. But there is reason in everything; and in this cunning but too instructive picture the transition from clear definition to downright blur is too sudden for my eye (which has perhaps too small a stop), and is underlined, besides, by the skill with which the artist plants his thistles and bushes, so as to catch

fascinating flecks of light. On the whole, work like Miss Mathilde Weil's, in which difficult focusing problems are not purposely set up for solution, and what focusing there is is quite simply done, with a view to the picture looking right, pleases my simple taste best. But do not conclude that I can not appreciate the Barbizonian charm of Mr. Cochrane's lanes and draught-horses, or that I would have their atmosphere marred by sharper focusing. His medal is one of the happy accidents of the "judging."
. . . .

If a calculation were made of the subjects represented by the total superficial area of silver, platinum, gum, and tissue in the galleries, the result would probably be ten per cent. of humanity, thirty per cent. of background, and sixty per cent. of clothes. In the New Gallery there is, amid acres of millinery and tailoring, just one small study of a whole woman, by Professor Ludwig von Jan, of a rich tawny-downy quality, which would be called superb, masterly, and so forth, had it been drawn by Henner. I invite our friends, the picture-fanciers, to look at it a moment and then think of the works of, say, Etty; or, if that is too dreadful, Ingres. Or say Correggio, and, at the opposite extreme of taste, the President of the Royal Academy. True, the camera will not build up the human figure into a monumental fiction as Michael Angelo did, or coil it cunningly into a decorative one, as Burne-Jones did. But it will draw it as it is, in the clearest purity or the softest mystery, as no draughtsman can or ever could. And by the seriousness of its veracity it will make the slightest lubricity intolerable. "Nudes from the Paris Salon" pass the moral octroi because they justify their rank as "high art" by the acute boredom into which they plunge the spectator. Their cheap and vulgar appeal is nullified by the vapid reality of their representation. Photography is so truthful—its subjects are so obviously realities and not idle fancies—that dignity is imposed on it as effectually as it is on a church congregation. Unfortunately, so is that false decency, rightly detested by artists, which teaches people to be ashamed of their bodies: and I am sorry to see that the photographic life-school still shirks the faces of its sitters, and thus gives them a disagreeable air of doing something they are ashamed of.

Photography in colors is either advancing with extraordinary strides or becoming very skilful in avoiding the subjects which baffle it. I remember seeing last year a color-photograph of a cauliflower which will haunt me to my grave, so very nearly right, and, consequently, so very exquisitely wrong was it. I was accustomed to cheerfully and flagrantly impossible groups of a strawberry, a bunch of grapes, a champagne-bottle, and a butterfly, remote alike from nature

and from art. But this confounded cauliflower was like Don Quixote's wits: it was just the millionth of a millimeter off the mark, and hence acquired a subtle impressiveness, the effect in the cauliflower's case being disquietingly baleful, as if the all but healthy green of the vegetable had been touched by the poison of the Borgias. I find no such horror in the fascinating peep-show arranged by Messrs. Lumière this year. It is true that they shun the cauliflower and revel only in garden-blooms, crockery, richly colored stuffs, French yellow-blacks, and elaborately tooled bookbindings. But the illusion is perfect; if the process is generally practicable, the "still-life" painter may pawn his poor box of squirts of gaudy clay and linseed, and apply for a place as bill-poster. In color-printing much ingenuity has been spent in forging old engravings of various kinds. Some of the attempts are quite successful; but why not forge banknotes instead? I no more doubt the capacity of photography for imitating the lower methods than I doubt Vasari's story of Michael Angelo successfully imitating the caricatures scrawled on the walls by the Roman rabble. What really did interest and stagger me were Mr. Roxby's three-color photographs from nature, by Dr. Gustav Selle's process. If that blue jar is not an accidental success out of a mass of failures—if Mr. Roxby can do it as often and as surely as Messrs. Window and Grove can photograph Miss Ellen Terry, then the advance represented by these prints is a very notable one indeed; for they are complete as pictures: it is no longer a question of getting a blue photograph of a blue jar: Mr. Roxby has got a complete picture of the jar, and a picture of fine quality at that. . . .

The conquest by photography of the whole field of monochromatic representative art may be regarded as completed by the work of this year. The conquest of color no longer seems far off or improbable; and the day may come when work like that of Hals and Velasquez may be done by men who have never painted anything except their own nails with pyro. The worst painters—those whose colors never were on sea or land—are the safest from supersession. As to the creative, dramatic, story-telling painters—Carpaccio and Mantegna and the miraculous Hogarth, for example—it is clear the photography can do their work only through a coöperation of sitter and camerist which would assimilate the relations of artist and model to those at present existing between playwright and actor. Indeed, just as the playwright is sometimes only a very humble employee of the actor- or actress-manager, it is conceivable that in dramatic and didactic photography the predominant partner will not be necessarily either the photographer or the model, but simply whichever of the twain contributes the rarest art to the coöperation. Already that instinctive animal, the public, goes

into a shop and says, "Have you any photographs of Mrs. Patrick Campbell?" and not "Have you any photographs by Elliott & Fry, Downey, etc., etc.?" The Salon is altering this, and photographs are becoming known as Demachys, Holland Days, Horsley-Hintons, and so forth, as you should say Greuzes, Hoppners, and Linnells. But then the Salon has not yet touched the art of Hogarth. When it does, "The Rake's Progress" will evidently depend as much on the genius of the rake as of the moralist who squeezes the bulb, and then we shall see what we shall see.

In conclusion, let me recommend these hasty notes of mine to an intelligently liberal construction by photographers. As to the painters and their fanciers, I snort defiance at them; their day of daubs is over.

Sadakichi Hartmann

"A Visit to Steichen's Studio" 1903

Edward Steichen (1879–1973) began as a painter and continued to paint until after World War I. His dual career as painter and photographer in the first decade of the century was taken by some as proof that photography must be an art. His early work met with great acclaim. Rodin thought him the perfect interpreter of his sculpture, critics said his gum prints were among the finest and most beautiful ever made, *Camera Work* devoted a supplement to his photographs in 1906. He collaborated very closely with Stieglitz during this time, sending art to his gallery from France. Sadakichi Hartmann (1867–1944) was a prominent critic of art and photography, whose writings appeared often in *Camera Notes* and *Camera Work*, frequently under the pseudonym Sidney Allan.

A dark, chilly December afternoon. The rain falls in thin, straight lines on the streets of New York, and the lighted shop windows are reflected, like some blurred and golden dream, on the slushy pavement.

You mount the slippery iron stairs of a humble and reticent office-building on Fifth Avenue. To the Negro, who comes to your ring, you say: "Mr. Steichen." He takes you up to the top floor, and carelessly, indifferently, as one points to a door, he points to the right. "Right in there, sir," he says.

You knock at the door. It is Mr. Steichen who admits you. It is a plain little room, without skylight, but with an artistic atmosphere of its own. The first impression is one of cool grays and pale terra-cotta, a studio void of furniture, but full of artistic accessories—a vagrom place, where a sort of orderly disorder, a sort of gypsy fashion prevails. The light of the waning day seems to rest in the center of the walls, while the corners are filled with twilight shadows, whose monotony is only here and there relieved by the color-notes of a Japanese lantern, a large glass vessel, or some other quaint accessory. A little plaster fragment of one of Rodin's statues hangs in proud isolation over the mantelpiece.

Mr. Steichen looms tall among his canvases, his arms crossed. With his square shoulders, his pallid, angular face, his dark, disheveled hair, his steady eyes, he reminds one of some old statue carved of wood, a quaint personality which has at times the air of some classical visionary, "a modern citizen of Calais," and at other times the deportment of some gallant figure of Sir Reynold's time.

He showed me his paintings, sketches, and photographs in rapid succession, which is one of the ordeals the art critic has to go through if he wants to become acquainted with a new man. I have probably passed through this severe experience oftener than any other man. I remember having visited at least four hundred and fifty American studios for a similar purpose—as I have convinced myself that it is the only way to get at a man's individuality. And art criticism is to me nothing but a peculiar mania for searching in every expression of art, and life as well, for its most individual, perhaps innermost, essence.

Biographical data do not interest me. What is the difference where a man is born, how old he is, where he studied, and where he was medaled? His art must speak—that is all I care for.

The first picture that attracted my attention in Steichen's studio was his Beethoven. It is all black and gray, huge and grim (though no canvass of colossal size) almost Doric in its severity. Everything is sacrificed to the idea, a study in the somber supremacy of genius and the martyrdom of the artist. It is Beethoven of the Fifth, not of the Ninth Symphony. It contains more strength and power than beauty. The simplicity of its composition is remarkable. This dark pyramidal shape of a seated figure, harsh and angular, as if cast in iron, crowned by a pale, apocalyptic face, is seen against a slab of grayish stone, whose monotony is scarcely broken by a vista of dark, twisted treetrunks in the upper corners. The face, haggard as a ghost of Dante's Inferno, makes one think of stormy tortuous nights, of sinister shadows trailing obstinately along the ground. It is a picture barbaric as the

clangor of iron chains against each other, the only attempt of the young painter in the epic field. It presents Steichen at the height of his ambition; but being a solitary effort, it is difficult to judge the artist's individuality solely from this exalted point of view. One cannot fully grasp his intentions, and it is very likely that he is not conscious of them himself.

In his landscapes, he reveals himself much more clearly. He has created a world of his own, but one based on actual things, translated into dreams. The rain still falls in thin, straight lines upon the blurred symphony of black and gold that glistens and glimmers on the wet pavements of Fifth Avenue, and there seems to be something analogous in the vertical lines of Steichen's landscapes and the gray lines of the rain outside. Nobody has carried the composition of lines further than Mr. Steichen. All his pictures are composed in vertical, diagonal, and outer-twisting line-work, but the lines are not as distinct and scientific as in Chavannes' or Tryon's pictures. They are not outlines, they only serve as accentuation. He endows each line with a mystic quality, and they run like some strange rune through his tonal composition. French critics have compared his pictures with musical compositions, but I beg to differ. To me all his tree-trunks, whether ethereally thin, repeating their wavering lines in some moon-hazed water, or crudely massive, towering into some dismal twilight atmosphere, are purely decorative. In order to be musical, the line composition has to serve as outlines for the color-patches which should in turn repeat or accentuate the motive of the spacing. In Steichen's pictures color is always subordinate to one tonal value, and the dominating idea is rather the expression of a single sentiment than the varying subtleties of a musical theme.

To me Steichen is a poet of rare depth and significance, who expresses his dreams, as does Maeterlinck, by surface decoration, and with the simplest of images—for instance, a vague vista of some nocturnal landscape seen through various clusters of branches, or a group of beech- and birch-trees, whose bark forms a quaint mosaic of horizontal color suggestions—can add something to our consciousness of life. His lines, blurred and indistinct as they generally are, are surprisingly eloquent and rhythmical. They become with him as suggestive as the dividing-line of some sad woman's lips, as fragile as some tremulous flower-branch writing strange hieroglyphics on the pale-blue sky, or as mystic as the visionary forms which rise in our mind's eye, as we peer through the prison-bars of modern life into some nocturnal landscape or twilight atmosphere. The only fault that I find with his landscapes, as with the majority of his pictures, is that they are not finished

pictures. They are sketches. A mere suggestion suffices him. It is left to the imagination of the spectator to carry them out to their full mental realization.

There are many other pictures of interest, mixtures of fantasy and reality clearly characteristic of the gifts and methods of Steichen. I mention some at random. A violent color-study of a sailor, reclining, with a red bowl in his hand; the heads of four Parisian types; an old man; an artist with his model supposed to be crossing one of the Seine bridges, with the silhouette of another bridge, and a vague suggestion of the Louvre in the background; the sphinx-like profile of some phantom woman; portraits of F. H. Day and Mrs. Käsebier; and color-schemes of various types of womanhood, one of a young girl and another of a woman of the world. The manner in which he used flowers to tell the characters of his sitters (in the two latter portraits) shows how deeply he can read into the human soul. The young girl folds her hands listlessly around a large round flower with a straight stem, the other flowers resting in a long and narrow vase; while the woman of fashion throws a weary glance at the few pink blossoms which loom from some large, round vase and which repeat the color-note of her face.

To look immediately at monotypes after you have looked at a lot of paintings would prove in most cases very disastrous to the former. But, strange to say, Steichen's photographs hold their own. It proved to me once more that in art the method of expression matters naught; that every effort, no matter in what medium, may become a work of art provided it manifests with utmost sincerity and intensity the emotions of a man face to face with nature and life.

The artistic photograph answers better than any other graphic art to the special necessities of a democratic and leveling age like ours. I believe this, besides some technical charms like the solidity of dark tones and the facility with which forms can be lost in shadows, is the principal reason why Steichen has chosen it as one of his mediums of expression.

He never relies upon accidents; he employs in his photographic portraits the same creative faculty which he employs in his paintings. That is the secret of his success. Look at his portraits of Lenbach, Stuck, Watts, Maeterlinck, Besnard, Bartholomé, and Rodin. In each, with the exception of Maeterlinck—and Maeterlinck's face seems to be one of those which do not lend themselves to pictorial representation, being too subtle, perhaps—he has fully grasped the sitter's personality. Lenbach he has treated like a "Lenbach," with the light-effects of an old master and with copious detail bristling with intellectuality, such

as the Munich master is apt to use in all his important portraits. The Stuck portrait is full of a riotous technique, with a *bravado* touch in the white glare in the corner of the eyes. This is a man often vulgar and crude, but with healthy blood in his veins—an artist personifying the *storm and stress* element in genre art. How calm and dignified in comparison is Steichen's handling of Watts! And then, again, his Besnard, direct and realistic, and yet unforeseen in its effect. The treatment of the big fur mantle, with which the bulky form of the painter is clad, is symbolical of his tumultuous technique, and the burst of light behind the curtains suggestive of Besnard color-orgies in violent yellows, blues, and reds. The Bartholomé is deficient in composition, the Greek column against which the sculptor is leaning and the huge caryatid, which he is contemplating and which fills the rest of the picture, are too obtrusive, and yet they intimate the dreams of this poet of form, with their mixed savor of the modern and archaic.

But the masterpiece of this collection is the Rodin. It cannot be improved upon. It is a portrait of Rodin, of the man as well as his art, and to me by far more satisfactory than Alexander's portrait of the French sculptor, excellent as it is. It is a whole man's life condensed into a simple sihouette, but a silhouette of somber splendor, powerful and personal, against a vast background, where black and white seem to struggle for supremacy. This print should, once and for all, end all dispute whether artistic photography is a process indicative of decadence, an impression under which so many people and most artists will seem to labor. A medium, so rich and so complete, one in which such a masterpiece can be achieved, the world can no longer ignore. The battle is won!

But it is getting late. Only a few more words, about Mr. Steichen's nudes.

"These nudes nobody seems to understand," Mr. Steichen remarks. "Do they mean anything to you?" It has grown dark and the rain is still tapping, curiously and faintly, at the window panes.

My answer is a smile. He does not know that my whole life has been a fight for the nude, for liberty of thought in literature and art, and how I silently rejoice when I meet a man with convictions similar to mine.

Steichen's photographic nudes are not as perfect as the majority of his portraits, but they contain perhaps the best and noblest aspirations of his artistic nature. They are absolutely incomprehensible to the crowd.

To him the naked body, as to any true lover of the nude, contains the ideals, both of mysticism and beauty. Their bodies are no paeans

of the flesh nor do they proclaim absolutely the purity of nudity. Steichen's nudes are a strange procession of female forms, naive, nonmoral, almost sexless, with shy, furtive movements, groping with their arms mysteriously in the air or assuming attitudes commonplace enough, but imbued with some mystic meaning, with the light concentrated on their thighs, their arms, or the back, while the rest of the body is drowned in darkness.

What does this all mean? Futile question. Can you explain the melancholy beauty of the falling rain, or tell why the slushy pavements, reflecting the glaring lights of Fifth Avenue stores, reminds us of the golden dreams the poets dream?

I seize my umbrella and say "Good night" indifferently as I might say it to any stranger, and he answers absent-mindedly "Come again!" He is thinking of his soul, and I am thinking of mine. What a foolish occupation is this busy, practical world of ours!

Alan Trachtenberg

Lewis Hine: The World of His Art 1977

AN EXCERPT

Photographic documentation of conditions among the poor began as early as the mid-nineteenth century, when reproduction was necessarily by line engraving. Lewis Hine (1874–1940), a sociologist who took up the camera to illustrate his concerns in 1905, was a crusader, much like Jacob Riis, the police reporter who exposed tenement squalor in New York. Hine had the advantage of arriving on the scene a few years after Riis, when photographic reproduction was efficient enough to allow wide dissemination of his images. His best-known work focussed on miners, immigrants, and child labor; the photographs of children working were instrumental in achieving passage of a child labor law. Later he photographed *Men At Work*. Alan Trachtenberg, professor of American Studies and English at Yale, writes frequently on photography.

"Ever—the Human Document to keep the present and future in touch with the past."

—LEWIS W. HINE

Certain photographs seem the epitome of a time and a place: true facts as much as they are works of art. Think of Mathew Brady's Civil War,

238

Eugene Atget's Paris, Walker Evans' 1930's: images so evocative of the spirit as well as the physical look of their subjects that they have become our very conception of that place at that time. Lewis Hine belongs among these true masters of the camera's power. His pictures make a history for us. They are also enthralling personal realities. . . . Beginning with his Ellis Island pictures, continuing through his Pittsburgh and child labor work, on into his Red Cross pictures and his "work portraits" in the 1920's, his documentation for the WPA, TVA, and other government agencies related to the "reconstruction" of the Depression years, Hine's work remained in touch with the history of his times.

Lewis Hine's subject was America in the first third of the twentieth century, the life of working people and the changing life of work itself. Throughout his career he was, in his own words, "looking at labor."[1] What he saw, we now take for granted as definitive realities of American life: the look of immigrants arriving at Ellis Island; of tenements and crowded streets in New York's Lower East Side; and, most indisputably, of early twentieth-century American working children —thin, ragged, often wan, more often tough, in coal mines and cotton mills, in field and street and home. . . .

As we shall see, Hine wrote often about his distinctive goals as an artist. It is perhaps unnecessary to add that these goals differed sharply from those promoted by the early defenders of photography as a medium with its own "high art" aesthetic. Hine clearly was not a Photo-Secessionist. He did not share with Alfred Stieglitz and his followers the belief that the fine print, the excellently made photograph that like a great painting could hang alone on a wall, was the critical mark of the true photographic picture. Hine had much different standards for what is valuable in a photograph. He was absorbed by social results, not technical perfection.

This difference was part of a larger contrast. "From their ivory tower," wrote Hine about the Photo-Secessionists in 1938, "how could they see way down to the substrata of it all?"[2] Broadly speaking, the Secessionists looked at the world and saw certain self-evident aesthetic themes: motherhood, as represented by women in flowing gowns attending to bright, happy children; labor, as represented by maidens plucking fruit in peaceful arbors. Their subjects were often beautiful

1. "Looking at Labor." Enclosed in letter to Paul Kellogg, July 6, 1939. Hine described the enclosure (a three-paragraph statement) as a "home-made publicity statement." University of Minnesota Social Welfare History Archives Center.

2. Letter to Elizabeth McCausland, Sept. 7, 1938. Elizabeth McCausland Papers, Archives of the American Institute of Art.

women, artists, and well-appointed rooms adorned with paintings and other artworks. They tended to view the world itself as a work of art, free of poverty, real labor, and conflict. To be sure, Stieglitz included city scenes in his subject matter—"metropolitan scenes," in his own words, "homely in themselves . . . presented in such a way as to impart to them a permanent value because of the poetic conception of the subject displayed in their rendering." But the references to "permanent value" and "poetic conception" suggest that these pictures were primarily aesthetic experiences, made at the expense of their intrinsic immediacy as subjects.

For Hine, the *art* of photography lay in its ability to interpret the everyday world, that of work, of poverty, of factory, street, household. He did not mean "humble" subjects; he did not mean "beauty" or "personal expression." He meant how people live. He wanted his pictures to make a difference in that world, to make living in it more bearable. He thought of his pictures as communications, and he guided his technique thereby. "All along," he wrote, "I had to be doubly sure that my photo-data was 100% pure—not retouching or fakery of any kind. This had its influence on my continued use of straight photography."[3] He, too, was a "straight" photographer, anticipating the direction taken by Stieglitz and Paul Strand after the demise of the Photo-Secession and soft-focus romanticism. To be "straight" for Hine meant more than purity of photographic means; it meant also a responsibility to the truth of his vision.

•

Hine's obsession with human labor had its roots in his working-class experiences as a youth. "After Grammar-school in Wisconsin's 'Sawdust City,' " he wrote about himself, "my education was transferred for seven years to the manual side of factory, store and bank. Here I lived behind the scenes in the life of the worker, gaining an understanding that increased through the years."[4] A down-to-earth sense of what lay "behind the scenes" remained with him and gave his work a key focus. "Cities do not build themselves," he wrote in his only published book, *Men at Work* (1932), "—machines cannot make machines—unless, back of them all, are the brains and toil of Men." "Behind the scenes," "back of them all"—Hine's own work would be devoted to bringing forward the work of others, especially the industrial laborers responsible for the daily existence of modern society: to bringing forward, that is, what was invisible to the eyes which see only

3. *"Notes on Early Influence,"* 1938. Elizabeth McCausland Papers.
4. *"Fifty Years of Preparation."* Attached to Guggenheim application, Oct., 1940. Enclosed in letter to Roy E. Stryker, Oct. 17, 1940. Stryker Papers, National Archives.

the products, the commodities, of labor. "Human values in photography," he wrote in 1933 to Florence Kellogg of *Survey Graphic*, could provide "a very important offset to some misconceptions about industry. One is that many of our national assets, fabrics, photographs, motors, airplanes and what-not—'Just happen,' as the products of a bunch of impersonal machines under the direction, perhaps of a few human robots. You and I may know that it isn't so, but many are just plain ignorant of the sweat and service that go into all these products of the machine."[5] To show the "sweat and service"—to remove the mystery of how things get made, how resources get transformed into usable objects, was the persistent goal even of Hine's earliest photographs.

His concern with labor was not simply to celebrate it, to praise the humble worker; nor like his predecessor in social photography, Jacob Riis, did he wish only to expose the horrible living conditions of urban workers. Riis's mission—one which he performed with extraordinary success—was to arouse the middle-class public to the existence of an "other half" in the slums and the infested tenements of the Lower East Side. He took his camera into the slums as if invading a foreign territory and brought back trophies of human degradation which shocked the public into action. Only passingly was he concerned with work, with labor, with how and where the demoralized people who inhabit his pictures made their living. Like Hine, his goal was to make the invisible visible, but with a crucial if subtle difference. Riis was an evangelist who appealed to moral conscience; his subjects were victims who deserved their brothers' charity. "Behind the scenes," on the other hand, implies another kind of emphasis—less upon a moral code than upon moral intelligence. It implies a curiosity about how the world works, with a special value set upon knowing such truths as how the clothes we wear get made and where our electrical power comes from. A curiosity, that is, about the processes of labor.

The setting for Lewis Hine's work was the broad movement for social welfare that arose early in the century, in the Progressive Era, and proliferated into a number of channels, including separate organizations and journals. Hine's vision, both for society and for photography, owes a great deal to the hopeful atmosphere of social betterment within which he worked. We can watch, almost step by step, as he discovered opportunities for the camera and a vocation for himself.

The first significant setting was the Ethical Culture School in New York City, where he taught for several years after attending the University of Chicago to study "the new education." He joined the teach-

5. *Feb. 17, 1933. Elizabeth McCausland Papers.*

ing staff of ECS in 1901—nature study and geography were his subjects—and it was here that he took up photography. ECS, from its beginnings as a "Workingman's School" in 1878, had pioneered in the teaching of handwork, craft skills, and industrial education. Although by the time Hine arrived the school had lost much of its working-class clientele, it retained its character as innovative, "progressive" in its values, and concerned with the integration of knowing and doing.[6]

The school principal, Frank Manny, wanted to use the camera for records; Hine assumed the task and soon developed a full-scale photography program. In later years, Hine tended to denigrate what he called "polishing brains at the Ethical Informary,"[7] but several essays he published between 1906 and 1908 on the program show the influence of the school's educational theory on his developing concept of photography. His articles are also the first serious discussion in print of the place of photography in schools—not as a "hobby" but as a discipline in its own right. . . .

The educational value of photography, then, fit neatly into the goals and methods of the progressive education movement. The camera, he wrote, aided learning by sharpening perception. On excursions —nature study outings or visits to factories—the camera helped direct attention to "the salient features of the trip" and encouraged students to make a "systematic attempt . . . to get snapshot records of what they saw." Hine also stressed the *practical* values of camera work: its working procedures, its discipline, its concomitant experiences of co-operation. He did not ignore the role of art in photography, but even here, practicality provided the focus. Photography taught art appreciation, for, Hine argued, "in the last analysis, good photography is a question of art." Not art for its own sake, but art as a heightened awareness of the world: "This sharpening of the vision to a better appreciation of the beauties about one I consider the best fruit of the whole work." As an example of such vision, he included in a 1908 essay a picture titled "A Tenement Madonna. A Study in Composition," and described the work as "a study made by the instructor to represent maternity among the poor, following the conception used by Raphael in his 'Madonna of the Chair.' "

Hine's ideas were still in flux, but what needs underlining among his thoughts at this stage is, first, his view of the practice of photography as an embodiment, or enactment, of progressive values: not merely as a way of making pictures, but as a way of practicing one's beliefs.

6. *Howard B. Radest*, Toward Common Ground: The Story of the Ethical Societies in the United States (*New York, 1969*), *pp. 16–17, 27–30, 42–44.*
7. *Letter to Arthur and Paul Kellogg, Feb. 7, 1931.*

Photography was a means of focusing activity in the world, a "scientific" means of heightening perception, sharing experiences, clarifying vision. The camera would shortly become Hine's own instrument for inserting himself into his times, his way of being-in-the-world.

A second important theme found throughout his early essays—more implicit than fully expressed—concerned the well-being of children, their happiness in creative activity, their preparation for later life. Here his ideas are in complete accord with those of Jane Addams, the notable reformer, writer, and founder of Hull-House in Chicago, who wrote in 1905: "A school which fails to give outlet and direction to the growing intelligence of the child 'to widen and organize his experience with reference to the world in which he lives' merely dresses his mind in antiquated precepts and gives him no clue to the life he must lead."[8] The fusion of learning with work—not the fragmented, regimented factory work of "child labor," but the healthy, creative, imaginative activity of children working in common on a project—was the heart of the "new pedagogy" she advocated. Hine agreed: children must learn to respect themselves, he wrote, and come to realize that they "amount to something." He proposed photography—camera work—as work that fit the need.

•

Hine had been led to Ellis Island, as he later quoted his wife's recollection of how the project began, by an "urge to capture and record some of the most picturesque of what many of our friends were talking about." "Our air was full of the new social spirit," Frank Manny remembered,"[9] and the "new immigration" suddenly loomed as a social problem of enormous proportions; the important social reform journal *Charities and the Commons* (later to be known as *The Survey*) devoted a series of articles in 1904 to the waves of newcomers from eastern and southern Europe and their often painful efforts to adjust to a new life. Reformers had been slow to awaken to the special needs and unique experiences of non–English-speaking immigrants. Sympathetic understanding was made no easier by a public opinion that invoked such racist stereotypes as "the hatchet-faced, pimply, sallow-cheeked, rat-eyed young men of the Russian-Jew colony" and editorials troubled by the "menace" of "foreign ideas," "festering" slums, and loose morals. It is typical that Riis's *How the Other Half Lives* (1889) is laced with many racial stereotypes.

Hine's urge to record the Ellis Island scene matched a new sensi-

8. *"Child Labor Legislation: A Requisite for Industrial Efficiency," In* Child Labor *(New York, 1905), p. 130.*

9. *"Notes on Early Influence,"* loc. cit.

tivity among informed Americans toward the immigrant; at the same time, it put him in touch with a social experience that was destined literally to transform American life. Beginning in the 1880's, "pushed" by poverty, famine, and persecution at home, and "pulled" by tales of opportunity in the New World and by ardent campaigns of American industrialists looking for fresh supplies of labor, tens of millions of people from predominantly peasant societies of Europe undertook the hazardous adventure of founding a new life. The numbers were overwhelming: as many as five thousand people passed through the Ellis Island facilities on one day. What made the experience all the more poignant was its historical dimensions. The flood of immigrants fed directly into the two rushing forces that were rapidly altering the course of American life: the growth of cities and the spread of the machine. Immigrants swelled the cities—creating in New York's Lower East Side, for example, the highest population density known in any city outside of Asia—and filled the ranks of unskilled labor, at wages of $1.50 a day, demanded by the expanding industrial machine. By 1924, fully one-third of the country's population were immigrants or their children, and an even higher proportion made up the industrial work force.

Ellis Island represented the opening American act of one of the most remarkable dramas in all of history: the conversion of agricultural laborers, rural homemakers, and traditional craftsmen into urban industrial workers. This transformation, which occurred with such swiftness that we almost forget it happened (it took not much more than a generation in this country) was to become Lewis Hine's major theme.

There was also, for Hine, a personal drama at Ellis Island. Something happened to him in the course of photographing this experience. He went to Ellis Island as a school photographer; he left it a master. He learned his work there, not only technically (he later prided himself for his ability to deal with "difficult situations and light conditions"[10]) but aesthetically.
. . . .

It is true that most of his pictures are posed—his technical apparatus of stand-camera and flash tray required the subject's cooperation —but many are posed frontally, with unmistakable eye-contact between the subject and the camera lens. Such posing, which remained one of the hallmarks of Hine's photography, was a significant departure from the methods of conventional portraiture. It was a standing rule among pictorialists—and one of the stylistic devices they used to set

10. Ibid.

apart their portraits, which they called "studies," from commercial
work—to avoid direct eye-contact as if it were a plague. Otherwise,
they felt, the print would look too much like a mere photograph. At
Ellis Island, Hine apparently discovered for himself the unique power
of frontality (as Stieglitz had done some years earlier in his famous
open-air portraits).

He also discovered something else related to frontality, something
that might be called "decorum."

. . . .

Typically in Hine's pictures, the place of the picture is a social
space in which individuality is defined, related, and expressed through
the encompassing detail.

. . . .

Lewis Hine entered swiftly upon his new vocation. The Ethical
Culture School and the classes he took at New York and Columbia
universities introduced him to a number of prominent reformers. He
came to know such leaders as Florence Kelley, the young Francis Per-
kins, John Spargo, and the Kellogg brothers, Arthur and Paul, who
worked at *Charities and the Commons*. The new social spirit caught him
up and gave him a focus. In 1908, he quit teaching—"merely changing
the educational efforts from the school-room to the world"—and en-
listed as "social photographer" in the cause of reform. Shortly there-
after, he joined the staff of the National Child Labor Committee.

It is important to note that reform, not revolution, was the aim of
Hine and his associates, even the Socialists among them. Their intent
was to cure industrial capitalism of its ills, making it more equitable in
the distribution of its fruits. The reformers believed in democracy and
wanted it to work. Something less than the system itself was in the
wrong: they stressed the environmental causes of slums, family break-
downs, crime, and undertook careful, detailed analyses of poverty, of
poor housing, of working children. Investigation became their mode;
Hine's photography, one of their principal instruments.

An early investigative opportunity of great consequence for Hine
came in 1907, when Paul Kellogg, managing editor of *Charities and the
Commons*, invited him to participate in the Pittsburgh Survey, which
would be the largest and most intense effort yet made in America to
study in detail a typical industrial city.

The fact that Pittsburgh had been selected for such a project sig-
nified an important shift in public awareness. It was a big city, run by
the rulers of the steel industry and torn by labor violence—the bloody
Homestead strike of the 1890's, which destroyed the fledgling steel-
workers' union, was still a fresh memory. The city was divided be-
tween masses of immigrant, largely unskilled workers on one hand and

a comfortable middle class of managers, executives, and politicians on the other. Pittsburgh was a classic example of absentee ownership in the new capitalist style: the new rulers were not individuals like Carnegie and Henry Frick of the previous generation, but corporations with large staffs of planners, engineers, and research scientists whose main offices were elsewhere. The selection of Pittsburgh signaled a recognition of where the power now lay in American society—in industrial capitalism—and where the major social problems occurred—in factories, in working-class homes and neighborhoods.

The Survey investigators—social workers and specialists in such fields as labor economics—combed the city to uncover facts about the ethnic composition of Pittsburgh's workers, their housing conditions and family life; about the cost of living, the quality of education and recreation, and working conditions; about wages, hours, and the workers' exposure to industrial accidents.[11] The investigators left nothing untouched, their findings eventually appearing in six thick volumes. The study exposed the rawest nerves of modern America, and following as it did for Hine on the Ellis Island project, confirmed the direction of his work: to depict working-class life in industrial America.

Hine's pictures appear in each of the Survey's six volumes. He worked in Pittsburgh for only three months (the entire investigation lasted a year and a half), but his achievement was enormous. His images contributed immeasurably to the success of the Survey, and helped make it even today a lively document. The effect of the experience on his own work was also immeasurable. The "survey" idea became his guiding principle. It provided both a form and an ideology, a way of working and a purpose.

"Survey" was a key item in the reform outlook. A survey, like a map, assumes that the world is comprehensible to rational understanding and that understanding can result in *social* action. It assumes, too, that once the plain facts, the map of the social terrain, are clear to everyone, then change or reform will naturally follow. Reasonable men and women, the Progressive ideology held, would behave in their collective self-interest once they saw the true shape of their affairs. To see was to know, and to know was to act. On just such a pristine formula was Progressive optimism—and Hine's—based.

. . . .

. . . The photographer had the mission of procuring irrefutable visual evidence, and he followed a practice similar to that of the Ellis Island pictures—arranging individuals and groups within their set-

11. *Paul Kellogg, "The Pittsburgh Survey,"* Charities and the Commons, *19 (Jan., 1909) 524.*

tings. The evidence adduced through his pictures was determined by the strategy of the Survey to propose simple, self-evident contrasts between what was thought to be true and what was discovered actually to be true. For example, the volume devoted to the steelworkers opens with a description of the "glamour" of the industry, of the "majestic and illimitable" power of steelmaking, and then raises against this positive image an antagonistic one: the insufferable "working life" of the men who labor in the mills. The camera had the specific task of disclosing the unseen and presenting it within a frame of reference that claimed the original image to be not so much false as incomplete. Thus Hine's pictures, like the Survey itself, do not aim to shock the viewer into rebellion, or to move him to a condemnation of a Dantean system, but to persuade the viewer that the full picture, the complete scene, includes contradictory evidence. Such facts as crippled workers, crowded one-room dwellings, dirty streets—and with it all, the strength and worthiness radiant in the faces of workers—prove that something is wrong. The challenge for the viewer is to reconcile the opposing images: industrial power and human waste.

Photographs presumably do not lie. Yet, presented differently, in a different frame of reference, they might lead to other interpretations. Indeed, several of the Pittsburgh pictures appeared in the September, 1912, issue of the *International Socialist Review*, in an article that called for open rebellion and urged workers to turn against both their industrial bosses and their conservative union leaders. To assure communication of the meaning intended by the photographer, the Survey recognized how important it was to key the pictures to a text, to establish a clearly articulated structure of presentation.

Finally, in Hine's Pittsburgh pictures, we witness the unfolding of a pedagogical purpose: the showing of the work place as central to human experience. His photographs do not break the rhythm of work but only interrupt it for a moment of reflection; they always allow the figure of the worker to dominate the instruments of his labor, the open hearths, the mine pits, the shovels and tongs and trolleys. Other photographers took their cameras into factories and workshops, but none developed the scene as fully as did Hine. The Pittsburgh Survey inaugurates his visual conception of industrial labor, a conception that would gather into a thundering critique and rebuke in the child labor pictures, and then into an affirmative summation in the "work portraits" and "men at work" series of the 1920's and 1930's.

•

"I'm sure I am right in my choice of work." Hine wrote to Frank Manny in 1910, two years after joining the staff of the National Child Labor Committee. "My child-labor photos have already set the author-

ities to work to see 'if such things can be possible.' They try to get around them by crying 'Fake' but therein lies the value of the data and a witness. My 'sociological horizon' broadens hourly." [12]

Written from the field, this statement provides a revealing slant on the photographs that have been hailed as Hine's greatest work. He would later comment that he thought his "work portraits" his best efforts, but there seems no doubt that his years with the NCLC were the most creative and inventive of his career. The aim of his photographs for the Committee was strictly functional; he wanted to move people to action. The photographs were evidence in the court of public opinion. And in gathering the evidence Hine learned the nature of the beast he was up against: not only the deadening effects of industrial labor on both children and adults, and its cruel effects on family life, but the connivance among employers, inspectors, and sometimes even parents and the working children themselves to pretend that all was well and natural. Thus his "sociological horizon" broadened to take in a complex social mechanism.

. . . The extraordinary and unprecedented body of thousands of child labor pictures not only records a vivid history of weary faces, exhausted and often crippled bodies, but also reflects a history of the artist's discoveries of the expressive range of his medium.

The two horizons, sociological and photographic, became one. Sociologically, Hine learned that not truth but self-interest moved "the authorities" and that only irrefutable truth, delivered in a package of photographic image and data (dates, places, names, ages, heights, hours of work, daily earnings), would appeal to the sole force capable of moving them: public opinion. Photographically, he learned that the image which packed the most powerful social punch was that with the strongest aesthetic impact, because this was the image that most effectively made the public a witness to the scenes of degradation that filled his angry vision in these years.

Hine gathered verbal data along with his pictures, wrote copious reports, gave lectures and slide talks, and often published brief essays on his investigations. These writings, often moving and acute in their own right, deserve our attention; they express Hine's feelings about his labor in the cause of a better life for working people, as well as his ideas about the cause. But his true labor was photography, and this period of intense commitment and agitation resulted in a body of images that virtually revolutionized the medium.

.

12. "Notes on Early Influence," loc. cit.

There was real heroism in this project that covered tens of thousands of miles, entailing as it did physical adventure and risk. The 1909 annual NCLC report described Hine as having made over 800 photographs the previous year, photographs that were "of great value in furnishing visual testimony in corroboration of evidence gathered in field investigation." The evidence was often hidden, kept out of sight. Bosses guarded their mills and cotton fields and sweatshops with a jealous eye. (They still do, as contemporary photographers chased from factory gates and migrant worker camps can testify.) Hine devised an ingenious bag of tricks to elude the barriers. He sometimes pretended he was after pictures of machines, not children, or he passed himself off as a salesman. Often, one hand in his pocket made notes on ages and sizes while the other worked the camera, the buttons on his coat serving as a measure of height. "Sneak" work was common, and so was physical threat: "I have a number of times been very near getting what has been coming to me from those who do not agree with me on child labor matters," he once wrote.[13]

. . . Wherever possible, Hine tried to photograph the work place itself, showing the details of labor. Where this was not feasible, he waited at factory gates to catch his damning images and followed children to their homes. But the work place was—and became again in his pictures of the 1920's and 1930's—his quarry. It was there that he made one of the exciting discoveries in the history of photography, equal to Brady's on the battlefield: that the work site could become the site of powerful pictures, rich in a special human content. In a significant sense, Hine can be said to have created his own subject matter. His camera is no mere recording device; others looked at the same scene, but Hine *saw* what he looked at. One might surmise that the reason he saw it so clearly was that he recognized how much his own seeing participated in the act he photographed. Insofar as his camera became part of the scene, the work place became his own place of work, the place where his particular photographic art came into its own. It is appropriate, and significant, that his pictures frequently showed signs, such as his own shadow, of the process that produced them.

. . . But the task of revealing what he saw was a multiple one. It could not depend on single images. The nature of his assignments and the function to which his pictures would be put served to diminish the independent value of any single image in favor of an amassing of images: so many accumulated details, so much truth, meant all the more

13. *"Tasks in the Tenements,"* Child Labor Bulletin, *3 (1914–15), 95.*

irrefutable evidence. While each picture, then, had its own backing of data, its own internal story, it took its meaning ultimately from the larger story. This is the task that perhaps requires the most strenuous act of imagination on the part of Hine's audience today—to see his individual images in the context of their companions. As much as possible, his work should be seen in its original form, in the myriad of reports and pamphlets of the NCLC and on the pages of *The Survey* and other journals: single pictures with captions (one can guess that Hine himself wrote most of these); groups of pictures dealing with specific industries; pictures sequenced parallel to actual narratives, stories written for schoolchildren (again presumably written by him) to teach them about the labor represented by their cotton dresses, their medicine bottles, their coal heat; and frequent montages of images (an early use of this device) in exhibition posters and especially in the brilliant form, which he undoubtedly invented, called "Time Exposures by Lewis Hine."

The montage posters are perhaps the most controlled sequences Hine developed in the sense of being tightly organized, and here the interplay between the single image and overall ideology, or social "map," is clearest. The message cannot be misconstrued: child labor, the photographs *show* us, is "making human junk." Yet the situation is not hopeless: "What Are We Going to Do About It?" depicts several solutions. Hine saw child labor as a process, a "vicious circle," in which everyone suffered. The photographed children are not simply victims tugging at our hearts for charity; they are signs of a collective predicament, a concrete and systematic social process. "You all know how the circle goes," Hine wrote; "child labor, illiteracy, industrial inefficiency, low wages, long hours, low standards of living, bad housing, poor food, unemployment, intemperance, disease, poverty, child labor, illiteracy, industrial inefficiency, low wages—but we are repeating."

Thus Hine describes the making of a chronically underprivileged, unskilled working class, a systematic destruction of morale and human resources. And the blame, at bottom is simply profit. Not work by itself, which can be healthy for children, but work dictated by the economic needs of the capitalist. "There is work which profits the children, and there is work that brings profit only to employers. . . . The object of employing children is not to train them, but to get high profits from their work."[14] And not only from *their* work: ". . . the employer of children forces all wages down to the level of the child's wage."[15]

14. *"The High Cost of Child Labor,"* Child Labor Bulletin, *3 (1914–15), 66.*
15. *"The High Cost of Child Labor" (Exhibit Handbook),* loc. cit., *30.*

Hine's posters, as well as his articles, were not simply exposés; they were polemics. And the antagonist was an irrational, self-destructive social system which he described with Dickensian sarcasm: "Industry, with its usual unselfish, altruistic spirit, has been demonstrating for years how we may utilize waste. . . . The master minds of industry have been greatly disturbed over the forces and activities in the home that, like the mighty Niagara, are sweeping onward and accomplishing nothing. They see mothers spending whole days at housework, children at play, neighbors visiting with each other. But what does it all amount to? If these golden moments could be harnessed to the wheels of Industry—Ah, what a millennium! If each of our 25,000,000 children, for example, could knit for three hours a day . . . we could keep the world in socks."[16]

But if Hine's pictures take their full force from their context, we can still see his particular social vision, his own humanity, in single images. Unlike the subjects in Jacob Riis's pictures, who are usually downtrodden, passive, and objects of pity or horror, Hine's people are alive and tough. His children have savvy—*savoir-faire*, a worldly air. They have not succumbed. Their spirit is at odds with their surroundings. And this contradiction fills the pictures with an air of tension—not between such abstractions as "suffering, helpless children" and "a brutal system" but between living creatures and a very particular fate.

"For many years," Hine wrote, "I have followed the procession of child workers winding through a thousand industrial communities, from the canneries of Maine to the fields of Texas. I have heard their tragic stories, watched their cramped lives and seen their fruitless struggles in the industrial game where the odds are all against them. I wish I could give you a bird's-eye view of my varied experiences."[17] Hine's work sets a special value upon firsthand experience in grander terms, upon the artist's role as *witness*. He held with Whitman that "the true use for the imaginative faculty of modern times is to give ultimate vivifications to facts, to science, and to common lives." With other artists of his time, Hine shared a focus on the everyday: in the social reporting of Lincoln Steffens and Jack London; in the fiction of Stephen Crane, Theodore Dreiser, and, later, John Dos Passos; and in the new subject matter of city streets painted by the Ashcan group, especially Robert Henri and John Sloan.

That he was entirely conscious of this role is clear from an essay he wrote in 1909, early in his work for the NCLC, which he delivered as a lecture with slides. "Social Photography: How the Camera May

16. *"Tasks in the Tenements,"* loc. cit., *95–96*.
17. *"The High Cost of Child Labor,"* loc. cit., *63*.

252 PHOTOGRAPHY IN PRINT

Help in the Social Uplift" is a personal manifesto. It laid the basis for
a certain *art* of photography to which he remained true for the rest of
his life.

. . . In his essay, Hine makes clear that he gave serious thought to
the aesthetic issues involved in photography as a medium of commu-
nication.

"Where lies the power in a picture?" he asked as he flashed on the
screen an image of newsies huddled under the Brooklyn Bridge at 3
A.M., waiting for customers. The picture, he explained, "is a symbol
that brings one immediately into close touch with reality"; it tells "a
story packed into the most condensed and vital form." Indeed, it is
even "more effective than the reality would have been, because, in the
picture, the non-essential and conflicting interests have been elimi-
nated." A picture, then, is the product of a specific understanding, and
to communicate its story it must be clear about its own message. Its
vital form depends upon the maker's deliberate elimination of the non-
essential.

So much is equally true of all pictures—paintings, engravings, or
photographs. But, Hine added, "the photograph has an added realism
of its own"—an "inherent attraction" that engenders the common belief
that "the photograph cannot falsify." Because "this unbounded faith in
the integrity of photography is often rudely shaken" (for "while pho-
tographs may not lie, liars may photograph"), it is doubly important,
"in our revelation of the truth, to see to it that the camera we depend
upon contracts no bad habits." Because of its inherent "realism" or
literalism, the photograph might be used as a powerful weapon of
deception. For the same reasons, its power as a "lever . . . for the social
uplift" is equally impressive. But how to draw upon this power? Here
Hine takes a step toward a coherent and advanced theory of photogra-
phy by placing the power for "uplift" in the effect that a verbal caption
can have upon a photograph. He dramatized this effect by reading a
passage from Hugo on the "dismal servitude" of children against a
picture "of a tiny spinner in a Carolina cotton-mill." "With a picture
thus sympathetically interpreted, what a lever we have for the social
uplift." . . .

One other aspect of Hine's work demands comment: its *democratic*
element. Hine was determined to share not only his firsthand experi-
ences in the form of images but also his experiences in the craft and
technique of his art. "The greatest advance in social work," he wrote in
his 1909 essay, "is to be made by the popularizing of camera work, so
these records can be made by those who are in the thick of the battle."
He wished to share, to democratize, the apparatus of picture-making,

to dispel the aura of the arcane from the camera. "Fight it out for yourselves," he urged his audience, "for better little technique and much sympathy than the reverse."

"I have had all along, as you know," he wrote to a friend in 1910, "a conviction that my demonstration of the value of the photographic appeal can find its real fruition best if it helps the workers to realize that they themselves can use it as a lever even tho it may not be the mainspring of the works. . . ."[18]

18. *"Notes on Early Influence,"* loc. cit.

Berenice Abbott

The World of Atget
1964
AN EXCERPT

From 1898 till his death in 1927, Eugène Atget (1856–1927)
roamed the streets of Paris with his view camera, recording
the alleys, house fronts, store windows, and some of the city's
people. Sometimes he took consecutive images of a street that
resemble cinematic sequences. He barely eked out a living
selling photographs. At his death, he was practically un-
known, though the Surrealists had been interested in what he
did. Berenice Abbott, herself a photographer, met Atget in
Paris in the twenties while she was working for Man Ray.
After Atget's death, she saved his negatives, printed and pub-
lished them. When his work gained recognition through her
efforts, it made a strong impression on documentary photog-
raphers everywhere.

I believe the photographer's eye develops to a more intense awareness
than other people's, as a dancer develops his muscles and limbs, and a
musician his ear. I cannot agree with M. Jean Leroy who said in *Camera
Magazine* that Atget was merely a disappointed painter or actor, and a
little ashamed of his medium. While both photographer and painter
produce visual images on two-dimensional surfaces, they differ funda-
mentally in their ways of seeing. In most cases it is the act of painting

that absorbs the painter. But this act is highly subjective. His focus is on the canvas itself; his fancy is purely his own.

The photographer's act is to see the outside world precisely, with intelligence as well as sensuous insight. This act of seeing sharpens the eye to an unprecedented acuteness. He often sees swiftly an entire scene that most people would pass unnoticed. His vision is objective, primarily. His focus is on the world, the scene, the subject, the detail. As he scans his subject he sees as the lens sees, which differs from human vision. Simultaneously he sees the end result, which is to say he sees photographically.

In Atget's time, photography was so young and so new a medium, that the custom of adopting it solely and formally as a profession was not yet established. There were almost no schools for photography; it was not considered an art. At best, it was a commercial trade or a hobby for the wealthy.

Today this has changed. There are schools of all shades of excellence, and young people set out on careers of photography. This is quite natural, since the language of the lens is attuned to the accelerated pace and tension of our time. Photography as an art is the offspring of the scientific age.

There have been repeated references to Atget's "naïveté," conjectures that he did not really know what he was doing, that reflections in his shop front windows were accidents which he did not even see. It is of course impossible for this to be true. Most photographers today use small cameras and consider this to be "modern." They see their subjects through a very inadequate view finder, reduced to a "fine print" size, incapable of giving full detail, especially detail in shadow. Or they may use the small ground glass where the eye is rarely shielded sufficiently from light to see completely. A scene reduced to a dim image on a ground glass even 4 x 5 inches in size does not bring to the eye all that is in the scene. Such photographers are often surprised when they see details in the print that they never noticed at the scene.

I invite those who think that Atget's reflections in his shop fronts were "accident" to look more than once at a fair-sized ground glass. Seeing reflections in windows is as natural for photographers as seeing shadows and the wonders of light. Reflections are mysterious and suggestive. They are a very legitimate montage effect in reality itself. Is there anything more mysterious than reality? The photographer particularly is endowed by nature and necessity to probe and search these mysteries. A man who knew so unfailingly where to place his camera knew very well what he was doing.

With a hand camera there is often accident. Background figures

may not be related and can appear unexpectedly. Speed negates precise framing and spatial relationships. Any number of unforeseen things can happen. Some photographers even use the accident as a crutch. The experts are few and they know the type of subject matter to be handled by such a camera.

When a camera is firmly attached to a tripod, and the large ground glass is carefully scanned for overall focus under a huge dark cloth, draped to shield the eyes from light, it becomes possible to see all parts of the image. Not only does focusing become an act of decision (Atget had to make many peculiar ones) depending on action, depth of field, light intensity, to mention only a few factors involved, but it can also become a subtle and conscious creative act. Before that, the photographer has another important decision to make: that one best spot to place his camera. What must the perspective be? That question alone requires a number of decisions, with final careful adjustments. Every step in the process of making a photograph is preceded by a conscious decision which depends on the man in back of the camera and the qualities that go to make up that man, his taste, to say nothing of his philosophy.

Atget began to understand the effects of light and shade, of texture and mood, of perspective and depth—qualities inherent in the art of photography.

.

Why or how he became an actor I do not know. Calmette wrote to me in answer to further questions that Atget became an actor in 1887, or, at most, a few years before that. His life in the theater may have lasted about fifteen years; but in any case his theatrical itinerary broadened his knowledge of Paris and its environs, and so must have stimulated his historical curiosity as well as his esthetic appreciation.

Inter-relation of actor with audience developed a psychology for human exchange and sympathy, evident in his pictures of people, who appear to have coöperated with the photographer. He did not treat these pictures as still-lifes. Human dignity is expressed in each and all of them. This could only result from his sure and sympathetic approach and handling of even the most recalcitrant subjects.

To Atget the visible world became the stage; man himself and the effects of man, the great drama. Men and women in the Paris streets became the cast of characters. He knew how to dramatize his subjects, but his photographs were never merely theatrical. The stage was now transformed to the larger scene in front of his lens, and the photographs repeatedly suggest the stage setting which one beholds after the curtain goes up.

This new calling became an act of discovery. He pursued it with the passion essential for any great artist through whatever medium he may function. What else could have driven Atget to the exhausting task of physical drudgery, with an unbelievably heavy load of glass plates, large view camera, tripod, holders, and the like? Twelve plates alone weigh four pounds. And a camera the size of his, with accessories, can weigh from forty to fifty pounds. This load he carried over and around and up and down Paris, to his last year.

On top of this, consider the years of painstaking drudgery in the darkroom, where patience and accuracy are of absolute necessity. Furthermore, identification was written on each print, which was then stamped and placed in an album, itself annotated and numbered.

To sell his pictures for the money to buy plates and other materials he made innumerable trips across the city to prospective clients. In his notebook, on the face of which is printed "Repertoire," he listed many names of buyers and the particular interests of some of them. This is a partial list of professions to which he catered: designers, illustrators, amateurs of Old Paris, theatrical decorators, cinema (Pathé Frères and many others), architects, tapestry makers, couturiers, theater directors, sign painters, editors, sculptors and painters, among them Bourgain, Vallet, Dunoyer de Segonzac, Vlaminck, Utrillo, Braque, Kisling, Foujita, and many more. He noted the hour at which they could be seen, at which floor and which door, and at which Metro exit. Some trips were made to get permission to photograph certain places.

There are also entries of the prices he received, indicative of the value placed on photographs by his French clientele. Masterpieces of photography sold for pennies. The prices range from 0.25 francs to 1.25 francs by 1911. Occasionally there were thirteen for 12 francs, but the prices went up later, from 1.50 to 5 francs.
. . . .

George Santayana

"The Photograph and the Mental Image" n.d.

AN EXCERPT

Santayana (1863–1952), who retired from the Harvard faculty in 1912, presented this paper as a talk to the Harvard Camera Club. Convinced of the truth of the theory of biological evolution, Santayana consistently sought a means of relating aesthetic experience to the biological context of human nature. His emphasis on art's ability to call back fleeting experience echoes in a generalized way the first commentators' gratefulness to photography for keeping distant friends and loved ones who had died close at hand. Santayana's assertion that photography cannot have spiritual value is doubtless based on the distinction he drew between practical and fine arts. The question of whether photography was an art and if so, what kind of art, reached beyond the art journals.

The mental image already carries us . . . from the animal to the spiritual sphere—to the sphere of practical wisdom and free speculation. But perception, however useful and enlightening for the moment, would not do us much service if it could not be revived upon occasion, just as an animal's victory over a given enemy would not do much for his safety, if that enemy could not be recognised and headed off upon a second approach. The organism must not only react upon objects, it

must react upon them regularly. Reflex action must settle down into instinct. So too the mental image becomes important chiefly by becoming permanent. To acquire conscious experience we must be able to retain past images and compare them with their successors, just as to attain practical skill we must keep open those cerebral paths which were cut and cleared by our first training. . . .

. . . The greater part of the experiences which fill a life are lost irretrievably—although their lesson and influence may remain—because the brain, in spite of its prodigious complexity, has no room for so many impressions, has not signals and wires and energy enough for so many successive messages, for so many exact revivals of experience, as a perfect memory would require. Therefore, although everything in the physical world seems to us at times to change quickly enough, everything physical is stable in comparison with the absolute instability of images in the mind. They cannot be retained unchanged for an instant, nor recalled unchanged at any subsequent time.

This absolute flux of mental images is annoying in life and melancholy in reflection. To be sure, those images do not make up the best part of the mind nor the kernel of our individuality: if they did, we should not be able to lament their flight, which we should ourselves accompany. There is something comparatively permanent in us that takes note of mutation and is the standard of its celerity. There are instincts and ideals and intelligible truths which make a background for that flux of sensibility, as the moon and stars make a background for the drifting clouds. The moon and stars move also, but not so quickly, nor at the rate we may attribute to them by an optical illusion, when we but half see them behind those moving veils. But just because we and our interests endure, we lament the lapse of those vivid perceptions which have been the filling of our lives, the material, as it were, of our being. We survive them with a certain sense of emptiness and futility, as if we were surviving ourselves. For the very reason that the higher functions of the human mind have some kinship with the eternal [and the abstract super-structure of thought and expression can endure], we are disconcerted to find that the rest is gone. Hence we are glad when some chance encounter rekindles old memories, and makes Richard himself again. We are grateful to any art which restores that sensuous filling of experience, which was its most lively and substantial part in passing, but which now is so hopelessly past.

And this—for I come at last to our main subject—precisely this is the function of photography. The eye has only one retina, the brain a limited capacity for storage; but the camera can receive any number of plates, and the new need never blur nor crowd out the old. Here is a

new and accurate visual memory, a perfect record of what the brain must necessarily forget or confuse. Here is an art that truly imitates the given nature, in the proper meaning of this much-abused phrase—an art that carries on in the spirit of nature, but with another organ, functions which the given nature imperfectly performs. Photography imitates memory, so that its product, the photograph, carries out the function imperfectly fulfilled by the mental image. The virtue of photography is to preserve the visible semblance of interesting things so that the memory of them may be fixed or accurately restored.

Once before in the history of mankind, or rather at a time before the history we know began to gather, there was a mechanical discovery which served a similar purpose—I mean when an artificial memory for words, and through words for events and ideas, was invented in writing. Writing was of course a more momentous discovery than photography. The farther down we pass in the history of inventions the more rapid and numerous they are, since they suggest and prepare one another: yet the farther back we go in time the more important the inventions become and the more rare. Writing preceded printing, and was more important than printing: and the invention of speech was older than that of writing and far more important; for the first steps of progress have to make that human nature which the later steps merely subserve and develop. Yet those ancient and magnificent inventions of speech and writing helped human memory to retain only those things which the understanding had already worked over: they recorded and transmitted the intelligible, the describable, what has passed through the processes of abstraction and verbal expression: our humbler art of photography has come to help us in the weakest part of our endowment, to rescue from oblivion the most fleeting portion of our experience—the momentary vision, the irrevocable mental image.

That this is the function of photography is made clear by the use to which it was first put. Photography was first employed in portraiture; that is, it was employed to preserve those mental images which we most dislike to lose, the images of familiar faces. Photography at first was asked to do nothing but to embalm our best smiles for the benefit of our friends and our best clothes for the amusement of posterity. Neither thing lasts, and photography came as a welcome salve to keep those precious, if slightly ridiculous, things a little longer in the world. It consoled both our sorrows and our vanity, and we collected photographs like little relics and mementoes of the surfaces of our past life. For many years photography had merely this sentimental function; but sentiment is akin to humour, and now for one photograph that is made to be enshrined a hundred are made to be smiled at.

Portraits are no longer the only product of photography. The

technique of the art has of late so much improved that it can be turned to many other uses. It now renders for us not only monuments and works of other arts, but every aspect of life in its instantaneous truth; and as a means of enjoying travel by the fireside and a gallery of old masterpieces at home, it has wholly outstripped prints and poetry and verbal descriptions of every kind. I do not know how you may feel, but I confess that in cutting the pages of a magazine—and I never cut them unless they are illustrated—it is only the photographs that really interest me: the drawings are seldom the work of a hand that, in Michael Angelo's phrase, obeys an intellect; they are usually feeble and sketchy representatives of the fact and still more feeble representatives of the ideal. The photographs, on the other hand, are truly graphic; there is the unalloyed fact; there is what you would go to see if you had wings and an infinite circle of acquaintance; there is the proof that all they tell us about China or South Africa is no myth, but that men on two legs walk about there, looking quite recognisably human, caught in the act and gesture of life, in spite of their strange surroundings and peculiar gear. With such objects before me, I open my eyes. I look with the same inevitable interest as if the whole procession of life were passing under my windows. The sophisticated concern about art sinks before the spontaneous love of reality, and I thank the photograph for being so transparent a vehicle for things and sparing me, in my acquaintance with remote fact, the [untrustworthy and] impertinent medium of a reporting mind.

Henceforth history need not be a prosy tome in fine print without illustrations: posterity will know of us not merely what we did and thought, but how we looked and what we saw. The reportable outline of events will be filled in with the material of sense, faithfully preserved and easily communicable. Even as it is, the remnants of graphic arts of antiquity give us the most vivid notion we can have of those times; yet those works betray rather than depict the age that produced them, for they were meant for objects of worship or were at any rate largely predetermined by traditional mannerisms, by symbolic conventions, and by the love of absolute beauty. If such ideal works, surviving by accident and in small numbers, yet vivify for us the records of past time, how much more illuminating will be those innumerable reproductions of everything that surrounds and interests us, direct reproductions uninfluenced by any human bias other than that shown in the selection of their subjects! As students of zoology put on their slides infinitely fine and numerous sections of the specimens they study, so the photographer can furnish for the instruction of posterity infinitely fine and numerous cross-sections of the present world of men.

But perhaps I am not saying what you expected to hear; and it

may seem that in my praises of photography I miss the main point, and say nothing about its latest successes and its highest ambitions. Cannot photographs be beautiful? Is not photography a branch of fine art? Cannot the impression of a sunset, snapped at the right moment on the right day and printed on the right paper with reagents of the right variety, have all the sweep and subtlety of a Turner? Cannot a model's head be so posed and lighted that the result will wonderfully resemble a Rembrandt or a Holbein? Yes, and there is no limit that I know of to the progress which photography may make in these directions. I have a great faith in natural science, for being very ignorant in that field I find it more favourable to the exercise of faith in buried treasures, than other fields where I have rummaged more. Natural science may find in the processes of photography applications no less brilliant than it finds in mechanical arts: and I fully expect to find colour and permanence and many unthought of perfections soon added to those which good photographs already have. And while the processes of the art are being perfected, the experience and taste of photographers may also grow; the more they are masters of their art the better they will know what objects gain most by photography, what lights and what poses are permanently pleasing, and what treatment and retouching can be occasionally helpful. The resources of invention in arranging models can increase indefinitely, and also the tact in catching the beautiful aspects of cloud, mountain and sea. But when we speak of coordinating photography with the fine arts, we must beware of confusion. There is no occasion to be niggardly in the use of pleasant words, and since the word art has in some circles a sacramental value, we may gladly use it to describe any ingenious process by which man produces things which by their use or beauty are delightful to him. And, in a genuine sense, the taking and developing of a photograph requires art; and this art, being governed by a desire for beauty and being productive of beautiful things, may well be called a fine art. For fine art is usually said to be distinguished from useful art by having beauty for its chief aim and the love of beauty for its chief inspiration.

But a wide use of words, legitimate if it is inevitable or if it gives anybody pleasure, should not be allowed to blind us to important distinctions in things: and while photography is surely an art and its products are often beautiful, there remains a deep and quite unbridgeable chasm between it and that other kind of art whose essence is not so much to mirror or reproduce the outer aspects of things, however bewitching, as to create in imitation of the processes of Nature, but in different materials, things analogous to the natural. These products of creative art are shadows rather than replicas of reality and present

things as they could never have actually existed: men of stone, passions that obey the rules of prosody, heart-throbs that keep time with an orchestra, tragedies that unravel themselves in five acts without irrelevant incidents—in a word, substitutes for reality that transform it into the materially impossible, in order to bring it within the sphere of the persuasive and the divine. In order to touch creative art of this sort, it is not enough to produce beautiful things, else the gardener no less than the photographer would be a creative artist; the gardener also watches his opportunity, training and guiding his natural engine, the plant, to desirable issues. And the gardener, too, is no utilitarian, but exists wholly in the service of beauty. Indeed, if some voluptuary should walk about the earth choosing none but the pleasant places and refusing to lift his eyes on anything but the beautiful, and should studiously keep in his mind's album nothing but images of beautiful things—he would not be a creative artist; his art of opportune perception and enchanted memory would have weakened his energies without producing anything of spiritual value to himself or to the world. And what would have been lacking in that luxurious passivity? Surely the humane reaction, the selective glance that neglects what it despises in order to extricate and remodel what it loves. What constitutes ideal art, then, is the making of something over under the guidance of a human interest. What issues from any process not guided by a human impulse cannot have ideal value, even if that process went on in the *camera obscura* of a passive and indolent brain.

Now a photograph is produced by a machine, just as the images of fancy and memory are reproduced by a machine; both the camera and the brain transform their impressions in many ways, but not as a moral and conscious interest would transform them. The accidental transformations of the image in photography and memory are consequently defects and imperfections, while the intentional transformations of ideal art are beauties. For the function of photographs and of mental images is to revive experience, but the function of creative art is to interpret experience. Creative art must transform the object, in order to tell us something more about it; for an interpretation that merely repeated the identical terms of its text would be a laughable and stupid thing. Yet just this literal repetition makes the success of an art whose function is revival. When you ask a man to explain his words, it is an insult if he merely repeats them; when you ask him to repeat his words, he is a fool if he sets about to explain them. So when I ask a photograph to come to the succour of my weak memory and visual imagination, and to tell me how things look, I do not want that photograph to be retouched or blurred or idealized; and when I ask a poet to tell me what

his passions meant, I do not wish him to inform me of the time of day or of the colours of the rainbow. There is one art to focus and revive experience, there is another art to digest and absorb it. The one is an artificial memory, the other a petrified intelligence.

Accordingly it seems to me that a profound misunderstanding lurks in the criticism often made of photography, that it is crude and literal. Its defects are the exact opposite: namely, that as yet it cannot reproduce our visual sensations without subtracting something from their colour and motion, without dropping something of their stimulating and instructive power. When photography becomes perfect, all our visual experience will be revivable at will—and this would be a truly miraculous triumph over mortal limitations, won, as all triumphs are won, by docility to the facts and laws of the real world. To complain of a photograph for being literal and merciless, is like complaining of a good memory that will not suffer you to forget your sins. A good memory is a good thing for a good man, and to admit all the facts is the beginning of salvation. So with the contemplation of Nature and man; a genuine love of mere perception, a clear vision of things as they are, is the necessary condition of artistic power or of critical capacity. Photography is useful to the artist because it helps him to see and to keep seeing, and helpful to every intelligent man because it enables him to see much that from his station in space and time, is naturally invisible. To be accurate and complete is therefore the ideal of photography, as of memory: an ideal which is not the less genuine because it is not absolutely realisable and not the less worthy because, even if it could be realised, it would still leave room for other and higher things. For a virtue of subordinate things, when they are genuine, is to remain subordinate. If memory were perfectly developed it would not prevent us from imagining all sorts of possible and yet unrealised things: on the contrary it would furnish the mind with clearer and more numerous analogies for its invention to follow, and keep its ideals from being childish and irrelevant. So too the prevalence of photography will not tend to kill the impulse to design, but rather stimulate and train it by focussing attention on that natural structure of things by which all beautiful design is inspired.

The same misunderstanding which occasions this reproach of literalness addressed to photography, is the cause also of a mistaken ambition on its part—the ambition to be ideal [a very different thing, I need hardly say, from the ambition to be beautiful]. For good photographs will be beautiful when their object is beautiful and poetical when their object is poetical; but to be ideal they would have to transform the object so as to make it a clearer response to the observer's

predetermined interests. The camera cannot have a human bias, it cannot exercise a selective attention or be guided by an imaginative impulse: it will do its honest work in an honest way. Therefore the sentimental photographer is driven to manipulate the model, to try to give it an interesting expression, to make it smile or bend or dress up to resemble something ideal which he has seen upon the stage or in the works of old masters. The art of photography is thus superposed, as it were, on the art of posing, and the new interest which the photograph acquires is the somewhat meretricious interest of the living picture it represents. No, that is a false ambition; and whoever is seriously tempted by it ought to abandon photography altogether, take pen or pencil in hand, and train himself to the production of things not seen by the retina not transferable to a plate, but visible only to the imagination and not to be rendered except by a hand miraculously obedient to the intellect.

Yet, while we may fail to see any genuine affinity between photography and creative art, we need not share that supercilious attitude towards reality and its photographic image, which is affected by some votaries of the imagination. Imagination is a good thing, but it is a substitute for vision which would be better. And while photography can never have the spiritual value, the pathetic and humane meaning of creative art, that real world and that natural beauty which photography reproduces have always been, are now, and ever will be the ultimate object of human interest. The real world is the subject of creative art; it is what the true artist is himself in love with. If you meet a poet who is more interested in his own verses—or in any verses—than in what inspired them; if you meet a painter who cares more for his art than for his perceptions, or a sculptor who delights more in statues than in moving and living forms—set him down without hesitation for a sham. Art is secondary, life and perception are primary; since it is only the fascination exercised over us by real things that can suggest to us the possibility of their ideal perfection: and if we hasten to render this ideal perfection in some artificial medium, and are enraptured even by the dead suggestion of a complete beauty, how much more must we desire that complete beauty itself, as Nature or a better life might some day actually produce it!

It is true that the man of imagination is able, at the present stage of human development, to give human nature much more adequate expression than the scientific . . .[1]

. . . of creative art, we must not think that it excels in potential dignity

1. *The following four pages of the manuscript are missing.*

that reality which it transmutes into an appearance, in order to reduce it more easily to a human scale. We should rather admit creative art as the best mediator between our half-lighted minds and our half-tamed environment—as a medium through which these two can communicate in their primitive estrangement. Yet, to help us bridge that chasm, we should welcome any mechanical arts which, like photography, improve and extend our perceptions, helping us to see and to remember; for by such means the real world may be made clearer and more familiar to us—that real world from which all beauty is derived and in which all beautiful forms, if they could have their way, would be ultimately embodied.

Man Ray

Self Portrait
1963

AN EXCERPT

Man Ray (1890–1976) was an artist who made a mark in many fields; he was a painter, sculptor, printmaker, designer, collage artist, writer, photographer. He participated in both the Dada and Surrealist movements—a younger American artist called him "the Dada of us all." He once said that he became a photographer in the late teens because "I had to get money to paint. If I'd had the nerve, I'd have become a thief or a gangster, but since I didn't I became a photographer." The bulk of his photographic work was in portraits and fashion. He discovered the photogram, which he dubbed the Rayograph, quite by chance, at about the time Moholy-Nagy first succeeded with his own experiments. Christian Schad preceded them both with his abstract photograms of 1918. Talbot, of course, had made realistic impressions of leaves and lace on photosensitive paper as early as the 1830s, a process Man Ray had repeated in his teens. At the time of this account, Man Ray had been taking fashion photographs for the French designer Paul Poiret.

. . . .

Again at night I developed the last plates I had exposed; the following night I set to work printing them. Besides the trays and chemical

solutions in bottles, a glass graduate and thermometer, a box of photographic paper, my laboratory equipment was nil. Fortunately, I had to make only contact prints from my large plates. I simply laid a glass negative on a sheet of light-sensitive paper on the table, by the light of my little red lantern, turned on the bulb that hung from the ceiling, for a few seconds, and developed the prints. It was while making these prints that I hit on my Rayograph process, or cameraless photographs. One sheet of photo paper got into the developing tray—a sheet unexposed that had been mixed with those already exposed under the negatives—I made my several exposures first, developing them together later—and as I waited in vain a couple of minutes for an image to appear, regretting the waste of paper, I mechanically placed a small glass funnel, the graduate and the thermometer in the tray on the wetted paper. I turned on the light; before my eyes an image began to form, not quite a simple silhouette of the objects as in a straight photograph, but distorted and refracted by the glass more or less in contact with the paper and standing out against a black background, the part directly exposed to the light. I remembered when I was a boy, placing fern leaves in a printing frame with proof paper, exposing it to sunlight, and obtaining a white negative of the leaves. This was the same idea, but with an added three-dimensional quality and tone graduation. I made a few more prints, setting aside the more serious work for Poiret, using up my precious paper. Taking whatever objects came to hand; my hotel-room key, a handkerchief, some pencils, a brush, a candle, a piece of twine—it wasn't necessary to put them in the liquid but on the dry paper first, exposing it to the light for a few seconds as with the negatives—I made a few more prints, excitedly, enjoying myself immensely. In the morning I examined the results, pinning a couple of the Rayographs—as I decided to call them—on the wall. They looked startlingly new and mysterious. Around noon, Tristan Tzara came in to see if we might lunch together. We got on pretty well in spite of the handicap of language—he spoke a little English—after all, his use of language was a complete mystery to the more academic critics; it would have been a mystery in any language. He spotted my prints on the wall at once, becoming very enthusiastic; they were pure Dada creations, he said, and far superior to similar attempts—simple flat textural prints in black and white—made a few years ago by Christian Schad, an early Dadaist.

Tzara came to my room that night; we made some Rayographs together, he disposing matches on the paper, breaking up the match box itself for an object, and burning holes with a cigarette in a piece of paper, while I made cones and triangles and wire spirals, all of which

produced astonishing results. When he proposed to continue with other materials, I did not encourage him, as I felt somewhat jealous of my discovery and did not care to be influenced by his ideas. He must have sensed this, as he never suggested working with me again, although his enthusiasm did not diminish. Later that year, when I conceived the idea of doing an album of some prints, in a limited edition, which I called *Les Champs Délicieux*, he wrote a fine preface.

Shortly after this diversion I went to see Poiret with my fashion prints. I slipped in a couple of the Rayographs, figuring that as a patron of modern art he might be interested in them, and it would take me out of the class of mere photographers. I went directly upstairs to his office, was about to knock on the door, but stopped, hearing loud voices inside. They were English voices; a woman telling Poiret she was dissatisfied with her gown, it did not fit, wasn't even smart. He shouted that he knew his business, he was Paul Poiret, and that if he told a woman to wear a nightgown with a chamber pot on her head, she would do just that. The woman came out and brushed by me. Poiret saw me and motioned to me to come in. Some women don't know what's good for them, he said. I smiled appreciatively. He sat down at his desk, relaxed a moment, then asked what I had to show him. I handed him the folder, and he examined the prints one at a time, nodding his head. When he came to the blond in the pale satin dress, he lingered a little longer and said it was very smart—I might have the makings of a fine fashion photographer. I could have told him it was perhaps because I was more interested in the girl than in the clothes, but I kept my mouth shut. Then he saw the two Rayographs, and asked what they were. I explained I was trying to do with photography what painters were doing, but with light and chemicals, instead of pigment, and without the optical help of the camera. He did not quite get it; I described the process as I had worked it in my darkroom. He nodded and said it was very interesting, handing me back the folder. He liked my work. I could come and make more pictures whenever I wished.

I asked if he'd keep these first prints, then, hesitating, could he give me an advance to buy more materials. He looked at me in surprise: these were for the fashion magazines, he never paid for photographs and photographers considered it a privilege to work in his house; these should be taken to the magazines. I stammered, saying I had no contacts, did not know how to go about such matters, and thought this was his personal order. Again that look of impatience he had shown in our first interview, then, extracting the two Rayographs, said he liked new experiments, would pay me for these, and took out some 100-

franc notes from his pocket. I thanked him and told him to keep all the pictures; I'd make duplicates and take them to a fashion magazine. Promising to get to work soon on a new series, I left, quite elated. I had never received so much money for my more commercial work. Poiret was one of those rare businessmen: generous and imaginative. If I did nothing else, my next job would be his portrait. In the meantime, Tzara had been spreading the news about my new work, and people began to come in to see it.

. . . .

Dorothy Norman

Alfred Stieglitz:
An American Seer
1960

AN EXCERPT

Alfred Stieglitz's (1864–1946) *Equivalents* and his writings
about them had a distinguished following among American
photographers such as Minor White and Aaron Siskind. His
stated attempt to equal or rival music, an ambition which has
a very long history, echoes numerous nineteenth-century
writings about the aims and potential of art.

. . . .

The year 1922 marked the beginning of a new and important phase in
Stieglitz's photographic career. He wrote at the time from Lake George
of how "one of America's young literary lights believed the secret
power in my photography was due to the power of hypnotism I had
over my sitters, etc.

"I was amazed when I read the statement. I wondered what he
had to say about the street scenes—the trees, interiors—and other
subjects, the photographs of which he had admired so much: or
whether he felt they too were due to my powers of hypnotism. . . .
What . . . had [been] said annoyed me. . . . I was in the midst of my
summer's photographing, trying to add to my knowledge, to the work
I had done. Always evolving—always going more and more deeply
into life—into photography. . . .

"Thirty-five or more years ago I spent a few days in Murren

271

(Switzerland), and I was experimenting with ortho plates. Clouds and their relationship to the rest of the world, and clouds for themselves, interested me, and clouds which were most difficult to photograph— nearly impossible. Ever since then clouds have been in my mind most powerfully at times and I always knew I'd follow up the experiment made over thirty-five years ago. I always watched clouds. Studied them. Had unusual opportunities up here on this hillside. . . . I wanted to photograph clouds to find out what I had learned in forty years about photography. Through clouds to put down my philosophy of life—to show that my photographs were not due to subject matter —not to special trees, or faces, or interiors, to special privileges, clouds were there for everyone—no tax as yet on them—free.

"So I began to work with the clouds—and it was great excitement —daily for weeks. Every time I developed I was so wrought up, always believing I had nearly gotten what I was after—but had failed. A most tantalising sequence of days and weeks. I knew exactly what I was after. . . . I wanted a series of photographs which when seen by Ernest Bloch (the great composer) he would exlaim: Music! music! Man, why that is music! How did you ever do that? And he would point to violins, and flutes, and oboes, and brass, full of enthusiasm, and would say he'd have to write a symphony called 'Clouds.' Not like Debussy's but *much, much more.*

"And when finally I had my series of ten photographs printed, and Bloch saw them—what I said I wanted to happen happened *verbatim.*

"Straight photographs, all gaslight paper, except one palladiotype. All in the power of every photographer of all time, and I satisifed I had learnt something during the forty years. . . .

"Now if the cloud series are due to my powers of hypnotism I plead 'Guilty'. . . . My photographs look like photographs—and in [the] eyes [of pictorial photographers] they therefore can't be art. . . . My aim is increasingly to make my photographs look so much like photographs that unless one has *eyes* and *sees*, they won't be seen—and still everyone will never forget them having once looked at them." [1]

After 1922 Stieglitz used the word *Equivalents* to describe his photographs of clouds, his *Songs of the Skies*, his *Songs of Trees.*

He said, "My cloud photographs are *equivalents* of my most profound life experience, my basic philosophy of life." In time he claimed that all of his prints were equivalents; finally that all art is an equivalent of the artist's most profound experience of life.

. . . .

1. *From letter written by Steiglitz "With no idea of publication," as printed in* The Amateur Photographer and Photography, *September 19, 1923; pp. 255.*

Constance Rourke

Charles Sheeler:
Artist in the American Tradition
1938
AN EXCERPT

Charles Sheeler (1883–1965) was a fine painter who photo-
graphed architecture and sometimes art for a living. Some of
his paintings were based directly on his own photographs,
and in 1920 he had one of the earliest shows in which art and
photography appeared as equals. Like Strand in the mid
teens, he began taking highly formal, semi-abstract photo-
graphs; Steichen said "Sheeler was objective before the rest
of us were." Sheeler concentrated on the barns, buildings,
and interiors of Bucks County, Pennsylvania. He collabo-
rated with Strand on the film *Mannahatta*, about the dyna-
mism and geometry of a modern city, and he took for the
Ford Motor Company an extensive series on their River
Rouge plant. The quotes in the following excerpt are from an
autobiography commissioned from Sheeler by the publisher
and made available to Constance Rourke.

. . . .

From the time of his exhibition at the Modern gallery in 1918, Sheeler's
photography had been remarked for its unsentimentalized renderings,
which were not always understood by those who preferred their reali-
ties veiled or enshrouded. As might be expected from the direction
which his painting has taken he has consistently stood for the simplest

273

technical means. Believing that ready duplication of a print is charac-
teristic of the medium, he has preferred the silver rather than the
platinum base for the greater facility afforded, and avoids the various
elaborate processes employed by some of the pictorialists which involve
extensive manipulation to obtain the final result. He insists that pho-
tography should not be a hybrid, taking on the aspects of painting,
becoming "neither fish nor fowl, photography nor art." He uses
"straight" photography, the undisturbed record by the camera eye
upon the sensitized emulsion and the conversion from negative to pos-
itive by the most direct methods.

"When one goes back to our early photography whose mechanics
was extremely simple and from our modern point of view often crude,
it's easy to see that the present immense elaboration of means isn't very
important. One wonders whether there is such a thing as progress, for
some of this early work has never been surpassed."

Sheeler uses and indeed helped to create for present-day photog-
raphers one of their primary canons, no retouching, which means full
acceptance of the disciplines of the medium. "Zoop for the moment!"

"Photography is nature seen from the eyes outward, painting from
the eyes inward. No matter how objective a painter's work may seem
to be, he draws upon a store of images upon which his mind has
worked. Photography records inalterably the single image, while paint-
ing records a plurality of images willfully directed by the artist. In
photography the lapse of time consumed between the selection of a
subject and the final evidence of accomplishment is negligible. This has
to do with the mechanics of the medium. The time elapsing between
the conception of the painting and the final fulfillment is necessarily
immeasurably longer. This has to do with the mechanics of painting.
It is inevitable that the eye of the artist should see not one but a
succession of images.

"Perhaps it would be well to call attention to the difference in
operation between the lens and the eye, in viewing a subject. With the
lens, obviously the point of observation is fixed, and everything within
the plane of focus is in equal definition at the same time, but the eye is
roving, and includes at one time only a very small area that is sharply
defined. Moving on, it performs the same function within another area,
so that the total vision of a landscape, for instance, is really a mosaic of
small fragments separately seen, which become united in our memory.
This composite image creates the illusion that we have seen at one time
everything within the landscape sharply defined, from the rocks at our
feet to the distant blue hills, but we have not.

"The lens, because of its greater speed in registering the image,

has added to our knowledge much information of which we would have remained ignorant if we were dependent upon the eye. Notable in this respect during recent years has been that phase of photography which is able to record the swiftness of movements taking place on earth, sea, and in the air. With the additional facilities provided by fast lenses which make possible these records of speed, we now have visual records of the most casual glimpses of people under transitory conditions of light and in changing circumstances which previously could not be achieved—which the eye alone cannot see.

"Because of the differences between the two processes it would seem that the encroachment of one upon the territory of the other is impossible. I have come to value photography more and more for those things which it alone can accomplish rather than to discredit it for the things which can only be achieved through another medium. In painting I have had a continued interest in natural forms and have sought the best use of them for the enhancement of design. In photography I have striven to enhance my technical equipment for the best statement of the immediate facts. I have never seen in any painting the fleeting glimpse of a person's character that I have seen depicted in some photographs, nor have I seen in any photograph the fully rounded summation of character that Rembrandt or Greco portrays.

"Photography is only visual, thank God! The lens is an unpsychological piece of glass whether formulated by Zeiss or Bausch and Lomb or whomever."

. . . .

Paul Strand

"The Art Motive in Photography"
1923

Paul Strand (1890–1976) claimed to have learned the modern-
ist aesthetic from looking at art in "291," Stieglitz's gallery.
In the nineteen-teens, he applied that aesthetic to semi-
abstract pictures of grouped bowls or picket fences. His street
pictures of the time, direct and sharp focus, were usually
taken through a lens on the side of his camera; the subjects
were unaware they were being observed. Stieglitz devoted
the last issue of *Camera Work* to Strand, marking a shift from
pictorialism to sharp-focus, cubist-inspired photographs.
Strand became a vocal proponent of the new style. He was
among the first to be fascinated with precision machinery,
especially the car. In later years he made films and put to-
gether extended photographic essays in several different
countries.

(From an address delivered at the Clarence White School of Photogra-
phy in 1923)

A discussion of all the ramifications of photographic methods in mod-
ern life would require more time and special knowledge than I have at
my disposal. It would include all the diverse uses to which photogra-

phy is being put in an essentially industrial and scientific civilization. Some of these applications of the machine, the camera, and the materials which go with it, are very wonderful. I need only mention as a few examples the X-ray, micro-photography in astronomy as well as the various photo-mechanical processes which have so amazingly given the world access to pictorial communication, in much the same revolutionary way that the invention of the printing press made extensive verbal communication possible and easy.

Of much less past importance than these in its relationship to life, because much less clearly understood, is that other phase of photography which I have particularly studied and worked with, and to which I will confine myself. I refer to the use of the photographic means as a medium of expression in the sense that paint, stone, words and sound are used for such purpose. In short, as another set of materials which, in the hands of a few individuals and when under the control of the most intense inner necessity combined with knowledge, may become an organism with a life of its own. I say a few individuals, because they, the true artists, are almost as rare a phenomenon among painters, sculptors, composers as among photographers.

Now the production of such living organisms in terms of any material, is the result of the meeting of two things in the worker. It involves, first and foremost, a thorough respect and understanding for the particular materials with which he or she is impelled to work, and a degree of mastery over them, which is craftsmanship. And secondly, that indefinable something, the living element which fuses with craftsmanship, the element which relates the product to life and must therefore be the result of a profound feeling and experience of life. Craftsmanship is the fundamental basis which you can learn and develop provided you start with absolute respect for your materials, which, as students of photography, are a machine called a camera and the chemistry of light and other agents upon metals. The living element, the plus, you can also develop if it is potentially there. It cannot be taught or given you. Its development is conditioned by your own feeling which must be a free way of living. By a free way of living I mean the difficult process of finding out what your own feeling about the world is, disentangling it from other people's feelings and ideas. In other words, this wanting to be what may truthfully be called an artist, is the last thing in the world to worry. You either are that thing or you are not.

Now the general notion of artist is quite a different matter. This notion uses the word to describe anyone who has a little talent and ability, particularly in the use of paint, and confuses this talent, the

commonest thing in the world, with the exceedingly rare ability to use it creatively. Thus everybody who slings a little paint is an artist, and the word, like many other words which have been used uncritically, ceases to have any meaning as a symbol of communication.

However, when you look back over the development of photography, when you look at what is being done today still in the name of photography in "Photograms of the Year," in the Year Book of the Pictorial Photographers, it is apparent that this general erroneous notion of artist has been and is the chief worry of photographers and their undoing. They, too, would like to be accepted in polite society as artists, as anyone who paints is accepted, and so they try to turn photography into something which it is not; they introduce a paint feeling. In fact, I know of very few photographers whose work is not evidence that at bottom they would prefer to paint if they knew how. Often, perhaps, they are not conscious of their subjugation to the idea of painting, of the absence of all respect and understanding of their own medium which this implies and which sterilizes their work. But, nevertheless, either in their point of view toward the things they photograph, or more often in the handling of certain unphotographic materials, they betray their indebtedness to painting, usually, second-rate painting. For the pathetic part is that the idea which photographers have had of painting is just as uncritical and rudimentary as this popular notion of the artist. There is every evidence in their work that they have not followed the whole development of painting as they have not perceived the development of their own medium.

You need not take my word for this. The record is there. You can see for yourself the whole photographic past, its tradition in that extraordinary publication, *Camera Work*. For photography has a tradition although most of those who are photographing today seem to be unaware of the fact. That is at least one of the reasons why they are prey to the weaknesses and misconceptions of that tradition, and are unable to clarify or to add one iota to its development. So if you want to photograph, and if you are not living on a desert island, look at this tradition critically, find out what photography has meant to other people, wherein their work succeeds or fails to satisfy, whether you think you could hang it on the same wall with a Durer wood-cut, a painting by Rubens or even Corot, without the photograph falling to pieces. For this is, after all, the test, not of Art but of livingness.

In my own examination of the photographic tradition I have found out for myself, and I think it can be demonstrated, that there are very few photographs that will meet this test. And they will not, because although much of the work is the result of a sensitive feeling for life, it

is based, nevertheless, on that fundamental misconception that the photographic means is a short cut to painting. But from the point of view of genuine and enthusiastic experimentation, however it may have been on the wrong track, this work will always have great historical importance, will be invaluable to the student. The gum prints of the Germans, Henneberg, Watzek, the Hoffmeisters and Kuhn, those of Steichen will never happen again. Nobody will be willing to spend the time and energy or have the conviction necessary to the production of these things. And it is when one finds, as one does today, photographers all over the world, in England, Belgium, Germany, in this country, going right ahead as though nothing had ever happened, using this and other manipulative processes without one one-thousandth of the intensity or ability with which their predecessors worked, that such work ceases to have any meaning and becomes merely absurd.

Let us stop for a moment before discussing further the photographic past and present, to determine what the materials of photography really are, what, when they are not perverted, they can do. We have a camera, a machine which has been put into our hands by science. With its so-called dead eye, the representation of objects may be recorded upon a sensitive emulsion. From this negative a positive print can be made which without any extrinsic manual interference will register a scale of tonal values in black and white far beyond the power of the human hand or eye. It can also record the differentiation of the textures of objects as the human hand cannot. Moreover, a lens optically corrected can draw a line which, although different from the line drawn by hand, let us say the line of Ingres, for example, may nevertheless be equally subtle and compelling. These, the forms of objects, their relative colour values, textures and line, are the instruments, strictly photographic, of your orchestra. These are the things the photographer must learn to understand and control to harmonise. But the camera machine cannot evade the objects which are in front of it. No more can the photographer. He can choose these objects, arrange and exclude, before exposure, but not afterwards. That is his problem, these the expressive instruments with which he can solve it. But when he does select the moment, the light, the objects, he must be true to them. If he includes in his space a strip of grass, it must be felt as the living differentiated thing it is, and so recorded. It must take its proper but no less important place as a shape and a texture, in relationship to the mountain, tree or whatnot, which are included. You must use and control objectivity through photography because you cannot evade or gloss over by the use of unphotographic methods.

Photography so understood and conceived is just beginning to

emerge, to be used consciously as a medium of expression. In those other phases of photographic method which I mentioned, that is, in scientific and other record making, there has been at least, perhaps of necessity a modicum of that understanding and control of purely photographic qualities. That is why I said these other phases were nearer to a truth than all the so-called pictorialism, especially the unoriginal, unexperimental pictorialism which today fills salons and year-books. Compared with this so-called pictorial photography, which is nothing but an evasion of everything photographic, all done in the name of art and God knows what, a simple record in the National Geographic Magazine, a Druot reproduction of a painting or an aerial photographic record is an unmixed relief. They are honest, direct, and sometimes informed with the beauty, however unintentional. I said a simple record. Well, they are not so simple to make, as most of the pictorial photographers would find out if they threw away their oil pigments and their soft-focus lenses, both of which cover a multitude of sins, much absence of knowledge, much sloppy workmanship. In reality they do not cover them for anyone who sees.

Gums, oils, soft-focus lenses, these are the worst enemies, not of photography which can vindicate itself easily and naturally, but of photographers. The whole photographic past and present, with few exceptions, has been weakened and sterilized by the use of these things. Between the past and the present, however, remember that there is this distinction—that in the past these extrinsic methods were perhaps necessary as a part of photographic experimentation and clarification. But there is no such excuse for their continued use today. Men like Kuhn and Steichen, who were masters of manipulation and diffusion, have themselves abandoned this interference because they found the result was a meaningless mixture, not painting, and certainly not photography. And yet photographers go right on today gumming and oiling and soft-focusing without a trace of that skill and conviction which these two men possessed, who have abandoned it. Of course, there is nothing immoral in it. And there is no reason why they should not amuse themselves. It merely has nothing to do with photography, nothing to do with painting, and is a product of a misconception of both. For this is what these processes and materials do—oil and gum introduce a paint feeling, a thing even more alien to photography than colour is in an etching, and lord knows a coloured etching is enough of an abomination. By introducing pigment texture you kill the extraordinary differentiation of textures possible only to photography. And you destroy the subtleties of tonalities. With your soft-focus lens you destroy the solidity of your forms, likewise all differentiation of tex-

tures; and the line diffused is no longer a line, for a significant line, that is, one that really has a rhythmic emotional intensity, does not vibrate laterally but back, in a third dimension. You see, it is not a question of pure or straight photography from a moral point of view. It is simply that the physical, demonstrable results from the use of unphotographic methods do not satisfy, do not live, for the reason I have mentioned. The formless halated quality of light which you get at such cost with a soft-focus lens will not satisfy. The simplification so easily achieved with it and with these manipulative processes will not satisfy. It is all much too easy, as I know, because I have been through the mill myself. I have made gum-prints, five printings, and I have Whistlered with a soft-focus lens. It is nothing to be ashamed of. I had to go through this experience for myself at a time when the true meaning of photography had not crystallised, was not so sharply defined as it is today, a crystallization, by the way, which is the result not of talk and theorizing but of work actually done. Photography, its philosophy, so to speak, is just beginning to emerge through the work of one man, Alfred Stieglitz, of which I will speak later.

In short, photographers have destroyed by the use of these extrinsic methods and materials, the expressiveness of those instruments of form, texture and line possible and inherent in strictly photographic processes. And these instruments, although they are different in the source and manner of production, therefore different in the character of their expressiveness, from those of any other plastic method, are nevertheless related to the instrumentation of the veritable painter and etcher.

For if photographers had really looked at painting, that is, all painting, critically as a development, if they had not been content to stop with the superficial aspects of Whistler, Japanese prints, the inferior work of German and English landscape painters, Corot, etc., they might have discovered this—that the solidity of forms, the differentiation of textures, and colour are used as significant instruments in all the supreme achievements of painting. None of the painting just referred to comes in that category. Photographers, as I have said before, have been influenced by and have sought to imitate either consciously or not consciously the work of inferior painters. The work of Rubens, Michael Angelo, El Greco, Cezanne, Renoir, Marin, Picasso, or Matisse can not be so easily translated into photography, for the simple reason that they have used their medium so purely, have built so much on its inherent qualities that encroachment is well-nigh impossible. And it is being demonstrated today that a photography cannot be imitated or encroached upon in any way by painter or etcher. It is as much a thing

with its own unalienable character, with its own special quality of expressiveness, as any fully realized product of other media.

The unintelligence of present-day photographers, that is of so-called pictorial photographers, lies in the fact that they have not discovered the basic qualities of their medium, either through the misconceptions of the past or through working. They do not see the thing which is happening, nor which has happened, because they do not know their own tradition. This is proven by their continued puerile use of the unphotographic methods just dealt with, evidence that they are still dominated by a rudimentary, uncritical conception of painting, that they see in a half-baked, semi-photographic product a short cut to what they conceive painting to be, and to the recognition of themselves as artist. But, above all, the lack of knowledge of their own tradition is proved by the fact that thousands of numbers of *Camera Work* lie idle today in storage vaults, in cellars, clutter up shelves. These marvelous books which have no counterpart or equal, which contain the only complete record of the development of photography and its relationship to other phases of life, to the publication of which Stieglitz devoted years of love and enthusiasm and hard work, photographers have left to rot on his hands, a constant weight upon him, physical and financial. That he has not destroyed every copy is a miracle. But he continues to preserve them as well as the collection of photographs representing this past development of photography, the only collection of its kind in existence, and most of which he purchased—all this he preserves perhaps because he has faith in photography, in the work he has done, and in the young generation of students, who, he hopes, will seek them out and use them; that is, use all this past experiment, not to imitate, but as a means of clarifying their own work, of growing, as the painter who is also an artist can use his tradition. Photographers have no other access to their tradition, to the experimental work of the past. For whereas the painter may acquaint himself with the development and past achievements of his medium, such is not the case for the student-worker in photography. There is no place where you can see the work of Hill, White, Kasebier, Eugene, Stieglitz as well as the work of Europe, on permanent exhibition. Yet the photographers do not seem to be interested. They have done nothing to help preserve or use these things. This is in itself a criticism of their intensity, and it shows in the quality of their work. All the way through there is this absence of faith in the dignity and worth of their own medium, however used or mis-used, and, at the same time, the absurd attempt to prove to the world that they too, are artists. The two things do not jibe. So I say to you again, the record is there, accessible to anyone sufficiently interested.

If when you have studied it, you still have to gum, oil, or soft-focus, that is all right, that is your experience to go through with. The human animal seems unable for some reason or other to learn much from either the blunder or the wisdom of the past. Hence the war. But there are, nevertheless, laws to which he must ultimately conform or be destroyed. Photography, being one manifestation of life, is also subject to such laws. I mean by laws those forces which control the qualities of things, which make it impossible for an oak tree to bring forth chestnuts. Well, that is what photographers have been trying to make photography do—make chestnuts, and usually old chestnuts, grow on an oak tree. I won't say it can't be done, but it certainly has not been done. I don't care how you photograph—use the kitchen mop if you must, but if the product is not true to the laws of photography, that is, if it is not based on the inherent qualities I have mentioned, as it will not, you have produced something which is dead. Of course, it does not follow that if you do make what has been called a good straight photograph, you will thereby automatically create a living organism, but, at least, you will have done an honest piece of work, something which may give the pleasure of craftsmanship.

And if you can find out something about the laws of your own growth and vision as well as those of photography you may be able to relate the two, create an object which has a life of its own, which transcends craftsmanship. That is a long road, and because it must be your own road nobody can teach it to you or find it for you. There are no short cuts, no rules.

Perhaps you will say, But wait; how about design and composition, or in painter's lingo, organisation and significant form? My answer is that these are words which, when they become formulated, signify, as a rule, perfectly dead things. That is to say when a veritable creator comes along, he finds the only form in which he can clothe his feelings and ideas. If he works in a graphic medium he must find a way to simplify the expression and eliminate everything that is irrelevant to it. Every part of his picture, whether a painting, etching, or a photograph, must be meaningful, related to every other part. This he does naturally and inevitably by using the true qualities of his medium in its relation to his experience of life. Now when he has done this transcendent thing, after much hard work, experiment and many failures, the critic and the professors, etc., appear on the scene usually fifteen or twenty years after the man has died, and they deduce from his work rules of composition and design. Then the school grows and academic imitation, until finally another man comes along, and, also naturally and inevitably, breaks all the rules which the critic and the professors

have neatly tied up with blue ribbon. And so it goes. In other words, composition, design, etc., cannot be fixed by rules, they are not in themselves a static prescription by which you make a photograph or anything that has meaning. They signify merely the way of synthesis and simplification which creative individuals have found for themselves. If you have something to say about life, you must also find a way of saying it clearly. If you achieve that clarity of both perception and the ability to record it, you will have created your own composition, your own kind of design, personal to you related to other people's, yet your own. The point I want to make is that there is no such thing as The Way; there is only for each individual, his or her way which in the last analysis, each one must find for himself in photography and in living. As a matter of fact, your photography is a record of your living, for anyone who really sees. You may see and be affected by the other people's ways, you may even use them to find your own, but you will have eventually to free yourself of them. That is what Nietzsche meant when he said, "I have just read Schopenhauer, now I have to get rid of him." He knew how insidious other people's ways could be, particularly those which have the forcefulness of profound experience, if you let them go between you and your vision. So I say to you that composition and design mean nothing unless they are the moulds you yourself have made, into which to pour your own content, and unless you can make the mould, which you cannot if you do not respect your materials and have some mastery over them, you have no chance to release that content. In other words, learn to photograph first, learn your craft, and in the doing of that you will find a way, if you have anything to say, of saying it. The old masters were craftsmen first, some one of them artist, afterwards. Now this analysis of photography and photographers is not a theory, but derived from my own experience as a worker, and more than that, even, is based on the concrete achievements of D. O. Hill, who photographed in 1843 and of Alfred Stieglitz, whose work today is the result of thirty-five years of experimentation. The work of those two men, Hill, the one photographic primitive, Stieglitz, who has been the leader in the fight to establish photography, not photographers, stands out sharply from that of all other photographers. It embodies in my opinion, the only two fully realised truly photographic expressions, so far, and if a critical comment upon the misconceptions of the intermediary past and the sterility of the present. The work of both disclaims any attempt to paint, either in feeling or in handling.

The psychology of Hill is interesting. He himself was a painter, a member of the Royal Scotch Academy and one of his commissions was

to paint a picture in which were to appear recognizable portraits of some one hundred or more notable people of the time. He had heard of the lately invented process of photography, and it occurred to him that it might be of considerable assistance in the painting of his picture. He began to experiment with a crude camera and lens, with paper negatives, exposures in the sun five or six minutes, and he became so fascinated by these things that he neglected his painting. He worked for three years with photography and then finally, when his wife and friends got at him and told him he was an artist and wasting his time, in other words, gave him a bad conscience, he gave it up and, as far as we know, never photographed again. In other words, when Hill photographed he was not thinking of painting. He was not trying to turn photography into paint or even to make it do an equivalent. Starting with the idea of using photography as a means. It so fascinated him that it soon became an end in itself. The results of his experimentation reveal, therefore, a certain directness, a quality of perception which, with Hill's extraordinary feeling for the people whom he photographed, has made his work stand unsurpassed, until today. And this, mind you, despite the crudity of the materials with which he had to work, the long exposures, etc., and in spite of the fact that George Eastman was not there to tell Hill that all he (Hill) had to do was press the button and he (Eastman) would do the rest. He was not trying to paint with photography. Moreover, it is interesting to note that his painting, in which he was constrained by the academic standards of the time, has passed into obscurity. His photography in which he was really free lives.

The work of Stieglitz, from the earliest examples done thirty-five years ago, to the amazing things he is doing today, exhibits to even a more marked degree this remarkable absence of all interference with the authentic qualities of photography. There is not the slightest trace of paint feeling or evidence of a desire to paint. Years ago, when he was a student in Germany painters who saw his photographs often said, "Of course, this is not Art, but we would like to paint the way you photograph." His reply was, "I don't know anything about Art, but for some reason or other I have never wanted to photograph the way you paint." There you have a complete statement of the difference between the attitude of Stieglitz towards photography, and practically every other photographer. And it is there in his work, from the earliest to the latest. From the beginning Stieglitz has accepted the camera machine, instinctively found in it something which was part of himself, and loved it. And that is the pre-requisite for any living photographic expression of anyone.

I do not want to discuss in detail this work of Stieglitz, as another exhibition of his most recent photographs opens April first at the Anderson Galleries. Go and see these things yourself. If possible, look at the earlier photographs in *Camera Work*, so that you can follow the development of his knowledge and of his perceptions. Stieglitz has gone much further than Hill. His work is much wider in scope, more conscious, the result of many more years of intensive experiment. Every instrument, form, texture, line and even print colour are called into play, subjugated through the machine to the single purpose of expression. Notice how every object, every blade of grass, is felt and accounted for, the full acceptance and use of the thing in front of it. Note, too, that the size and shape of his mounts become part of the expression. He spends months sometimes just trying to mount a photograph so sensitive is the presentation. Observe also how he has used solarisation, really a defect, how he has used it as a virtue consciously, made the negative with that in mind. That is truly creative use of material, perfectly legitimate, perfectly photographic.

In other words, go and see what photography really is and what it can record in the hands of one who has worked with intense respect and intelligence, who has lived equally intensely, without theories, Stieglitz fought for years to give other people a chance to work and to develop, and he is still fighting. The photographers failed. They did not develop, and did not grow. Stieglitz has done for photography what they have not been able to do. He has taken it out of the realm of misconception and a promise, and made it a fulfillment.

In his exhibition two years ago he set aside the question of whether photography is or is not art is of no importance to him, just as he did thirty-five years ago. Exactly, because nobody knows what art is or God or all the other abstractions, particularly those who make claims to such knowledge. There are a few, however, who do know what photography is and what painting is. They know that there is as much painting which is bad photography as most photography is bad painting. In short, they have some idea whether a thing is genuine and alive or false and dead.

In closing, I will say this to you as students of photography. Don't think when I say students that I am trying to talk down. We are all students, including Stieglitz. Some a little longer at it than the others, a little more experienced. When you cease to be a student you might as well be dead as far as the significance of your work is concerned. So I am simply talking to you as one student to others, out of my own experience. And I say to you, before you give your time, and you will have to give much, to photography, find out in yourselves how much

it means to you. If you really want to paint, then do not photograph
except as you may want to amuse yourselves along with the rest of Mr.
Eastman's customers. Photography is not a short cut to painting, being
an artist, or anything else. On the other hand, if this camera machine
with its materials fascinates you, compels your energy and respect,
learn to photograph. Find out first what this machine and these mate-
rials can do without any interference except your own vision. Photo-
graph a tree, a machine, a table, any old thing; do it over and over
again under different conditions of light. See what your negative will
record. Find out what your papers, chloride, bromide, palladium, the
different grades of these, will register, what differences in colour you
can get with different developers, and how these differences affect the
expression of your prints. Experiment with mounts to see what shape
and size do to your photograph. The field is limitless, inexhaustible,
without once stepping outside the natural boundaries of the medium.
In short, work, experiment and forget about art, pictorialism and other
unimportant more or less meaningless phrases. Look at *Camera Work*.
Look at it critically, know at least what photographers have done. Look
also just as critically at what is being done and what you are doing.
Look at painting if you will, but the whole development; don't stop
with Whistler and Japanese prints. Some have said that Stieglitz por-
traits were so remarkable because he hypnotized people. Go and see
what he has done with clouds; find out whether his hypnotic power
extends to the elements.

Look at all these things. Get at their meaning to you; assimilate
what you can, and get rid of the rest. Above all, look at the things
around you, the immediate world around you. If you are alive, it will
mean something to you, and if you know how to use it, you will want
to photograph that meaningness. If you let other people's vision get
between the world and your own, you will achieve that extremely
common and worthless thing, a pictorial photograph. But if you keep
this vision clear you may make something which is at least a photo-
graph, which has a life of its own, as a tree or a matchbox, if you see it,
has a life of its own. An organism which refuses to let you think about
art, pictorialism or even photography, it simply is. For the achievement
of this there are no short cuts, no formulae, no rules except those of
your own living. There is necessary however, the sharpest kind of
self-criticism, courage and hard work. But first learn to photograph.
That alone I find for myself is a problem without end.

Milton Brown

Interview with Paul Strand
1971
AN EXCERPT

. . . .

"I would say three important roads opened up for me," he told an interviewer in 1971. "They helped me find my way in the morass of very interesting happenings which came to a head in the big Armory Show of 1913. My work grew out of a response to, first, trying to understand the new developments in painting; second, a desire to express certain feelings I had about New York where I lived; third, another equally important desire—where it came from, I don't know exactly—I wanted to see if I could photograph people without their being aware of the camera. Although *Blind Woman* has enormous social meaning and impact, it grew out of a very clear desire to solve a problem. How do you photograph people in the streets without their being aware of it? Do you know anybody who did it before? I don't.

"The work that I did beginning in 1914, 1915, 1916, which was the nucleus of what I took to show Stieglitz and which was subsequently shown at 291 and published in *Camera Work*, falls into three directions or developments that have continued ever since and are sort of milestones along my particular way. One was the abstract, purely abstract photographs, the experiments which were intended to clarify for me what I now like to refer to as the abstract method, which was first revealed in the paintings of Picasso, Matisse, Braque, Léger, and

others. Those paintings were brought to this country through the efforts of Steichen, and Stieglitz showed them as being antithetical to photography, things that were—as he used to use the word—'antiphotographic'; Stieglitz was very interested in this work because nobody here really quite understood why and what these men were doing.

"They made an enormous impression on every American painter who was in any way open to anything new in painting. And of course they aroused a great deal of bitterness, real bitterness, and hatred among those of the successful American academic painters who felt themselves threatened by anything new and anything very different. My first approach might be illustrated by my work of the summer of 1915. I was in Connecticut, and the simplest of subject matter, or maybe object matter would be a better term in this case—such as kitchen bowls, cups, plates, pieces of fruit, a table, a chair, the railing of the porch, the shadows of the railing of the porch—things as simple as that were my material for making experiments to find out what an abstract photograph might be, and to understand what an abstract painting really was.

"A second line of approach that developed in those days was to begin experimentation to see whether one could photograph the movement in New York—movement in the streets, the movement of traffic, the movement of people walking in the parks. This approach led to such photographs as *Wall Street* and the photograph that I took from the jury room in City Hall Park.

"I realize now that if I hadn't made those photographs, I doubt whether I would have been able to make other photographs like *The Market, Luzzara* or some things that I did in Morocco in 1962, in Ghana in 1963–64, and in Rumania in 1968; the same problem was before me, to photograph people in movement.

"The third and equally important approach, was to photograph people without their being aware that they were being photographed. That was the problem: to make candid photographs long before there were any candid cameras. For the solution, I worked with the Ensign camera, and put a false lens on the side of the camera, screwed it onto the side of the camera's very shiny brass barrel, and then shot with the brass barrel directed at right angles to the person I was going to photograph; but the other lens, the real lens, came out under my arm because it was a long extension. Anyone who knew anything about photography would have known that this was a fraud. Actually it was a very clumsy solution of the problem. All the portraits that I made at that time, however, were made that way. It was quite nerve-racking

because there was always the possibility that you would be challenged either by the person being photographed or by some bystander who might realize that you were up to something not quite straight.

"There were two toughs watching me when I made one of the first photographs: 'Aw, he was photographing out of the side of the camera,' one of them said. So, like the Arabs, I folded my tent and went over to the park in Five Points Square and made the photograph of the old man with the strange eyes. I continued that experimentation with portraits for only about a year because I felt that I had to wait until I had worked out the technical problems.

"These beginnings were like something that grows out of a seed. You come back to them. All through your life they remain important, enabling you to solve the problems posed by whatever you've undertaken to do.

"After the so-called purely abstract photographs that I made in 1915 (not purely abstract but abstract in intention), I never did such things again. I felt no desire and no need to photograph shapes per se.

"I learned from these photographs what the painters were doing . . . and that no matter what is included, that unity must be there and must be continuous. I went next very naturally towards trying to apply the method that I had worked out in pictures, like the shadows of the porch railing and the bowls, to what I tackled thereafter in landscape —landscape being also the parts of New York that I had photographed from the viaduct.

"The New York photographs were followed by the *White Fence*, the next step in abstraction. It was the basis for all the work I've done."

Edward Steichen

A Life in Photography
1963
AN EXCERPT

> Steichen's photography changed radically after the war. In
> his terse and relatively impersonal autobiography, he talks
> about some of his aims at that time.

. . . .

The wartime problem of making sharp, clear pictures from a vibrating,
speeding airplane ten to twenty thousand feet in the air had brought
me a new kind of technical interest in photography completely different
from the pictorial interest I had had as a boy in Milwaukee and as a
young man in Photo-Secession days. Now I wanted to know all that
could be expected from photography.

One of my experiments has become a sort of legend. It consisted
of photographing a white cup and saucer placed on a graduated scale of
tones from pure white through light and dark grays to black velvet.
This experiment I did at intervals over a whole summer, taking well
over a thousand negatives. The cup and saucer experiment was to a
photographer what a series of finger exercises is to a pianist. It had
nothing directly to do with the conception or the art of photography.

There were other things I wanted to learn. I was particularly
interested in a method of representing volume, scale, and a sense of
weight. Growing in espalier fashion on the walls of my garden were

trees that produced fine, large apples and pears. On them were a few particularly good specimens. I used these apples and pears in my attempts to render volume and weight. At first it made no difference how I placed the fruit. Whether they were in direct sunlight, or in interiors, I did not get the feeling of volume. But I noticed that diffused light came closer to giving the desired result. In my small greenhouse I constructed a tent of opaque blankets, put a single apple inside, and cut off all direct light. From a tiny opening not larger than a nickel, I directed light against one side of the covering blanket, and this light, reflected from the blanket, was all. Then, to get as much depth as possible, I made a small diaphragm that must have been roughly f128. I removed some of the blankets to compose and focus the picture, replaced them, and made a series of exposures that ran from six hours to thirty-six. The most successful ones took thirty-six hours. But something happened that I hadn't counted on.

The fact that the longer exposures lasted more than two days and one night meant that, as the nights were cool, everything, including the camera and the covering, contracted and the next day expanded. Instead of producing one meticulously sharp picture, the infinitesimal movement produced a succession of slightly different sharp images, which optically fused as one. . . . Here for the first time in a photograph, I was able to sense volume as well as form. What was more, when both pictures were enlarged to four by five feet, the scale or actual size of the objects represented became unimportant. This elimination of the realistic element of scale made abstract images of these photographs.

The "Wheelbarrow with Flower Pots" . . . was certainly as realistic a photograph as I had ever made. Yet, friends remarked that it made them think of one thing or another that had nothing to do with the wheelbarrow and the flower pots. They thought of "heavy artillery" and "log jams," for example. I began to reason that, if it was possible to photograph objects in a way that makes them suggest something entirely different, perhaps it would be possible to give abstract meanings to very literal photographs. I made many pictures exploring the idea.

. . . .

The New York Times
March 6, 1923

Steichen, one of the first masters of pictorial photography,
made it quite clear when he thought that movement was over.

RAPS PHOTOGRAPHY TODAY

No Progress Since The Daguerreotype,
says E. J. Steichen

No progress has been made in photography since the daguerreotype,
Eduard (sic) J. Steichen, widely known photographer and a former
colonel in the photographic section of the A.E.F., said last night. He
called the soft focus lens "the most pernicious influence in the pictorial
world," and bitterly criticized "the movement in fuzziness" now in
vogue among supposedly artistic photographers. He spoke at a meeting
of the Pictorial Photographers of America, at their exhibition at the Art
center, 63 [or 65?] East Fifty-sixth Street.

According to Mr. Steichen, since photography is an objective art,
a photographer is supposed to take things as they are, without injecting
his personality into the picture. In the days of the daguerreotype so
many difficulties surrounded camera artists, he said, that they were
satisfied to get any kind of an exact reproduction. Mr. Steichen urged

a return to the sharp pictures and praised "the meticulous accuracy of the camera."

"I don't care about making photography an art," said Mr. Steichen. "I want to make good photographs. I'd like to know who first got it in his head that dreaminess and mist is art. Take things as they are; take good photographs and the art will take care of itself."

Tom Hopkinson

Introduction to
Scoop, Scandal and Strife:
A Study of Photography in Newspapers
1971

Although some allege that television has replaced newspapers as the visual source of the news, the news photograph has had a strong influence on public opinion throughout the century and has some still. News photography began as early as the 1840s, but it was not until the halftone plate was invented in the 1880s that illustrated newspapers became feasible. (It is worth remembering, in the context of photography and printing presses, that both Niépce and Talbot were looking for a means of reproductive printing.) Before the halftone plate, and for some years afterward, most news photographs were converted into line engravings for use in print. The following account was written by an Englishman for an English audience.

Newspaper photography was the first means whereby the man in the street came into direct visual contact with the world in which he lived. His horizon was lifted beyond his street, beyond his village and his native town, without the intervention of any visualising artist. He began to see himself, for the first time in history, as the citizen of a world for which he had some personal responsibility, a world peopled not with unknown 'foreigners' but with fellow human beings who suffered and loved as he did.

Through the photographs in his daily newspaper he came to know what the important men and women of his time—not only the politicians but the actresses and sportsmen—looked like. He formed some impression of foreign countries and their ways of life. For the first time it could come home to him what is meant by such words as 'war,' 'famine,' 'pestilence' and 'flood.' At the same time he derived a new enjoyment from the excitement of sporting events and the splendour of great occasions. He was no longer one of the mass who had always been excluded.

That heightened sense of the tragedy and richness of life, the aching awareness of the huge gap between what life is and what it ought to be which we derive today from television, began filtering through to our grandfathers and great-grandfathers nearly a century ago from press photography.

Newspaper photography, as distinct from the taking of photographs with a news interest, was born ninety-odd years ago on 4 March 1880, when Stephen H. Horgan published the first mechanical reproduction of a photograph in a newspaper. This was 'A Scene in Shanty Town' and the paper was the New York *Daily Graphic*. In October 1882, using a similar process, Georg Meisenbach published photographs in the *Leipziger Illustrierte*. But development was slow and publishers timorous, so that it was not until 1896 that the *New York Times* ventured on a weekend illustrated supplement using numbers of halftone blocks, and not until 1904 that the world's first true 'picture newspaper' was launched in Britain.

The immense growth of the popular press in Britain in the early decades of this century is generally ascribed to the Elementary Education Act of 1870, and the other education acts which followed. These produced a mass audience which could read, but in many cases no doubt only with difficulty. However, they could certainly follow pictures, and were eager for something better suited to their tastes than the stolid newspapers and periodicals of Victorian times. For such an audience the popular 'picture tabloid' was exactly right, and its price, one halfpenny, was just right for their pockets.

The *Daily Mirror*, first newspaper in the world to be illustrated exclusively with photographs, came out on 7 January 1904. America did not follow this lead until 1919 when the New York tabloid, *The Illustrated Daily News*, started its career. *The Times*, though it had of course frequently published photographs, only gave recognition to the trend with a regular picture page in 1922.

Meantime, the *Mirror* had given the lead in a new field, the creating of 'news' pictures without waiting for events! Arkas Sapt, its re-

nowned art editor, sent his photographers to climb Mont Blanc, cross the Alps in a balloon, descend into the erupting crater of Vesuvius. As the paper's prestige grew, it was even able to persuade Queen Alexandra to allow a picture of King Edward VII's body lying in state to be taken for its front page—an astonishing privilege for that time.

Press photographers of early days are generally unknown since their pictures were not credited to them, though magazines such as the *Illustrated London News* frequently gave credit to news agencies. Cameramen of this early period whose names have come down to us include Thomas Bolas, F. W. Mills, James Jarché, who later worked for the magazine *Illustrated*, Hartford Hartland, who covered the Boer War in Natal for *The Navy and Army Illustrated*, and a German, Reinhold Thiele, who had made a name working for the London magazine *The Graphic*, which sent him out to South Africa as one of the first staff war photographers.

Significantly, this was also the first war covered by newsreelmen, whose films were regularly projected as part of music-hall shows. The pioneer in this field was an amateur, John Bennett Stanford, whose films, shown at the Alhambra Theatre, caused such a stir that the leading British film company, the Warwick Trading Company, sent out three staff cameramen. Stereoscopic photographs were still highly popular at this time—as a kind of family entertainment before the advent of radio or television—and Underwood and Underwood, of New York, produced a quantity of war pictures.

Also significant of social change was the fact that among the early press photographers was a woman, Mrs. Albert Brown, who built up a successful freelance practice, specializing, rather surprisingly, in military events. She became photographer to the Household Brigade, and held her own with men in covering such occasions as the funeral of Edward VII and the coronation of George V. She also took many pictures of life in London during the First World War. Possibly the most celebrated pictures of this time were Arthur Barrett's shots of suffragettes in the dock at Bow Street (1908), taken through a hole in his top hat, and the much reproduced picture from the *Daily Sketch* of the 1913 Derby, in which a suffragette was killed, throwing herself in front of the King's horse.

Cameras at the turn of the century were large and heavy, requiring stands or tripods, and using glass plates. Then came cameras which could be held, though requiring strong wrists and steady hands. Far handier than stand cameras, they were still cumbersome, and photographers did not waste either the film or their own energy in taking a lot of shots. Their subject for choice had to be motionless and strongly lit.

'What's the picture?' a man would ask his art editor before going out on an assignment. And 'the' picture, nine times out of ten, was a politician with a toothy grin and a raised bowler, socialites simpering at a wedding or garden party, or perhaps a successful sportsman holding up his award. Sharpness was essential, and any sign of movement was a sign of failure.

Then in the mid-twenties came a development which would transform newspaper photography. It began in Germany on a magazine, and involved a new camera and a new kind of cameraman—the 'photojournalist.' The camera was the Ermanox, a compact instrument for which lenses were available of far greater light-passing power than any then in use. In the words of the manufacturers' catalogue: 'this extremely fast lens opens a new era in photography, and makes accessible hitherto unknown fields with instantaneous or brief time exposures without flashlight: night pictures, interiors by artificial light, theatre pictures during performance etc. etc.'

Those words 'without flashlight' in the Ermanox advertisement had a crucial importance. At that time, and right on up till 1929, 'flashlight' meant an open pan of magnesium powder which was touched off—always unexpectedly—by the photographer or his assistant. This gave off a blinding violet flash and a cloud of acrid smoke which left the subjects startled and often gasping for breath. The ensuing photograph showed them haggard as though after a week's debauch, or suspended in the middle of a maniacal laugh—a result as distasteful as the experience had been irritating. Photographers in consequence were unwelcome at any gathering and enjoyed—if that is the word—the status of a waiter or chauffeur, and it was common for journalists interviewing great men to enquire, 'Do you mind if I bring in my photographer?' as though he were some unkempt and evil-smelling animal.

The man who was going to change all this, Dr. Erich Salomon (he always insisted on the 'Doctor') was the son of wealthy German-Jewish parents living in Berlin. Post-war inflation melted away the family fortunes, and Salomon took a job in the publicity department of the renowned magazine publishing house of Ullstein. What Salomon was after—the pictures which made him famous during the late twenties and early thirties—were candid snapshots of statesmen and groups of politicians taken in unguarded moments, and the Ermanox was the first camera to make these possible.

Europe, for perhaps the last time, was then the recognized centre of the world. Politicians, such as Austen Chamberlain, Aristide Briand, Gustav Stresemann and their successors, were endeavouring in a series of international conferences to reconcile old conflicts and to

establish a new authority—The League of Nations. Had they suc-
ceeded, Hitler might not have found the emotional dynamic on which
he could seize power, and the Second World War, which Churchill
called 'the unnecessary war,' might not have needed to be fought.
These closely guarded conferences Salomon set himself to penetrate,
planning to convey to the world their atmosphere and the personalities
of those taking part. With a combination of good manners and effron-
tery, having a thorough mastery of his camera and of photographic
techniques, backed by an excellent education—he could speak seven
languages—Salomon secured scoop after scoop for his magazine, the
Berliner Illustrierte Zeitung. In so doing he gave rise to a new expression,
the candid camera; greatly raised the status of the photographer; and
profoundly—though not immediately—affected newspaper photogra-
phy and the techniques of the press photographer.

What Salomon, who later died in a Nazi concentration camp,
proved was that the impression of life, the sense that the reader is
actually inside the picture looking at the happening, matters more than
clarity and precision of detail. The public, art editors and photogra-
phers themselves grasped the point only slowly, but later the difficul-
ties and inefficiency of the old-style of press photography under war
conditions drove the lesson home. So that, whereas in the 1930's a
press cameraman working with a miniature camera and 35 mm film
could expect a good deal of ridicule from colleagues for 'wasting time
and getting in our way,' by the forties miniature cameras such as the
Leica were an essential part of a press photographer's equipment, and
by the fifties and sixties had virtually superseded the ponderous old
instruments.

This change in equipment was accompanied by a change in the
result; atmosphere and feeling were now more important than sharp-
ness and ease of reproduction. The possibilities of this new style of
photography, however, were exploited far more in the picture maga-
zines which now sprang up, than in the newspapers.

The twenty years from 1935 to 1955 will probably come to be
looked on as the 'golden age' of the picture magazine. *Life* was founded
in the U.S.A. in 1936, *Look* in 1937, and *Picture Post* was launched in
Britain at the end of 1938. *Match*—precursor of the *Paris-Match* re-
founded in 1949 after the Second World War—was born about the
same time. All, in different ways, were immediately successful, as
were many of the host of imitators in their own and other countries.
Most, by the late sixties, were either dead or facing serious difficulties
But during those twenty years their influence was paramount. On
newspapers this showed itself chiefly in four ways.

 1. A new respect for the photograph itself. In the thirties and

earlier it had been commonplace for picture editors and make-up subs to demonstrate their talents by messing up the photographs they handled in a variety of ingenious ways. Parts of the block would be trimmed away from figures so that they stood out as silhouettes; blocks would be pierced, and panels of type—or sometimes even other pictures—inserted in the hole; corners of pictures would be cut or trimmed and sprays of decoration painted on or round them. Headings would frequently be set over photographs to their mutual confusion. But the simple direct layouts of the picture magazines soon began to put a stop to such contemptuous treatment.

2. With this respect for the photograph came a tendency to use fewer pictures in a much larger size. Norman Hall, a former editor of the magazine *Photography*, carried this so far, on becoming picture editor of *The Times*, as regularly to use a single photograph—chosen often for pictorial, not solely for news, value—across half a page with great effect.

3. The intriguing 'picture-stories' and 'picture-sequences' of the magazines were copied as 'picture-features' in such newspapers as the *Daily Express*, *Daily Mail*, *Daily Herald*, *Daily Mirror*, and *Daily Sketch*, once paper rationing dwindled in the late forties and early fifties. And in the United States such papers as the *New York Herald-Tribune*, *Louisville Courier-Journal*, and *Milwaukee Journal* published numbers of feature stories and essays in photographic form.

4. The picture magazines gave prominence to the names of their photographers, whose status rose in consequence. When these photographers left their magazines to join agencies or become independent, papers were glad to credit their work, and the names of such men as Robert Capa, Cartier-Bresson, Werner Bischof, Eugene Smith, and Bert Hardy were soon widely known among the public. Under pressure from their own photographers, newspapers then began to print staff men's names almost as freely as they did those of the journalists. And though it was no doubt true that, in the words of one of the most talented and successful of newspaper photographers, Stanley Devon: 'rewards are few, the work arduous, and results as fleeting as the weather,' yet cameramen now enjoyed a status and a public interest far greater than they had known before picture magazines came in. This was signalized by the formation of the National Press Photographers' Association in 1948.

A different kind of 'picture magazine,' however, the newsreels produced by three or four specialist organizations for showing in cinemas or four specialist organizations for showing in cinemas as an additional attraction to the main film, had comparatively little effect on the

development of newspaper photography. This was largely because, apart from some first-class wartime reportage, their choice of subject was pedestrian, controversy avoided, and the commentaries as a rule either neutered or facetious.

During the last fifteen years the newspapers have been increasingly affected by the much more serious threat posed by television. In competing with even the wealthiest and most skilfully handled magazines, newspapers always had time on their side. If they got the pictures, they could print them first. But with television the boot is on the other foot. A newspaper only publishes once a day, even if it prints a number of editions, but television can be putting out news pictures in any of half-a-dozen news or magazine programmes up till midnight— and the TV pictures move.

Naturally, in face of this challenge, an enormous amount of newspaper money has gone into speeding up the flow of pictures by such means as phototelegraphy or wire transmission. In America, the Associated Press Wirephoto network, started in 1935 with forty members, had grown by 1964 to serve 700 members in the United States and others in a hundred countries. The last ten years have also seen the transmission of three-colour separation prints, and the use of the satellite Telstar II for sending photographic impressions between America and Europe. Most dramatic development of all has been the successful transmission of pictures from space vessels in flight, and from the Moon itself.

New techniques for the rapid sending of pictures have been accompanied by developments in printing, which have cut down sharply the amount of time between the arrival of a photograph in the office and its appearance in a newspaper page. But the major loss of time from a newspaper's point of view has for long lain not in getting the picture into the page, but in getting the paper to the reader, and in this respect half a century has shown little change. Does this mean, as many think, that the still news photograph is doomed?

The still photograph has power to 'freeze' an event and to convey an emotion which is peculiarly its own. The photograph first published in Britain in *The Times* of a police chief in Saigon shooting a Vietcong prisoner through the head was far more powerful as a still picture than ever it could have been as part of a filmed record. And this example might be multiplied many times. But in the long run the still photograph can only hold its own with film in conveying news events, if it can be brought to the reader at least as quickly as film reaches the viewer. Many experiments are on foot to enable complete newspapers to be transmitted, for example, over the television set on to specially

sensitized pages which the reader can carry with him in the morning to factory or office. But unless some of these progress from the experimental to the practical, the importance of the still photograph as a news medium seems certain to decline. This need not, of course, affect its value as a *record* of news, or in the many other fields in which photography plays a growing part in the modern world.

Edward Weston

Daybooks
1923-1930
AN EXCERPT

Edward Weston (1886–1958) first made his living as a portrait photographer and employed a primarily soft-focus style. In the early twenties he switched to sharp-focus realism with an emphasis on the abstract qualities inherent in the forms he photographed. In 1931, he was one of the founders of the group called *f/64* (after a small shutter stop), dedicated to sharp, detailed photography. Weston was the straight photographer *par excellence*, seeking by technical as well as aesthetic means to capture the essential quality of the thing itself. He insisted on previsualization of the image, a requirement best met by the 8- by 10-inch view camera that was his standard instrument. In 1937, Weston received the first Guggenheim fellowship ever awarded a photographer.

In Mexico in 1923, Weston began keeping a kind of diary or journal which he called his daybooks. In it he wrote about his friends, his sons, his many lovers, and his continuous struggle to perfect his art and still manage to make enough money to live on. He kept on with the daybooks when he returned to the United States in 1926 but stopped abruptly in 1934. The following passages deal with a few of his most famous photographs.

3. DISCUSSION ON DEFINITION

APRIL 20, 1923—Glendale, California. Johan is here—has been here for over a week—Days and nights of intensity—burning discourses on many topics—of course mostly photography!

Johan brought new work—fine industrial things—nicely seen—but lacking in definition—an inexcusable fault when it comes to photographing modern architecture and machinery—even the "mood" could be better interpreted with sharp—clean lines—"-But if I see things this way—Edward—I must render them as I see them"—"Nevertheless—Johan—photography has certain inherent qualities which are only possible with photography—one being the delineation of detail—So why not take advantage of this attribute? Why limit yourself to what your eyes see when you have such an opportunity to extend your vision?—now this fine head of your sister—if it was focussed sharper you would have expressed your idea even more profoundly—Here is a proof (Bertha Wardell) which may explain what I mean"—"By God! I do see now—in this case at least—that a more clearly defined—searching definition would have unveiled and exposed the very suffering and strife I have tried to portray—but in some other prints I show you—it seems almost necessary that there should not be so much revealed—however in the portrait under consideration I realize that I skimmed over the surface and did not penetrate as I might have—I do not accept —swallow—what you say as a whole—but I have gotten something from the talk which makes me see more clearly and will make me surer of what I wish to do—Let me question again—if in a certain mood why should I not interpret that state through my picture and not merely photograph what is before me?—in such instances the use of diffusion would aid me—"

"Yes, it would aid you—to cloud and befog the real issue—and prevent you from telling the truth about the life towards which your lens is pointing—if you wish to 'interpret' why not use a medium better suited to interpretation or subjective expression—or—let some one else do it —Photography is an objective means to an end—and as such is unequaled—It comes finally to the question: For what purpose should the camera be used?—and I believe you have misused it—along with many others—including myself!" And so—on we went pro and con—
. . . .

OCTOBER 21, 1925. "Form follows function." Who said this I don't know, but the writer spoke well!

I have been photographing our toilet, that glossy enameled receptacle of extraordinary beauty. It might be suspicioned that I am in a cynical mood to approach such subject matter when I might be doing beautiful women or "God's out-of-doors,"—or even considered that my mind holds lecherous images arising from restraint of appetite.

But no! My excitement was absolute aesthetic response to form. For long I have considered photographing this useful and elegant accessory to modern hygienic life, but not until I actually contemplated its image on my ground glass did I realize the possibilities before me. I was thrilled!—here was every sensuous curve of the "human form divine" but minus imperfections.

Never did the Greeks reach a more significant consummation to their culture, and it somehow reminded me, in the glory of its chaste convolutions and in its swelling, sweeping, forward movement of finely progressing contours, of the Victory of Samothrace.

Yet the blind will turn longingly back to "classic days" for art! Now I eagerly await the development of my exposed film.
. . . .

OCTOBER 30. Trying variations of the W. C., different viewpoints, another lens. From certain angles it appeared quite obscene: so does presentation change emotional response.

Only one more negative so far, which I might have liked, not having done the first one. However I am not through, the lines seen from almost floor level are quite elegant, but to work so low I must rig up some sort of camera-stand other than my tripod.

NOVEMBER 1. It was more simple than I had thought: by placing my camera on the floor without tripod I found exactly what I wanted and made four negatives with no change of viewpoint except that which came from substituting my short focus R. R. Unhesitatingly I respond to my new negatives, and shall choose one to print from.

NOVEMBER 4. Questioned—I could hardly answer which of my loves, the old or the new privy I like best: perhaps the first, yet the second, or rather the last which is such a different conception as to be hardly

comparable, is quite as elegant in line and as dignified as the other. Taken from floor level the opening circle to the receptacle does not enter into the composition, hence to nice people it may be more acceptable, less suggestive; however, "to the pure"—etc. I like best the negative made with my R. R. lens of much shorter focus, for by getting closer and underneath the bowl I attained finer proportions.

But I have one sorrow, all due to my haste, carelessness, stupidity, and I kick myself with pleasure. The wooden cover shows at the top, only a quarter inch, but distracting enough. Of course I noted this on my ground glass, but thought I must make the best of it; such a simple act as unscrewing the cover did not occur to me. I have only one excuse for myself, that I have done all these negatives under great stress, fearing every moment that someone being called by nature would wish to use the toilet for other purposes than mine.

Now shall I retouch the cover away—difficult to do—being black, or go to the effort and expense of doing my "sitting" over? I dislike to touch a pencil to this beautiful negative—yet it is in the unimportant background—and to do the thing over means a half day's work and confusion plus expensive panchromatic films. I shall start to retouch and see how I react!

AFTERNOON—Now that I am "nicely" stewed from beer imbibed at Mercedes' birthday dinner, for which we bought a keg, I see with more clarity.

To take off the toilet's cover, either by unscrewing or retouching, would make it less a toilet, and I should want it more a toilet rather than less. Photography is realism!—why make excuses?
. . . .

4. THE SHELLS IN MEXICO: LETTERS FROM TINA MODOTTI

JULY 25, 1927.—CONTINUED. I must take time to write about the reactions to my shell prints, as written by Tina from Mexico after showing them to several old acquaintances. First, to quote briefly the most salient remarks. "My God Edward, your last photography surely took my breath away! I feel speechless in front of them. What purity of vision. When I opened the package I couldn't look at them very long, they stirred up all my innermost feelings so that I felt a physical pain."

Later—same morning—

"Edward—nothing before in art has affected me like these photographs. I cannot look at them long without feeling exceedingly perturbed, they disturbed me not only mentally but physically. There is something so pure and at the same time so perverse about them. They contain both the innocence of natural things and the morbidity of a sophisticated, distorted mind. They make me think of lilies and of embryos. They are mystical and erotic."

Same day—evening—after showing them to Felipe and Pepe—"On the whole their reactions were very similar to mine—Felipe was so carried away he made an impulsive promise to write you."

"We three spent about two hours discussing the photographs and all kinds of problems stimulated by them—

"Since the creation of an artist is the result of his state of mind and soul at the time of creation, these last photographs of yours clearly show that you are at present leaning toward mysticism.

"At the same time they are very sensuous."

Next morning—

"Last eve, René called. Without my saying a word he used 'erotic' also. Like me, he expressed the disturbance these prints caused him. He felt 'weak at the knees.' "

JULY 4—
"At last Diego saw your photographs! After the first breath-taking impression was over, and after a long silent scrutiny of each, he abruptly asked: 'Is Weston sick at present?' Then he went on: 'These photographs are biological, beside the aesthetic emotion they disturb me physically—see my forehead is sweating.' Then—'Is W. very sensual?' Then—'Why doesn't W. go to Paris? Elie Faure would go wild over these things.' "

JULY 7—
"Last evening Orozco was here. I got out the shell prints. Well, in a few words, he liked them better than all your collection put together. Of one he said, 'This suggests much more than the 'Hand of God' than the hand Rodin made.' It is the one that has made everybody, including myself, think of the sexual act."

From the above quotations it will be seen that I have created a definite impression, but from an angle which surprised me!

Why were all these persons so profoundly affected on the physical side? For I can say with absolute honesty that not once while working with the shells did I have any physical reaction to them: nor did I try to record erotic symbolism. I am not sick and I was never so free from sexual suppression—which if I had, might easily enter into my work, *as it does* in Henry's painting.

I am not blind to the sensuous quality in shells, with which they combine the deepest spiritual significance: indeed it is this very combination of the physical and spiritual in a shell like the Chambered Nautilus, which makes it such an important abstract of life.

No! I had no physical thoughts—never have. I worked with clearer vision of sheer aesthetic form. I knew that I was recording from within, my feeling for life as I never had before. Or better, when the negatives were actually developed, I realized what I felt—for when I worked, I was never more unconscious of what I was doing.

No! The Shells are too much a sublimation of all my work and life to be pigeon-holed. Others must get from them what they bring to them: evidently they do!
. . . .

2. "POINT LOBOS! I SAW IT WITH DIFFERENT EYES—"

THURSDAY, MARCH 21, 1929. Point Lobos! I saw it with different eyes yesterday than those of nearly fifteen years ago. And I worked, how I worked! And I have results! And I shall go again—and again! I did not attempt the rocks, nor any general vista: I did do the cypress! Poor abused cypress—photographed in all their picturesqueness by tourists, "pictorialists," etched, painted and generally vilified by every self-labelled "artist." But no one has done them—to my knowledge—as I have, and will. Details, fragments of the trunk, the roots—dazzling records, technically superb, intensely visioned. Brett and Merle Armitage exclaimed over the negatives: one "like a flame," Merle said.

I worked first with rocks near Jeffers, but though they are good, [they] do not equal the desert rocks, and certainly take second place to the cypress. But I shall do them again, the hour was a bit misty: the material is there. But again the cypress!—amazing trees—those stark,

bone-white, aged ones, storm swept and twisted into the most amazing forms. This sounds all too picturesque—but wait—I have seen them with *my* eyes, at my best.
. . . .

7. "How little subject matter counts in the ultimate reaction!"

SATURDAY, MARCH 8, 1930. Yesterday I made photographic history: for I have every reason and belief that two negatives of kelp done in the morning will someday be sought as examples of my finest expression and understanding. Another is almost as good, and yet another might be considered a very strong example of a more usual viewpoint: this latter several steps beyond the salon type of photograph. But my two best—they are years beyond.

I had found the kelp the evening before, almost at the foot of Ocean Avenue, washed there by the recent storm, the heavy sea. I knew it would not stay put, perhaps not even the night, so early next morning I walked down to see what the tides had done: and there it lay unchanged, twisted, tangled, interwoven, a chaos of convulsed rhythms, from which I selected a square foot, organized the apparently complex maze, and presented it, a powerful integration. This was done of course with no manual arrangement—the selection was entirely my viewpoint as seen through the camera. I get a greater joy from finding things in Nature, already composed, than I do from my finest personal arrangements. After all, selection is another way of arranging: to move the camera an eighth of an inch is quite as subtle as moving likewise a pepper.

These kelp negatives are as strong as any of my rocks: indeed I think they are stronger. A few of my rock details have lace-like delicacy. How little subject matter counts in the ultimate reaction!

MARCH 11. On Monday, my day off, we drove early to the beach—the Carmel front. I wishing to work with kelp, noted on a Sunday evening walk. But alas, kelp does not stay put, like rocks and trees, so the several noted arrangements had disappeared, or were disarranged, maybe by the tide, or Sunday revelers. So I found and worked with dried kelp, three negatives. They were far different from the powerful kelp of the previous week: exquisite curves, almost dainty lines. Then we drove to a remembered beach ten miles down the coast where there

were rock forms of amazing texture. But the extension bed of my camera pulled out, the screw loose, so I found working close to impossible, and there was not much I could do: one negative only made. While working the tide came in and my camera case was turned over in the salt water and holders pretty well saturated. A poor day for me!
. . . .

8. "THE STARK BEAUTY A LENS CAN SO EXACTLY RENDER—"

MARCH 15. Long ago I thought of printing my own work—work not done for the public—on high gloss paper. This was some years back in Mexico: but habit is so strong that not until this last month did I actually start mounting glossy prints for my collection.

I had to make some twenty such prints for an article in *Touring Topics* —they purchased thirteen. When I compared the returned balance with the same copies in my portfolio I made my decision at once. It will take a long time to print even my favorite negatives again: I imagine two thirds of my older work will never be reprinted, and too, the expense would be prohibitive. But I have already made a showing, and hope my next exhibit will be on glossy paper. What a storm it will arouse!—from the "Salon Pictorialists." It is but a logical step, this printing on glossy paper, in my desire for photographic beauty. Such prints retain most of the original negative quality. Subterfuge becomes impossible, every defect is exposed, all weakness equally with strength. I want the stark beauty that a lens can so exactly render, presented without interference of "artistic effect." Now all reactions on every plane must come directly from the original seeing of the thing, no secondhand emotion from exquisite paper surfaces or color: only rhythm, form and perfect detail to consider. Honesty unembellished —first conceptions coming straight through unadulterated—no suggestion, no allegiance to any other medium. While on the subject of printing: I recall an article, about Stieglitz if my memory serves. It spoke of his making a hundred prints or so to get one just right. At the time, though I admired the effort and patience, it seemed to indicate a woeful lack of surety, or lack of skill, or a pretty poor negative, or maybe just good publicity. But now more than ever, I want to be able—and am most of the time—to make one or two tests, and then the final print, as I would have it. This way is my ideal. It indicates decisive thinking in making the negative, and carrying that already formed image conception, without wavering, on through into the print. It necessitates fine negatives and printing ability.

SUNDAY, MARCH 16. For two Saturdays now, I have "received" at my exhibit—Denny-Watrous Gallery. The last time most interesting, and most profitable. A tourist purchased a print of cypress branches—not one of my important things: and John O'Shea bought the first print sold of my kelp, and the first print sold, done in my new way, on glossy paper. He said, "I am going to have a whole portfolio of your prints." The kelp, shown for the first time, created quite a stir: and I will say they are photographs to be proud of.
. . . .

APRIL 24. I sent the following statement to Houston, Texas, where I am showing forty prints during May:

Clouds, torsos, shells, peppers, trees, rocks, smoke stacks, are but interdependent, interrelated parts of a whole, which is Life.

Life rhythms felt in no matter what, become symbols of the whole.

The creative force in man, recognizes and records these rhythms with the medium most suitable to him, to the object, or the moment, feeling the cause, the life within the outer form. Recording unfelt facts by acquired rule, results in sterile inventory. To see the *Thing Itself* is essential: the quintessence revealed direct without the fog of impressionism—the casual noting of a superficial phase, or transitory mood.

This then: to photograph a rock, have it look like a rock, but be *more* than a rock.

Significant presentation—not interpretation.

—and I sent these Technical Notes:

These photographs—excepting portraits—are contact prints from direct 8 x 10 negatives, made with a rectilinear lens costing $5—this mentioned because of previous remarks and questions. The portraits are enlarged from 3¼ x 4¼ Graflex negatives, the camera usually held in hands.

My way of working—

I start with no preconceived idea——

discovery excites me to focus——

then rediscovery through the lens——

final form of presentation seen on ground glass, the finished print previsioned complete in every detail of texture, movement, proportion,

before exposure——the shutter's release automatically and finally fixes my conception, allowing no after manipulation——

the ultimate end, the print, is but a duplication of all that I saw and felt through my camera.

APRIL 26. Someone reading over my statement questioned my use of the word "impressionism." To me it has always meant for example, a tree momentarily shimmering in a brilliant sun or the same tree rain drenched, half hidden by a passing storm: painted, etched or photographed under such conditions—the transitory instead of the eternal.

But I do not want the play of sunlight to excite the fancy, nor the mystery of gloom to invoke the imagination—wearing colored glasses——

I want the *greater mystery* of *things revealed more clearly than the eyes see*, at least more than the layman—the casual observer notes. I would have a microscope, shall have one some day.

On the other hand what a valuable way of recording just such passing moments is the camera! And I certainly would be the first to grasp the opportunity, if I were ready at the time! I cannot, never have been bound by any theory or doctrine, not even my own. Anything that excites me, for any reason, I will photograph: not searching for unusual subject matter, but making the commonplace unusual, nor indulging in extraordinary technique to attract attention. Work only when desire to the point of necessity impels—then do it honestly. Then so called "composition" becomes a personal thing to be developed along with technique as a personal way of seeing. So composition cannot be taught. Rules of composition are theories deducted by the disciples of some master who without thought of how or why, recorded his own intense observations in his own way. Others then copy and set to formulae.

APRIL 28. I have finished, since starting to print on glossy paper, eighty-five prints. All new negatives—that is, those made last year but not printed, and a number of old favorites which have become new favorites, so incomparably finer do they register on glossy paper. It is a joy like unto making a first print, to reprint negatives I was tired of. No other surface is now to be thought of. I can print much deeper than heretofore, with no fear of losing shadows, or muddying half tones by

drying down: or I can use a more contrasty grade of paper, resulting in amazingly rich blacks yet retaining brilliant whites.

I actually look forward to the great labor of reprinting all my best work. Then I shall have a bargain sale of the old!

Besides giving me all possible quality from a given negative, glossy paper deprives me of any chance to spot—repair—a print from a damaged or carelessly seen negative. Everything is revealed—retouching on the negative or spotting on the print. And too, there can be no relying upon beautiful paper textures—one is faced with the real issue, significant presentation of the Thing Itself with photographic quality.

APRIL 29. The widely used arguments against photography ever being considered a fine art are: the element of chance which enters in—finding things ready-made for a machine to record, and of course the mechanics of the medium. Besides disproving chance with my own work amongst others, finding everywhere ready-made "arrangements," I say that chance enters into all branches of art: a chance word or phrase starts a trend of thought in a writer, a chance sound may bring new melody to a musician, a chance combination of lines, new composition to a painter. I take advantage of chance—which in reality is not chance—but being ready, attuned to one's surroundings—and grasp my opportunity in a way which no other medium can equal in spontaneity, while the impulse is fresh, the excitement strong. The nearest to photography is a quick line sketch, done usually as a note for further elaboration. And how much finer, stronger, more vivid these sketches usually are than the finished painting.

So in photography—the first fresh emotion, feeling for the thing, is captured complete and for all time at the very moment it is seen and felt. Feeling and recording are simultaneous—hence the great vitality in *pure* photography and its loss in manipulated photography—by the devitalizing influence of the hand.

As to photography's mechanicalness—art is a way of seeing, not a matter of technique. A moron can be a superb technician. And besides the spontaneity of the machine—camera, time, and energy can be saved for creative thought, inner development.

This is not a defense of photography to bolster up my own misgivings. I would not change to any other way of working. This is a dissertation with morning coffee, the trend of thought started by Myrto, who said

she wrote better, her thoughts registered more directly through her typewriter: the machine again—

MAY 7. Until yesterday, I had not been away on an outing for over five weeks. Brett has been in the south with car and camera. He returned last week bringing Cole! Almost at once, the peace we had ended, the clash of personalities began, the quiet evenings turned noisy. Neil changed the moment Cole appeared. Cole the restless, excitable, exciting others, mischievous—but a dear, fine boy, with a certain sadness beneath his roguishness.

So we started for Point Lobos. I made but four negatives all day. I should find a new place to work: the excitement over new subject matter is no longer there. Not that I have done everything, or even done as well as could be, many things already worked with—but that necessary thrill of discovery, amazement over new material, I no longer have.

However I have three new negatives to print, (one discarded, moved, camera wind-shaken).

This from foreword to exhibit, *Das Lichtbild*, München—

"There will scarcely be anyone who now and then, has not been deeply impressed by a photo . . . for the mere fact that its subject modified and improved his own imagination of the universe, granting him an outlook far beyond his visible surroundings."
. . . .

Edward Weston

Leaflet,
Written for the Los Angeles Museum
1934
AN EXCERPT

The invention of photography was the inevitable result of necessity: the need of a changing world for another technique, a means of expression through which, in certain essentials, a clearer communication, based on contemporary premises could be established. The new scientific approach to life demanded a method of recording which could meet the quickened tempo of the day; a means of unlimited print duplications (mass production); an art form which would be a synthesis of the apparently irreconcilable viewpoints of science and aesthetics. In fulfilling these requirements photography has extended horizons and created a new world-vision. . . .

David Octavius Hill, a Scotsman, made a series of photographs, mostly portraits, which even today are recognized as outstanding examples of fine photography. These portraits should have indicated the unique possibilities of the medium, thus serving as a guide to photographers of that day, and those to follow. Perhaps Hill's influence was negligible because his approach was instinctive rather than affirmatively intentional. One way or another his work was unheeded and forgotten, and for many years photographers, blind to the significance of their new adventure, indulged in abortive attempts to imitate the particular qualities belonging to painting and other arts, until photography, stigmatized by these travesties, lost all recognition as an original art form. . . .

315

Imitation must eventually die from its own false assumptions, but in an age of confused aims, misrepresentation, and indifference, it dies hard; so it seems necessary to note that exhibitions of pure photography are all too rare, that the medium still suffers from misguided workers, who in turn mislead the public, to the detriment of photography.

In viewing an exhibition of photographs one must seek those examples which justify their existence as fine photography by achieving a correlation between meaning and expression which is free from all irrelevant connotations, all suggestions of other forms of expression. They will not be difficult to recognize because photography is such a basically honest medium that even a tyro can detect falsifications. Look for the exquisite rendition of surface textures beyond the skill of human hand, beyond the seeing of human eye; or consider the uninterrupted sequence of subtle gradations from black to white. Realize that these qualities can be recorded in fractions of seconds at the very instant when they are most significantly revealed and felt; that this same split-second technique can be used to capture illumined expressions of the human face and fleeting gestures. In the application of camera principles, thought and action so nearly coincide that the conception of an idea and its execution can be almost simultaneous. The previsioned image, as seen through the camera, is perpetuated at the moment of clearest understanding, of most intense emotional response.

The chemico-mechanical nature of photography precludes all manual interference with its essential qualities, and indicates a fully integrated understanding of the aesthetic problem before exposure. The conception must be seen and felt on the camera ground glass complete in every detail: all values, textures, exact dimensions must be considered once and for all, for with the shutter's release the isolated image becomes unalterably fixed. Developing the negative and making the final print, completes the original conception. This is the procedure in straight, real photography. . . .

The mechanical camera and indiscriminate lens-eye, by restricting too personal interpretation, directs the worker's course toward an impersonal revealment of the objective world. "Self expression" is an objectification of one's deficiencies and inhibitions. In the discipline of camera technique, the artist can become identified with the whole of life and so realize a more complete expression. . . .

Far from being limited to unqualified realism, photography admits the possibility of considerable departure from factual recording. A lens may be selected to give perspective at great variance with the eye. The addition of an indicated color-filter will change or even eliminate certain values. The choice between films, plates, printing papers, and

chemicals, available in endless variety, affords full opportunity for emphasis or for divergence from nature. All these are relevant to straight photography, and justified if used with intention.

Faced with this choice of technical equipment, the artist selects those means best suited to his ends—and always with full understanding that his tools are no more than means. One may easily become lost in the fascinating technical intricacies and difficulties of photography and so make them the end. Due to these difficulties, as well as to widespread confusion of purpose amongst photographers, very few workers have stood out among the countless thousand of photographers as historically important. To be sure, a child can be taught to make creditable records within a few weeks; but to acquire a technique adequate to the consummation of intention may well be considered, as in any art, a lifework.

For all landscape, still life, in fact any stationary subject, I use an 8 x 10 camera on tripod. The camera is fitted with several lenses for various purposes, but the one I have used most often in recent years is a slow rectilinear lens costing $5.00; I mention this cost because of a prevalent opinion that an expensive lens is prerequisite for fine work. Of course I have no objection to the finest apparatus procurable, and a fully corrected lens is sometimes a necessity. I use panchromatic films, pyro-soda developer, and print contact on glossy Chloro-bromide paper. For portraits, or any animated subject, I use a 4 x 5 Graflex fitted with a faster, fully corrected anastigmat lens; all other data being the same. . . .

The final examination of the projected image is all important in straight photograph; at this moment one uses the experience of a lifetime; for—as has been noted already—the shutter's release determines all succeeding procedures. This way of working bars accidental successes, demands quick seeing and decisions. A photograph so conceived on the ground glass has a vitality and integrity not to be found in one depending upon subsequent changes, such as enlarging portions of the negative, alterations or corrections by retouching, or any phase of manual interference. One form of "improvement" to be decried is in the use of printing methods or papers which have in their own right exquisite textures thus tending to hide or even destroy the intrinsic beauty of the negative.

If the subject to be photographed is alive . . . I use a camera of the reflecting type, in which the image is seen on the ground glass up to the very second of shutter-release. Since I never "pose" a subject but rather wait for significant moments—and they happen continually—it becomes less possible to start with preconceived ideas. The moment

presents and suggests what to do, and how to do it. The slightest movement, the lift of a hand, the flicker of an eye, must not escape. The concentration required is comparable to that of a painter making a quick sketch, grasping essentials in a few spontaneous lines. The photographer, however, may have to effect a full integration within a few seconds. . . .

It must be stressed that man, himself, is the actual medium of expression, not the tool he elects to use. The hand directing brush, chisel, or camera, does not act without guidance. In the 15th century, Leonardo da Vinci protested when the "intelligentsia" defined painting as a mechanical art because it was done by hand! The human eye, too, is just as mechanical, quite as nonselective in its seeing as the camera lens: in back of the eye as well as the lens, there must be a directing intelligence, the creative force. . . .

An excellent conception can be quite obscured by faulty technical execution, or clarified by flawless technique. Look then, with a discriminating eye, at the photograph exposed to view on the museum wall. It should be sharply focused, clearly defined from edge to edge —from nearest object to most distant. It should have a smooth or gloss surface to better reveal the amazing textures and details to be found only in a photograph. Its values should be convincingly rendered; they should be clear-cut, subtle or brilliant—never veiled. These physical characteristics of an authentic photograph are repeated for final emphasis.

If the example viewed has all these qualities, and yet is not pleasing, the competent critic will not blame photography; he will attribute the failure to a photographer who could not affirm his intention, who could not correlate his technique and his idea—who was not an artist.

Walter Benjamin

"The Work of Art in the Age of Mechanical Reproduction"

Translated by Harry Zohn

1936

AN EXCERPT

The German literary critic, translator, and essayist Walter Benjamin (1892–1940) developed his own personal version of Marxism. He wrote about the impact of technology on several branches of the arts and on the relation of the masses to culture, and is one of the few who have looked at photography in a political context. Benjamin's observation that the contemporary masses yearn to hold objects close by obtaining their reproductions is a curious echo of Oliver Wendell Holmes's prediction that people would prefer the "skins" of things, their images, to the objects themselves. *Illuminations*, the volume of Benjamin's essays that includes "The Work of Art in the Age of Mechanical Reproduction," was compiled and edited by Hannah Arendt.

"Our fine arts were developed, their types and uses were established, in times very different from the present, by men whose power of action upon things was insignificant in comparison with ours. But the amazing growth of our techniques, the adaptability and precision they have attained, the ideas and habits they are creating, make it a certainty that profound

changes are impending in the ancient craft of the Beautiful. In all the arts there is a physical component which can no longer be considered or treated as it used to be, which cannot remain unaffected by our modern knowledge and power. For the last twenty years neither matter nor space nor time has been what it was from time immemorial. We must expect great innovations to transform the entire technique of the arts, thereby affecting artistic invention itself and perhaps even bringing about an amazing change in our very notion of art." [1]

—Paul Valéry, PIÈCES SUR L'ART, "La Conquète de l'ubiquité," Paris

Preface

When Marx undertook his critique of the capitalistic mode of production, this mode was in its infancy. Marx directed his efforts in such a way as to give them prognostic value. He went back to the basic conditions underlying capitalistic production and through his presentation showed what could be expected of capitalism in the future. The result was that one could expect it not only to exploit the proletariat with increasing intensity, but ultimately to create conditions which would make it possible to abolish capitalism itself.

The transformation of the superstructure, which takes place far more slowly than that of the substructure, has taken more than half a century to manifest in all areas of culture the change in the conditions of production. Only today can it be indicated what form this has taken. Certain prognostic requirements should be met by these statements. However, theses about the art of the proletariat after its assumption of power or about the art of a classless society would have less bearing on these demands than theses about the developmental tendencies of art under present conditions of production. Their dialectic is no less noticeable in the superstructure than in the economy. It would therefore be wrong to underestimate the value of such theses as a weapon. They brush aside a number of outmoded concepts, such as creativity and genius, eternal value and mystery—concepts whose uncontrolled (and at present almost uncontrollable) application would lead to a processing of data in the Fascist sense. The concepts which are introduced into the theory of art in what follows differ from the more familiar terms in

1. *Quoted from Paul Valéry,* Aesthetics, *"The Conquest of Ubiquity," translated by Ralph Manheim, p. 225. Pantheon Books, Bollingen Series, New York, 1964.*

that they are completely useless for the purposes of Fascism. They are, on the other hand, useful for the formulation of revolutionary demands in the politics of art.

I

In principle a work of art has always been reproducible. Man-made artifacts could always be imitated by men. Replicas were made by pupils in practice of their craft, by masters for diffusing their works, and, finally, by third parties in the pursuit of gain. Mechanical reproduction of a work of art, however, represents something new. Historically, it advanced intermittently and in leaps at long intervals, but with accelerated intensity. The Greeks knew only two procedures of technically reproducing works of art: founding and stamping. Bronzes, terra cottas, and coins were the only art works which they could produce in quantity. All others were unique and could not be mechanically reproduced. With the woodcut graphic art became mechanically reproducible for the first time, long before script became reproducible by print. The enormous changes which printing, the mechanical reproduction of writing, has brought about in literature are a familiar story. However, within the phenomenon which we are here examining from the perspective of world history, print is merely a special, though particularly important, case. During the Middle Ages engraving and etching were added to the woodcut; at the beginning of the nineteenth century lithography made its appearance

With lithography the technique of reproduction reached an essentially new stage. This much more direct process was distinguished by the tracing of the design on a stone rather than its incision on a block of wood or its etching on a copperplate and permitted graphic art for the first time to put its products on the market, not only in large numbers as hitherto, but also in daily changing forms. Lithography enabled graphic art to illustrate everyday life, and it began to keep pace with printing. But only a few decades after its invention, lithography was surpassed by photography. For the first time in the process of pictorial reproduction, photography freed the hand of the most important artistic functions which henceforth devolved only upon the eye looking into a lens. Since the eye perceives more swiftly than the hand can draw, the process of pictorial reproduction was accelerated so enormously that it could keep pace with speech. A film operator shooting a scene in the studio captures the images at the speed of an actor's speech. Just as lithography virtually implied the illustrated newspaper, so did photog-

raphy foreshadow the sound film. The technical reproduction of sound was tackled at the end of the last century. These convergent endeavors made predictable a situation which Paul Valéry pointed up in this sentence: "Just as water, gas, and electricity are brought into our houses from far off to satisfy our needs in response to a minimal effort, so we shall be supplied with visual or auditory images, which will appear and disappear at a simple movement of the hand, hardly more than a sign" (*op. cit.*, p. 226). Around 1900 technical reproduction had reached a standard that not only permitted it to reproduce all transmitted works of art and thus to cause the most profound change in their impact upon the public; it also had captured a place of its own among the artistic processes. For the study of this standard nothing is more revealing than the nature of the repercussions that these two different manifestations—the reproduction of works of art and the art of the film—have had on art in its traditional form.

II

Even the most perfect reproduction of a work of art is lacking in one element: its presence in time and space, its unique existence at the place where it happens to be. This unique existence of the work of art determined the history to which it was subject throughout the time of its existence. This includes the changes which it may have suffered in physical condition over the years as well as the various changes in its ownership.[2] The traces of the first can be revealed only by chemical or physical analyses which it is impossible to perform on a reproduction; change of ownership are subject to a tradition which must be traced from the situation of the original.

The presence of the original is the prerequisite to the concept of authenticity. Chemical analyses of the patina of a bronze can help to establish this, as does the proof that a given manuscript of the Middle Ages stems from an archive of the fifteenth century. The whole sphere of authenticity is outside technical—and, of course, not only technical —reproducibility.[3] Confronted with its manual reproduction, which

2. *Of course, the history of a work of art encompasses more than this. The history of the "Mona Lisa," for instance, encompasses the kind and number of its copies made in the 17th, 18th, and 19th centuries.*

3. *Precisely because authenticity is not reproducible, the intensive penetration of certain (mechanical) processes of reproduction was instrumental in differentiating and grading authenticity. To develop such differentiations was an important function of the trade in works of art. The invention of the woodcut may be said to have struck at the*

was usually branded as a forgery, the original preserved all its authority; not so *vis à vis* technical reproduction. The reason is twofold. First, process reproduction is more independent of the original than manual reproduction. For example, in photography, process reprduction can bring out those aspects of the original that are unattainable to the naked eye yet accessible to the lens, which is adjustable and chooses its angle at will. And photographic reproduction, with the aid of certain processes, such as enlargement or slow motion, can capture images which escape natural vision. Secondly, technical reproduction can put the copy of the original into situations which would be out of reach for the original itself. Above all, it enables the original to meet the beholder halfway, be it in the form of a photograph or a phonograph record. The cathedral leaves its locale to be received in the studio of a lover of art; the choral production, performed in an auditorium or in the open air, resounds in the drawing room.

The situations into which the product of mechanical reproduction can be brought may not touch the actual work of art, yet the quality of its presence is always depreciated. This holds not only for the art work but also, for instance, for a landscape which passes in review before the spectator in a movie. In the case of the art object, a most sensitive nucleus—namely, its authenticity—is interfered with whereas no natural object is vulnerable on that score. The authenticity of a thing is the essence of all that is transmissible from its beginning, ranging from its substantive duration to its testimony to the history which it has experienced. Since the historical testimony rests on the authenticity, the former, too, is jeopardized by reproduction when substantive duration ceases to matter. And what is really jeopardized when the historical testimony is affected is the authority of the object.[4]

One might subsume the eliminated element in the term "aura" and go on to say: that which withers in the age of mechanical reproduction is the aura of the work of art. This is a symptomatic process whose significance points beyond the realm of art. One might generalize by saying: the technique of reproduction detaches the reproduced object from the domain of tradition. By making many reproductions it substi-

root of the quality of authenticity even before its late flowering. To be sure, at the time of its origin a medieval picture of the Madonna could not yet be said to be "authentic." It became "authentic" only during the succeeding centuries and perhaps most strikingly so during the last one.

4. *The poorest provincial staging of* Faust *is superior to a* Faust *film in that, ideally, it competes with the first performance at Weimar. Before the screen it is unprofitable to remember traditional contents which might come to mind before the stage—for instance, that Goethe's friend Johann Heinrich Merck is hidden in Mephisto, and the like.*

tutes a plurality of copies for a unique existence. And in permitting the reproduction to meet the beholder or listener in his own particular situation, it reactivates the object reproduced. These two processes lead to a tremendous shattering of tradition which is the obverse of the contemporary crisis and renewal of mankind. Both processes are intimately connected with the contemporary mass movements. Their most powerful agent is the film. Its social significance, particularly in its most positive form, is inconceivable without its destructive, cathartic aspect, that is, the liquidation of the traditional value of the cultural heritage. This phenomenon is most palpable in the great historical films. It extends to ever new positions. In 1927 Abel Gance exclaimed enthusiastically: "Shakespeare, Rembrandt, Beethoven will make films . . . all legends, all mythologies and all myths, all founders of religion, and the very religions . . . await their exposed resurrection, and the heroes crowd each other at the gate."[5] Presumably without intending it, he issued an invitation to a far-reaching liquidation.

III

During long periods of history, the mode of human sense perception changes with humanity's entire mode of existence. The manner in which human sense perception is organized, the medium in which it is accomplished, is determined not only by nature but by historical circumstances as well. The fifth century, with its great shifts of population, saw the birth of the late Roman art industry and the Vienna Genesis, and there developed only only an art different from that of antiquity but also a new kind of perception. The scholars of the Viennese school, Riegl and Wickhoff, who resisted the weight of classical tradition under which these later art forms had been buried, were the first to draw conclusions from them concerning the organization of perception at the time. However far-reaching their insight, these scholars limited themselves to showing the significant, formal hallmark which characterized perception in late Roman times. They did not attempt—and, perhaps, saw no way—to show the social transformations expressed by these changes of perception. The conditions for an analogous insight are more favorable in the present. And if changes in the medium of contemporary perception can be comprehended as decay of the aura, it is possible to show its social causes.

5. Abel Gance, *"Le Temps de l'image est venu,"* L'Art cinématographique, *Vol. 2, pp. 94 f, Paris, 1927.*

The concept of aura which was proposed above with reference to historical objects may usefully be illustrated with reference to the aura of natural ones. We define the aura of the latter as the unique phenomenon of a distance, however close it may be. If, while resting on a summer afternoon, you follow with your eyes a mountain range on the horizon or a branch which casts its shadow over you, you experience the aura of those mountains, of that branch. This image makes it easy to comprehend the social bases of the contemporary decay of the aura. It rests on two circumstances, both of which are related to the increasing significance of the masses in contemporary life. Namely, the desire of contemporary masses to bring things "closer" spatially and humanly, which is just as ardent as their bent toward overcoming the uniqueness of every reality by accepting its reproduction.[6] Every day the urge grows stronger to get hold of an object at very close range by way of its likeness, its reproduction. Unmistakably, reproduction as offered by picture magazines and newsreels differs from the image seen by the unarmed eye. Uniqueness and permanence are as closely linked in the latter as are transitoriness and reproducibility in the former. To pry an object from its shell, to destroy its aura, is the mark of a perception whose "sense of the universal equality of things" has increased to such a degree that it extracts it even from a unique object by means of reproduction. Thus is manifested in the field of perception what in the theoretical sphere is noticeable in the increasing importance of statistics. The adjustment of reality to the masses and of the masses to reality is a process of unlimited scope, as much for thinking as for perception.

IV

The uniqueness of a work of art is inseparable from its being imbedded in the fabric of tradition. This tradition itself is thoroughly alive and extremely changeable. An ancient statue of Venus, for example, stood in a different traditional context with the Greeks, who made it an object of veneration, than with the clerics of the Middle Ages, who viewed it as an ominous idol. Both of them, however, were equally confronted with its uniqueness, that is, its aura. Originally the contex-

6. *To satisfy the human interest of the masses may mean to have one's social function removed from the field of vision. Nothing guarantees that a portraitist of today, when painting a famous surgeon at the breakfast table in the midst of his family, depicts his social function more precisely than a painter of the 17th century who portrayed his medical doctors as representing this profession, like Rembrandt in his "Anatomy Lesson."*

tual integration of art in tradition found its expression in the cult. We know that the earliest art works originated in the service of a ritual—first the magical, then the religious kind. It is significant that the existence of the work of art with reference to its aura is never entirely separated from its ritual function.[7] In other words, the unique value of the "authentic" work of art has its basis in ritual, the location of its original use value. This ritualistic basis, however remote, is still recognizable as secularized ritual even in the most profane forms of the cult of beauty.[8] The secular cult of beauty, developed during the Renaissance and prevailing for three centuries, clearly showed that ritualistic basis in its decline and the first deep crisis which befell it. With the advent of the first truly revolutionary means of reproduction, photography, simultaneously with the rise of socialism, art sensed the approaching crisis which has become evident a century later. At the time, art reacted with the doctrine of *l'art pour l'art*, that is, with a theology of art. This gave rise to what might be called a negative theology in the form of the idea of "pure" art, which not only denied any social function of art but also any categorizing by subject matter. (In poetry, Mallarmé was the first to take this position.)

An analysis of art in the age of mechanical reproduction must do justice to these relationships, for they lead us to an all-important insight: for the first time in world history, mechanical reproduction emancipates the work of art from its parasitical dependence on ritual. To an ever greater degree the work of art reproduced becomes the work of art designed for reproducibility.[9] From a photographic nega-

7. *The definition of the aura as a "unique phenomenon of a distance however close it may be" represents nothing but the formulation of the cult value of the work of art in categories of space and time perception. Distance is the opposite of closeness. The essentially distant object is the unapproachable one. Unapproachability is indeed a major quality of the cult image. True to its nature, it remains "distant, however close it may be." The closeness which one may gain from its subject matter does not impair the distance which it retains in its appearance.*

8. *To the extent to which the cult value of the painting is secularized the ideas of its fundamental uniqueness lose distinctness. In the imagination of the beholder the uniqueness of the phenomena which hold sway in the cult image is more and more displaced by the empirical uniqueness of the creator or of his creative achievement. To be sure, never completely so; the concept of authenticity always transcends mere genuineness. (This is particularly apparent in the collector who always retains some traces of the fetishist and who, by owning the work of art, shares in its ritual power.) Nevertheless, the function of the concept of authenticity remains determinate in the evaluation of art; with the secularization of art, authenticity displaces the cult value of the work.*

9. *In the case of films, mechanical reproduction is not, as with literature and painting, an external condition for mass distribution. Mechanical reproduction is inherent in the very technique of film production. This technique not only permits in the most direct way but virtually causes mass distribution. It enforces distribution because the production*

tive, for example, one can make any number of prints; to ask for the "authentic" print makes no sense. But the instant the criterion of authenticity ceases to be applicable to artistic production, the total function of art is reversed. Instead of being based on ritual, it begins to be based on another practice—politics.

V

Works of art are received and valued on different planes. Two polar types stand out: with one, the accent is on the cult value; with the other, on the exhibition value of the work.[10] Artistic production begins

of a film is so expensive that an individual who, for instance, might afford to buy a painting no longer can afford to buy a film. In 1927 it was calculated that a major film, in order to pay its way, had to reach an audience of nine million. With the sound film, to be sure, a setback in its international distribution occurred at first: audiences became limited by language barriers. This coincided with the Fascist emphasis on national interests. It is more important to focus on this connection with Fascism than on this setback, which was soon minimized by synchronization. The simultaneity of both phenomena is attributable to the depression. The same disturbances which, on a larger scale, led to an attempt to maintain the existing property structure by sheer force led the endangered film capital to speed up the development of the sound film. The introduction of the sound film brought about a temporary relief, not only because it again brought the masses into the theaters but also because it merged new capital from the electrical industry with that of the film industry. Thus, viewed from the outside, the sound film promoted national interests, but seen from the inside it helped to internationalize film production even more than previously.

10. This polarity cannot come into its own in the aesthetics of Idealism. Its idea of beauty comprises these polar opposites without differentiating between them and consequently excludes their polarity. Yet in Hegel this polarity announces itself as clearly as possible within the limits of Idealism. We quote from his Philosophy of History:

"Images were known of old. Piety at an early time required them for worship, but it could do without beautiful images. These might even be disturbing. In every beautiful painting there is also something nonspiritual, merely external, but its spirit speaks to man through its beauty. Worshipping, conversely, is concerned with the work as an object, for it is but a spiritless stupor of the soul. . . . Fine art has arisen . . . in the church . . . , although it has already gone beyond its principle as art."

Likewise, the following passage from The Philosophy of Fine Art indicates that Hegel sensed a problem here.

"We are beyond the stage of reverence for works of art as divine and objects deserving our worship. The impression they produce is one of a more reflective kind, and the emotions they arouse require a higher test. . . ."—G. W. F. Hegel, The Philosophy of Fine Art, trans., with notes, by F. P. B. Osmaston, Vol. 1, p. 12, London, 1920.

The transition from the first kind of artistic reception to the second characterizes the history of artistic reception in general. Apart from that, a certain oscillation between these two polar modes of reception can be demonstrated for each work of art. Take the

with ceremonial objects destined to serve in a cult. One may assume that what mattered was their existence, not their being on view. The elk portrayed by the man of the Stone Age on the walls of his cave was an instrument of magic. He did expose it to his fellow men, but in the main it was meant for the spirits. Today the cult value would seem to demand that the work of art remain hidden. Certain statues of gods are accessible only to the priest in the cell; certain Madonnas remain covered nearly all year round; certain sculptures on medieval cathedrals are invisible to the spectator on ground level. With the emancipation of the various art practices from ritual go increasing opportunities for the exhibition of their products. It is easier to exhibit a portrait bust that can be sent here and there than to exhibit the statue of a divinity that has its fixed place in the interior of a temple. The same holds for the painting as against the mosaic or fresco that preceded it. And even though the public presentability of a mass originally may have been just as great as that of a symphony, the latter originated at the moment when its public presentability promised to surpass that of the mass.

With the different methods of technical reproduction of a work of art, its fitness for exhibition increased to such an extent that the quantitative shift between its two poles turned into a qualitative transformation of its nature. This is comparable to the situation of the work of art in prehistoric times when, by the absolute emphasis on its cult value, it was, first and foremost, an instrument of magic. Only later did it come to be recognized as a work of art. In the same way today, by the absolute emphasis on its exhibition value the work of art becomes a creation with entirely new functions, among which the one we are conscious of, the artistic function, later may be recognized as inci-

Sistine Madonna. Since Hubert Grimme's research it has been known that the Madonna originally was painted for the purpose of exhibition. Grimme's research was inspired by the question: What is the purpose of the molding in the foreground of the painting which the two cupids lean upon? How, Grimme asked further, did Raphael come to furnish the sky with two draperies? Research proved that the Madonna had been commissioned for the public lying-in-state of Pope Sixtus. The Popes lay in state in a certain side chapel of St. Peter's. On that occasion Raphael's picture had been fastened in a nichelike background of the chapel, supported by the coffin. In this picture Raphael portrays the Madonna approaching the papal coffin in clouds from the background of the niche, which was demarcated by green drapes. At the obsequies of Sixtus a pre-eminent exhibition value of Raphael's picture was taken advantage of. Some time later it was placed on the high altar in the church of the Black Friars at Piacenza. The reason for this exile is to be found in the Roman rites which forbid the use of paintings exhibited at obsequies as cult objects on the high altar. This regulation devalued Raphael's picture to some degree. In order to obtain an adequate price nevertheless, the Papal See resolved to add to the bargain the tacit toleration of the picture above the high altar. To avoid attention the picture was given to the monks of the far-off provincial town.

dental.[11] This much is certain: today photography and the film are the most serviceable exemplifications of this new function.

VI

In photography, exhibition value begins to displace cult value all along the line. But cult value does not give way without resistance. It retires into an ultimate retrenchment: the human countenance. It is no accident that the portrait was the focal point of early photography. The cult of remembrance of loved ones, absent or dead, offers a last refuge for the cult value of the picture. For the last time the aura emanates from the early photographs in the fleeting expression of a human face. This is what constitutes their melancholy, incomparable beauty. But as man withdraws from the photographic image, the exhibition value for the first time shows its superiority to the ritual value. To have pinpointed this new stage constitutes the incomparable significance of Atget, who, around 1900, took photographs of deserted Paris streets. It has quite justly been said of him that he photographed them like scenes of crime. The scene of a crime, too, is deserted; it is photographed for the purpose of establishing evidence. With Atget, photographs become standard evidence for historical occurrences, and acquire a hidden political significance. They demand a specific kind of approach; free-floating contemplation is not appropriate to them. They stir the viewer; he feels challenged by them in a new way. At the same time picture magazines begin to put up signposts for him, right ones or wrong ones, no matter. For the first time, captions have become obligatory. And it is clear that they have an altogether different character than the title of a painting. The directives which the captions give to those looking at pictures in illustrated magazines soon become even more explicit and more imperative in the film where the meaning of each single picture appears to be prescribed by the sequence of all preceding ones.
. . . .

11. *Bertolt Brecht, on a different level, engaged in analogous reflections: "If the concept of 'work of art' can no longer be applied to the thing that emerges once the work is transformed into a commodity, we have to eliminate this concept with cautious care but without fear, lest we liquidate the function of the very thing as well. For it has to go through this phase without mental reservation, and not as noncommittal deviation from the straight path; rather, what happens here with the work of art will change it fundamentally and erase its past to such an extent that should the old concept be taken up again—and it will, why not?—it will no longer stir any memory of the thing it once designated."*

XII

Mechanical reproduction of art changes the reaction of the masses toward art. The reactionary attitude toward a Picasso painting changes into the progressive reaction toward a Chaplin movie. The progressive reaction is characterized by the direct, intimate fusion of visual and emotional enjoyment with the orientation of the expert. Such fusion is of great social significance. The greater the decrease in the social significance of an art form, the sharper the distinction between criticism and enjoyment by the public. The conventional is uncritically enjoyed, and the truly new is criticized with aversion. With regard to the screen, the critical and the receptive attitudes of the public coincide. The decisive reason for this is that individual reactions are predetermined by the mass audience response they are about to produce, and this is nowhere more pronounced than in the film. The moment these responses become manifest they control each other. Again, the comparison with painting is fruitful. A painting has always had an excellent chance to be viewed by one person or by a few. The simultaneous contemplation of paintings by a large public, such as developed in the nineteenth century, is an early symptom of the crisis of painting, a crisis which was by no means occasioned exclusively by photography but rather in a relatively independent manner by the appeal of art works to the masses.

Painting simply is in no position to present an object for simultaneous collective experience, as it was possible for architecture at all times, for the epic poem in the past, and for the movie today. Although this circumstance in itself should not lead one to conclusions about the social role of painting, it does constitute a serious threat as soon as painting, under special conditions and, as it were, against its nature, is confronted directly by the masses. In the churches and monasteries of the Middle Ages and at the princely courts up to the end of the eighteenth century, a collective reception of paintings did not occur simultaneously, but by graduated and hierarchized mediation. The change that has come about is an expression of the particular conflict in which painting was implicated by the mechanical reproducibility of paintings. Although paintings began to be publicly exhibited in galleries and salons, there was no way for the masses to organize and control themselves in their reception.[12] Thus the same public which responds in a

12. *This mode of observation may seem crude, but as the great theoretician Leonardo has shown, crude modes of observation may at times be usefully adduced. Leonardo*

progressive manner toward a grotesque film is bound to respond in a reactionary manner to surrealism.

XIII

The characteristics of the film lie not only in the manner in which man presents himself to mechanical equipment but also in the manner in which, by means of this apparatus, man can represent his environment. A glance at occupational psychology illustrates the testing capacity of the equipment. Psychoanalysis illustrates it in a different perspective. The film has enriched our field of perception with methods which can be illustrated by those of Freudian theory. Fifty years ago, a slip of the tongue passed more or less unnoticed. Only exceptionally may such a slip have revealed dimensions of depth in a conversation which had seemed to be taking its course on the surface. Since the *Psychopathology of Everyday Life* things have changed. This book isolated and made analyzable things which had heretofore floated along unnoticed in the broad stream of perception. For the entire spectrum of optical, and now also acoustical, perception the film has brought about a similar deepening of apperception. It is only an obverse of this fact that behavior items shown in a movie can be analyzed much more precisely and from more points of view than those presented on paintings or on the stage. As compared with painting, filmed behavior lends itself more readily to analysis because of its incomparably more precise statements of the situation. In comparision with the stage scene, the filmed behavior item lends itself more readily to analysis because it can be isolated more easily. This circumstance derives its chief importance from its tendency to promote the mutual penetration of art and science. Actually, of a screened behavior item which is neatly brought out in a certain situation, like a muscle of a body, it is difficult to say which is more fascinating, its artistic value or its value for science. To demonstrate the identity of the artistic and scientific uses of photography which heretofore usually were separated will be one of the revolutionary functions of the film.[13]

compares painting and music as follows: "Painting is superior to music because, unlike unfortunate music, it does not have to die as soon as it is born. . . . Music which is consumed in the very act of its birth is inferior to painting which the use of varnish has rendered eternal." (Trattato I, 29.)

13. Renaissance painting offers a revealing analogy to this situation. The incomparable development of this art and its significance rested not least on the integration of a number of new sciences, or at least of new scientific data. Renaissance painting made use of anatomy and perspective, of mathematics, meteorology, and chromatology. Valéry

By close-ups of the things around us, by focusing on hidden details of familiar objects, by exploring commonplace milieus under the ingenious guidance of the camera, the film, on the one hand, extends our comprehension of the necessities which rule our lives; on the other hand, it manages to assure us of an immense and unexpected field of action. Our taverns and our metropolitan streets, our offices and furnished rooms, our railroad stations and our factories appeared to have us locked up hopelessly. Then came the film and burst this prison-world asunder by the dynamite of the tenth of a second, so that now, in the midst of its far-flung ruins and debris, we calmly and adventurously go traveling. With the close-up, space expands; with slow motion, movement is extended. The enlargement of a snapshot does not simply render more precise what in any case was visible, though unclear: it reveals entirely new structural formations of the subject. So, too, slow motion not only presents familiar qualities of movement but reveals in them entirely unknown ones "which, far from looking like retarded rapid movements, give the effect of singularly gliding, floating, supernatural motions." [14] Evidently a different nature opens itself to the camera than opens to the naked eye—if only because an unconsciously penetrated space is substituted for a space consciously explored by man. Even if one has a general knowledge of the way people walk, one knows nothing of a person's posture during the fractional second of a stride. The act of reaching for a lighter or a spoon is familiar routine, yet we hardly know what really goes on between hand and metal, not to mention how this fluctuates with our moods. Here the camera intervenes with the resources of its lowerings and liftings, its interruptions and isolations, its extensions and accelerations, its enlargements and reductions. The camera introduces us to unconscious optics as does psychoanalysis to unconscious impulses.
. . . .

Epilogue

The growing proletarianization of modern man and the increasing formation of masses are two aspects of the same process. Fascism attempts to organize the newly created proletarian masses without affecting the

writes: *"What could be further from us than the strange claim of a Leonardo to whom painting was a supreme goal and the ultimate demonstration of knowledge? Leonardo was convinced that painting demanded universal knowledge, and he did not even shrink from a theoretical analysis which to us is stunning because of its very depth and precision. . . ."*—Paul Valéry, Pièces sur l'art, *"Autour de Corot," Paris, p. 191.*

14. *Rudolf Arnheim*, Film als Kunst, *Berlin, 1932, p. 138.*

property structure which the masses strive to eliminate. Fascism sees its salvation in giving these masses not their right, but instead a chance to express themselves.[15] The masses have a right to change property relations; Fascism seeks to give them an expression while preserving property. The logical result of Fascism is the introduction of aesthetics into political life. The violation of the masses, whom Fascism, with its *Führer* cult, forces to their knees, has its counterpart in the violation of an apparatus which is pressed into the production of ritual values.

All efforts to render politics aesthetic culminate in one thing: war. War and war only can set a goal for mass movements on the largest scale while respecting the traditional property system. This is the political formula for the situation. The technological formula may be stated as follows: Only war makes it possible to mobilize all of today's technical resources while maintaining the property system. It goes without saying that the Fascist apotheosis of war does not employ such arguments. Still, Marinetti says in his manifesto on the Ethiopian colonial war: "For twenty-seven years we Futurists have rebelled against the branding of war as antiaesthetic. . . . Accordingly we state: . . . War is beautiful because it established man's dominion over the subjugated machinery by means of gas masks, terrifying megaphones, flame throwers, and small tanks. War is beautiful because it initiates the dreamt-of metalization of the human body. War is beautiful because it enriches a flowering meadow with the fiery orchids of machine guns. War is beautiful because it combines the gunfire, the cannonades, the cease-fire, the scents, and the stench of putrefaction into a symphony. War is beautiful because it creates new architecture, like that of the big tanks, the geometrical formation flights, the smoke spirals from burning villages, and many others. . . . Poets and artists of Futurism! . . . remember these principles of an aesthetics of war so that your struggle for a new literature and a new graphic art . . . may be illumined by them!"

This manifesto has the virtue of clarity. Its formulations deserve

15. *One technical feature is significant here, especially with regard to newsreels, the propagandist importance of which can hardly be overestimated. Mass reproduction is aided especially by the reproduction of masses. In big parades and monster rallies, in sports events, and in war, all of which nowadays are captured by camera and sound recording, the masses are brought face to face with themselves. This process, whose significance need not be stressed, is intimately connected with the development of the techniques of reproduction and photography. Mass movements are usually discerned more clearly by a camera than by the naked eye. A bird's-eye view best captures gatherings of hundreds of thousands. And even though such a view may be as accessible to the human eye as it is to the camera, the image received by the eye cannot be enlarged the way a negative is enlarged. This means that mass movements, including war, constitute a form of human behavior which particularly favors mechanical equipment.*

to be accepted by dialecticians. To the latter, the aesthetics of today's war appears as follows: If the natural utilization of productive forces is impeded by the property system, the increase in technical devices, in speed, and in the sources of energy will press for an unnatural utilization, and this is found in war. The destructiveness of war furnishes proof that society has not been mature enough to incorporate technology as its organ, that technology has not been sufficiently developed to cope with the elemental forces of society. The horrible features of imperialistic warfare are attributable to the discrepancy between the tremendous means of production and their inadequate utilization in the process of production—in other words, to unemployment and the lack of markets. Imperialistic war is a rebellion of technology which collects, in the form of "human material," the claims to which society has denied its natural material. Instead of draining rivers, society directs a human stream into a bed of trenches; instead of dropping seeds from airplanes, it drops incendiary bombs over cities; and through gas warfare the aura is abolished in a new way.

"*Fiat ars—pereat mundus*," says Fascism, and, as Marinetti admits, expects war to supply the artistic gratification of a sense perception that has been changed by technology. This is evidently the consummation of "*l'art pour l'art.*" Mankind, which in Homer's time was an object of contemplation for the Olympian gods, now is one for itself. Its self-alienation has reached such a degree that it can experience its own destruction as an aesthetic pleasure of the first order. This is the situation of politics which Fascism is rendering aesthetic. Communism responds by politicizing art.

James Thurber

"Has Photography Gone Too Far?" 1934

James Thurber (1894–1961), humorist, cartoonist, and fixture at *The New Yorker*, was not the sort to be daunted by the serious nature of photographic controversy. This philistine look at Surrealism and the collage aesthetic pokes fun at the endless argument over straight vs. manipulated prints. Mr. Thurber would doubtless have drawn a moral from the fact that the dispute has not abated even today, despite his effort to lay it to rest.

It would be cowardly to answer the question I have posed for myself with a time-worn and evasive "Yes and no," just as it would be flippant to answer it with "Who cares?" and ignorant to reply "I do not know." I think there can be no question but that photography has gone too far, but I feel confident that it can get back, *if it wants to.* In that phrase "if it wants to," which I have italicized, there might seem to be a certain ominous significance, but as a matter of fact there isn't at all; I italicized it simply because I wanted to sharpen the interest of my readers, if any are still sticking with me. The whole subject of photography has to be italicized for the average reader or he will turn to some other subject quicker than you can say "Alfred Stieglitz."

I became interested in the question as to whether photography has

335

gone too far when I read a recent article by Mr. Edward Alden Jewell, the art critic, in which he began by saying that the present summer quiet has been "ruffled by the recrudescence of an old dispute"— namely, should photographic plates and prints be let alone? The article, a long one, dealt with photography as an art and concerned itself chiefly with a discussion as to whether or not a photographer-artist has a right to monkey with a negative or print; that is, put things in that weren't originally there or take things out that were originally there. *Let us consider this important question a moment!*

Several years ago I remember going to an exhibition of photographs in the modern manner. Most of the pictures were highly artistic. There were no straightforward photographs of your child or my child. There were photographs of balls of twine, of shadows cast by the Sixth Avenue "L," of a lady's hand holding some eggshells and rubies, of a horse's mouth taken from the ground just in front of the horse by a photographer who was lying on his back (it was a gentle, old horse), of a clothesline with clothes on it, of a girl lying on her back as seen through a champagne glass, etc. It was difficult for me, an amateur, to know what to say about many of the pictures, especially the one of the horse's mouth, because you could see his teeth and the picture looked at first like a balloon landing in a cemetery. So I didn't say anything.

This kind of photography started, I believe, in fairly recent years. Somebody, maybe Man Ray (I never go into any subject thoroughly enough to know much about it), first began to take pictures of such groupings as a litter of tenpenny nails, a white door-knob, an elk's tooth, and a strip of silk lining torn from a gentleman's dressing-gown. Thus one picture led to another until now there are several hundred million photographs of this nature, no two of them exactly alike but thousands of them seeming to be exactly alike. Any given object, whether animal, vegetable, or mineral, has been photographed in juxtaposition to every other known object. I have seen pictures of spark-plugs lying next to hairpins; a chipmunk's skull with bachelor's-buttons for eyes; a woman's hand holding the sawed-off part of a double-barrelled shotgun; a silk hat in which several eggbeaters and a whisk-broom had been tastefully arranged; and a Bengal tiger studying with mild alarm a plate of buttons from a naval officer's mess jacket.

Of course, it would be unfair to say that all art photographers have gone in for such bizarre compositions; many of them are content to lie on the floor and photograph people or get up on stepladders and photograph people. It all comes to the same thing, however: it is virtually impossible nowadays to find a straightaway photograph of a person standing and looking at the camera. Personally, I don't care how many

strange photographs are taken and exhibited. All that worries me (and this is always true of me during any trend, from art photography to proletarianism) is what is going to happen to *me*. I like to be photographed, and I come from a long line of ancestors who liked to be photographed. My Grandfather Fisher liked to be photographed so well that we have one old Fisher family album in which there is nothing but photographs of my grandfather. In not one of them, however, is he shown lying on his back with a dahlia in his mouth or lying on his side with shadows on his face cast by the wire netting of a chicken coop. I don't think he would have submitted to any such poses, and he was man enough to have successfully fought off any photographer who might have wanted to throw him to the floor or trap him into lying down on the floor. Grandfather's black beard would, I suppose, have looked terribly effective photographed between a vase and a wastebasket, but there is no man alive today who could have persuaded him to try and find out.

With me it is different from what it would have been with Grandfather. Certain photographers, particularly the grim, intense ones with the steely eyes, could probably inveigle me into assuming any remarkable position they desired (barring lying down and peering up into the face of a tiger). It is for this reason that I have not been photographed for several years. At Christmas time now I make records of my voice and send them to my family, instead of photographs.

But to get back to the moot question—has an art photographer a right to put things in, or take things out of, a negative or a print? Mr. Jewell, in his article, quotes Mr. Yosei Amemya, the Japanese photographer and painter, as follows: "In even the hands of the most expert technician it [the camera's eye] often cheats, many of the elements that appeared in it being missing when the plate is developed, not the least of which is color." Not the least of which was, in one picture *I* took some years ago, the Washington Monument. I spotted the Washington Monument directly in the center of the camera's finder, snapped the shutter, and later took the film to be developed. There was no Washington Monument in the print the camera-shop man finally turned over to me. "The Washington Monument should be right in the center of this print," I told him. He picked up the negative and looked at it against the light. "You must have missed it," he said. I told him I *couldn't* have missed it. "Well," he said, "you *must* have missed it." The mystery was never cleared up. And that leaves my position in regard to "controlled" negatives rather anomalous ("controlled" is a word the art photographers use for the commoner and less classy "retouched").

A controversy about controlled photography is now raging in the

land, Mr. Jewell's article reveals. You could have knocked me down with an old box-style Brownie No. 1 Kodak when I discovered, in reading Mr. Jewell's piece further, that the Camera Club has been "arguing the question of straight versus controlled photography for fifty years." Without, apparently, getting anywhere. Of course, as is usual with me in connection with subjects I know very little about, I have a suggestion to make. It seems to me that more control should be exerted upon the subjects before they are photographed and less upon the plates afterward. I mean an art photographer should be able to make up his mind long before he goes into the darkroom whether or not he really wants a picture of seven jackstones and the works of a watch scattered upon a polo shirt. But maybe I don't grasp the main idea. Maybe the real art—and the real fun—comes in controlling the plates and prints rather than the objects themselves. At any rate, I completely agree with Mr. Jewell when he says, "Those who insist that 'controlled' prints are bad do not, I am sure, mean to suggest that the artist should not at all times be in control." I should certainly hope not! Once the camera itself got the upper hand, the Lord Himself only knows *what* might happen.

László Moholy-Nagy

"From Pigment to Light"
1936

László Moholy-Nagy (1895–1946) was a protean figure:
painter, sculptor, designer, deviser of light machines, teacher,
photographer. He taught at the Bauhaus in Germany in the
twenties, and from 1937 on at the New Bauhaus in Chicago
(later called the Institute of Design), exerting a strong influ-
ence on design. In 1921 he made his first successful photo-
grams, direct images of objects placed on photosensitive
paper. He wrote that he wished to express "the concretization
of light phenomena . . . peculiar to the photographic process
and to no other technical invention." He went on to experi-
ment with multiple images, photomontage, bird's-eye views,
and numerous other techniques to fashion a new reality, a
new abstraction from photographs. Here he makes the fa-
mous prediction that the illiterate of the future will be the
person who does not know how to use a camera.

The terminology of art "isms" is truly bewildering. Without being
exactly certain what the words imply, people talk of impressionism,
neo-impressionism, pointillism, expressionism, futurism, cubism,
suprematism, neoplasticism, purism, constructivism, dadaism, super-
realism—and in addition there are photography, the film, and light

339

displays. Even specialists can no longer keep abreast of this apocalyptic confusion.

It is our task to find the common denominator in all this confusion. Such a common denominator exists. It is only necessary to study the lessons of the work of the last hundred years in order to realize that the consistent development of modern painting has striking analogies in all other spheres of artistic creation.

THE COMMON DENOMINATOR

The invention of photography destroyed the canons of representational, imitative art. Ever since the decline of naturalistic painting, conceived as "color morphosis," unconsciously or consciously sought to discover the laws and elementary qualities of color. The more this problem emerged as the central issue, the less importance was attached to representation. *The creator of optical images learned to work with elementary, purely optical means.*

Approached from this point of view all the manifold "isms" are merely the more or less individual methods of work of one or more artists, who in each case commenced with the destruction of the old representational image in order to achieve new experiences, a new *wealth of optical expression.*

SIGNS OF THE NEW OPTICS

The elements of the new imagery existed in embryo in this very act of destruction. Photography with its almost dematerialized light, and especially the use of direct light rays in camera-less photography and in the motion picture, made clarification an urgent necessity.

Investigations, experiments, theories of color and light, abstract displays of light-images—as yet far too fragmentary and isolated—point towards the future, though they cannot as yet provide a precise picture of anything like the future's scope.

But one result has already emerged from these efforts: the clear recognition that apart from all individual emotion, apart from the purely subjective attitude of the spectator, objective factors determine the effectiveness of an optical work of art: factors conditioned by the material qualities of the optical medium of expression.

MINIMUM DEMANDS

Our knowledge concerning light, brightness, darkness, color, color harmony—in other words our knowledge of the elementary foundations of optical expression is still very limited (in spite of the tireless work of the numerous artists). Existing theories of harmony are no more than the painters' dictionary. They were elaborated to meet the needs of traditional art. They do not touch our present aesthetic sensibilities, our present aims, much less the entire *field of optical expression*. Uncertainty reigns even with regard to the most elementary facts. Innumerable problems of basic importance still confront the painter with the need for careful experimental enquiry: What is the nature of light and shade? Of brightness—darkness? What are light values? What are time and proportion? New methods of registering the intensity of light? The notion of light? What are refractions of light? What is color (pigment)? What are the media infusing life with color? What is color intensity? The chemical nature of color and effective lights? Is form conditional on color?—On its position in space?—On the extent of its surface area? Biological functions? Physiological reactions? Statics and dynamics of composition? Spraying devices, photo and film cameras, screens? The technique of color application? The technique of projection? Specific problems of manual and machine work? etc., etc., etc. Research into the physiological and psychological properties of the media of artistic creation is still in its elementary stages, compared with physical research. Practical experience in the creative use of artificial color (light) as yet scarcely exists.

THE FEAR OF PETRIFICATION

Artists frequently hesitate to apply the results of their experiments to their practical work, for they share the universal fear that mechanization may lead to a petrification of art. They fear that the open revelation of elements of construction, or any artificial stimulation of the intellect or the introduction of mechanical contrivances may sterilize all creative efforts.

This fear is unfounded, since the conscious evocation of *all* the elements of creation must always remain an impossibility. However, many optical canons are elaborated in detail, all optical creation will

retain the unconscious spontaneity of its experience as its basic element of value.

Despite all canons, all inflexible laws, all technical perfection, this inventive potency, this genetic tension which defies analysis, determines the character of every work of art. It is the outcome of intuitive knowledge both of the present and of the basic tendencies of the future.

ART AND TECHNIQUE

The attempt was made, at least partially, to restore the capacity for spontaneous color experience—which had been lost through the spread of the printed word and the recent predominance of literature—by intellectual means. This was only natural, for in the first phase of industrial advance the artist was overwhelmed by the intellectual achievements of the technician, whose achievements embodied the constructive side of creation.

Given a clear determination of function, the latter could without difficulty (at least in theory) produce objects of rational design. The same was assumed to be true in art, until it became apparent that an exaggerated emphasis on its determinable intellectual aspects merely served as a smoke-screen, once the elements of optical expression as such—quite apart from their "artistic" qualities—had been mastered. It was, of course, necessary first to develop a standard language of optical expression, before really gifted artists could attempt to raise the elements thus established to the level of "art." That was the basic aim of all recent artistic and pedagogic efforts in the optical sphere. If today the sub-compensated element of feeling revolts against this tendency, we can only wait until the pendulum will react in a less violent manner.

FROM PAINTING TO THE DISPLAY OF LIGHT

All technical achievements in the sphere of optics must be utilized for the development of this standard language. Among them the *mechanical and technical* requisites of art are of primary importance.

Until recently they were condemned on the grounds that manual skill, the "personal touch," should be regarded as the essential thing in art. Today they already hold their own in the conflict of opinions; tomorrow they will triumph; the day after tomorrow they will yield results accepted without question. Brushwork, the subjective manipulation of a tool is lost, but the clarity of formal relationships is increased

to an extent almost transcending the limitations of matter; an extent in which the objective context becomes transparently clear. Maximum precision, the law of the norm, replaces the misinterpreted significance of manual skill.

It is difficult today to predict the formal achievements of the future. For the formal crystallization of a work of art is conditioned not merely by the incalculable factor of talent, but also by the intensity of the struggle for the mastery of its medium (tools, today machines). But it is safe to predict even today that the optical creation of the future will not be a mere translation of our present forms of optical expression, for the new implements and the hitherto neglected medium of light must necessarily yield results in conformity with their own inherent properties.

PURPOSIVE PROGRESS OF THOUGHT, CIRCULAR ADVANCE OF TECHNIQUE

During the intermediary stages, however, we must not overlook a well-known factor retarding the advance of art: individual pioneers invent new instruments, new methods of work, revolutionizing the traditional forms of production. But usually a long time must elapse before the new can be generally applied. The old hampers its advance. The creative potentialities of the new may be clearly felt, but for a certain time it will appear clothed in traditional forms that are rendered obsolete by its emergence.

Thus in the sphere of music we must for the present content ourselves with the noisy triumphs of the mechanical piano and of the cinema organ, instead of hearing the new electro-mechanical music that is entirely independent of all previously existing instruments. In the sphere of painting the same revolutionary significance already applies to the use of spraying devices, of powerful enamel reflectors and of such reliable synthetic materials as galalith, trolit, bakelite, zellon, or aluminum. The situation is similar in the realm of the cinema, where a method of production is regarded as "revolutionary," whose creative achievements are scarcely greater than those that might be obtained could classical paintings be set in motion.

This situation is unsatisfactory and superannuated when judged in terms of a future in which light displays of any desired quality and magnitude will suddenly blaze up, and multicolored floodlights with transparent sheaths of fire will project a constant flow of immaterial, evanescent images into space by the simple manipulation of switches.

And in the film of the future we shall have constant change in the speed and intensity of light; space in motion constantly varied through the medium of light refracted from efflorescent reflectors; flashes of light and black-outs; chiaroscuro, distance and proximity of light; ultra-violet rays, infra-red penetration of darkness rendered visible—a wealth of undreamt-of optical experiences that will be profoundly stirring to our emotions.

A NEW INSTRUMENT OF VISION

In photography we possess an extraordinary instrument for reproduction. But photography is much more than that. Today it is in a fair way to bringing (optically) something entirely new into the world. The specific elements of photography can be isolated from their attendant complications, not only theoretically, but tangibly, and in their manifest reality.

THE UNIQUE QUALITY OF PHOTOGRAPHY

The photogram, or camera-less record of forms produced by light, which embodies the unique nature of the photographic process, is the real key to photography. It allows us to capture the patterned interplay of light on a sheet of sensitized paper without recourse to any apparatus. The photogram opens up perspectives of a hitherto wholly unknown morphosis governed by optical laws peculiar to itself. It is the most completely dematerialized medium which the new vision commands.

WHAT IS OPTICAL QUALITY?

Through the development of black-and-white photography, light and shadow were for the first time fully revealed; and thanks to it, too, they first began to be employed with something more than a purely theoretical knowledge. (Impressionism in painting may be regarded as a parallel achievement). Through the development of reliable artificial illumination (more particularly electricity), and the power of regulating it, an increasing adoption of flowing light and richly gradated shadows ensued; and through these, again a greater animation of surfaces, and

a more delicate optical intensification. This manifolding of gradations is one of the fundamental "materials" of optical formalism: a fact which holds equally well if we pass beyond the immediate sphere of black-white-grey values and learn to think and work in terms of colored ones.

When pure color is placed against pure color, tone against tone, a hard, poster-like decorative effect generally results. On the other hand the same colors used in conjunction with their intermediate tones will dispel this poster-like effect, and create a more delicate and melting impression. Through its black-white-grey reproductions of all colored appearances photography has enabled us to recognize the most subtle differentiations of values in both the grey and chromatic scales: differentiations that represent a new and (judged by previous standards) hitherto unattainable quality in optical expression. This is, of course, only one point among many. But it is the point where we have to begin to master photography's inward properties, and that at which we have to deal more with the artistic function of expression than with the reproductive function of portrayal.

SUBLIMATED TECHNIQUE

In reproduction—considered as the objective fixation of the semblance of an object—we find just as radical advances and transmogrifications, compared with prevailing optical representation, as in direct records of forms produced by light (photograms). These particular developments are well known: bird's-eye views, simultaneous interceptions, reflections, elliptical penetrations, etc. Their systematic co-ordination opens up a new field of visual presentation in which still further progress becomes possible. It is, for instance, an immense extension of the optical possibilities of reproduction that we are able to register precise fixations of objects, even in the most difficult circumstances, in a hundredth or thousandth of a second. Indeed, this advance in technique almost amounts to a psychological transformation of our eyesight,[1] since the sharpness of the lens and the unerring accuracy of its delineation have now trained our powers of observation up to a standard of visual perception which embraces ultra-rapid snapshots and the millionfold magnification of dimensions employed in microscopic photography.

1. *Helmholtz used to tell his pupils that if an optician were to succeed in making a human eye, and brought it to him for his approval, he would be bound to say: "this is a clumsy job of work."*

IMPROVED PERFORMANCE

Photography, then, imparts a heightened, or (in so far as our eyes are concerned) increased, power of sight in terms of time and space. A plain, matter-of-fact enumeration of the specific photographic elements —purely technical, not artistic, elements—will be enough to enable us to divine the power latent in them, and prognosticate to what they lead.

THE EIGHT VARIETIES OF PHOTOGRAPHIC VISION

1. Abstract seeing by means of direct records of forms produced by light: the photogram which captures the most delicate gradations of light values, both chiaroscuro and colored.

2. Exact seeing by means of the normal fixation of the appearance of things: reportage.

3. Rapid seeing by means of the fixation of movements in the shortest possible time: snapshots.

4. Slow seeing by means of the fixation of movements spread over a period of time: *e.g.*, the luminous tracks made by the headlights of motor cars passing along a road at night: prolonged time exposures.

5. Intensified seeing by means of:
 a) micro-photography;
 b) filter-photography, which, by variation of the chemical composition of the sensitized surface, permits photographic potentialities to be augmented in various ways—ranging from the revelation of far-distant landscapes veiled in haze or fog to exposures in complete darkness: infra-red photography.

6. Penetrative seeing by means of X-rays: radiography.

7. Simultaneous seeing by means of transparent superimposition: the future process of automatic photomontage.

8. Distorted seeing: optical jokes that can be automatically produced by:
 a) exposure through a lens fitted with prisms, and the device of reflecting mirrors; or
 b) mechanical and chemical manipulation of the negative after exposure.

WHAT IS THE PURPOSE OF THE ENUMERATION?

What is to be gleaned from this list? That the most astonishing possi-
bilities remain to be discovered in the raw material of photography,
since a detailed analysis of each of these aspects furnishes us with a
number of valuable indications in regard to their application, adjust-
ment, etc. Our investigations will lead us in another direction, how-
ever. We want to discover what is the essence and significance of
photography.

THE NEW VISION

All interpretations of photography have hitherto been influenced by
the aesthetic-philosophic concepts that circumscribed painting. These
were for long held to be equally applicable to photographic practice.
Up to now, photography has remained in rather rigid dependence on
the traditional forms of painting; and like painting it has passed through
the successive stages of all the various art "isms"; though in no sense to
its advantage. Fundamentally new discoveries cannot for long be con-
fined to the mentality and practice of bygone periods with impunity.
When that happens all productive activity is arrested. This was plainly
evinced in photography, which has yielded no results of any value
except in those fields where, as in scientific work, it has been employed
without artistic ambitions. Here alone did it prove the pioneer of an
original development, or of one peculiar to itself.

In this connection it cannot be too plainly stated that it is quite
unimportant whether photography produces "art" or not. Its own basic
laws, not the opinions of art critics, will provide the only valid measure
of its future worth. It is sufficiently unprecedented that such a "me-
chanical" thing as photography, and one regarded so contemptuously
in an artistic and creative sense, should have acquired the power it has,
and become one of the primary objective visual forms, in barely a
century of evolution. Formerly the painter impressed his own perspec-
tive outlook on his age. We have only to recall the manner in which we
used to look at landscapes, and compare it with the way we perceive
them now! Think, too, of the incisive sharpness of those camera por-
traits of our contemporaries, pitted with pores and furrowed by lines.
Or an air-view of a ship at sea moving through waves that seem frozen
in light. Or the enlargement of a woven tissue, or the chiselled delicacy

of an ordinary sawn block of wood. Or, in fact, any of the whole gamut of splended details of structure, texture, and "factor" of whatever objects we care to choose.

THE NEW EXPERIENCE OF SPACE

Through photography, too, we can participate in new experiences of space, and in even greater measure through the film. With their help, and that of the new school of architects, we have attained an enlargement and sublimation of our appreciation of space, the comprehension of a new spatial culture. Thanks to the photographer, humanity has acquired the power of perceiving its surroundings, and its very existence, with new eyes.

THE HEIGHT OF ATTAINMENT

But all these are isolated characteristics, separate achievements, not altogether dissimilar to those of painting. In photography we must learn to seek, not the "picture," not the aesthetic of tradition, but the ideal instrument of expression, the self-sufficient vehicle for education.

SERIES (PHOTOGRAPHIC IMAGE SEQUENCES OF THE SAME OBJECT)

There is no more surprising, yet, in its naturalness and organic sequence, simpler form than the photographic series. This is the logical culmination of photography. The series is no longer a "picture," and none of the canons of pictorial aesthetics can be applied to it. Here the separate picture loses its identity as such and becomes a detail of assembly, an essential structural element of the whole which is the thing itself. In this concatenation of its separate but inseparable parts a photographic series inspired by a definite purpose can become at once the most potent weapon and the tenderest lyric. The true significance of the film will only appear in a much later, less confused and groping age than ours. The prerequisite for this revelation is, of course, the realization that a knowledge of photography is just as important as that of the alphabet. The illiterate of the future will be ignorant of the use of camera and pen alike.

Roy Emerson Stryker

"The FSA Collection of Photographs"
1973

Roy Stryker (1893–1975) was an economist at Columbia University who was called to Washington in 1935 to head the Historical Section of the Resettlement Administration, later called the Farm Security Administration (FSA). He was not a photographer himself, but he recognized the importance of photography as record, document, and propaganda, and he had a keen eye for a good photographer, hiring Walker Evans, Dorothea Lange, Russell Lee, Ben Shahn, Arthur Rothstein, and others. Stryker insisted his photographers know the economic and historic background of the depressed areas they visited. The FSA archive constitutes the biggest documentary project ever undertaken in America; the negatives are in the Library of Congress.

For nearly eight years, from 1935 to 1943, it was my great privilege to direct a small group of photographers working out of a grubby little government office in Washington, D.C. These gifted men and women of the Historical Section of the Farm Security Administration produced 270,000 pictures during that time. It is called a great collection now, perhaps the greatest ever assembled in the history of America. But I am not interested in adjectives. I am only interested in pictures.

And what pictures they were. I had no idea what was going to happen. I expected competence. I did not expect to be shocked at what began to come across my desk. The first three men who went out— Carl Mydans, Walker Evans and Ben Shahn—began sending in some astounding stuff that first fall, about the same time that I saw the great work Dorothea Lange was doing in California and decided to hire her. Then Arthur Rothstein, who had set up the lab, started taking pictures. Every day was for me an education and a revelation. I could hardly wait to get to the mail in the morning.

I especially remember one of Walker's early pictures—one of a cemetery and a stone cross, with some streets and buildings and steel mills in the background. Months after we'd released that picture a woman came in and asked for a copy of it. We gave it to her and when I asked her what she wanted it for, she said, "I want to give it to my brother who's a steel executive. I want to write on it, '*Your* cemeteries, *your* streets, *your* buildings, *your* steel mills. But *our* souls. God damn you.' "

Pictures like these were pretty heady. It was important that they came in when they did, so early in our experience. They gave me the first evidence of what we could do. They made it clear that the FSA collection was going to be something very special.

Just how special, though, we could not appreciate at the time. Sure, we had a sense that we were in on the beginning of something. In 1936 photography, which theretofore had been mostly a matter of landscapes and snapshots and family portraits, was fast being discovered as a serious tool of communications, a new way for a thoughtful, creative person to make a statement. Flash bulbs and small cameras were being used for the first time. The rotogravure was dying; the first big picture magazines, which would take its place, were already being roughed out. In a year or so, and with a suddenness matched only by the introduction of television twelve years later, picture-taking became a national industry. We would have been insensitive indeed not to have realized that we were an important part of a movement.

In a sense, by experimenting freely with new forms and techniques, our unit was doing for professional photography what the WPA Theater was doing for the stage. Still, we had no idea that we were doing anything of the importance that later historians have credited us with. We particularly underestimated the content of our work. We know now that we helped open up a brand-new territory of American life and manners as a legitimate subject for visual commentary. We did not know it then. Day to day, we were too busy taking routine pictures for other Farm Security units, feeding pictures to

newspapers, providing illustrations for reports and exhibits. There was one exception, however—and I guess I may as well admit it now. During the whole eight years, I held onto a personal dream that inevitably got translated into black-and-white pictures: I wanted to do a pictorial encyclopedia of American agriculture. My footnotes to the photographers' instructions ("keep your eyes open for a rag doll and a corn tester") undoubtedly accounted for the great number of photographs that got into the collection which had nothing to do with official business.

In truth, I think the work we did can be appreciated only when the collection is considered as a whole. The total volume, and it's a staggering volume, has a richness and distinction that simply cannot be drawn from the individual pictures themselves. There's an unusual continuity to it all. Mostly, there's rural America in it. It's the farms and the little towns and the highways between.

But most important, there is in this collection an attitude toward people. To my knowledge there is no picture in there that in any way whatsoever represents an attempt by a photographer to ridicule his subject, to be cute with him, to violate his privacy, or to do something to make a cliché. However they might have differed in skill and insight, our photographers had one thing in common, and that was a deep respect for human beings. Russell Lee's picture of the gnarled hands of the old woman, for instance—Russell took that with every degree of commiseration and respect. He wanted to say, "These are the hands of labor," and he said it eloquently. So it is all the way through the file. There's honesty there, and compassion, and a natural regard for individual dignity. These are the things that, in my opinion, give the collection its special appeal.

I think, too, that our work assumes particular significance when seen against the backdrop of contemporary photography as exemplified by the big picture magazines. By now, the bloom is off. Our eyes are literally assaulted by pictures every day. We're surfeited with pictures. But the problem is not so much that the public is used to pictures but that pictures are being badly used. Our editors, I'm afraid, have come to believe that the photograph is an end in itself. They've forgotten that the photograph is only the subsidiary, the little brother, of the word. Too many times nowadays the picture is expected to tell the whole story, when in truth there's only one picture in a hundred thousand that can stand alone as a piece of communication. As a result, news reporting itself has come to have a hurried, superficial, unsatisfying quality. Too often, too, the pictures are planned in advance by an editor who never sees the subject and there's no chance for the

photographer's spontaneity to come through. Most of all, though, our big picture magazines were guilty of the same thing that's infected our movies, our theater, and our literature. Everything now has to happen on stage. Everything has to be shown, even the syphilis scabs.

I remember once at *Life* arguing with one of their photographers and a layout man. We were looking at a photograph of a man and a woman and a little girl. Their backs were to us. The woman was distraught. Her husband had his arm around her. The little girl at their side was winding up her overalls with one finger. The tension was unmistakable—the daughter of this man and woman had drowned in a lake and they were dragging for her. The little girl with them was their daughter's playmate. The *Life* men insisted that it would have been a better picture had the photographer taken it from the front. I could not possibly agree. Theirs was the attitude of the news photographer—always show the face, even if it's awkward—and I'm afraid that in too many instances the news photographer has taken over. This is to be regretted, I think, because too often what is communicated by this kind of overstatement, this reliance on the obvious, is not the essence of a situation but only the insincerity of the photographer.

In the light of what's happened since, it's clear that what we did at FSA constitutes a unique episode in the history of photography. And yet what was it precisely that we did? What, in a word, was our contribution?

Was it, for instance, art? Certainly we had some artists working for us. Walker Evans thought of his work as art and, to prove it, had a one-man show at the Museum of Modern Art. Ben Shahn, indubitably one of America's great moderns, was on the team; indeed, some of the scenes he took for us found their counterparts later in some of his oils. I remember sending young Jack Delano on assignment to Vermont. He spent hours asking himself, a bit self-consciously, "What is the *one* picture I can take that will say Vermont?" There's no question that photographers like these produced some great pictures, pictures that will live the way great paintings live. But is it art? Is any photography art? I've always avoided this particular controversy. Nothing strikes me as more futile, and most of us in the unit felt the same way.

Was it sociology? I'm sure it was more than a little bit sociology. Ansel Adams, in fact, once told me, "What you've got are not photographers. They're a bunch of sociologists with cameras." When the author of *Middletown*, Bob Lynd, saw some of our pictures he got terribly excited and said, "This is a wonderful device for sociologists." He then got off onto a long discourse on the need to make people really *see*. "I wonder," he said, "how many people know what's even down their own street." Interestingly enough, one of the last boys I hired,

John Collier, later developed a technique for using photographs to make people see more clearly "what's down their own street." He found that pictures frequently would stimulate seemingly inarticulate people into volunteering important anthropological data.

Was it journalism? Yes and no. We took news pictures, of course. We were in the same seedbed with *Life* and *Look*, for which some of our old staff later worked. (We are, as a matter of fact, said to have contributed substantially to the rise of photo-journalism. It would make just as much sense to speak of word-journalism. It seems to me that there's only journalism, plain and unhyphenated, and journalism consists of both words and pictures and sometimes you use more words than pictures and sometimes vice versa.) But we had no news photographers, as such. By this I mean we had no people especially gifted at knowing how to get to the dog fight, how to get to the place where the excitement was, point a camera, and get out. I think it's significant that in our entire collection we have only one picture of Franklin Roosevelt, the most newsworthy man of the era—this, mind you, in a collection that's sometimes said to have reported the feel and smell and taste of the thirties even more vividly than the news media. No, I think the best way to put it is that newspictures are the noun and the verb; our kind of photography is the adjective and adverb. The newspicture is a single frame; ours, a subject viewed in series. The newspicture is dramatic, all subject and action. Ours shows what's back of the action. It is a broader statement—frequently a mood, an accent, but more frequently a sketch and not infrequently a story.

Was it history? Of course. At least it was a slice of history. We provided some of the important material out of which histories of the period are being written. But you'll find no record of big people or big events in the collection. There are pictures that say labor and pictures that say capital and pictures that say Depression. But there are no pictures of sit-down strikes, no apple salesmen on street corners, not a single shot of Wall Street, and absolutely no celebrities.

Was it education? Very much so, and in more ways than one. For me, it was the equivalent of two Ph.D.'s and a couple of other degrees thrown in. I know it was an education to every photographer we had, too. And I'm sure it's made a contribution to public education. If I had to sum it up, I'd say, yes, it was more education than anything else. We succeeded in doing exactly what Rex Tugwell said we should do: *We introduced Americans to America.* We developed the camera team, in contrast to the cameraman, and the full effect of this team's work was that it helped connect one generation's image of itself with the reality of its own time in history.

The reason we could do this, I think (and perhaps the reason it

could never be done again), was that all of us in the unit were so personally involved in the times, and the times were so peculiarly what they were. It was a trying time, a disturbed time. None of us had suffered personally from the Depression, but all of us were living close to it, and when the photographers went out they saw a great deal of it. Curiously, though, the times did not depress us. On the contrary, there was an exhilaration in Washington, a feeling that things were being mended, that great wrongs were being corrected, that there were no problems so big they wouldn't yield to the application of good sense and hard work. There was apprehension, sure—but no apprehension to compare with our current fear of the bomb. There was a unifying source of inspiration, a great intelligence at work. It was called the New Deal and we were proud to be in on it. And with it all there was the willingness to strike out and do new things. You could do them, too, without fearing that somebody would take your job away or that you might be hauled before some Congressional committee and be made to confess your sins. There was a spirit in Washington that wrapped up our whole group. Some of us later came into positions of real authority. Some of us have even acquired what passes for fame. But I dare say that not one of us has felt more purposeful, or had more fun, than when at FSA.

I cannot, however, attribute the success of our unit entirely to the times. I can't dismiss it all as a product of the spirit of the thirties. I was in charge of the unit. I was given more freedom in the running of it than I had any reasonable right to expect, and whatever came of it, I was—as they say in government—both accountable and responsible. I never took a picture and yet I felt a part of every picture taken. I sat in my office in Washington and yet I went into every home in America. I was both the Stabilizer and the Exciter. Now at eighty I have the honesty to advance the somewhat immodest thought that it was my ideas, my biases, my passions, my convictions, my chemistry that held the team together and made of their work something more than a catalogue of celluloid rectangles in a government storehouse.
. . . .

Paul Taylor

"Migrant Mother: 1936"
1970

Paul Schuster Taylor (b. 1895) taught economics at the University of California at Berkeley. He was a man with a strong commitment to social action. When Dorothea Lange (1895–1965) met Taylor (whom she later married), she was already shifting her interest away from studio portraiture to the unrest in the streets during the Depression. The team of Taylor and Lange was immensely effective; their report on migrant housing conditions in California in 1935, carefully maneuvered through editors and government officials, was instrumental in persuading the government to finance the first federally funded housing in America. Lange's photograph *Migrant Mother* is surely one of the best-known photographs of the entire era.

"Ragged, ill, emaciated by hunger, 2,500 men, women and children are rescued after weeks of suffering by the chance visit of a Government photographer."

San Francisco News, *March 10, 1936*

The photographer had made her way to the *News* office with hardly-dry prints in hand. The editor lost no time notifying the United Press. The UP immediately contacted relief authorities, who sent a represen-

tative to the pea-pickers' camp at Nipomo to tell the faintly cheering pickers that food was on its way from Los Angeles.

Then the *News* published the story, with two poignant photographs of a starving mother and her children beside a lean-to tent shelter. Their car had been stripped of tires, which were sold to buy food. Beside the photographs was a column detailing the story, with a cross-reference to the lead editorial, "Starving Pea Pickers."

With the news in print, the editor acknowledged the photographer's effectiveness in a sincerely appreciative letter accompanied by clippings of photographs, news, and editorial columns. Nowhere in the newspaper did the name of the photographer appear; in those days photographers were anonymous. . . .

Was it mere "chance" that Dorothea Lange, a government photographer, brought about the rescue of starving pea-pickers at Nipomo? Can the answer be so simple?

First, there was the photographer herself. She was not just a woman with a camera. From youth she had always known that she would be a photographer. The impulse came from the depths. In retrospect she explained that she was "compelled to photograph as a direct response to what was around" her. To the question, "What are you going to do with photographs?" she recommended the answer, "Don't let that question stop you, because ways often open that are unpredictable, if you pursue it far enough." Artists, she generalized, "are controlled by the life that beats in them, like the ocean beats in on the shore. They're almost pursued." All this comes through in Dorothea's own account of "Migrant Mother." Having convinced herself while driving twenty miles beyond the pea-pickers' camp that she could continue on, she turned about "like a homing pigeon," drove back to the camp, and parked her car by the tent of the "hungry and desperate mother." As intimate, intense, and vital as it is, Dorothea's account leaves open, as much as it closes, the answer to the question. Was it "chance?"

Dorothea Lange was a "government photographer," as the *News* editorial said. How did that happen? Was *that* "chance?" There was the New Deal, and the New Deal had purpose. In January, 1935, the Rural Rehabilitation Division of the California State Emergency Relief Administration asked me, as field director, to conduct research to recommend a suitable program.

"What staff would you need?" they asked.

"Well, about three or four assistants and a photographer."

"Why do you need a photographer? Would social scientists generally ask for a photographer?"

"No," I acknowledged, "they would not." I explained that I wanted to bring from the field itself visual evidence of the nature of the problem to accompany my textual reports made to those unable to go into the field but responsible for decision.

The office manager suspended further discussion of the usefulness of a photographer when he put Dorothea Lange on the payroll as a typist. In the budget no provision had been made for a photographer. The matter was not closed; Dorothea was allowed to remain on the payroll, but on a trial basis for a month.

Before the probationary month expired, the rural rehabilitation director, Harry E. Drobish (later a state senator), met with the California State Emergency Relief Commission to discuss the program. In his hand Drobish held a report recommending construction of camps for migratory laborers, documented with photographs. After these photographs were passed around the table, the commission voted $200,000 to initiate the program. The question was not raised again, Why a photographer?

Leslie Katz

"An Interview with Walker Evans" 1971

Walker Evans's (1903–1975) clear-eyed, dispassionate, formally arranged photographs of ordinary towns and the interiors of poor homes, and his compassionate shots of sharecroppers—in *Let Us Now Praise Famous Men*, with James Agee—in the thirties strongly influenced the post-war generation of photographers. It is revealing that Evans mentions Flaubert and Baudelaire as influences on himself; the realistic current in nineteenth-century literature is the closest approximation to the photographic aesthetic of any of the arts of the time. Evans's view of Depression America has made its way into public consciousness. For a brief while, he worked for the FSA. In his later career, he worked for *Fortune* magazine and taught at Yale.

Walker Evans is a legendary master of the medium of still photography, one of the few practitioners recognized to have elevated that ubiquitous preoccupation to the level of high and serious art. He is an elusive and usually taciturn man who has the self-effacing air of a practicing magician, and interviewing him may be compared to interviewing a sphinx; you have to propound a riddle that interests him. But when he does answer, his statement, like one of his photographs, has authority, is literate, and tends to transcend the subject.

Evans now teaches at the Yale School of Art and Architecture. There he gives his encouragement to the young copiously when it is called for, but he does not suffer outside interviewing gladly. The occasion for the words of his that follow is the large and magnificent retrospective of his work now on view at the Museum of Modern Art, accompanied by the publication—by the Museum—of an important new volume of his photographs. The Museum is planning to reissue his famous book *American Photographs*, first published in 1938.

Mr. Evans, do you understand the tape-recording process?

Understand it? I know all about the infernal machine. You talk and it records inconsequential persiflage—illogical, totally misleading stuff. That thing would vitiate Bernard Shaw, Samuel Johnson and Socrates. Well, all right, but you have to let me edit it. Even so, if I chirp it may come out birdbrained. Besides that, as soon as you transcribe from tape, the damned thing becomes a lie detector. But go ahead—you mean it's already on?

Where and when did your interest in photography begin?

Well, I began to practice photography seriously just after returning to New York in the late 1920's, after living two years in Paris, where I went to classes at the Sorbonne. In Paris I made a few snapshots of streets, but nothing serious, nothing with my mind. I didn't give myself to it. When I came back to the United States I began to make many photographs. Even then I didn't take it seriously, I suppose, until I showed them to other people. I thought maybe it was a left-handed hobby of mine. A few others made me take it more seriously.

Who were they?

Well, there was Stefan Hirsch, a painter. Hirsch sent me to Stieglitz, who certainly didn't take fire over the work I had. Hart Crane, in his raving way, made a fuss over my things—my first publication, I think, was in the original edition of *The Bridge*. Ben Shahn and I saw a lot of each other. Lincoln Kirstein and Agee, Kirstein first, came into my work much more strongly. Kirstein was an aggressive, quite unrestrained young man, still a Harvard undergraduate, when I met him somewhere. He invaded you; you either had to throw him out or listen to him. As a matter of fact I thought at the time he was great and still do. Oddly enough, what happened was that this undergraduate was *teaching* me something about what I was doing—it was a typical Kirstein switcheroo, all permeated with tremendous spirit, flash, dash and a kind of seeming high jinks that covered a really penetrating intelligence about and articulation of all esthetic matters and their contem-

porary applications. It's hard to believe, but as I say the man was essentially explaining to me just what I was doing in my work. It was immensely helpful and hilariously audacious. Professor Kirstein. Agee of course was another matter altogether. He didn't teach, he perceived; and that in itself was a stimulation. We all need that kind of stimulation, wherever it comes from. In a sense you test your work through that and it bounces back strengthened. My work happened to be just the style and matter for his eye. I could go on at length about Agee, but won't. Actually I think most artists are really working for a very small personal audience. I always have. I think the artist's famous "solitude" is a vacuum. Psychologically you are communing and sharing with someone else, several others, that is.

You took photographs of whatever interested you?

Oh yes. I was a passionate photographer, and for a while somewhat guiltily. I thought it was a substitute for something else—well, for writing, for one thing. I wanted to write. But I became very engaged with all the things there were to be had out of the camera, and became compulsive about it. It was a real drive. Particularly when the lighting was right, you couldn't keep me in. I was a little shame-faced about it, because most photography had about it a ludicrous, almost comic side, I thought. A "photographer" was a figure held in great disdain. Later I used that defiantly. But then, I suppose, I thought photographing was a minor thing to be doing. And I guess I thought I ought to be writing. In Paris, I had been trying to write. But in writing I felt blocked—mostly by high standards. Writing's a very daring thing to do. I'd done a lot of reading, and I knew what writing was. But shy young men are seldom daring.

Who were your favorite authors? Did they influence your photography?

Flaubert, I suppose, mostly by method. And Baudelaire in spirit. Yes, they certainly did influence me, in every way.

Well, your photographs are known for showing an indigenous American esthetic that doesn't even know it is an esthetic—an archetypal classicism of the ordinary. It's almost as if Flaubert had a camera.

I wasn't very conscious of it then, but I know now that Flaubert's esthetic is absolutely mine. Flaubert's method I think I incorporated almost unconsciously, but anyway used in two ways: his realism and naturalism both, and his objectivity of treatment; the non-appearance of author, the non-subjectivity. That is literally applicable to the way I want to use a camera and do. But spiritually, however, it is Baudelaire who is *the* influence on me. Even though I haven't really studied Baudelaire very much I consider him the father of modern literature, the whole modern movement, such as it is. Baudelaire influenced me and

everybody else too. Now that I think about it, mine was the first generation that went to Europe and got a European perspective and technique and came back and applied it to America. Who could be more wonderful masters than Baudelaire and Flaubert? That had really been lacking. Of course everyone went to Europe differently. I don't think Scott Fitzgerald got anything much out of Europe, but Hemingway did. For one thing, Fitzgerald didn't pay any attention to the French language. Hemingway became a sort of master of languages; he could speak and *think* French and Italian and Spanish.

When you began to photograph, how were you affected by the cultural atmosphere and the photography you found in New York when you returned?

I found myself operating direct from the French esthetic and psychological approach to the world. I applied that to the problem of rendering what I saw. I think I operated in reaction to mediocrity and phoniness. In the late twenties the battle against gentility in the arts and in behavior was still on. Everybody a little bit advanced was busy misbehaving in order to shock gentility. Mencken was still leading the attack. William Dean Howells was gone. The attack was a branch of "épater le bourgeois." A kind of esthetic and literary revolution was taking place. Anybody wandering in became a part of that. I did, I'm sure. It's hard to believe now, but we had barnacles of Victorianism hanging around that wouldn't scrape off. I was brought up with Victorian English standards of behavior. I thought that was something to hide. I was in rebellion against my parents' standards. In round terms, I was damn well going to be an artist and I wasn't going to be a businessman.

How did you make a living?

I had a night job on Wall Street in order to be free in the daytime. It paid for room and food. You didn't have to sleep or eat much. In those days I was rather ascetic; I didn't lead the bohemian life Crane led. My friends were mostly Europeans. I shared an apartment with Paul Grotz and the German painter Hans Skolle. I was really anti-American at the time. America was big business and I wanted to escape. It nauseated me. My photography was a semi-conscious reaction against right-thinking and optimism; it was an attack on the establishment. I could just hear my father saying, "Why do you want to look at those scenes, they're depressing. Why don't you look at the nice things in life?" Nothing original about that, though. The Ashcan School of painting and Upton Sinclair and maybe Dreiser had already done it. Although I felt above having a "cause" like Sinclair. I disdained Sinclair Lewis, too, thinking he lacked taste and breadth and cultivation—though he was a very gifted Yankee word-slinger.

When did you begin to take pictures that caught hold with you?

About 1928 and 1929. I had a few prescient flashes and they led me on. I found I wanted to get a type in the street, a "snapshot" of a fellow on the waterfront, or a stenographer at lunch. That was a very good vein. I still mine that vein.

You're a collector; you collect postcards, and found objects. Is there any relation between your collecting and your work?

A great deal. It's almost the same thing. A collector becomes excessively conscious of a certain kind of object, falls in love with it, then pursues it. I notice that in my work for a certain time I'm interested in nothing but a certain kind of face or type of person. You start selecting people with the camera. It's compulsive and you can hardly stop. I think all artists are collectors of images.

There is an abstract quality about the most literal photograph of yours. Do you think in terms of composition?

I don't think very much about it consciously, but I'm very aware of it unconsciously, instinctively. Deliberately discard it every once in a while not to be artistic. Composition is a schoolteacher's word. Any artist composes. I prefer to compose originally, naturally rather than self-consciously. Form and composition both are terribly important. I can't stand a bad design or a bad object in a room. So much for form. The way it's placed is composition . . . When you stop to think about what an artist is doing one question is, what is the driving force, the motive? In this country it is rather obvious; different, say, from European culture. The artist here is very angry and fighting. Everything makes him angry: the local style of living, and one's competitors. Even coworkers in the arts anger and stimulate him. I was stimulated by Stieglitz. When I got around to looking at photography I found him somebody to work against. He was artistic and romantic. It gave me an esthetic to sharpen my own against—a counter-esthetic. But I respect Stieglitz for some things. He put up a very good fight for photography.

In literature or painting, the artist creates in a prolongation of time. Photography is an instant. Your photographs show the monumentality of an instant. What role does accident and what role does intention play? How do they come together? Or is that too mysterious a question to discuss?

In the act of photographing? It's all done instinctively, as far as I can see, not consciously. But after having made it instinctively, unless I feel that the product is a *transcendence* of the thing, of the moment in reality, then I haven't done anything, and I throw it away. Take Atget, whose work I now know very well. (I didn't know it at all for a while.) In his work you do feel what some people will call *poetry*. I do call it that also, but a better word for it, to me, is, well—when Atget does

even a tree root, he *transcends* that thing. And by God somebody else does not. There are millions of photographs made all the time, and they don't transcend anything and they're not anything. In this sense photography's a very difficult art and probably depends on a gift, an unconscious gift sometimes, an extreme talent. Of course there are many extremely gifted and talented people who wouldn't think of operating with a camera, but when they do, it shows. You know, that runs through all art. What's great about Tolstoi? A paragraph of his describing a young Russian girl is universal and transcendent, while what another author writes on the same subject may amount to nothing much.

In other arts one can speak of technique of hand or of mind, the draftsmanship of the painter, the craft of the author. In photography there is a mechanical instrument and a moment when the eye, having looked through the lens, allows the hand to click a lever. How can all that we've expected of literature and art find a commensurate expression in a medium that is basically a mechanism?

Well, that's what makes photography so special and interesting and unknown as an art, and that's why so many people don't see anything in it at all. The point is difficult and abstruse. And that's why I say half jokingly that photography's the most difficult of the arts. It does require a certain arrogance to *see* and to *choose*. I feel myself walking on a tightrope instead of on the ground. With the camera, it's all or nothing. You either get what you're after at once, or what you do has to be worthless. I don't think the essence of photography has the hand in it so much. The essence is done very quietly with a flash of the mind, and with a machine. I think too that photography is editing, editing after the taking. After knowing what to take you have to do the editing. The secret of photography is, the camera takes on the character and the personality of the handler. The mind works on the machine— through it, rather.

Do you take many photographs to get one photograph?

Quite often. I'll do anything to get one photograph. That's another matter I would have to quarrel with a man like Stieglitz about. Stieglitz wouldn't cut a quarter of an inch off a frame. I would cut any number of inches off my frames in order to get a better picture. Stieglitz once made a very revealing remark to me. He said, "I would have been one of the greatest painters ever born." That gave me plenty of thought. I believe it revealed great insecurity on his part. And yet the same man, to his credit, stuck to pure photography and felt that the camera ought to be photographic and not painterly. He was a purist that way. The real photographer who is an artist would never produce a romantic print now, as so many early nineteenth- and twentieth-century photog-

raphers did, using tricks of soft focus and of retouching to disguise the photograph and push it in the direction of painterliness—which is ridiculous. Photography should have the courage to present itself as what it is, which is a graphic composition produced by a machine and an eye and then some chemicals and paper. Technically, it has nothing to do with painting.

How important is the print and the variation in prints?

Very important. The printing technique is hidden and should be. A print has to be true and efficient too, and it can—photographically. You have to have taste and know what's right, about the rendition of light, for example—not too little. Take one negative and print it several ways, and just one will be right. It's a question of truth. You can make a very false picture from a wonderful negative, or you can make a true one.

One notices that in your photographs people are unselfconscious before your camera and all the more themselves for that, formally unselfconscious. Also, in your photographs of things, you seem to seek and discover what you once termed "unconscious arrangements." Do you efface yourself, or seek a quality of concentration?

No, but I do it psychologically, and again, unconsciously. It comes about through some quality of mine that I don't know how I bring into play. People react to me in one way, and to another kind of person in another way. They react the way I *want* them to when I'm doing it right. I'm often asked by students how a photographer can overcome self-consciousness in himself and in his subjects. I say any sensitive person is bothered unless his belief in what he is doing and motive is very strong. The picture is the important thing. In making pictures of people no harm is being done to anybody or deception practiced. One is carrying on a great tradition in a branch of art practiced by Daumier and Goya, for instance. Daumier's *Third Class Carriage* is a kind of snapshot of actual people sitting in a railway carriage in France in the mid-nineteenth century. Although he didn't use a camera, he sketched those people on the spot, like a reporter, and they probably saw him doing it. What of it?

Then photographs can be documentary as well as works of art?

Documentary? That's a very sophisticated and misleading word. And not really clear. You have to have a sophisticated ear to receive that word. The term should be *documentary style*. An example of a literal document would be a police photograph of a murder scene. You see, a document has use, whereas art is really useless. Therefore art is never a document, though it certainly can adopt that style. I'm sometimes called a "documentary photographer," but that supposes quite a subtle

knowledge of the distinction I've just made, which is rather new. A man operating under that definition could take a certain sly pleasure in the disguise. Very often I'm doing one thing when I'm thought to be doing another. I've certainly suffered when philistines look at certain works of mine having to do with the past, and remark, "Oh, how nostalgic." I hate that word. That's not the intent at all. To be nostalgic is to be sentimental. To be interested in what you see that is passing out of history, even if it's a trolley car you've found, that's not an act of nostalgia. You could read Proust as "nostalgia," but that's not what Proust had in mind at all.

People live by mythic images, by icons. Certain of your photographs have become classics, have found their way into what could be called national consciousness. They've found a permanent audience, not immediately as fashion does, but as art does, by a residual process. How did you come upon those images?

As I said, by instinct, like a bird, entirely by instinct. Like a squirrel too, burying and hiding, and divining where the nuts are. I've been doing that all the time. But I find it inhibiting to discuss this. It suggests speculation, and doubt, doubt of my own sure action.

But millions of people feel they're performing an instinctual act when they take a snapshot. What distinguishes what they do from a photograph of yours?

I don't know. It's logical to say that what I do is an act of faith. Other people might call it conceit, but I have faith and conviction. It came to me. And I worked it out. I used to suffer from a lack of it, and now that I've got it I suppose it seems self-centered. I have to have faith or I can't act. I think what I am doing is valid and worth doing, and I use the word *transcendent*. That's very pretentious, but if I'm satisfied that something transcendent shows in a photograph I've done, that's it. It's there, I've done it. Without being able to explain, I know it absolutely, that it happens sometimes, and I know by the way I feel in the action that it goes like magic—this is it. It's as though there's a wonderful secret in a certain place and I can capture it. Only I can do it at this moment, only this moment and only me. That's a hell of a thing to believe, but I believe it or I couldn't act. It's a very exciting, heady thing. It happens more when you're younger, but it still happens, or I wouldn't continue. I think there is a period of esthetic discovery that happens to a man and he can do all sorts of things at white heat. Yeats went through three periods. T. S. Eliot was strongest in his early period, I think. E. E. Cummings seemed to go on without losing much. After all, poetry is art and these fields are related. It's there and it's a mystery and it's even partly mystical and that's why it's hard to talk about in a rational, pragmatic society. But art goes on. You

can defend it in spite of the fact that the time is full of false art. Art schools are fostering all sorts of junk, but that's another matter. There are always a few instances of the real thing that emerge in unexpected places and you can't stop it; there it is. Even in a puritan, materialistic, middle-class bourgeois society like America. Because the country is like that, the artist in America is commonly regarded as a sick, neurotic man. (And tends to regard himself that way.) Until recently, true art in America was sick from being neglected. Now of course it's sick the other way: too much is being made of it. The period that's just finishing, of fame and fortune for a few artists, is outrageous. It's outrageous for a few to make hundreds of thousands of dollars while a number of very good artists cannot even make a living. It makes you sick to think about it. The art world is part of our very sick society. Think of what a man of letters is in Paris or in England and what he is here. Here he's either outrageously famous and rich, or treated as less than nothing, never understood, never honestly appreciated. In those countries everyone understands that there are many excellent, poor, almost starving artists, and they are very much respected, just as old age is respected. The unappreciated artist is at once very humble and very arrogant too. He collects and edits the world about him. This is especially important in the psychology of camera work. This is why a man who has faith, intelligence and cultivation will show it in his work. Fine photography is literate, and it should be. It does reflect cultivation if there *is* cultivation. This is also why, until recently, photography has had no status, as it's usually practiced by uncultivated people. I always remember telling my classes that the students should seek to have a cultivated life and an education: they'd make better photographs. On the other hand, Eugène Atget was an uneducated man, I think, who was a kind of medium, really. He was like Blake. His work sang like lightning through him. He could infuse the street with his own poetry, and I don't think he even was aware of it or could articulate it. What I've just been saying is not entirely true. Since I'm a half-educated and self-educated man, I believe in education. I do note that photography, a despised medium to work in, is full of empty phonies and worthless commercial people. That presents quite a challenge to the man who can take delight in being in a very difficult, disdained medium.

What are the names of some of the photographers, past and present, you particularly admire?

That doesn't much matter. You're drawn to people who share your taste. My favorites are Brady and Atget. After I discovered myself, I found that they were working in ways that appeal to me and in ways that I would like to work too. I don't look at much contemporary photography. With occasional exceptions. I remember coming across

Paul Strand's *Blind Woman* when I was very young, and that really bowled me over. I'd already been in that and wanted to do that. It's a very powerful picture. I saw it in the New York Public Library file of "Camera Work," and I remember going out of there overstimulated: "That's the stuff, that's the thing to do." It charged me up. I don't look at much contemporary photography and I don't want to. I've watched Lee Friedlander and Robert Frank and Diane Arbus come up, though. I'm quite conscious of them; they're good. And there are many others, I suppose.

An observable quality of your photographs is that whether they were taken in 1930 or 1970 they're essentially timeless. They don't date. Your recent photographs of street gutters and graffiti are, like your earlier photographs, each a world entire. Have your interests changed with the passing of time?

I find that my interests are amplified somewhat, but I haven't dropped and I don't think I've outgrown any of my original interests. You see I learned awfully fast without teachers. I was very lucky. I just came upon my true line without going down bypaths or blind alleys or dead ends. I did do some wrong things when I first started to use a camera, but very quickly and very early on I learned the true straight path for me, the path of getting away from "arty" work, the obviously beautiful. When you are young you are open to influences, and you go to them, you go to museums. Then the street becomes your museum; the museum itself is bad for you. You don't want your work to spring from art; you want it to commence from life, and that's in the street now. I'm no longer comfortable in a museum. I don't want to go to them, don't want to be "taught" anything, don't want to see "accomplished" art. I'm interested in what's called vernacular. For example, finished, I mean educated, architecture doesn't interest me, but I love to find American vernacular. Museums have a wonderful function, but there comes a time when the artist had better stay out of them, I think.

In your photographs there is often an extraordinary clarity, a quality of classicism, substance precisely defined by light and texture. Do you achieve that by instinct too, or do you have to work for it?

Well, you have to work for it, but I'm not interested in it technically, or not even interested in photography really—only in that I can make it do what I want, for example, as you just said, for its classicism and clarity. If I can bring it to that, I will; but for its own sake, no. Photography, I said before, really doesn't interest me, the technique of it either. I do know that I want to be able to do something with it, though.

You don't believe that in order to do something with it, the new improved equipment is of help?

No, not at all. But you do have to be able to make the camera do

what you want it to do, instinctively and competently. That is a technical problem. You want to put this technical problem where it belongs, as something to serve you. Not as itself, a piece of technical mastery and virtuosity. For example, both Ansel Adams and Paul Strand are really great technicians. They sometimes show they're too great. They do the perfect thing with the camera, and you say ohh and ahh, how perfect. Then you don't get their content clearly enough, however. As in typography and printing, technique shouldn't arrest you. Something should be said through it, not by it. Your mood and message and point have to come through as well as possible. Your technique should be made to serve that, kept in place, as a servant to that purpose. That does require skill, knowledge and technical ability, and you have to have done the work in order to make it *not* show. You asked me if I was interested in texture and light. Not really. In fact, I feel that's what's wrong with a whole lot of photography. It's just a piece of texture and light. I could, anybody could, do excellent photography with rather poor and certainly inexpensive equipment. In fact, there is a danger in having thousand-dollar equipment. You fall in love with that, it becomes complex in another way. I want to keep it simpler. In photography you do reach a point where your equipment is somewhat like your motor car. You learn the operation of the thing so well, it can submerge into an automatic reflex action—you can think about something else while you're using it. And I've gotten that way with my cameras. A certain period of time and practice is required, and you must do it as a drill. Once you do it, once you have learned it, if you change your instrument you have to learn all over again.

I understand that Saul Steinberg once said you taught a generation what and how to see. In a sense you have been a recorder of the unconscious folk art that appears in the streets, in houses, in the cities and in the hinterlands— unconscious art that is the root evidence and primal source of culture—

I don't know whether or how Steinberg said that of me, but I'm aware of the remark. It's a great exaggeration. No one could live up to it or make it true. There is always somebody around doing that for each of us. E. E. Cummings, for example, did teach me what to see, what was poetic. T. S. Eliot, particularly, did that for me too. However there are certain artists whom I see nothing in, and they may end up by being perfectly great. . . . Look at Joyce. He had very poor judgment of everybody around. He was ignorant of Proust, of all the great writers of his time. Yet look who he was.

You know, I really think with a good part of myself that an artist shouldn't talk very much about his work, or himself, or his peers, as I've been doing with you. It may seem to be fun while it's going on,

and doing it just once. But an artist is too special a man in society anyway. He thinks art is too important, and he thinks he's too important. For example, who *really* appreciates or understands Baudelaire, who I think is a kind of god? Spiritually and psychologically, the work of Baudelaire has become an important force, the source of a whole psychology and movement that in the end affects art and life. But the individual artist himself, being an artist, goes around with a lot of stuff in his head that doesn't fit or count or act as part of the world. I could sum up most of all this by remarking that art is a very private thing. I hope that's not rude—to throw that remark into your talking-machine.

M. F. Agha

"Whistler's Hippopotamus"
1937

The quest for a way to define opposing camps in photography goes on. Not the least authoritative is M. F. Agha's. Mehemed Fehmy Agha (1896–1978) was art director of *Vogue* magazine from 1929 to 1942, and was often called upon to judge competitions and write about the subject. *Vogue* employed many talented photographers and made some of their reputations. Agha's explanation of the Traditional and the Modern schools of photography is accurate enough in its way, and it seems safe to venture that it is the first, and quite possibly the last, comparison of the two schools to September Morn and the tonsils of a hippopotamus.

What is that extraordinary animal on the facing page—another Surrealist in disguise?"

"No, it is a hippopotamus saying '*aaaaaaaa*.' "

"Why does he say '*aaaaaaaa*?' "

"Because he is being photographed by a Modern Photographer."

"What is the difference between a Modern Photographer and just-a-photographer?"

"A Modern Photographer is a man who thinks that the hippopotamus' tonsils are more beautiful than Whistler's Mother."

"And just-a-photographer?"

"Just-a-photographer (known also as a 'Pictorial Photographer') is a man who thinks that September Morn is more beautiful than an Egg."

"Why such extremes? Isn't there anything else to photograph between September Morn and an Egg?"

"Practically nothing. There are only four photographic subjects in the world, and they are evenly divided between two schools of thought. The Traditionalists have Whistler's Mother and September Morn. The Modernists have the Hippopotamus' Tonsils and the Egg. Everything else can be reduced to these four basic types."

"How is that?"

"Haven't you seen thousands of photographs representing sweet, kindly old ladies sitting quietly with their hands folded in their laps? Sometimes they are called 'The Evening of Life' and sometimes 'Memories,' but they are really Whistler's Mothers, all of them. Other subjects, utterly different in appearance, can be so imbued with the same spirit that permeates Whistler's Mother that they, too, become Whistler's Mothers. Take, for instance, a kitten playing with a ball of thread —a very popular photographic subject. It is really nothing but a very typical manifestation of Whistler's Mother. Whistler's Mother stands for everything that is homey, sentimental, sweet, appeals to our better nature, touches our heart-strings, and generally elevates the soul. All the small animals are cases of Whistler's Mothers: babies, kittens, puppies, lion cubs, and even young elephants. I suppose it's the maternal instinct in us, or perhaps a Whistler's Mother fixation.

But it is really much broader than just a love for a cute kitten. In its more sublimated form, the Whistler's Mother fixation can cover such things as windmills in the sunset, fields of wheat under a gentle breeze, swans reflected in a calm pond, square-rigged clipper ships in full sail, and even the Grand Canyon and Niagara Falls. Anything that elevates the soul is a Whistler's Mother, in one disguise or another."

"What about September Morn?"

"September Morn, on the contrary, appeals to our more carnal instincts and baser nature. I must say, however, that the September Morn manifestations are always of a rather healthy and red-blooded kind (boys will be boys). The pure September Morn, by its very nature, is apt to be rather repetitious: a nude young lady with a mirror may be called 'Veritas'; a nude young lady with a soap-bubble, 'The Spirit of the Dance'; a nude young lady with feathers in her hair, 'Indian Love-Song'; a nude young lady smeared with vaseline, 'Porcelain'—but basically it is always the same young lady.

The variations, however, are easily produced by combining Whistler's Mother with September Morn. A girl in a bathing-suit, playing on a beach with a puppy (or a baby elephant), is definitely a combination of Whistler's Mother and September Morn in its appeal. And when it comes to more complicated subjects, such as a nursing mother, it takes an analyst to be able to decide where Whistler's Mother ends and September Morn begins. That does not matter, however. As long as a photograph is based on Whistler's Mother or September Morn, or both, we may definitely classify it as belonging to the traditional Pictorial school of photography."

"Sounds like a pretty dull tradition to me. Where does it come from?"

"All this started about thirty-five years ago. At that time, photography was definitely in the gutter, as far as the public was concerned. The so-called art photographers did not exist—only the fellows with velvet jackets and flowing neckties, taking pictures at so many dollars a dozen. The patient's head was screwed in a 'head-rest,' placed against a backdrop representing an English park, and photographed with the eyes fixed on a 'Little Birdie,' then retouched within one inch of its life so as to eliminate 'the ravages of time' and bring out 'the ideal beauty.' The results were so incredible that there is right now a movement, started by Cecil Beaton, in favour of reviving all that—just for the hell of it, and *pour épater les photographs.*"

"And is this 'watch-the-little-birdie' photography at the bottom of present-day tradition?"

"Not at all. The tradition of today's Traditionalists started as a revolutionary movement *against* the Little Birdie. A group of bright young Americans, calling themselves 'The Photo Secession,' decided that photography is ART. This group included such names as Stieglitz, Steichen, Clarence White, Gertrude Casebier (sic), Alan Coburn (sic). They had sympathizers and fellow revolutionists abroad: Craig Annan in England, Demachy and Puyo in France, Kuehn in Austria, Misonne in Belgium. Later, The Photo Secession took on a new and quaint name, just a number: '291,' because the address of their headquarters was 291 Fifth Avenue, New York. Their conception of art might have been quite modern. '291,' for instance, introduced the first Matisses and Picassos in the United States. But so far as Art was reflected in their photographs, it looked as though they firmly believed in the school-teacher's formula: 'Rembrandt is in painting what Shakespeare is in drama and Beethoven in music.' "

"Is anything wrong with this?"

"Nothing, so long as it made Master Photographers follow in the

steps of Master Painters. Photo Secession produced several master-pieces, which were possibly an improvement on Rembrandts and Rae-burns. At least, some people think so. But when the followers of Master Photographers started to follow the followers of Master Painters —the results were pretty sad. The shades of Bouguereau, Gérome, and Meissonier were still hovering over the art world, notwithstanding the Cubist explosion, and the less sophisticated photographers went directly to these pale ghosts for their pictorial inspiration. The ambi-tion of a Pictorialist was to make a photograph to look like a painting —it did not matter to him that it often looked like a pretty rotten painting."

"How did they make the photographs look like a painting, even a rotten one?"

"By selecting the subjects that bad painters have already treated (hence Whistler's Mother and September Morn); but especially by all kinds of technical tricks and 'manipulations' that gave the photographs the appearance of a crayon drawing, pastel painting, or a lithograph— in short, anything but a photograph. The studio photographers re-touched photographs to make the sitter younger: the Pictorialists re-touched them to make the photograph look like a mezzotint."

"How long did this last?"

"Until after the War. War made people sick of a great many things, and, among them, of fake mezzotints. The cynical and disillu-sioned generation of post-War artists—particularly the Dadaists and Surrealists, with their general debunking of Art and artiness—contrib-uted greatly to this reaction against Pictorial Photography. The good, clean fun to be had by photographing a nude rolling a hoop was much too bourgeois for the Moderns. They were not interested in sweet old ladies or juicy young maidens—Freud took care of that. They wanted to paint and to photograph strange, weird, grotesque things: garbage-cans, George Washington's false teeth, snakes swallowing rabbits, Cae-sarean operations, smiling horses, behinds of elephants, eye of newt and toe of frog, wool of bat and tongue of dog. . . ."

"And hippopotamus' tonsils?"

"Exactly. Our friend, the hippopotamus, represents the spirit of modern photography in more ways than one. He stands for everything that is strange and bewildering, formidable and repulsive; but, at the same time, he symbolizes the triumph of honest photography over fake photography. Just look at his skin."

"What has his skin got to do with honest photography?"

"It's full of spots and blotches—as the skin should be in an honest, unretouched, Modern photograph. You see, retouching was very im-

portant to the studio photographers (to beautify the sitter) and to Pictorialists (to beautify the picture). Naturally, the Moderns will not have anything to do with retouching; they delight in taking sharp, close-up pictures of people—dermatological orgies that show every single blackhead and pore. Moholy-Nagy started all this around 1922, I believe."

"Why? Just to annoy people?"

"Partly to annoy the traditional photographers—but also because the Moderns have, or had, quite a sincere admiration for the beauty of texture and detail revealed by the photographic lens. With them, it was photography coming into its own, after all these years of 'fogs in oil' and soft-focus work. Diffused, hazy photographs were out. Sharpness became the motto—sharpness at all costs, sharpness for sharpness' sake."

"Was there anything difficult in taking sharp photographs? I thought any one could do that."

"Yes. In fact, it is much easier to take an 'honest' photograph than to slave over it for weeks to make a dishonest 'manipulated' print. There was a poor Frenchman named Atget—an ambulant photographer whose business it was to take photographs of anything at all: heaps of refuse, corset shops, trees, et cetera, and sell them for a nickel as documents to painters who were too lazy to make their own sketches. Poor Atget was taking sharp, honest pictures, probably because he did not know better. After his death, the Moderns discovered him, made him into a Saint and Martyr of Modern photography, published several books about him. Honesty is the best policy, even in photography."

"So Modern photography is really honest photography?"

"This is the theory, or at least a part of it. Did I tell you that the Moderns have two principal fixations: the Hippopotamus and the Egg? We have seen that the Hippopotamus is the father of everything that is brutally honest, and, at the same time, bewildering, shocking, and repulsive. Well, the Egg is the mother of everything that is form, design, and pattern."

"I do not see any pattern in an Egg, unless it is an Easter Egg."

"That is a pretty poor joke. The fact is that there are thousands and thousands of Modern photographs of Eggs (Paul Outerbridge alone took several hundreds of them). Anton Bruehl claims the distinction of being the only modern photographer who never took a picture of an egg."

"But why do they photograph eggs?"

"Because eggs are egg-shaped."

"?????"

"Eggs are the nearest thing to a globe—and a globe is the nearest thing to geometric perfection, and geometric perfection is one of the chief assets of Modern photography. Apples are pretty good, too; that is why Steichen, and so many after him, photographed a number of nice globular apples. I suppose it is Cézanne's influence seen through Cubist eyes. Anyhow, a photograph in which the design, the pattern, or the texture is more important than the subject or the sentimental ambiance is essentially a photograph of an Egg.

"The factory chimneys, in distorted perspective (first introduced by Renger Patch); the sky-scrapers and their rectilinear geometry (capitalized first by Ralph Steiner); even the clouds—when photographed by Moderns—become members of the Egg group. So do coils of rope, fish-nets, railroad bridges, Ferris wheels, cart-wheels, cabbages cut in half with drops of dew on them (Edward Weston and the whole California school of photography have a patent on that); barns made of weathered old boards; footmarks on the sand; and, of course, Eggs: broken eggs, scrambled eggs, ham and eggs. . . ."

"How about Human Beings? Can the Moderns treat them in this geometric, eggy fashion?"

"Very easily. I might have given you the impression that the Moderns do not photograph nudes—but they do (boys will be boys). Man Ray is one of the chief exponents of the art of geometric nude photography. The idea is to twist the model so as to make her really look like one (or several) eggs. You can also create a pattern—by throwing the striped shadow of a Venetian blind on the model, which makes her look like a tiger—a very popular device. Such photographs are really combinations of Egg with September Morn, and show that basic appeals change only slightly from generation to generation. There are other possible combinations of old and new photography; for instance, a girl on the beach at Coney Island is a cross between September Morn —and the Hippopotamus."

"But I thought you said that Moderns object to photography imitating painting?"

"They do, in theory. They do not believe in imitating the appearance of a painting; but September Morn is not a painting—it is an attitude in life, a *Weltanschauung*, and will take more than just a few photographers to uproot it. Besides, the Moderns are not above imitating a painting even in appearance, if it is the right kind of painting: Moholy-Nagy and Man Ray in their early photogrammes followed the lead of the Cubists; and to-day there is an attempt at imitating photographically the spirit and the appearance of the Surrealist paintings."

"Do you object to that?"

"I do not object to anything. Art tendencies come and go and unite with each other, ruled by the law that some one called the law of recurring aesthetic nausea. What is a revolutionary *Putsch* to-day—is an accepted popular style in fifteen years, and an emetic in thirty years from the moment of its inception. Some people have stronger stomachs than others—and this explains why the Whistler's Mother-September Morn style of photography still has a great number of admirers to-day. Other people have very delicate, oversensitive stomachs—and this explains why the hippopotamus-egg style, although apparently at the apogee of its career, begins to give us a feeling of slight uneasiness. You know that there is no such thing as a pretty good Egg. An Egg must be perfect—or nothing."

Ansel Adams

"A Personal Credo"
1943

AN EXCERPT

Ansel Adams (b. 1902) began as a musician with an amateur's love of pictorial photography. In 1930, having met Paul Strand and seen his negatives, Adams decided to devote his career to straight photography. He has trained his camera and his brilliant printing techniques on the grandest sights of the West; his work has certain affinities with the spirit of nine-teenth-century American landscape photographers. The "zone system" of previsualization which Adams worked out gives photographers great control and a capacity to reproduce with certainty their perception of the tonal relations in the scene they are photographing. This system has been made widely available through Adams's teaching and writing. Adams helped found the first department of photography as a fine art at the Museum of Modern Art in New York in 1940, and started the first university department to teach photog-raphy as a profession in San Francisco in 1946.

. . . .

I have been asked many times, "What is a great photograph?" I can answer best by showing a great photograph, not by talking or writing

about one. However, as word definitions are required more often than not, I would say this: "A great photograph is a full expression of what one feels about what is being photographed in the deepest sense, and is, thereby, a true expression of what one feels about life in its entirety. And the expression of what one feels should be set forth in terms of simple devotion to the medium—a statement of the utmost clarity and perfection possible under the conditions of creation and production." That will explain why I have no patience with unnecessary complications of technique or presentation. I prefer a fine lens because it gives me the best possible optical image, a fine camera because it complements the function of the lens, fine materials because they convey the qualities of the image to the highest degree. I use smooth papers because I know they reveal the utmost of image clarity and brilliance, and I mount my prints on simple cards because I believe any "fussiness" only distracts from and weakens the print. I do not retouch or manipulate my prints because I believe in the importance of the direct optical and chemical image. I use the legitimate controls of the medium only to augment the *photographic* effect. Purism, in the sense of rigid abstention from any control, is ridiculous; the logical controls of exposure, development and printing are essential in the revelation of photographic qualities. The correction of tonal deficiencies by dodging, and the elimination of obvious defects by spotting, are perfectly legitimate elements of the craft. As long as the final result of the procedure is *photographic*, it is entirely justified. But when a photograph has the "feel" of an etching or a lithograph, or any other graphic medium, it is questionable—just as questionable as a painting that is photographic in character. The incredibly beautiful revelation of the lens is worthy of the most sympathetic treatment in every respect.

Simplicity is a prime requisite. The equipment of Alfred Stieglitz or Edward Weston represents less in cost and variety than many an amateur "can barely get along with." Their magnificent photographs were made with intelligence and sympathy—not with merely the machines. Many fields of photography demand specific equipment of a high order of complexity and precision; yet economy and simplicity are relative, and the more complex a man's work becomes, the more efficient his equipment and methods must be.

Precision and patience, and devotion to the capacities of the craft, are of supreme importance. The sheer perfection of the lens-image implies an attitude of perfection in every phase of the process and every aspect of the result. The relative importance of the craft and its expressive aspects must be clarified; we would not go to a concert to hear scales performed—even with consummate skill—nor would we enjoy

the sloppy rendition of great music. In photography, technique is frequently exalted for its own sake; the unfortunate complement of this is when a serious and potentially important statement is rendered impotent by inferior mechanics of production.

Of course, "seeing," or visualization, is the fundamentally important element. A photograph is not an accident—it is a concept. It exists at, or before, the moment of exposure of the negative. From that moment on to the final print, the process is chiefly one of *craft;* the pre-visualized photograph is rendered in terms of the final print by a series of processes peculiar to the medium. True, changes and augmentations can be effected during these processes, but the fundamental thing which was "seen" is not altered in basic concept.

The "machine-gun" approach to photography—by which many negatives are made with the hope that one will be good—is fatal to serious results. However, it should be realized that the element of "seeing" is not limited to the classic stand-camera technique. The phases of photography which are concerned with immediate and rapid perception of the world—news, reportage, forms of documentary work (which may not admit contemplation of *each* picture made) are, nevertheless, dependent upon a basic attitude and experience. The instant awareness of what is significant in a rapidly changing elusive subject presupposes an adequate visualization more general in type than that required for carefully considered static subjects such as landscape and architecture. The accidental contact with the subject and the required immediacy of exposure in no way refutes the principles of the basic photographic concept. Truly "accidental" photography is practically non-existent; with pre-conditioned attitudes we *recognize* and are arrested by the significant moment. The awareness of the *right moment* is as vital as the perception of values, form, and other qualities. There is no fundamental difference in the great landscapes and quiet portraits of Edward Weston and the profoundly revealing pictures of children by Helen Leavett. Both are photographic perceptions of the highest order, expressed through different, but entirely appropriate, techniques.

Not only does the making of a photograph imply an acute perception of detail in the subject, but a fine print deserves far more than superficial scrutiny. A photograph is usually looked *at*—seldom looked *into*. The experience of a truly fine print may be related to the experience of a symphony—appreciation of the broad melodic line, while important, is by no means all. The wealth of detail, forms, values— the minute but vital significances revealed so exquisitely by the lens— deserve exploration and appreciation. It takes *time* to really see a fine

print, to feel the almost endless revelation of poignant reality which, in our preoccupied haste, we have sadly neglected. Hence, the "look-through-a-stack-of-prints-while-you're-waiting" attitude has some painful connotations.

Sympathetic interpretation seldom evolves from a predatory attitude; the common term "*taking* a picture" is more than just an idiom; it is a symbol of exploitation. "*Making* a picture" implies a creative resonance which is essential to profound expression.

My approach to photography is based on my belief in the vigor and values of the world of nature—in the aspects of grandeur and of the minutiae all about us. I believe in growing things, and in the things which have grown and died magnificently. I believe in people and in the simple aspects of human life, and in the relation of man to nature. I believe man must be free, both in spirit and society, that he must build strength into himself, affirming the "enormous beauty of the world" and acquiring the confidence to see and to express his vision. And I believe in photography as one means of expressing this affirmation, and of achieving an ultimate happiness and faith.

. . . .

Lewis Mumford

Art and Technics
1952
AN EXCERPT

Lewis Mumford (b. 1895) is best known as an historian and social critic of cities, city planning, and utopias. Here he addresses the problems raised by mass mechanical reproduction, principally the photomechanical reproduction of images, which he claims has removed us from direct contact with life to the position of spectators of a simulacrum. And although nineteenth-century commentators expected the spread of images of art to raise the general level of taste, Mumford contends that it has vitiated the impact of art by dulling the senses.

. . . .

The fact is that in every department of art and thought we are being overwhelmed by our symbol-creating capacity; and our very facility with the mechanical means of multifolding and reproduction has been responsible for a progressive failure in selectivity and therefore in the power of assimilation. We are overwhelmed by the rank fecundity of the machine, operating without any Malthusian checks except periodic financial depressions; and even they, it would now seem, cannot be wholly relied on. Between ourselves and the actual experience and the actual environment there now swells an ever-rising flood of images

which come to us in every sort of medium—the camera and printing press, by motion picture and by television. A picture was once a rare sort of symbol, rare enough to call for attentive concentration. Now it is the actual experience that is rare, and the picture has become ubiquitous. Just as for one person who takes part in the game in a ball park a thousand people see the game by television, and see the static photograph of some incident the next day in the newspaper, and the moving picture of it the next week in the newsreel, so with every other event. We are rapidly dividing the world into two classes: a minority who act, increasingly, for the benefit of the reproductive process, and a majority whose entire life is spent serving as the passive appreciators or willing victims of this reproductive process. Deliberately, on every historic occasion, we piously fake events for the benefit of photographers, while the actual event often occurs in a different fashion; and we have the effrontery to call these artful dress rehearsals "authentic historic documents."

So an endless succession of images passes before the eye, offered by people who wish to exercise power, either by making us buy something for their benefit or making us agree to something that would promote their economic or political interests: images of gadgets manufacturers want us to acquire; images of seductive young ladies who are supposed, by association, to make us seek other equally desirable goods, images of people and events in the news, big people and little people, important and unimportant events; images so constant, so unremitting, so insistent that for all purposes of our own we might as well be paralyzed, so unwelcome are our inner promptings or our own self-directed actions. As the result of this whole mechanical process, we cease to live in the multidimensional world of reality, the world that brings into play every aspect of the human personality, from its bony structure to its tenderest emotions: we have substituted for this, largely through the mass production of graphic symbols—abetted indeed by a similar multiplication and reproduction of sounds—a secondhand world, a ghost-world, in which everyone lives a secondhand and derivative life. The Greeks had a name for this pallid simulacrum of real existence: they called it Hades, and this kingdom of shadows seems to be the ultimate destination of our mechanistic and mammonistic culture.

One more matter. The general effect of this multiplication of graphic symbols has been to lessen the impact of art itself. This result might have disheartened the early inventors of the new processes of reproduction if they could have anticipated it. In order to survive in this image-glutted world, it is necessary for us to devaluate the symbol and to

reject every aspect of it but the purely sensational one. For note, the very repetition of the stimulus would make it necessary for us in self-defense to empty it of meaning if the process of repetition did not, quite automatically, produce this result. Then, by a reciprocal twist, the emptier a symbol is of meaning, the more must its user depend upon mere repetition and mere sensationalism to achieve his purpose. This is a vicious circle, if ever there was one. Because of the sheer multiplication of esthetic images, people must, to retain any degree of autonomy and self-direction, achieve a certain opacity, a certain insensitiveness, a certain protective thickening of the hide, in order not to be overwhelmed and confused by the multitude of demands that are made upon their attention. Just as many people go about their daily work, as too often students pursue their studies, with the radio turned on full blast, hearing only half the programs, so, in almost every other operation, we only half-see, half-feel, half-understand what is going on; for we should be neurotic wrecks if we tried to give all the extraneous mechanical stimuli that impinge upon us anything like our full attention. That habit perhaps protects us from an early nervous breakdown; but it also protects us from the powerful impact of genuine works of art, for such works demand our fullest attention, our fullest participation, our most individualized and re-creative response. What we settle for, since we must close our minds, are the bare sensations; and that is perhaps one of the reasons that the modern artist, defensively, has less and less to say. In order to make sensations seem more important than meanings, he is compelled to use processes of magnification and distortion, similar to the stunts used by the big advertiser to attract attention. So the doctrine of quantification, Faster and Faster, leads to the sensationalism of Louder and Louder; and that in turn, as it affects the meaning of the symbols used by the artist, means Emptier and Emptier. This is a heavy price to pay for mass production and for the artist's need to compete with mass production.

. . . .

Henri Cartier-Bresson

The Decisive Moment
1952

AN EXCERPT

The Leica, first marketed in 1924, made possible unposed snapshots taken in most light conditions without flash. It was small, light, and easily handled. The "candid camera" was now a fact. Henri Cartier-Bresson (b. 1908) first used the miniature camera in 1933. He exploited its reportorial possibilities with a sharp eye for the "rhythm in the world of real things." His notion of "the decisive moment," the instant when action and composition resolve themselves into the most telling, most revealing arrangement, was important to a whole generation of photographers. His eye for composition is as fast as the shutter; he rarely crops. Cartier-Bresson has made films, published many books, and was the subject of the Louvre's first one-man photography show.

. . . .

COMPOSITION

If a photograph is to communicate its subject in all its intensity, the relationship of form must be rigorously established. Photography implies the recognition of a rhythm in the world of real things. What the eye does is to find and focus on the particular subject within the mass

of reality; what the camera does is simply to register upon film the decision made by the eye. We look at and perceive a photograph, as a painting, in its entirety and all in one glance. In a photograph, composition is the result of a simultaneous coalition, the organic co-ordination of elements seen by the eye. One does not add composition as though it were an afterthought superimposed on the basic subject material, since it is impossible to separate content from form. Composition must have its own inevitability about it.

In photography there is a new kind of plasticity, product of the instantaneous lines made by movements of the subject. We work in unison with movement as though it were a presentiment of the way in which life itself unfolds. But inside movement there is one moment at which the elements in motion are in balance. Photography must seize upon this moment and hold immobile the equilibrium of it.

The photographer's eye is perpetually evaluating. A photographer can bring coincidence of line simply by moving his head a fraction of a millimeter. He can modify perspectives by a slight bending of the knees. By placing the camera closer to or farther from the subject, he draws a detail—and it can be subordinated, or he can be tyrannized by it. But he composes a picture in very nearly the same amount of time it takes to click the shutter, at the speed of reflex action.

Sometimes it happens that you stall, delay, wait for something to happen. Sometimes you have the feeling that here are all the makings of a picture—except for just one thing that seems to be missing. But what one thing? Perhaps someone suddenly walks into your range of view. You follow his progress through the view-finder. You wait and wait, and then finally you press the button—and you depart with the feeling (though you don't know why) that you've really got something. Later, to substantiate this, you can take a print of this picture, trace on it the geometric figures which come up under analysis, and you'll observe that, if the shutter was released at the decisive moment, you have instinctively fixed a geometric pattern without which the photograph would have been both formless and lifeless.

Composition must be one of our constant preoccupations, but at the moment of shooting it can stem only from our intuition, for we are out to capture the fugitive moment, and all the interrelationships involved are on the move. In applying the Golden Rule, the only pair of compasses at the photographer's disposal is his own pair of eyes. Any geometrical analysis, any reducing of the picture to a schema, can be done only (because of its very nature) after the photograph has been taken, developed and printed—and then it can be used only for a post-mortem examination of the picture. I hope we will never see the

day when photo shops sell little schema grills to clamp onto our view-finders; and that the Golden Rule will never be found etched on our ground glass.

If you start cutting or cropping a good photograph, it means death to the geometrically correct interplay of proportions. Besides, it very rarely happens that a photograph which was feebly composed can be saved by reconstruction of its composition under the darkroom's enlarger; the integrity of vision is no longer there. There is a lot of talk about camera angles; but the only valid angles in existence are the angles of the geometry of composition and not the ones fabricated by the photographer who falls flat on his stomach or performs other antics to procure his effects.

. . . .

William M. Ivins, Jr.

Prints and Visual Communication
1953
AN EXCERPT

William M. Ivins, Jr. (1881–1961) was curator of prints at the
Metropolitan Museum of Art in New York. In the book from
which this excerpt is taken, he dealt with the effects of the
conventions of reproductive printmaking on perception, par-
ticularly perceptions of art. It is Ivins's contention that pho-
tography has no visible syntax equivalent to that of
engravings and other graphics, and that by changing per-
ceived information, photographs exerted a great influence on
changes in taste.

. . . .

. . . The ancients had all the materials and basic techniques that were
needed to make many kinds of prints. The one thing that they lacked
was the idea of making prints. With photography, however, we come
to a kind of print that no one could have made before the nineteenth
century. The reason for this was that photography, instead of being
based upon simple manual techniques and immemorially familiar ma-
terials, was based on quite recent developments in the sciences of phys-
ics and, especially, of chemistry. I have an idea that a very good
argument could be put up for the claim that it is through photography
that art and science have had their most striking effect upon the thought

of the average man of today. From many points of view the histories of techniques, of art, of science, and of thought, can be quite properly and cogently divided into their pre- and post-photographic periods. It may be doubted if even the renaissance itself, or, if one prefers, the baroque seventeenth century, brought about such thoroughgoing changes in values, attitudes, and ideas, as took place in the nineteeth century and the early years of this one. Many of these new notions are intimately related to photography and its materials. . . .

It occurred to Talbot that it would be possible to make a photographic aquatint plate that could be used in the etching press. It also occurred to him that the dots in his aquatints would be more regular and dependable if they were made by the use of a screen instead of by the necessarily irregular methods of powdering the surface or flowing a solution of resin over it. In 1852 he took out a patent for using what he called a screen made either of textile or of ruled lines on glass. His scheme was to coat a plate with a bichromated layer of suitable colloid and then expose it to the light, first under a screen and then under a pictorial negative. Where the light came through the screen it would harden the coating in bigger or smaller dots according to the amount of light that came through the negative. Where either the screen or the negative kept the light from coming through, the coating would remain soluble. After the soluble coating was washed away it was an easy matter to bite the plate with acid in such a way that the lines between the dots were sunk below the surface of the plate. Talbot sent some prints made from such a printing surface to Paris in 1853.

Talbot's patent envisaged the making of intaglio printing surfaces, but the same technique was applicable to the making of relief printing surfaces. The early commercial half-tones, however, were made not with a screen but with rather a coarse aquatint grain. Easily available examples are to be found in some of the art journals of the early 1880's, such as *L'Artiste*, in which they were used to reproduce drawings by the masters. It would have been impossible to achieve comparable results by any of the older hand made methods of making relief blocks for book illustration. Poor as the blocks were, the only personal qualities visible in them were those of the men who made the drawings that were reproduced.

In the 1870's various experimenters began to use screens made of glass ruled with parallel lines, which sometimes were straight and sometimes were waved. This method, however, had its distinct drawbacks and limitations. In 1880 a New York newspaper ran the first cross-line half-tone to appear in a daily newspaper. It was made through a screen of textile and was very rough and imperfect. In 1886

Ives, of Philadelphia, patented his idea of the modern ruled cross-line half-tone screen—which he produced by taking two sheets of glass, each of which was covered with ruled parallel lines, and fastening them together face to face in such a manner that their lines ran at right angles to each other. In 1892 Levy patented his method of ruling the lines on sheets of glass in such a way that the screens became both cheap and practicable. Before the outbreak of the first world war the ruled cross-line half-tone screen was in common use all over the world. The older generation of reproductive wood-engravers had nothing to do but die out, their hard-won art and craft a victim of what the engineers so simply call technological obsolescence.

The great importance of the half-tone lay in its syntactical difference from the older hand made processes of printing pictures in printer's ink. In the old processes, the report started by a syntactical analysis of the thing seen, which was followed by its symbolic statement in the language of drawn lines. This translation was then translated into the very different analysis and syntax of the process. The lines and dots in the old reports were not only insistent in claiming visual attention, but they, their character, and their symbolism of statement, had been determined more by the two superimposed analyses and syntaxes than by the particularities of the thing seen. In the improved half-tone process there was no preliminary syntactical analysis of the thing seen into lines and dots, and the ruled lines and dots of the process had fallen below the threshold of normal vision. Such lines and dots as were to be seen in the report had been provided by the thing seen and were not those of any syntactical analysis. If there remained the same complete transposition of colour and loss of scale that had marked the older processes, the preliminary syntactical analyses and their effects had been done away with, and the transposition of colours was uniform. At last men had discovered a way to make visual reports in printer's ink without syntax, and without the distorting analyses of form that syntax necessitated. Today we are so accustomed to this that we think little of it, but it represents one of the most amazing discoveries that man has ever made—a cheap and easy means of symbolic communication without syntax.

. . . the photograph made it possible for the first time in history to get such a visual record of an object or a work of art that it could be used as a means to study many of the qualities of the particular object or work of art itself. Until photography came into common use there had been no way of making pictures of objects that could serve as a basis for connoisseurship of the modern type, that is for the study of objects as particulars and not as undifferentiated members of classes.

The photograph in its way did as much for the study of art as the microscope had done for the study of biology.

Up to that time very few people had been aware of the difference between pictorial expression and pictorial communication of statements of fact. The profound difference between creating something and making a statement about the quality and character of something had not been perceived. The men who did these things had gone to the same art schools and learned the same techniques and disciplines. They were all classified as artists and the public accepted them all as such, even if it did distinguish between those it regarded as good and as poor artists. The difference between the two groups of artists was generally considered to be merely a matter of their comparative skill. They all drew and they all made pictures. But photography and its processes quietly stepped in and by taking over one of the two fields for its own made the distinction that the world had failed to see.

The blow fell first on the heads of the artists—painters, draughtsmen, and engravers—who had made factual detailed informational pictures. The photograph filled the functions of such pictures and filled them so much better and with so much greater accuracy and fullness of detail that there was no comparison. For many purposes the drawing, as for instance in such a science as anatomy, preserved its utility because it could schematically abstract selected elements from a complex of forms and show them by themselves, which the photograph could not do because it unavoidably took in all of the complex. The drawing, therefore, maintained its place as a means of making abstractions while it lost its place as a means of representing concretions. The ground was cut from under the feet not only of the humble workaday factual illustrators of books and periodicals but of artists like Meissonier and Menzel, who had built up pre-photographic reputations by their amazing skill in the minute delineation of such things as buttons, gaiters, and military harness for man and beast. An etcher like Jacquemart had gained a world-wide reputation for his ability to render the textures and sheens of precious objects, such as porcelains, glass, and metal work—but when it was discovered that the photographic processes did all that infinitely more accurately than Jacquemart could, it was also realized that Jacquemart had been merely a reporter of works of art and not a maker of them, no matter how extraordinary his technical skill. The devastation caused by the photograph rapidly spread through all the gamut of the merely sentimental or informational picture, from the gaudy view of the Bay of Naples or the detailed study of peasants and cows to the most lowly advertisement for a garment or a kitchen gadget. What was more, by 1914, the periodicals had begun to be so

full of the photographic pictures that the public was never able to get them out of its eyes.

The photograph was actually making the distinction that Michael Angelo had tried to point out to the Marchioness and her companions in the conversation that was related by Francesco da Hollanda—'The painting of Flanders, Madame . . . will generally satisfy any devout person more than the painting of Italy, which will never cause him to drop a single tear, but that of Flanders will cause him to shed many; this is not owing to the vigour and goodness of that painting, but to the goodness of such devout person. . . . They paint in Flanders only to deceive the external eye, things that gladden you and of which you cannot speak ill, and saints and prophets. Their painting is of stuffs, bricks, and mortar, the grass of the fields, the shadows of trees, and bridges and rivers, which they call landscapes, and little figures here and there; and all this, although it may appear good to some eyes, is in truth done without symmetry or proportion, without care in selecting or rejecting, and finally without any substance or verve.'[1] Michael Angelo was attempting to point out that the pictorial report of things which people enjoy in stories and in actual life is not the same thing as design.

Inescapably built into every photograph were a great amount of detail and, especially, the geometrical perspective of central projection and section. The accuracy of both depended merely on the goodness of the lens. At first the public had talked a great deal about what it called photographic distortion—which only meant that the camera had not been taught, as human beings had been, to disregard perspective in most of its seeing. But the world, as it became acclimated, or, to use the psychologist's word, conditioned, to photographic images, gradually ceased to talk about photographic distortion, and today the phrase is rarely heard. So far has this gone that today people actually hunt for that distortion, and, except in pictures of themselves, enjoy it when found. A short fifty years ago most of the 'shots' of Michael Angelo's sculpture that were shown in the movie called *The Titan*, would have been decried for their distortion, but today they are praised. Thus by conditioning its audience, the photograph became the norm for the appearance of everything. It was not long before men began to think photographically, and thus to see for themselves things that previously it had taken the photograph to reveal to their astonished and protesting eyes. Just as nature had once imitated art, so now it began to imitate

1. *Quoted from Charles Holroyd's* Michael Angelo Buonarroti, *London*, 1903, *by permission of Gerald Duckworth & Co., Ltd.*

the picture made by the camera. Willy nilly many of the painters began to follow suit.

. . . .

The gradual introduction of photographic process in the last thirty years of the nineteenth century effected a most radical change in the methods of reproduction and publication of works of art. Not only did the reproductions become cheap, but they were dependable. Perhaps as easy a way as any to perceive this is to compare the illustrations of ancient and exotic art in the art books of the 1820's and 1830's with those in the art books of the 1870's and 1880's, and both with those in any cheapest little contemporary pamphlet or magazine. Until long after the middle of the century art books were much more a means by which the very rich could show their snobbishness than a means to convey truthful knowledge to the public. Actually the cheap modern photographic picture postcard contains so much more valid and accurate information than any of the expensive engravings and lithographs of the period of snobbery that there is no comparison between them. In this way photography introduced to the world a vast body of design and forms that previously had been unknown to it.

Objects can be seen as works of art only in so far as they have visible surfaces. The surfaces contain the brush marks, the chisel strokes, and the worked textures, the sum totals of which are actually the works of art. But the hand made prints after objects were never able to report about their surfaces. If the surface of a painting represented hair and skin, the print after the painting also represented hair and skin, but in its own forms and techniques which bore no resemblance to those embedded in the surface of the painting. In other words, the engraved representation of a painting was confined to generalized, abstract, reports about iconography and composition.

The magic of the work of art resides in the way its surface has been handled, just as the magic of a poem lies in the choice and arrangement of its words. The most exciting and the most boresome paintings can have the same objective subject matter. Their differences are subjective, and these subjective differences can only be seen in the choice and manipulation of the paint, that is in their actual surfaces. If Manet and Bouguereau had painted the same model in the same light, with the same accessories, and the same iconographical composition, any engravings made from them by the same engraver would have been remarkably alike. In a way the engravings were attempts, as the philosophers might say, to represent objects by stripping them of their actual qualities and substituting others for them—an undertaking which is logically impossible. The photograph, to the contrary, despite all its

deficiencies, was able to give detailed reports about the surfaces, with all their bosses, hollows, ridges, trenches, and rugosities, so that they could be seen as traces of the creative dance of the artist's hand, and thus as testimony of both the ability and the deliberate creative will that went to their making.

The result of this is never referred to, but it was very important in the formation of opinion and values. Thus, to take a particular case: the engravings, saying nothing about surfaces, could easily be read, and actually were read, by a world soaked in the pseudo-classical Renaissance tradition of forms, as reporting that the sculpture of the early and middle Christian periods was merely a set of debased forms representing the inability of a degraded society and its incompetent artisans to hold to classical ideals and precedents.

With the advent of photography, however, it became impossible to maintain the opinions based on the engravings, for photography gave detailed reports about the surfaces of the Christian sculpture, with all their sharp incident, and revealed the skilful, wilful, way in which they had been worked. It thus became obvious that those works of art represented not any degeneracy of workmanship but the emergence and volitional expression of new and very different intellectual and emotional values, and, therefore, had the right to be judged on their own merits and not from the point of view of the very ideals and assumptions which they challenged and against which they were engaged in an unrelenting warfare.
· · · ·

Minor White

"The Light Sensitive Mirage"
1958

Minor White (1908–1976) perpetuated Stieglitz's concept of the photograph as an image that could evoke an emotion that had no necessary connection to the subject itself; but White took the idea farther still, seeking the spiritual or transcendental in photographs. Intent on portraying the texture of rock, snow, tree branch, and such, he often came so close to the object that the resulting picture was hard to read, reinforcing his insistence that the photograph be seen as a metaphor. White also strung together photographs with no apparent connections, accompanied by his own writing or not, to create what he called *sequences*. These were meant to form their own kinds of connections. In 1952, White helped to found and for years edited *Aperture*, a magazine which in the beginning helped to spread the word about his kind of photography.

Stieglitz and Steichen were responsible for the militant Photo-Secessionists who fought to have photography accepted as an art by painters, and did, with the most painterly of photographs. After the first World War, Edward Steichen took unique or anti-painterly photography to the market place and amid the roar of his growing fame

raised the standards to the equal of the best in commercial art of both advertising photography and camera portraits of the prominent. Alfred Stieglitz chose the path least likely to be understood; inner growth through camera work. He sought to prove that it could be said of someone who used the camera as his medium, "there is no art, only artists." His work and his life made it clear that so far as art is an outward manifestation of inner growth, at least that much can be reached by men who stake their faith on a camera. He was not alone. Edward Weston on the West Coast, independently of Stieglitz, proved the same—and with pictures whose style is more accurate and less lyrical. (Both have brought down the acrimony of those who have set their sights on material gain to the deterioration of spiritual growth.)

In the early 1920's pictures by Stieglitz began to appear that were the forerunners of what he later entitled "equivalents." The first such pictures were of the Poplar Trees at his home at Lake George; then of his wife, the painter Georgia O'Keefe; later clouds, and it is with those that the title "Equivalents" is still associated. When serious laymen asked what he meant by the term he would illustrate, for example, how he materialized his feelings about a person with a photograph of a cloud. An accurate photographic rendering of a certain cloud, he would say, could be a portrait—an Expressionistic portrait in which the features could not be identified yet which would still be evocative of the person's uniqueness as known by Stieglitz—not precisely, because a cloud is not a person—but equivalent. (In the world of inner feelings "equivalent" if not the name of exactness, is at least a label of precision.)

Thus he explained the minimum meaning of the word: in practice his cloud pictures transcended the minimum, they were usually equivalent to his own experience with unseen and unseeable spirit itself! Hence in the hands of the artist Stieglitz, the mirror with a memory began to take on an expanded meaning: the renderings were accurate, which the craft of unique photography demands (weathermen find some of them excellent examples of cloud types); lyrical as the art of photography can be; and pertaining to otherworldliness, which photography must if it is ever to be used as an art medium. The mirror with a memory was taught to remember the spirit. And Alfred Stieglitz in mirroring the transcendent, established the core of "what kind of an art photography will be."

Continued investigation of photography's kind of an art indicates that the mirror is different than we thought. While we feel sure that if we had stood beside the camera we would have seen the same subject in the same way, we carelessly mistake the photographic rendition for authenticity and rarely realize just how extensive a mental adjustment

we make every time we look at a photograph. We permit two dimensions to stand for three, picture size to stand for life-size, an isolated moment for a living one, shades of grey for color, or chemical dyes to stand for earth colors. We adjust so easily that we permit the photograph with all its changes of the visual world to be the most convincing liar of any of the visual media. For all our giving in to the mirage, the fact remains that a photograph of a house cannot be lived in, and that for all its literalness a news photograph of the President does not eat breakfast.

Our complacent acceptance of the accuracy of the photograph is indeed amazing. Isolated tribes are reported to be quite unable to convert the dappled grey surface of a photograph into anything recognizable, especially portraits of themselves or other tribesmen. To such people the miracle-metamorphosis of the subject into photograph is complete—and unrecognizable. It takes sophisticated man to see the mirage.

If it only shimmered as mirages do! Sophisticated man would not be taken in by it, not freely let himself substitute the shadow for the substance, the mirror for the reality, or call it authentic. A photograph does not shimmer (though movies flicker) but look at one edgewise! Its mirage is instantly apparent. If one is tempted thereafter to distrust all photographs, turn the edge of a Picasso painting to your eye; or dissolve a tiny corner of the Elgin marbles with weak acid.

To get from the tangible to the intangible (which mature artists in any medium claim as part of their task) a paradox of some kind has frequently been helpful. For the photographer to free himself of the tyranny of the visual facts upon which his camera is utterly dependent, a paradox is the only possible tool. And the talisman paradox for unique photography is to work the "mirror with a memory" as if it were a mirage, and the camera as if it were a metamorphosizing machine, and the photograph as if it were a metaphor. This is the only way that he can learn to use for the purposes of spirit, not the derivations of characteristic photography all of which lead back to painting, but unique or "straight" photography. Mirage and metamorphosis open the way for the photographer to work with the truth of metaphor. Once freed of the tyranny of surface and textures, substance and form, he can use the same to pursue poetic truth. Only then can he make the literal and uninterpreted renditions of the objects of the visual world be at the same time the photographer's interpretation—Stieglitz's clouds for example. Through the help of the paradox, visual surfaces yield their sovereignty and exist only to be seen through—not by lenses and emulsions which are blind but by the spectator of the pho-

tograph whose mental images make access to insight and poetry. And we generally admit that poetry (whether visual, verbal or musical) if not as efficacious as meditation, is far better fitted to the elucidation of the inner world than documents. Paradoxically again, poetry is the name for documents of the inner world.

Regarding matters of insight, the authenticity of the photograph is most dangerous quicksand compared to its mirage nature. For that is based on the fact that only change is permanent. On the strength of the mirage, then, photography can serve the spiritual purposes of art. Is there another way?

Minor White

"Statement"
1959

AN EXCERPT

. . . .

At first given to me, later I learned to make chance moments occur by looking at anything until I see what else it is. Such looking leads below surfaces, so far below, indeed, that once I claimed 'creative photography hangs on the faith that outsides reveal insides.' Then I meant that photographed surfaces must reveal the essences of objects, places, persons and situations. Since then I know the opposite to be also true: photographs of rocks, water, hands, peeling paint or weathered fences consent to mirror my own inner occasions. Hence, in photographing things for what else they are, I can go either towards myself or away from myself. Ultimately there is little difference, as Master Eckhardt, the German mystic, said: 'The eye with which I see God is the same eye with which God sees me.'

I understand very well what Freud meant by the little 'gap' in consciousness during the creative act, because when I maintain the mental atmosphere in which revelation can occur, the instants of intuitive grasp always seem to emerge from an element of blank. Depth psychologists interpret this 'gap' or blank as the brief period when the depth mind, which is inarticulate, overrides the articulate surface mind. Maybe so. I prefer the words of the Zen Masters who say 'it takes over.' And bow to the momentary presence of the Buddha.

Because of the 'blank' I feel little ownership of individual photographs and sometimes refer to 'pictures that my camera gave me.' To make possession a little more secure, I play many photographs against each other until the fragmentary statement of two or more complete each other, or between them say more than their added-up meanings. I know what the poet meant who said, 'the line is given; the rest is up to me.' The photographs are given; I must create the sequence.

The question, 'Which is more creative, seeing or sequencing?' is of interest but of no real concern to me, because sequencing of given photographs resembles putting together the most spectacular fragments of many broken bowls—not to reconstruct, but to see what spirit is shouting.

Robert Frank

Statement
1958

Robert Frank (b. 1924), born in Switzerland, traveled across the United States on a Guggenheim fellowship in 1955 and 1956. The result was *The Americans*, a book strongly influenced by Walker Evans but imbued with more evident emotion (and sometimes bitterness), more social commentary, sense of tragedy, and irony. His very personal documentary style influenced many photographers in the following years; the book is often considered a major turning point in recent photography. Frank went on to make several films.

I am grateful to the Guggenheim Foundation for their confidence and the provisions they made for me to work freely in my medium over a protracted period. When I applied for the Guggenheim Fellowship, I wrote '. . . To produce an authentic contemporary document, the visual impact should be such as will nullify explanation. . . .'

With these photographs, I have attempted to show a cross-section of the American population. My effort was to express it simply and without confusion. The view is personal and, therefore, various facets of American life and society have been ignored. The photographs were taken during 1955 and 1956; for the most part in large cities such as Detroit, Chicago, Los Angeles, New York and in many other places during my journey across the country.

I have been frequently accused of deliberately twisting subject-matter to my point of view. Above all, I know that life for a photographer cannot be a matter of indifference. Opinion often consists of a kind of criticism. But criticism can come out of love. It is important to see what is invisible to others—perhaps the look of hope or the look of sadness. Also, it is always the instantaneous reaction to oneself that produces a photograph.

My photographs are not planned or composed in advance and I do not anticipate that the onlooker will share my viewpoint. However, I feel that if my photograph leaves an image on his mind—something has been accomplished.

It is a different state of affairs for me to be working on assignment for a magazine. It suggests to me the feeling of a hack writer or a commercial illustrator. Since I sense that my ideas, my mind and my eye are not creating the picture but that the editors' minds and eyes will finally determine which of my pictures will be reproduced to suit the magazine's purposes.

I have a genuine distrust and 'mefiance' toward all group activities. Mass production of uninspired photojournalism and photography without thought becomes anonymous merchandise. The air becomes infected with the 'smell' of photography. If the photographer wants to be an artist, his thoughts cannot be developed overnight at the corner drugstore.

I am not a pessimist, but looking at a contemporary picture magazine makes it difficult for me to speak about the advancement of photography, since photography today is accepted without question, and is also presumed to be understood by all—even children. I feel that only the integrity of the individual photographer can raise its level.

The work of two contemporary photographers, Bill Brandt of England and the American, Walker Evans, have influenced me. When I first looked at Walker Evans' photographs, I thought of something Malraux wrote: 'To transform destiny into awareness.' One is embarrassed to want so much for oneself. But, how else are you going to justify your failure and your effort?

Weegee

Weegee by Weegee
1961

Weegee (Arthur Fellig, 1900–1968) made his living and his fame on murders; he got to the scene so fast that it was once suggested he must have planned the killing. He often slept in his car, where he had installed a police radio so that he could pick up the calls. He had a makeshift darkroom in his trunk, and could rush pictures of fires and other disasters to the newspapers faster than most staff photographers. His use of flash produced stark contrasts, with deep shadows surrounding the main subject.

Things went back to normal. The cops and reporters were happy, and I was happy. Gang wars, shootings, stick-ups, kidnapings . . . I was in the chips again. My pictures . . . with my by-line: "Photo by Wee-gee" . . . were appearing in the papers every day. *Life* magazine took notice, and ran a two-and-a-half page spread in their "Speaking of Pictures" section on how I worked at police headquarters. I made the "Picture of the Week" several times.

Now all the papers and syndicates offered me jobs. I told them not to be insulting; I intended to remain a free soul.

I bought myself a shiny, new 1938 maroon-colored Chevvy coupe. Then I got my press card and a special permit from the Big Brass to

have a police radio in my car, the same as in police cars. I was the only press photographer who had one.

My car became my home. It was a two-seater, with a special extra-large luggage compartment. I kept everything there, an extra camera, cases of flash bulbs, extra loaded holders, a typewriter, fireman's boots, boxes of cigars, salami, infra-red film for shooting in the dark, uniforms, disguises, a change of underwear, and extra shoes and socks.

I was no longer glued to the teletype machine at police headquarters. I had my wings. I no longer had to wait for crime to come to me; I could go after it. The police radio was my life line. My camera . . . my life and my love . . . was my Aladdin's lamp.

I would start my tour at midnight. First, I checked the police teletype for background on what had been happening. Then, into my car. I would turn on the police radio, then the car radio, which I tuned to the egghead stations for classical music. Life was like a timetable, tragic but on schedule, with little bits of comedy relief interspersed among the crimes.

From midnight to one o'clock, I listened to calls to the stationhouses about peeping Toms on the rooftops and fire escapes of nurses' dormitories. The cops laughed those off . . . let the boys have their fun. From one to two o'clock, stick-ups of the still-open delicatessens . . . the cops were definitely interested in those. From two to three, auto accidents and fires . . . routine coverage that the cops had learned how to handle when they were still rookies at the Police Academy. At four o'clock, things became livelier. At that hour the bars closed, and the boys were mellowed by drinks. The bartender would holler "Closing up!" But the customers would refuse to leave . . . why go home to their nagging wives? The boys in blue would escort them out, then jump in for a few quick drinks themselves in the darkened back rooms. Then, from four to five, came the calls on burglaries and the smashing of store windows.

After five came the most tragic hours of all. People would have been up all night worrying about health, money, and love problems. They would be at their lowest physical and mental state and, finally, take a dive out of the window. I never photographed a dive . . . I would drive by. Nature was kind. A woman would land on the sidewalk, one shoe off, but with never a mark on her face. The cops would cover her body with newspapers. I couldn't take it; I was finished for the night.
. . . .

Colin L. Westerbeck, Jr.

"Night Light: Brassai and Weegee" 1976

Observers of the social scene and lowlife have been around with their cameras since the nineteenth century. Brassaï (Gyula Halász b. 1899), in *The Secret Paris*, picked a very special corner of that scene. He was born in Hungary, but transplanted himself to Paris as a young man. André Kertész lent him a camera; eventually he gave up journalism for it. Weegee was a reporter of a different stripe and an early success in the media game of attending disasters and photographing the immediate reactions of victims and bystanders. Colin L. Westerbeck, Jr., writes on film and photography.

The photographs of Brassaï and Weegee are like a discovery made independently in two different laboratories by scientists unaware of each other's research. Their similarity verifies certain things for us. We assume their visions of city life the way physicists assume gravity. At the same time, each man's experiment is distinct and individual. Although both photographers described for us the same phenomenon, the same dark underside of urban civilization, their affections, their methods of working, even their camera equipment turn out to have been remarkably different. In science it may be the sameness of the findings, some universal result of the experiment, that matters more.

But in art it is the personality of the experiment itself, the singularity of the description rather than the ubiquity of the phenomenon described.

Brassai is now 81 years old. He first came to Paris from Brasso in Transylvania in 1923, to study painting. Although he had seen the work of Atget in the late 1920s and had befriended André Kertész, he did not come to photography himself until 1929, and even then his thought was not to be a professional photographer, but only to preserve for himself the Paris of the time. By the end of 1932, however, only four years later, he had taken the bulk of what are now his most widely recognized photographs. In 1976, in conjunction with an exhibition at New York's Marlborough Gallery, he published a retrospective of those early photographs called *The Secret Paris of the '30s*. Considering Brassai's age, the book was undoubtedly intended to be the definitive edition of that Paris work. Two of the series in the book were made in 1933 or '34, but everything else is dated 1931 or '32. This is not to say that the photographs are old hat. Many are new in the sense that they had never been published before. Yet in large measure, the extraordinary power of the Marlborough show resulted from our awareness that an old man had gone back with such care and enthusiasm to work he had done over 40 years ago, at the very beginning of his career. One reason we were able to respond to this work was that the photographer himself could still do so after all this time.

Brassai initially published pictures taken on his nocturnal rambles through Paris in 1933 in a spiralbound paperback called *Paris de Nuit*. That original set of pictures has been expanded in the ten books of photographs and memoirs Brassai has published since, most notably in his 1952 collection *Volupté de Paris*. But *The Secret Paris* is the first book in which he has returned exclusively to those original photographs. When I talked with Brassai in 1976, he said that he had returned to work done so long ago in part because he could not publish many of the pictures until recently. Pictures of prostitutes lining up for customers or squatting on a bidet after servicing them couldn't be shown in public when he first took them. Now, with the passing of time, he said, these photographs have become "innocent." He's right. Amidst our own, publicly raunchy culture, the secretive, bohemian sinning of Paris in the '30s does look innocent.

In an odd way, the revision of *Paris de Nuit* that *The Secret Paris* represents might almost make one think of Wordsworth, who also turned at the end of his life to revising the major poem of his youth, *The Prelude*. Where Wordsworth found innocence in children like Lucy or in the leech-gatherer or the characters in *The Prelude* itself, Brassai

found it in floozies like Bijou and in derelicts. Wordsworth's memories of the Lake District romanticize all of nature for us, just as Brassai's photographs of Montmartre romanticize cities. Wordsworth even complained, as Brassai has in *The Secret Paris*, about a growth in local tourism for which, he apparently did not realize, his own work was largely responsible. And coming back in 1850 to the poem he had first published in 1805, Wordsworth altered subtly the rural landscape there in ways not so different from those in which Brassai has altered the urban landscape of *Paris de Nuit*.

To go back to *Paris de Nuit* after looking at *The Secret Paris* affords a surprise, for the dominant quality of the former seems almost completely absent from the latter. That quality is a starkly graphic one, a fascination with the abstract patterns that light makes on cobblestones or when it throws an iron fence into relief. The city that we see here is deserted, many of the pictures capturing familiar parks, boulevards and landmarks at an hour when no one is around. When people do appear, they are often glimpsed only at a distance and are subordinated to the graphic elements of the scene. Lovers kissing on a park bench blend into the background of a picture whose power comes from the way a strong sidelight picks up the slats of the bench like the keys of a xylophone. A man pissing against a wall, or perhaps carving grafitti, is dwarfed in the far background of a picture by the box-work of pillars and riveted beams on the underside of an elevated train line. Even the derelicts whose portraits crowd the pages of *The Secret Paris* are only a discrete, remote presence in *Paris de Nuit*. They huddle at the far end of an embankment in a picture whose sole purpose is to counterpoint their bonfire with the lone street lamp on the bridge overhead.

Though seven of the photographs in *Paris de Nuit* depict the same scenes obviously on the same nights as pictures in *The Secret Paris*, none of the pictures in the later book is actually in the earlier one. In general *Paris de Nuit* differs from *The Secret Paris* as much in substance as it does in style. Over a third of *Paris de Nuit* is high-angle shots, many of them panoramic, while only about one-tenth of *The Secret Paris* was made from a vantage point. The distinct character of *Paris de Nuit* makes me wonder, in fact, whether many of the photographs in it were not taken during the period 1929–31, when Brassai was first beginning photography and before he was capable of the cafe and street pictures of 1931–32.

André Kertész loaned Brassai his first camera in 1929, and a shot of the Eiffel Tower in *Paris de Nuit* can be seen to have been made that year since the date is emblazoned on the tower in lights, apparently to celebrate the 40th anniversary of its construction. Brassai has said that

it took him quite awhile to solve the problem of halation from street lamps at close range. In the meantime, he may have concentrated on longer shots where the long exposure times required for night photography simply suffused the light. Whether this is so or not, certainly everything done those first couple of years must have been done at the more respectful distance so apparent in *Paris de Nuit*. In our conversation, Brassai stressed that he had had to cultivate the friendship of the criminals and other habitues of Montmarte for several years before he could begin photographing them.

All these high-angle cityscapes in *Paris de Nuit* suggest that Brassai was at that time poised on the brink of the city, ready to descend and become a part of it in a way no photographer had. The two photographs accompanying the first chapter of the reminiscence in *The Secret Paris* seem to pick up where those high-angle shots in *Paris de Nuit* leave off, and to suggest that that descent into the city was a kind of descent into hell. Both pictures were made atop Notre Dame, where the suffused light drifts up from below as if born aloft on a sulphurous cloud from brimstone pavements. In the foreground of each photograph a gargoyle in silhouette or a winged demon with horns dominates half the picture space. The lighting coming up from below makes the demon look sinister, but the casual, almost languid way his head is cupped in his hands as he contemplates the city is comical. If this is a vision of hell, it is a very attractive and tempting one. It is just the sort of vision we might expect from a noctambulant Transylvanian, a countryman of Count Dracula.

From these heights *The Secret Paris* descends first into the streets, then into the cafes and music halls, and finally into the brothels, private "houses of illusion" and opium parlors. The photographs from the dens of iniquity which have not been seen before are wonderful, as are Brassai's remembrances of those places. But without taking anything away from this new material, I still feel that the finest of all Brassai's pictures are the ones he took in the mirror-lined cafes and dance halls of Montmartre. It is appropriate that he should have taken his best photographs halfway between the public settings of *Paris de Nuit* and the private ones seen for the first time in *The Secret Paris*. Those cafes were clearly very ambiguous spaces. They opened onto the street and anyone was free to come in; yet if a stranger should happen to do so, he was at once made to feel uneasy and unwelcome. The cafes straddled the private and public extremes of *The Secret Paris* and combined elements of both.

The graphic element so strong in *Paris de Nuit* is not really absent from the cafe pictures. It has just become implicit. It has insinuated

itself in the reality of cafe life. The cafe pictures are in fact a marvellous sort of *trompe l'oeil* in which Brassai's graphic sense and the self-images of his subjects combine. They combine to become the underpinnings of a vision which at first seems the opposite of graphic and studied, a vision that seems candid and spontaneous. I think most of us take it for granted that these pictures are unposed, and Brassai himself confirmed this to me. He never arranged a scene or instructed his subjects like a movie director, he said, "Never!" In one sense this is obviously true. When you talk to Brassai, you realize what extraordinary presence he has. It was apparent to me that his genius for photography lay in his disarming personality, not in any photographic technique. Along with the exceptional peripheral vision he has as a result of very prominent eyes, his energy and charm must have allowed him to catch any subject off guard.

But there were still limitations on his equipment that he must have been obliged to compensate for. The Bergheil Voigtlander camera he used in the '30s, a 6 x 9 cm plate camera, had to be mounted on a tripod and, under the available light in the cafes, would usually have required exposures of three or four seconds or more, sometimes much more. When such long exposures were not needed, it was only because Brassai had a magnesium-powder flash fired by an assistant. This means that Brassai's subjects were either keyed to his taking of a picture by his signals to his assistant synchronizing the flash, or else the subjects were asked to hold during a prolonged exposure some attitude into which they had happened. When you look closely at Brassai's pictures, the telltale signs of these impositions the camera must have made on the scene are apparent. In a brothel the flash gun is reflected in a mirror as an assistant extends it into the scene from the next room. Lovers stand idly at the bar in a lesbian cafe, but the bartender stares into space instead of watching where he is pouring a cocktail, and on closer inspection we notice that the cocktail shaker is empty.

In addition, slightly different versions of photographs published over the years make it clear that Brassai often took a series of exposures, frequently with the aid of a flash on each. The reason these contrivances do not register with us in the cafe pictures is that Brassai had found in the habitués of Montmartre the perfect subjects for his peculiar art. For the world Brassai photographed was, after all, that of the apache dancer—a world of poseurs and studied toughness, a world whose inhabitants were trying to wear their emotions on their rolled-up sleeves. Or so we assume, and Brassai's photographs get the benefit of that assumption. We take it for granted that the "natural" behavior of these cafe and dance-hall types was full of artifice, and the photo-

graphs themselves trade on our belief in their subjects' paradoxical behavior. We accept the candor of the attitudes being struck in these photographs because Brassai's sense of the art of photography is deftly hidden behind his subjects' sense of the art of living.

Illusions of this sort are what Brassai's photography is all about, and he created them by every means at his disposal. Even the limitations of his equipment were turned into a source of aesthetic illusion. A photograph of two smiling prostitutes, for instance, abruptly darkens in mood when we realize that in places we can see right through its subjects. This happens because the two women moved slightly during the long exposure, and one effect is to make their youth and their gaiety into something painfully ephemeral. The richest opportunity Brassai had for creating such illusions lay in the mirrors with which the walls of Parisian dance halls and cafes were lined. Here is where his sense of composition worked most effectively. Consider the way in which the alternation of moods in the picture just discussed occurs again in a photograph taken at "la Boule rouge" in 1933. A man smirks in a suggestive way at a woman whose smile shows that she is pleased by his attentions; but reflected uncertainly above them—perhaps in a mirror and through a plate glass partition as well—is another, dour-looking couple who are dancing. The romantic anticipation in the foreground is overshadowed by the sullen disappointment with which these ghostly dancers embrace.

Of course no visual artist since Impressionism, and particularly not an artist who spent his time in Parisian cafes, has been able to ignore the imagery of mirrors. The mirror's duplication of the real world in an illusion is central to the iconography of modern art. We must keep in mind, too, that it was as a painter Brassai first came to Paris. Arriving in the early '20s, he felt both the aftershocks of Cubism and the lingering influence of Impressionism itself. His own sense of pictorial space, at least in the cafe pictures, owes as much to the traditions of modern painting playing themselves out around him as it does to any potential that inhered in the camera alone. Brassai became a friend of Picasso's at just the time that he was taking these cafe pictures, and the influence of Picasso's imagination on them seems considerable.

In a sense the camera was the ideal instrument to achieve the goal Monet had set for himself, which was to arrest light. Even before the introduction of color film, the camera promised to achieve by mechanical means that spontaneous grasp of the world Impressionism strove for. Yet it seems clear that from the beginning of his career Brassai also wanted to achieve something contrary to this. He wanted to extend this spontaneous, intuitive act of taking pictures, *instantanes*, in a way

that would reconcile it with a more structural and analytical perception of space. The cafe pictures taken before mirrors do this. The figures reflected in the mirrors, whether they are the subjects seated before the mirror or someone out of the camera's field, always seem to appear from a different perspective. Profiles reflect away from themselves at skew angles, different planes of the composition intersect as if in a labyrinth, and lines of vision disperse in an oblique, controlled geometry just as they might in the most premeditated Cubism.

Brassai's photographs are the product of a cross-current between esthetics and sentiment. In the best of them, one can almost see the opposition writ large. Graphics and feelings seem to cross each other's paths travelling along the photograph's alternate diagonals, holding each other in suspension. For me the photograph in which the perfect balance is achieved is one Brassai took at a cafe on the Place d'Italie. There a couple presses together in a mirrored corner. While the two lovers meet face to face in the center of the picture, a reflection of each alone appears on the outsides imprisoned in a dart of glass. Just behind the lovers themselves, the darts meet point to point. There the lovers' heads are turned in the same direction, rather than toward each other, as if each were staring off into space dreamily. In the middle of the frame the two figures appear so intimate. They gaze into one another's eyes. But in the reflections we see that each is wrapped in a private revery. Even as they make love, they are isolated. The woman's hand moves to her ear in a gesture that is at once both casual and affected. She seems lost in love, yet not so lost that she is unmindful of the camera.

Although Brassai began photography out of a simple desire to record what he saw in Montmartre and Montparnasse, he never thought of photography itself as an indifferent tool or of his work as mere reportage. In our interview he told me,

> I don't like snapshots. I like to seize hold of things, and the form is very important for this. Of course, all photography presents chances to relate things of interest, but it lacks often a sense of form. Form is very important not only in order to create art, but because only through form can the image enter into our memory. It's like the aerodynamics of a car, don't you see? For me, form is the only criterion of a good photograph. One doesn't forget such a photograph and wants to see it again.

It is hard to imagine a better apology than this for the synthesis of form and content that the cafe pictures achieve. They have indeed entered

into our memory, and for just the reason Brassai said. Nevertheless, in recent years Brassai seems to have moved even further away from the sensibility of *Paris de Nuit* and toward a kind of naturalism in his valuing of his photographs. This is noticeable in the way he has come to crop certain of his most widely published pictures. The graphic tendency of *Paris de Nuit*, which becomes implicit in the cafe photographs, disappears altogether in his recropping of some of those photographs.

This seems especially significant in the picture which is perhaps the most famous Brassai has done, one made in 1932 at the Bal des Quatre Saisons. It depicts a young man and woman who sit sulking after, apparently, a lovers' quarrel. In the original version a woman's face, unfocussed but strikingly like the face of the female lover, is reflected in the mirror over the couple's heads. A little, star-shaped cleat holding the mirror in place appears where the reflected face's eye should be, and this disfigurement turns the mirror image into a realization of the fantasy that, we suspect, is going on at this moment in the man's mind. (An eye that is masked or blinded from the camera is a constant motif in Brassai's photographs.) Crucial as that face in the mirror is, Brassai has cropped it out of the picture for years. The whole photograph appears in the Focal Press edition of Brassai's work done in London in 1949, but in the 1952 Paris edition, and in each subsequent publication of the picture Brassai could control, including *The Secret Paris*, the picture has been cropped.

When I asked Brassai about the cropping of this photo, he claimed to be surprised, as if he had never noticed it before. "You know my photographs better than I," he declared with a note of mockery. He made it clear that he now preferred to have the viewer concentrate on the figures alone. Although I think I understand why he has made this decision, I don't agree with it. In the original, full-frame prints, there is a tension between subjects and backgrounds. We keep our distance from these people and have a certain ambivalence about them. The formal properties of the photograph hold back the emotion a bit. They hold the melodrama of these lives in check. Without that ironic structure, the tension in the pictures is relaxed. The subjects fill the frame. We are brought closer to them, and they are allowed to make greater demands on our sympathies. They become figures of nostalgia.

Brassai may not feel that's so bad, though. He is not the first artist who, growing old, preferred sentiment unmitigated by art. Large numbers of people who have no interest in photography *per se* came to Brassai's exhibition in 1976 or bought his book, and their interest in his work may not finally differ much from the interest he himself took in

going over all these pictures from the '30s again. But I don't mean to trivialize the changes that have occurred over the years in his attitude toward his pictures. His sense of them has just become more human, that's all.

Photographers both great and ordinary often begin with the kind of heavily graphic sensibility seen in *Paris de Nuit*. Seeing the world as an abstract pattern excuses the novice photographer's shyness, which makes it hard for him to confront people at close range. But as time goes on, the photographer becomes more confident and curious. He overcomes his standishoffness, and pays less attention to esthetics. In Brassaï's best work, as I said, the esthetics do not disappear; they are merely assumed and made implicit. But it is understandable that in old age an artist should want to concentrate on humanity, on the feeling alone, and exclude all else. This is what happened to Wordsworth, too, when he revised *The Prelude* almost half a century after first publishing it. The second version of the poem is less concerned with the grand design of Nature, and more concerned with the purely human pleasures of memory. Perhaps it is only natural that Brassaï's revision of *his* prelude should be the same.

•

Brassaï is, as Americans used to say back in the '30s, "the genuine article." He's a true original. His vision of city life is unprecedented. Yet his work isn't completely without analogy in the history of photography. In some ways, his work and Weegee's are much alike. Besides some chance coincidences between their lives—the one-word nicknames (Weegee's real name was Arthur Fellig), the fact that each was an immigrant to the country where he made his reputation, etc.—there are similarities in both the subjects they photographed and the photographs themselves. "I was friend and confidante to them all. The bookies, madams, gamblers, callgirls, pimps, con men, burglars and jewel fences . . ." Weegee told us in his 1961 autobiography *Weegee by Weegee*, and it could have been Brassaï talking. Each man descended into the lower depths. Each swam among sharks in order to get his pictures.

It is not only the personnel that is the same in the two men's work, but the very atmosphere of the city. The streets are largely deserted in their photographs so that there is about them a feeling of desolation. More than a time, night is a place here. The settings of their pictures, which are familiar to us by day, become in darkness some place we have never been before. The people who inhabit this landscape are similarly ambiguous. The facades of the shops in the background, blank and monolithic in the eery, electric flash, give us the feeling that the one or two figures who are on the street have been locked out of

this society. They are classic outsiders, wanderers, transients, figures of alienation and exclusion. Yet in night and darkness, these people are also obviously at home. They are like the troops in some guerilla war who are never seen by day, but "own" the night.

For Weegee and Brassai alike, the only refuge from the night, the only sanctuary, was in the bars and cafes. Weegee's Montmartre was the Bowery, and his Bal de Quatre Saisons was a dive called Sammy's. Like Brassai, Weegee went to costume balls and private parties as well; and the ambience of all his haunts was always as convivial and erotic as Brassai's Paris. Instead of wine glasses there are beer bottles on the grubby table around which four men sing, but the mood is the same as in Brassai's pictures. Flirtations, insults and posturings fly through the air. In one photograph, a pair of derelicts smooches passionately in the corner of a booth at Sammy's, mimicking in their shabbiness the rather elegant lovemaking going on in the mirrored corner in that Brassai photo.

Beyond all the coincidences between the two photographers' work, however, there are telling differences as well, and the differences are in the end perhaps more significant than the similarities. Although both men photographed the night world of the city, the underworld, they had very different relationships with that world. Brassai found life there enjoyable. Weegee found it laughable. As a result there is in Weegee's photographs a cruelty not found in Brassai's. Weegee's work looks forward to Arbus' as much as it looks back to Brassai's. While the world Brassai photographed was one of sin and pleasure, that Weegee photographed was one of crime and pain. Brassai's principal subjects were the criminals. Weegee's were the victims. Even when Weegee photographed a gangster, it was almost always because the man had himself been arrested or shot. In Weegee's photographs the violence of society is all explicit. He photographed even the good citizens at moments of lawlessness. In Brassai's photographs the violence remains only implicit. He photographed the outlaws, but caught them at moments of high sociability. An important difference in the quality of the two men's work is that Brassai's preserves the duality where Weegee's does not. Brassai's photographs give us the impression that even in the lower depths, life is paradoxical and complexly human. Weegee's often gives us the opposite feeling that even among the middle classes, society is merely brutal.

To a certain extent this difference may result from the fact that Brassai really knew the people he photographed, and Weegee did not. Weegee grew up in a poor neighborhood on the Lower East Side, and according to *Weegee by Weegee*, he spent a period living in flophouses on

the Bowery too. Yet his photography of tenement dwellers and bums is quite pitiless, as if he had no more feeling for them than for the gangland bosses he photographed. In *Naked City* he told us, "I cried when I took this," referring to a picture of two women watching relatives burn to death in a fire. But it is hard for us to believe Weegee did much crying. His pictures turn catastrophe to comedy too easily. As an elderly couple watches another fire burn down their home, the woman is caught so goggle-eyed by the camera that she and her husband are ludicrous. And of course there are various pictures of the gawking, gaping crowds that collected at murder scenes. Everybody —the murderer, the corpse, the bystander alike—was just part of the freak show. As opposed to Brassai, who took two years getting to know his subjects before even beginning to photograph them, Weegee knew none of his. He did not want to know them. Who would?

To give him his due, though, Weegee may well have represented the lives of his subjects and personality of his city as accurately as Brassai did his. Compared to Paris, New York *is* a tough, graceless town. Brassai's subjects were self-prepossessing and had a sense of their own style that was, if anything, overdeveloped. The archetypal Brassai subject was Bijou, and so his premeditated, carefully composed photography does his subjects justice. But if Weegee valued his subjects at all, he valued them because they were such schlepps and schlemiels. His subjects often had no sense of style, no self-image to project, nor was their behavior calculated before the camera in the way Brassai's subjects must have been. If Weegee's photos seem less artful than Brassai's, perhaps it is just because his subjects' lives had less artifice in them.

Yet at the same time, the human nature of Weegee's subjects only partially accounts for the impromptu and informal character of his photography. Equally important are the technical differences between his equipment and Brassai's. Beginning work a few years after Brassai, Weegee had available to him, instead of flash powder, the much brighter, faster, more maneuverable flash bulb. His camera was the Speed Graphic, a plate camera with a 4 x 5" format that was the standard press model of the day. But most important of all, with its automatic synchronization for the flash, this camera allowed Weegee to photograph always at 1/200th of a second—somewhere between one and four hundred times faster than Brassai could usually work.

The consequence of this technological advance was, ironically, to make Weegee much more of a primitive than Brassai was. To be sure, Weegee was anyway, by both inclination and background, a more primitive man than Brassai, whose father had been a university profes-

sor and who was himself part of the most influential Parisian cultural circles of his day. Since Weegee had no access to the sort of esthetic education Brassai enjoyed, it is not surprising that Weegee's was a less refined (or at least less bourgeois) sensibility. But even had his own tastes not prompted him to a cruder sort of picture than Brassai took, Weegee's equipment would have done so. Being fast enough to take completely candid, spontaneous pictures, the Speed Graphic inevitably produced a less formed, more inchoate vision of life. It was a camera that by its very nature demanded one shoot without thinking, working by instinct rather than intellection. The work methods and indeed the whole career of each photographer seem to have been geared to the speed at which his shutter operated.

On any given night, Brassai told me, he might make only one exposure after having left the camera set up before a subject for hours. But where his photography is a form of meditation on life, Weegee's is a gut reaction to it. Brassai told me that he has purposely waited years before publishing many of his photographs in order to let time select which were the best ones. But Weegee felt that, as he explained in *Weegee by Weegee*, "A picture is like a blintz . . . eat it while it's hot." Weegee worked at such a frenetic, indiscriminate rate that he at one point put himself right out of business by flooding his market. He claimed to have worn out ten Speed Graphics during the years 1935–45, and at last one editor told him, "You've been peddling the same pictures to us now for six years, and, for all I know, it's the same dead gangster and the same gray fedora lying on the sidewalk." "I had so many unsold murder pictures lying around my room," Weegee lamented, "I felt as if I were renting out a wing of the City Morgue."

Because of the uncomposed photograph that resulted from the speed at which both Weegee and his camera worked, there is in Weegee's pictures none of that dialectic Brassai gave us. Despite being "action" pictures when Weegee took them, they now seem, though certainly not lifeless, at least quieter than Brassai's pictures. The dialectic that is contained in the frame itself in Brassai's pictures seems to occur in Weegee's photography only in a relationship that we sense existed outside the frame, between the photographer and his subject. The very qualities that are the most distressing in Weegee's work—his aggressiveness and disregard for the feelings of his subjects—are also his most durable qualities. If an antagonism for his subjects is apparent everywhere in his work, the work is at its finest when that antagonism was at its strongest. This very often means when he was photographing the rich.

Although there are relatively few of them, Weegee's pictures of

cafe society achieve a subtlety not seen elsewhere in his work. (He was employed for awhile by *Vogue*, of all places.) The fine tuning seen in these pictures may have been possible because this was the one time Weegee was not dealing with traumatic events. Yet the pictures arrive at this new level of perception without sacrificing that quality of an action caught on the wing which was the Speed Graphic's specialty. It seems fairly clear that Weegee was responding to only two elements of the action in each picture: the movements of hands and eyes. All photographers tend to concentrate on the eyes of a subject because they are the most expressive feature and it is on them that the focus should be sharpest. But as the lens fixed the eyes in these pictures, the flash fixed the hands, giving them an exceptional presence in the frame because they were the lightest or most prominent part of the body.

Thus, for instance, as three people in evening dress crowd around a table at a party, two downcast glances and one blank stare betray any possibility of enjoyment or energy. The looks reveal the experience, and the people, to be utterly vacuous. And at just this moment, the man's hand rises toward his chest. The motion seems ever so febrile, the veins in his hand thrown into relief under translucent skin by the falling off of the blue light from the flash. He is listlessly reaching for —what else?—his wallet. It is a consummate gesture of money and power. In another picture a dead-level gaze seems to have very much the same message in it. A chauffeur helps a dowager out of her limousine. But as she and her husband look to the clumsy business of getting her disembarked, the chauffeur, whose right arm is doing all the work, looks straight ahead. He averts his eyes, not wanting to embarrass his mistress in her discomfiture—not daring to gaze on her presence. In his left hand, which holds aloft an umbrella, he is gripping his right glove, as if he were surreptitiously congratulating himself; and thus he leaves the right hand, offered in support to the old woman, abjectly naked. The imperiousness suggested by the eyes and hand in the first picture is confirmed by the servility of those features in this second one.

In perhaps the best of these pictures in the show, a young woman arches her eyebrows, tilts her head to one side, fingers her necklace with divine nonchalance and stares down the camera. But what undermines the figure she is trying to cut, besides the extravagance with which she does it, is the appearance on the dance floor just behind her of a man whose puffy, octopus eye leers over his partner's shoulder. In contrast to the carefully crooked wrist and hand fondling the necklace, his ham hand encircles his partner's waist and, with fingers splayed, menacingly grabs our attention by its stark contrast against the back of

a black dress. All the pretension and elegance the woman in the foreground summons for the occasion by her glance and gesture are at once destroyed by the dissipated lechery of the man's hand and eye in the background.

The difference between the conflict we see here and the one we might encounter in a Brassai cafe picture is that Weegee's photo is not held together by any kind of form. An accident snatched from a random flow of events, it is not contained by the frame in the same way that Brassai's observations are. The forces at work in Brassai's photographs are centripetal, while those in Weegee's are centrifugal. Brassai's show how people fit into their environment. His pictures are gravitational, pulling everything in them together, achieving a unity. Weegee's show how people do not fit into their environment. His pictures are explosive, blowing the world apart and achieving a kind of chaos. This quality is the one that Weegee's pictures of the rich share with his best work in other settings. Characters from all walks of life clash the way that the man in the background and the woman in the foreground do in the picture described above, or the way that the two society matrons and the charwoman do in Weegee's most famous picture, "The Critic."

Again, it is often the craziness of the eyes in a picture that makes it fly apart for us this way. In a picture where men in business suits stand around open-mouthed, seeming to holler, there is something disconcerting that we cannot quite put our finger on. That several of them hold swords is part of it, but more important is the fact that each man is looking in a different direction. Can each be having the same reaction to a different event? It makes no sense, which is its delight. In a photo of a crowd on a Brooklyn street gawking at something outside the frame, the effect of the eyes—some anguished, some inquisitive, some horrified, some turned-on—is similar. A photograph like this at last breaks down whatever compunctions we have had about Weegee's work. It has been made in a relentless, remorseless way, but perhaps not, after all, a truly heartless one. There is something almost playful about it. We realize that the people Weegee photographed were for him not finally beasts, but only screwballs. There are many times when this does not come across in the photographs, when the sensibility at work here fails so that the picture makes us cringe. But even at these moments, when Weegee allowed us to lose sight of what a bunch of characters he thought the human race to be, we still come away from the photograph with a sense of what a character Weegee was.

All photography of the sort Weegee and Brassai did is in essence an act of anticipation. In the most immediate sense, it is knowing when

to push the shutter release—summoning all your powers of concentration in order to stay ahead of events by that crucial second, or 1/200th of a second. For Weegee, in another sense that almost caricatures this first one, photography was also an act of prophecy. He got his nickname from having a sixth sense for news, and a whole chapter of *Naked City* is called "Psychic Photography." There are before and after pictures of a street corner in Chinatown that blew up while Weegee stood there waiting for something to happen. In another picture, Weegee got a burglar being caught in the act by the cops. In some others, a really pathetic series of the kind only Weegee could make, a derelict staggers to his feet from the sidewalk, is run down by a car when he wanders out in the street, and receives the last rites from a priest who happens by. At the beginning of the chapter in *Naked City* entitled "Murders," Weegee boasted, "Some day I'll follow one of these guys with a 'pearl gray hat,' have my camera all set and get the actual killing. . . ."

For Brassai photography has also required anticipation in still another, even more remarkable sense. It has required him to wait patiently for photographs to come into their own as art. During my interview with him he told with great relish a story that appears in his *Picasso and Company*. One day Picasso saw some of Brassai's drawings and declared that they were a gold mine Brassai should not neglect in order to do photography, which was a salt mine by comparison. Brassai's reply was that he felt the photographs were the true gold mine. Having waited all these years for the recognition he was sure would come—to be exhibited and sold in an art gallery like Marlborough, for instance—Brassai could not be more delighted. He loved the excitement publication of *The Secret Paris* created. On more than one occasion he went up to Marlborough while his exhibition was on and wandered among his pictures, waiting for someone to recognize him, for a crowd to form, for the enormous satisfaction of leading an impromptu band of admirers on a gallery tour of his own.

When I spoke to Brassai at that time, he told me,

> One begins to understand that painting is not our means of expression. It is a medium that comes from the past. Now there are new means of expression. There is television. There is the cinema, the film. And one begins to understand that it is the photographic image which is the means of expression of our century.

On the evidence of his own work, he may well be right. In a way Weegee's pictures, erratic as they are, may seem the more contempo-

rary. It is his eccentric sense of timing and of humor that seems to precede most profoundly the work of the best recent street photographers—Lee Friedlander, Garry Winogrand, Tod Papageorge, Joel Meyerowitz. Yet Brassai's precedent is still as keenly felt too. In these later photographers' sense of form—of the picture as a self-contained event in its own right, a work of art—Brassai's influence undeniably continues as well. His pictures hold out to today's photographers a formal ideal by which a potential of photography only inchoate in Weegee's work might yet be realized.

Harry Callahan

Statement
1964

Harry Callahan (b. 1912) taught for years in Chicago. He was head of the photography department at the Institute of Design there, and later of the photography department of the Rhode Island School of Design. In his photographs, he looks to the outside world for signs of an inner reality. Callahan's style and subject matter, always cool and formal, has changed numerous times, from bare and linear views of nature to candid street shots, formalistic architectural studies, and double exposures. Callahan says that in 1941 the work of Ansel Adams redirected his life.

In order to make a statement about one's photography, there should be some statement about oneself. I started photography as a hobbyist in 1938 at the age of 26. I had had no formal training. In 1941, as a member of the Detroit Photo Guild, I saw and recognized for the first time some fine photography by Ansel Adams. This was a revelation. It led me to search out my own way of photographing intuitively. Searching and stumbling revealed to me that my photography would be one of continual change.

In the early days the view camera was my real joy. I could study and feel the image through beautiful photographic values of tone and

texture. At this time I believed so strongly in tone and texture that I did nothing but contact printing—even later with two and a quarter square negatives. On a good cold winter day I was photographing in the snow in extremely soft and shadowless light and on the ground glass I suddenly saw just lines of the weeds in the snow. Making photos this way seemed a sort of sin in relation to tone and texture because the only image I printed was line—no snow texture. Semi-consciously this opened a whole new way of seeing for me. My first adventure and change—brought on by some kind of need.

I bought a 35mm camera. I had an urge to photograph people on the streets in downtown Detroit, and to do it freely. First I shot recognizable action, people talking to each other, laughing together, etc. This had a literal value which has never been satisfying to me. While shooting this way I found that people walking were lost in thought and this was what I wanted. After a while this too became confining for the moment. At this time I was working full time during the day and naturally did quite a few night shots. I started multiple exposing the street lights and went on to camera movement on the street lights, neon signs, etc. Realizing that these photographs were beautiful in color, I made my first decent color shots of camera movement on colored lights. I continued camera movement on all kinds of subjects in color and black and white.

It's the subject matter that counts, I'm interested in revealing the subject in a new way to intensify it. A photo is able to capture a moment that people can't always see. Wanting to see more makes you grow as a person and growing makes you want to show more of life around you. In each exploration or concern for the subject, I continue in the area for a great length of time, sometimes a couple of years. Working this way has been the result of my doing the photo series or groups. Many things I can't return to and many things I return to come out better.

I photograph continuously, often without a good idea or strong feelings. During this time the photos are nearly all poor but I believe they develop my seeing and help later on in other photos. I do believe strongly in photography and hope by following it intuitively that when the photographs are looked at they will touch the spirit in people.

Henry Holmes Smith

"New Figures in a Classic Tradition" 1965

Henry Holmes Smith (b. 1909) has been an experimental photographer since the early thirties and was briefly associated with Moholy-Nagy's New Bauhaus in Chicago. Aaron Siskind (b. 1903) taught for years at the Institute of Design, successor to the New Bauhaus, and was director of photography there; his influence has been widespread. In the thirties he was a documentary photographer. In the forties he turned to more formalistic concerns in the belief that reality resided in individual feelings, a belief akin to that of Alfred Stieglitz and Minor White. Siskind was friendly with the Abstract Expressionists, and his photographs are often compared to their paintings. H. H. Smith makes a strong case for Siskind's work as a reconciliation of traditional and modernist ideas in photographs.

Thomas Hess, in his essay, "Aesthetic in Camera," pays tribute from the art world to Aaron Siskind's photographs: tribute, one of a number, that places Siskind's work in the small body of photography for which major artists have evinced genuine interest and enthusiasm. This said, a larger question must be faced: What is *photography's* debt to Siskind, who is now in his early sixties? It is large and to a considerable extent unacknowledged; furthermore, many photographers remain unaware

that, because of Siskind's contribution, photography has finally com-
pleted its journey into the twentieth century. For, much to the joy of
his friends among the artists and to the dismay of a number of photog-
raphers, Siskind has proceeded during the past twenty-five years to
take up and solve some of the most difficult and tricky problems be-
queathed us in the late work of Alfred Stieglitz.

Siskind, himself, in a lecture in November 1958, traced the "basic
tradition for photographers today" to the work of Stieglitz after 1910.
This tradition, as Siskind remarked, "involved a simple procedure and
a rather uninvolved aesthetic, . . . (and) has established standards of
excellence and objectivity to which we all, no matter what our partic-
ular practice, go for nourishment and discipline." Siskind described
this kind of photograph as "sharp all over, . . . with a full tonal range,
. . . made with the light present at the scene, . . . using the largest
possible camera, preferably on a tripod, . . . the negative is printed by
contact to preserve utmost clarity of definition, . . . and the look of the
finished photograph is pretty well determined by the time the shutter
is clicked. . . ." He called this the "classic photograph"; since it is in
the "basic tradition of photography, the term "traditional" is useful in
discussing this kind of camera work. It is in this sense that the term is
used here. Siskind and Stieglitz, each in his own way, may be termed
traditional photographers. The way their work is related, the way their
contributions to the art of photography differ, and the singular impor-
tance of Siskind's work to traditional photography today are the con-
cerns of this essay.

The work of Stieglitz paved the way for Siskind's, but it took an
imagination of exceptional force to move from the Stieglitz sky pictures
(his "equivalents") to the remarkable visual figures of Siskind. Two
men, two separate generations of art, two different kinds of imagination
were necessary. Fortunately photography shares them both. Stieglitz,
however, for all his matchless accomplishments, will I think eventually
be regarded less as the North Star of photography and more as a
continental divide, an aesthetic watershed, on one slope the culmina-
tion of nineteenth century traditional photography and on the other
the first strong suggestion of what twentieth century photography is to
become. His position, and its significance in appraising Siskind's con-
tributions, may best be examined in the light of some historical events
of more than fifty years ago in which Stieglitz had a central role.

(The following account is sketched to cast light on the present, not
to scoff at decisions of the past. These we must defer to, since their
consequences always surround us. Must we also be reminded that
hindsight illuminates brilliantly but only the past?)

Having survived a green and footless sixty-one years of the nineteenth century, unwanted and unwed to any of the other arts, photography tried to enter the twentieth century art world in disguise consisting of a faint resemblance to etchings, engravings and chalk or charcoal drawings of some of the more familiar contemporary artists of Europe and America. In 1910 photography in this attractive motley again received generous recognition as an art form at the Albright Gallery in Buffalo, N.Y. What seemed at the time a monumental victory was but the prelude to a *coup de grâce* for misplaced ambition and misunderstood success. Instead of accolades, an avalanche impended, for which the masters of 1910 were totally unprepared. The wrong art had been imitated. Small exhibitions of work by Matisse, Cézanne, Rodin, African native sculptors and Picasso at Stieglitz's 291 and elsewhere were followed by the Armory Show in February 1913, which changed completely the public notion of how broad the face of art might be. Against the work of a Cézanne or Van Gogh and the even more exasperating departures from camera vision of Matisse and Picasso, camera imitations of Cassatt or Whistler or lesser artists of that day could no longer be viewed with unqualified complacency.

Though almost everyone was aware that photography now must *do* something, they were less certain *what* it should do. As always, the problem centered on what a photographer *ought* to do with an impulse to respond to some other art. Unfortunately, the solving of this problem took a degree of sophistication supplied to few photographers. Economic and aesthetic climates have done little to encourage photographers to resort to new visual forms, although some had been uncovered incidentally by certain scientists (for example, photomicroscopists, the discoverer of Roentgen rays, and the men who had used photography to analyze animal locomotion). Small wonder that many photographers had either meager or unexercised imaginations, or that their aspirations to make art brought them to the safe ground of accepted or conventional work. Nor did such experience give much help in answering the questions raised by the shocking new art introduced in the Armory Show. Was it *really* art? If it was, and photographs were art, why did the two look so strange together? Should, could, photographs be made that would bear any resemblance to these works? None of these questions could be easily or quickly answered. Stieglitz had said that photographs should be a "direct expression of today," and amplified this suggestion by expressing admiration for the "brutally direct" work of the young Paul Strand. As late as a decade after the Armory Show, Stieglitz wrote of his sky or cloud photographs: "I know exactly what I have photographed. I know

I have done something which has never been done . . ." No matter
how one might choose to interpret such Delphic utterances, two broad
courses lay open for photographers. They could study the new art for
structures that were adaptable to traditional photography and incor-
porate these into photographs made directly from nature. Or, by one
of several combinations of photographic and nonphotographic tech-
niques, they could create a synthetic imagery (more photo-pictures
than photographs) quite close in spirit to the new art, but a whole
world away from traditional photography.

In the circumstances, it is remarkable that any photographer
would consider either course. Photography, always a hand-me-down
of the arts, had won twentieth century recognition with a bet on art
that already had begun to look old fashioned. Must it now choose to
gamble its small prestige by trying to resemble art forms that had
aroused a storm of ridicule and rage in Europe and America? What
hardihood it must have taken to wager one's time and talent at such
odds. Yet some photographers did this; we have the photographs: early
Strand still lifes; Coburn's Vortographs; still lifes by the elder Weston,
of common household articles; by Bruguiere, of cut-out paper shapes;
and geometrical compositions by Steichen, of fruit and other objects.
All have an "artificial" look. After the War of 1914–1918, many artists
and photographers undertook work that rested on these same impulses:
photomontages by Max Ernst, John Heartfield. George Grosz and
Moholy-Nagy and a variety of work by a number of others in Dada,
Bauhaus or Surrealist ranks. Judged by their photographs, the tradi-
tionalists were a serious group, and this wild new work was hardly to
their taste. Most objectionable, however, was the tendency of the
"photomonteurs" to cut photographs into bits which were reassembled
in a totally new synthesis which could quite correctly be interpreted as
an attack on the traditional spatial structures of photography.

The remarkable document "Photo-Eye," edited by Franz Roh and
Jan Tschichold for the Film and Foto international exhibition in Stutt-
gart in 1929, shows the vigor with which these new images were pro-
duced.

(Roh's essay "Mechanism and Expression" in the same volume
gives the viewpoints of thirty-six to forty-five years ago that yielded
these synthetic photo-pictures. Although the translation printed here
is in awkward English, the ideas will reward any reader.)

Stieglitz did not take this road. Instead, with his customary vigor,
he enjoined photographers to believe in photography and avoid flim-
flam, trickery and any "ism." He then set out to revitalize traditional
photography, and succeeded so well that he made it look more like a

new style than an old one. For those who followed him, not only was photography dragged clear out of the quicksand of imitation, but many photographers were also persuaded that a camera picture should look only like an object a camera has been pointed at. Stieglitz did not mean this; certainly his concern for contemporary aesthetic theory and his concept of equivalents bear this out, but the impression held. He also, perhaps unintentionally, appeared to support the idea that great photographs should look a good deal like nineteenth century photographs, except that the tones should be black and modulated more subtly. But most importantly, his consummate skill with structures derived from twentieth century painting elevated photography's capacity for depiction (for producing impressive descriptive illusion of an object or scene) to a high art. For this unequaled accomplishment, traditional photography is ever in his debt, and all traditional photographers who came after him have had to walk in his gigantic shadow.

Unfortunately an equally important problem remained without solution: what resources of allusion were available to traditional photography? As is true in other arts, in photography descriptive illusion is to a great extent antagonistic to allusion (that is, a reference to some object or meaning not clearly pictured). The makers of synthetic photo-pictures lacked almost all access to descriptive illusion as a unified effect, which was the great strength of traditional photography. They did have, however, an endless capacity and means for inventing allusions. The traditionalists in photography, on the other hand, rejecting utterly the resources of the makers of synthetic photo-pictures, commanded an inexhaustible supply of descriptive illusion. These two resources must be satisfactorily reconciled before photography could be used effectively as a twentieth century art. For traditional photography, which had been too mechanical, crude and truthful to fit nineteeth century art standards, would find itself too heavily burdened with descriptive illusion and too lacking in a capacity for allusion to qualify for the twentieth century. This problem was coming over more clearly into view when, in 1937, Stieglitz for the last time laid aside his camera.

With his technical virtuosity, and the energy of his younger days, Stieglitz might have provided adequate solutions. As it was, the task fell to others, among them Aaron Siskind. From the early 1940's on, Siskind has addressed himself to the central problems of traditional photography still left unsolved. At first perhaps naively, but soon with the skill and uncanny sense of what is necessary and correct that always marks the indispensable pioneer, Siskind proceeded to provide the missing answers for which photographers, many of them without realizing it, had been waiting.

Noting that descriptive illusionistic detail, when redundant or over-precise, tends to cancel out both the strength and mystery of a figurative art, Siskind resorted to neglected methods within the scope of straightforward traditional photographic technique to restore the necessary balance between what the camera pictures and what the photographer feels. Using carefully composed details from nature, he placed descriptive illusion completely at the service of lively new figures rich with contemporary meaning.

As he continued working, Siskind also realized the exceptional clumsiness with which earlier photographers had handled allusions to the other arts. They had tried numerous devices: the directed subject clothed or unclothed, the simulated exotic costume, the simulated setting or predicament, and imitation of another way of marking, as with chalk or pencil. Based on such work, any injunction not to be influenced by the arts of painting and drawing was likely to be a doctrine less of wisdom than of despair.

Yet allusion has a peculiar power that need not be abandoned. Harold Rosenberg, in his book on Arshile Gorky, writes ". . . art as resurrection of art gave prominence to three formal principles: allusion, parody, quotation. Of these, the first is the most profound, the true ghostly principle of historical revival, since by allusion the thing alluded to is both there and not there . . . Allusion is the basis upon which painting could, step by step, dispense with depiction without loss of meaning: on the contrary, depiction as was already well realized in the nineteenth century, could be an obstacle to communication of the artists' meaning, besides having its age-old mystery extracted by the camera. . . ."

Siskind faced up to another central problem for photography at this point: how to strike a balance between depiction, which as Rosenberg indicates had become the *assigned* task of the photograph, and allusion through which the shapes of art and nature were now capable of generating new meanings. Siskind's masterly stroke was to demonstrate, well within the limits of traditional photographic means, that what had been seen, even by a perceptive critic, only as opposing forces could be reconciled and used in photography to support one another. It thus became possible for the photographer who so desired, to place the full power of descriptive illusion (which had always been the chief public virtue of the photograph) at the service of allusion. This permitted the use of visual figures in ways analogous to the metaphors of language. As for his own work, unlike his less fortunate predecessors who had chosen to imitate the appearance of art and not its impulse, Siskind, straightforward as always, chose to base his work on an inner impulse in complete harmony with the feelings and outlook

of the artists whom he knew so intimately in New York from the 1940's on. This impulse guided his eye, where many who preceded him in the years up to 1918 or thereabouts had preferred to let the eye and accepted taste control the impulse. Siskind, by his method, achieved a coincidence of image and feeling with only the simplest of technical means.

Equally important, Siskind found ways of alluding to a wide range of human experience. He did this by concentrating on the evocative forms and shapes and textures that carry for the human mind a host of inescapable associations. Thus, the event or meaning is "both there and not there" as Rosenberg puts it. By abandoning depiction in its usual form, Siskind thus gains all the powers of suggestion. In this way he can exploit the objects of parody and quotation as well as allusion that abound in the ragtag-bobtail world of what has been worn out, lost, abandoned or misused. Here he found a host of emblems and symbols for twentieth century mankind. In a brief commentary on one of his photographs, Siskind has written: "It makes no difference what the subject matter is. The idea, the statement, is the only thing that counts . . . I care only for people—I'm interested only in human destiny. It just happens that I work symbolically—not directly with people as subjects . . . Perhaps it is that the forms, the shapes (in signs) communicate more, and are more important than what was originally said on them."

Time after time he succeeds in making the part stand for the entire event or object; the likeness of unlike objects is demonstrated with unequivocal force, the mystery of light and dark enlivens the eye and remains to haunt the mind, and the awesome forces of nature that in every instance conspire to put man in his place parade into view on surfaces where time and change have worked their surgery.

He has shown many ingenious ways to restrain the destructive tendencies of descriptive illusion, which has been a notorious destroyer of metaphorical figures in photography. Using the devices of emphasis by tone, scale or repetition and then concentrating on unexpected detail in a context for which no one else's photographs fully prepare us, Siskind adds a constant stream of figures to replace those being worn out by the same means in the general run of photographs. We also see that Siskind has provided photography with a proper means of escape from every unreasonable restraint imposed upon it. Nineteenth century space had been forced on photography by the lenses of Paul Rudolph and his peers. Siskind exploited the detail-bearing aspect of these lenses of another day, by simply eliminating the three dimensional subject and concentrating on tone and shape and a nearly flat

surface. (Hess's essay gives a superb description of this accomplishment.)

He has also demonstrated some of the ways by which the photographer may restore to traditional tonal scales the force of metaphor by exaggeration and selective emphasis. In view of all this it is not too difficult to recognize that Siskind to a large degree has been responsible for bringing photography into the twentieth century.

Whatever claims may be made for others, and there are many that can be made justly, there is available at present no comparable body of work that has addressed these problems for so long with equal attention and competence and has produced new figures so rich and various. Siskind, whose pictures embrace the concepts of reconciliation and ecological equilibrium, has discovered some of the most important means by which the traditional conventions of the camera are brought into harmony with the symbolic and pictorial needs of the present.

Of course, discoveries of this magnitude are seldom the result of an entirely rational plan. Rather, as Henry James stated, they ". . . are like those of the navigator, the chemist, the biologist, scarce more than alert recognitions. He *comes upon* the interesting thing as Columbus came upon the Isle of San Salvador, because he had moved in the right direction for it—also because he knew, with the encounter, what 'making land' then and there represented. Nature has so placed it to his profit . . . by his fine unrest. . . ."

Within a span of twelve months, the microcosm of a "picture making experience" at Gloucester in the summer of 1944 became Aaron Siskind's San Salvador. The previous summer in Martha's Vineyard he began to work on the flat plane with organic objects in geometric settings. Every day he would go out with his old familiar equipment, all of which was relatively simple. He would spend the morning exposing six films on a variety of subjects and at noon when he was finished, although he had not consciously been aware of any immense effort, he would sit down to lunch exhausted. Thus was spent the entire season.

The following summer he returned to Gloucester, only this time fresh from a task of photographing a collection of pre-Columbian sculpture for a New York exhibition. Haunted by the force of these simple shapes and rugged surfaces, Siskind found the rocks providing echoes of the sculpture. This came as revelation to a photographer who had been looking for a form as meaningful as the music he loved and the poetry he had attempted. The rock was not denied, but the echo of the artifact was strong enough to hold its own form in the rock. Day after day, impelled by this sense of discovery he returned to the subjects of the previous summer only to find they were providing him with new

material. In a literal sense, his vision had been shaped by the art he had attended so closely as a photographer during the winter. He was seeing with new eyes. What he found that summer in Gloucester in the early 1940's provided firm direction for his future work. This account demonstrates the falseness of the injunction that photography is an art so unique and special that interchanges with the other arts are never to photography's advantage and must be avoided at any cost.

In this instance an overwhelming body of art work had provided him with a symbol system that completely reorganized his own vision and started him on the mature phase of his career . . .

Siskind's program cannot be matched for exploration and expansion of the photographic possibilities remaining to the traditionalist. The traditional nature of his method must be emphasized because his work contains so much material that is rich and new that anyone who first encounters it may see very few connections between it and the work of Stieglitz and his direct aesthetic descendants. Yet there are several and some of them are important. Siskind has adhered strictly, almost totally, to the most rigid conventions laid down by the masters who set the style for twentieth century traditional photography: the use of a relatively large, firmly supported camera and a sharp lens; and the found object untouched, shown as it is found, where it is found. His distortions of this prescription are generally simple and available to all photographers.

By staying technically within the strictest limits of traditional photography, Siskind has demonstrated that descriptive illusion may be diverted from its age-old task in photography, where it has been slayer of metaphors. Under his guidance it has become instead foster father to a host of new figures that may yet assume all the functions of a language of the spirit.

Brassai

Picasso and Company
Translated by Francis Price

1966
AN EXCERPT

Brassai (Gyula Halász, b. 1899) and Picasso were friends, and some of the *clichés verres* Brassai produced owe a debt to Picasso's style. Picasso admired Brassai's draftsmanship. Whether art turned to abstraction under the impetus of photography is a profound question. Renoir remarked some years before Picasso that photography had saved art from the tedium of depicting the corner grocer.

. . . .

PICASSO: When you see what you express through photography, you realize all the things that can no longer be the objective of painting. Why should the artist persist in treating subjects that can be established so clearly with the lens of a camera? It would be absurd, wouldn't it? Photography has arrived at a point where it is capable of liberating painting from all literature, from the anecdote, and even from the subject. In any case, a certain aspect of the subject now belongs to the domain of photography. So shouldn't painters profit from their newly acquired liberty, and make use of it to do other things?

. . . .

Paul Hill and Thomas Cooper

Interview with W. Eugene Smith
1977

AN EXCERPT

Gene Smith (1918–1978) was a conscientious photojournalist who would study his subject for as much as several weeks before beginning to photograph. He also insisted on control over captions and layouts to preserve the intention of his essays. This insistence caused more than a little friction with his editors; Smith resigned from *Life* not once but twice. He was seriously wounded covering World War II and years later badly hurt in an attack made while he was exposing the effects of mercury poisoning on a Japanese fishing village. Paul Hill and Thomas Cooper are photographers who for some years have conducted interviews for *Camera* magazine.

How did photography become interesting to you?
Oddly enough, I started out wanting to be an aircraft designer, because the fascination of the sky and flying is something that intrigued me very much. I still have that love of the sky—not in an airliner, but in a small plane, a soaring plane when there's just me and the elements. I was living in Wichita, Kansas, and there was a lot of aviation activity there. I started trying to talk news photographers in the city into giving me prints of the planes they photographed in national races and time trials. I hounded one local news photographer not just to give me photographs but to let me go along with him on assignments—espe-

cially those that involved aircraft. In a short time I had purchased a camera from him, and finally I became more interested in photography than in becoming an aircraft designer, which is to the benefit of the aviation world, because my supersonic plane probably would have been noisier than the Concorde! Within six months I was taking pictures for the local paper.

How old were you then?

. . . Fourteen.

You have said that literature, music, and philosophy were perhaps your greatest influences. At what point did you become involved with these studies?

When I was about ten years old I started reading serious books. I had been in an accident and they said that I would never walk again. I had to spend six months in bed and I read about fifteen volumes of history. This had much to do with my early thinking and, perhaps, early seriousness. The other thing that affected me a great deal when I was growing up was seeing my family go down in the Kansas Dust Bowl period. I photographed the Dust Bowl at that time. I also photographed sports, which gave me a sense of timing that still comes in handy. But I think my involvement with humanity, seriousness, and compassion began back in those early days. I matured very quickly.

Were there any photographers . . . who affected you?

The only photography I really knew was news photography, and a lot of that was dull or sensational. It wasn't until I was around seventeen that I saw some photographs by a Hungarian photographer named Martin Munkacsi. His name doesn't mean much to people now, which is too bad. For the first time I realized how tremendously deep, rhythmic, and powerful photography could be. It was this simple revelation by Munkacsi—that photography offered a great deal more than I had seen—that affected me greatly.

. . . .

. . . My family dealt in grain, and we were destroyed. We lost everything we had, and my father committed suicide. I was photographing for the paper that reported his death, and they distorted his suicide to the point where I felt that I just couldn't work in such a profession. When I read the stories, I swore that I could not continue in journalism, but then somebody pointed out a very simple, even a cliché, truth —a profession is not intrinsically honest, but the people who practice the profession can be. I've tried to follow that. It's one of the reasons why I'm so temperamental.

Why did you destroy all your early work?

I thought it wasn't any good.

. . . .

What date was this?

1936, the year following the year that *Life* was first published I was fired from *Newsweek* because I insisted on using a 2¼ instead of a 4 x 5. But that was fortunate because I went to work for *Life*.

Didn't you receive a photojournalism scholarship to Notre Dame University?

It was not a photojournalism scholarship. I had been in journalism at Notre Dame, but they simply created a photographic scholarship for me, the only one of its kind.

What made you leave college?

They wouldn't give me enough freedom to photograph as I thought I should in those days. Also, I had to be in by eleven o'clock every night; and sometimes to do a proper job of photography—the Senior Prom, for instance—I would have to go on until at least one o'clock. So I would be forbidden to leave the campus and punished for trying to do a good job!

· · · ·

Do you believe there is a distinction between photojournalism and documentary photography?

No. I think photojournalism is documentary photography with a purpose. I think the only thing wrong with the word "documentary" is that it can give some people the idea that you can make absolutely dull pictures of the *ingredients* of something instead of the *heart* of something.

What exactly did you do at Life? *How did they react to your work?*

They had me do a lot of theatrical photographs, which I enjoyed, because I was interested in the theater. I think it was also good training, and I still like to do it occasionally. But the thing I couldn't stand was "*Life* Goes to a Party" and things like that. Actually, I joined *Life* the day they ran out of other photographers because Bourke-White, Carl Mydans, and their other aces were running around the world with the U.S. Fleet. Finally, they were at the bottom of the barrel, and they said: "We're just going to have to send that nineteen-year-old out." And eventually, I ended up with a cover and many pages on the inside.

· · · ·

. . . I resigned from *Life* when I was twenty-one. I became disturbed and fed up with assignments such as "Sadie Hawkins' day" and the "Butlers' Ball," things like that. So I wrote a long letter to the picture editor of *Life* saying what I wanted out of photography and what I believed in. He wrote back, saying that he, too, once wanted to write the Great American Novel! My contract was coming up for renewal and he asked me whether I was going to renew, and I said: "I'm sorry but I'm not willing to renew the contract." . . .

· · · ·

I had made a mistake by resigning. I didn't know the war was going to happen. *Life* was really the only outfit to work for if you covered a war. They had the greatest freedom, the greatest power, and the best expense accounts!

Steichen tried to get me into the naval unit that he had set up. But I had already been in a dynamite explosion, suffering some severe physical injuries, and my eyes were weak. These two things combined made the Navy turn me down. Steichen appealed, but the statement from the hierarchy was: "Although Eugene Smith appears to be a genius in his field, he does not measure up to naval standards." So Steichen managed to arrange with Ziff-Davis publications to send me out as a correspondent. When I came back, *Life* wanted to hire me again and I turned them down three times. I wanted to work for them on the basis that we were intelligent human beings trying to do the best job we could. This was the only way we could cooperate, but they weren't interested.

. . . .

You wrote that you felt the Japanese, as well as the Americans, were your brothers in your family.

Yes. My private thoughts were that I wanted to use my photographs to make an indictment against war. I hoped that I could do it so well that it might influence people in the future and deter other wars.

Do you think that was a little naïve?

Of course it was, but I still believe it. There are some things which you must attempt to do, even though you know you're going to fail. Sometimes, enough can be done in small ways. I know I, at least, changed the concentration camp into something better. Small things . . .

An American concentration camp?

An American concentration camp; only they called it a civilian stockade, which sounded nicer. The Navy had asked me to photograph it after I'd come back and was preparing for the next Pacific landing. They wanted me to photograph it so that *Life* would run a story about how wonderfully well we were treating those who surrendered to us. Then the Navy could drop the magazine on other islands, and on Japan itself, so that more people would surrender.

I said: "It's a terrible place, a stinking hell-hole."

And the admiral said: "I just had a report this morning that conditions are very good there."

So I said: "All right, I'll show you your concentration camp, your stockade." And I went out and I photographed with a great deal of anger, because there were six people dying for every one that should have. Fifteen thousand people had access to only one or two water

supplies. They had no plumbing facilities for daily needs. It was just a terrible mess, badly run by our own people. I brought the pictures back and the censors were furious.

Which censors?

The American Navy censors. For once, they became angry at the pictures and not at me. They took it to higher authorities, and the concentration camp was completely changed around. The officials were replaced. It never was a paradise, but at least they brought it up to the minimal standards of human decency.

Recently, when I went to Minamata, I was on television one morning and an ex-P.O.W. saw the show. Before the show had ended, he managed to make his way to the studio to publicly state that I'd saved his life. It was truly rewarding. It's at times like that that I realize the power to activate people that photographs truly have.

During the two years that you were recuperating from war injuries, you didn't photograph. What did you do during that time?

I had thirty-two operations on my mouth and nose alone. The shell had entered my head over the roof of my mouth and nearly cut off my tongue and took all the bone structure out of it. Part of the shell is still lodged a fraction of an inch from my spine. I was also hit in the hand, arm, leg, and chest. I really didn't know whether I was ever going to be able to photograph again. My first thought when I was wounded was that I still had music. When I managed to get my eyes open (I didn't know my glasses had exploded into my face and that some glass had gone into my eye), I saw a blurred sky, and I said to myself that I still had photography. The third thing I thought was that I wanted to use a camera and photograph what was happening. Not because it was me, but because it was a picture that was important to me.

I tried to retain consciousness in order to write out instructions for someone to pick up my stashed film, but I couldn't see to write. Then I tried to take a sulphur pill, but I found I had several mouths and I couldn't swallow it.

What was the first photograph that you took after your recuperation?

I wanted to make a good photograph, but I was out of control. I just couldn't do it, and I did not know whether I would ever photograph again. Finally, I decided to try, but it was very difficult. My face was still pouring pus and it was draining into the camera and my nerves were . . . I was not only about to go through the ceiling but through the sky. I decided to try, anyway.

I got the whole family out of the house, except my two children. Then, I took them for a walk. I wanted it to be a good picture, to

contradict and contrast with my war pictures, the last photographs that I had taken. So I followed the children, and I saw them stepping into this space as they went along the path. I stopped and clumsily tried to focus, and as they stepped into the space, I made the photograph. I felt that it was fairly good.

How did you come to title it the way you did?

"The Walk to Paradise Garden?" Most people think it has a religious connotation, but it's as much a tribute to music as anything. There is an opera by Delius called *A Village Romeo and Juliet,* and one piece of the music is called "The Walk to Paradise Garden." I've left it with an ambiguous title so that anyone can take from it what they wish. But it's basically my tribute to music and to humanity, because I think it shows hope.

You've always been called a moralist with a camera—

No, I'm a compassionate cynic.

—but in this picture you seem to set up what becomes a constant duality in most of your work, the battle of dark versus light, and in it there is the actual release of the subject into the light.

You've said it all. I don't have to say anything.

Will you talk a bit about that?

I don't know how capable I am of talking exactly. In music I still prefer the minor key, and in printing I like the light coming from the dark. I like pictures that surmount the darkness, and many of my photographs are that way. It is the way that I *see* photographically. For practical reasons, I think it looks better that way in print, too.

. . . .

It seems from "The Country Doctor" essay that you began to put a stamp on the medium of magazine photojournalism that has never been erased, a way of seeing that nobody else had been brave enough to follow before. Was this a conscious attempt?

I learned it all from Beethoven.

. . . .

. . . . I went to midwife school and became a midwife. I asked the nurse who taught me if she could put up with me for six weeks, and she turned out to be the greatest human being that I have ever known, as far as having a useful and fulfilled life is concerned. In the back of my mind was the racial problem in the United States. Here I was, doing a story on a black, and a black had never before been the subject of a major serious essay in an American magazine.

There were three things about the midwife story that were important: its medical significance; the fact that it was a story of a great human being; and third, I was fighting racism without ever making

racism the point. I had long crusaded about racism, not by hitting people over the head with a hammer, but by compassionate understanding, presenting something that people could learn from, so they could make up their own minds.

How did you talk Life *into doing something that radical?*

They finally agreed to my doing the story. But then, as I often do, I more or less disappeared, because they didn't want me to spend so much time on a story. They had become used to this by now, but they never found it acceptable to let me take time and do a story the way I wanted to. Just before my "Country Doctor" piece, they put out a memo which stated: "Just as soon as we break the idealism out of Smith, we'll get more mileage out of him as a photographer." But, since "The Spanish Village" was one of their most successful stories, they more or less let me get away with doing "Midwife" my way. They thought they were running it as a prestige piece. They never expected it would have such a response.

. . . .

Is there a difference between the "picture story" and the "photo essay"?

I think a picture story is a portfolio put together by an editor, while an essay has to be thought out, with each picture in relationship to the others, the same way you would write an essay. Perhaps the writing of a play comes closer. You keep working out the relationships between the people, and you look back at the relationships you have established, and you see whether other relationships must be established or strengthened. There should be a coherence between the pictures which I don't think you find in the usual publication of a group of pictures which are called picture stories.

It has been said that "The Spanish Village" is the classic photo essay . . .

I think that "Midwife" is better. But the Spanish essay is more poetic perhaps.

. . . .

What was the goal you sought when working for mass-circulation magazines?

Magazines such as *Life* were the best vehicles for a photographer's work. Even if you didn't get as much in as you might have wished, it was the best chance of influencing people. When I went to Minamata, I found two people in this little village in Japan who had complete scrapbooks of my work. This is the kind of influence that I think is very important. A book cannot reach that number of people. It may last longer, but "The Country Doctor" has lasted from 1948 on. I think the world is much worse off because some of the fine, and not so fine, magazines have disappeared.

Around 1955 you joined Magnum. Why?

There were many photographers at Magnum who were friends of mine and who I had considerable respect for. I am also very stupid about handling contracts and dealing with people. I was starting to do the Pittsburgh story and the man I was involved with over the story was a very sharp person. I actually joined Magnum to get protection from him, but they were as foolish as I was. It turned into a rather disastrous situation. In short, the reason I left was that I wanted to stick to my ideals by refusing to work for publications unless I had the right to withdraw a story if it was being distorted. I also wanted to do the layouts—or certainly the work on them—although I never insisted that a magazine use my layout exactly. I would have compromised on some of the details, but not on the distortions of my story. And, as I understand it, some of these magazines were threatening Magnum by saying: "Well, if you can't control Smith, maybe we won't be able to use any Magnum photographers." I thought that I was a bad person for Magnum to have around. I didn't believe there was any reason why anybody else should suffer for my ideals, so I left.

· · · ·

There appears to be a humanitarian link between the way that you, Paul Strand, Cartier-Bresson, and Dorothea Lange photograph.

It's called romanticism.

In your great exhibition at the Jewish Museum in New York, in 1971, it seems you wanted the pictures to have the power of transcendence. Is that true?

That is a more pompous way than I would have put it.

How would you have put it?

I wanted those who saw the pictures to leave with an experience that carried them across the sidewalk and even into the taxicab. I don't know how many letters I got from the show but there were a great many. Some said they were thinking of suicide until they saw it.

What was the concept behind the show?

I was trying to state everything about life—both its cynicisms and its compassion. I wasn't interested in whether they came out of that saying: "Isn't Smith a great photographer." I didn't give a damn. I wanted them to come out emotionally stunned and moved so that they would think, and think in a good way. It was huge, and obviously there were too many pictures for everybody to see.

How big was it?

640 pictures. I not only wanted the individual pictures to stand up, I wanted them to go deep down inside. I can't stand these damn shows on museum walls with neat little frames, where you look at the images as if they were pieces of art. I want them to be pieces of life!

. . . .

Minamata is one of the most important works you have done. How did it come about?

When the Jewish Museum show went to Japan, some Japanese friends came over and asked me what I wanted to photograph, and I said I didn't know. I'd always thought of a fishing village and they had in their minds all the time that they wanted to entice me to Japan to do Minamata. They gave me a book on Minamata. In the early fifties, the Japanese fishing and farming village of Minamata was contaminated by industrial wastes expelled by the factory of the Chisso Corporation. Mercury poisoning, carried in the fish, reached epidemic proportions by 1956. I looked at the book and they talked to me about it, and I said: "Sure, I'll go."

The next day I was married, and I spent my honeymoon in Minamata. We rented a house and started meeting some of the victims. We'd talked to the company so that they could clearly get their side of the argument on record for us. We hoped to overcome all the resistance they had toward journalists who had come in. We slowly got to know the people before we started to photograph them intimately.

We photographed the fishing first, because we knew we needed fishing pictures and it was a safe subject—you didn't need to know the individuals involved intimately. But we began to know the people better and we ate their food. It was such an exciting time, and because I was not working for a magazine, I stayed as long as I wanted to. I didn't know where we were going to get money from, because we had none. However, we were limping along. It was very difficult. At times we were six thousand miles from home with only three dollars, wondering where the hell we were going to get money to go on. But the longer we stayed, the more we became neighbors and friends instead of journalists. This is the way to make your finest photographs.
. . . .

Did you set out to make a picture essay on it?

I was thinking in terms of a book, not so much of the smaller publications. Many of my photographs were used while the conflict was going on, many shows on prime-time television in Japan, and they were published in magazines, books, newspapers, etc. I think this is one of the reasons I was attacked. We were being so influential that they wanted to try to stop publication if they could. And it was one of their greatest mistakes, because I'm a kind of a folk hero in Japan for reasons I don't know. When I was attacked, many people in the nation rose up in real fury against the company. The people thought there must be something wrong with the company and they really turned

the feelings of the country toward the victims—much more than they had before.

How did the famous picture of the mother washing her daughter come about?

By that process of getting to know the individuals. We looked after the child at times when the parents were on protests. They lived about a ten-minute walk from our house. Every time we went by the house, we would see that someone was always caring for her. I would see the wonderful love that the mother gave. She was always cheerful, and the more I watched, the more it seemed to me that it was a summation of the most beautiful aspects of courage that people were showing in Minamata in fighting the company and the government. Now this is called romanticism. But it was the courage that I was interested in. Courage is romantic, too. I wanted somehow to symbolize the best, the strongest, element of Minamata.

One day, I said to Aileen, my wife, "Let's try to make that photograph." I imagined a picture in which a child was being held by the mother and the love was coming through. I went to the house, tried very clumsily to explain to the mother that I wanted to show a picture in which Tomoko was naked so we could see what had happened to her body. I wanted to show her caring for the child. And she said: "Yes, I'm just about to give Tomoko her bath. Maybe that will help you." She first held the child on the outside of the bath and washed her as the Japanese do; then she put her into the bath. And I could see the picture building into what I was trying to say. I found it emotionally moving, and I found it very difficult to photograph through my tears. However, I made that photograph. It's as romantic as could be.

Jerry N. Uelsmann

"Some Humanistic Considerations of Photography" 1971

AN EXCERPT

Jerry N. Uelsmann (b. 1934) studied with Minor White at the Rochester Institute of Technology. From White he would have heard a lot about the potential of photography to express emotion and spirit. The allusive qualities of Uelsmann's prints depend on their combination of images in a near Surreal manner. He says that he admires H. P. Robinson and O. G. Rejlander, whose combination prints are widely criticized today. He speaks of postvisualization, discovering the image in process, as opposed to Weston's and Adams's previsualization. Many artists have made collages from photographs, but Uelsmann's are seamless prints, the joining having been effected in the enlarger, and all the images are from his own photographs.

The following selection is excerpted from a speech which Jerry Uelsmann gave in Great Britain before The Royal Society, London.

Now I don't know how well known Minor White is in this country. He is a man of great spiritual content, perhaps a bit of a mystic, but there is a sense of presence and a sense of concern that he has about photography and about the camera as a kind of metamorphosing ma-

chine that was instilled in me as an undergraduate. I went on to Indiana University and did graduate work in photography which I understand is very difficult to do in this country. I could go into some of the difficulties of studying photography when I was a graduate student in photography. I must confess that, while not clearly stated, there was a media hierarchy: painting was somewhere at the top and photography was somewhere very near the bottom. In any case at Indiana I encountered Henry Holmes Smith, a man who challenged me in ways that caused me to venture into the deep water and hopefully into myself. Immediately after graduate school I went to the University of Florida where I have been teaching photography for the past eleven years.

One of my concerns as a teacher of photography is with some of the humanistic implications of the medium and I am very much involved now with the kind of photography course that emphasizes the humanistic experiences, the way in which the camera provides an opportunity for people to relate to the world and to themselves. I base a lot of my teaching on these attitudes.
. . . .

AMERICAN FOLKLORE

During my last semester at Indiana University I had some free time so I took a course in American folklore. Now folklore is an unusual subject in America but I think a very popular one over here. I was very much excited by it so when I first went to Florida—which was my first trip to the South—I began collecting both with a camera and with a tape recorder. The significance of some of my photographs of that time as far as I am concerned is that they represented one of the dominant aesthetics that has operated in serious photography since, perhaps, the forties or late thirties. It is perhaps best exemplified by the French photographer Cartier-Bresson, namely the whole decisive selecting of a fragment of life in flux, the way in which the camera can preserve that moment and allow us to study it in ways which we could not do otherwise. I was very much excited by the work of Cartier-Bresson and I did for a period of time work with a small camera. When I was a student of Minor White's, he used to have a dictum that went "One should photograph objects, not only for what they are but for what else they are." We were concerned with the kind of metamorphosis that photography could allow, that while literally a photograph might show a broken balustrade, a fragment of an old building, the shapes themselves were very anthropomorphic, they were very human, there were

other qualities that the image had that transcended the literal subject matter.

These early photographs of mine were done in what is now known as the "straight tradition." I think most of you who are photographers realize what I mean by that. The "straight tradition" implies that the image is basically fully conceived at the camera; when one proceeds into the darkroom one gets involved with the craftsman who brings the initial idea into being. I have found that my own photography has questioned me in ways that have allowed me to grow. I once came upon a Civil War tombstone in a small cemetery. The light was dramatically breaking across the plain. I was very moved. I made one photograph and then for reasons which I honestly cannot personally explain, I picked up a tiny flower and in my own private ritual wedged it next to the soldier's gun. That was important to me in that it was the first time that I had in any way imposed myself upon the subject matter.

I am very concerned as a teacher that we develop attitudes that allow for freeing purposes, that expand the concepts of the spirit, that expand the concepts of photography. If one accepts the fact that you can impose yourself on subject matter then perhaps you can literally create subject matter. This is a technique that is similar to the assemblage in art, where things are brought together, in this case solely for the purpose of the photograph.

DEVELOPING AN AESTHETIC

About this time I became interested in working with the technique known as the "negative sandwich." Most photographers know this is not an edible thing but is simply placing two negatives on top of each other in the enlarger. The effect is very much similar to that of double exposure, with the exception that by negative sandwich techniques you can bring together negatives taken at far different times.

Something that happened to me that I think is of particular importance to those of you who are students of photography is that I slowly began developing an aesthetic. This was not happening at a conscious level and this, I think, is very important. I became interested in creating literally a visual metaphor. Aesthetics dominated my way of working. I didn't think this all out until afterwards when I began to look at my work and talk about it.

At the same time as I was working this way, I made an image which was a seed image that questioned me. I liked the photograph

very much and I began to ask myself what I liked most about it. It seemed to me that the thing that was most appealing to me was the fluctuating space, the duality of the space, the way in which the image could be read at two different levels—that was the exciting thing.

This challenged the whole concept of the neatly resolved metamorphose-type image. It freed me in simple terms. From then on I began to work with some ideas exploring this near-far kind of spatial relationship. I have also been very much concerned with the figure in relation to nature. I was born and raised in a very urban industrial area in Detroit, Michigan, and being in the South for the first time in an area that is very wooded, I began to develop attitudes towards nature that I had never felt before. Many of these images I think have a sort of earth-type quality, have a genesis quality, and hopefully for me they somehow translate some of my responses to the environment that I was encountering.

I once made a print of another seed-type photograph: it was difficult to make. When I had finished it I was discouraged—I didn't like it. I continued to wash the print and I let it dry and it sat on my desk and every week I'd sort of glance at it and I found myself falling back in love with the image. Finally I really liked it so I asked myself why had I initially rejected it? My conclusion was that I was as much affected by our popular picture-magazine culture as anyone else. I'm used to flipping through an issue of *Life* magazine in ten minutes before a business appointment or before a haircut—when I used to get one! In any case, this image was not of that kind—it was not easily readable. It was a difficult to comprehend image. It was a complex photograph, so I began to question this notion of complexity. Had we had complex photographs? I spent some brief time this morning looking at the magnificent Rejlander "Two Ways of Life" in the Collection of The Royal Photographic Society. This is an amazing image in that it is so intricately complex yet so infinitely resolved; a beautiful testament to this man's ability to conceive of an image, perhaps in a theatrical kind of setting, but one seen in the context of its time that is truly magnificent. I have since explored the notion of the complex photograph—hopefully not complexity for complexity's sake. . . .

One of my more important photographs is titled "Room No. 1." It happened in 1963. I hesitate to use such words—I just said it happened and then I caught myself saying it. Sometimes I see myself more or less as an image midwife. I think there are ways in which you sort of create conditions for things to happen. This particular photograph puzzles me in a way, and I am excited about it. It seems to me that there is a renewed effort in art today to restore mystery, to restore

enigma. I like this photograph because it is one that engages the viewer. I think of many of my photographs as being obviously symbolic but not symbolically obvious. There isn't any specific correlation between the symbols in this image and any content that I have in mind.

INVENTIVE CONSCIOUSNESS

Most of what is happening in modern art today directs itself beyond the perceptual consciousness. It is a matter of not just looking at what we see. We get involved with what I like to call the inventive consciousness, where you engage yourself, you participate as a viewer. You are given the option of viewing or not but I think that the reward is greater if you do.

In "Simultaneous Intimations" the same figure is seen in positive as in a previous photograph is used in negative. The day I began to work on this particular photograph I started with the assumption that in photography as with all other media we begin with a blank piece of paper. The piece of paper is white. I began adding first the negative head, then the out-of-focus figure, then this tiny little organic thing that comes out of a palm tree on the right side. I had got that far and I was disturbed with the way in which these three elements floated in this white space and I went to the refrigerator to get something to drink and there was a head of lettuce there, and for reasons which I can't explain I tore off a leaf of the lettuce, put it between two pieces of glass and used it as a negative. So the organic material which unifies these elements is literally a piece of lettuce. Now after one or two prints I began to become aware of the beam that runs out of the eye which is the central organ for anyone involved in the arts. The disadvantage of this of course was that after I had made six or seven prints the lettuce leaf started doing its own thing. I suppose a slight advantage is that when you've done you can eat the negative.

I must admit I have critics. However in America today I have fewer critics than ever before. They used to divide themselves into two schools. One group of critics said I was too literal: this is a criticism I never particularly understood. The other said that I was not photographic: that upset me a great deal because it seemed to me that if anything I was hyper-photographic. The out-of-focus image is a photographic phenomenon. The negative image is a photographic phenomenon. The multiple exposure is a natural aspect of photography. A lot of these phenomena have been more effectively exploited by people in other media but they belong naturally to photography and in my opinion should be very much a part of every photographer's vocabulary.

My first effort to define some of my attitudes towards photography was in a paper published in 1966 called "Post-Visualization." As you may know the dominant aesthetic in photography has been called pre-visualization. This means that the image is essentially fully previsioned at the time the shutter is clicked. Now I propose that photographers keep themselves open to in-process discovery. Another of my photographs is simply titled "Strawberry Day." I have a thing about strawberries—I really love strawberries. Where I live in Florida they are grown and there is a certain season and in the season I eat them regularly. They are a magic thing for me. I can't understand exactly why I like them better than most other fruits. The only thing I've been able to conclude is that, unlike most fruits that hide the seeds inside, the daring strawberry has them all over the outside. But I do love strawberries.

This is titled "Quest of Continual Becoming." Now that's a Jungian title. There is a psychologist in the States who has written a very lengthy complex article on my work and one that I must confess is difficult for me to read. He is very concerned with what are known as archetypal images—kinds of images that man has created since man has created images, and he sees some of my images very much as Earth Mother kind of images. Symmetry, it seems to me, is something that has been thought of as relatively dull until recently: the now generation, with its psychedelic art concerns, has shown us that once again symmetry can be quite exciting. And in photography, certainly, symmetry is the unanticipated, it is the unexpected image.

IN-PROCESS DISCOVERY

I mentioned previously, briefly, my post-visualization concerns. It seems to me that all other areas of art allow for in-process discovery. The painter does not begin with a fully-conceived canvas, the sculptor with a fully-conceived piece. They allow for a dialogue to evolve, to develop, and as far as I'm concerned the darkroom is truly capable of being a visual research laboratory, a place for discovery, observation and meditation.

The bottom portion of one of my photographs is literally a tiny leaf that has been eaten away by some small bug. I have a box behind my desk at home and on it is written "Found Negatives." Now found negatives are not negatives left behind by the students; they are anything that light can pass through. If I had to define photography I would simply say "Photography is the use of light-sensitive material." This image also reminds me of a statement that is usually attributed to

the painter Paul Klee, that the microcosm reflects the macrocosm, that in the smallest growing form one can find evidence of all growing forms. It seems to me that we are involved today in a very exciting way in a constant redefinition of photography. Such exhibits as have occurred at the Museum of Modern Art in New York, such as "Photography as Printmaking," "Photography as Sculpture" have expanded very much our concept of what the medium is capable of being. . . .

At one point I had a hang-up about using the same negative several times: was this ethical to do? And at the same time as this happened, I came upon a book by Picasso which had infinite variations on a theme, a tremendous variety, and this freed me in a way, it allowed me to use negatives time and time again.

Another of my photographs is simply titled "Rock Tree" and it shows the tree which is almost my favourite tree. I used to call it a banyan tree when I discovered it in Sarasota, Florida, but an old man who had lived there all his life once said "That's a strangler fig" so I may have been misinforming my public. But it interested me when he said that; I began to think about the extent to which we place knowledge into verbal form; that like knowing the name of that tree correctly was very important. Yet somehow I felt I knew that tree. I knew that tree in visual ways, I knew it in non-verbal ways and that was a form of knowledge too. In another photograph you see the same tree essentially inverted. Now a lot of these simple little acts of inversion are ones that were very difficult for me to come by because I'm very much influenced. We are given attitudes—as a matter of fact one of the things I think is most wrong with our university system is that attitudes are given to students in such a way as they assume that they have thought them up themselves. You will find many students with very similar thoughts—all feeling that they are very individual in their attitudes. It is keeping one's mind open to possibilities that is the exciting aspect of life. The visual concept of the tree being inverted I could not have done until a few years ago.

I haven't spent much time talking about technique. I do in the States travel around and give demonstrations. If you are interested in symmetry it is advisable to take two negatives at the same time with your camera on a tripod. You then have two different enlargers and one negative is put in each enlarger, the first negative emulsion side up, the second emulsion side down, and they are blended together. You can't know what it is going to look like until you get in the darkroom and try it. I find it very exciting.

Maybe very briefly we can talk about "reality." It seems to me that as we come into the 20th century from the 19th century several

important changes occur. One is we essentially move from what is outer directive art to inner directive art, from art that is essentially promoting the ideas and attitudes of the culture of society to art that is very individual and is very personal. Concomitant with this we find in the 20th century that the artist can no longer accept what is literally given to be art. There is somehow the belief that he can recreate a more meaningful, a more personal kind of reality. I align very strongly with these attitudes.

COMMUNICATION

Some of my photographs I don't understand. This disturbs some people. I would like to think that today we are sophisticated enough to realize that first of all there are systems of knowledge which are not necessarily verbal. There are levels of consciousness that we can engage ourselves in when we are encountering the world of photography that are not easy to talk about. I think this happens to all of us, I think many times we are pressured into a verbalization of things that we don't fully understand but somehow the words are important. I made a discovery, which I am embarrassed to admit happened only about three years ago, that when I went to a museum with a friend—and the one that I go to most frequently is the Museum of Modern Art—as long as we were together we would say the most trivial things to each other, things like "Oh there's a Picasso," "There's a Klee." We would be flaunting a sort of naïve knowledge, and it occurred to me there was great pressure somehow to verbalize, to say "That's interesting, that's right"—this kind of thing. And so I have learned that when I go to a museum now I go alone to the things that I want to look at. I relate to them as best I can visually; sometimes there are things about them that I share verbally with people; sometimes there are things that I can't share. Certainly a lot of my images come out of my concern effectively to communicate with the world out there, with the few friends, the close friends, I have and also very much objectively communicate with myself.

One recent photograph disturbs me a great deal. Literally I know what's happening: there is a wave and an organic form that was washed up on the beach after a hurricane two years ago. (We have a hurricane season in Florida.) But there is some strange thing happening, some strange statement within that I am in no way capable of articulating. I think the sooner that we as photographers become aware of this phenomenon that we can perhaps address each other visually at times, I

think the happier we'll all be, because so many times I am pressed to have verbal responses to things that I can't defend verbally.

Certain variations in an image can occur only after you are involved in the process, only after something begins to happen. I have a lot of students who like to talk about images and I get very concerned. I am anxious to talk about images but I am also anxious to see images and it seems to me that there are certain conditions which allow for things to happen and if I'm going to have things happen I have to be in the darkroom. I like a kind of time break-down that happens to you. If you look very closely at one particular photograph of mine the children in it are in two different positions. They were gathering coquina, a very tiny shellfish from the beach, which you can boil and make a mild soup from. Because the same children are in two different positions in the same photograph you have a destruction of the traditional time-space concept in photography that something happened at a given time at a given place in front of the camera. And this sort of bridge between perhaps a cinematic experience and a still photograph excites me.
· · · ·

PHOTOGRAPHY IS ALCHEMY

In conclusion I want to discuss some of my attitudes toward the dark-room and toward light. I mentioned my post-visualization theory. In this next group of slides you can see how an image evolved. I began by taking a roll of film of one of my graduate students in relation to some trees. At a later date, looking at the proof sheets, it occurred to me that they could be blended together in a particular image. Then this occurred in the development; believe me, photography is alchemy, it is magic—that moment when that thing comes up in the developer—that is truly magic. The thrill of that moment is as intense now as it was the very first time. After this occurred another version occurred. In the second version actually all three figures across the top occurred in the bottom in negative. I was disturbed by the perfect symmetry so I took the light—and that's what photography's about—and darkened out the central figure to make a slight asymmetrical element. This was in essence the third version. In the fourth version the figures were once again introduced on the top and resolved the quality of the negative image on the bottom. This is titled, by the way, "Small woods where I met myself." I began working on this at about ten in the morning; it was about ten in the evening that I was home free. That's the best example I can give you of the kind of in-process discovery that can happen.

I have only done one major commercial assignment in my life. It was done for Container Corporation of America which sponsors what are called "company image ads." I was to create an ad—and it was part of a series that dealt with the great ideas of western man—which somehow created a visual equivalent for a very beautiful William Faulkner quote. I was given complete freedom on this. The quote was the last paragraph of his Nobel Prize speech and it went "I believe that man will not merely endure, he will prevail. He is immortal, not because he alone among the creatures has an inexhaustible voice but because he has a soul, a spirit capable of compassion, sacrifice and endurance."

I am an incurable romantic, I believe in that quote, I believe in photography; I make no apologies for it—I think it is the most important graphic medium of our day and it is my way of relating to the world and to myself. Thank you.

Allan Sekula

"On the Invention of Photographic Meaning"
1975

Allan Sekula, a photographer and critic who teaches at the
University of California, here investigates the nature of pho-
tographic context and meaning. His analysis is clearly influ-
enced by the writings of Roland Barthes, as well as by a
desire to understand the political implications and the politi-
cal uses to which photography may be put. The split between
art and documentary that lies behind the recurrent question
"Is photography a fine art?" is here related to late nineteenth-
and early twentieth-century aesthetic philosophies, and it is
suggested that such philosophies can impose hidden interpre-
tations on photographers and their subjects.

The meaning of a photograph, like that of any other entity, is inevita-
bly subject to cultural definition. The task here is to define and engage
critically something we might call the "photographic discourse." A
discourse can be defined as an arena of information exchange, that is,
as a system of relations between parties engaged in communicative
activity. In a very important sense, the notion of discourse is a notion
of limits. That is, the overall discourse relation could be regarded as a
limiting function, one that establishes a bounded arena of shared ex-
pectations as to meaning. It is this limiting function that determines

the very possibility of meaning. To raise the issue of limits, of the closure effected from within any given discourse situation, is to situate oneself *outside*, in a fundamentally metracritical relation to the criticism sanctioned by the logic of the discourse.

Having defined discourse as a system of information exchange, I want to qualify the notion of exchange. All communication is, to a greater or lesser extent, tendentious: all messages are manifestations of interest. No critical model can ignore the fact that interests contend in the real world. We should from the start be wary of succumbing to the liberal-utopian notion of disinterested "academic" exchange of information. The overwhelming majority of messages sent into the "public domain" in advanced industrial society are spoken with the voice of anonymous authority and preclude the possibility of anything but affirmation. When we speak of the necessary agreement between parties engaged in communicative activity, we ought to beware of the suggestion of freely entered social contract. This qualification is necessary because the discussion that follows engages the photograph as a token of exchange both in the hermetic domain of high art and in the popular press. The latter institution is anything but neutral and anything but open to popular feedback.

With this notion of tendentiousness in mind, we can speak of a message as an embodiment of an argument. In other words, we can speak of a rhetorical function. A discourse, then, can be defined in rather formal terms as the set of relations governing the rhetoric of related utterances. The discourse is, in the most general sense, the context of the utterance, the conditions that constrain and support its meaning, that determine its semantic target.

This general definition implies, of course, that a photograph is an utterance of some sort, that it carries or is, a message. However, the definition also implies that the photograph is an "incomplete" utterance, a message that depends on some external matrix of conditions and presuppositions for its readability. That is, the meaning of any photographic message is necessarily context determined. We might formulate this position as follows: a photograph communicates by means of its association with some hidden, or implicit text; it is this text, or system of hidden linguistic proportions, that carries the photograph into the domain of readability. (I am using the word "text" rather loosely; we could imagine a discourse situation in which photographs were enveloped in spoken language alone. The word "text" is merely a suggestion of the weighty, institutional character of the semiotic system that lurks behind any given icon.)

Consider for the moment the establishment of a rudimentary dis-

course situation involving photographs. The anthropologist Melville Herskovits shows a Bush woman a snapshot of her son. She is unable to recognize any image until the details of the photograph are pointed out. Such an inability would seem to be the logical outcome of living in a culture that is unconcerned with the two-dimensional analogue mapping of three-dimensional "real" space, a culture without a realist compulsion. For this woman, the photograph is unmarked as a message, is a "nonmessage," until it is framed linguistically by the anthropologist. A metalinguistic proposition such as "This is a message," or, "This stands for your son," is necessary if the snapshot is to be read.

The Bush woman "learns to read" after learning first that a "reading" is an appropriate outcome of contemplating a piece of glossy paper.

Photographic "literacy" is learned. And yet, in the real world, the image itself appears "natural" and appropriate, appears to manifest an illusory independence from the matrix of suppositions that determines its readability. Nothing could be more natural than a newspaper photo, or, a man pulling a snapshot from his wallet and saying, "This is my dog." Quite regularly, we are informed that the photograph "has its own language," is "beyond speech," is a message of "universal significance"—in short, that photography is a universal and independent language or sign system. Implicit in this argument is the quasi-formalist notion that the photograph derives its semantic properties from conditions that reside within the image itself. But if we accept the fundamental premise that information is the outcome of a culturally determined relationship, then we can no longer ascribe an intrinsic or universal meaning to the photographic image.

But this particularly obstinate bit of bourgeois folklore—the claim for the intrinsic significance of the photograph—lies at the center of the established myth of photographic truth. Put simply, the photograph is seen as a re-presentation of nature itself, as an unmediated copy of the real world. The medium itself is considered transparent. The propositions carried through the medium are unbiased and therefore true. In nineteenth-century writings on photography we repeatedly encounter the notion of the unmediated agency of nature. Both the term "heliography" used by Samuel Morse and Fox Talbot's "pencil of nature" implicitly dismissed the human operator and argued for the direct agency of the sun. Morse described the daguerreotype in 1840 in these terms:

> . . . painted by Nature's self with a minuteness of detail, which the pencil of light in her hands alone can trace . . . —

they cannot be called copies of nature, but portions of nature herself.
(Quoted in Richard Rudisill, *Mirror Image: Influence of the Da-
guerreotype on American Society*, Albuquerque, p. 57, 1971.)

In the same year, Edgar Allan Poe argued in a similar vein:

> In truth the daguerreotype plate is infinitely more accurate
> than any painting by human hands. If we examine a work of
> ordinary art, by means of a powerful microscope, all traces of
> resemblance to nature will disappear—but the closest scru-
> tiny of the photographic drawing discloses only a more abso-
> lute truth, more perfect identity of aspect with the thing
> represented. (Rudisill, p. 57.)

The photograph is imagined to have a primitive core of meaning, de-
void of all cultural determination. It is this uninvested analogue that
Roland Barthes refers to as the denotative function of the photograph.
He distinguishes a second level of invested, culturally determined
meaning, a level of connotation. In the real world no such separation is
possible. Any meaningful encounter with a photograph must necessar-
ily occur at the level of connotation. The power of this folklore of pure
denotation is considerable. It elevates the photograph to the legal status
of document and testimonial. It generates a mythic aura of neutrality
around the image. But I have deliberately refused to separate the pho-
tograph from a notion of task. A photographic discourse is a system
within which the culture harnesses photographs to various representa-
tional tasks.
. . . .

The problem at hand is one of *sign emergence:* only by developing
a historical understanding of the emergence of photographic sign sys-
tems can we apprehend the truly *conventional* nature of photographic
communication. We need a historically grounded sociology of the
image, both in the valorized realm of high art and in the culture at
large. What follows is an attempt to define, in historical terms, the
relationship between photography and high art.

II

I'd like to consider two photographs, one made by Lewis Hine in 1905,
the other by Alfred Stieglitz in 1907. The Hine photo is captioned
Immigrants Going Down Gangplank, New York; the Stieglitz photo is titled
The Steerage. I'm going to assume a naive relation to these two photos,

forgetting for the moment the monumental reputation of the Stieglitz. If possible, I would extend my bogus ignorance to the limit, divesting both images of authorship and context, as though I and the photographs fell from the sky. I'm aspiring to a state of innocence, knowing full well that I'm bound to slip up. Regarded separately, each image seems to be most significantly marked by the passage of time. My initial inclination is to anchor each image temporally, somewhere within a decade. Already I'm incriminating myself. Viewed together, the two photographs seem to occupy a rather narrow iconographic terrain. Gangplanks and immigrants in middle-European dress figure significantly in both. In the Hine photo, a gangplank extends horizontally across the frame, angling outward, toward the camera. A man, almost a silhouette, appears ready to step up onto the gangplank. He carries a bundle, his body is almost halved by the right edge of the photo. Two women precede the man across the gangplank. Both are dressed in long skirts; the woman on the left, who is in the lead, carries a large suitcase. Given this information, it would be somewhat difficult to identify either the gangplank or the immigrant status of the three figures without the aid of the legend. In the Stieglitz photo, a gangplank, broken by the left border, extends across an open hold intersecting an upper deck. Both this upper deck and the one below are crowded with people: women in shawls, Slavic-looking women in black scarves holding babies, men in collarless shirts and worker's caps. Some of the people are sitting, some appear to be engaged in conversation. One man on the upper deck attracts my eye, perhaps because his boater hat is a highly reflective ellipse in a shadowy area, or perhaps because his hat seems atypical in this milieu. The overall impression is one of a crowded and impoverished seagoing domesticity. There is no need even to attempt a "comprehensive" reading at this level.

Although rather deadpan, this is hardly an innocent reading of the two photographs. I've constructed a scenario within which both images appear to occupy one end of a discourse situation in common, as though they were stills from the same movie, a documentary on immigration perhaps. But suppose I asserted the autonomy of each image instead. For the moment, I decide that both images are art and that a meaningful engagement with the two photographs will result in their placement, relative to each other, on some scale of "quality." Clearly, such a decision forces an investment in some theory of "quality photography"; already the possibility of anything approaching a neutral reading seems to have vanished.

Undeterred, I decide that quality in photography is a question of design, that the photograph is a figurative arrangement of tones in a

two-dimensional, bounded field. I find the Hine attractive (or unattrac-
tive) in its mindless straightforwardness, in the casual and repetitive
disposition of figures across the frame, in the suggestion of a single
vector. And I find the Stieglitz attractive (or unattractive) for its com-
plex array of converging and diverging lines, as though it were a pro-
found attempt at something that looked like Cubism. On the other
hand, suppose I decide that quality in photographic art resides in the
capacity for narrative. On what grounds do I establish a judgment of
narrative quality in relation to these two artifacts, the Hine and the
Stieglitz? I like/dislike, am moved/unmoved by the absolute banality of
the event suggested by the Hine; I like/dislike, am moved/unmoved by
the suggestion of epic squalor in the Stieglitz. The problem I am con-
fronted with is that every move I could possibly make within these
reading systems devolves almost immediately into a literary invention
with a trivial relation to the artifacts at hand. The image is appropriated
as the object of a secondary artwork, a literary artwork with the illusory
status of "criticism." Again, we find ourselves in the middle of a dis-
course situation that refuses to acknowledge its boundaries; photo-
graphs appear as messages in the void of nature. We are forced, finally,
to acknowledge what Barthes calls the "polysemic" character of the
photographic image, the existence of a "floating chain of significance,
underlying the signifier" (Roland Barthes, "Rhétorique de l'image,"
Communications, 4, 1964, p. 44). In other words, the photograph, as it
stands alone, presents merely the *possibility* of meaning. Only by its
embeddedness in a concrete discourse situation can the photograph
yield a clear semantic outcome. Any given photograph is conceivably
open to appropriation by a range of "texts," each new discourse situa-
tion generating its own set of messages. We see this happening repeat-
edly, the anonymously rendered flash-lit murder on the front page of
the *Daily News* is appropriated by The Museum of Modern Art as an
exemplary moment in the career of the primitive freelance genius Wee-
gee, Hine prints that originally appeared in social-work journals reap-
pear in a biographical treatment of his career as an artist only to
reappear in labor-union pamphlets. Furthermore, it is impossible even
to conceive of an *actual* photograph in a "free-state," unattached to a
system of validation and support, that is, to a discourse. Even the
invention of such a state, of a neutral ground, constitutes the establish-
ment of a discourse situation founded on a mythic idea of bourgeois
intellectual privilege, involving a kind of "tourist sensibility" directed
at the photograph. Such an invention, as we have already seen, is the
denial of invention, the denial of the critic's status as social actor.

How then are we to build a criticism that can account for the

differences or similarities in the semantic structures of the Hine and Stieglitz photographs? It seems that only by beginning to uncover the social and historical contexts of the two photographers can we begin to acquire an understanding of meaning as related to intention. The question to be answered is this: what, in the broadest sense, was the *original* rhetorical function of the Stieglitz and the Hine?

Stieglitz's *Steerage* first appeared in *Camera Work* in 1911. *Camera Work* was solely Stieglitz's invention and remained under his direct control for its entire 14-year history. It is useful to consider *Camera Work* as an artwork in its own right, as a sort of monumental container for smaller, subordinate works. In a profound sense, Stieglitz was a magazine artist; not unlike Hugh Hefner, he was able to shape an entire discourse situation. The covers of *Camera Work* framed avant-garde discourse, in the other arts as well as in photography, in the United States between 1903 and 1917, and whatever appeared between these covers passed through Stieglitz's hands. Few artists have been able to maintain such control over the context in which their work appeared.

Through *Camera Work* Stieglitz established a genre where there had been none: the magazine outlined the terms under which photography could be considered art, and stands as an implicit text, as scripture, behind every photograph that aspires to the status of high art. *Camera Work* treated the photograph as a central object of the discourse, while inventing, more thoroughly than any other source, the myth of the semantic autonomy of the photographic image. In this sense, *Camera Work* necessarily denied its own intrinsic role as text, in the valorization of the photograph.

Seen as a monumental framing device, *Camera Work* can be dissected into a number of subordinate ploys: one of the most obvious is the physical manner in which photographs were presented within the magazine. The reproductions themselves were quite elegant; it has been claimed that they often were tonally superior to the originals. Stieglitz tipped in the gravures himself. Each image was printed on extremely fragile tissue; the viewer could see the print only by carefully separating the two blank sheets of heavier paper that protected it. One of these sheets provided a backing for the otherwise translucent image. The gravures were often toned, usually in sepias but occasionally in violets, blues, or greens. No more than a dozen or so prints were included in any one issue of the magazine, and these were usually distributed in groupings of three or four throughout the text. No titles or legends were included with the images; instead they were printed on a separate page prefacing each section of photographs.

The point quite simply is this: the photographs in *Camera Work* are marked as precious objects, as products of extraordinary craftsmanship. The very title *Camera Work* connotes craftsmanship. This may seem like a trivial assertion when viewed from a contemporary vantage point—we are by now quite used to "artful" reproductions of photographs. But it was *Camera Work* that established the tradition of elegance in photographic reproduction; here again is a clear instance of sign emergence. For the first time the photographic reproduction signifies an intrinsic value, a value that resides in its immediate physical nature, its "craftedness." The issue is not trivial; consider the evolving relationship between craftsmanship and the large-scale industrial reproduction of images in the nineteenth and early twentieth centuries. With the invention of the ruled cross-line halftone screen in the late 1880s, photographs became accessible to offset printing, allowing rapid mechanical reproduction of photographic copy. *Camera Work*'s 14-year history parallels the proliferation of cheap photographic reproductions in the "mass" media. By 1910 "degraded" but informative reproductions appeared in almost every illustrated newspaper, magazine, and journal. Given this context, *Camera Work* stands as an almost Pre-Raphaelite celebration of craft in the teeth of industrialism. In a technological sense, the most significant feature of the photograph is its reproducibility; the status of the photograph as "unique object" had an early demise with Talbot's invention of a positive-negative process. And yet the discourse situation established around the unique image in *Camera Work* is prefigured historically in the folklore that surrounded the daguerreotype. The daguerreotype process produced a single, irreproducible silver image on a small copper plate. Photographic literature of the 1840s is characterized by an obsession with the jewel-like properties of the image.

> The specimen at Chilton is a most remarkable gem in its way. It looks like fairy work, and changes its color like a camelion [sic] according to the hue of the approximating objects. (*N.Y. Morning Herald*, September 30, 1839, quoted in Robert Taft, *Photography and The American Scene*, New York, 1938, p. 16.)

Manifesting a kind of primitive value, a value invested in the object by nature, the daguerreotype achieved the status of the aeolian harp. The fetishism surrounding the daguerreotype had other manifestations, all stemming from a popular uncertainty about the process; women were commonly held to feel their eyes "drawn" toward the lens while being

photographed (*Godey's Lady's Book*, 1849, quoted in Rudisill, p. 209). The daguerreotype took on the power of evoking the presence of the dead. Dead children were photographed as though asleep. In one documented case, the camera was thought to be capable of conjuring up an image of a long buried infant (*Daguerreian Journal*, January 15, 1851, quoted in Rudisill, p. 281).

But outright spiritualism represents only one pole of 19th-century photographic discourse. Photographs achieve semantic status as fetish objects *and* as documents. The photograph is imagined to have, depending on its context, a power that is primarily affective or a power that is primarily informative. Both powers reside in the mythical truth value of the photograph. But this folklore unknowingly distinguishes two separate truths: the truth of magic and the truth of science. The fetish (such as the daguerreotype of a dead child) evokes meaning by virtue of its imaginary status as relic—that is, by the transcendental truth of magic. The evocation is imagined to occur in an affectively charged arena, an arena of sentiment bounded by nostalgia on one end and hysteria on the other. The image is also invested with a magical power to penetrate appearances to transcend the visible; to reveal, for example, secrets of human character.

At the other pole is what I have chosen to call the "informative" function of the photograph, that by which it has the legal power of proof; this function is grounded in empiricism. From this point of view the photograph represents the real world by a simple metonymy: The photograph stands for the object or event that is curtailed at its spatial or temporal boundaries, or, it stands for a contextually related object or event. An image of a man's face stands for a man, and perhaps, in turn, for a class of men. Thus, bureaucratic "rationalism" seized the photograph as a tool, the Paris police, for example, appropriated photography as an instrument of class war when they documented the faces of the survivors of the Commune of 1871. Here was the first instance of the photographic identity card and the photographic wanted poster; other equally "rational" functions were invented for photography during the 19th century; solemn portraits of American Indians were made as the race was exterminated; French imperial conquests in Egypt were memorialized. Reproduced, these images served as an ideologically charged reification of the expanding boundaries of the bourgeois state. The mythical image of the "frontier" was realized by means of photographs. While theories of affect regard the photograph as a unique and privately engaged object, informative value is typically coupled to the mass reproduction of the image. The carte-de-visite represented a move in this direction; every French peasant could own

a visiting-card portrait of Louis Napoleon and family. According to Walter Benjamin, mass reproduction represents a qualitative as well as a quantitative change in the status of the photographic message. In "The Work of Art in the Age of Mechanical Reproduction" (1936) he defined a developing antagonism between artwork as unique-and-precious-object and artwork as reproducible entity. In Benjamin's terms, the unique artwork is necessarily a privileged object. The unique art object stands in the center of a discourse within which ideology is obscured; the photograph, on the other hand, is characterized by a reproducibility, an "exhibition value," that widens the field of potential readers, that permits a penetration into the "unprivileged" spaces of the everyday world. As a vehicle for explicit political argument, the photograph stands at the service of the class that controls the press.

French romantic and proto-symbolist criticism saw both journalism and photography as enemies of art. The complaints against the emergent "democratic" media are couched in esthetic terms but devolve, almost always, into a schizophrenic class hatred aimed at both the middle and working classes coupled with a hopeless fantasy of restoration. Theophile Gautier expends the preface of *Mademoiselle de Maupin* in an assault on Fourier, Saint-Simon, and the realist-utilitarian demands of republican journalism:

> a book does not make gelatin soup; a novel is not a pair of seamless boots; a sonnet, a syringe with a continuous jet; or a drama, a railway. . . . Charles X . . . by ordering the suppression of the newspapers, did a great service to the arts and to civilization. Newspapers deaden inspiration and fill heart and intellect with such distrust; that we dare not have faith either in a poet or government; and thus royalty and poetry, the two greatest things in the world, become impossible. . . . If Louis-Philippe were to suppress the literary and political journals for good and all, I should be infinitely grateful to him . . . (*Mademoiselle de Maupin*, London, 1899, pp. 28–44; originally published 1834.)

Edmond and Jules de Goncourt argue in a similar vein (1854):

> Industry will kill art. Industry and art are two enemies which nothing will reconcile. . . .
> Industry starts out from the useful; it aims toward that which is profitable for the greatest number; it is the bread of the people.
> Art starts out from the useless; it aims toward that which

is agreeable to the few. It is the egotistic adornment of aris-
tocracies. . . .

Art has nothing to do with the people. Hand over the
beautiful to universal suffrage and what becomes of the beau-
tiful? The people rise to art only when art descends to the
people. ("The Death of Art in the 19th-Century," in Linda
Nochlin, ed., *Realism and Tradition in Art* 1848–1900, Engle-
wood Cliffs, 1966, pp. 16–18.)

Finally we come to Baudelaire's famous dictum on photography:

. . . a new industry arose which contributed not a little to
confirm stupidity in its faith and to ruin whatever might re-
main to the divine in the French mind. The idolatrous mob
demanded an ideal worthy of itself and appropriate to its
nature—that is perfectly understood. In matters of painting
and sculpture, the present-day Credo of the sophisticated,
above all in France . . . is this: "I believe in Nature, and I
believe only in Nature (there are good reasons for that). I
believe that Art is, and cannot be other than, the exact repro-
duction of Nature . . . Thus an industry that could give us a
result identical to Nature would be the absolute of art." A
revengeful God has given ear to the prayers of this multitude.
Daguerre was his Messiah. And now the faithful says to him-
self: "Since Photography gives us every guarantee of exacti-
tude that we could desire (they really believe that, the mad
fools!), then Photography and Art are the same thing." From
that moment our squalid society rushed, Narcissus to a man,
to gaze at its trivial image on a scrap of metal. . . . Some
democratic writer ought to have seen here a cheap method of
disseminating a loathing for history and for painting among
the people. . . . (Jonathan Wayne, ed., *Art in Paris* 1845–
1867, London, 1965, pp. 153–54; originally published 1859.)

Where does this rhetoric, the rhetoric of emergent estheticism,
stand in relation to *Camera Work?* The American avant-garde was in-
vented in French terms; the tradition of a dead generation of French
intellectuals weighed on Stieglitz's brain like a nightmare. Photography
necessarily had to overcome the stigma of its definition at the hands of
Baudelaire. The invention of photography as high art is grounded
fundamentally in the rhetoric of romanticism and symbolism. The
fundamental ploy in this elevation is the establishment of the photo-
graph's value, not as primitive jewel, not as fact, but as cameo, to use
Gautier's metaphor for his poems. Within this mythos the photograph

displays a preciousness that is the outcome of high craftsmanship. This craftsmanship is primarily that of the poet, while only marginally that of the workman.

The 36th issue of *Camera Work*, the issue in which *The Steerage* appeared for the first time, was a Stieglitz retrospective of sorts. Perhaps a dozen photographs covering a period of 18 years (1892–1910) were included. No other photographers' work appeared in this issue, nor were there any gravures of nonphotographic work. Among the prints included are *The Hand of Man*, *The Terminal*, *Spring Showers, New York*, *The Mauritania*, *The Aeroplane*, and *The Dirigible*. The prints cluster around a common iconographic terrain; they are marked by a kind of urban technological emphasis marked as a kind of landscape emerging out of an industrial culture. This terrain is defined negatively by its exclusion of portraiture and "natural" landscape, although Stieglitz produced images of both types in his early career. I think we can discern a kind of montage principle at work, a principle by which a loose concatenation of images limits the polysemic character of any given component image. I would argue, however, that this apparent attempt at "thematic unity" is less functional in establishing an arena of photographic meaning than the critical writing that appears in another section of the magazine. The major piece of criticism that appears in this particular issue is Benjamin de Casseres's "The Unconscious in Art." Without mentioning photography, Casseres establishes the general conditions for reading Stieglitz.

> . . . there are aesthetic emotions for which there are no corresponding thoughts, emotions that awaken the Unconscious alone and that never touch the brain; emotions vague, indefinable, confused; emotions that wake whirlwinds and deep-sea hurricanes. . . . Imagination is the dream of the Unconscious. It is the realm of the gorgeous, monstrous hallucinations of the Unconscious. It is the hasheesh of genius. Out of the head of the artist issues all the beauty that is transferred to canvas, but the roots of his imagination lie deeper than his personality. The soul of the genius is the safety-vault of the race, the treasure pocket of the Unconscious soul of the world. Here age after age the Secretive God stores in dreams. And the product of genius overwhelms us because it has collaborated with the Infinite. ("The Unconscious in Art," *Camera Work*, 1911.)

It would be hard to find a better example of modern bourgeois esthetic mysticism. In its own time, of course, this piece was hardly an expres-

sion of institutional esthetics, but stood as the rhetoric of a vanguard, moving beyond the romantic-symbolist catechism of "genius and the imagination" into proto-Surrealism. And yet the echoes of Poe and Baudelaire are explicit to the point of redundancy. Casseres's argument has its roots in a discourse situation from which photography, in its "mechanical insistence on truth" had been excluded. In *Camera Work*, however, this text serves to elevate photography to the status of poetry, painting and sculpture. A drastic boundary shift has occurred, an over-lap of photographic discourse and esthetic discourse where no such arena had existed, except in the most trivial terms. Casseres's inflated symbolist polemic both frames and is a manifestation of this emergent discourse situation. But in order to get close to the semantic expecta-tions surrounding any specific artwork, such as *The Steerage*, we need evidence more substantial than polemic. In 1942 a portion of Stieglitz's memoirs was published, including a short text called "How *The Steerage* Happened":

Early in June, 1907, my small family and I sailed for Europe. My wife insisted upon going on the "Kaiser Wilhelm II"— the fashionable ship of the North German Lloyd at the time. . . . How I hated the atmosphere of the first class on the ship. One couldn't escape the "nouveaux riches. . . ."

On the third day I finally couldn't stand it any longer. I had to get away from that company. I went as far forward on deck as I could. . . .

As I came to the end of the deck I stood alone, looking down. There were men and women and children on the lower deck of the steerage. There was a narrow stairway leading up to the upper deck of the steerage, a small deck right at the bow of the steamer.

To the left was an inclining funnel and from the upper steerage deck there was fastened a gangway bridge which was glistening in its freshly painted state. It was rather long, white, and during the trip remained untouched by anyone.

On the upper deck, looking over the railing, there was a young man with a straw hat. The shape of the hat was round. He was watching the men and women and children on the lower steerage deck. Only men were on the upper deck. The whole scene fascinated me. *I longed to escape from my surround-ings and join these people. . . . I saw shapes related to each other. I saw a picture of shapes and underlying that of the feeling I had about life. And as I was deciding, should I try to put down this seemingly new vision that held me—people, the common people, the feeling of ship and ocean and sky and the feeling of release that I was away from*

the mob called the rich—Rembrandt came into my mind and I won-
dered would he have felt as I was feeling. . . .
 I had but one plate holder with one unexposed plate.
Would I get what I saw, what I felt? Finally I released the
shutter. My heart thumping, I had never heard my heart
thump before. Had I gotten my picture? I knew if I had,
another milestone in photography would have been reached,
related to the milestone of my "Car Horses" made in 1892,
and my "Hand of Man" made in 1902, which had opened up
a new era of photography, of seeing. In a sense it would go
beyon'd them, for *here would be a picture based on related shapes*
and on the deepest human feeling, a step in my own evolution, a
spontaneous discovery.
 I took my camera to my stateroom and as I returned to
my steamer chair my wife said, "I had sent a steward to look
for you. . . ." I told her where I had been.
 She said, "You speak as if you were far away in a distant
world," and I said I was.
 "How you seem to hate these people in the first class."
No, I didn't hate them, but I merely felt completely out of
place. ("Alfred Stieglitz: Four Happenings," Natha Lyson,
ed., *Photographers on Photography*, Englewood Cliffs, 1966, pp.
129–30; my emphasis.)

As I see it, this text is pure symbolist autobiography. Even a superficial
reading reveals the extent to which Stieglitz invented himself in sym-
bolist clichés. An ideological division is made; Stieglitz proposes two
worlds: a world that entraps and a world that liberates. The first world
is populated by his wife and the nouveaux-riches, the second by "the
common people." The photograph is taken at the intersection of the
two worlds, looking out, as it were. The gangplank stands as a barrier
between Stieglitz and the scene. The photographer marks a young man
in a straw hat as a spectator, suggesting this figure as an embodiment
of Stieglitz as Subject. The possibility of escape resides in a mystical
identification with the Other: "I longed to escape from my surround-
ings and join these people." I am reminded of Baudelaire's brief fling as
a republican editorialist during the 1848 revolution. The symbolist
avenues away from the bourgeoisie are clearly defined: identification
with the imaginary artistocracy, identification with Christianity, iden-
tification with Rosicrucianism, identification with Satanism, identifi-
cation with the imaginary proletariat, identification with imaginary
Tahitians, and so on. But the final Symbolist hideout is in the Imagi-
nation, and in the fetishized products of the Imagination. Stieglitz
comes back to his wife with a glass negative from the other world.

For Stieglitz, *The Steerage* is a highly valued illustration of this autobiography. More than an illustration, it is an embodiment; that is, the photograph is imagined to contain the autobiography. The photograph is invested with a complex metonymic power, a power that transcends the perceptual and passes into the realm of affect. The photograph is believed to encode the totality of an experience, to stand as a phenomenological equivalent of Stieglitz-being-in-that-place. And yet this metonymy is so attenuated that it passes into metaphor. That is to say, Stieglitz's reductivist compulsion is so extreme, his faith in the power of the image so intense, that he denies the iconic level of the image and makes his claim for meaning at the level of abstraction. Instead of the possible metonymic equation: common people = my alienation, we have the reduced, metaphorical equation: shapes = my alienation. Finally by a process of semantic diffusion we are left with the trivial and absurd assertion: shapes = feelings.

This is Clive Bell's notion of significant form. All specificity except the specificity of form is pared away from the photograph until it stands transformed into an abstraction. But all theories of abstraction are denials of the necessity of metalanguage, of the embeddedness of the artwork in a discourse. Only if the reader has been informed that "this is symbolist art" or "this photograph is a metaphor" can he invest the photograph with a meaning appropriate to Stieglitz's expectations. With a proposition of this order supplying the frame for the reading, the autobiography, or some related fictional text, can be read back into the image. That is, the reader is privileged to reinvent, on the basis of this photograph, the saga of the alienated creative genius. Casseres's "The Unconscious in Art" provides the model.

Stieglitz's career represents the triumph of metaphor in the realm of photography. *The Steerage* prefigures the later, explicitly metaphorical works, the *Equivalents*. By the time Stieglitz arrived at his equation of cloud photographs and music the suggestion of narrative had been dropped entirely from the image:

> I wanted a series of photographs which when seen by Ernest Bloch . . . he would exclaim: Music! Music! Man, why that is music! How did you ever do that? And he would point to violins, and flutes, and oboes, and brass . . . ("How I Came to Photograph Clouds," *Photographers On Photography*, p. 117.)

The romantic artist's compulsion to achieve the "condition of music" is a desire to abandon all contextual reference and to convey meaning by virtue of a metaphorical substitution. In photography this compulsion

requires an incredible denial of the image's status as report. The final outcome of this denial is the discourse situation represented by Minor White and *Aperture* magazine. The photograph is reduced to an arrangement of tones. The gray scale, ranging from full white to full black, stands as a sort of phonological carrier system for a vague prelinguistic scale of affect.

Predictably, Baudelaire's celebration of synthesia, of the correspondence of the senses, is echoed in *Aperture:*

> Both photographer and musician work with similar fundamentals. The scale of continuous gray from black to white, within a photographic print, is similar to the unbroken scales of pitch and loudness in music. A brilliant reflecting roof, can be *heard* as a high pitch or a very loud note against a general fabric of sound or gray tone. This background fabric serves as a supporting structure for either melodic or visual shapes. (Eric Johnson, "The Composer's Vision: Photographs by Ernest Bloch," *Aperture*, 1972, 16:3.)

Minor White, true to Baudelaire, couples correspondence to affect; an interior state is expressed by means of the image:

> When the photographer shows us what he considers to be an Equivalent, he is showing us an expression of a feeling, but this feeling is not the feeling he had for the object that he photographed. What really happened is that he *recognized* an object of a series of forms that, when photographed, would yield an image with specific suggestive powers that can direct the viewer into a specific and known feeling, state or place within himself. ("Equivalence: The Perennial Trend," *Photographers on Photography*, p. 170.)

With White the denial of iconography is complete. *Aperture* proposes a community of mystics united in the exchange of fetishes. The photograph is restored to its primitive status as "cult object." White's recent *Aperture* publication *Octave of Prayer* is a polemical assertion of the photograph's efficacy as a locus of prayer and meditation.

I would argue that the devolution of photographic art into mystical trivia is the result of a fundamental act of closure. This closure was effected in the first place in order to establish photography *as an art*. A clear boundary has been drawn between photography and its social character. In other words, the ills of photography are the ills of estheticism. Estheticism must be superseded, in its entirety, for a meaningful art, of any sort, to emerge. The Kantian separation of the esthetic

idea from conceptual knowledge and interest is an act of philosophical closure with a profound influence on romanticism, and through romanticism, on estheticism. By the time *Camera Work* appeared, idealist esthetics had been reduced to a highly polemical program by Benedetto Croce:

> Ideality (as this property which distinguishes intuition from concept, art from philosophy and history, from assertion of the universal, and from perception of narration of events, has also been called) is the quintessence of art. As soon as reflection or judgment develops out of that state of ideality, art vanishes and dies. It dies in the artist, who changes from artist and becomes his own critic; it dies in the spectator or listener, who from rapt contemplator of art changes into a thoughtful observer of life. (*Guide to Aesthetics*, Patrick Romanell, trans., New York, 1965, p. 15; originally published 1913.)

Croce is the critical agent of the expressive. Art is defined by reduction as the "true aesthetic a priori synthesis of feeling and image within intuition" (p. 31); any physical, utilitarian, moral, or conceptual significance is denied. In the *Aesthetic* (1901), Croce wrote:

> And if photography be not quite an art, that is precisely because the element of nature in it remains more or less unconquered and ineradicable. Do we ever, indeed, feel complete satisfaction before even the best of photographs? Would not an artist vary and touch up much or little, remove or add something to all of them? (*Aesthetic: As Science of Expression and General Linguistic*, Douglas Ainslie, trans., New York, 1953. p. 17.)

Croce had an impact of sorts on American photography through Paul Strand. Strand's reply (1922) to the argument above is revealing:

> Signor Croce is speaking of the shortcomings of photographers and not of photography. He has not seen, for the simple reason that it did not exist when he wrote his book, fully achieved photographic *expression*. In the meantime the twaddle about the limitations of photography has been answered by Stieglitz and a few others of us here in America, by work done. ("Photography and the New God," *Photographers on Photography*, p. 143; my emphasis.)

Strand's rebuttal is, in fact, a submission to the terms of idealist esthetics. The "element of nature" is eradicated by denying the representational status of the photograph.

Croce, Roger Fry, and Clive Bell form a kind of loose esthetic syndicate around early 20th-century art. Fry's separation of the "imaginative" and the "actual" life, and Bell's "significant form" are further manifestations of the closure effected around modernist art. These critics represent the legitimacy that photography aspired to. The invention of the "photographer of genius" is possible only through a disassociation of the image maker from the social embeddedness of the image. The invention of the photograph as high art was only possible through its transformation into an abstract fetish, into "significant form."

With all this said, we can return finally to Lewis Hine. Hine stands clearly outside the discourse situation represented by *Camera Work:* any attempt to engage his work within the conditions of that discourse must necessarily deprive him of his history. While *The Steerage* is denied any social meaning from *within*, that is, is enveloped in a reductivist and mystical intentionality from the beginning, the Hine photograph can only be appropriated or "lifted" into such an arena of denial. The original discourse situation around Hine is hardly esthetic, but political. In other words, the Hine discourse displays a manifest politics and only an implicit esthetics, while the Stieglitz discourse displays a manifest esthetics and only an implicit politics. A Hine photograph in its original context is an explicit political utterance. As such, it is *immediately* liable to a criticism that is political, just as *The Steerage* is *mediately* liable to a criticism that is political.

Hine was a sociologist. His work originally appeared in a liberal-reformist social work journal first called *Charities and Commons* and then *Survey.* He also wrote and "illustrated" pamphlets for the National Child Labor Committee and eventually was employed by the Red Cross, photographing European battle damage after the First World War. I think it's important to try, briefly, to define the politics represented by *Charities and Commons* and *Survey* during the early part of this century. The magazines represent the voice of the philanthropic agents of capital, of an emergent reformist bureaucracy that, for its lack of a clear institutional status, has the look of a political threat to capital. The publications committee included Jane Addams, Jacob Riis, and William Guggenheim. Articles were written by state labor inspectors, clergymen, prohibitionists, probation officers, public health officials, dispensers of charity and a few right-wing socialists and had such titles as "Community Care of Drunkards," "Industrial Accidents and the

Social Cost," "The Boy Runaway," "Fire Waste," "Children and In-
dustrial Parasites," "Strike Violence and the Public." Politically the
magazines stood clearly to the right of the Socialist Party, but occasion-
ally they employed "socialist" polemic (especially in editorial cartoons)
on reform issues.

A photograph like *Immigrants Going Down Gangplank* is embedded
in a complex political argument about the influx of aliens, cheap labor,
ghetto housing and sanitation, the teaching of English, and so on. But
I think we can distinguish two distinct levels of meaning in Hine's
photography. These two levels of connotation are characteristic of the
rhetoric of liberal reform. If we look at a photograph like *Neil Gallagher,
Worked Two Years in Breaker, Leg Crushed Between Cars, Wilkes Barre,
Pennsylvania, November, 1909*, and another like *A Madonna of the Tene-
ments* we can distinguish the two connotations. One type of meaning is
primary in the first photo; the other type of meaning is primary in the
second.

Neil Gallagher is standing next to the steps of what looks like an
office building. His right hand rests on a concrete pedestal, his left
leans on the crutch that supports the stump of his left leg. About
fifteen, he wears a suit, a cap and a tie. He confronts the camera
directly from the center of the frame. Now I would argue that this
photograph and its caption have the status of legal document. The
photograph and text are submitted as evidence in an attempt to effect
legislation. The caption anchors the image, giving it an empirical valid-
ity, marking the abuse in its specificity. At the same time, Neil Gal-
lagher stands as a metonymic representation of a class of victimized
child laborers. But the photograph has another level of meaning, a
secondary connotation. Neil Gallagher is named in the caption, granted
something more than a mere statistical anonymity, more than the status
of "injured child." Hine was capable of photographing child workers
as adults, which may be one of the mysteries of his style of interaction
with his subject, or it may be that these laborers do not often display
"childish" characteristics. The squareness with which Gallagher takes
his stance, both on the street and in the frame, suggests a triumph over
his status as victim. And yet the overall context is reform; in a political
sense, every one of Hine's subjects is restored to the role of victim.
What is connoted finally on this secondary level is "the dignity of the
oppressed." *Neil Gallagher*, then, functions as two metonymic levels.
The legend functions at both levels, is both an assertion of legal fact
and a dispensation of dignity to the person represented. Once anchored
by the caption, the photograph itself stands, in its typicality, for a
legally verifiable class of injuries and for the "humanity" of a class of

wage laborers. What I am suggesting is that we can separate a level of *report*, of empirically grounded rhetoric, and a level of "spiritual" rhetoric.

This second type of rhetoric informs *A Madonna of the Tenements* in its entirety. This photograph appeared on the cover of *Survey*, in a circular vignette. A Slavic-looking woman sits holding her four- or five-year-old daughter. Another child, a boy of about nine, kneels at his mother's side with his left hand against his sister's side. The woman looks pensive; the daughter looks as though she might be ill; the boy looks concerned until we detect the suggestion of an encroaching smile in his features. The dress of the family is impoverished but neat; the daughter wears no shoes but the boy wears a tie. An unfocused wallpaper pattern is visible in the background. The overall impression is of a concerned and loving family relationship. In a sense, what is connoted by this image is the capacity of the alien poor for human sentiment. In addition, the image is invested with a considerable element of religiosity by the title, *Madonna*. That is, this woman and her family are allowed to stand for the purely spiritual elevation of the poor.

A passage in Judith Gutman's biography of Hine suggests his esthetic roots in 19th-century realism:

> . . . he quoted George Eliot . . . as he spoke to the Conference of Charities and Corrections in Buffalo in 1909. . . . "do not impose on us any aesthetic rules which shall banish from the reign of art those old women with work-worn hands scraping carrots, . . . those rounded backs and weather-beaten faces that have bent over the spade and done the rough work of the world, those homes with their tin pans, their brown pitchers, their rough curs and their clusters of onions. It is needful that we should remember their existence, else we may happen to leave them out of our religion and our philosophy, and frame lofty theories which only fit the world of extremes." (*Lewis W. Hine and the American Social Conscience*, New York, 1967, p. 29.)

If Hine ever read an essay entitled "What Is Art?," it wasn't Croce's version, or Clive Bell's, but Tolstoy's:

> The task for art to accomplish is to make that feeling of brotherhood and love of one's neighbor, now attained only by the best members of society, the customary feeling and instinct of all men. By evoking under imaginary conditions the feeling of brotherhood and love, religious art will train men to expe-

rience those same feelings under similar circumstances in ac-
tual life; it will lay in the souls of men the rails along which
the actions of those whom art thus educates will naturally
pass. And universal art, by uniting the most different people
in one common feeling by destroying separation, will educate
people to union and will show them, not by reason but by life
itself, the joy of universal union reaching beyond the bounds
set by life. . . . The task of Christian art is to establish broth-
erly union among men. (*What Is Art?*, London, 1959, p. 288.)

Hine is an artist in the tradition of Millet and Tolstoy, a realist mystic.
His realism corresponds to the status of the photograph as report, his
mysticism corresponds to its status as spiritual expression. What these
two connotative levels suggest is an artist who partakes of two roles.
The first role, which determines the empirical value of the photograph
as report, is that of *witness*. The second role, through which the pho-
tograph is invested with spiritual significance, is that of *seer*, and entails
the notion of expressive genius. It is at this second level that Hine can
be appropriated by bourgeois esthetic discourse, and invented as a
significant "primitive" figure in the history of photography.

III

I would like to conclude with a rather schematic summary. All
photographic communication seems to take place within the conditions
of a kind of binary folklore. That is, there is a "symbolist" folk-myth
and a "realist" folk-myth. The misleading but popular form of
this opposition is "art photography" vs. "documentary photography."
Every photograph tends, at any given moment of reading in any given
context, toward one of these two poles of meaning. The oppositions
between these two poles are as follows: photographer as seer vs. pho-
tographer as witness, photography as expression vs. photography as
reportage, theories of imagination (and inner truth) vs. theories of em-
pirical truth, affective value vs. informative value, and finally, meta-
phoric signification vs. metonymic signification.

It would be a mistake to identify liberal and "concerned" docu-
mentary entirely with realism. As we have seen in the case of Hine,
even the most deadpan reporter's career is embroiled in an expressionist
structure. From Hine to W. Eugene Smith stretches a continuous tra-
dition of expressionism in the realm of "tact." All photography that
even approaches the status of high art contains the mystical possibility

of genius. The representation drops away and only the valorized figure of the artist remains. The passage of the photograph from report to metaphor (and of photographer from reporter to genius) in the service of liberalism is celebrated in one of the more bizarre pieces of photography ever written. This is the enemy:

> [Strand] believes in human values, in social ideals, in decency and in truth. These are not clichés to him. That is why his people, whether Bowery derelict, Mexican peon, New England farmer, Italian peasant, French artisan, Breton or Hebrides fisherman, Egyptian fellahin, the village idiot, or the great Picasso, are all touched by the same heroic quality —humanity. To a great extent this is a reflection of Strand's personal sympathy and respect for his subjects. But it is just as much the result for his acuteness of perception which finds in the person a core of human virtue and his unerring sense of photographic values that transmits that quality to us. It is all part of an artistic process in which the conception of form, the just balance of mass and space and pattern to frame, the richness of texture and detail transform a moment of intuition into an immutable monument. (Milton Brown in *Paul Strand: A Retrospective Monograph, The Years 1915–1968*, Millerton, N.Y., 1971, p. 370.)

The celebration of abstract humanity becomes, in any given political situation, the celebration of the dignity of the passive victim. This is the final outcome of the appropriation of the photographic image for liberal political ends; the oppressed are granted a bogus Subjecthood when such status can be secured only from within, on their own terms.

Harold Rosenberg

Introduction to Avedon's "Portraits" 1976

AN EXCERPT

Richard Avedon (b. 1923) has been a leading fashion photographer since the first collections opened again in France after World War II. He is almost equally well known for his portraits of the famous and fashionable, portraits which have sometimes been kind to beauties but rather less than kind to everyone else. Harold Rosenberg (1906–1978), the art critic, credits photography with a revolution in portraiture, the unposed naturalness of the snapshot. Avedon, of course, is not involved with snapshots; his portraits are photographs of people who know they are being photographed.

. . . .

In our century, it has become customary to believe that if appearances are deceitful, reality is no less so. The need for masks is no longer felt —faces are enigmatic enough. Nixon had no Mr. Hyde; his alter ego was just another Nixon. Types whose motivations are graspable on sight have become rare even in the theater. In contrast to Elizabethan dissembling, the modern urge is toward self-disclosure, an urge heightened by the promise of psychotherapy that a clean breast will put an end to inner conflict. In practice, self-disclosure proves to be an

endless process, one whose product is a species of fiction, like the Avedon family album. To rid oneself of all falsifications, poses, self-dramatizations is a Utopian ideal, very likely left over from the Romantic striving for naturalness. Today, self-exposure goes hand in hand with make-up and mannerism.

In the early days of photography, sitters for photo portraits were posed in the same way as for paintings. Educated photographers depended on canvases they had seen for compositional ideas. In turn, painters depended on photographs for more accurate likenesses. In most of the painted and photographed portraits I have compared, the photograph is superior in credibility and depth and in uniqueness of expression. The often-reproduced daguerreotype of Poe is far more mysterious and intriguing than the etching by Manet, which subsumes the poet under the type of a successful French papa; and a similar superiority marks the photos taken of Baudelaire, with the possible exception of the lithograph by Rouault.

Serious painters might in the long run have abandoned portraiture because of the competition of the camera, although there are qualities that can be achieved by painting that no photograph can match; for example, the rendering of emotion through color, as in a portrait by van Gogh or Matisse. The most decisive revolutionary impact of photography came, however, not through its ability to surpass in accuracy the posed likenesses of the portrait painter. The genuinely momentous transformation in capturing the human physiognomy was wrought by the snapshot, which put an end to the need for posing, since poses could by *found* by the photographer and did not require to be staged. The unpremeditated postures, including those of children, snared by the rapid shutter and increasingly fast films brought about an immeasurable expansion in the variety of human gesture—and in human self-consciousness. No doubt it was the snapshot that made people more appreciative of the richness that lay in being natural. Artists, first among them the Impressionists, discovered the aesthetic possibilities of random arrangement in contrast to constructed order. Things, people were found to attain their maximum authenticity when they were present without presenting themselves.

All portraits surprise their subjects in some degree. Individuals have a general notion of what they look like, and this notion tends to be jarred by any particular likeness, almost as if there were a double exposure. "It's a good picture," is the usual verdict, "but the resemblance is off." Portraits are probably most convincing to people who are unfamiliar with the persons portrayed. The snapshot multiplies the quantity of fragmentary or inexact likenesses of each individual to the

point where he is assimilable into a universe of light and shadow. Whatever remains recognizable of the photographed object has been rescued from anonymity either by chance or by the skill and discipline of the photographer. "We photographers," said Cartier-Bresson, "deal in things which are continually vanishing." This consciousness can lead logically to abandoning as hopeless the demand for affirmation of individual identity in portraits. The situation is symbolized by Magritte's painting of a gentleman with a huge apple directly in front of his face —which is a companion piece to a photograph of J. P. Morgan with his head completely blocked out by his silk hat.

Optical phenomena are infinite in quantity and each is susceptible to being recorded in countless variations and refractions. Within the endless flood of visual arrangements and rearrangements, the painter seeks an effect of coherence, if only one derived from the habitual reflexes of the hand. Lacking the inhibitions of a nervous system, the camera holds the threat of a mindless accumulation of data, without limit and without purpose, like the accumulation of profit in the economic system in which photography originated. One-man exhibitions of photographs occasionally display the stylistic consistency and formal subtlety of the individual craftsman. Such accomplishments do not, however, alter the fundamental fact that, in the photographic medium, finding can be substituted for making. It is undeniably a factor in the vast popularity of snap shooting that no concept of the subject is needed to take pictures—the thing pictured can be found and refound with each click of the shutter. One can make aesthetic choices from a roll of film shot without a single insight, the way one chooses among pebbles on a beach.

The inauguration by photography of the aesthetics of finding has exerted an incalculable influence on the culture of our time, from the apparently insatiable popular demand for collecting to the innovations in painting and sculpture brought about by incorporating ready-made and found materials.

Finding includes combining. Collage, perhaps the most radical departure in this century from traditional assumptions in painting, arose directly out of the technology of reproduction, which includes photography. Collage was stimulated by the cameraman's bent toward foraging for subjects. In the collage, "finds" consisting of photographic likenesses, real objects, and passages created by the artist are mixed and united in a single dimension. Collage realizes in art the principle cited by Ivins and Szarkowski that the photo is equal in reality to the object or event. In the collage, and in its sculptured equivalent, the assemblage, things are transformed into images and derive their mean-

ing from the new context in which they are set. The visible world is thus conceived as susceptible to unlimited manipulation and readjustment. A Cubist portrait, such as Picasso's of Kahnweiler, symbolizes this liberation from objective solidity, or "things as everyone sees them" (Gertrude Stein), by translating its subject into a complex coordination of physical fragments and abstract shapes. A political equivalent of this domination of external reality by the reconstituting will is to be found in societies governed by revolutionary ideologies.

Finding involves recognition—of particulars that arouse feeling directly (a familiar figure glimpsed in a crowd) or through association (a fruit that resembles a detail of the female anatomy). Theoreticians of photography stress its reliance on selection or choice. Effective photographers know in advance what they are seeking, though this will not prevent them from appropriating images other than those they expect to find. Aaron Siskind found Abstract Expressionist art everywhere— on barns, on rock formations, on stretches of sand. Selection is as vital —and for the same reason—in photography as it is in paintings based on chance, whether composed of found materials, such as collages by Arp or Schwitters, or through automatic drawing or processing, as by Ernst or Masson, or by the thrown paint of Pollock. All these artists find, and only selecting can prevent them from bringing in everything.

Recently, experiments have been made in art consisting of randomly thrown matter in which selection has been abandoned, as in the aleatory music of John Cage, in "scatter" sculpture, and in films made by allowing camera to record whatever occurs in front of the lens. Finding without selection, however, undermines the concept of finding, which implies the realization of some sort of seeking. The extreme in finding is the flea market and the garbage dump, where something desirable may appear by chance, but which only a dogmatist would present as realizing the logic of collage.

In addition to accident and selection, there is what might be called inspired finding, the advent of transcendental or magical objects or persons, such as the momentous talismans and encounters in legends and in the lives of heroes. Occurrences of this order, sought but not planned, presumably transpire only among those who have psychically prepared the way for them by the search itself, as in the adventures of the Holy Grail. The Surrealists, combing the streets and shop windows of Paris in search of what they called "objective hazards," stumbled over an unusually high frequency of significant "correspondences." There is such a thing as training oneself to be lucky. The shots in the dark of Breton, Arp, and Miró almost always hit a valid mark. "To produce an accident of this sort," said Hans

Hofmann of one of his great blot paintings, "one must be in a certain state." There are, in sum, more advanced forms of finding than to bag what is available and choose what one likes. The findings of exceptional photographers occur as the result of exceptional preparations.

Every art has its own moral principle, without which its creations are mere stimulants of sensation. There is nothing to prevent photography from operating on the moral level of the beachcomber, the brothelkeeper, or the second-story man. It is nothing new for the camera to deal with people in public places as potential salvage, to be a source of supply for peddlers of touched-up nudes, to be used to collect testimony in hotel rooms. Lately, it has been argued in court that photographers may appropriate human likenesses as a matter of right. The story of portraits extracted by force is not restricted to mug shots in police stations.

The moral principle of photographic portraiture is respect for the identity of the subject. Such respect does not come naturally in a medium that can without effort produce countless unrelated likenesses of the same object. Light, of which photographs are made, can endow people and scenes with emotional associations that are completely irrelevant to them—a half-lighted face transforms every girl reading into a pensive madonna. To achieve truth, the photographer needs to curtail his resources, which means he must make photography more difficult.

Avedon is a difficult photographer, in the sense that Barnett Newman and Clyfford Still are difficult painters. Like them, Avedon is a "reductionist," that is, one who purges his art of inessential or meretricious elements. Photo portraits of artists, writers, intellectuals, and leaders generally endow them with nobility and thoughtfulness by steeping their features in deepening layers of shadow or catching them in meaningful attitudes. "Personality" is added by drawing on the photographer's repertory of staging devices; the subject is shown with his paintings as background, or peeping around or through a sculpture, or cuddling a cat.

Avedon's camera refuses to confer poetry or distinction on his painters, writers, and other famous personages. It meets each individual head-on; he is allowed only such graces as may come through the vacant stare of the lens. With Avedon the camera seems less a tool of presentation than a source of self-enlightenment. "The photographs," he has said, "have a reality for me that the people don't. It's through the photographs that I know them." He has returned to the posed picture, but only to the extent that his "sitters" (they usually stand) face the lens with an expression of their choice. No snapshots. No

taking by surprise, catching people with their mouths full of food or (with the exception of Ezra Pound) opened in a shriek. None of the portraits in this book is made with a "candid" camera. Avedon uses an 8 x 10 Deardorf and a Rolleiflex. "A photographic portrait," he has written, "is a picture of someone who knows he's being photographed."
. . . .

A. D. Coleman

"The Directorial Mode:
Notes toward a Definition"
1976

A. D. Coleman was regularly reviewing photography in *The Village Voice* and *The New York Times* by the late sixties, when photography was all but ignored by most critics and publications. In 1979 he published a collection of ten years of his photographic criticism; circumstances being what they are, there are not many around who have ten years worth of writing to collect. The following article attempts to define a mode or type of photograph which Coleman calls *directorial*. The issue here is not whether the photographer manipulated the print but the subject.

Within the century and a half of photography's history, two recurrent controversies have had strong influence on its evolution into a graphic medium with a full range of expressive potential. These conflicts, centering around issues which have masqueraded as debates over style and even technique, are, in fact, philosophical clashes. The first—which for all intents and purposes is finally over—was the fight to legitimize photographic imagery *per se* as a suitable vehicle for meaningful creative activity.

The initial stage of this fight had more to do with the art establishment's defensive antagonism toward photography than with the prac-

titioners' attitudes toward the medium, or the public's. The general public has always been interested in looking at photographs, even (perhaps especially) at photographs which were not certified as Art. The problem has never been the lack of an audience but rather the withholding of certain kinds of incentives: prestige, power, and money.

The morphology of photography would have been vastly different had photographers resisted the urge to acquire the credentials of aesthetic respectability for their medium, and instead simply pursued it as a way of producing evidence of intelligent life on earth. However, photographers—some of them, at least—have chosen to enter the "artistic" arena. So, there have been cyclical confrontations between the dominant public definitions of art at various times and photography's concurrent definitions of itself.

Though he was neither the first nor the last to take up these cudgels, the key figure in our century was that decidedly bourgeois gentleman with aristocratic tendencies, Alfred Stieglitz. Stieglitz desired—*noblesse oblige*—to lead a crusade; his was for the acceptance of photography as High (Salon) Art. At the time he embarked on his quest, the most rampant forms of High Art were recognizable via adherence to conventions of subject matter and style, among them livestock in rural settings, sturdy peasants, fuzziness, and orientalia.

Initially, it appears what Stieglitz meant by Art Photography was imagery resembling Whistler prints or genre paintings, or both—at least to judge by his own early work and the photographs by others which he presented in *Camera Notes* and *Camera Work*, the major critical organs which he edited (and, in the case of the latter, published). He and his cohorts successfully addressed these accepted themes and evoked the requisite mannerisms from their medium, which is, in fact, adaptable enough to almost any end to make even that possible. The final result, however, was an attenuated school of photography based on imitation of the surface qualities of a nostalgic, enervated school of painting.

That this definition of both High Art and High Art Photography was a creative dead end eventually became apparent. (Indeed, it becomes increasingly apparent that the battle for the acceptance of photography as Art was not only counter-productive but counter-revolutionary. The most important photography is most emphatically not Art.) And whereas Stieglitz began by advocating and sponsoring a brand of photography which still exists in the antiquated and slightly debased form of camera-club pictorialism, he subsequently became aware of—and, to his credit, embraced—that ferment in which post-impressionist seeing and camera vision commingled to generate radical

new forms of visual expression. So he ended up proselytizing for a way of working in photography which was diametrically opposed to what he had initially propounded; the last issues of *Camera Work* were devoted to the blunt, harsh, Cubist-influenced early images of the young Paul Strand.

Strand and others, both here and abroad, were persuaded that different media were much like sects, to whose dogma practitioners should hew closely, and that a medium was best defined by its inherent and unique characteristics—those aspects which were shared by no other. Curiously, they did not consider photography's almost infinite adaptability to any style of expression as such a characteristic, but settled instead on the related (though not identical) qualities of sharpness of focus and realism. And, as purists tend to do, they made of these qualities not merely stylistic choices but moral imperatives.

This was an approach to photography which found corollaries in many art and design movements around the world; its connections with no-frills utilitarianism, form-following-function theories, and the general mechanophile tendencies in literature and the arts are self-evident. Coincidentally, it also happened that at the same time photographic historiography was beginning to evolve from the purely technical to the chronological and aesthetic. (The next stage, the morphological, is only now beginning to be reached.)

Photography, being a hybrid medium, looked at askance by the art establishment almost everywhere except the Bauhaus, received remarkably little attention as a field of scholarly and critical inquiry, a situation which persisted until the beginning of this decade. So, incredible as it seems in retrospect, during the 1930s the historiography of the most radical innovation in communication since the invention of the printing press and the most democratically accessible image-making tool since the pencil was vested in a mere handful of people—somewhere between six and twelve, depending on how and whom you count.

Inevitably infected with the aesthetic *Zeitgeist*, these historians were understandably anxious to prove that their medium was distinct from its predecessors in the graphic arts and yet directed toward the same field of ideas as was the vanguard of the arts in general at that point. Naturally, then, they explicated the development of photography as apostles of realism. The rest, one might say, is history—though what they wrote, in most cases, more nearly approaches theology.

People believe photographs.
Whatever their response may be to sculptures, etchings, oil paint-

ings, or wood-block prints, and regardless of the level of sophistication they bring to encounters with such works, people do not think them credible in the way they do photographs.

Their credence is based on many factors. These are a few:

1. Photography institutionalizes Renaissance perspective, reifying scientifically and mechanistically that acquired way of perceiving which William Ivins called "the rationalization of sight." Thus photography reassures us constantly that our often arbitrary procedures for making intellectual sense out of the chaos of visual experience "work."

2. Although in its physical form the photographic print is nothing more than a thin deposit of (most commonly) silver particles on paper, the image composed thereby does encode a unique optical/chemical relationship with a specific instant of "reality." Remote and equivocal it may be, but undeniable. A certain lack of aesthetic distance is virtually built into the medium.

3. The mechanical, non-manual aspects of the process combine with the verisimilitude of the rendering to create the illusion of the medium's transparency, or, as Ivins put it, its lack of "syntax."

After all, infants, lower primates, and even servo-mechanisms can take photographs which display the qualities just cited. Photographing appears to be nothing more than concretized seeing, and seeing is believing.

These and other factors have, from its inception, created an atmosphere around photography within which the medium's credibility is not to be questioned—not lightly, at any rate. The assumption has been that the photograph is, and should properly remain, an accurate, reliable transcription. This, of course, is restrictive and inhibiting to some image-makers, who have refused to accept love-it-or-leave-it dicta from the medium's purists. So photography's second major struggle has been to free itself from the imperative of realism.

Viewing this crucial philosophical relationship to photography (and, implicitly, to reality) in terms of a continuum, we can say that at one end there is a branch of photography concerned with justifying the medium's credibility. It operates as an essentially religious discourse between image-maker and viewer. It involves an act of faith on both parts, requiring as it does the conviction that the image-maker has not significantly intervened in the translation of event into image. In responding, the viewer is not supposed to consider the image-maker's identity, but only the original event depicted in the image. the photographer's choice as to which (and what sort of) events to address is the only personal, subjective evaluation permitted in this mode. All other

aspects of presentation are supposed to be neutral; a high degree of technical bravura is acceptable in some circles, but anathema in others.

We have long attached to images in this mode—and must now laboriously disengage from them—two misleading labels: *documentary* and *straight/pure*. The former is generally applied to images depicting human social situations, the latter to formal, studied images of traditional graphic-arts subject matter—nudes, still lifes, landscapes, portraits. I would tentatively suggest that we consider the terms *informational* and *contemplative/representational*, respectively, as somewhat more accurate replacements.

In its relationship to the photograph's credibility, this latter mode might be described as theistic. Another, an agnostic one, permits a more active intermediation between the *Ding an sich* and the image. Here there is no great leap of faith required; the image-maker openly interprets the objects, beings, and events in front of the lens. The subjectivity of these perceptions is a given, as is their fleetingness. A certain amount of chance and accident is also accepted in this method, sometimes even courted; for photographers, like politicians, tend to take credit for anything praiseworthy that happens during their administrations.

The viewer's engagement with these images usually involves a conscious interaction with the photographer's sensibility. However, the photographer is still presumed not to interfere with the actual event going on, though in some situations—especially if the event in question is taking place within the photographer's personal/private life, rather than in the "outside world"—that line is hard to draw. In theory, such a photographer is simply free to impose his/her understandings of—and feelings about—the "real" event onto the image thereof; the viewer is made equally aware of both.

We have no labels specifically attached to this mode; its practitioners have been categorized according to other systems. Among them I would include Robert Frank, Dave Heath, Brassaï, André Kertész, Manuel Alvarez Bravo, Henri Cartier-Bresson, Sid Grossman, W. Eugene Smith—quite a mixed lot in terms of subject matter and style, but attitudinally related. William Messer has proposed the use of the term "responsive" to define this mode.

A third, atheistic branch of photography stands at the far end of this continuum. Here the photographer consciously and intentionally *creates* events for the express purpose of making images thereof. This may be achieved by intervening in ongoing "real" events or by staging tableaux—in either case, by causing something to take place which would not have occurred had the photographer not made it happen.

Here the "authenticity" of the original event is not an issue, nor the photographer's fidelity to it, and the viewer would be expected to raise those questions only ironically. Such images use photography's overt veracity against the viewer, exploiting that initial assumption of credibility by evoking it for events and relationships generated by the photographer's deliberate structuring of what takes place in front of the lens as well as of the resulting image. There is an inherent ambiguity at work in such images, for even though what they purport to describe as "slices of life" would not have occurred except for the photographer's instigation, nonetheless those events (or a reasonable facsimile thereof) did actually take place, as the photographs demonstrate.

Such falsified "documents" may at first glance evoke the same act of faith as those at the opposite end of this scale, but they don't require the permanent sustaining of it; all they ask for is the suspension of disbelief. This mode I would define as the *directorial*.

There is an extensive tradition of directorial photography as such. But directorial activity also plays a part in other modes as well. I would suggest that the arranging of objects and/or people in front of the lens is essentially directorial. Thus I would include most studio work, still lifes, and posed nudes, as well as formal portraiture, among the varieties of photographic imagery which contain directorial elements. Edward Weston was not functioning directorially when he photographed a dead pelican in the tidepools of Point Lobos, but he surely was when he placed a green pepper inside a tin funnel in his studio; and he was doing so consciously when he made his wartime satires (such as "Dynamic Symmetry") or the 1931 image which he felt it necessary to title "Shell and Rock (Arrangement)."

When—as evidence from other photographs indicates—Alexander Gardner moved the body of a Confederate soldier for compositional effect to make his famous image "Home of a Rebel Sharpshooter," he was functioning directorially. So was Arthur Rothstein when, by his own testimony, he told the little boy in his classic Dust Bowl photograph to drop back behind his father. So was the late Paul Strand when—according to reports—he "cast" his book on an Italian village, *Un Paese*, by having the mayor of the town line up the residents and picking from them those he considered most picturesque.

The substantial distinction, then, is between treating the external world as a given, to be altered only through photographic means (point of view, framing, printing, etc.) en route to the final image, or rather as raw material, to be itself manipulated as much as desired prior to the exposure of the negative.

It should be obvious from the above examples—and many more could be cited—that directorial elements have entered the work of a

vast number of photographic image-makers, including many who have been taken for or represented themselves as champions of documentary/straight/pure photography. Things are not always as they seem; as Buckminster Fuller says, "Seeing-is-believing is a blind spot in man's vision."

The problematic aspect of straight photography's relationship to directorial activity is not the viability of either stance; both are equal in the length of their traditions and the population densities of their pantheons. Rather, it is the presumption of moral righteousness which has accrued to purism, above and beyond its obvious legitimacy as a creative choice. This posture is not only irrelevant and—as the above examples indicate—often hypocritical, but baseless. Even if all purists adhered strictly to the tenet that any tampering with reality taints their imagery's innocence and saps its vital bodily fluids, the difference between that passive approach and a more aggressive, initiatory participation in the *mise en image* is—though highly significant within the medium—still only one of degree. We must recognize that the interruption of a fluidly and ceaselessly moving three-dimensional *Gestalt* and its reduction to a static two-dimensional abstraction is a tampering with reality of such magnitude that the only virginity one could claim for any instance of it would be strictly technical at best.

I am not a Historian, I create History. These images are anti-decisive movement. It is possible to create any image one thinks of; this possibility, of course, is contingent on being able to think and create. The greatest potential source of photographic imagery is the mind.

This statement was made by Les Krims in 1969.[1] Krims has been working in the directorial mode (he refers to his works as "fictions") for over a decade. He has explored it thoroughly and prolifically, enough so that the above quotation could serve as a succinct credo for all those who use the camera in this fashion.

Krims is by no means the first photographer to take this position, nor is he the only one of his generation to do so. Yet it is apparent that, both inside and outside photographic circles, there is little recognition that there does exist a tradition of directorial photography. Certainly you would not know it from reading any of the existing histories of the medium. This widespread unawareness is traceable to two sources: the biases and politics of photographic historiography to date, and the ignorance about photography of most of the art critics who have dealt with the medium. The consequences have been 'that photographers

1. *In a letter published in* Camera Mainichi/8 *(Japan), 1970.*

with a predilection for this approach to image-making have had to undertake it in the face of outright hostility from a purist-oriented photography establishment, with no sense of precedent to sustain their endeavors; and that the current crop of conceptual artists employing photography directorially are on the whole even less informed in this regard than their contemporaries in photography, and thus have no concern about and no accountability for the frequency with which they duplicate and plagiarize previous achievements in this mode.

Perhaps the first large-scale flowering of directorial photography —the point at which such work entered the average Western home and became an intrinsic part of our cultural experience of the medium— came with the introduction of the stereopticon viewer and the stereographic image, circa 1850. Stereo photographs of all kinds, mass produced by the millions, became a commonplace form of entertainment and education during the next three decades, and survived as such well into the twentieth century. Among the standard genres of stereo imagery was the staged tableau, often presented sequentially and narratively; the scenarios ranged from Biblical episodes and classics of literature to domestic comedies and schoolboy pranks.

Through the stereograph, Western culture received its first wide exposure to fictionalized photographs. This initial experience has been followed by many others: erotic, fashion, and advertising photography are only a few of the forms which have been, by and large, explicitly directorial from their inception. Most of these, however, are not considered "serious" usages of the medium; their commercial function and/ or popular appeal presumably render them insignificant, even though they reach and influence a vast audience. (As I noted before, the public has never been unwilling to look at photographs.)

Within the more self-conscious arena of Art Photography, whose audience has always been comparatively scant, the advent of directorial photography as an active mode and an acknowledged alternative to realism dates back to the same period—the 1850s—and the work of two men: O. G. Rejlander and Henry Peach Robinson.[2] Both staged events for the purpose of making images thereof—mostly genre scenes and religious allegories; both used the process of combination printing, involving the superimposition of one negative on another, which fic-

2. *Strangely, in 1888 a public controversy between Robinson and Peter Henry Emerson began over these same issues. Emerson advocated a purist approach to the medium: no interference with the external event, no multiple negatives, no retouching (though, inconsistently, he allowed for the "burning in" of fake clouds, since the real ones would not register on the slow films of the day). Emerson's position was called "naturalism"; Robinson's was called* realism!

tionalized the resulting print even further. Their work was the subject of heated debate from all sources—photographers, artists, art critics, and the public as well. Until recently, the sentimentality of the most popular of their images (Rejlander's "Two Ways of Life" and Robinson's "Fading Away") was used by photo-historians as a basis for dismissing their entire *œuvres* and their way of working as well. (Reexamination of their output turns up some astonishing, little-seen imagery; in Rejlander's case, for instance, "The Dream," "The Juggler," and "Woman Holding a Pair of Feet.")

Beginning in 1864, the Victorian photographer Julia Margaret Cameron also produced an extended body of directorial work in which she blended, for better or worse, current literary themes and attitudes with the visual conventions of Pre-Raphaelite painting. Some of her images were studio portraits of famous artists and *literati;* others were enactments of scenes from literature. Also sentimental, for which they too have been often dismissed, they are nonetheless powerful images whose illusions are effective despite—and perhaps even because of— the viewer's knowledge of what was "really happening" at the time.

Subsequently, there rose and flourished the photographic movement generally known as *pictorialism.* That word itself is problematic, even though the dictionary definition is non-judgmental. (Certainly as a term it is less absolute, and therefore less enticing to true believers, than its ostensible opposite in photography, *purism.*)

At different times *pictorialism* has had different meanings and implications in photography. Presently it is employed to describe bland, pretty, technically expert executions of such clichés as peasants tilling the fields, fisherfolk mending nets, and sailboats in the sunset, still being cranked out by mentally superannuated hobbyists. As such, it is essentially derogatory. Initially, however, it had quite a different import; it indicated adherence to a set of conventions—prescribing styles and subject matter—which were thought to be essential to any work of fine art, not just art photographs.

That it became trapped within those conventions is regrettable, though doubtless inevitable. However, an attitude toward the medium of photography underlay the pictorial impulse, and that attitude is of great importance. It could be summarized thus: photography is only a means. Whatever tools or methods are required for the full realization of the image as conceived should be at the disposal of the image-maker, and should not be withheld on the basis of abstract principle. Man Ray said much the same thing: "A certain amount of contempt for the material employed to express an idea is indispensable to the purest realization of this idea."

Pictorialism, then, was the first photographic movement to oppose the imposition of realism as a moral imperative. The pictorialists felt free to exercise full control over the appearance of the final image/object and, equally, over the event it described. Practitioners staged events —often elaborate ones—for their cameras, and resorted to every device from specially made soft-focus lenses to handwork on the negative in order to produce a final print that matched their vision. Much of the imagery they created was, and is, extremely silly; much of it was, and is still, beautiful and strong. For all their excesses, Anne Brigman, Clarence White, F. Holland Day, Gertrude Käsebier, and many others produced some remarkable and durable work.

Creatively, the kind of photography we now call pictorialism reached its peak during and shortly after the Photo-Secession era— from the turn of the century through the early 1920s. Then it began to come up against the purist attitude. The clash between these two opposing camps came to a head in the pages of *Camera Craft*, a West Coast magazine, in the early thirties, in the form of a heated exchange of letters between various members and sympathizers of the f/64 movement (among them Ansel Adams and Willard Van Dyke) and William Mortensen.

Mortensen was a practitioner of and articulate spokesman for pictorialism, though by the time he achieved recognition the form was already in decline. In the minds of most, the purist-pictorialist schism was simplistically conceptualized as hard sharp prints on glossy paper versus soft blurry prints on matte paper. The actual issue at stake was far more complex: it concerned the right of the image-maker to generate every aspect of a photographic image, even to create a "false" reality if required. (Mortensen himself worked almost entirely in the studio, creating elaborate symbolist allegories filled with demons, grotesques, and women both ravishing and ravaged.)

The debate was a draw, at least in retrospect, but second-stage Hegelianism won the day: the aesthetic pendulum swung to purism, and pictorialism fell into disrepute. Mortensen—who, in addition to this debate, was widely published in photography magazines and authored a series of how-to books which are to pictorialism what Ansel Adams's instructional volumes are to purism—was actually purged from the history of photography in what seems a deliberate attempt to break the movement's back.[3]

3. *From the first one in 1937 to the most recent of 1964, no edition of Beaumont Newhall's* The History of Photography: From 1839 to the Present Day—*the standard reference in the field—so much as mentions the name of William Mortensen. It*

For the next three decades—until the late 1960s, in fact—there were commercial outlets for certain kinds of directorial images, but any photographers working directorially in a non-commercial context did so over the vociferous opposition of most of their peers and of the aesthetic-economic establishment which controls the medium's access to the public and to money. Still, some persevered: Clarence John Laughlin, making his Southern Gothic image-text pieces in New Orleans; Edmund Teske, pouring out his passionate homoerotic lyrics in Los Angeles; Ralph Eugene Meatyard photographing the ghoulish masked charades of his family and friends in Lexington, Kentucky; Jerry Uelsmann resurrecting lost techniques in Florida. There were others too, hoeing that hard row.

The 1960s were a time of ferment in photography, as in most other media. Old attitudes and assumptions were put to the test. Purism, it was found by a sizable new generation of photographers, was still viable as a chosen approach but restrictive as an absolute. Even so, old attitudes die hard, and these younger photographers found themselves facing an establishment and a public that was so accustomed to equating creative photography with purism that it was (and still is) considerably perplexed by anything else.

But they too have persevered. It would be difficult to compile a complete list of those working in this mode at this time—there are a great many, and the number is increasing rapidly. Les Krims and Duane Michals must certainly be counted among the pioneers of their generation in this form; both are prolific, both have published and exhibited widely, both are reference points for the current generation of younger photographers and are obvious sources for much of the mediocre directorial photography which passes for "conceptual art" nowadays.

John Pfahl, Ken Josephson, and Joseph Jachna have all produced extended series in which they enter into or visibly alter the landscape, with related hermeneutic inquiries into the illusionism of the medium. Lee Friedlander (in *Self-Portrait*), Lucas Samaras, and the late Pierre Molinier have all used the camera as a dramatic device, in front of which their fantasies and obsessions are acted out. Eikoh Hosoe, Richard Kirstel, Arthur Tress, Adal Maldonado, Ed Sievers, Doug Stew-

will be instructive to see whether the forthcoming edition—a major revision supported by the Guggenheim foundation—rectifies this omission.

In fact, none of the books on the history of twentieth-century photography refers to Mortensen. If this could be considered even an oversight, the only questions it would raise would concern standards of scholarship. Since it cannot be construed as anything less than a conscious choice, however, the issue is not only competence but professional ethicality.

art, Paul Diamond, Ralph Gibson, Irina Ionesco, Mike Mandel, Ed Ruscha, William Wegman, Robert Cumming, and Bruce Nauman (among others) also have things in common.

This article was conceived as an examination of those connections, with a historical prologue to set current ideas in their full context. The prologue has grown to engulf the main text and is still too summary. But, to conclude: willingly or no, whether or not they consider themselves "photographers" or "artists" or whatever, these individuals and many others are exploring the same field of ideas. That field of ideas is built into and springs from the medium of photography itself; it has a history and tradition of its own which is operative on many levels of our culture. There is no direct equation between ignorance of history and originality. Disclaiming one's ancestry does not eliminate it. It is regrettable that in most cases these creative intelligences are not aware of their lineage; it seems foolish that in many cases they attempt to deny it. The moment would seem to be ripe for them to acknowledge their common sources and mutual concerns; their real differences will make themselves apparent in due time.

Leo Rubinfien

"The Man in the Crowd"
1977

Garry Winogrand (b. 1928) follows in the Cartier-Bresson–
Robert Frank tradition of candid photographs of people in
public places. Though he has scrutinized many public occa-
sions and recorded some telling moments, he has been less
interested in the decisive moment than in the decisive formal
arrangement, or at least the instant when the two coalesce. In
the early sixties he adopted a wide-angle lens which approxi-
mates the field of vision and honed his apparently random but
actually highly controlled style with its multiple centers of
interest and occasionally tilted horizons. One emphasis in this
kind of reporting has been on a kind of picture that is felt to
depend on a purely photographic aesthetic rather than on
traditional criteria for art. Leo Rubinfien is a photographer
who has written on art and photography.

As a photographer, Garry Winogrand owns the 1960s, in the special
sense in which it is commonly said that Robert Frank owns the 1950s,
or Walker Evans the 1930s. These artists' photographs are distin-
guished by the extraordinary conjunction of a form that comes to mir-
ror, and stand for, the dominant sensibility of a time with subjects that
are the era's main symbols and events. While Edward Weston's nudes

belong clearly but allusively to their decades, it was Evans who made sharecroppers, impoverished shacks and crude, popular art central concerns of his own fine art. These are things we take, 40 years after, as quintessential symbols of the Great Depression.

Of course, Evans and Frank have themselves had a great deal to do with forming our conventional symbols for their milieux. With time we forget that they pictured their periods selectively, that they offered no more than fictional versions of the Depression years and the complacent '50s: we take them as speaking truth. What was an opaque collage of objects—mundane objects that spoke out loud to these photographers of generous sensibility—becomes a transparent glass through which we think we may return to history.

"Public Relations," Winogrand's current show at the Museum of Modern Art, comes at a time when the '60s have begun to be publicly reckoned. The last two years have seen an abundance of '60s memoirs. That frantic, flamboyant decade, which no one any longer lives, is presently being distilled into the myths by which we will retain it in the future. Yet the '60s were recent enough, if one counts all the Nixon years as part of the era, to leave an image in memory that is still fresh. We now see Winogrand's work at a stage where it is in the process of attaining transparency, where it is no longer esoteric or difficult (as many once thought it to be) but where it has not yet come to dominate the way we see its times.

"Public Relations" consists of pictures Winogrand made at various kinds of public events. It only partially represents an extensive and enormously varied oeuvre, although there is no difference of form between the pictures in this show and others the photographer made at the same time. All are wide, 35mm camera frames, dense with ranges of details and small incidents. One thinks at first that these details and incidents are all equally important, so fascinating do they all seem to be. Winogrand has become famous for this style, which Tod Papageorge, guest curator of "Public Relations," describes as "discursive." Even once one has recognized which objects and events are preeminent in a picture, it will never cease elaborating. In those photographs which were made by the light of a flash, tangential glances, marginal faces, extra lapels and spells of pleated drapery only fade out in the blackest corners of a scene.

This much has been said by Papageorge and other writers on the subject of Winogrand's form: that it descends from tradition via the work of Robert Frank, who was the first small-camera photographer to turn a consistent esthetic from the wide-angle lens; that the virtuosity with which Winogrand balances galaxies of detail is tremendous; that

his discursive form reflects and comments upon what is perhaps photography's signal quality as a medium—its ability to describe great wealths of small things. Papageorge also implies a connection between the prolific manner of Winogrand's frames and the equally prolific manner of his personal speech. We are left asking how this visual voracity extends from, fictionalizes, and actually characterizes the subject of Winogrand's work—which, in sum, is no less than life in the United States during a crucial measure of its history. Abstractly put, this is the question of how Winogrand's form itself makes up a large part of the content of his pictures.

I am speaking of a time in which people of all classes and kinds, many of whom had never before led public lives to any degree, adopted postures, made statements and donned symbols that were aimed entirely at public effect. Perhaps more than at any time in America's past it was felt that to participate in society—not just in the specialties of governmental and cultural politics—it was necessary to make oneself publicly visible. And to be visible in the '60s meant to behave, to costume oneself, to pontificate in ways that would be positively conspicuous, and even unacceptably so, in the subsequent decade.

Slang terms of the period, "outrageous," "far-out," and "out-of-sight," referred directly to the extent to which a thing, a gesture, a style or a statement made public waves, and to how it did so. And one had the sense, whether it was true or false, that everyone was talking, and flamboyantly too; only the general bombardment of speech made it seem, at times, that there was not very much difference between what different people said. Perhaps this is why Nixon's appeal to the "great silent majority" provoked such fury, and why an angry poster of the time placed that infamous slogan beneath a photograph of Arlington National Cemetery. It seemed inconceivable that anyone could be keeping silent who had not been silenced.

Winogrand placed himself in the midst of this crowd, and his photographs mimicked its loquacity. Why, one might ask, did Winogrand not choose to operate as did some of his contemporaries, who picked out and displayed the most bizarre or touching details of the scene? Editing from the fluctuating world of fact as all photographers do, he selected what appears in each picture to be the whole vista—the whole flood of overlapping arguments.

One of many photographs Winogrand made at Norman Mailer's 50th birthday party gives us the famous writer besieged at a dais. Mailer is surrounded by a chorus of eyes and hands—one of which belongs to a young woman who is gesturing at him with splayed fingers. While it would be false to say that this picture had no center of attention—everything does revolve around this woman's urgent profile

—nothing escapes our notice, not even the disembodied hand aiming an electronic flash toward the back of Mailer's head. It is as if one had gotten drunk at this party: not blind drunk, but drunk enough so that one could not keep pace with the dense conversation, and found oneself turning repeatedly to the trivial details of the surrounding crush. One returns intermittently to this picture's dominant motif as one would hasten to recover some thread of conversation just now so innocently dropped.

We touch here on the symbiosis that exists between Winogrand's form and the visage of the era to which it was being addressed. It was the phenomenon of a whole flood of arguments, rather than any one among them, that was most significant during the '60s Winogrand has said that public events of the period seemed to be organized for the benefit of the news media which covered them. As much of a motive, at least in the antiwar movement, was simply the joy of seeing itself in strength; demonstrations were as much self-serving as they were pointed political moves. Spectators and spectacle became one of a piece.

Thus, to make pictures that emphasized, took seriously, and lent dignity to each individual posture that surfaced from the crowd, would have been to ignore the inherent irony of the times. The form one used would have to be able to simulate the general drum of speech and to leave room, at the same time, for the urgency of each individual gesture. Other artists of the period, especially Robert Rauschenberg, seemed aware of this necessity. Winogrand managed to turn it to consummate use, in part because of his medium's enormous appetite for fact.

There are no adjectives in photographs, only nouns. The items that populate a given photograph appear replete with all their descriptives; modifier and modified are fused. Where a writer might easily spend a paragraph reconstructing the leathery boa one Winogrand woman wore to the Met's Centennial Ball, a photographic picture makes the boa and its connoted qualities inseparable. Meaning resides in every object and every quality, and the outcome—the general meaning—of that picture is almost untranslatable.

Doubly crammed with detail, Winogrand's pictures are among the most extreme examples of this compaction that photography has produced. At the same time they take an ironic stance toward their own medium. Commonly photographers use larger cameras and finer films to extract more detail from their subjects. Winogrand shoves the detail in from around the edges. His pictures challenged other '60s artists (in painting, collage and prose) to portray a social scene which was confused by the breadth of its own multiplicity. Photography also seems

to have been suited to that scene for the illusion of immediacy that accompanies the camera's illusory literalness. The '60s gave scant time to recollect in tranquility; but photography did not require that one do so.

Let me phrase my point about the '60s in terms of the Vietnam War. The war was, of course, the determining event in American consciousness at the time. Yet the war is paramount as fact only if one marks out history according to its episodes of violence. True, new technology was used to pursue the war in Vietnam, but the war's motives, as many contestants in the '60s agreed, did not differ tremendously from American motives in Korea 15 years earlier. What *was* novel about Vietnam, and what may have been far-reaching in effect, was the stridency of the various reactions the war produced at home. Traces of this stridency are visible in the nipple-revealing boa Winogrand's character wore to the Met, in the attention a phalanx of hard-hats lavishes on an eight-year-old wearing flags and a sign reading "Little Miss Patriotism," in the desperate eyes of a crazed man who rushes among the bystanders in Central Park, in the loony wallpaper of which one goggle-eyed dancer at the Met seems almost an extension, even in the American-cut disregard for dress or decor that amounts almost to a kind of haughtiness on the part of Winogrand's NASA technologists.

The decade's stridency is evident above all in the degree to which Winogrand's subjects seem so often to be performing for, and responding to, each other. This is so even in Winogrand's book *Women Are Beautiful* (1975), where single characters dominate many frames; three times out of four these women act for the photographer himself, who weaves them into a continuous story of mutual lust and distrust. We may note the fact that the cowboys, provincials and small-time politicians of Winogrand's precursor, Robert Frank, also perform. But the dominant sense Frank's *The Americans* gives is that these people have been thoroughly deprived of an audience. Here lies a major difference between the two decades, at least as they have been rendered and handed to us in myth.

There is in Winogrand's photographs a cycle of attitudes that neither conflict nor merge. His pictures have most often been recognized for their comedy and for their attention to the grotesque, but they also contain bitterness, love and joy, a great delight in physical grace, and a degree of desperation. These various emotions coexist in many frames, maintaining the plural ways one has to see a time in which one was too much a part of the crowd to have any objectivity toward it. Thus the sneering, misshapen lips on one of Winogrand's Met guests will paradoxically become graceful, as a comical and simply

lustful incident will be tinged with despair in another picture from the same party. The feather-boaed woman has here found her way to the lap of a tuxedoed gent who is pulling the garment away to examine her breast, while she clutches him by the back of his neck and grins with fierce approval. The wantonness that this couple shares with a shiny young man dancing wildly a few feet away—and with Winogrand whose tilted frame is also wanton (not *actually* wanton, but calculatedly and precisely so)—carries the feeling, the fear, that time is running out. The viewer of this photograph is left free to ask whether it is simply that the night has grown late and the party is expiring frantically, or whether this is the quality of a society that appeared to be coming apart at the seams—or both.

That Winogrand's pictures are so much addressed to the eccentricities of the '60s does not mean that his work is empty of wider reference. The hardheaded verisimilitude of all photographs does not prevent them from operating metaphorically. But metaphor is less a summit at which we have finally deciphered a photograph's prolix language than a pressure that informs a camera image from underneath, affecting the way we read it at each turn. Consider Winogrand's desperate, naked man in Central Park.

He moves amid a crowd of intrigued, amused, astonished and embarrassed people, with his arms upraised in a gesture half hortatory, half pleading. Indeed, it is with the benedictional pose of a priest that he closes in behind a young man and woman, his hands almost pressing their heads; his eyes are lost in the inward and distant stare of someone possessed. We cannot know what brand of lunacy goads this man, but he is stamped with the frustration of someone who bears an arcane and urgent message and yet cannot form the words with which to preach it. Naturally this man recalls, and may well have been, one type of his times—the drugged visionary. But we do not fail also to read him as a Coleridgian artist of flashing eyes and floating hair, whose private yet guiseless obsession compels him to grasp for articulation before an audience that is irked by his frenzy—that, absorbed in its own trials, couldn't care less. Once one has admitted such resonances into his reading of Winogrand's pictures, they are half-removed from history, into the territory of continuing myths. One has removed the '60s as well, shaping them as they may well stand when their specifics have been forgotten, as a time of buoyancy and decadence, filled with prophecies.

For the time being, however, Winogrand's photographs bring us back to their pungent specifics, and we wonder at the generosity of his vision in a time when so much of America was manufacturing propaganda. To have described hardhats, radicals, hustlers, the elites of art

and science, exhibitionists, clowns, and those who themselves purported to describe, the ubiquitous reporters and cameramen—to have described all these evenhandedly, with the same mixture of comedy, cruelty and respect, might well have outraged the typically partisan citizen of the '60s. That Winogrand's photographs are respectful should go without saying: they evidence what may be the most mature form of respect—the permitting of one's contemporaries to pursue their glories and follies free from one's own interference.

This amounts to a form of liberalism that was scarce in the decade. Not "bleeding-heart" liberalism, of which there was plenty, and for which there was plenty of derision, but a ruthless liberalism, lenient and strict, that would at once give everyone an ear yet hold all to themselves. It is a view that would seem to be possible only from a safe position of great power. Of course it was not the view of those who were powerful in the '60s: warmakers, didacts and rock-and-roll musicians. Perhaps its explanation lies in an earlier period, the ebullient time when America had survived the Depression triumphantly, when it was winning World War II and achieving world power, and when Winogrand was growing up.

It is worth speculating that Winogrand's sensibility survives from that brief spell when—so popular art and film would tell us—the United States rightfully thought of itself as democratic, and the V-J Day sailor in Times Square—the man in the street—could be authentically heroic. The generation whose violent youth had been relieved by this euphoric passage went on to create and incite the 1960s, blowing our self-assurance all out of proportion, until our sense of noblesse oblige came to be expressed with napalm. It seems that Gary Winogrand became estranged, however, and brought that man in the street back as the fictional describing persona of his art: the artist himself as the man in the crowd. Those whom Winogrand held to themselves in his photographs of the '60s must have been, above all, the parents of that period, the men and women of his own generation.

History, *histoire*, is not made while events are being enacted. It is made after the fact, in the telling and retelling. Gradually, of course, events that once occurred will blur and seem—as the Vietnam War and the movement against it already do—opposite sides of the same coin. It should be clear that I do not use "history" to mean documentation, and that, in any case, a photograph does not document, but distorts, its moment of inception. The charm and satirical paradox of Winogrand's telling is that it attends to fact selectively, yet holds its chosen facts down with a vengeance. His subjective eye may prove to be one of the best historians we have.

Garry Badger

"The Modern Spirit—
American Painting 1908-1935
at the Hayward Gallery, London"
1977

AN EXCERPT

This brief excerpt from an Englishman's review of a show of
American paintings and photographs casts an interesting light
on American photography from across the ocean.

. . . .

Edward Weston once contended that photography is a medium suited
particularly to the American psyche, and indeed, if one looks at the
simple fact of the scope of America's singular contribution to twentieth
century photography, such a hypothesis could well be suggested at
least. There are many reasons for the predominant position of America
in world photography—a unique figure called Alfred Stieglitz and the
founding of an institution named the Museum of Modern Art had
much to do with it. Yet a concrete and reasonable argument in favour
of Weston's speculation would seem to emerge from a general exami-
nation of American painting.

The straight photographic aesthetic demands above all else respect
for the primacy of the object and, in terms of artistic expression, an
allowance for transcendent experience through the objective significa-
tion of the thing itself. This kind of philosophy has been an almost
unbroken characteristic of American painting, from the primitive lim-
ner tradition onwards, with important manifestations in Luminism and

Magic Realism during the Nineteenth Century, and in Precisionism and Hyper Realism during the Twentieth. American artists have tended from colonial times up to the present to guard the integrity of the things of this world, which then often became, as Novak has written, 'vessels or carriers of metaphysical meaning.'

American art has developed from a very strong folk tradition, and to this day has retained much closer links with that tradition. Thus American painting reflects a vigorous tradition of conceptual realism, tending toward 'the measured and the planar, the smooth-surfaced and the anonymous, the timeless and the contained.' Ralph Waldo Emerson's description of the artist as a 'transparent eyeball' is the epitome of American artistic philosophy—in complete contrast to the British and European view of the artist as genius.

Here are the salient qualities, I would suggest, which mark the American, and by extension the broadly understood contemporary photographic tradition. The objective facts of the world are seen and recorded with an exactitude which at the same time goes beyond mere exactness and mere realism 'to register a magnified intensity that transcends realism to become a form of impersonal expressionism.' Most of the photographers seen at the Hayward exemplify this approach completely—Weston and Evans in particular it seems to me—thus their work lies not only within the mainstream of modern photographic expression, but is closely bound to the mainstream of American art in its broadest and most fundamental sense.

Such an artistic heritage, and such an aesthetic tradition I believe has ensured—albeit unconsciously—the natural acceptance of the camera in America as a means of creative expression, and the resulting vigour of her photographic tradition. In the States there has been a more natural and less divisive adoption of the pure photographic medium than either in Britain or Europe, where entrenched divisions between art and science, between art and document, between artist and tradesman, between expressiveness and mimicry, have served to cloud the issue of photographic expression—and do so to this day.

Vicki Goldberg

"White Women"
1977

In the late sixties and the seventies, fashion photography, ever sensitive to what is socially acceptable, began to pick up on a certain license in morality that had begun to enter the visual media. Avedon began the trend in American fashion magazines, but the chief proponents were European photographers such as Helmut Newton, Guy Bourdin, and Chris von Wangenheim. The new mix of fashion, sex, and violence achieved its widest audience and most pungent commentary in Antonioni's film *Blow-Up*. Sex and sadism in photography, long recognized as the preserve of some men's magazines, became acceptable on record covers and respectable in magazines that would previously have shunned such a combination. What was unusual in the case of photographers like Newton and Bourdin was that many of their photographs were reproduced in magazines ostensibly designed for women, and upper-middle-class women at that, who would not in past years have been considered the target audience for such a sensibility.

Helmut Newton has created the ultimate book for the closet misogynist. *White Women* (Stonehill, $25), as elegant an invective on women as

fine design and production could deliver, parades as a book of photographs about upper-class lust. Assured, accomplished photographs, their message is coded in visual dazzle and splendidly tailored improprieties.

Newton is a German-born fashion photographer based in France. In the last few years, he has helped raise the temperature of *Vogue* with pictures of two women dancing together on the lip of a crater, a man fondling a woman's breast or biting her ear, a woman cradling a perfume bottle in handcuffed hands. His fashion work sometimes hints that the sexes are antagonistic and competitive, and that sex itself is a battle with only one victor. *White Women* is more open and more naked, particularly in its loathing.

The book is bracketed by voyeurism and hate, flamboyantly decked out in fantasy. (Psychiatrists say the Peeping Tom form of voyeurism is equivalent to hatred, a kind of rape accomplished with the eyes.) In the first picture, Newton lies below us on a bed, fully clothed. A naked woman has flung herself on him, clawing at his shirt. Newton, holding a camera to his eye, coolly snaps the picture in the overhead mirror. The photographer-voyeur wittily depicts himself in the happiest of male fantasies, the irresistible man in total control. In the next picture, a woman reclines on a couch, her robe open to expose her breasts and garters. Two black-and-white photographs behind her demand attention. Newton explains, "My father and I in Berlin, 1924" —as if to say, *looking was all I could do then*, Papa (he was four at the time), *but now I'm as big as you are*—"and a portrait of me taken by my wife. . . . 1955"—which could mean, *I'm still going strong, honey; this is what I do in the presence of your image of me*. Newton the voyeur goes on to construct a world like Berlin in the '20s and '30s, when he was growing up, an amalgam of decadence, narcissism, lesbianism, and emotional distance, a bit like Visconti's vision in *The Damned*.

The last picture in the book is the face of a woman in pain. Her hand, with meat-red fingernails, clutches to her eye a raw and bloody steak, viscid with fat. A dramatic finale, it confirms what the rest of the book implies: that women are just so many expensive cuts of meat. The text opposite the picture reads: "My mother always said: 'If you have any problems, Helmut, don't tell us, tell the doctor.' And my father, screwing in his monocle, used to say: 'My boy, you'll end up in the gutter.' " A peculiar confession, one which suggests that the book is an attempt to pay back an indifferent mother and a disapproving father.

Between Newton the voyeur and woman as meat are some images of strange beauty. A naked diver suspended between ice-blue water

and trees like black splotches of watercolor bleeding into purple skies. A wax-pale nude in a salmon-colored satin robe caught against the dark-chocolate and pink patterns of Oscar Wilde's room. Newton's photographic competence sometimes veils his bitchy message. It's an odd case of form belying content, the seductive surfaces almost building up excitement while the photographer smirks into his sleeve. The publisher says the book is selling 1300–1400 copies a week in New York, and that Rizzoli reports their customers are mostly homosexuals and women. If women turn on to this book, it is probably because Newton seems to confirm two fundamental and ugly elements in feminine self-esteem: the common conviction that one's sexual fantasies are shameful and degrading, and the powerful idea that one's body is inferior and, therefore, somehow *bad* if it doesn't measure up to a fashionable standard. Newton's standard has to do with the high-fashion pursuit of perfection in accessories and surroundings as well as anatomy. He adds a kind of female correlative of machismo, an aggressive, almost angry self-sufficiency that passes for self-assurance.

Newton understands all too well the guilt and shame of fantasy. Slyly he removes the human reference. A dog stands with its paw on a woman's naked thigh, but the woman's head is obscured by architecture; so we may safely consider a body rather than an individual. In a tableau of two women, a flower droops down to cover the naked body's face, exactly as flowers in paintings once artfully covered the genitals of Adam and Eve. He uses all the trappings and scenarios of pornography, but discreetly, and with a finicky, up-to-the-minute chic, as if sex had been redesigned this year by a couturier. Whips, gloves, furs that open on nakedness, high-heeled shoes . . . the last are an obsession: red shoes atop coiled red hoses, women who clomp around swimming pools naked in gold platforms, women who relax at home by stripping down to their spikes. (Fetishists and sadistic daydreamers have always relished spikes, but high heels also exaggerate women's powerlessness. Courtesans in Renaissance Venice wore such ungainly stilts they needed a servant on each arm to keep them from toppling into lagoons.)

He touches all bases. A whiff of female bondage: women spread-eagled in gym or spa, hoses aimed between their legs. A strong dose of lesbianism, as stylized as dancing figures on music boxes, women so polished and static they could scarcely manage more than mechanical couplings. Two bare-breasted models lean close to kiss, one wearing hat and veil. Two melancholy models stand in the street, one naked except for a hat, the other in a man-tailored suit and with a man's haircut. A woman in garter belt and stockings pushes the head of

another down over the toilet "in the powder room at Regine's." This is what women do to each other. As to what women do to men: scenes of women murdering men (originally a fashion spread for men's suits in *Oui*). In the last murder, the woman straddles the man to suffocate him with a pillow. The next picture is "Wibeke riding her husband's mechanical bear" in exactly the same straddling position. The bear seems to scream, the closest approximation to passion in the book. Are we to infer she is metaphorically murdering her beastly husband, or merely his animal nature?

Like his theme, Newton's color is often acid or neon, harsher than life. Compositions are complex and intelligent, if overstudied, and he has a finely calibrated sense of visual shock. So adept is he at capturing the look of luxe that his photographs exude the authority of a privileged class: another layer of fantasy for the beholder. He concentrates so hard on sumptuous backgrounds that his models are frequently reduced to decoration, to nude furniture for expensive hotels. Newton's women are not so much objects as *objets*.

But often these women are so stony, so hostile, so tough and blasé that a man would have to bludgeon or fuck them into insensibility to soften them up and avoid being slowly devoured, as the male praying mantis is during the sexual act. The few heterosexual relationships—if you exclude the dog—are on the order of "Mr. and Mrs. Christopher Ward." Mr. Ward stands fully clothed, sporting a triumphant smile, and holding Mrs. Ward, naked, possibly unconscious, spread out across his arms. Picture of the modern wife as contented cavewoman.

Some of the insidious approach to the fantasy, violence, ambiguous sex, estrangement, and enmity between the sexes that mark *White Women* has begun to surface in fashion displays. Newton himself has contributed. High-fashion photographs have often delivered a few disquieting messages to women, generally envy of such faultless beauty, which neither rumples nor perspires. Now there is an added footnote: alienation from others, or from oneself, if the fantasy is too provoking. Last year, female mannequins in Bloomingdale's and Bendel's store windows began to lust for one another or contemplate suicide. Deborah Turbeville shot fashion photographs for *Vogue* in settings reminiscent of Auschwitz. Bloomingdale's last lingerie catalogue, photographed by Guy Bourdin, had numbers of women with their hands between their legs, and page after page of women who either eyed one another with distrust or would not look at one another at all. The sense of isolation is being used as a kind of seductive gimmick; the little flutter of anxiety adds still more electricity to the sexual atmosphere. But is it women who do not trust women, or homosexuals in the fashion world who,

this year, are selling women three-piece men's suits to mask the threat of female difference?

Helmut Newton's photographs of the fashionably undressed (and sometimes his fashion photographs as well) veil the threat in opulence and stamp it with the spurious authority of chic. The photographs in *White Women* say less about sex and pleasure than they do about alienation between men and women and, perhaps, between women and themselves. The nude body has been photographed with all kinds of emotions, desire not the least among them. Newton's camera, focused on the female body, prints out images of icy distrust and antagonism. It is all rather too beautiful for comfort.

Susan Sontag

"America, Seen Through Photographs, Darkly" 1977

AN EXCERPT

Susan Sontag (b. 1933), philosopher, essayist, author, created a stir among photographers and great interest on the part of the public with her book *On Photography*. Diane Arbus (1923–1971) is a provocative subject. She worked for a while in fashion photography. The pictures she took of people on the fringes of society in one respect or another were influenced by Weegee, Brassai, August Sander, and Bill Brandt. She first attracted a sizable audience in a 1967 show at the Museum of Modern Art in New York in company with the work of Lee Friedlander and Garry Winogrand. The theme of the show was that the aim of these new documentary photographers was "not to reform life, but to know it." A year after Arbus's death in 1971 her work was shown at the Venice Biennale, the first American photographer's to appear there.

As Walt Whitman gazed down the democratic vistas of culture, he tried to see beyond the difference between beauty and ugliness, importance and triviality. It seemed to him servile or snobbish to make any discriminations of value, except the most generous ones. Great claims were made for candor by our boldest, most delirious prophet of cultural revolution. Nobody would fret about beauty and ugliness, he implied,

who was accepting a sufficiently large embrace of the real, of the inclusiveness and vitality of actual American experience. All facts, even mean ones, are incandescent in Whitman's America—that ideal space, made real by history, where "as they emit themselves facts are showered with light."

The Great American Cultural Revolution heralded in the preface to the first edition of *Leaves of Grass* (1855) didn't break out, which has disappointed many but surprised none. One great poet alone cannot change the moral weather; even when the poet has millions of Red Guards at his disposal, it is still not easy. Like every seer of cultural revolution, Whitman thought he discerned art already being overtaken, and demystified, by reality. "The United States themselves are essentially the greatest poem." But when no cultural revolution occurred, and the greatest of poems seemed less great in days of Empire than it had under the Republic, only other artists took seriously Whitman's program of populist transcendence, of the democratic transvaluation of beauty and ugliness, importance and triviality. Far from having been themselves demystified by reality, the American arts—notably photography—now aspired to do the demystifying.

In photography's early decades, photographs were expected to be idealized images. This is still the aim of most amateur photographers, for whom a beautiful photograph is a photograph of something beautiful, like a woman, a sunset. In 1915 Edward Steichen photographed a milk bottle on a tenement fire escape, an early example of a quite different idea of the beautiful photograph. And since the 1920s, ambitious professionals, those whose work gets into museums, have steadily drifted away from lyrical subjects, conscientiously exploring plain, tawdry, or even vapid material. In recent decades, photography has succeeded in somewhat revising, for everybody, the definitions of what is beautiful and ugly—along the lines that Whitman had proposed. If (in Whitman's words) "each precise object or condition or combination or process exhibits a beauty," it becomes superficial to single out some things as beautiful and others as not. If "all that a person does or thinks is of consequence," it becomes arbitrary to treat some moments in life as important and most as trivial.

To photograph is to confer importance. There is probably no subject that cannot be beautified; moreover, there is no way to suppress the tendency inherent in all photographs to accord value to their subjects. But the meaning of value itself can be altered—as it has been in the contemporary culture of the photographic image which is a parody of Whitman's evangel. In the mansions of pre-democratic culture, someone who gets photographed is a celebrity. In the open fields of

American experience, as catalogued with passion by Whitman and as sized up with a shrug by Warhol, everybody is a celebrity. No moment is more important than any other moment; no person is more interesting than any other person.

The epigraph for a book of Walker Evans's photographs published by the Museum of Modern Art is a passage from Whitman that sounds the theme of American photography's most prestigious quest:

> I do not doubt but the majesty & beauty of the world are latent in any iota of the world . . . I do not doubt there is far more in trivialities, insects, vulgar persons, slaves, dwarfs, weeds, rejected refuse, than I have supposed. . . .

Whitman thought he was not abolishing beauty but generalizing it. So, for generations, did the most gifted American photographers, in their polemical pursuit of the trivial and the vulgar. But among American photographers who have matured since World War II, the Whitmanesque mandate to record in its entirety the extravagant candors of actual American experience has gone sour. In photographing dwarfs, you don't get majesty & beauty. You get dwarfs.

Starting from the images reproduced and consecrated in the sumptuous magazine *Camera Work* that Alfred Stieglitz published from 1903 to 1917 and exhibited in the gallery he ran in New York from 1905 to 1917 at 291 Fifth Avenue (first called the Little Gallery of the Photo-Secession, later simply "291")—magazine and gallery constituting the most ambitious forum of Whitmanesque judgments—American photography has moved from affirmation to erosion to, finally, a parody of Whitman's program. In this history the most edifying figure is Walker Evans. He was the last great photographer to work seriously and assuredly in a mood deriving from Whitman's euphoric humanism, summing up what had gone on before (for instance, Lewis Hine's stunning photographs of immigrants and workers), anticipating much of the cooler, ruder, bleaker photography that has been done since—as in the prescient series of "secret" photographs of anonymous New York subway riders that Evans took with a concealed camera between 1939 and 1941. But Evans broke with the heroic mode in which the Whitmanesque vision had been propagandized by Stieglitz and his disciples, who had condescended to Hine. Evans found Stieglitz's work arty.

Like Whitman, Stieglitz saw no contradiction between making art an instrument of identification with the community and aggrandizing the artist as a heroic, romantic, self-expressing ego. In his florid, brilliant book of essays, *Port of New York* (1924), Paul Rosenfeld hailed Stieglitz as one "of the great affirmers of life. There is no matter in all

the world so homely, trite, and humble that through it this man of the black box and chemical bath cannot express himself entire." Photographing, and thereby redeeming the homely, trite, and humble is also an ingenious means of individual expression. "The photographer," Rosenfeld writes of Stieglitz, "has cast the artist's net wider into the material world than any man before him or alongside him." Photography is a kind of overstatement, a heroic copulation with the material world. Like Hine, Evans sought a more impersonal kind of affirmation, a noble reticence, a lucid understatement. Neither in the impersonal architectural still lifes of American façades and inventories of rooms that he loved to make, nor in the exacting portraits of Southern sharecroppers he took in the late 1930s (published in the book done with James Agee, *Let Us Now Praise Famous Men*), was Evans trying to express himself.

Even without the heroic inflection, Evans's project still descends from Whitman's: the leveling of discriminations between the beautiful and the ugly, the important and the trivial. Each thing or person photographed becomes—a photograph; and becomes, therefore, morally equivalent to any other of his photographs. Evans's camera brought out the same formal beauty in the exteriors of Victorian houses in Boston in the early 1930s as in the store buildings on main streets in Alabama towns in 1936. But this was a leveling up, not down. Evans wanted his photographs to be "literate, authoritative, transcendent." The moral universe of the 1930s being no longer ours, these adjectives are barely credible today. Nobody demands that photography be literate. Nobody can imagine how it could be authoritative. Nobody understands how anything, least of all a photograph, could be transcendent.

Whitman preached empathy, concord in discord, oneness in diversity. Psychic intercourse with everything, everybody—plus sensual union (when he could get it)—is the giddy trip that is proposed explicitly, over and over and over, in the prefaces and the poems. This longing to proposition the whole world also dictated his poetry's form and tone. Whitman's poems are a psychic technology for chanting the reader into a new state of being (a microcosm of the "new order" envisaged for the polity); they are functional, like mantras—ways of transmitting charges of energy. The repetition, the bombastic cadence, the run-on lines, and the pushy diction are a rush of secular afflatus, meant to get readers psychically airborne, to boost them up to that height where they can identify with the past and with the community of American desire. But this message of identification with other Americans is foreign to our temperament now.

•

The last sigh of the Whitmanesque erotic embrace of the nation,

but universalized and stripped of all demands, was heard in the "Family of Man" exhibit organized in 1955 by Edward Steichen, Stieglitz's contemporary and co-founder of Photo-Secession. Five hundred and three photographs by two hundred and seventy-three photographers from sixty-eight countries were supposed to converge—to prove that humanity is "one" and that human beings, for all their flaws and villainies, are attractive creatures. The people in the photographs were of all races, ages, classes, physical types. Many of them had exceptionally beautiful bodies; some had beautiful faces. As Whitman urged the readers of his poems to identify with him and with America, Steichen set up the show to make it possible for each viewer to identify with a great many of the people depicted and, potentially, with the subject of every photograph: citizens of World Photography all.

It was not until seventeen years later that photography again attracted such crowds at the Museum of Modern Art: for the retrospective given Diane Arbus's work in 1972. In the Arbus show, a hundred and twelve photographs all taken by one person and all similar—that is, everyone in them looks (in some sense) the same—imposed a feeling exactly contrary to the reassuring warmth of Steichen's material. Instead of people whose appearance pleases, representative folk during their human thing, the Arbus show lined up assorted monsters and borderline cases—most of them ugly; wearing grotesque or unflattering clothing; in dismal or barren surroundings—who have paused to pose and, often, to gaze frankly, confidentially at the viewer. Arbus's work does not invite viewers to identify with the pariahs and miserable-looking people she photographed. Humanity is not "one."

The Arbus photographs convey the anti-humanist message which people of good will in the 1970s are eager to be troubled by, just as they wished, in the 1950s, to be consoled and distracted by a sentimental humanism. There is not as much difference between these messages as one might suppose. The Steichen show was an up and the Arbus show was a down, but either experience serves equally well to rule out a historical understanding of reality.

Steichen's choice of photographs assumes a "human condition" or a "human nature" shared by everybody. By purporting to show that individuals are born, work, laugh, and die everywhere in the same way, the "Family of Man" denies the determining weight of history—of genuine and historically embedded differences, injustices, and conflicts. Arbus's photographs undercut politics just as decisively, by suggesting a world in which everybody is an alien, hopelessly isolated, immobilized in mechanical, crippled identities and relationships. The pious uplift of Steichen's photograph anthology and the cool dejection

of the Arbus retrospective both render history and politics irrelevant. One does so by universalizing the human condition, into joy; the other by atomizing it, into horror.

The most striking aspect of Arbus's work is that she seems to have enrolled in one of art photography's most vigorous enterprises—concentrating on victims, on the unfortunate—but without the compassionate purpose that such a project is expected to serve. Her work shows people who are pathetic, pitiable, as well as repulsive, but it does not arouse any compassionate feelings. For what would be more correctly described as their dissociated point of view, the photographs have been praised for their candor and for an unsentimental empathy with their subjects. What is actually their aggressiveness toward the public has been treated as a moral accomplishment: that the photographs don't allow the viewer to be distant from the subject. More plausibly, Arbus's photographs—with their acceptance of the appalling—suggest a naïveté which is both coy and sinister, for it is based entirely on distance, on privilege, on a feeling that what the viewer is asked to look at is really *other*. Buñuel, when asked once why he made movies, said that it was "to show that this is not the best of all possible worlds." Arbus took photographs to show something simpler—that there is another world.

The other world is to be found, as usual, inside this one. Avowedly interested only in photographing people who "looked strange," Arbus found plenty of material close to home. New York, with its drag balls and welfare hotels, was rich with freaks. There was also a carnival in Maryland, where Arbus found a human pincushion, a hermaphrodite with a dog, a tattooed man, and an albino sword-swallower; nudist camps in New Jersey and in Pennsylvania; Disneyland and a Hollywood set, for their dead or fake "landscapes" without people; and the unidentified mental hospital where she took some of her last, and most disturbing, photographs. And there was always daily life, with its endless supply of oddities—if one has the eye to see them. The camera has the power to catch so-called normal people in such a way as to make them look abnormal. The photographer chooses oddity, chases it, frames it, develops it, titles it.

"You see someone on the street," Arbus wrote, "and essentially what you notice about them is the flaw." The insistent sameness of Arbus's work, however far she ranges from her prototypical subjects, shows that her sensibility, armed with a camera, could insinuate anguish, kinkiness, mental illness with any subject. Two photographs are of crying babies; the babies look disturbed, crazy. Resembling or having something in common with someone else is a recurrent source of

the ominous, according to the characteristic norms of Arbus's dissociated way of seeing. It may be two girls (not sisters) wearing identical raincoats whom Arbus photographed together in Central Park; or the twins and triplets who appear in several pictures. Many photographs point with oppressive wonder to the fact that two people form a couple. In Arbus's vision, every couple is an odd couple: straight or gay, black or white, in an old-age home or in a junior high. People looked eccentric because they didn't wear clothes, like nudists; or because they did, like the waitress in the nudist camp who's wearing an apron. Anybody Arbus photographed was a freak—a boy waiting to march in a pro-war parade, wearing his straw boater and his "Bomb Hanoi" button; the King and Queen of a Senior Citizens Dance; a thirtyish Westchester couple sprawled in their lawn chairs; a widow sitting alone in her cluttered bedroom. In "A Jewish giant at home with his parents in the Bronx, NY, 1970," the parents look like midgets, as wrong-sized as the enormous son hunched over them under their low living-room ceiling.

The authority of Arbus's photographs derives from the contrast between their lacerating subject matter and their calm, matter-of-fact attentiveness. This quality of attention—the attention paid by the photographer, the attention paid by the subject to the act of being photographed—creates the moral theater of Arbus's straight-on, contemplative portraits. Far from spying on freaks and pariahs, catching them unawares, the photographer has gotten to know them, reassured them—so that they pose for her as calmly and stiffly as any Victorian notable sat for a studio portrait by Julia Margaret Cameron. A large part of the mystery of Arbus's photographs lies in what they suggest about how her subjects felt after consenting to be photographed. Do they see themselves, the viewer wonders, like *that?* Do they know how grotesque they are? It seems as if they don't.

The subject of Arbus's photographs is, to borrow the stately Hegelian label, "the unhappy consciousness." But most characters in Arbus's Grand Guignol appear not to know that they are ugly. Arbus photographs people in various degrees of unconscious or unaware relation to their pain, their ugliness. This necessarily limits what kinds of horrors she might have been drawn to photograph: it excludes sufferers who presumably know they are suffering, like victims of accidents, wars, famines, and political persecutions. Arbus would never have taken pictures of accidents, events that break into a life; she specialized in slow-motion private smashups, most of which had been going on since the subject's birth.

Though most viewers are ready to imagine that these people, the citizens of the sexual underworld as well as the genetic freaks, are

unhappy, few of the pictures actually show emotional distress. The photographs of deviates and real freaks do not accent their pain but, rather, their detachment and autonomy. The female impersonators in their dressing rooms, the Russian midgets in a living room on 100th Street, the Mexican dwarf in his Manhattan hotel room, and their kin are mostly shown as cheerful, self-accepting, matter-of-fact. Pain is more legible in the portraits of the normals: the quarreling elderly couple on a park bench, the New Orleans lady bartender at home with a souvenir dog, the boy in Central Park clenching his toy hand grenade.

Brassaï denounced photographers who try to trap their subjects off-guard, in the erroneous belief that something special will be revealed about them.[1] In the world colonized by Arbus, subjects are always revealing themselves. There is no "decisive moment." Arbus's view that self-revelation is a continuous, evenly distributed process is another way of maintaining the Whitmanesque imperative: treat all moments as of equal consequence. Like Brassaï, Arbus wanted her subjects to be as fully conscious as possible, aware of the act in which they were participating. Instead of trying to coax her subjects into a "natural" or typical position, they are encouraged to be awkward—that is, to pose. (Thereby, the revelation of self gets identified with what is strange, odd, askew.) Standing or sitting stiffly makes them seem like images of themselves.

Most Arbus pictures have the subjects looking straight into the camera. This often makes them look even odder, almost deranged. Compare the 1912 photograph by Lartigue of a woman in a plumed hat and veil ("Racecourse at Nice") with Arbus's "Woman with a Veil on Fifth Avenue, NYC, 1968." Apart from the characteristic ugliness of Arbus's subject (Lartigue's subject is, just as characteristically, beautiful), what makes the woman in Arbus's photograph strange is the bold unselfconsciousness of her pose. If the Lartigue woman looked back, she might appear almost as strange.

In the normal rhetoric of the photographic portrait, facing the camera signifies solemnity, frankness, the disclosure of the subject's essence. That is why frontality seems right for ceremonial pictures (like weddings, graduations) but less apt for photographs used on billboards

1. *Not an error, really. There is something on people's faces when they don't know they are being observed that never appears when they do. If we did not know how Walker Evans took his subway photographs (riding the New York subways for hundreds of hours, standing with the lens of his camera peering between two buttons of his topcoat), it would be obvious from the pictures themselves that the seated passengers, although photographed close and frontally, didn't know they were being photographed; their expressions are private ones, not those they would offer to the camera.*

514 PHOTOGRAPHY IN PRINT

to advertise political candidates. (For politicians the three-quarter gaze is more common: a gaze that soars rather than confronts, suggesting instead of the relation to the viewer, to the present, the more ennobling abstract relation to the future.) What makes Arbus's use of the frontal pose so arresting is that her subjects are often people one would not expect to surrender themselves so amiably and ingenuously to the camera. Thus, in Arbus's photographs, frontality also implies in the most vivid way the subject's cooperation. To get these people to pose, the photographer has had to gain their confidence, has had to become "friends" with them.

Perhaps the scariest scene in Tod Browning's film *Freaks* (1932) is the wedding banquet, when pinheads, bearded women, Siamese twins, and living torsos dance and sing their acceptance of the wicked normal-sized Cleopatra, who has just married the gullible midget hero. "One of us! One of us! One of us!" they chant as a loving cup is passed around the table from mouth to mouth to be finally presented to the nauseated bride by an exuberant dwarf. Arbus had a perhaps over-simple view of the charm and hypocrisy and discomfort of fraternizing with freaks. Following the elation of discovery, there was the thrill of having won their confidence, of not being afraid of them, of having mastered one's aversion. Photographing freaks "had a terrific excitement for me," Arbus explained. "I just used to adore them."

•

Diane Arbus's photographs were already famous to people who follow photography when she killed herself in 1971; but, as with Sylvia Plath, the attention her work has attracted since her death is of another order—a kind of apotheosis. The fact of her suicide seems to guarantee that her work is sincere, not voyeuristic, that it is compassionate, not cold. Her suicide also seems to make the photographs more devastating, as if it proved the photographs to have been dangerous to her.

She herself suggested the possibility. "Everything is so superb and breathtaking," Arbus once wrote of her work. "I am creeping forward on my belly like they do in war movies." While photography is normally an omnipotent viewing from a distance, there is one situation in which people do get killed for taking pictures: when they photograph people killing each other. Only war photography combines voyeurism and danger. Combat photographers can't avoid participating in the lethal activity they record; they even wear military uniforms, though without rank badges. To discover (through photographing) that life is "really a melodrama," to understand the camera as a weapon of aggression, implies there will be casualties. "I'm sure there are limits," she wrote. "God knows, when the troops start advancing on you, you do

approach that stricken feeling where you perfectly well can get killed."
Arbus's words in retrospect describe a kind of combat death: having
trespassed certain limits, she fell in a psychic ambush, a casualty of her
own candor and curiosity.

In the old romance of the artist, any person who has the temerity
to spend a season in hell risks not getting out alive or coming back
psychically damaged. The heroic avant-gardism of French literature in
the late nineteenth and early twentieth centuries furnishes a memorable
pantheon of artists who fail to survive their trips to hell. Still, there is
a large difference between the activity of a photographer, which is
always willed, and the activity of a writer, which may not be. One has
the right to, may feel compelled to, give voice to one's own pain—
which is, in any case, one's own property. One volunteers to seek out
the pain of others.

Thus, what is finally most troubling in Arbus's photographs is not
their subject at all but the cumulative impression of the photographer's
consciousness: the sense that what is presented is precisely a private
vision, something voluntary. Arbus was not a poet delving into her
entrails to relate her own pain, but a photographer venturing out into
the world to *collect* images that are painful. And for pain sought rather
than just felt, there may be a less than obvious explanation. According
to Reich, the masochist's taste for pain does not spring from a love of
pain but from the hope of procuring, by means of pain, a strong sen-
sation; those handicapped by emotional or sensory analgesia only prefer
pain to not feeling anything at all. But there is another explanation of
why people seek pain, diametrically opposed to Reich's, that also seems
pertinent: that they seek it not to feel more but to feel less.

Insofar as looking at Arbus's photographs is, undeniably, an or-
deal, they are typical of the kind of art popular among sophisticated
urban people right now: art that is a self-willed test of hardness. Her
photographs offer an occasion to demonstrate that life's horror can be
faced without squeamishness. The photographer once had to say to
herself, Okay, I can accept that; the viewer is invited to make the same
declaration.

Arbus's work is a good instance of a leading tendency of high art
in capitalist countries: to suppress, or at least reduce, moral and sensory
queasiness. Much of modern art is devoted to lowering the threshold
of what is terrible. By getting us used to what, formerly, we could not
bear to see or hear, because it was too shocking, painful, or embarrass-
ing, art changes morals—that body of psychic custom and public sanc-
tions that draws a vague boundary between what is emotionally and
spontaneously intolerable and what is not. The gradual suppression of

queasiness does bring us closer to a rather formal truth—that of the arbitrariness of the taboos constructed by art and morals. But our ability to stomach this rising grotesqueness in images (moving and still) and in print has a stiff price. In the long run, it works out not as a liberation of but as a subtraction from the self: a pseudo-familiarity with the horrible reinforces alienation, making one less able to react in real life. What happens to people's feelings on first exposure to today's neighborhood pornographic film or to tonight's televised atrocity is not so different from what happens when they first look at Arbus's photographs.

The photographs make a compassionate response feel irrelevant. The point is not to be upset, to be able to confront the horrible with equanimity. But this look that is not (mainly) compassionate is a special, modern ethical construction: not hardhearted, certainly not cynical, but simply (or falsely) naïve. To the painful nightmarish reality "out there," Arbus applied such adjectives as "terrific," "interesting," "incredible," "fantastic," "sensational"—the childlike wonder of the Warhol pop mentality. The camera—according to her deliberately naïve image of the photographer's quest—is a device that captures it all, that seduces subjects into disclosing their secrets, that broadens experience. To photograph people, according to Arbus, is necessarily "cruel," "mean." The important thing is not to blink.

"Photography was a license to go wherever I wanted and to do what I wanted to do," Arbus wrote. The camera is a kind of passport that annihilates moral boundaries and social inhibitions, freeing the photographer from any responsibility toward the people photographed. The whole point of photographing people is that you are not intervening in their lives, only visiting them. The photographer is supertourist, an extension of the anthropologist, visiting natives and bringing back news of their exotic doings and strange gear. The photographer is always trying to colonize new experiences, or find new ways to look at familiar subjects—to fight against boredom. For boredom is just the reverse side of fascination: both depend on being outside rather than inside a situation, and one leads to the other. "The Chinese have a theory that you pass through boredom into fascination," Arbus noted. Photographing an appalling underworld (and a desolate, plastic overworld), she had no intention of entering into the horror experienced by the denizens of those worlds. They are to remain exotic, hence "terrific." Her view is always from the outside.

•

"I'm very little drawn to photographing people that are known or even subjects that are known," Arbus wrote. "They fascinate me when

I've barely heard of them." However drawn she was to the maimed and the ugly, it would never have occurred to Arbus to photograph Thalidomide babies or napalm victims—public horrors, deformities with sentimental or ethical associations. Arbus was not interested in ethical journalism. She chose subjects that she could believe were found, just lying about, without any values attached to them. These subjects are necessarily ahistorical—private rather than public pathology, secret lives rather than open ones.

For Arbus, the camera photographs the unknown. But unknown to whom? Unknown to someone who is protected, who has been schooled in moralistic and in prudent responses. Like Nathanael West, another artist fascinated by the deformed and mutilated, Arbus came from a verbally skilled, compulsively health-minded, indignation-prone, well-to-do Jewish family, for whom minority sexual tastes lived way below the threshold of awareness and risk-taking was despised as another goyish craziness. "One of the things I felt I suffered from as a kid," Arbus wrote, "was that I never felt adversity. I was confined in a sense of unreality. . . . And the sense of being immune was, ludicrous as it seems, a painful one." Feeling much the same discontent, West took a job as a night clerk in a seedy Manhattan hotel in 1927. Arbus's way of procuring experience, and thereby acquiring a sense of reality, was the camera. By experience was meant, if not material adversity, at least psychological adversity—the shock of immersion in experiences that cannot be beautified, the encounter with what is taboo, perverse, evil.

Arbus's interest in freaks expresses a desire to violate her own innocence, to undermine her sense of being privileged, to vent her frustration at being safe. Apart from West, the 1930s yield few examples of this kind of distress. More typically, it is the sensibility of someone educated and middle-class who came of age after 1935 and before 1955—a sensibility that was to flourish precisely in the 1960s.

The decade of Arbus's serious work coincides with, and is very much of, the sixties, the decade in which freaks went public, and became a safe, approved subject of art. What in the 1930s was treated with anguish—for example, *Miss Lonelyhearts*—would in the 1960s be treated in a perfectly deadpan way (Warhol) or with positive relish (the comics of R. Crumb; the films of Fellini, Arrabal, Alejandro Jodorowsky; the spectacles of Alice Cooper, David Bowie, the New York Dolls). At the beginning of the 1960s, the thriving Freak Show at Coney Island was outlawed; the pressure is on to raze the Times Square turf of drag queens and hustlers and cover it with skyscrapers. As the inhabitants of deviant underworlds are evicted from their re-

stricted territories—banned as unseemly, a public nuisance, obscene, or just unprofitable—they increasingly come to infiltrate consciousness as the subject matter of art, acquiring a certain diffuse legitimacy and metaphoric proximity which creates all the more distance.

Who could have better appreciated the truth of freaks than someone like Arbus, who was by profession a fashion photographer—a fabricator of the cosmetic lie that masks the intractable inequalities of birth and class and physical appearance. But unlike Warhol, who spent many years as a commercial artist, Arbus did not make her serious work out of promoting and kidding the aesthetic of glamour to which she had been apprenticed, but turned her back on it entirely. Arbus's work is reactive—reactive against gentility, against what is approved. It was her way of saying fuck *Vogue*, fuck fashion, fuck what's pretty. This challenge takes two not wholly compatible forms. One is a revolt against the Jews' hyper-developed moral sensibility. The other revolt, itself hotly moralistic, turns against the success world. The moralist's subversion advances life as a failure as the antidote to life as a success. The aesthete's subversion, which the sixties was to make peculiarly its own, advances life as a horror show as the antidote to life as a bore.

Most of Arbus's work lies within the Warhol aesthetic, that is, defines itself in relation to the twin poles of boringness and freakishness; but it doesn't have the Warhol style. Arbus had neither Warhol's narcissism and genius for publicity nor the self-protective blandness with which he insulates himself from the freaky nor his sentimentality. It is unlikely that Warhol, who comes from a working-class family, ever felt any of the ambivalence toward success which afflicted the children of the Jewish upper middle classes in the 1960s. To someone raised as a Catholic, like Warhol (and virtually everyone in his gang), a fascination with evil comes much more genuinely than it does to someone from a Jewish background. Compared with Warhol, Arbus seems strikingly vulnerable, innocent—and certainly more pessimistic. Her Dantesque vision of the city (and the suburbs) has no reserves of irony. Although much of Arbus's material is the same as that depicted in, say, Warhol's *Chelsea Girls* (1966), her photographs never play with horror, milking it for laughs; they offer no opening to mockery, and no possibility of finding freaks endearing, as do Warhol's films and those of Paul Morrissey. For Arbus, both freaks and Middle America were equally exotic: a boy marching in a pro-war parade and a Levittown housewife were as alien as a dwarf or a transvestite; lower-middle-class suburbia was as remote as Times Square, lunatic asylums, and gay bars. Arbus's work expressed her turn against what was public (as she experienced it), conventional, safe, reassuring—and boring—in favor of what was private, hidden, ugly, dangerous, and fascinating. These

contrasts, now, seem almost quaint. What is safe no longer monopolizes public imagery. The freakish is no longer a private zone, difficult of access. People who are bizarre, in sexual disgrace, emotionally vacant are seen daily on the newsstands, on TV, in the subways. Hobbesian man roams the streets, quite visible, with glitter in his hair.

•

Sophisticated in the familiar modernist way—choosing awkwardness, naïveté, sincerity over the slickness and artificiality of high art and high commerce—Arbus said that the photographer she felt closest to was Weegee, whose brutal pictures of crime and accident victims were a staple of the tabloids in the 1940s. Weegee's photographs are indeed upsetting, his sensibility is urban; but the similarity between his work and Arbus's ends there. However eager she was to disavow standard elements of photographic sophistication such as "composition," Arbus was not unsophisticated. And there is nothing journalistic about her motives for taking pictures. What may seem journalistic, even sensational, in Arbus's photographs places them, rather, in the main tradition of Surrealist art—their taste for the grotesque, their professed innocence with respect to their subjects, their claim that all subjects are merely *objets trouvés*.

"I would never choose a subject for what it meant to me when I think of it," Arbus wrote, a dogged exponent of the Surrealist bluff. Presumably, viewers are not supposed to judge the people she photographs. Of course, we do. And the very range of Arbus's subjects itself constitutes a judgment. Brassaï, who photographed people like those who interested Arbus—see his " 'Bijou' of Montmartre" of 1932—also did tender cityscapes, portraits of famous artists. Lewis Hine's "Mental Institution, New Jersey, 1924" could be a late Arbus photograph (except that the pair of Mongoloid children posing on the lawn are photographed in profile rather than frontally); the Chicago street portraits Walker Evans took in 1946 are Arbus material, as are a number of photographs by Robert Frank. The difference is in the range of other subjects, other emotions that Hine, Brassaï, Evans, and Frank also photographed. Arbus is an *auteur* in the most limiting sense, as special a case in the history of photography as is Giorgio Morandi, who spent a half century doing still lifes of bottles, in the history of modern European painting. She does not, like most ambitious photographers, play the field of subject matter—even a little. On the contrary, all her subjects are equivalent. And making equivalences between freaks, mad people, suburban couples, and nudists is a very powerful judgment, one in complicity with a recognizable political mood shared by many educated, left-liberal Americans. The subjects of Arbus's photographs are all members of the same family; inhabitants of a single village.

Only, as it happens, the idiot village is America. Instead of showing identity between things which are different (Whitman's democratic vista), everybody is shown to look the same.

Succeeding the more buoyant hopes for America has come a bitter, sad embrace of experience. There is a particular melancholy in the American photographic project. But the melancholy was already latent in the heyday of Whitmanesque affirmation, as represented by Stieglitz and his Photo-Secession circle. Stieglitz, pledged to redeem the world with his camera, was still shocked by modern material civilization. He photographed New York in the 1910s in an almost quixotic spirit—camera/lance against skyscraper/windmill. Paul Rosenfeld described Stieglitz's work as a "perpetual affirmation of a faith that there existed, somewhere, here in very New York, a spiritual America." The Whitmanesque appetites have turned pious: the photographer now patronizes reality. One needs a camera to show that "running right through the dull and marvelous opacity called the United States" are spiritual patterns.

Obviously, a mission as rotten with doubt about America—even at its most optimistic—was bound to get deflated fairly soon, as post-World War I America committed itself more boldly to business and consumerism. Photographers with less ego and magnetism than Stieglitz gradually gave up the struggle. They might continue to practice the atomistic visual stenography inspired by Whitman. But, without Whitman's delirious powers of synthesis, what they documented was discontinuity, detritus, loneliness, greed, sterility. Stieglitz, using photography to challenge the materialist civilization, was, in Rosenfeld's words, "the man who believed that a spiritual America existed somewhere, that America was not the grave of the Occident." The implicit intent of Frank and Arbus, and of many of their contemporaries and juniors, is to show that America *is* the grave of the Occident.

Since photography cut loose from the Whitmanesque affirmation —since it has ceased to understand how photographs could aim at being literate, authoritative, transcendent—the best of American photography (and much else in American culture) has given itself over to the consolations of Surrealism, and America has been discovered as the quintessential Surrealist country. It is obviously too easy to say that America is just a freak show, a wasteland—the cut-rate pessimism typical of the reduction of the real to the surreal. But the American partiality to myths of redemption and damnation remains one of the most energizing, most seductive aspects of our national culture. What we have left of Whitman's discredited dream of cultural revolution are paper ghosts and a sharp-eyed witty program of despair.

Roland Barthes

"The Photographic Message"
Translated by Stephen Heath
1977
AN EXCERPT

The relatively new discipline of semiology seeks to determine
the structure of forms by interpreting the societal role of signs
and symbols. Walter Benjamin was a forerunner of the sci-
ence; Roland Barthes, a Frenchman, was one of its chief for-
mulators. In the following investigation of the structure of
the photographic message, Barthes asserts that the photo-
graph is a message without a code, an observation related to
William Ivins's, that the photograph has no syntax. But he
asserts that the photograph (here he is dealing with the press
photograph) has, paradoxically, a second order of meaning, a
connotation, which must be deciphered, and that the text or
caption complicates that meaning.

The press photograph is a message. Considered overall this message is
formed by a source of emission, a channel of transmission and a point
of reception. The source of emission is the staff of the newspaper, the
group of technicians certain of whom take the photo, some of whom
choose, compose and treat it, while others, finally, give it a title, a
caption and a commentary. The point of reception is the public which
reads the paper. As for the channel of transmission, this is the news-
paper itself, or, more precisely, a complex of concurrent messages with

the photograph as centre and surrounds constituted by the text, the title, the caption, the lay-out and, in a more abstract but no less 'informative' way, by the very name of the paper (this name represents a knowledge that can heavily orientate the reading of the message strictly speaking: a photograph can change its meaning as it passes from the very conservative *L'Aurore* to the communist *L'Humanité*). These observations are not without their importance for it can readily be seen that in the case of the press photograph the three traditional parts of the message do not call for the same method of investigation. The emission and the reception of the message both lie within the field of a sociology: it is a matter of studying human groups, of defining motives and attitudes, and of trying to link the behaviour of these groups to the social totality of which they are a part. For the message itself, however, the method is inevitably different: whatever the origin and the destination of the message, the photograph is not simply a product or a channel but also an object endowed with a structural autonomy. Without in any way intending to divorce this object from its use, it is necessary to provide for a specific method prior to sociological analysis and which can only be the immanent analysis of the unique structure that a photograph constitutes.

Naturally, even from the perspective of a purely immanent analysis, the structure of the photograph is not an isolated structure; it is in communication with at least one other structure, namely the text— title, caption or article—accompanying every press photograph. The totality of the information is thus carried by two different structures (one of which is linguistic). These two structures are co-operative but, since their units are heterogeneous, necessarily remain separate from one another: here (in the text) the substance of the message is made up of words; there (in the photograph) of lines, surfaces, shades. Moreover, the two structures of the message each occupy their own defined spaces, these being contiguous but not 'homogenized,' as they are for example in the rebus which fuses words and images in a single line of reading. Hence, although a press photograph is never without a written commentary, the analysis must first of all bear on each separate structure; it is only when the study of each structure has been exhausted that it will be possible to understand the manner in which they complement one another. Of the two structures, one is already familiar, that of language (but not, it is true, that of the 'literature' formed by the language-use of the newspaper; an enormous amount of work is still to be done in this connection), while almost nothing is known about the other, that of the photograph. What follows will be limited to the definition of the initial difficulties in providing a structural analysis of the photographic message.

THE PHOTOGRAPHIC PARADOX

What is the content of the photographic message? What does the photograph transmit? By definition, the scene itself, the literal reality. From the object to its image there is of course a reduction—in proportion, perspective, colour—but at no time is this reduction a *transformation* (in the mathematical sense of the term). In order to move from the reality to its photograph it is in no way necessary to divide up this reality into units and to constitute these units as signs, substantially different from the object they communicate; there is no necessity to set up a relay, that is to say a code, between the object and its image. Certainly the image is not the reality but at least it is its perfect *analogon* and it is exactly this analogical perfection which, to common sense, defines the photograph. Thus can be seen the special status of the photographic image: *it is a message without a code;* from which proposition an important corollary must immediately be drawn: the photographic message is a continuous message.

Are there other messages without a code? At first sight, yes: precisely the whole range of analogical reproductions of reality—drawings, paintings, cinema, theatre. In fact, however, each of those messages develops in an immediate and obvious way a supplementary message, in addition to the analogical content itself (scene, object, landscape), which is what is commonly called the *style* of the reproduction; second meaning, whose signifier is a certain 'treatment' of the image (result of the action of the creator) and whose signified, whether aesthetic or ideological, refers to a certain 'culture' of the society receiving the message. In short, all these 'imitative' arts comprise two messages: a *denoted* message, which is the *analogon* itself, and a *connoted* message, which is the manner in which the society to a certain extent communicates what it thinks of it. This duality of messages is evident in all reproductions other than photographic ones: there is no drawing, no matter how exact, whose very exactitude is not turned into a style (the style of 'verism'); no filmed scene whose objectivity is not finally read as the very sign of objectivity. Here again, the study of these connoted messages has still to be carried out (in particular it has to be decided whether what is called a work of art can be reduced to a system of significations); one can only anticipate that for all these imitative arts —when common—the code of the connoted system is very likely constituted either by a universal symbolic order or by a period rhetoric, in short by a stock of stereotypes (schemes, colours, graphisms, gestures, expressions, arrangements of elements).

When we come to the photograph, however, we find in principle nothing of the kind, at any rate as regards the press photograph (which is never an 'artistic' photograph). The photograph professing to be a mechanical analogue of reality, its first-order message in some sort completely fills its substance and leaves no place for the development of a second-order message. Of all the structures of information,[1] the photograph appears as the only one that is exclusively constituted and occupied by a 'denoted' message, a message which totally exhausts its mode of existence. In front of a photograph, the feeling of 'denotation,' or, if one prefers, of analogical plenitude, is so great that the description of a photograph is literally impossible; *to describe* consists precisely in joining to the denoted message a relay or second-order message derived from a code which is that of language and constituting in relation to the photographic analogue, however much care one takes to be exact, a connotation: to describe is thus not simply to be imprecise or incomplete, it is to change structures, to signify something different to what is shown.[2]

This purely 'denotative' status of the photograph, the perfection and plenitude of its analogy, in short its 'objectivity,' has every chance of being mythical (these are the characteristics that common sense attributes to the photograph). In actual fact, there is a strong probability (and this will be a working hypothesis) that the photographic message too—at least in the press—is connoted. Connotation is not necessarily immediately graspable at the level of the message itself (it is, one could say, at once invisible and active, clear and implicit) but it can already be inferred from certain phenomena which occur at the levels of the production and reception of the message: on the one hand, the press photograph is an object that has been worked on, chosen, composed, constructed, treated according to professional, aesthetic or ideological norms which are so many factors of connotation; while on the other, this same photograph is not only perceived, received, it is *read*, connected more or less consciously by the public that consumes it to a traditional stock of signs. Since every sign supposes a code, it is

1. *It is a question, of course, of 'cultural' or culturalized structures, not of operational structures. Mathematics, for example, constitutes a denoted structure without any connotation at all; should mass society seize on it, however, setting out for instance an algebraic formula in an article on Einstein, this originally purely mathematical message now takes on a very heavy connotation, since it* signifies *science.*

2. *The description of a drawing is easier, involving, finally, the description of a structure that is already connoted, fashioned with a* coded *signification in view. It is for this reason perhaps that psychological texts use a great many drawings and very few photographs.*

this code (of connotation) that one should try to establish. The photo-graphic paradox can then be seen as the co-existence of two messages, the one without a code (the photographic analogue), the other with a code (the 'art,' or the treatment, or the 'writing,' or the rhetoric, of the photograph); structurally, the paradox is clearly not the collusion of a denoted message and a connoted message (which is the—probably inevitable—status of all the forms of mass communication), it is that here the connoted (or coded) message develops on the basis of a message *without a code*. This structural paradox coincides with an ethical para-dox: when one wants to be 'neutral,' 'objective,' one strives to copy reality meticulously, as though the analogical were a factor of resistance against the investment of values (such at least is the definition of aes-thetic 'realism'); how then can the photograph be at once 'objective' and 'invested,' natural and cultural? It is through an understanding of the mode of imbrication of denoted and connoted messages that it may one day be possible to reply to that question. In order to undertake this work, however, it must be remembered that since the denoted message in the photograph is absolutely analogical, which is to say *continuous*, outside of any recourse to a code, there is no need to look for the signifying units of the first-order message; the connoted message on the contrary does comprise a plane of expression and a plane of content, thus necessitating a veritable decipherment. Such a decipherment would as yet be premature, for in order to isolate the signifying units and the signified themes (or values) one would have to carry out (per-haps using tests) directed readings, artificially varying certain elements of a photograph to see if the variations of forms led to variations in meaning. What can at least be done now is to forecast the main planes of analysis of photographic connotation.

CONNOTATION PROCEDURES

Connotation, the imposition of second meaning on the photographic message proper, is realized at the different levels of the production of the photograph (choice, technical treatment, framing, lay-out) and rep-resents, finally, a coding of the photographic analogue. It is thus pos-sible to separate out various connotation procedures, bearing in mind however that these procedures are in no way units of signification such as a subsequent analysis of a semantic kind may one day manage to define; they are not strictly speaking part of the photographic structure. The procedures in question are familiar and no more will be attempted here than to translate them into structural terms. To be fully exact, the

first three (trick effects, pose, objects) should be distinguished from the last three (photogenia, aestheticism, syntax), since in the former the connotation is produced by a modification of the reality itself, of, that is, the denoted message (such preparation is obviously not peculiar to the photograph). If they are nevertheless included amongst the connotation procedures, it is because they too benefit from the prestige of the denotation: the photograph allows the photographer to *conceal elusively* the preparation to which he subjects the scene to be recorded. Yet the fact still remains that there is no certainty from the point of view of a subsequent structural analysis that it will be possible to take into account the material they provide.

1. *Trick effects.* A photograph given wide circulation in the American press in 1951 is reputed to have cost Senator Millard Tydings his seat; it showed the Senator in conversation with the Communist leader Earl Browder. In fact, the photograph had been faked, created by the artificial bringing together of the two faces. The methodological interest of trick effects is that they intervene without warning in the plane of denotation; they utilize the special credibility of the photograph—this, as was seen, being simply its exceptional power of denotation—in order to pass off as merely denoted a message which is in reality heavily connoted; in no other treatment does connotation assume so completely the 'objective' mask of denotation. Naturally, signification is only possible to the extent that there is a stock of signs, the beginnings of a code. The signifier here is the conversational attitude of the two figures and it will be noted that this attitude becomes a sign only for a certain society, only given certain values. What makes the speakers' attitude the sign of a reprehensible familiarity is the tetchy anti-Communism of the American electorate; which is to say that the code of connotation is neither artificial (as in a true language) nor natural, but historical.

2. *Pose.* Consider a press photograph of President Kennedy widely distributed at the time of the 1960 election: a half-length profile shot, eyes looking upwards, hands joined together. Here it is the very pose of the subject which prepares the reading of the signifieds of connotation: youthfulness, spirituality, purity. The photograph clearly only signifies because of the existence of a store of stereotyped attitudes which form ready-made elements of signification (eyes raised heavenwards, hands clasped). A 'historical grammar' of iconographic connotation ought thus to look for its material in painting, theatre, associations of ideas, stock metaphors, etc., that is to say, precisely in 'culture.' As has been said, pose is not a specifically photographic procedure but it is difficult not to mention it insofar as it derives its effect from the analogical principle at the basis of the photograph. The

message in the present instance is not 'the pose' but 'Kennedy praying':
the reader receives as a simple denotation what is in actual fact a double
structure—denoted-connoted.

3. *Objects*. Special importance must be accorded to what could be
called the posing of objects, where the meaning comes from the objects
photographed (either because these objects have, if the photographer
had the time, been artificially arranged in front of the camera or be-
cause the person responsible for lay-out chooses a photograph of this
or that object). The interest lies in the fact that the objects are accepted
inducers of associations of ideas (book-case = intellectual) or, in a more
obscure way, are veritable symbols (the door of the gas-chamber for
Chessman's execution with its reference to the funeral gates of ancient
mythologies). Such objects constitute excellent elements of significa-
tion: on the one hand they are discontinuous and complete in them-
selves, a physical qualification for a sign, while on the other they refer
to clear, familiar signifieds. They are thus the elements of a veritable
lexicon, stable to a degree which allows them to be readily constituted
into syntax. Here, for example, is a 'composition' of objects: a window
opening on to vineyards and tiled roofs; in front of the window a
photograph album, a magnifying glass, a vase of flowers. Conse-
quently, we are in the country, south of the Loire (vines and tiles), in
a bourgeois house (flowers on the table) whose owner, advanced in
years (the magnifying glass), is reliving his memories (the photograph
album)—François Mauriac in Malagar (photo in *Paris-Match*). The con-
notation somehow 'emerges' from all these signifying units which are
nevertheless 'captured' as though the scene were immediate and spon-
taneous, that is to say, without signification. The text renders the
connotation explicit, developing the theme of Mauriac's ties with the
land. Objects no longer perhaps possess a *power*, but they certainly
possess meanings.

4. *Photogenia*. The theory of photogenia has already been devel-
oped (by Edgar Morin in *Le Cinéma ou l'homme imaginaire* [3]) and this is
not the place to take up again the subject of the general signification of
that procedure; it will suffice to define photogenia in terms of infor-
mational structure. In photogenia the connoted message is the image
itself, 'embellished' (which is to say in general sublimated) by tech-
niques of lighting, exposure and printing. An inventory needs to be
made of these techniques, but only insofar as each of them has a cor-
responding signified of connotation sufficiently constant to allow its
incorporation in a cultural lexicon of technical 'effects' (as for instance

3. *Edgar Morin*, Le Cinéma ou l'homme imaginaire, *Paris 1956*.

the 'blurring of movement' or 'flowingness' launched by Dr. Steinert and his team to signify space-time). Such an inventory would be an excellent opportunity for distinguishing aesthetic effects from signifying effects—unless perhaps it be recognized that in photography, contrary to the intentions of exhibition photographers, there is never *art* but always *meaning;* which precisely would at last provide an exact criterion for the opposition between good painting, even if strongly representational, and photography.

5. *Aestheticism.* For if one can talk of aestheticism in photography, it is seemingly in an ambiguous fashion: when photography turns painting, composition or visual substance treated with deliberation in its very material 'texture,' it is either so as to signify itself as 'art' (which was the case with the 'pictorialism' of the beginning of the century) or to impose a generally more subtle and complex signified than would be possible with other connotation procedures. Thus Cartier-Bresson constructed Cardinal Pacelli's reception by the faithful of Lisieux like a painting by an early master. The resulting photograph, however, is in no way a painting: on the one hand, its display of aestheticism refers (damagingly) to the very idea of a painting (which is contrary to any true painting); while on the other, the composition signifies in a declared manner a certain ecstatic spirituality translated precisely in terms of an objective spectacle. One can see here the difference between photograph and painting: in a picture by a Primitive, 'spirituality' is not a signified but, as it were, the very being of the image. Certainly there may be coded elements in some paintings, rhetorical figures, period symbols, but no signifying unit refers to spirituality, which is a mode of being and not the object of a structured message.

6. *Syntax.* We have already considered a discursive reading of object-signs within a single photograph. Naturally, several photographs can come together to form a sequence (this is commonly the case in illustrated magazines); the signifier of connotation is then no longer to be found at the level of any one of the fragments of the sequence but at that—what the linguists would call the suprasegmental level—of the concatenation. Consider for example four snaps of a presidential shoot at Rambouillet: in each the illustrious sportsman (Vincent Auriol) is pointing his rifle in some unlikely direction, to the great peril of the keepers who run away or fling themselves to the ground. The sequence (and the sequence alone) offers an effect of comedy which emerges, according to a familiar procedure, from the repetition and variation of the attitudes. It can be noted in this connection that the single photograph, contrary to the drawing, is very rarely (that is, only with much difficulty) comic; the comic requires movement, which

is to say repetition (easy in film) or typification (possible in drawing), both these 'connotations' being prohibited to the photograph.

TEXT AND IMAGE

Such are the main connotation procedures of the photographic image (once again, it is a question of techniques, not of units). To these may invariably be added the text which accompanies the press photograph. Three remarks should be made in this context.

Firstly, the text constitutes a parasitic message designed to connote the image, to 'quicken' it with one or more second-order signifieds. In other words, and this is an important historical reversal, the image no longer *illustrates* the words; it is now the words which, structurally, are parasitic on the image. The reversal is at a cost: in the traditional modes of illustration the image functioned as an episodic return to denotation from a principal message (the text) which was experienced as connoted since, precisely, it needed an illustration; in the relationship that now holds, it is not the image which comes to elucidate or 'realize' the text, but the latter which comes to sublimate, patheticize or rationalize the image. As however this operation is carried out accessorily, the new informational totality appears to be chiefly founded on an objective (denoted) message in relation to which the text is only a kind of secondary vibration, almost without consequence. Formerly, the image illustrated the text (made it clearer); today, the text loads the image, burdening it with a culture, a moral, an imagination. Formerly, there was reduction from text to image; today, there is amplification from the one to the other. The connotation is now experienced only as the natural resonance of the fundamental denotation constituted by the photographic analogy and we are thus confronted with a typical process of naturalization of the cultural.

Secondly, the effect of connotation probably differs according to the way in which the text is presented. The closer the text to the image, the less it seems to connote it; caught as it were in the iconographic message, the verbal message seems to share in its objectivity, the connotation of language is 'innocented' through the photograph's denotation. It is true that there is never a real incorporation since the substances of the two structures (graphic and iconic) are irreducible, but there are most likely degrees of amalgamation. The caption probably has a less obvious effect of connotation than the headline or accompanying article: headline and article are palpably separate from the image, the former by its emphasis, the latter by its distance; the first

because it breaks, the other because it distances the content of the image. The caption, on the contrary, by its very disposition, by its average measure of reading, appears to duplicate the image, that is, to be included in its denotation.

It is impossible however (and this will be the final remark here concerning the text) that the words 'duplicate' the image; in the movement from one structure to the other second signifieds are inevitably developed. What is the relationship of these signifieds of connotation to the image? To all appearances, it is one of making explicit, of providing a stress; the text most often simply amplifying a set of connotations already given in the photograph. Sometimes, however, the text produces (invents) an entirely new signified which is retroactively projected into the image, so much so as to appear denoted there. *'They were near to death, their faces prove it,'* reads the headline to a photograph showing Elizabeth and Philip leaving a plane—but at the moment of the photograph the two still knew nothing of the accident they had just escaped. Sometimes too, the text can even contradict the image so as to produce a compensatory connotation. An analysis by Gerbner (*The Social Anatomy of the Romance Confession Cover-girl*) demonstrated that in certain romance magazines the verbal message of the headlines, gloomy and anguished, on the cover always accompanied the image of a radiant cover-girl; here the two messages enter into a compromise, the connotation having a regulating function, preserving the irrational movement of projection-identification.

PHOTOGRAPHIC INSIGNIFICANCE

We saw that the code of connotation was in all likelihood neither 'natural' nor 'artificial' but historical, or, if it be preferred, 'cultural.' Its signs are gestures, attitudes, expressions, colours or effects, endowed with certain meanings by virtue of the practice of a certain society: the link between signifier and signified remains if not unmotivated, at least entirely historical. Hence it is wrong to say that modern man projects into reading photographs feelings and values which are characterial or 'eternal' (infra- or trans-historical), unless it be firmly specified that *signification* is always developed by a given society and history. Signification, in short, is the dialectical movement which resolves the contradiction between cultural and natural man.

Thanks to its code of connotation the reading of the photograph is thus always historical; it depends on the reader's 'knowledge' just as though it were a matter of a real language [*langue*], intelligible only if

one has learned the signs. All things considered, the photographic 'language' ['*langage*'] is not unlike certain ideographic languages which mix analogical and specifying units, the difference being that the ideogram is experienced as a sign whereas the photographic 'copy' is taken as the pure and simple denotation of reality. To find this code of connotation would thus be to isolate, inventoriate and structure all the 'historical' elements of the photograph, all the parts of the photographic surface which derive their very discontinuity from a certain knowledge on the reader's part, or, if one prefers, from the reader's cultural situation.

This task will perhaps take us a very long way indeed. Nothing tells us that the photograph contains 'neutral' parts, or at least it may be that complete insignificance in the photograph is quite exceptional. To resolve the problem, we would first of all need to elucidate fully the mechanisms of reading (in the physical, and no longer the semantic, sense of the term), of the perception of the photograph. But on this point we know very little. How do we read a photograph? What do we perceive? In what order, according to what progression? If, as is suggested by certain hypotheses of Bruner and Piaget, there is no perception without immediate categorization, then the photograph is verbalized in the very moment it is perceived; better, it is only perceived verbalized (if there is a delay in verbalization, there is disorder in perception, questioning, anguish for the subject, traumatism, following G. Cohen-Séat's hypothesis with regard to filmic perception). From this point of view, the image—grasped immediately by an inner metalanguage, language itself—in actual fact has no denoted state, is immersed for its very social existence in at least an initial layer of connotation, that of the categories of language. We know that every language takes up a position with regard to things, that it connotes reality, if only in dividing it up; the connotations of the photograph would thus coincide, *grosso modo*, with the overall connotative planes of language.

In addition to 'perceptive' connotation, hypothetical but possible, one then encounters other, more particular, modes of connotation, and firstly a 'cognitive' connotation whose signifiers are picked out, localized, in certain parts of the analogon. Faced with such and such a townscape, I *know* that this is a North African country because on the left I can see a sign in Arabic script, in the centre a man wearing a gandoura, and so on. Here the reading closely depends on my culture, on my knowledge of the world, and it is probable that a good press photograph (and they are all good, being selected) makes ready play with the supposed knowledge of its readers, those prints being chosen

which comprise the greatest possible quantity of information of this kind in such a way as to render the reading fully satisfying. If one photographs Agadir in ruins, it is better to have a few signs of 'Arabness' at one's disposal, even though 'Arabness' has nothing to do with the disaster itself; connotation drawn from knowledge is always a reassuring force—man likes signs and likes them clear.

Perceptive connotation, cognitive connotation; there remains the problem of ideological (in the very wide sense of the term) or ethical connotation, that which introduces reasons or values into the reading of the image. This is a strong connotation requiring a highly elaborated signifier of a readily syntactical order: conjunction of people (as was seen in the discussion of trick effects), development of attitudes, constellation of objects. A son has just been born to the Shah of Iran and in a photograph we have: royalty (cot worshipped by a crowd of servants gathering round), wealth (several nursemaids), hygiene (white coats, cot covered in Plexiglass), the nevertheless human condition of kings (the baby is crying)—all the elements, that is, of the myth of princely birth as it is consumed today. In this instance the values are apolitical and their lexicon is abundant and clear. It is possible (but this is only a hypothesis) that political connotation is generally entrusted to the text, insofar as political choices are always, as it were, in bad faith: for a particular photograph I can give a right-wing reading or a left-wing reading (see in this connection an IFOP survey published by *Les Temps modernes* in 1955). Denotation, or the appearance of denotation, is powerless to alter political opinions: no photograph has ever convinced or refuted anyone (but the photograph can 'confirm') insofar as political consciousness is perhaps non-existent outside the *logos:* politics is what allows *all* languages.

These few remarks sketch a kind of differential table of photographic connotations, showing, if nothing else, that connotation extends a long way. Is this to say that a pure denotation, a *this-side of language*, is impossible? If such a denotation exists, it is perhaps not at the level of what ordinary language calls the insignificant, the neutral, the objective, but, on the contrary, at the level of absolutely traumatic images. The trauma is a suspension of language, a blocking of meaning. Certainly situations which are normally traumatic can be seized in a process of photographic signification but then precisely they are indicated via a rhetorical code which distances, sublimates and pacifies them. Truly traumatic photographs are rare, for in photography the trauma is wholly dependent on the certainty that the scene 'really' happened: *the photographer had to be there* (the mythical definition of denotation). Assuming this (which, in fact, is already a connotation);

the traumatic photograph (fires, shipwrecks, catastrophes, violent deaths, all captured 'from life as lived') is the photograph about which there is nothing to say; the shock-photo is by structure insignificant: no value, no knowledge, at the limit no verbal categorization can have a hold on the process instituting the signification. One could imagine a kind of law: the more direct the trauma, the more difficult is connotation; or again, the 'mythological' effect of a photograph is inversely proportional to its traumatic effect.

Why? Doubtless because photographic connotation, like every well-structured signification, is an institutional activity; in relation to society overall, its function is to integrate man, to reassure him. Every code is at once arbitrary and rational; recourse to a code is thus always an opportunity for man to prove himself, to test himself through a reason and a liberty. In this sense, the analysis of codes perhaps allows an easier and surer historical definition of a society than the analysis of its signifieds, for the latter can often appear as trans-historical, belonging more to an anthropological base than to a proper history. Hegel gave a better definition of the ancient Greeks by outlining the manner in which they made nature signify than by describing the totality of their 'feelings and beliefs' on the subject. Similarly, we can perhaps do better than to take stock directly of the ideological contents of our age; by trying to reconstitute in its specific structure the code of connotation of a mode of communication as important as the press photograph we may hope to find, in their very subtlety, the forms our society uses to ensure its peace of mind and to grasp thereby the magnitude, the detours and the underlying function of that activity. The prospect is the more appealing in that, as was said at the beginning, it develops with regard to the photograph in the form of a paradox—that which makes of an inert object a language and which transforms the unculture of a 'mechanical' art into the most social of institutions.

Wright Morris

"In Our Image"
1978

Writer, critic, and photographer, Wright Morris is probably best known as a novelist. To an extent, his writing career has obscured his reputation as a photographer. Morris has combined his two talents in several works that sensitively meld words and pictures. In the following essay, he accosts the supposed authenticity of the photographic image and our apparent preference for image over object. Like other thoughtful observers, most notably Susan Sontag in *On Photography*, Wright struggles with the proliferation of images brought on by photography and the changes such a surfeit has wrought in our lives.

Let us imagine a tourist from Rome, on a conducted tour of the provinces, who takes snapshots of the swarming unruly mob at Golgotha, where two thieves and a rabble rouser are nailed to crosses. The air is choked with dust and the smoke of campfires. Flames glint on the helmets and spears of the soldiers. The effect is dramatic, one, that a photographer would hate to miss. The light is bad, the foreground is blurred, and too much is made of the tilted crosses, but time has been arrested, and an image recorded, that might have diverted the fiction of history. What we all want is a piece of the cross, if there was such a

cross. However faded and disfigured, this moment of arrested time authenticates, for us, time's existence. Not the ruin of time, nor the crowded tombs of time, but the eternal present in time's every moment. From this continuous film of time the camera snips the living tissue. So that's how it was. Along with the distortions, the illusions, the lies, a specimen of the truth.

That picture was not taken, nor do we have one of the flood, or the crowded ark, or of Adam and Eve leaving the garden of Eden, or of the Tower of Babel, or the beauty of Helen, or the fall of Troy, or the sacking of Rome, or the landscape strewn with the debris of history— but this loss may not be felt by the modern film buff who might prefer what he sees at the movies. Primates, at the dawn of man, huddle in darkness and terror at the mouth of a cave: robots, dramatizing the future, war in space. We see the surface of Mars, we see the moon, we see planet earth rising on its horizon. Will this image expand the consciousness of man or take its place among the ornaments seen on T-shirts or the luncheon menus collected by tourists? Within the smallest particle of traceable matter there is a space, metaphorically speaking, comparable to the observable universe. Failing to see it, failing to grasp it, do we wait for it to be photographed?

•

There is a history of darkness in the making of images. At Peche Merle and Altamira, in the recesses of caves, the torchlit chapels of worship and magic, images of matchless power were painted on the walls and ceilings. These caves were archival museums. Man's faculty for image-making matched his need for images. What had been seen in the open, or from the cave's mouth, was transferred to the interior, the lens in the eye of man capturing this first likeness. The tool-maker, the weapon-maker, the sign-maker, is also an image-maker. In the fullness of time man and images proliferate. Among them there is one God, Jehovah, who looks upon this with apprehension. He states his position plainly.

> *Thou shalt not make unto thee any*
> *graven image, or any likeness of*
> *any thing that is in heaven above,*
> *or that is in the earth beneath, or*
> *that is in the water under the earth:*
> *. . . for I the Lord thy God am a jealous*
> *God. . . .*

Did Jehovah know something the others didn't, or would rather not know? Did he perceive that images, in their kind and number,

would exceed any likeness of anything seen, and in their increasing proliferation displace the thing seen with the image, and that one day, like the Lord himself, we would see the planet earth orbiting in space, an image, like that at Golgotha, that would measurably change the course of history, and the nature of man.

Some twenty years ago, in San Miguel Allende, Mexico, I was standing on a corner of the plaza as a procession entered from a side street. It moved slowly, to the sombre beat of drums. The women in black, their heads bowed, the men in white, hatless, their swarthy peasant faces masks of sorrow. At their head a priest carried the crucified figure of Christ. I was moved, awed, and exhilarated to be there. For this, surely, I had come to Mexico, where the essential rituals of life had their ceremony. This was, of course, not the first procession, but one that continued and sustained the tradition. I stood respectfully silent as it moved around the square, in the direction of the church. Here and there an impoverished Indian, clutching a baby, looked on. The pathetic masquerade of a funeral I had observed in the States passed through my mind. Although a photographer, I took no photographs. At the sombre beat of the drums the procession approached the farther corner, where, in the shadow of a building, a truck had parked, the platform crowded with a film crew and whirring cameras. The director, wearing a beret, shouted at the mourners through a megaphone. This was a funeral, not a fiesta, did they understand? They would now do it over, and show a little feeling. He wrung his hands, he creased his brows. He blew a whistle, and the columns broke up as if unravelled. They were herded back across the square to the street where they had entered. One of the mourners, nursing a child, paused to ask me for a handout. It is her face I see through a blur of confusing emotions. In my role as a gullible tourist, I had been the true witness of a false event. Such circumstances are now commonplace. If I had been standing in another position or had gone off about my business, I might still cherish this impression of man's eternal sorrow. How are we to distinguish between the real and the imitation? Few things observed from one point of view only can be considered *seen*. The multifaceted aspect of reality has been a commonplace since cubism, but we continue to see what we will, rather than what is there. Image-making is our preference for what we imagine, to what is there to be seen.

•

With the camera's inception an *imitation of life* never before achieved was possible. More revolutionary than the fact itself, it might

be practiced by anybody. Intricately part of the dawning age of technology, the photographic likeness gratified the viewer in a manner that lay too deep for words. Words, indeed, appeared to be superfluous. Man, the image-maker, had contrived a machine for making images. The enthusiasm to take pictures was surpassed by the desire to be taken. These first portraits were daguerreotypes, and the time required to record the impression on a copper plate profoundly enhanced the likeness. Frontally challenged, momentarily "frozen," the details rendered with matchless refinement, these sitters speak to us with the power and dignity of icons. The eccentrically personal is suppressed. A minimum of animation, the absence of smiles and expressive glances, enhances the aura of suspended time appropriate to a timeless image. There is no common or trivial portrait in this vast gallery. Nothing known to man spoke so eloquently of the equality of men and women. Nor has anything replaced it. With a strikingly exceptional man the results are awesome, as we see in the portraits of Lincoln: the exceptional, as well as the common, suited the heroic mould of these portraits. Fixed on copper, protected by a sheet of glass, the miraculous daguerreotype was a unique, one-of-a-kind creation. No reproductions or copies were possible. To make a duplicate one had to repeat the sitting.

•

Although perfect of its kind, and never surpassed in its rendering of detail, once the viewer's infatuation had cooled, the single, unique image aroused his frustration. Uniqueness, in the mid-19th century, was commonplace. The spirit of the age, and Yankee ingenuity, looked forward to inexpensive reproductions. The duplicate had about it the charm we now associate with the original. In the decade the daguerreotype achieved its limited perfection, its uniqueness rendered it obsolete, just as more than a century later this singularity would enhance its value on the market.

After predictable advances in all areas of photographic reproduction, it is possible that daguerreotype uniqueness might return to photographic practice and evaluation. This counter-production esthetic has its rise in the dilemma of over-production. Millions of photographers, their number increasing hourly, take billions of pictures. This fact alone enhances rarity. Is it beyond the realm of speculation that single prints will soon be made from a negative that has been destroyed?

•

Considering the fervor of our adoption it is puzzling that some ingenious Yankee was not the inventor of the camera. It profoundly

gratifies our love for super gadgets, and our instinct for facts. This very American preoccupation had first been articulated by Thoreau:

> If you stand right fronting and face to face to a fact, you will see the sun glimmer on both its surfaces, as if it were a cimiter, and feel its sweet edge dividing you through the heart and marrow, and so you will happily conclude your mortal career. Be it life or death, we crave only reality.

This might serve many photographers as a credo. At the midpoint of the 19th century a new world lay open to be seen, inventoried, and documented. It has the freshness of creation upon it, and a new language to describe it. Whitman has the photographer's eye, but no camera.

> Wild cataract of hair; absurd, bunged-up felt hat, with peaked crown; velvet coat, all friggled over with gimp, but worn; eyes rather staring, look upward. Third rate artist.

Or the commonplace, symbolic object:

> *Weapon shapely, naked, wan,*
> *Head from the mother's bowels drawn*

Soon enough the camera will fix this image, but its source is in the eye of the image-maker. Matthew Brady and staff are about to photograph the Civil War. In the light of the camera's brief history, does this not seem a bizarre subject? Or did they intuit, on a moment's reflection, that war is the camera's ultimate challenge? These photographers, without precedent or example, turned from the hermetic studio, with its props, to face the facts of war, the sun glimmering on all of its surfaces. Life or death, what they craved was reality.

A few decades later Stephen Crane stands face to face to a war of his imagination.

> He was being looked at by a dead man who was seated with his back against a columnlike tree. The corpse was dressed in a uniform that once had been blue, but was now shaded to a melancholy shade of green. The eyes, staring at the youth, had changed to the dull hue to be seen on the side of a dead fish. The mouth was open. Its red had changed to an appalling yellow. Over the gray skin of the face ran little ants. One was trundling some sort of bundle along the upper lip.

Crane had never seen war, at the time of writing, and relied heavily on the photographs of Brady and Gardner for his impressions. A decade after Crane this taste for what is real will flower in a new generation of writers. The relatively cold war of the depression of the 1930's will arouse the passions of the photographers of the Farm Security Administration, Evans, Lee, Lange, Vachon, Rothstein, Russell, and others. They wanted the facts. Few facts are as photographic as those of blight. A surfeit of such facts predictably restored a taste for the bizarre, the fanciful, the fabled world of fashion, of advertising, of self-expression, and of the photo as an *image*.

•

Does the word image flatter or diminish the photographs of Brady, Sullivan, Atget, and Evans? Would it please Bresson to know that he had made an "image" of Spanish children playing in the ruins of war? Or the photographers unknown, numbering in the thousands, whose photographs reveal the ghosts of birds of passage, as well as singular glimpses of lost time captured? Does the word image depreciate or enhance the viewer's involvement with these photographs? In the act of refining, does it also impair? In presuming to be more than what it is, does the photograph risk being less? In the photographer's aspiration to be an "artist" does he enlarge his own image at the expense of the photograph?

What does it profit the photograph to be accepted as a work of art? Does this dubious elevation in market value enhance or diminish what is intrinsically photographic? There is little that is new in this practice but much that is alien to photography. The photographer, not the photograph, becomes the collectible.

•

The practice of "reading" a photograph, rather than merely looking at it, is part of its rise in status. This may have had its origin in the close scrutiny and analysis of aerial photographs during the war, soon followed by those from space. Close readings of this sort result in quantities of disinterested information. The photograph lends itself to this refined "screening," and the screening is a form of evaluation. In this wise the "reading" of a photograph may be the first step in its critical appropriation.

A recent "reading" of Walker Evans "attempted to disclose a range of possible and probable meanings." As these meanings accumulate, verbal images compete with the visual—the photograph itself becomes a point of referral. If not on the page, we have them in mind. *The Rhetorical Structure of Robert Frank's Iconography* is the title of a recent paper. To students of literature, if not to Robert Frank, this will sound

familiar. The ever expanding industry of critical dissertations has already put its interest in literature behind it, and now largely feeds on criticism. Writers and readers of novels find these researches unrewarding. Fifty years ago Laura Riding observed, "There results what has come to be called Criticism. . . . More and more the poet has been made to conform to literature instead of literature to the poet—literature being the name given by criticism to works inspired or obedient to criticism."

Is this looming in photography's future? Although not deliberate in intent, the apparatus of criticism ends in displacing what it criticizes. The criticism of Pauline Kael appropriates the film to her own impressions. The film exists to generate those impressions. In order to consolidate and inform critical practice, agreement must be reached, among the critics, as to what merits critical study and discussion. These figures will provide the icons for the emerging pantheon of photography. Admirable as this must be for the critic, it imposes a misleading order and coherence on the creative disorder of image-making. Is it merely ironic that the rise of photography to the status of art comes at a time the status of art is in question? Is it too late to ask what photographs have to gain from this distinction? On those occasions they stir and enlarge our emotions, arousing us in a manner that exceeds our grasp, it is as photographs. Do we register a gain, or a loss, when the photographer displaces the photograph, the shock of recognition giving way to the exercise of taste?

In the anonymous photograph, the loss of the photographer often proves to be a gain. We see only the photograph. The existence of the visible world is affirmed, and that affirmation is sufficient. Refinement and emotion may prove to be present, mysteriously enhanced by the photographer's absence. We sense that it lies within the province of photography to make both a personal and an impersonal statement. Atget is impersonal. Bellocq is both personal and impersonal.

•

In photography we can speak of the anonymous as a genre. It is the camera that takes the picture; the photographer is a collaborator. What we sense to be wondrous, on occasion awesome, as if in the presence of the supernatural, is the impression we have of seeing what we have turned our backs on. As much as we crave the personal, and insist upon it, it is the impersonal that moves us. It is the camera that glimpses life as the Creator might have seen it. We turn away as we do from life itself to relieve our sense of inadequacy, of impotence. To those images made in our own likeness we turn with relief.

•

Photographs of time past, of lost time recovered, speak the most poignantly if the photographer is missing. The blurred figures characteristic of long time exposures is appropriate. How better to visualize time in passage? Are these partially visible phantoms about to materialize, or dissolve? They enhance, for us, the transient role of humans among relatively stable objects. The cyclist crossing the square, the woman under the parasol, the pet straining at the leash, are gone to wherever they were off to. On these ghostly shades the photograph confers a brief immortality. On the horse in the snow, his breath smoking, a brief respite from death.

These photographs clarify, beyond argument or apology, what is uniquely and intrinsically photographic. The visible captured. Time arrested. Through a slit in time's veil we see what has vanished. An unearthly, mind-boggling sensation: commonplace yet fabulous. The photograph is paramount. The photographer subordinate.

As a maker of images I am hardly the one to depreciate or reject them, but where distinctions can be made between images and photographs we should make them. Those that combine the impersonality of the camera eye with the invisible presence of the camera holder will mingle the best of irreconcilable elements.

•

The first photographs were so miraculous no one questioned their specific nature. With an assist from man, Nature created pictures. With the passage of time, however, man predictably intruded on Nature's handiwork. Some saw themselves as artists, others as "truth seekers." Others saw the truth not in what they sought, but in what they found. Provoked by what they saw, determined to capture what they had found, numberless photographers followed the frontier westward, or pushed on ahead of it. The promise and blight of the cities, the sea-like sweep and appalling emptiness of the plains, the life and death trips in Wisconsin and elsewhere, cried to be taken, pleaded to be reaffirmed in the teeth of the photographer's disbelief. Only when he saw the image emerge in the darkness would he believe what he had seen. What is there in the flesh, in the palpable fact, in the visibly ineluctable, is more than enough. Of all those who find more than they seek the photographer is preeminent.

In his diaries Weston speaks of wanting "the greater mystery of things revealed more clearly than the eyes see—" but that is what the observer must do for himself, no matter at what he looks. What is there to be seen will prove to be inexhaustible.

Compare the photographs of Charles van Schaik, in Michael Lesy's *Wisconsin Death Trip,* with the pictures in *Camera Work* taken at

the same time. What is intrinsic to the photograph we recognize, on sight, in van Schaik's bountiful archive. What is intrinsic to the artist we recognize in Stieglitz and his followers. In seventy years this gap has not been bridged. At this moment in photography's brief history, the emergence and inflation of the photographer appears to be at the expense of the photograph, of the miraculous.

•

If there is a common photographic dilemma, it lies in the fact that so much has been seen, so much has been "taken," there appears to be less to find. The visible world, vast as it is, through overexposure has been devalued. The planet looks better from space than in a close-up. The photographer feels he must search for, or invent, what was once obvious. This may take the form of photographs free of all pictorial associations. This neutralizing of the visible has the effect of rendering it invisible. In these examples photographic revelation has come full circle, the photograph exposing a reality we no longer see.

•

The photographer's vision, John Szarkowski reminds us, is convincing to the degree that the photographer hides his hand. How do we reconcile this insight with the photo-artist who is intent on maximum self-revelation! Stieglitz took many portraits of Georgia O'Keefe, a handsome unadorned fact of nature. In these portraits we see her as a composition, a Stieglitz arrangement. Only the photographer, not the camera, could make something synthetic out of this subject. Another Stieglitz photograph, captioned "Spiritual America," shows the rear quarter of a horse, with harness. Is this a photograph of the horse, or of the photographer?

•

There will be no end of making pictures, some with hands concealed, some with hands revealed, and some without hands, but we should make the distinction, while it is still clear, between photographs that mirror the subject, and images that reveal the photographer. One is intrinsically photographic, the other is not.

Although the photograph inspired the emergence and triumph of the abstraction, freeing the imagination of the artist from the tyranny of appearances, it is now replacing the abstraction as the mirror in which we seek our multiple selves. A surfeit of abstractions, although a tonic and revelation for most of this century, has resulted in a weariness of artifice that the photograph seems designed to remedy. What else so instantly confirms that the world exists? Yet a plethora of such affirmations gives rise to the old dissatisfaction. One face is the world, but a world of faces is a muddle. We are increasingly bombarded by a

Babel of conflicting images. How long will it be before the human face recovers the aura, the lustre and the mystery it had before TV commercials—the smiling face a debased counterfeit.

•

Renewed interest in the snapshot, however nondescript, indicates our awareness that the camera, in itself, is a picture-maker. The numberless snapshots in existence, and the millions still to be taken, will hardly emerge as art objects, but it can be safely predicted that many will prove to be "collectibles." Much of what appears absurd in contemporary art reflects this rejection of romantic and esthetic icons. The deployment of rocks, movements of earth, collections of waste, debris and junk, Christo's curtains and earthbound fences, call attention to the spectacle of nature, the existence of the world, more than they do the artist. This is an oversight, needless to say, the dealer and collector are quick to correct. Among the photographs we recognize as masterly many are anonymous. Has this been overlooked because it is so obvious?

•

If an automatic camera is mounted at a window, or the intersection of streets, idle or busy, or in a garden where plants are growing, or in the open where time passes, shadows shorten and lengthen, weather changes, it will occasionally take exceptional pictures. In these images the photographer is not merely concealed, he is eliminated. Numberless such photos are now commonplace. They are taken of planet earth, from space, of the surface of the moon, and of Mars, of the aisles of stores and supermarkets, and of much we are accustomed to think of as private. The selective process occurs later, when the photographs are sorted for specific uses. The impression recorded by the lens is as random as life. The sensibility traditionally brought to "pictures," rooted in various concepts of "appreciation," is alien to the impartial, impersonal photo image. It differs from the crafted art object as a random glance out the window differs from a painted landscape. But certain sensibilities, from the beginning, have appreciated this random glance.

The poet, Rilke, snapped this:

> In the street below there is the following composition: a small wheelbarrow, pushed by a woman; on the front of it, a hand-organ, lengthwise. Behind that, crossways, a baby-basket in which a very small child is standing on firm legs, happy in its bonnet, refusing to be made to sit. From time to time the woman turns the handle of the organ. At that the

small child stands up again, stamping in its basket, and a little girl in a green Sunday dress dances and beats a tambourine up toward the windows.

This "image" is remarkably photogenic. Indeed, it calls to mind one taken by Atget. The poet is at pains to frame and snap the picture, to capture the look of life. His description is something more than a picture, however, since the words reveal the presence of the writer, his "sensibility." This very sensitivity might have deterred him from taking the snapshot with a camera. Describe it he could. But he might have been reluctant to take it. In his description he could filter out the details he did not want to expose. From its inception the camera has been destined to eliminate *privacy*, as we are accustomed to conceive it. Today the word describes what is held in readiness for exposure. It is assumed that privacy implies something concealed.

The possibility of filming a life, from cradle to the grave, is now feasible. We already have such records of laboratory animals. If this film were to be run in reverse have we not, in our fashion, triumphed over time? We see the creature at the moment of death, gradually growing younger before our eyes. I am puzzled that some intrepid avant garde film creator has not already treated us to a sampling, say the death to birth of some short-lived creature. We have all shared this illusion in the phenomenon of "the instant replay." What had slipped by is retrieved, even in the manner of its slipping. Life lived in reverse. Film has made it possible. The moving picture, we know, is a trick that is played on our limited responses, and the refinement of the apparatus will continue to outdistance our faculties. Perhaps no faculty is more easily duped than that of sight. Seeing is believing. Believing transforms what we see.

•

If we were to choose a photographer to have been at Golgotha, or walking the streets of Rome during the sacking, who would it be? Numerous photographers have been trained to get the picture, and many leave their mark on the picture they get. For that moment of history, or any other, I would personally prefer that the photograph was stamped *Photographer Unknown*. This would assure me, rightly or wrongly, that I was seeing a fragment of life, a moment of time, as it was. The photographer who has no hand to hide will conceal it with the least difficulty. Rather than admiration, for work well done, I will feel the awe of revelation. The lost found, the irretrievable retrieved.

Or do I sometimes feel that image proliferation has restored the value of the non-image. Perhaps we prefer Golgotha as it is, a construct

of numberless fictions, filtered and assembled to form the uniquely original image that develops in the darkroom of each mind.

Images proliferate. Am I wrong in being reminded of the printing of money in a period of wild inflation? Do we know what we are doing? Are we able to evaluate what we have done?

Index

VICKI GOLDBERG studied art history at New York University's Institute of Fine Arts and taught undergraduates for several years. She has written on art and photography for such magazines as *Réalités*, *Saturday Review*, and *The Village Voice*, and is a contributing editor to *American Photographer*.